BURT FRANKLIN: BIBLIOGRAPHY & REFERENCE SERIES 8

A DICTIONARY

OF

MINIATURISTS

ILLUMINATORS, CALLIGRAPHERS

AND COPYISTS

—

VOL. III.

A DICTIONARY

OF

MINIATURISTS

ILLUMINATORS, CALLIGRAPHERS

AND COPYISTS

WITH REFERENCES TO THEIR WORKS, AND NOTICES OF THEIR PATRONS

From the Establishment of Christianity to the Eighteenth Century

COMPILED FROM VARIOUS SOURCES
MANY HITHERTO INEDITED

BY JOHN W. BRADLEY,

IN THREE VOLUMES.

VOL III.

BURT FRANKLIN
New York, N. Y.

Published by LENOX HILL Pub. & Dist. Co. (Burt Franklin)
235 East 44th St., New York, N.Y. 10017
Originally Published: 1887-1889
Reprinted: 1973
Printed in the U.S.A.

Burt Franklin: Bibliography and Reference Series 8

The Library of Congress cataloged the original printing of this title
as follows.

Bradley, John William, 1830-1916.
 A dictionary of miniaturists, illuminators, calligraphers, and
copyists, with references to their works, and notices of their patrons,
from the establishment of Christianity to the eighteenth century.
New York, B. Franklin 1958.

 3 v. 25 cm. (Burt Franklin bibliographical series,8)
 1. Artists—Dictionaries. 2. Illumination of books and manuscripts. 3. Calli-
graphers. 4. Copyists.
ND2890.B83 703 61-35160
ISBN 0-8337-0353-6

A DICTIONARY

OF

MINIATURISTS,

ILLUMINATORS, CALLIGRAPHERS,

AND COPYISTS.

—

VOL. III.

DICTIONARY OF MINIATURISTS.

OBERTO, FRANCESCO DI. *Miniaturist.* **Saec. XIV.**
Of Genoa.

> An artist who worked in 1368 at Ferrara.—*Cittadella: Notizie relative a Ferrara*, 640.

OBREGON, PEDRO DE. *Miniaturist.* **Saec. XVI.**
A Spaniard.

> Painted in 1564 the Prayer-books used at vespers, of the Cathedral of Toledo.—*Bermudez: Diccionario, &c.*, iii. 246.

OBREGON, PEDRO DE. *Miniaturist.* **Saec. XVI.**
Probably son of the preceding.

> Was a painter and engraver, and a pupil of Vincencio Carducho. He was born at Madrid in 1597. Died 1659.—*Bermudez: Ibid.*

VOL. III. B

OBRY, JEAN. *Illuminator.* Saec. XV.
A native of Amiens.

Illuminated in 1484 the "Livre des Compositions intervenues entre l'Évêque d'Amiens et les maire et échevins de la même ville." It appears, however, that his occupation was not a profitable one, for he was obliged to add to it that of gatekeeper of the porte-Beauvais ; and used to do this service and sweep the road in front for the modest sum of 40 sols a year.—*Dusevel : Recherches historiques sur les Ouvrages exécutés dans la Ville d'Amiens*, 31. Obry's experience was not singular. So little was the encouragement to art in Amiens for many years, that in 1518 no painter was found there equal to the task of illuminating the Book of "Chants Royaux," executed for presentation to Louise de Savoie. *See* PINCHON.

OCHON, JOANNES. *Copyist.* Saec. XVI.

Employed in the Apostolic Chamber in 1537, as "scriptor librorum," under Paul III.—*Müntz : La Bibliothèque du Vatican au XVI⁰ Siècle*, 101.

ODEBERT. *Copyist.* Saec. X. et XI.
Abbot of St. Bertin.

Assisted between 980 and 1008 in the execution of a Psalter now in the Public Library at Boulogne.—*Cahier : Biblioth.*, 132. —*Dehaisnes : l'Art, &c.*, 34–36.

ODERICO. *Miniaturist.* Saec. XIII.
A Canon of Siena.

Executed the miniatures of an "Ordo Officiorum Senensis Ecclesiæ," preserved in the Library of the Royal Academy of Siena. It has initials containing little pictures, and borders with animals. The pictures are wretchedly dry and poor, but valuable as belonging to the year 1213. The MS. was published at Bologna in 1766, by Trombelli. Della Valle's idea that he might be the same as Oderigo d' Agobbio is quite untenable, for apart from Dante's reference to the latter as of Gubbio near Perugia, and other objections, an artist who died about 1300 could scarcely have been working in 1213.—*Lanzi : Storia Pittorica della Italia, &c.*, i. 256 (4th edit. Firenze).—*Della Valle : Lettere Senesi*, i. 278.—*Zani : Enciclopedia Metodica*, xiv. 122.

ODERISI, GUBBIO DA. *Miniaturist.* Saec. XIII.

A famous miniaturist of Tuscany, placed by Dante among those punished for pride, in his "Purgatory," canto xi., 79–84, in the well-known lines :—

"Non se' tu Oderisi [Oderigi]
L' onor d' Agubbio e l' onor di quell' arte
Ch' alluminar e chiamata in Parisi
Frate, diss' egli, più ridon le carte
Che penelleggia Franco Bolognese
L' onore è tutto or suo, e mio in parte."

The painter's reply shows that he had repented of his pride and now placed Franco Bolognese above himself. Who Oderisi or his master was, is not certainly known. Baldinucci assigns him to the school of Cimabue. Nagler places him at Bologna, and calls Franco the Giotto of the Bolognese School. Oderisi, however, died in 1299, the year before Cimabue, and Giotto entered Cimabue's studio in 1286, when he was only ten years old ; he was, therefore, still a boy when Oderisi was grown up. The first who mentions him after Dante was his earliest commentator, whose

words are "Oderigi d' Agobbio essere stato miniatore ottimo, il quale, vedendosi così eccellente nella sua arte, montò in grande superbia, ed aveva opinione che miglior miniatore di lui non fosse al mondo." And Benvenuto da Imola, in his comment on the same passage adds: "Iste Oderisius fuit magnus miniator in civitate Bononia qui erat valde vanus jactator de arte sua.' Vasari says : " Fu in questo tempo *a Roma* molto amico di Giotto, per non tacere cosa degna di memoria che appartenga all' arte, Oderigi d' Agobbio, eccellente miniatore in quei tempi ; il quale, condotto per ciò dal papa, miniò molti libri per la libreria di palazzo, che sono in gran parte oggi consumati dal tempo. E nel mio libro de' disegni antichi, sono alcune reliquie di man propria di costui, che in vero fa valente uomo." If the work of Oderigi had mostly perished by the lapse of years in Vasari's time, it is still more hopeless now to expect any "relics of his hand." It is, however, just possible that something, which is now not even suspected to exist, may turn up in the Vatican Library.—*Rosini: Storia della Pittura Italiana, &c.*, i. 179 (Pisa, 1848).—*Nagler*, v. 414.— *Vasari: Vite, &c.*, i. 321 (*Lemonnier*, 1846). The above appears to be all that is known about Oderigi ; though Baldinucci, whom Lanzi critizes severely, says much more. Lanzi's opinion was that Oderigi, as a miniaturist, was not likely to have studied under Cimabue, a fresco painter. But there is no weight in this opinion, for Pietro da Perugia and Stefano da Verona, mentioned together by Vasari in the Life of Agnolo Gaddi, were excellent fresco-painters and also miniaturists. It is, however, most probable that Oderigi worked and studied in Bologna, and not in Florence or Siena.—*Vasari*, ii. 156 (*Lemonnier*).—*Lanzi : Storia Pittorica della Italia, &c.*, i. 21-23 ; ii. 11 ; v. 9-11 (4to ed. Firenze).—*Giornale d' Erudizione artistica* (Perugia, 1873), ii. 1.

OISBERT. *Calligrapher.* Saec. XI.
 A Monk at Lisieux.

 Illuminated several MSS. in the Monastic Library, Citeaux.— *Hist. Littér. de la France*, ix. 98.

OLBERT. *Copyist.* Saec. IX.
 Abbot of Gembloux.

 Set the example of transcribing to his monks.—*Cahier : Biblioth.*,
 130.—*D'Achery : Spicilegium*, vi. 529.

OLIVA, FRANCESCO. *Miniaturist and Cartographer.*
 Saec. XVII.

 " Franciscus Oliva me fecit in civitate Marsilia."—*Zani :
 Encicloped. Metod.*, xiv. 133. *See* RIEZO.

OLIVA, JOANNES. *Miniaturist and Cartographer.*

 Executed a portolano on vellum, containing ten charts of the
 Coasts of Europe in Italian. Large fol. On fol. 10 *v.*–11,
 " Typus orbis terrarum " with an oblong elliptical cartel. At foot
 in black capitals : " Joannes Oliva fecit in ciuitate Marsiliæ Año
 1613." Now in Brit. Mus., *Egert. MSS.*, 813.

OLIVAS, FRAY CONSTANCIO DE MONTE. *Copyist.*
 Saec. XVI.

 Wrote a Roman Missal in 1512. Finely illuminated with the
 music on an old tetragram. Formerly belonged to the Cathedral of
 Toledo. Now in the Bibl. Nac. de Madrid, 526.—*Riaño : Notes
 on Early Spanish Music*, 68.

OLIVER, } ISAAC. *Miniaturist.* Saec. XVI.
OLIVIER, }

Born 1556 (*Nagler* says 1551). Died 1617.

Probably of French extraction, as on his drawings he spells his name Olivier, though Oliver in his will. One of the most celebrated of English portrait miniaturists, studied first under Nicholas Hilliard, then under Federigo Zuccaro. His characteristics are delicate fidelity to nature and elaborate finish of execution. In this he differs from Cooper, his nearest rival, whose work, though most masterly, is of a rougher and bolder type. Some of Oliver's finest works were formerly in the collection of Dr. Meade. Among them was a portrait of himself, a head of Mary Queen of Scots, which Zinck copied in enamel, Queen Elizabeth, Henry Prince of Wales, a full-length of Sir P. Sidney and Ben Jonson. These passed into the collection of the Prince of Wales. Walpole says he himself possessed the best preserved of all his works—a head of Lady Lucy Percy, mother of Lady Digby. Another of his remarkable works is the group of Lord Montacute and his brother. It bears Oliver's monogram, O crossed by I, forming a Greek Φ. His portrait of James I. served for Vandyke's picture. In an account-book of Lord Harrington, the King's Treasurer, was an entry of payment to Isaac Oliver, picture-drawer, by a warrant dated Lincoln, April 4th, 1617, for four several pictures drawn for the prince's highness, with account annexed, for £40. In Charles I.'s Catalogue are accounts of several of his works. James II. had still more, the Earl of Arundel many others. Many of Oliver's works are at present in the Royal Collection. He occasionally painted sacred and historical subjects, one of his finest being an Entombment. *Walpole: Anecdotes of Painting in England*, i. 176–182 (Wornum).—*Nagler*, x. 336.

OLIVER, } PETER. *Miniaturist.* Saec. XVII.
OLIVIER, }

Born in London between 1594 and 1601.

Studied under his father, Isaac Oliver, and worked chiefly, but by no means exclusively, on portrait-painting. His copies from

the old Masters in the collection of Charles I. are among his best works. Most of them are still in the Royal Collection. One of his finest portraits,—that of his wife,—belonged to the Duchess of Portland. " A Holy Family," 8 in. by 5 in., is mentioned by Vertue as of singular merit. It was in Mr. Halsted's sale in 1726, and bore the artist's signature, " P. Ollivier fecit 1628." A number of his own and his father's best works were found in an old mansion in Wales belonging to the Digbys, and were preserved by the descendants of Sir Kenelm Digby, some dated as late as 1633. Among them were many portraits of members of the Digby family. One very fine miniature was a copy after Vandyke of the knight and his wife and children. But the most perfect miniature in the world, according to Walpole, was the portrait of Lady Lucy Percy, mother of the beautiful Lady Venetia Digby. They were bought at a great price by the owner of Strawberry Hill, and very highly valued by him. At the great sale of the Strawberry Hill Collection this famous miniature was bought by Robert Holford, Esq., for 100 guineas. Wornum adds a list of purchasers of other miniatures. Considering the great number of miniatures that Peter Oliver must have painted, Walpole thought it extraordinary that so few were known. Sir Andrew Fountaine lost many miniatures by a fire at White's old chocolate house in St. James's Street, about 1758, and possibly some of Oliver's were among them. Peter died in 1647, and was buried in St. Anne's, Blackfriars.— *Walpole: Anecdotes of Painting, &c.,* i. 221–226 (Wornum). —*Propert: A History of Miniature Art,* 69 (1887, sm. fol.).

OLIVIER, } *See* OLIVER.
OLLIVIER, }

OLLIVIER, MARTIN. *Copyist.* Saec. XIII.

Wrote the copy of the Decretals of Gratian, now MS. lat. 16,899, National Library, Paris.—*Delisle: Cabinet des MSS.,* ii. 245.

OLMUCZ,
OLMŰTZ, } JACOB VON. *Miniaturist.* Saec. xv. et xvi.

Illuminated at Bechinia in 1499, 1500, a large Gradual in two volumes, now in the Ambras Collection at Vienna.—*Primisser : Die K.K. Ambraser-Sammlung*, 257-8. They were executed for Ladislaus von Sternberg. Very large fol. Vol. i. 198 ff. ; vol. ii. 212 ff. Vol. i., on fol. i. *v.* in the lower border are the arms of Sternberg (*az.* an 8-rayed star, *or*).

Fol. 23. In the dead-gold nimbus of the Virgin Mary, " Jacobus de Olomuncz me fecit 1499," in late Gothic minuscules. The artist's name appears again on fol. 171 *v.*

Vol. ii. fol. 2 *v.* In the nimbus of Christ again the name of the artist.

Fol. 5 *v.* " Jacobus de Olomuncz me fecit in Bechinia."

On fol. 96 *v.* is the date 1500 at the end of a short prayer, on a label.

Fol. 98 *v.* Again the artist puts his name, adding the place, as *Castrum Bechinense.*

Fol. 121 *v.* Signature again.

Fol. 176 *v.* He is named twice, once with the date 1500, and on the same page Ladislaus (Stebliger) Sternberg is named, with his arms, once more.

Seventeen large and twenty small initials and borders are executed in the MSS. The larger initials are adorned with foliages, while the borders enclose scenes from Holy Writ. Among the foliages of the borders are small figures in local and contemporary costume. The miniatures and historiations on the initials are executed in crude body colours and pencil-gold ; the latter being in less use than leaf. Both volumes are noticed in the Inventory of 1613, 83, 84.—*Sacken : Die K.K. Ambraser-Sammlung.* Wien, 1855.—*Waagen : Die vornehmsten Kunstdenk-mäler in Wien*, ii. 360. The completest account, however, together with a heliogravure of a piece of the border-painting, is given by *Frimmel (Dr. Th.) : Urkunden, Regesten u. Artistisches Quellenmaterial aus der Bibliothek der Kunsthistorischen Samm-lungen des Allerhöchsten Kaiserhauses*, viii. xi. Wien, 1887. 4°.

ONKRINT, THEOD. *Miniaturist.* Saec. XVIII.

Practised chiefly in portrait, at Utrecht, about 1770,

being then about fifty years old.—*Nagler: Künstlerlexicon*, x. 356.

Opizon. *Calligrapher.* Saec. x. et xi.
A Monk at Clugny.
Serapeum for 1844, 39.

Opizon, De Cizus (Cisus). *Copyist.* Saec. xv.

Wrote at Parma in 1428, "M. T. Ciceronis De Oratore ad Qu. Fratrem. Lib III. Orator ad Brutum." Sm. fol. Vell. 115 ff. At end: "M. T. Ciceronis ad Quintum fratrem et etiam Orator. similiter et Brutus explicit, ad instantiam viri nobilis et egregii Andreæ de Valeriis de Parma per me Opizonem de Cisiis scriptorem et civem Parmensem ann. dñi MCCCCXXVIII die undecimo mensis Februarii." Now in Library of St. Mark's, Venice.— *Zanetti: Lat. et Ital. D. Marci. Bibl. Codd. Msstor., &c.*, 167. 1741. Fol.

Oppavia, Johannes de. *Copyist.* Saec. xiv.
Priest and Canonicus of Brünn.

Wrote in 1368, a most splendid "Evangeliarium." Vell. Fol. 191 ff. Now in the Imperial Library at Vienna. It is written mostly in golden letters, in a firm and handsome Gothic text. Initials historiated, and at the beginnings of chapters illuminated in gold and colours. Almost every page is surrounded by a blue band-like border, with red and gold corners, executed with the utmost care and patience. The Version is that of the Latin Vulgate.

Fol. 1 *v.* sets forth the Acts of St. Matthew in twelve large minia-
tures, whilst attached to the four corners are the arms of the four
provinces of the Austrian Empire,—Styria, Austria, Tyrol, and
Carinthia, from which Denis conjectured that the MS. was executed
either to the order of, or for presentation to, Albert III., Archduke
of Austria. The arms, by the way, of Styria, are *vert:* a lion
rampant, having two tails, *arg.* Those of Austria proper: per
pale 1. *az.* 5 eaglets displayed *or;* 2. *gu.* a fess *arg.* Those of
Tyrol: *arg.* an eagle displayed *gu.* crowned and collared *or.*
Those of Carinthia: *arg.* an eagle displ. *az.*, crowned *or*, and
bearing on its breast a crescent, chequé, *or* and *gu.* Albert III.,
son of Albert the Wise, Duke of Austria, and his three brothers
were the first to bear the title of Archdukes, although none of
their dominions were called Archduchies. In 1379 he acquired
Austria and parts of Styria by treaty with his brother Leopold, who
was killed in 1386 at the battle of Sempach. In 1387, by arrange-
ment with his nephews, he undertook the administration of Carin-
thia and all the other domains of his house, having by treaty made
the previous year been expressly named Duke of Austria, Styria,
Carinthia, and Carniola, Count of Tyrol, &c. He died at Luxem-
burg in 1395.

Fol. 2 begins the Gospel of St. Matthew, and is entirely occupied
with the initial L. It is adorned with the figures of angels playing
various musical instruments; while surrounding it in a five-fold
series of heads of both sexes. Denis could not decide whether
these were intended for progenitors of Christ or of the Archduke.
In the margin is continued the text in Gothic letters, "Iber
generationis ihesu christi filii David filii Abraham."

Fol. 55 *v.* The beginning of St. Mark's Gospel is similarly treated
to that of St. Matthew's, except that in place of Styria are placed
the arms of Austria. On the following folio is the initial I,
occupying the full page except the border, and then the text as
before.

Fol. 91 *v.*, beginning St. Luke's Gospel, exhibits the insignia of
Austria again, and the next folio, 92, a splendid initial F, with
continuation in margin "Uit in diebus herodis regis judee." Thus
it omits the usual preface to Theophilus.

Fol. 148 *v.*, which begins the Gospel of St. John, has insignia as
before and a superb initial I on the following page, with continuation
"N principio," &c. At the foot of this page, in lines alternately
gold and blue, and Gothic letters nearly half an inch in height, is
this inscription: "Et ego Joh'es de Oppavia psbiter Canonic⁹

Brunniensis Plebanus in Lantskrona hunc librum cum auro puris-
simo de penna Scripsi Illuminavi Atq: deo cooperante 9plevi. In
anno domini Millesiō Trecentesimo Sexageūs VIII°." Oppavia
is now called Troppau, and is a town of Austrian Silesia. In the
fifteenth century the MS. came to Frederick III., who added his
device, A. E. I. O. V., on fol. 1 *v*. Of this device Lambecius
gives no fewer than forty interpretations. One found in the
Emperor's handwriting after his death is : " Austriæ est imperare
orbi universo." " It is the business of Austria to govern the
whole world." The modesty of this version confirms its accuracy.
The pacific Emperor "pro merito" had the precious volume
enclosed in a silver gilt case, with clasps, on which is engraved the
above device, with the date 1446 :—*Denis : Catal. Codd. Theol.*
&c., Vindobon, i. 120.—*Silvestre : Paléogr. Univ.* Pl. CCLXIII.
(Eng. tr., ii. 729).—*Palliser : Historic Devices, &c.* 88.—*L'Art de
Vérifier les Dates,* xvii. 44. Paris, 1819. 18 vols. 8°.

OPPIERI, NICOLÒ DEGL'. *Miniaturist.* Saec. XV.

Employed at Ferrara.—*Cittadella: Notizie relative a Ferrara,* 70.

ORLANDINI, FRANCESCO. *Miniaturist.* Saec. XVIII.

Worked at Venice.—*Zani: Enciclop. Metod.,* xiv. 162.

ORLÉANS, FAMILY OF. *Patrons.* Saec. XIV. et XVI.

In the notice of Charles V., King of France, we recorded the
beginnings of the various libraries founded by the different mem-
bers of the Royal Family. Charles was himself the originator of

the collection afterwards known as the Library of the Louvre. Two of his brothers, perhaps even more generally renowned than himself for their love and patronage of the arts, were lavish in their expenditure on books. The elder Louis, called Louis I., Duke of Anjou, was the founder of the second branch of the kings of Naples and Sicily, and expended his life and fortune on the evil bequest. The younger was the famous John, Duke of Berry, whose splendid MSS. have given a character to the book-illumination of the time, and still remain as the typical examples of the art at the period of, perhaps, its noblest development. A third brother, Philip, called *Le Hardi*, founder of the second branch of the Dukes of Burgundy, was also gifted with like tastes, but was moderate in their indulgence. But, prodigal and extravagant as were the elder of these princes, they were surpassed by their nephew, Louis, Duke of Orleans, the ancestor of the Royal branch of that great family. During the troubles of the reign of Charles VI. Louis was the central political figure, and his excesses, his unblushing and unscrupulous usurpations, in the face of his uncles and the will of the French people, made him hated, both in public and private life. His assassination in the Rue Barbette in 1407 was the natural end of his reckless and dissipated career. He was the founder of the Library at Blois. In 1393 Jehan Frois-sart presented to him his " Dit Royal." His name appears repeatedly in illuminated books, as either the giver or recipient, and especially in the Blois Bibles, and in the great " Mirouer historial " of Vincent de Beauvais, compiled for Saint Louis, and translated by Jehan de Vignay. The quittance for the writing and illumination of Louis's copy of the " Mirouer," in four volumes, is still preserved. Of this, vols. i., ii., and iv. are now in the National Library at Paris (Fds. fr., 312-314). But his more distinguished son, Charles, sometimes called the Poet, who, for twenty-five years, was a prisoner in England, possessed a still greater collection of precious manuscripts. His library in the Château of Blois was the nucleus of that which subsequently became celebrated by the addi-tions of his son Louis, afterwards Louis XII., and his grand-nephew Francis, Count of Angoulême, afterwards Francis I. Its contents have been described by various writers, particularly by M. Leroux de Lincy in *La Bibliothèque de l'Ecole des Chartes*, v. 59. The Inventory which Charles of Orleans had made in 1427 still exists in the Paris National Library. He was then a prisoner in England, and, learning that the English army in France were resolved to destroy the party of Charles VII., and were advancing

upon the Loire, naturally became alarmed for the safety of his property at Blois, and had the books and other valuables removed to Saumur in Anjou, and deposited in the mansion of the Seigneur de Mortemart, his chamberlain. Accordingly this was done, and among the documents preserved in the vast collection of charters, quittances, letters, &c., forming the so-called Archives de Joursanvault, at Paris, is the following : (Article 3,510) "Charles d'Orleans ordonne a H. de Saint Mars et a H. Perrier d'aller a la Rochelle pour retirer des mains du sire de Mortemart *les chartes, liuures, bijoux, tapisseries,* &c., qui lui auaint été remis lorsque les Anglais vinrent mettre le siége à Orleans, 1435." It is seen from the catalogue or inventory of the books that many of them are not only signed with the names of Charles or his father, but are richly "esmaillies aux armes de Monseigneur d'Orleans." Some, of course, are heirlooms from his great-grandfather ; others written and illuminated to his own order. Among the copyists employed by Louis were Thevenin and Etienne Angevin, and Jehan Colin, and Colard de Laon is named among the painters as "paintre et valet de chambre de Monseigneur le duc d'Orliens." Thevenin Angevin appears as the copyist and perhaps illuminator of the "Mirouer historial" already mentioned (3 Juin, 1396. Archives de Joursanvault, No. 838). "Sachent tuit que je Theuenin Angeuin confesse auoir eu et receu de Monseigneur le duc d'Orliens, par les mains de Godefroy Lefeure varlet de chambre du dit seigneur, la somme de cinquante francs, pour acheter parchemins et escrire et enluminer le liure nomme le Mirouer historial et autres liures. En tesmoing de ce jay escript ceste cedule de ma propre main le tiers jour de juing l'an mille iiie iiiixx et xvi. T. Angeuin." Similarly the documents still exist showing that in 1463 "Angelot de la Presse, peintre et enlumineur," was employed by Charles to illuminate *and bind* a Missal, to present to Notre Dame de Chambourdin. This was two years before the duke's death. There are several MSS. in the National Library, Paris, in which his autograph occurs, *e.g.,* in 7,203 MS. fr., "L'apparition Maitre Jehan de Meun, par Honnoré Bonnet." The MS. was written for Valentina of Milan, his mother, and contains her arms : parti : 1. France, 2. Orléans. "Ce liure est a Charles duc d'Orliens, &c. Charles." The arms of Orleans occur repeatedly. They are *az.* des fleurs de lis d'*or ;* en chef, un lambel de trois points, *arg.* (MS. fr., 7,276, "Traduct. de l'Imitation de Jesus Christ," &c., 7,163. "Compendium Romanorum Historiar.," &c.). The portrait of Charles occurs in a MS. decorated with his arms,

which belonged to his third wife, Marie de Clèves (MS. fr., 966), executed about 1451. It was carelessly engraved about 1780 by G. S. Gaucher. The Royal MS. 16 F II. in the British Museum has miniatures in which he is represented, but without any very serious attempt at portraiture —*Paris: Les MSS. fr., &c.,* ii. 222; iv. 261, &c.—*Didot: Nouvelle Biographie Générale,* xxxviii. 805, &c.— *L'Illustration,* 1845, vi. 253.—*Millin: Antiquités Nationales,* i. pl. 11 —*Vallet de Viriville: Visite du British Museum, Notice du MS. Reg.* 16 (16 F II.), *contenant les poés. de Ch. d'Orleans,* in *Bulletin du Bibliophile,* 1845.—*Le Roux de Lincy: La Bibliothèque de Charles d'Orléans à son Château de Blois en* 1427 (Paris, 1843, 8°). According to a supposed discovery of MM. Buchon and Kervyn de Lettenhove, Charles of Orleans is stated to be the author of a French translation of the Consolation of Boethius which is dedicated to Charles VII. about 1423 — *Études de Froissart,* 1857, 16°, ii. 343. M. Delisle, however, denies this attribution, although previously assented to by M. Paulin Paris and M. Vallet de Viriville. He shows that the portion supposed to have been addressed to Charles VII. in 1422 already existed in 1414. A copy (Fds. fr., 12,459) has this subscription : "Cy fine le liure de Boëce de Consolacion, escript par la main de Jehan de Lengres, clerc, et fut complet le xxie jour du moys d'auril lan mil cccc et xiiii. Dieu doient a cellui qui la fait escripre bonne vie et a lescripuain paradis. Amen.—*Delisle. Anciennes Traductions françaises de la Consolation de Boëce Con-servées à la Bibl. Nationale,* 1873, 28.—*Delisle: Le Cabinet des MSS.,* i. 98-121 ; iii. 344-5. Among Orléans MSS. may be mentioned the following in the National Library, Paris :— No. 7,133. "Le Miroir du Mondes," en 2 livres. Sm. folio. 114 ff. 2 cols. Pretty miniatures, vignettes, and initials, fifteenth century. (Fontainebleau, No. 645.—*Anc. Catalogue,* 421.) At bottom of frontispiece the arms of France, au lambel d'argent a trois pendants chargés d'un croissant de gueules parti de Rohan. These are the arms of Jean d'Orleans, Comte d'Angoulême, husband of Marguerite de Rohan. The MS. is a *résumé* of ancient history to the coming of Christ. It is neither Orosius, nor V. de Beauvais, nor J. Mansel, but probably an abridgment of the "Fleur des Histoires" of the latter. Genesis furnishes the author with his first fourteen chapters. Then we pass on to the Realm of Féminie, *i.e.,* the Amazons. Then to those of Egypt and Troy. On fol. 8 we see that dances were invented by the devil on the occasion of the honours rendered by Ninus to

the memory of Belus. Book ii. commences with the history of Moses. The Trojan War and the Roman history to Augustus are related at length. The last chapter is "Comment Octavien voulut faire nombrer le peuple de son règne."

No. 7,031. "Le Rational des divins Offices, de Guill. Durant evêque de Mende, traduit par Jehan Golein." Large 4°. 398 ff. Vellum, 2 cols. Vignette and initials, fourteenth century. (Fontainebleau, 671.—*Anc. Catal.*, 22.)

This beautiful volume was executed for Charles V. in 1374, On fol. 398 are the words : " Cest livre nome . Rasional . des . divins. ofices . est a nous Charles le V. de nostre nom . et le fimes translater escrire et tout . parfere." Then, in the same hand, but later, "L'an M.ccc.Lxxiiii (1374)." It was carried off, among those bought by the Duke of Bedford, to England, and was rebought by Jean, Count of Angoulême, as seen on a folio pasted into the cover : "Cest liure est a Jehan Conte d'Angolesme, lequel lacheta a Londres en Engleterre lan de grace, 1441." Jean was the third son of Louis, Duke of Orleans, and of Valentine of Milan. Like his brother, Charles of Orleans, he employed the time of his captivity in rebuying books which had formerly belonged to his grandfather, Charles V. Born 1404, he was sent as hostage into England in 1412, and was only released from captivity in 1444. Five years afterwards he married Marguerite de Rohan, who was still living in 1496. He died at Cognac, Angoumois, on April 30, 1467.

The MS. was all written by Henry de Trevou, the able copyist of Charles V. and of the Chancellor Pierre d'Orgemont (whose arms are *az.* trois épis d'*or*). Guill. Durand, the author of the "Rationale," was a Provençal, and came from Puy-Messon, in the diocese of Riez. In 1286 he became Bishop of Mende, and died, apparently at Rome, in 1294.--*Paris : Les MSS. fr.*, iv. 101, No. 7,031.

No. 6,840 (another copy) was translated (1372–4) by Jean Golein for Charles V. ; transcribed, M.ccc.Lxxix., for Jean, Duc de Berry. At end : " ce liure est a Jehan fils de roy de France duc de Berry et d'Auuergne Conte de Poitou et d'Auuergne.—Jehan."

No. 7,058 has arms on back : France : in chief a label of three branches with a crescent *gu.* (not *az.*, as stated by P. Anselme, i. 205, 209) on the middle one.—*Paris*, iv. 307. This is the shield of the Dukes of Orleans of the issue of Charles V. Written at the end, in rubric : " Mon tres redoubte et puissant seigneur Mons.

le Comte d'Angoulesme germain du Royme fist escrire cestuy present Songe de Vergier en la Ville de la Rochelle en lan de grace mil quatre cens cinquante deux."—*Ball.* This "Songe du Vergier" (Somnium Viridarii), was written in Latin in 1376, and translated into French.—*Paris,* iv. 308. *See* CHEVREUL, HAIN-CELIN, MOREAU, MOTE, MOURARD, NICOLAS ASTESANUS, ORLIENS, PRESSE, TONNELIER, &c.

ORLIENS, RAOULET D'. *Copyist.* Saec. XIV.

One of the copyists employed by Charles V. King of France (1350–1380). In 1367 he copied a Treatise on the Game of Chess moralised. At end: "Cy fine le liure de la moralite des nobles hommes et des gens du pueple, fait sus le gieu des esches, translate de latin en françois. Et fu escript de Raoulet d'Orliens, lan de grace mil IIIᶜ LX et VII." Now in the National Library, Paris (MS. fr., 1160). In 1371, five livres were paid to "Raoulet d'Orliens" for transcribing the Ethics and Politics of Aristotle for the King. At least, so says the MS., but M. Boivin, in his researches on the history of the Bibl. du Roi, gives the quittance to the year 1376. Barrois cites a copy of the Ethics as being in the library of the Dukes of Burgundy, and signed "Raoulet d'Orliens lan mil ccc soixante seize."—*Barr.: Biblioth. Protypogr.*, 294, No. 2,068. In 1371 also, Raoulet completed a copy of the Voyage de Jehan de Mandeville for Gervais Chrestien, the King's physician. At end : "Ce liure cy fist escrire honorables hommes sages et discret maistre Gervaise Crestien maistre en medecin et premier phisicien de tres puissant noble et excellent prince Charles, par la grace de Dieu roy de France. Escript par Raoulet d'Orliens lan de grace mil CCCLXXI, le XVIII jour de septembre." This MS. was purloined from the National Library between 1840 and 1845, and was sold among the Barrois MSS. to Lord Ashburnham.—*Eighth Report of the Royal Commission on Historical MSS.* Appendix iii. 73, No. 24. It was restored with others in 1884.

Raoulet is stated by Lelong to have been the copyist of the Bible presented to the King in 1373 by Vaudetar, and Van Praet

repeats the statement.—*Lelong: Bibliotheca Sacra*, i. 316.—*Van Praet: Recherches sur Louis de Bruges*, 86. In favour of this attribution it may be said that any one who studies Raoulet's penmanship may readily distinguish it, even without signature. In 1396 he finished for Louis Duc d'Orleans one folio volume out of four of the Mireoir Hystorial,—the French translation by J. de Vignay, now in the National Library, Paris (Anc. Fds. fr., 312, 313, 314). The third volume was already lost in the fifteenth century, whilst lent to the Comte de Dunois, son of the famous Bâtard d'Orleans. In the inventory of 1417 the four volumes are thus noticed : "Les quatre volumes du Mirouer historial couvres de veloux noir," and again, in 1427, "Le liure du Mirouer historial en quatre grans volumes, neuf, en françois et lettre de forme, historiez a mi couvers de veloux noir, chacun liure a deux fermoers esmaillez armoiez." In 1487 another inventory notices the absence of vol. iii., and mentions the reason : "Trois des quatre volumes du Miroer ystorial, et mons. de Dunois a lautre." (MS. fr., 22,335, fol. 263). Charles, Duke of Orleans, the poet, died in 1466 ; and Marie de Clèves, his widow, had these volumes carried to the Château de Chauny. It was she, probably, who lent the missing volume to François d'Orleans, Comte de Dunois. The other three found their way back to Blois, and a notice was placed in them by the librarian of Louis XII. to indicate their location in the library. At the end of vol. i. : "Ci fine le premier uolume du liure dit mireoir hystorial escript par Raoulet dorliens lan Mil trois cẽs quatre vins et seize parfait a dieu graces rendy de Juing le premieR vendredy." In the frontispiece of the volume are given the Duke's arms, supported by two wolves* (*loups* being a play upon his name Louys). His signet contained both a wolf and a porcupine. Charles, his son, had a room furnished with blue velvet, embroidered with large golden fleurs-de-lis, forming the arms of Orleans, and little wolves with the legend : IL EST LOU IL EST.—*Laborde*, iii. 302, n. 6,427. In MS. fr., 1,213, the arms of Orleans are placed between two wolves.—*Delisle*, i. 100. At the sale of the collection of M. Delignières de Bommy of Abbeville, was a copy of the French translation of Boethius, by Raoulet d'Orleans. This proves that the translation was not made, as has sometimes been asserted, by Charles d'Orleans. The MS. came into the National Library in 1872, and in 1873 M. Delisle gave an account of it in the Bibliothèque de l'Ecole des Chartes for 1873 (xxxiv. 30). In the "congie de l'escrivain" occur these words : "R. dit Amen

* Paris calls them *foxes*.

d'Orliens Qui cest escript a droit verra Nom et seurnom y trouuera."
Lastly, in a copy of "Le Pelerinage de l'Ame," after the second
part of the Pelerinages de Guillaume de Digulleville, are the words :
R. DORLIENS. (MS. fr., 12,465.) Many details respecting Raoulet
are given by Delisle in his " Inventaire Général et Méthodique des
MSS. fr. de la Bibl. Nationale," ii. 341–5 ; and still more in his
Mélanges de Paléographie et de Bibliographie, 270–2.—*Delisle :
Cabinet des MSS., &c.*, i. 36, 100 ; ii. 317 ; iii. 328 ; iv. pl. XLVI. 6.
Also, *Exemplaires Royaux et Princiers du Miroir Historial*, in
Gazette Archéologique, 1886, 17. The numbers assigned by Paulin
Paris to the Miroir historial are MS. fr., 6,934, 5 and 7. No.
6,936 is the second volume of another set, not the third of this.
At the end of the fourth volume is the signature of Guillaume
Hervi. (*See* HERVI.) At the foot of the first page in each volume
are the arms of Orleans ; in vol. i. supported by two wolves (says
Paris) ; in vol. ii. by two lions : and in vol. iii. by two young fawns.
If intended for wolves, both the artist and the Duke must have
been easily satisfied. If not, it is clear that supporters were not
considered as essential parts of the heraldry of the fourteenth
century.—*Paris : Les MSS. fr., &c.*, ii. 327.

ORMAND, ⎫
ORMANI, ⎬ MARIA. *Copyist.* Saec. XV.
 ⎭

Wrote in 1453 a " Breviarium cum Calendario" for the use of
the Order of Augustines. Now in the Imperial Library, Vienna.
Very neatly written. On fol. 89 is elegantly depicted the portrait
of the lady copyist, in the habit of the Augustinian Order. Flow-
ing round her is a band containing the inscription : "Ancilla Yhesu
Christi Maria Ormani filia scripsit, M°cccc L. III. From her
manner of writing May as Madius it is probable that she was taught
in some Italian house.—*Denis : Catalog., &c.*, iii. 3,084, Cod.
DCCCLVI.

ORRY, JEHAN. *Copyist.* Saec. XV.

Wrote in 1426, " Johannis de Chaumont historia Mortis Domini
Nostri Jesu Christi," &c. On Paper 112 ff. At end : " Ci

fenist la destruction de Jherusalem et la vengence de Jhesu Crist. Et la justice et la male fin de Pylatte escript par la main de Jehan Orry de Chaumont en Bassigny, le xxiii. jour du moys de Septembre lan de grace noistre seigneur Mcccc. and xxvi. Ainsy signée par moy Jean Orry." Now in the Royal Library, Turin. Cod. CXV. b. iv. *32.—Pasini: Codd. Mssti. Biblioth. Taurinens,* ii. 488.

ORSINI, MARCHESA. *Miniaturist.* Saec. XVIII.
Donna Theresa di Cassine.

A learned lady of Alessandria, drew and painted in miniature, especially flowers. She also possessed an important collection of paintings, and among other things a whole volume of drawings by Michelangelo—chiefly designs for cupolas. Worked about 1770, and died 1778.—*Zani: Enciclop. Metod.*, xiv. 168.—*Nagler: Künstlerlexicon*, x. 382.

ORSINI, SER GIOVANNI. *Miniaturist.* Saec. XV.
A Priest and Chaplain of S. Antonio in the Duomo of Siena.

Received, in 1482 5 lire, 9 soldi, for certain miniatures in a Commentary on the Bible, compiled by P. de Rosi.—*Milanesi: Documenti*, ii. 382, 387.

ORTA, BERNARDO DE. *Miniaturist.* Saec. XVI.
A Spaniard.

About 1540 he painted the Choir-books of the cathedral of Seville: viz. a "Sanctorale" and a "Dominicale." He was the

father and master of Diego de Orta and of other professors
of ability in this style. In association with them he painted
the above-named MSS., Archiv. de la Catedral de Sevilla.—
Bermudez: Diccionario, &c., iii. 278. The names of the artists
who illuminated these Choir-books were Bernardo de Orta and
his son Diego, Luis Sanchez, Andres Ramirez, and Padilla.—
Riano : Notes on Early Spanish Music, 136.

ORTA, DIEGO DE. *Miniaturist.* Saec. XVI.

Son of the above, and in 1555 assisted him to paint the Choir-
book called the "Festa di S. Pedro" at Seville, and others,
receiving 47,237 maravedis for each book. He was working
on the volumes in 1575 (Archiv. de la Catedr. de Sevilla).—
Bermudez: Diccionario, &c., iii. 278.—*Riano : Notes on Early
Spanish Music,* 136.

ORTINO, PIERLEONE. *Copyist.* Saec. XV.

Wrote, in 1461, "SEXTI JULII FRONTINI STRATAGEMATON."
Vellum. Sm. 8vo. 152 pp. In the ordinary upright cursive. At
end, in red : "Mcccc. 61, die xiij Februarij petrusleo Ortinus
scripsit. Qui me furatur in trib9 tignis suspendat." DEO GRAS.
Now in British Museum, Burney MSS., 173.

ORTOLANO, IL. *Miniaturist.* Saec. XV.

Known also as Giov. Battista Benvenuti. Worked at Ferrara
for Alfonso I., on the "Officium Virginis," now in the library at
Modena.—*Bucher: Geschichte der Technischen Künste,* i. 260.

ORVIETO, FRANCESCO DA. *Copyist.* Saec. XIV.

Wrote, in 1389, "La Divina Commedia." On paper, 153 ff. At end of last Cantica : "Explicit prim⁹ scds. et tertˢ. liber Dantis Aldagherij de Florā. Script. per Franciscu Andree de Urbenet. (Orvieto.) Sub annis dnj milliō trecetesimo octuagesimo nono. Deo. Grās. Amen." Now in the National Library, Paris. Suppl. Fr., No. 2,679.—*Batines*, ii. 229.

OSBERNUS. *Calligrapher.* Saec. XV.
Rector of the Church of S. Evront.

Mentioned by Ordericus Vitalis in his Eccles. Hist., lib. iii. Was a great scholar and a skilful artist, and assisted with his own hands in building a Scriptorium for boys and unlearned persons.—*Duchesne : Scriptores Normanniæ*, 1185.

OSDENDARFER, ⎫ HANS. *Miniaturist.* Saec. XVI.
OSTENDORFFER, ⎰

Was Court-miniaturist at Munich between 1510 and 1541, when he painted the famous "Turnier-Buch" of William IV., Duke of Bavaria, now in the Royal Library at Munich. It contains on thirty-four leaves a series of tournament scenes in which the Duke is depicted as taking part. They are shown as single contests, two horsemen only appearing on each sheet of the book. In these the Duke is not always represented as victorious. The first leaf is dated 1510, and the whole number were bound together in 1540. On the first page in the lower border appears the artist's name, H. Ostendarfer, and the date 1541. On the last he names the ducal Wappenmeister Hanns Schenkh, who planned the work. The last leaf bears the date 1543, from which it would seem that the signature on the first page was not placed there by the artist himself. In Füssly's time the MS. was at Gotha, and it was kept there until the early part of the present century, when it was returned to Munich. In 1817 it was facsimiled in chromolithography, by Schlichtegroll and Senefelder. A copy of the facsimile exists in the British Museum.—*Nagler : Künstlerlexicon,*

X. 412.—*Füssli: Allgemeines Künstlerlexicon, &c.* In 1515, Kaiser Maximilian, "the last Ritter," held at Vienna a convention of the Jagellon brothers, and King Ladislaus of Hungary and Bohemia, and Sigismund of Poland. At this diet was concluded the famous "Doppelheirath," which attached the succession of the Houses of Hungary and Bohemia to the crown of Austria. Austria, indeed, has been built up out of fortunate marriages. Many German princes were invited. Among them were Duke William of Bavaria, the Kaiser's nephew, the Markgraves Casimir and George of Brandenburg and Duke Albert of Mechlenburg. A sham-fight, or tournament, was one among the many festivities which celebrated the occasion. Hans Jacob Fugger, in his Austrian Ehrenspiegel, mentions the grand ceremony when the princes and gentlemen of the empire met on St. James's Day, July 25th, 1515, on the grand place before the Palace, called the Turnier-Platz, surrounded by 1,500 citizens and attended by 100 footmen. On either side of the square were grand scaffolds erected and a magnificent throne for the Kaiser and his royal and princely guests, also for the other nobles, ladies, and gentlemen who were present. Thirty-two knights, on fully-equipped horses, well armed and adorned with splendid helmets and heraldic bearings, rode into the arena. At first they contended in single pairs, then 16 against 16. After the onset with lances, many of which were shivered, they finished with their swords a contest of two hours' duration. Duke William of Bavaria was one of the most famous tourneyers of the time, and it is his exploits on this occasion that are celebrated in Ostendorffer's (or Osdendarffer's) Turnier-Buch. Of the painter and his surroundings we can only learn that he was probably the son of Michael Ostendorffer of Regensburg, and that in 1532 he appears in the Munich Guild-Book as Dean of the Guild. In 1551 he is mentioned as Court-Painter to Duke Albert V., by whom he was employed for many years. The year of his death is unknown. Baron Aretin, in his work on the antiquities and art memorials of the Electoral House of Bavaria, says that the Turnier-Buch was executed between 1541 and 1544. In the Royal Cabinet of Engravings at Munich are preserved four beautifully-painted pedigrees with portraits, which bear the monogram H. O., and the date 1540. The Turnier-Buch was carried off in 1632 by the Swedes, with many other treasures, and kept by the famous Duke Bernard of Weimar. For a long time it was one of the treasures of the Library at Gotha, but in 1816 it was

sent by the reigning Duke of Saxe-Gotha as a present to the
Crown Prince Ludwıg of Bavaria, the afterwards famous King
Ludwig, the creator of modern Munich and its treasures of art.
The year after its return, as already mentioned, it was reproduced
in coloured lithography by F. Schlichtegroll, assisted by the
Senefelders.— *Aretin : Alterthümer und Kunstdenkmäler des
Bayerischen Herscher-Hauses.*

OSMUND (SAINT). *Calligrapher and Illuminator.*

Saec. XI.

Or Edmund, Bishop of Salisbury.

Son of the Comte de Seez, and a native of Normandy, accom-
panied William I. to England, and, in 1066 became Lord
Chancellor. In 1078 he was appointed to the see of Salisbury,
where he built and rebuilt the first cathedral, erected a noble
library, &c. With many Bishops and Abbots of the Middle Ages, the
art of the penman and illuminator was almost a *sine quâ non* of
their appointment. With Osmund it was one duty among others :
" ille nec scribere nec libros ligare fastidiret." He died in 1099.
In 1458 he was canonized by Calixtus III. He established the
" Sarum use," as it is called, and composed a treatise on Ecclesias-
tical Duties, called " Liber ordinalis," or " Consuetudinarum."—
Hist. Littér. de la France, viii. 574.—*Butler : Lives of the Saints,
&c.,* ii. 979.—*Leland : Collectanea,* ii. 251 (Oxon. 1715). *Jones :
Fasti Eccles. Salisberiensis,* 41.

OSNIER, COLIN. *Copyist.* ## Saec. XI. (?)

Is said to have written " Heures et Matines" for the Duchess
de Vernon in 1061. Vell. 8º (6⅛ × 4¼ in.). 486 ff. With ivy-leaf
borders, miniatures, and initials. On the fly-leaf is an enigmatical
inscription, stating that this MS. was written " par moy Misse
Collin Osnier Prestre Segretain de la Paroisse Dasse pour la
Duchesse de Vernon, durant le resne de Allexandre segond, &c.
MLXI." There is a clumsy mistake here, as ivy-leaf borders are
not used earlier than the thirteenth century, and Alexander II.

reigned from 1061 to 1073. The inscription is undoubtedly a forgery, the true date of the MS. being at least three centuries later. Indeed, many of the saints mentioned in the calendar were not in existence until long after the death of Alexander II.— *Bragge: Sale Catalogue*, No. 356.

OTFRID. *See* WEISSENBURG.

OTHLONUS. *Copyist.* Saec. XI.
 Monk of St. Emmeram, Ratisbon.

Was born about 1013. In his book, " De ipsius tentationibus, varia fortuna, et scriptis," he has given us an account of his literary labours, and of the circumstances which led to his writing the various works of his which we possess. He learned writing in the monastery of Tegernsee, in Bavaria, where he wrote many books. " And being sent into Franconia while I was yet a boy, I worked so hard at writing while I was there, that, before I returned, I had nearly lost my sight. . . . Then, after I came to be a monk in the monastery of St. Emmeram, I was soon induced, by the request of some of them, to occupy myself so much in writing that I seldom got any rest, except on festivals, and at such times as work could not be performed. In the meantime, there came more work upon me ; for as they now saw that I was generally reading, writing, or composing, they made me the school-master." As only part of his labours he enumerates nineteen missals, three books of the Gospels, two with the Epistles and Gospels (lectionaries) and four Service books for Matins.—*Mait-land : The Dark Ages*, 416–19.—*Cahier : Bibliothèques*, 133.— *Zeigelbauer*, ii. 523 ; i.

OTHO. *Copyist.* Saec. XV.

Wrote, in 1464–5, part of the third volume of a Bible with miniatures, of which Antoine Tonis wrote the remainder (Comptes des Chartreux de N. D. de Scheutlez, Bruxelles).— *Pinchart : Archives des Arts, &c.*, ii. 192–9.

OTTAVANTI, JACOPO. *Copyist.* Saec. xv.
A Florentine.

> Wrote, in 1460, " La Divina Commedia." Paper. Folio (or 4°).
> At end : "Questo libro edi Jacopo di giovanni di neri de nanni
> ottauanti cittadino fiorentino. El quali schrissi di mia propria
> mano finito a di iij di marzo 1460." Once in the Trivulzio Library,
> MSS. xv.—*Batines*, ii. 142.

OTT, FRIDOLIN. *Miniaturist.* Saec. XVIII.
Born, 1755, at Bishopzell, near canton of St. Gallen.

> Worked chiefly on portraits.—*Nagler : Künstlerlexicon*, x. 418.

OTT, JACOB. *Miniaturist.* Saec. XVIII.
Born, 1762, at Zurich. Died 1818.

> *Nagler : Künstlerlexicon*, x. 418.

OUTRECHT, HENRY D'. *Copyist.* Saec. XIV.

> Given under 1382 in *Laborde : Ducs de Bourg.*, i. pt. II. 528.

OUVILLY, BALTHASAR GERBIER D'. *Miniaturist.*
 Saec. XVI. et XVII.

> Under the name of Gerbier I have mentioned this singular
> charlatan. It is not of much consequence, perhaps, but I was
> led by Nagler into the error of saying that he perished in

VOL. III. E

the fire at Lord Craven's country seat. Walpole says that he designed that mansion, which was called Hempsted Marshal, and which was subsequently destroyed by fire, and that he died whilst superintending its erection in 1667. In the library of Secretary Pepys, at Magdalen College, Cambridge, is a miscellaneous collection in French of "robes, manteaux, couronnes, armes, &c. d'Empereurs, Rois, Papes, Princes, Ducs, et Comtes anciens et modernes, blazonés et enluminés, par Balthasar Gerbier."—*Wal pole : Anecdotes of Painting, &c.,* i. 279 (Wornum).

Ovo. *Calligrapher.* Saec. VIII.
A Frison.

Converted by St. Wulfran, who had snatched him miraculously from death. He became a Benedictine of Fontenelle, and distinguished as a copyist.—*Cahier : Bibliothèques,* 128. " Erat in arte pictoria eruditus : plurimos codices in prædicto transcripsit monasterio."—*Mabillon : Annales Bened. Ann.* 720 ; iii. 344.

Paccini, Franco. *Copyist.* Saec. xv.

Wrote a Missal in 1488 with miniatures.—*Complexus Msstor. Jo. Guibel. de Bergen,* 5, No. 3.—*Vogel : Serapeum,* 1844.

Pachelbein, Amalia. *Miniaturist.* Saec. xviii.
Born at Nuremberg 1688. Died 1723.

Painted chiefly flowers. She also engraved on copper.—*Zani : Encicloped. Metod.,* xiv. 204.—*Nagler : Künstlerlexicon,* x. 451.

PACIOLI, FRA LUCA. *Calligrapher.* Saec. XVI.
 A Minorite of Venice.

 Wrote a work on the correct proportions of the Latin capital
letters, published in 1509 under the title " De divina proportione."
Jansen : Essai sur l'Origine de la Gravure, et de la Calligraphie,
ii. 48.—*Doppelmayr : Nachricht. v. den Nürnberg'schen Mathe-*
maticis und Künstlern, 153.—*Bucher : Geschichte der Technischen*
Künste, i. 260.

PADERBORN, JOH. DE. *Copyist.* Saec. XV.
 Died 1475.

 Zani : Encicloped. Metod., xiv. 207.

PADILLA. *Miniaturist.* Saec. XVI.
 An illuminator of MSS. at Seville.

 In 1555 the Chapter of the Cathedral employed him on twenty-
four historiated initials for the Choir-book of the " Fiesta de S.
Pedro," for which he received 9,750 maravedis.—*Bermudez : Dic-*
cionario, &c., iv. 23. *See* ORTA.

PADOVA, CLEMENTE DA. *Miniaturist.* Saec. XV.

 Employed about 1446 at public expense in Lucca.—*Memorie e*
Documenti per Servire all Istoria del Ducato di Lucca, viii. 36.

PADOVA, FRANCESCO DA. *See* VENDRAMINO.

PADOVA GIROLAMO DA. *See* PADOVANO.

PADOVANO, FRANCESCO. *Copyist, &c.* Saec. XV.

Employed at Ferrara.—*Cittadella : Notizie relative a Ferrara.*
See VENDRAMINO.

PADOVANO, GIROLAMO. *Miniaturist.* Saec. XVI.
A Painter and Miniaturist.

Worked in the manner of Don Bartolommeo, Abbot of San
Clemente at Florence, in certain miniatures executed in the Choir-
books of Stª Maria Nuova.—*Vasari : Vite, &c.,* v. 54 (*Lemonnier*).
Orlandi adds : an excellent painter of Padua, contemporary with
Mantegna. Ridolfi speaks of him as an able miniaturist, and
states also, perhaps merely following Vasari, that he worked on
the Choir-books of Stª Maria Novella at Florence.—*Orlandi :*
Abeced. Pittorico, 307 (Venice, 1753. 4°).

PADUA, JACOB. PHIL. DE. *Copyist.* Saec. XIV.
A Monk of the " Eremitani" of St. Augustine.

Wrote "Serapione, ossia della vertù medicinale che si troua
nelle piante e negli animali." Vell. Fol. 289 ff., with two illu-
minated borders and drawings of plants, fruits, &c. On last page,
in same hand : " Frat' Jacob⁹ phyllipus de pad ordis heჳ scripsit."
Then a cypher. Now in British Museum, Egerton MSS.,
2020.

PAGANINO, GUIDO. *Miniaturist, &c.* **Saec. XV.**
An Italian, and native of Modena.

> Employed by Charles VIII. among the artists brought from Italy after the Naples expedition. He is mentioned in the accounts : " A messire guydo paganino chevalier painctre et enlumineur, aussi de nombre des dicts ouvriers, la somme de sept cens troys liures deux solz tournoys à lui aussi ordonnée pour ses gaiges et entretenement des dicts neuf moys commençans et finissans comme dessus, qui est a la raison (rate) de L ducatz par moys. Pour ce par vertu du dict estat cy deuant rendu, comme dit est, et de la quictance du dict paganino cy rendue appert pour cecy, v^c iii. L. ii^s. vi^d t." He remained for more than twenty years in France, and returned to Modena in June, 1516. He died in 1518, and was buried in the church of the Carmine, where is his tomb, bearing his arms, to which Charles VIII. had added a fleur-de-lis, and this epitaph : " Hic ossa quiescunt Magnifici Equitis, Domini Guidonis Paganini *alias* de Mazonibus qui obiit xii. sept^bris MDXVIII.—*Archives de l'Art français, &c.,* i. 117, 125.

PAGE, JEAN LE. *Copyist.* **Saec. XV.**

> Wrote a MS. formerly in the Collège de Foix, now MS. lat., 4,809, National Library, Paris. " Istud volumen completum fuit in vigilia assumptionis B. Marie per manum Johannis le Page."—*Delisle,* i. 508, n. 11.

PAGGI, GIOVANBATTISTA. *Miniaturist and Painter.*
Saec. XVI.

> A Genoese nobleman who took up art from intense love of it, and became one of the most famous of the Genoese masters. He was a polished scholar, and wrote several treatises for young artists. He applied himself to every branch of painting, studied under Luca Cambiaso, of Genoa, and the best masters of Florence,

where he lived for twenty years. Born 1554. Died 1627.—*Soprani: Vite de' Pittori, &c., Genovesi, s. v.—Lanzi: Storia Pittorica della Italia,* i. 210; v. 256, 262 (Firenze, 1822). His portrait is given in *Museo Fiorentino,—Ritratti,* i. 245.

PAGLIARA, LELIO DELLA. *Miniaturist.* Saec. xv.

Miniaturist at Rome in fifteenth century. — *Bertolotti: Artisti Subalpini in Roma,* 168.

PAGLIAROLO, DOMENICO. *Miniaturist.* Saec. xv.

Worked at Bologna in 1478.—*Zani: Enciclopedia Metodica,* xiv. 223.

PAIRMENCHINGEN. *See* RÜTTEL.

PAKINGTON, WILL. *Illuminator.* Saec. xiv.

Worked in England about 1360.—*Zani: Enciclop. Metod.,* xiv. 226.

PALATINO, GIOVANBATTISTA. *Calligrapher.* Saec. XVI.

Executed at Rome, in 1540, a Writing-book, among the examples in which are plates of interlaced monograms of feminine names, as Lucretia, Virginia, Giulia, Flaminia, and others then common in Italy. In his richly-flourished Gothic alphabets he gives examples of what he calls French letters brought to Italy by the scriveners of Charles VIII. They are similar, not to the French bâtarde used by Aubert, Du Ries, and other copyists of the fifteenth century, but to what is popularly termed old English or black letter. The author's signature is given to some pages, as " Palatinus Rom. scribebat."—*L'Art pour Tous*, iii. 280, 288. He was particularly skilful in imitating the regularity of the finest Gothic texts. This book, published in Rome in 1545, is the second edition of Palatino's work. It is entitled " Libro nuovo d' imparare a scrivere di tutti sorte di lettere antiche e moderne di tutte nationi, con nuove regole, misure, ed essempi." 4º. 60 ff. Forty-eight of these folios were written and engraved on wood by himself. The eighth edition (not, as Jansen says, the third) appeared in 1561, from the office of Valerio Dorico, with a supplement of Roman capitals with ornamental flourishes.—*Jansen: Essai sur l'Origine de la Gravure*, ii. 49, 50. The first edition was that of Ant. Blado Roma, 1540. 4º.—*Brunet: Manuel du Libraire. Suppl.* iii. 2 (1834).

PALENCIA, FRAY MARTINO DE. *Copyist and Miniaturist.*

Saec. XVI.

A Monk of the Benedictine Monastery at Avila.

Was ordered by Philip II. to write and illuminate certain of the Choir-books for the use of San Lorenzo of the Escorial. For this service he received 100 ducats a year. In 1574 he had leave to go to the monastery of San Martino in Madrid. In 1575, whilst still in Madrid, the king gave him 50 ducats more. In the monastery of Suso, says Bermudez, is preserved with great and just estimation one of his precious books called " De las Procesiones," which Fray Martino wrote on vellum in a find hand and

adorned with elegant miniatures. The volume is garnished with clasps of silver and inlaid with silver-gilt medallions of the saints of the Benedictine Order. At the beginning is this inscription : "Anno a nativitate Dñi millesimo quingentesimo octagesimo secundo, frater Martinus de Palencia monachus indignus ordinis S. P. N. Benedicti scripsit hunc librum. Et depinxit cum orationibus ad processiones, epistolis, et evangeliis diebus principalib. tantum monasterio S. P. N. Emiliani ejusd. ordinis ubi fuit professus. Decoravitque illum frater Alvarus de Salazar abbas ejusd. monasterii, miro opere argenti et auri, qui fuit reformator ordinis n̄rī in Lusitania jussu Philippi regis Hispaniar. anno supradicto cum scribentis subscriptione,"—and it concludes with the autograph of Fray Martino de Palencia.—*Bermudez*, iv. 25. The Choir-books of the Monastery of San Lorenzo del Escorial contain the music for the masses and feasts of the year. They are very important and numerous, and are splendidly illuminated. The music and liturgy are copied from the rituals of Toledo. Philip II. ordered the books to be written in 1572, and the writing and illuminating of them occupied seventeen years, being finished only in 1589. They form, probably, the largest collection known, as they consist of 216 volumes of the finest vellum. There is a story told of the delay in the execution of the task arising from the fact that in all Spain there could not be found a sufficient quantity of vellum, of such a quality as would satisfy the king. Messengers had, therefore, to be sent into Germany to obtain the requisite material for the enormous undertaking.—*Riaño : Notes on Early Spanish Music*, 137. For further details concerning these remarkable Choir-books, *see* LEON, FRAY ANDRES DE.

PALAIOCAPPA, PALAIOCAPPOS, } CONSTANTINOS. *Copyist and Calligrapher*

Saec. XVI.

Concerning this industrious and accomplished calligrapher I can find scarcely any information, but his works are numerous and

mostly known. He wrote his name Κωνσταντῖνος Παλαιόκαππα, or Παλαιόκαππος. The latter spelling occurs in the Royal MS., 16 C vi., British Museum, which contains a list of twenty-six MSS. written by him, and now at Paris. He was a native of the town of Cydonia in Crete. From some of the subscriptions to MSS. written by him, it would seem that he entered the monastic life, taking the name of Pachomius, in the Convent of St. Athanasius on Mount Athos, 1539–41. Soon after this he came westward and entered the service of the Archbishop and Duke of Reims, Charles de Guise, usually known as the Cardinal de Lorraine (1538–1574). Whilst in this service he wrote a copy of the Tract of Anastasius, Patriarch of Antioch, on Providence. The MS. is now in the National Library, Paris, No. 517. The commencement of this MS. is adorned with a richly-gilt altar or tomb, surmounted by a crescent-crowned obelisk, around which twines a green and leafy stem. In front of the altar are painted the arms of the Cardinal. A Latin inscription surrounding the coat of arms, on the altar frieze, is thus worded : Caro Card : Lothar : Arch . Duci : Rhem. and may be read:—" To Charles Cardinal of Lorraine, Archbishop, Duke of Reims." A device, partly on each side of the obelisk, runs thus : "ΣΟΥ ΣΤΑΝΤΟΣ. ΧΛΟΑΣΩ " in allusion to the twining stem, which is here declared to bloom as long as the obelisk remains standing, and symbolises the artist (probably Palæocappa) and ˙ other dependents of the liberal and powerful prelate. On each side is the Title of the work in bold blue, red, and green capitals : "ΤΟΥ ΑΓΙΟΥ ΑΝΑΣΤΑΣΙΟΥ ΠΑΤΡΙΑΡΧΟΥ ΑΝΤΙΟΧΕΙΑΣ ΠΕΡΙ ΠΡΟΝΟΙΑΣ." These letters are at least half an inch high, and very striking. The handwriting is free, and though much contracted, is quite easily legible.—*Silvestre : Paléogr. Universelle,* ii. (60). To the Cardinal, Palæocappa dedicated several MSS., and others to Henry II. Those addressed to Charles of Lorraine, are MSS. gr., 10,57, 10,58 ; Suppl. gr., 143, 303 ; St. Geneviève A° 2 bis. Fol. Reims, E. 291, 292. For the King he worked at Fontainebleau, under the direction of Angelus Vergecius, busying himself with the formation of the famous Catalogue, and its transcripts, five of which are due to his hand : viz. MS. gr., 3,066 ; Suppl. gr., 10,298 ; Leyden Voss. gr. Fol. 47. Venice : Nani, 245. On the last see " Bibl. de l'École des Chartes," 1886, xlvii. 201–207. The original is now MS. 10 of the "Supplement Grec." Many of the MSS. of the old Fontainebleau Library are annotated by him, several being completed or corrected by Verge-

cius. *See* VERGECIUS. Two MSS. copied by Palæocappa bear the arms of Granvelle, but were not written to the order of the latter patron. Of course *most of the MSS. copied by Palaiocappos, are at Paris.* One or two, however, are found elsewhere. Thus the Royal MS. 16 C VI., as stated above, is by him. Its Explicit runs thus : "Ταῦτα Κωνσταντῖνος Παλαιόκαππος ὁ Κυδωνιάτης γέγραφεν εν Λευκετίᾳ τῶν Παρισίων." It is a small, thin 12°, finely written. Paper, 30 ff. Its contents have been published by M. Omont, in *L'Annuaire de l'Association pour l'Encouragement des Etudes grecques en France*, 20ᵉ *Année*, 1886, 241-279.—*Omont : Const. Palæocappa, Catal. de MSS. gr. copiés à Paris au xvi Siècle par C. P. See* REIMS.

PALLAVICINI, GIOV. BATTISTA. *Copyist.* Saec. xv.

Wrote for his uncle, the Marquess of Saluzzo, a "Josephus." At the end of which he added twenty-four verses, and an epilogue, saying under what circumstances the work was accomplished. It was finished 15th November, 1437, by a Benedictine, Lodovicus de Prioribus. *See* PRIORIBUS.

PALLAVICINI, TRIULZI, CAV. *See* TRIVULZI.

PALLIDIO, ALBERTUS DE. *Copyist.* Saec. xv.

Wrote, on paper, " Parpaliæ lectiones in primum codicis librum." 123 ff. At end of first tract : " Hic finit lex Cunctos populos, de

Summa Trinitate & Fide Catholica per spectabilem & generosum
juris utriusque Doctorem Thomam Parpalia et Dominis Re-
viglasci notabiliter et luculentissime lecta, et per me Albertum de
Pallidio ut possibile fuit scripta anno Domini 1503, die 8 Junii."
Now in the Royal Library at Turin.—*Pasini : Catal., &c.,* ii. 84.

PALMA, GIOV. MARCO CINICO DI. *Copyist.* Saec. xv.

Employed from 1471 to 1492 by the kings of Naples. Wrote
"Ciceronis orationes," now in the Imperial Library, Vienna (No. 4).
It is thus dedicated : "Fernando Aragonis regi italico pacis et
militiæ ductori semper invicto æterno musarum splendori, unico
iustitiæ cultori principi optimo, Cinicu *excripsit.*" His signature
as Joannes Marcus occurs at end of MS. lat., 12,947 at Paris :
"Reprehensio in calumniatorem divini Platonis," written in 1471.
Riccio : Cenno Storico della Accademia Alfonsina, n. 23.—*Delisle :
Cabinet des MSS., &c.,* iii. 360. The style of ornament in the
Vienna "Cicero" is somewhat like that of the British Museum
"Josephus," but more richly architectural in the borders, and
varied with fine Florentine (Attavantesca) foliages, treated in
the stiffer Sicilian manner. Beautiful imperial medals are painted
in some of the initials and borders.—*J. W. B. : MS. Notes of Visits
to Foreign Libraries.*

PAMPLONA, PEDRO DE. *Illuminator.* Saec. XIII.

Wrote, for Alfonso X. (the Learned), King of Leon and Castile
(1252–1284), a Bible in two volumes, enriched with barbaric bril-
liancy. They are, or were, until recently, kept in the archives of
Seville cathedral. On the last page the artist has placed this
record : "HIC LABOR EXPLETUS EST SIT PER SÆCULA . LÆTUS .

Scriptor . Grata dies sit sibi sitque ynico . Scriptor laudatur Scripto Petrus . que vocatur . Pampilonensis . Ei Laus sit Honorque Dei."—*Stirling-Maxwell : Annals of the Artists of Spain,* i. 173. Alfonso X., of Leon and Castile, surnamed *El Sabio,* was a remarkable man and a most distinguished monarch. Besides his brilliant career as the descendant of the Royal line of Leon, and the inheritor especially of the talents and projects of an illustrious father, he was ambitious of a wider reputation as Emperor of Germany. He was, indeed, the rival competitor for the honour with the wealthy but imprudent Richard, Earl of Cornwall and King of the Romans. But while Richard, notwithstanding all his wealth, could not establish his authority, though elected Emperor by a powerful faction, Alfonso, grandson of Philip of Suabia—also duly elected, was too busy with his Spanish affairs to enforce his claim. Hence to the Empire the double election had the force of an Interregnum. It is, however, not as Emperor, but as King of Leon and Castile, that Alfonso claims attention here. He shares with his sainted father the credit of the famous code *Las Siete partidas,* but not, perhaps, with equal wisdom, notwithstanding the occasional translation of El Sabio as *the Wise.* The most conspicuous effect of his interpretations of the code was to involve his descendants in contests with the papacy respecting the patronage of the Church. But his claim to the surname of Learned rests rather on the labours which he initiated and perhaps shared, in the compilation of the famous Astronomical Tables that bear his name. In these labours he was assisted by the most accomplished mathematicians and astronomers of his time, who were almost all educated in the Moorish schools of Spain. He also superintended the formation of a general chronicle of Spanish history, and gave great attention to the cultivation of his native language as a means of literary culture, employing it in the public documents, which, until his time, had always been drawn up in Latin. In this he rivalled, if, indeed, he did not anticipate, the English custom, our earliest vernacular legal document since Saxondom being a brief proclamation of Henry III., and the earliest regular application of English to legal instruments occurring only under Edward III. English and Latin had, indeed, been used as the two exclusive vehicles of legislation from 600 to 1160. From 1160 to 1215 Latin alone was used. In 1215 French appeared, and then no more English until this enactment of Henry III. in 1259. It is, therefore, a fair parallel with the legal instruments of Alfonso, although the exclusive use of English in

such instruments can only be first assigned to 1362, when the
mother tongue once more and finally became the language of the
Law Courts.

PANCI, LANFRANCO. *Illuminator.* Saec. XIII.
Born at Cremona.

Worked in 1258.—*Zani : Enciclop. Metod.*, xiv. 247.

PANCIATICHI, LUCREZIA DE'. *Illuminator.* Saec. XVI.
A Nun of St. Jacopo di Ripoli, Florence, about 1500.

Zani : Encicloped. Metod., xiv. 248.

PANDOLFI, GIAN. ANTONIO. *Copyist.* Saec. XVI.

Worked at Bologna in 1514. " Joannes Antonius de Pandulphis
de Bononia scripsit.—*Zani : Encicloped. Metod.*, xiv. 250.

PANETTI, DOMENICO. *Miniaturist.* Saec. XV.

One of the artists who worked on the " Officium Virginis," now
in the Library at Modena, for Alfonso I. of Ferrara.—*Bucher :
Geschichte der Technischen Künste*, i. 260.

PANHOLZ, GERTHIUS. *Copyist.* Saec. XV.

Wrote, in 1418, a copy of "Gorini Johannis de S. Geminiano Ordinis Prædicator." Florentia (1300–19), Quadrigesimale—Expositio super quadrigesim. Epistolas et Evangelias.—*Jäck: Beschreibung, &c.*, 72.

PANNILINI, NICCOLÒ. *Copyist and Miniaturist.*

Saec. XV.

Called N. di Bernardino Pannilini.

In 1498 was employed to write and illuminate a Psalter for the Duomo of Orvieto. A memorandum of this is preserved in the Archivio del Duomo in a volume called " Libro di Allogagioni, &c., dal 1486–1500." He is confounded by Della Valle with a certain *Merlo.* But Milanesi, who carefully examined the above documents, twice corrects the error.—*Milanesi: Documenti dell' Arte Senese*, ii. 462.

PANTALEONI, GIOVANNI DE'. *Miniaturist.* Saec. XV.

Of Udine.

Employed on the Choir-books of the Duomo of Siena, about the same time or somewhat later than Liberale of Verona, Mariano d'Antonio and Girolamo of Cremona.—*Vasari: Le Vite, &c.*, vi. 179. (*Nuove Indagini.*) In 1468 he was paid 82 lire, 12 soldi, for certain small miniatures in the Choir-books of Siena.—*Milanesi: Documenti dell' Arte Senese*, ii 384.

PAOLO, FRA. *Copyist.* Saec. XVI.

A Benedictine Monk of Florence, about 1442.

Excelled as a copyist.—*Zani: Encicloped. Metod.*, xiv. 264.

PAOLO, FRANCESCO DI. *Copyist.* Saec. XV.
An excellent copyist at Florence in 1463.

> Wrote a Livy with miniatures. "Scritto per me Francesco di Pagolo. . . . Cittadino Fiorentino oggi questo di x di Giugno, 1463."—*Zani : Enciclop. Metod.*, xiv. 266, 341.

PAPE, JEAN DE. *Miniaturist.* Saec. XVI.

> Painted at La Haye, in 1527, two maps, on parchment, by order of the Procureur-Général of the Grand Council of Malines, on occasion of a trial maintained by the Emperor Charles V. against the town of Ziericzee.—*Messager des Sciences, &c.*, 1856, 185.

PARADIS, JEHAN. *Copyist.* Saec. XV.
Of Hesdin.

> "Scriver van Hesdin," was employed by Louis de Bruges and the Duke of Burgundy. He became a member of the Gild of St. John in 1471, and lived until 1508. In 1473 he wrote for the former patron : "La Chronique de Jehan de Courcy." 2 vols. Vell. Largest fol. Written in two cols., with very beautiful miniatures, vignettes, and initials. It has for general title : " Le Liure de la Bouquechardiere," a title which seems to have come from the fief of Bourg-Achard, which belonged to the Norman House of Courcy. In the borders the arms of Gruthuyse are covered by those of France, showing the MS. to have been among those acquired from the library of Louis de Bruges by Louis XII. of France. At the end of the prologue is this note : " Lesquels six liures dessus dits ont ete grosses et mis en deux volumes cest asçavoir au premier vol. les trois prem[rs] liures, et au sec[d] les trois

liures ensieuant par le commandement et ordonnance de mon tres hault et redoubte seigneur monseigneur le conte de Wincestre" (the seigneur must have been very proud of his English Earldom) " seigneur de la Gruthuyse prince de Stenhuse, &c., par moi Jehan Paradis, son indigne escripuain l'an mil quatre cent soixante treize." Paradis was the copyist of nearly all Gruthuyse's most beautiful MSS. He was admitted in 1470 into the Booksellers' Gild of Bruges, which enrolled among its members all persons connected with the execution or production of books. In 1471 he had already executed another MS. for Gruthuyse, called " La Somme Rurale." But the " Chronique de Jehan de Courcy " was probably his masterpiece. Vol. I. contains three magnificent miniatures 221 × 203 m. Though the arms of Gruthuyse have disappeared, the devices still remain untouched, such as the mortar and the motto *Plus est en vous*, while in the large initial of fol. 179 is the monogram L M, for Louis and Marguerite (de Borssele). In some MSS. acquired by Louis XII., the M has been altered into an A, for Anne de Bretagne (*e.g.*, in the " Miroir Historial," Nos. 6,930–6,933 MS. fr., National Library, Paris). Again, on fol. 279, are the same monogram and device of L M and the mortar. There are several fine MSS. of this chronicle in various libraries. One, for instance, like the present, in the National Library, Paris, which was in the Vallière Library. Another is in the Public Library at Geneva. A third, with splendid miniatures, in the Collection of the Prince de Condé. Three others magnificently executed, in the Library at Anet. Also a copy which Edwards notices in the " Bibliotheca Parisiana," thus : " Magnificent MS. on vellum, from the library of Claude d'Urfé, No. 497, Chronique de Jehan de Courcy, qui est aussi nommé la Boucachar*dine*, 2 vols. large fol., *green velvet*." This beautiful book was executed about the middle of the fifteenth century, and contains 378 leaves ; it is ornamented with very rich borders, with arabesque ornaments, and six grand miniatures about 7½ in. by 6 in. In one is a curious view of Babylon, built according to the style of the fifteenth century, and the Tower of Babel half finished, with the Angel confounding their language : Nimrod is represented as a monstrous giant armed cap-à-pie, and holding a halbert in his right hand. In the beginning of this MS. we have a preface, where the author tells us he was named " Jehan de Courcy, a Norman knight, that in the year 1416, finding himself grow old, and no more fit for fields of battle, being favoured with the goods of fortune, and seeking repose, to avoid idleness he was going to employ himself

in writing ancient histories, and conclude with moral and pious reflexions." Van Praet says that the statement of its coming from the library of Claude de Urfé is an error. It formerly belonged to Clermont-Tonnerre, like all the other books stated in this catalogue to have come from the d'Urfé Collection. In 1611, Henri de Clermont, Comte de Tonnerre, gave the books of his family to the *minimes* of that town. The monks sold the best of them, in 1788, to the Archbishop of Sens, and he, in 1791, to Edwards, who got them confounded with those which P. Paris had commissioned him to sell. Paris, by the way, describes the following copies of the same work : " Chron. de Jehan de Courcy," No. 6,951, Fds. fr. (National Library, Paris). Large fol., 2 vols., with six miniatures. Belonged to Jehanne de France, daughter of Charles VII. Among the ornaments are the arms of Courcy : *az., fretté d'or* de 6 pièces. Another copy, No. 6,952, in same library, written on paper ; and another, No. 7,139, containing the first three books, with three miniatures, initials, and borders. This is described as a very handsome volume, with three exceedingly fine miniatures, one in each volume. Contains an episcopal coat of arms that is traced by means of the accompanying cypher, J. LV. to Jean Louis (Gian Ludovico) de Savoie, Bishop of Geneva. Fragments of other copies exist also in the same library. Lastly, there is a very fine copy of the Chronicle, with its sub-title, of " Liure de la Boucachardière," in the British Museum, Harley MS., No. 4,376, in six books, which the author says he began on his return from Greece in 1416. The arguments of the six books are : 1. Le premier fera mention comme apres le Deluge qui fut au temps Noe fut la terre de Grece premier restauree et des haultes histoires des anciens Gregois qui en icelle contree longuement habiterent. 2. Le second liure fera mention de lancienne creacion de Troye et comme elle fut par les Gregois destruite. 3. Le troisiesme du peuple de Troye qui eschappe de la destruction et comme plusieurs pays furent depeuples de cette lignie. 4. Le quatriesme des assiriens et de leurs grandes dominiacions. 5. Le cinquiesme nous declairera des macedonois et des grands faiz du Roy Alexandre le grant, &c. 6. Le sixiesme de Matathias et des Machabieux comme ilz se combatirent pour la loy de Dieu. Cy apres aura en chascun de ces six liures plusieurs histoires et de plusieurs mainiers et chascune histoire partie par chapitres ordinairement comme cy ensuivent apperia et le pourrez trouuer." An ample table of contents is prefixed to each book, and also a large and splendid illumination.—*Paris : Les MSS. fr. de la Bibl.*

du Roi, i. 78 ; ii. 332–335.—*Edwards : Bibliotheca Parisiana*, 115,
&c.—*Van Praet : Recherches sur Louis de Bruges*, 135, 207–210.
—*Pinchart : Miniaturistes Enlumineurs, Calligraphes, &c.*, 12.
— *Weale : Beffroi*, iv. 282–328.

PARIS, HUGUES DE. *Copyist.*　　　Saec. (?)

Wrote, with much care, a MS. now in the National Library,
Paris (MS. lat., 2,032), containing a Table of the Discourses of
S. Augustine, made by Jean de Fait (Abbot of S. Bavon of Ghent).
On fol. 1 it has the Papal arms : "*gu.* a deux clefs d'argent en
sautoir," four representations of the armorial bearings of Cle-
ment VI. It may have been a presentation copy to that Pope.
At end : " Ista tabula fuit scripta per manum Hugonis de Parisis,
clerici, Ruthenensis diocesis." Also a Table of the Homilies of
S. Augustine on St. John in same library (Fds. lat., 1,968). At
end : "Scripta est per manum Hugonis de Parisis."—*Delisle :
Cabinet des MSS.*, i. 488, 489.

PARIS, MATTHEW. *Copyist and Miniaturist.*

Saec. XIII.

A Monk of St. Albans, and, notwithstanding his
name of Matthæus Parisiensis, or Parisiacensis, pro-
bably an Englishman.

His familiarity with French words and localities, may imply
that he had resided in Paris, perhaps as a student, but families
bearing the name of de Paris, de Parisius, Parisiensis, &c., were
common in England, particularly in Lincolnshire, in the thirteenth
century. He says himself that he assumed the religious habit at
St. Albans on 21 Jan., 1217. For many years he seems to have
been sedulously employed in the transcription of books, and
meantime, also acquired a reputation for historical knowledge and
ability in written composition. In 1236 he went to Westminster

to attend and describe the splendid nuptials of Henry III. and Alienor of Provence. His account of the event is most vivid and interesting. In 1247 he was again in Westminster to witness the Feast of St. Edward the Confessor, and on this occasion was invited to dine with the king. In 1250 he was sent into Norway. In 1251–52 he went to York to attend the wedding of Alexander II. of Scotland to Henry's daughter Margaret. His death probably took place soon after May, 1259. The Abbey of St. Albans, to which Matthew belonged, was one of the famous schools of English Calligraphy and Illumination. As a religious foundation it owes its origin to Offa II., king of Mercia, in compunction for the murder of Ethelbert, king of the East Angles, and in honour of St. Alban, the English proto-martyr. It was founded about 793, and was attached to the then pre-eminent Order of St. Benedict. When Matthew Paris joined its community, and for thirty-eight years longer, it was under the government of William de Trumpington, the twenty-second abbot. Adrian IV. had created it a mitred abbacy, in remembrance of his childhood, which, under the name of Nicholas Breakspear, he had passed in the neighbouring village, and very speedily the Abbey of St. Albans attained the front rank among English Benedictine houses. Its importance was constantly being augmented by the addition of fresh privileges. Under a bull of Alexander IV. it was exempted from episcopal authority. Its Abbot ranked next after the Bishops, taking precedence, except for a short interval, even of Westminster. Hence its importance as a school both of literature and art. Nor did its influence ever decline during the whole period of its existence. On the introduction of printing, the press of St. Albans was the third of those set up in England. Its earliest production was the rare "Rhetorica nova Fratris Laurencii Gulielmi de Saona, 1480," three copies only of which are known to exist,—at Althorpe, Cambridge, and the British Museum. Another of its rarities was the "Boke of St. Albans," written by Dame Juliana Barnes, or Berners, Prioress of the neighbouring nunnery of Sopwell, and printed in 1486. Indeed the great Benedictine Abbey, which produced able writers like Roger of Wendover, Matthew Paris, William Rishanger, and Thomas Walsingham, and supported a scriptorium that ranked second to none in the kingdom, might well claim to have been one of the chief places of light and leading throughout all the Middle Ages. Its story is told at length in several extant MS. records, the completest, perhaps, being the Cotton MS. Nero,

D. 7, in the British Museum. Such at one time was its extent and wealth, that "if the old lands were united together, its worth at this day," says Stevens in 1722, "in all rents, profits, and revenues, about two hundred thousand pounds a year." The monastic buildings were demolished in 1540 by Sir Richard Lee, to whom they had been granted after their suppression in 1538.

Matthew Paris is known chiefly from his Chronicle or History of the English, but he wrote many other works, and transcribed a still greater number. Besides his literary accomplishments he was a skilful scribe, artist, and cartographer. Walsingham, in the " Liber de Benefactoribus" of the Abbey, after calling him "pictor peroptimus," says:—" Providet præterea libros multos scriptos tam manu propria quam externa, in quibus quam excellens in doctrina et pictura fuit satis claret." (MS. Cotton, Nero, D. 7, fol. 30 *v.*; Claud. E. 4, fol. 332 *v.*) Many of the MSS. dealing with the history of the Abbey and relating to Matthew Paris, or written by him and other copyists of the St. Alban's scriptorium, are fortunately still preserved, and contain very valuable contributions to our knowledge of the arts, customs, costumes, &c., of the Middle Ages, particularly during the first half of the thirteenth century. Many are in the Cotton Collection in the British Museum; others in the Harley, Lansdowne, and Arundel Collections. The specially important MS., perhaps of all, is Royal MS. 14 C. vii., as being the autograph copy of the author, which was presented to Henry III., and probably containing examples of Paris's skill as an illuminator, miniaturist, and herald painter. On fol. 6 is a miniature of the Virgin seated, and holding the Infant Christ, whom she kisses. Beneath is the artist in monastic habit, prostrate, and evidently intended for a portrait. Above him is written in capital letters, alternately blue and red : FRAT⁵ MATHIẌS PARISIENSIS. On fol. 6 *v.*, below the table to find the Dominical letter, is : "Hunc librū dedit f͞r Math's Parisiensis. Anima Math'i et anime omniū fidelium defunctoↄ, requiescant in pace. Amen." The erased words, as ascertained from other copies, were probably : " Deo et ecclē sc̄i Albani." Large and handsome initials in blue and red, in the usual style of the time, shields of arms of English and foreign sovereigns and nobles, are drawn in the margins, and occasional illustrative drawings occur from time to time. At the year 1259, after his death, his portrait is again given by a fellow-monk as he lay dead on his pallet; and a third portrait is given in the " Liber Benefactorum" by the illuminator Alan Strayler (Cotton, Nero D. 7,

fol. 50 *v.*) This portrait is very coarse, and wanting in character. Miniatures ascribed to Paris occur in the C.C.C.C. MS., xxvi., at Cambridge, which contains a compendium of the benefactors of the Abbey, and is very similar in contents to Cotton MS., Nero D. 7; also in Nero D. 1, "Vitæ Offarum." In Roy., 2 B. vi., are others, including a figure of the Virgin. He probably owed his knowledge of drawing to Walter of Colchester, Sacrist. of St. Albans in the time of Abbot William of Trumpington (1214–1255), whose wonderful talents as a sculptor and painter we find so frequently noticed in the records. Paris calls him "pictor et sculptor incomparabilis." He also mentions a Master Richard, son of Simon, monk of St. Albans. In Nero, D. 1, fol. 185, is a brief list of his pictorial works, entitled, " Opera Ricardi pictoris usque ad annum domini MCCL. infra IX. annos et dimidium." In the same MS. is a magnificent semi-transparent drawing of the full-length figure of Christ, executed by a Friar Minor named William (fol. 155), over it is inscribed in red, by Paris : " Hoc opus fecit frater Willelmus de Ordine Minorum socius beati Francisci, secundus in ordine ipso, in conversatiōe sanctus, natione Anglus." And in the MS. of the Greater Chronicle at Cambridge (C.C.C.C. xvi. fol. 67), Paris has drawn his portrait in the monastic habit ; above is written : " Frater Willelmus nacione Anglus socius scti Francisci." Other MSS. exist at Lambeth Palace, the Heralds' and Record Offices, in the Bodley Library, Oxford ; in those of Magdalen, Jesus, and Trinity Colleges, and in that of Corpus Christi College, Cambridge, already referred to, and the list may be considerably extended by reference to the Catalogues of the British Museum and to works referring to St. Albans.—*Madden : Matthæi Parisiensis. . . . Historia Anglorum, in Rolls Publications, I. Præf., III. Præf.* i.-xxii. &c.—*Gairdner : Early Chroniclers of Europe—England,* ch. vi. 243–257.—*The Abbey of St. Alban,* &*c.* (London : 1857, 8°), 19, 73–79.

PARMA, ARCANGELO DA. *Miniaturist.* Saec. xv.
Lived at Ferrara.

Referred to in a document of 1487 : " Ad petitionem Magistri Arcangeli aminiatoris filii . . . de Parma habitatoris Ferrarie in

domo habitationis Magistri Laurentij de Rubeis Cartolarij (and printer) de Valentia, &c.—*Cittadella: Documenti, &c.* 179.

Parma, Ilario da. *Copyist.* Saec. xv.

Wrote "Cicero de Amicitia et Somnium Scipionis." Vellum. Sm. fol. On fol. 57 *v.* is this note: " Mci Tullij Ciceronis de Amicitia liber finit. Scriptus per me Hilarium Parmensem." The writing is a rather heavy, common, half-Roman text. Now in the British Museum, Add. MSS., 18,842.

Parma, Jacobus de Cassola de. *Copyist.* Saec. xv.

Wrote at Ferrara: 1. C. Julii Cæsaris Historiæ Belli Gallici. 2. Suetonii Tranquilli de Gestis Cæsaris in Galliis. 3. De Bellis Civilibus. Vell. Fol. In double col., with titles in red and initials in gold, with ornaments and figures in colours. Those of books 1, 2, 4, 8, 9, and 12 have, besides, an elegant border, which takes up the whole of the left margin of the page.

In the initial of book 1. is painted the portrait of a crowned king, seated, and with a sword in his right hand. Annotations in margins by Guarino. At end: " Ego Jacobus de Cassola de Parma scripsi hunc librum in domo dñe dñe Nicolai Marchionis Estensis dñe generalis civitatis Ferrariæ nec non civitatis Mutinæ." And afterwards, "Emendavit Guarinus Veronensis adjuvante Io. Lamola cive Bononiense an. Xti. Mccccxxxii.(c.) iiii. nonas Julias, Ferrariæ. Cat. N. ccccxx." Now in Este Library, Modena.— *Campori: Cenni Storici, &c., Estense,* p. 41.

Parma, Janes de. *Copyist.* Saec. xvi.

Wrote " La Divina Commedia." Vell. Sm. fol. 101 ff., 2 cols. In Gothic hand, with titles, &c., in red, and illuminated initials to every canto. Now in the Corsini Library, Rome. (Cod. Rossi 368.)—*Batines: Bibliogr. Dantesca,* ii. 184.

PARMA, LUDOVICO DA. *See* RAIMONDI.

PARMENSIS. *See* PARMA.

PARUTI, SALVADOR. *Copyist.* Saec. xv.

Wrote " Marco Polo, Veneto, degli Regioni Orientali." Paper.
Thin 4⁰ 2 cols, 39 ff. Written in rapid, upright, cursive
minuscule. At end: " Questo libro scrisse Salvador parutj al
1457," &c. Now in British Museum, Sloane MSS., 251.

PARVULUS, JOANNES. *Copyist.* Saec. xv.

Wrote, in 1423, a large volume entitled Duns Scotus, in
librum 4tum, Sententiarum. Vell. Fol., 210 ff. At end: "A.D.
1423. Dominica quadragesimali in qua cantabatur. Oculi
scriptus est iste liber, et per scripturam finitus per manus Joannis
Parvuli lectoris ecclesiæ Augustensis. Magister Rudolphus Com-
par'." Now in the Royal Library at Munich, Cod. lat., 3,834.—
Steichele: Archiv für die Geschichte des Bist. Augsburg, i. 160.

PARVUS, JOHANNES. *Copyist.* Saec. xv.

Wrote a Book of Offices, in Latin and French, and in a large
clear hand. Vell. Large 4⁰, 238 ff. With miniatures, initials,
and borders. Besides the small miniatures or stories in the initials

are twenty-five large ones containing the usual subjects. The names in the calendar point to a French diocess as the locality of its execution. In gold are Genviève, Vincent, Nicholas, Eloy, Louys, Leu (Lupus Senonensis), Denis, Yvo, and Clement. It is attributed to Jo. Parvus or Jean Le Petit by Denis. Now in the Imperial Library, Vienna; DcccLxxxix.—*Denis: Catal., &c.,* 3, 128. Perhaps, by the same hands, is a "Breviarium antiquum," with illuminated initials, now in the Public Library at Cambrai. It is written in a very beautiful handwriting, and said to have been executed for Raoul Du Prêtre, Archdeacon of Hainaut and Canon of Cambrai. The copyist began it on St. Paul's day, 1400, and finished it on St. Paul's day, 1402. (Fol. 340) : "Istud breviarium completum in duobus voluminibus fecit fieri Radulphus Presbyteri, Archidiaconus Hannonia et Canonicus in Ecclesia Cameracensi, a festo beatorum aptorum Petri et Pauli anno quadringentesimi usq̃. ad ip̄m festum anni iiij^c ij per me Joħem *Parvi* de Britania (Brittany) Si placet pro nobis orate."—*Le Glay : Catalogue des MSS. de la Bibliothèque de Cambrai,* 12.

PARVUS, Jo. *Copyist.* Saec. XVI.

Employed in 1549 in the Apostolic Chamber under Paul III. as "Scriptor librorum."—*Müntz : La Bibliothèque du Vatican au XVI^e Siècle,* 101.

PASSEROTTI, AURELIO. *Miniaturist.* Saec. XVI.

Of Bologna.

Son of Bartolommeo Passerotti, and brother of Tiburzio ; distinguished as a miniaturist : "miniò senza paragone." He also made architectural drawings for the Emperor Rodolph II.—*Malvasia : Felsina pittrice,* i. 189.—*Lanzi : History of Painting in Italy* (Bohn's Translation), iii. 47.

Passerotti, Bartol. *Printer and Miniaturist.*

Saec. xvi.

A memoir and portrait of this artist are given in the *Museo Florentino*, i. 9.

Passerotti, Gasparo. *Miniaturist.* Saec. xvii.
Son of Tiburzio, of Bologna.

Distinguished in miniature, especially for Choir-books. He worked for the Princess of Modena. *Malvasia : Felsina pittrice,* i. 188.—*Lanzi : History of Painting, &c.,* iii. 47.

Pasto, Ferrante. *Miniaturist.* Saec. xvi.

Worked at Verona in 1568. Some relative, perhaps, of Matteo the medallist and painter. Painted the Virgin and Saints on an oval ivory tablet $3 \times 2\frac{1}{2}$ inches. Signed " Pasto Ferrante, pin. Verona, 1568.—*Catal. of Loan Collection of Illum. MSS.* (Liverpool, 1876), 43.

Pavia, Bastiano da. *Copyist.* Saec. xvi.

Worked, in 1507, on a Psalter for the Convent of St. Augustine, in Rome : " 1507 . Novembre. Ad misser Bastiano cappellano de Pavia per parte della scriptura del Salterio quale da lui se fenisce : 2 duc. d'oro largi." (Sag de S. Agostino, 1505–1518, fol. 25 ; Cf. fol. 250, 260)—*Müntz : La Bibliothèque du Vatican au XVI^e Siecle. Notes et Documents* (Paris, 1886), 21. Again : " 1520 . 18 Octobr. A. M. Bastiano scriptore de lectera formata (lettre de forme) duc. trenta per scriptura di doi libri di ceremonie, per N. S. quando si pare." (T. S. 1519, 1520, fol. 83 *v.*).—*Documents* (above) 59.

PEDEMONTE, HERCULE. *Miniaturist.* Saec. XVI.
Miniaturist at Rome.

> Among the signatories to the petition in favour of Cesare Franchi, of Perugia.—*Bertolotti: Il Bibliofilo.* 1882, 68.

PEDIET, ODDOT LE. *Illuminator.* Saec. XV.
A Clerk of Dijon, in the service of the Duke of Burgundy.

> Laborde preserves the following notice : "No. 277 Rec. Gén. 1416. A Oddot le Pediet. clerc demourans en la ville de Dijon pour auoir minue et grosse jusques au nombre de XL lettres de mandement de Mds . tant de justice comme de finance et plusieurs coppies touchans le pays et demaine de Flandres, le XVᵉ jour de septembre lan mil cccc et xv . . . vi f."—*Laborde : Hist. des Ducs de Bourgogne, &c.*, i. pt. II., 102. His name is given also in the list of painters, under 1409.—*Ibid. :* 528.

PELCHINZER, ANTONIUS. *Copyist.* Saec. XV.
Of Hofen.

> "Scriptor egregius." D . 1442 . Monk of Tegernsee.—*Jos. v. Hefner, in Oberbairisches Archiv, &c.*, ii. 27.

PELLEGRINO, DI MARIANO. *Miniaturist.* Saec. XV.
See ROSSINI.

Pellificus. *Illuminator or Copyist.* **Saec. xv.**
A German.

> Worked about 1443.—*Zani: Enciclop. Metod.*, xv. 21.

Pelous, Le Petit. *Copyist.* **Saec. xv.**

> Wrote, in 1458: " Dioscorides, tractatus de herbis," &c. Vell. Folio. In 2 columns. With initials in various colours and gold, and figures of the various plants painted as from nature. On first page of index: " Explicit tractatus herbarum Dioscorides & Platonis, atq Galieno & Macrone *traslatate* manu et intellectu Bartholomei Mund'senis in arte speciarie semper infusus, &c. Explicit cest herbolaire, auquel a lieuasses affaire *Abourt* il a este escript Mil cccc cinquante et huit. Et la escript cest tout certain Le patron de sa propre main Pries pour luy je vous en prye Pour amour de la compaignye Le petit pelous," &c., Mcccclviii. Then follows a copious index, at end of which : " Hoc scripsi totum pro pena date michi potum Nomen scriptoris Le petit pelous plenus amoris." A magnificent manuscript. Now in the Este Library, Modena (Catalogue 993).—*Campori : Cenni Stor., &c., Estense,* 52.

Pendasi, Girolamo. *Copyist.* **Saec. xv.**

> *Cittadella : Docum., &c.,* 171–181.

Penna, Valerio. *Miniaturist or Copyist.* **Saec. xvii.**

> Famous at Bologna about 1631.—*Zani : Enciclop. Metod.,* xv. 26.

Pergula, Jacobus de. *Copyist.* Saec. xv.

Wrote for the Malatesta Library at Cæsena, nine volumes, briefly described by Muccioli, viz. [1.] "S. Augustini Enarrationes in Psalmos a Ps. lxxviii. ad Ps. ultimum usque, cl." On folio 1 is a miniature containing the figure of St. Augustine, in episcopal vestments, wearing a richly-decorated mitre, a black cowl and blue pallium, and holding in his left hand a pastoral staff. At the end : "Scripsit Jacobus de Pergula pro Magnifico Dom⁰ Domino Malatesta Novello, anno mccccli. et finitus die xv. Septembris." Pl. iii. 2. [2.] "Gregorii Magni in Job, libri 35." On the first page a miniature of St. Gregory, in Pontifical dress, richly illuminated. At the end : "Scripsi hunc librum ego Jacobus de Pergola pro magnifico et potenti Domino D. Malatesta Novello de Malatestis, quem perfeci die v. Nov^bris mccccli. xiii. indict. in civitate Bertinorii." Beautifully written. Pl. v. 5. [3.] "S. Augustini de Civitate Dei, libri xxii." All the initials in this volume are vividly illuminated with colours and burnished gold, and with extraordinary skill. In the first initial is the figure of St. Augustine, exquisitely painted, wearing the pallium of the Order "Eremitarum"; and seated on a sort of tripod beneath an apsis, supported by columns of the greatest architectural beauty. He raises his eyes and left hand towards a view of the heavenly city. In his right hand he holds a pen as if just about to write. The page is surrounded by a full marginal border of floral ornaments interspersed with birds, &c., and containing the Malatesta arms and the letters in gold, M N., as in other MSS. in this library. On each side border is a medallion, one containing an ox lying on the ground, the other a peahen finely painted—devices of the Malatesta family. This MS. is especially beautiful in its handwriting, nor would it be easy to find another MS. equal to it in this respect. At the end is written : "Scriptus per me Iacobum de Pergula pro Magnifico et Potenti Dño Dño Malatesta Novello, quem complevi in Civitate Fani anno mccccl. die x. Februarii." Pl. ix. 1. [4.] "S. Augustini contra Faustum, libri xxxiii.," &c. (seven other tracts). Similar to the above. At end : "Scriptus per Jacobum Pergulitanum pro Magnifico et Potenti Dño Dño Malatesta Novello de Malatestis, et perfectus est die xxix. Julii mcccliv." Pl. x. 1.

The remaining volumes are [5.] "Enchiridion Augustini," &c. Pl. x. 2. [6.] "Plinii Hist. Naturalis," libri xxxvii. Finished xi. Octobr. mccccxlvi." Pl. xi. 1. [7.] "Iornandis Getharum Hist." Dated iii. Jan. mcccliv. Pl. xii. 5. [8.] "T. Livii Hist." libri x.

Dated "xiii. Nov^bris MCCCCLIII." Pl. XIII. 1. [9.] " T. Livii de
Bello Punico," libri x. Dated " xii. Juni millesimo CCCCLVIII."
Pl. XIII. 2.—*Muccioli : Catalogus Codd. MSStor. Malatestianæ
Cæsenatis Bibliothecæ, s. vv.*

PERGULA, LUCAS PERI DE. *Copyist.* Saec. XV.

 Wrote, in 1487 : " Honestis (Christophorus de) Liber de Vene-
nis. Paper. 4° (8½ × 5⅝ in.) 83 ff.—*Bragge : Sale Catal., No.* 256.

PERICCIOLI, FRANCESCO. *Copyist.* Saec. XVII.

 A Priest. Worked at Siena about 1608.—*Zani : Enciclop.
Metod.*, xv. 43.

PERRÉAL, JEAN. *Miniaturist, &c.* Saec. XV.

 Called also Jehan de Paris. He is styled painter and valet-de-
chambre to the king. The earliest mention of him, it is said,
occurs in 1472, when he executed the glass paintings for the
Carmelite Church at Tours, an edifice due to the liberality
of Lous XI., whose devotion to the Madonna is well known.
—*Grandmaison : Documents inédits pour servir à l'Histoire des
Arts en Touraine,* 24, *&c.* To this account of the glass-paintings
M. Charvet adds many other particulars; he also attempts to
identify him with a Jehan de Paris in the service of Charlotte
de Savoie, wife of Louis XI. He tells us that a certain Jean de
Paris lived at Bourges about 1484, and the Baron de Girardot
remarks that at that date there occur, among others, the names

of Jehan de Paris and Jehan Lemaire as illuminators.—*Montaiglon: Archives de l'Art franc.*, 2nd. sér. i. 217. There is a Jehan de Paris employed in the XVI. century at Aix in Provence. Clearly not *this* Jehan de Paris. In 1483 Louis XI., being then sick at Plessis-lès-Tours, sought the intervention of the famous Calabrian hermit, Francis de Paul. This man, famous for the sanctity of his life, was invited to traverse France in a sort of religious progress, and for the purpose Jehan de Paris (Perréal) is charged to prepare a sort of state carriage. In December 1485 the Cardinal de Bourbon made his entry into Lyons, and Perréal was employed in the decorations prepared for the occasion. Among the emblems then employed are mentioned a flaming sword, a lion, and a winged stag. In 1489 the Duke of Savoy entered Lyons, and again Perréal is employed on the decorations. This time two escutcheons containing the arms of the city, a grand sun and moon, &c. In 1490 great preparations were made for the first triumphal entry of Charles VIII., and among the artists employed are Jehan Prévost (*see* PREVOST) and Jehan de Paris, Claude Dalmet, and Clement Tric, to invent, "trouver," quelques beaux mystères, moralites, ystoires, and autres joyeusetés joyeuses ; plaisans and honnestes, le touts reuenant à l'amour, exaltacion, gré and plaisir du Roy and des seigneurs de son rang et lignage.— *Rolle: Archives de l'Art français.* For his services on this occasion he received 20 livres t. and two ells and a-half of " drap gris de Perpignan pour faire une robe." In 1491 Perréal painted the royal arms for the "porte de Bourgneuf," accompanied by two angels and supported by a lion. For this and for painting another lion placed on the new bridge over the Saone 12 livres tournois. To pass over intermediate labours, in 1494 Charles VIII., and soon afterwards Anne of Brittany, entered Lyons, and again the services of Perréal were required. He was invited by the "Sénéchal" of Lyon to invent certain "belles histoires and mistères." In 1502 he is in Italy. In 1504 he is in the pay of Margaret of Austria. In 1507 he is allowed 10 livr. in consideration of his horse, and in 1509 is the following entry in the Household Expenses : " Pour la livrée et despence de la mulle de Jehan Bourdichon (*see* B.), et du cheval de Jehan de Paris peintre dudit sieur, &c., x. l. t." The last entry to similar effect is in 1521, here he is mentioned alone, Bourdichon having probably died about 1520 or 1521. In a volume in the National Library, Paris, MS. 8,463, entitled " Mémoires du Règne de Louis XII.," is an undated document in which Perréal is placed among the valets-de-chambre. The

accounts of 1523 of the Royal Household under Francis I. contained this passage :—À Jehan Perréal, dit de Paris valet-dechambre ordinaire du Roy, 240 livres tournois." This was a usual mode of paying artists for their services. If unmarried they received abbeys like Il Rosso and Primaticcio, De l'Orme and Lescot. The title of valet-de-chambre under the ancient kings of France, and other sovereign princes, was formerly a possession of considerable value. It conferred nobility and the title of esquire, and was transmissible with its privileges by will or heirship. Artists and literary men of celebrity were frequently enrolled among them as a reward or mark of favour. Jean van Eyck held this position under Philip of Burgundy, and similarly the Court painters under Charles V. and his successors. Perréal is called painter to the King in the accounts of the town of Lyons referring to the entry of Lous XII. into that city in 1499. His name appears first on the list of signatories to the " Confirmatio Statutorum Ministerii Pretorum," &c., of the city of Lyons, granted by Charles VIII., and next to his name stands that of Jehan Prévost, whose name occurs in the Expense Books of the Bâtimens du Roy. On the death of Lous XII., as before on that of Anne of Brittany, Perréal was employed to provide the funeral paraphernalia. But his various occupations are innumerable, as was the case with most of those who enjoyed the rank of valets-de-chambre and court-painters. Mrs. Pattison is inclined to assign to him the execution of the masterly miniatures in the Oglethorpe Bible at Corpus Christi College, Oxford. These miniatures are certainly of the school of Tours rather than of Paris, though not so marked as to exclude Northern influence altogether, and they betray that minute facility in ornamental details in the armour, &c., which is so common an accomplishment with artists like Perréal, Bourdichon, and the costume designers generally. The taste is very prevalent in Renaissance work, especially in France and the Netherlands. Godefroi carries it to great perfection in his miniatures to the Cæsar's Commentaries in the British Museum, &c. There exists in the Cluny Museum a tablet painting in oil, known as the " Messe de St. Gregoire," which is attributed to Perréal, and another in possession of M. Bancel representing the Marriage of Charles VIII. with Anne of Brittany, inscribed on which are the initials J. P. —*Mrs. Pattison: the Renaissance of Art in France,* i. 304, &c. Perréal's death probably occurred about 1528.—*Charvet: Jean Perréal,* in *Biogr. d'Architectes,* 6, &c. Lyon, 1874, 8°.—*Renouvier: Jehan Perréal.*

PERRENOT, ANTOINE. *Patron.* Saec. XVI.
See GRANVELLE.

PERRET, CLEMENT. *Copyist.* Saec. XV.
Lived at Brussels.

Wrote "Exercitatio alphabetica nova et utiliss. varijs expressa
linguis et characterib : raris ornamentis umbris et recessis, pictura
Architecturaq. speciosa. Nunquam ante hac edita. Clementis Per-
reti, Bruxellani, nondum 18 annum egressi Industria. Anno 1569."
Fol. Antdorf, 1596. 4⁰. The 1569 ed. of this book is a thin oblong
fol. The title page and every other page is surrounded with
a very elegant cartel frame, with figures, grotesques, fruits, jewels,
wreaths, &c., in the manner of Theod. de Bry. It contains 34 folios,
and is really a beautiful piece of work. Some of the frames, *e.g.*
on folio 5, are most elegant, and executed with the most careful
precision of drawing. The copies of text are in various languages ;
and the last folio contains an elegant and fanciful design in which
the line of text is written in form of a strapwork or ribbon of words,
twisted into a very elegant and symmetrical design. Now in the
British Museum (556. b. 1).

PERUGIA, LORENZO SPIRITO DA. *Copyist.* Saec. XV.

Wrote on paper, occasionally interleaved with parchment, a folio
volume, of which the following is the title : " Incomincia il libro
chiamato altro Marte facto e composto per mano di me Lorenzo
Spirito da Per*ur*sa de la Vita e gesti delo illustrissimo et potenti
Capitano Nicolo Picinino Visconte de Aragonia." 252 ff. In up-
right Italic, or half Roman. The title is in thick gold capitals
within a white stem border on gold trellis. In middle of border is
an interlaced knot, except at foot, where are the arms of Priuli of

Venice, paly of 6 or and az : in chief gu. (no charge), on a ground within a gold circlet, then a green wreath and another gold circlet. Over the knot in the right (outer) border is a large grassshopper. In other parts of the border are green parrots. The initial D(ivino Apollo) is a very handsome letter. At end, in red : "Qui finissi illibro chiamato altro marte fatto ecomposto p mano dime lorenço Spirito da perugia dela vita e gesti delo illustrissimo Capitano Nicolo picinino francesco picinino et conte jacomo. E copiato p mia propria mano. Al magnifico Mesere Antonio Priolj di Vinegia al mille quattrocento sexanta nove a di 15 di marzo deo gratias LAURENTIUS SPIRITUS : IMPERA*TRIX* FENIX AMEN. The capitals are alternately red and black. Now in the Bodley Library, Oxford.—*MSS. Canonici Ital.* No. 41. *Catal. Codici MSS. Canoniciani Italici*, 50.

PERUGIA, PIETRO DA. *Miniaturist.* Saec. xv.

An imitator of Stefano Veronese. He illuminated, says Vasari, "all the books of the Duomo of Siena in the library of Pius II." He must not be confounded, on the one hand, with Pietro Perugino (Vanucci) or, on the other, with Pietro or Perino Cesarei, another Perugino, who worked at the end of the sixteenth century. The dispersion of the Piccolomini archives has prevented the identification of this artist, now known only by name. It may be supposed, therefore, that the MSS. illuminated by him for Pius II., or rather for Pius III., were those that were carried off to Spain by the Cardinal of Burgos, who was appointed governor of Siena by Charles V. in 1556. It may be convenient here to observe that the rich collection of Choir-books which now are seen in the Cathedral Library, and which were executed at the expense of the "Opera," were not placed there until the commencement of the last century, when the Piccolomini family transferred to the Duomo the possession of the library.—*Vasari : Le Vite, &c.*, ii. 156, n. 1. (*Lemonnier*) *Nagler : Künstlerlexicon*, xi. 134.

PERUGINO. *See* CESAREI.

PERUGINO, POLONIO. *Miniaturist.* **Saec. (?)**

A distinguished miniaturist of Perugia, cited by Padre G. F. Morelli in his " Descrizione delle Pitture e Scolture della Città di Perugia," 104 (1683).—*Orlandi : Abecedario Pittorico*, 437 (Ven. 1753, 4⁰).

PESLOE, RICARDUS. *Copyist.* **Saec. XIII.**

Wrote "Liber de tripartita domo Dei." Vell. 4⁰. At end : " Ricard⁹ pesloe sc'psit hūc librum." Appears to have belonged to a monastery at Pavia.—*Cochran : Catal. of MSS., &c.* 19, 1829.

PETERSSOEN, CLAES. *Copyist.* **Saec. XV.**

Wrote " Ierst Alexander's Historiens : item Machabeorum," 1⁰, &c. At end: " Dit boek, &c., door Claes Peterssoen, &c., gescreven anno M.cccc eenen en dertich." (1431). Vell. Fol. With miniatures, initials, and gantois borders of acanthus foliages. Now in the Royal Library at Brussels. No. 9,019.—*Marchal : Catal. des MSS. de la Bibl. Royale des Ducs de Bourgogne*, ii. 116.

PETITOT, JEAN. *Miniaturist, &c.* **Saec. XVII.**

A most celebrated portrait miniaturist and enamel painter. He was born at Geneva in 1607, and was apprenticed to a jeweller in that city, but finding that he succeeded best in painting and enamel work, he devoted himself entirely to those branches, and came to London with a recommendation to the King's goldsmith. The latter soon discovered Petitot's superiority to any other artist in enamel, and showed several jewels which he had finished to the

King, who was fond of such work. The King expressed a wish to see the artist, and thus Petitot was introduced to his first Royal patron, Charles I., who at once put him in communication with his physician, Theodore Mayerne, in order to learn more about the chemistry of colours. The able chemist, after several experiments, furnished our artist with fresh colours, hitherto wanting to the palette of the enameller. Vandyck was also called into requisition to assist Petitot with his suggestions, in order that the latter might devote himself entirely to portraiture. Petitot then undertook the likenesses of the King and of the Royal Family, after the paintings of Vandyck. His great ability and close application to study soon put him in the way of excelling his teachers; and for a considerable time he was employed solely by the King himself; nor did he undertake any private portraits whatever until 1642, when he painted the Countess of Southampton. A goldsmith-enameller, named Jacques Bordier, whom probably he had known in Geneva, became his assistant. Bordier, born at Geneva in 1616, had been in the employment of King Charles I. before 1640, after which he had travelled in Italy in order to perfect himself in painting, and had been imprisoned by the Inquisitor at Milan. On his release, he found his way once more to England, and immediately joined Petitot as his assistant. In this partnership each had his special work, Petitot making the design and Bordier painting the draperies and backgrounds, after which Petitot resumed and finished the subject. On the unhappy death of Charles in 1649, both the partners went and established themselves in Paris. Whilst there they entered into a still closer relationship. Bordier, in August, 1651, married Madeleine Cuper, daughter of a Comptroller of Finances at Blois, and in the November following Petitot married her sister Marguerite. Though then in his 45th year, before 1674 she bore him no fewer than nine sons and eight daughters. Of these, the eldest son, Jean, was the only one who followed his father's profession. Petitot and Bordier never separated, but lived together in the strictest friendship, and always worked in concert. Their reputation had preceded them to Paris, where they were joyfully received. Petitot was besieged by personages of the highest rank, and was soon appointed portrait painter to Louis XIV. From this moment it became his principal duty to reproduce the King's portraits to be presented to ambassadors and others from foreign courts. Bordier died in 1684. After the revocation of the Edict of Nantes in 1685, Petitot, who was a zealous Calvinist, desired to return to his native city. In 1687 he petitioned the King to allow

him to leave Paris, but so far from allowing his request he was thrown into prison at For-l'Evêque, where strenuous efforts were made to convert him to Romanism. He only recovered his liberty by a form of abjuration. On reaching Geneva, he declared that he had only yielded to force, and was again received into the Protestant Church. He afterwards withdrew to Vevay, still continuing to paint to the day of his death. He died suddenly whilst painting his wife's portrait in 1691. In conjunction with Bordier he produced a great number of portraits. But the enamels of his imitators, often put forward in his name, are much more numerous. The extreme softness of finish and exquisite harmony of colouring, however, which renders his own work at once attractive and unapproachable, easily separates It from that of his followers. After his retreat to Paris he copied the works of Philippe de Champagne, Lebrun, and Mignard. However small his copy, he could always exactly reproduce the true proportions of the work with perfect freedom. The Museum of the Louvre possesses a fine and authentic collection of his enamels, among which are several portraits of Anne of Austria, of Louis XIV., and Marie Thérèse; also the fine portrait of Cardinal Richelieu after Ph. de Champagne. England is still richer in works confidently attributed to his pencil. The Royal collection at Windsor, and that of the Duke of Cambridge, those of Mr. John Jones (now at South Kensington), Lords Gosford, Taunton, Fitzhardinge, and Cremorne, Miss Baring, Lady Burdett-Coutts, and Mr. Holford, most of which were exhibited at South Kensington in 1862 and 1865, are among the most important. Mr. Holford possesses the famous portrait of the Countess d'Olonne, the frame to which consists of an oval wreath of enamelled flowers —the masterpiece of Gilles Legaré, goldsmith to Louis XIV. A reproduction of this portrait is given in the "Gazette des Beaux Arts," xxii. 1 sér. To these collections should be added those at St. Petersburg, the Hague, Vienna, and many other places. No fewer than 156 (Bordier says 158), half of which belonged to John Jones alone, were exhibited at South Kensington in 1865, with 10 ascribed to Jean Petitot the younger.—*Bordier*: in *Gazette des Beaux Arts,* 1 sér. xxii. 168, 251.—*Labarte*: *Les Arts Industriels, &c.,* iii. 232–5. (2nd edit.). The account given by Walpole of this artist is a mass of confusion, such of its facts as are correct being displaced in their chronology. The King's physician, sometimes called Thomas, here called Theodore, is called Turquet de Mayerne, Genevois, in one of his own pocket-books, still preserved in the British Museum. —*Sloane MSS.,* 2,052.

PETITOT, JEAN. *Miniaturist.* **Saec. XVII.**
The younger. Born at Blois, 1653.

When quite young he entered his father's atelier, and in 1677 was taken to England and established in London, where he obtained under Charles II. the post held by his father under Charles I. He painted many excellent portraits, among which were those of the Queen, Catherine of Braganza, and other members of the Royal Family. In 1682 he returned to France and married Madeleine Bordier, his cousin. After his father's departure to Geneva he worked alone. In 1695 he returned once more to England, where, probably, he died, but in what year is not known.—*Labarte: Les Arts Industriels au Moyen Age, &c.,* iii. 232, 235. (2nd edit., 1875.)

PETRINI, ANDREA DE'. *Copyist.* **Saec. XV.**

Wrote " Ciceronis Tusculanæ Quæstiones." Vell. Sm. Folio. 85 ff. In a small ordinary half-Roman text. At end : " Deo gratias. Scriptū fuit in Castro Mutine, et expletū Año Dñi Millesimo ccccᵒxxvij. de mense sectĕbr' die xv. p̄ me Andreï Sr Jħõis de Petrinis deflorentia." Large initial C(um defensionum, &c.) of white stem pattern, gold on panel of colours. Now in British Museum, Harl. MSS., 2,468.

PETRONI, SISTER GIOVANNA. *Miniaturist.* **Saec. XIV.**
A Nun of St. Maria in Siena.

Was directress of the school of illumination in the convent, which furnished eight Choir-books for the neighbouring Cathedral of Leceto about 1375–1380. Zani gives her date 1335.—*Pautassi: I Codici Miniati,* 63.—*Zani: Enciclop. Metod.,* xv. 86.

PETRUS. *Calligrapher.* Saec. IX.
Schoolmaster of Hautvilliers.

Wrote a "Codex Evangeliorum" in golden letters, at the command of Ebo, Bishop of Rheims. — *Mabillon: Annales Bened.,* lib. xxx. 2.—*Le Long: Biblioth. Sacra,* i. 247. *See* PLACIDUS.

PETRUS. *Copyist.* Saec. XI.

Wrote, in era 1098 or A.D. 1055, a Psalter, known as the "Diurno del Rey Don Fernando I°." It contains the Calendar, Psalms, and several Nocturns and Responsories. Music given in Responsories written without lines in dots, in some instances on the text on a red line. On the page before the nocturns is this note: "Era millena novies. Dena quoque terna. Petrus erat scriptor. Frictosus deniq: pictor." Now in the library of the University of Santiago de Galicia.—*Riaño: Notes on Early Spanish Music,* 27.

PETRUS. *Copyist.* Saec. XII.

Wrote a Bible in four volumes. Vell. Folio. At end of vol. i.: "Anno ab incarnatione Domini MCLXXXVIIII. Era MCCXXVII. Petrus scripsit hunc Codicem." Formerly in the Lower Library, Valladolid.—*Morales: Viage per orden del Rey D. Philipe II., &c.,* 10. (Madrid, 1765. Fol.)

PETTENBACH, THOMAS DE. *Copyist.* Saec. XV.

Wrote, in 1424, a copy of the Commentary of Dionysius on Valerius Maximus. Paper. Fol. 288 ff. It is entitled : "Fr. Dionysii de Burgo, S. Sepulcri Ord S. Aug. Commentarius in

Valerium Maximum," and has this note at end: "Explicit liber
iste per manu Thomæ de Pettenbach, A.D. 1424. Sabb. die ante
fest. Purif. Mar." Now in the Royal Library, Munich. Cod. lat.,
3,863 —*Steichele: Archiv für die Geschichte des Bisthums Augs-
burg* i. 133.

PETTINATO, BARTOLOMMEO. *Miniaturist.* Saec. XVI.
A Neapolitan.

A pupil of Giov. Battista Anticone.—*Dominici: Vite dei Pittori,
&c., Napoletani,* ii. 392. *See* ANTICONE.

PHARIZEIS, FOSCARINO DE. *Copyist.* Saec. XIV.

Wrote, in 1389, at Parma, the Third Decade of Livy on 80 ff.,
in one month, from 15 Feb. to 15 March.—*Wattenb.*, 241, from
Valentinelli, Biblioth. S. Marci, vi. 13.

PHILECTICUS, NICOLAUS ROMANUS. *Copyist.* Saec. XV.

Wrote "M. Accii Plauti Comœdiæ." 4°. Vell. Finely written
initials. At end: "Nicolaus Philecticus Romanus hunc Plautum
celeri manu scripsit feliciter, anno Dñi millesimo CCCC°LIX. Now
in the Este Library, Modena. Cat. No. cxcvi.—*Cenni: Storici della
R. Bibl. Estense,* 34.

Philip (the Handsome). *Patron.* **Saec. xvi.**
Son of Maximilian I., Emperor of Germany, and
Marie of Burgundy.

For him were executed many beautiful examples of illuminated
books now in various public libraries. Among them is "Officium
Beatæ Mariæ Virginis." Vell. 4º. 176 ff. With 23 extraordinarily fine
whole-page miniatures and many smaller ones, lovely borders and
initials. The ownership by Philip is noted on fol. 83 : "phs van
oosterich." It is now in the Familien Fideicommiss. Bibliothek
of his Imperial Majesty at Vienna. Exhibited in the Church Fur-
niture Exhibition at Vienna, 1887.—*Illustrirter Katalog der Aus-
stellung, &c.,* 9, No. 42.

Philip II. *See* Spain.

Philip II. *See* Stettin.

Philippa, Donna. *Miniaturist.* **Saec. xv.**
A Nun.

Daughter of the unfortunate Pedro, Duke of Coimbra, and
sister-in-law to Alfonso V., of Portugal (1438–1481), illuminated
a book of Homilies on the Gospels for the whole year, which she
bequeathed to the Convent of Odivellas.—*Raczynski : Les Arts en
Portugal,* 306.

PHILIPPART. *Copyist.* Saec. xv.
Of Mons.

 Employed as copyist and binder.—*Pinchart: Archives des Arts,*
&c., ii. 26, &c.

PHILIPPUS. *Copyist.* Saec. xiv.

 Wrote " Biblia Latina, cum Glossis," in three stout small folio
volumes on vellum. With illuminations, initials, &c. At end of
Psalter, with which the first volume closes, is the very common
inscription : " Finito libro referamus gratias Christo. Qui scripsit
scribat : semper cum domino vivat : Vivat in celis Phylippus
nomine felix."—*Quaritch : Rough List,* No. 88, 652.

PHILIPPUS. *Copyist.* Saec. xiv.

 Wrote, at Florence, about the end of the fourteenth century,
" La Divina Commedia." Vell. Sm. folio. 104 ff. In a good
large round Gothic letter, with titles and arguments in red. At
end : " Ego philippus qda3 (quidam) sr honofrii, *sr honofrii,* sr pieri
de *remformatiōb^9* de floR̄tia scrissi istū librū dantis Aldegherij."
Now in the Vatican Library, No. 3,200. —*Batines : Bibliogr. Dan-*
tesca, ii. 172.

PHILIPPUS. *Copyist.* Saec. xv.
Priest of Trèves.

 Wrote, on vellum, in three volumes, large folio, 88, 365, and
435 ff., "Biblia Sacra, ex versione vulgata." At the end of
vol. iii. : "Volumen istud tertium scripsit Philippus presbiter.

Natus urbe Trecensium existens naturaliter : Sed in hoc bene-
ficium sortitus spiritaliter. Hinc cum Maria filium Jhesum lau-
demus pariter. Anno Dei millesimo Qui summus regit omnia
simul et ducentesimo ex quo venit inpropria octogesimo decimo
finita est pars tertia Biblie benignissimo dante cui sit gloria,
Amen," &c. Now in the Library of New College, Oxford.—
Coxe : Catal. Codd. MS., Collegii Novi, 1, 2.

PHILOMENA, JOHANNES. *Copyist.* Saec. XIII.

Wrote, in 1266, "Epistola totius anni ad usum Episcopi
Cameracensis. Vell. Fol. At end: "Johannes Philomena
scripsit has anno incarnatois domini MCCLXVI." With large
initials. For the use of Nicholas de Fontaines, Bishop of
Cambrai, in the thirteenth century.—*Le Glay : Catalogue . . . des
MSS. de la Biblioth. de Cambray,* 29.

PHULLENDORF, JODOCUS VON. *Copyist.* Saec. XV.

Was "Stadtshreiber" at Nördlingen in 1422, or under-scribe
for the Hoorns, and was employed in the copying of books.—
Beyschlag. : Beyträge, &c., ii. 49.

PICAULT, MARC. *Miniaturist.* Saec. XVI.

Lived in the first half of the sixteenth century, and was
employed in the illumination of MSS.—*Nagler : Künstlerlexi-
con,* xi. 266.

PICCOLOMINI, FRANCESCO, CARDINAL. *Patron.*

Saec. XV.

Nephew of Pius II., and afterwards Pope as Pius III.

Invited Bernardo Pinturicchio, of Perugia, the elder scholar of Pietro Perugino, to Siena, to decorate the library, said to have been founded by Pius II. in the Duomo. This work Pinturicchio accomplished in the famous scenes from the Life of Enea Silvio Piccolomini (Pius II.), and was assisted in it by his then youthful fellow-pupil, Raffaelle. Vasari's statement that the younger artist made the designs is, however, more than doubtful, since the agreement made by Pinturicchio expressly binds him to execute the designs himself, and it is, moreover, extremely improbable that an accomplished artist of mature age with a reputation already acquired, would depute a mere youth twenty years his junior to do what he expressly undertook to do with his own hand. The Library building was actually constructed at the expense of Cardinal Francesco about 1495. It is located on the left of the entrance of the Cathedral, and near the chapel previously founded in 1485, and was intended to contain the works composed or collected by Pius II., many of which, both Greek and Latin, were enriched with splendid miniatures and illuminated ornaments. Among them were the magnificent choir-books executed by Angelo Gaddi, Pietro da Perugia, and Liberale da Verona. These Choir-books, executed for the Piccolomini Library, are not to be confounded with those executed from 1466 to 1519 for the Cathedral services, which belonged to the Opera del Duomo. The latter were kept in a separate room, and were not added to the Piccolomini Collection until the last century. Nor must the Cathedral Choir-books be confounded with those said to have been carried off by the Cardinal of Burgos to Spain, when that prelate was appointed Governor of Siena by Charles V. It is certain that these Choir-books never suffered any such loss, as on referring to the inventories kept in the Cathedral, the number is shown to have remained unaltered to the present time. The spoils really taken by the Cardinal of Burgos were certain statues and several utensils of silver. If, as some think, any MSS. were among the things carried off, they must have been taken out of the private collection of Pius II., not from those of the Cathedral.

Some evidence of this possibility seems to exist in the absence from that collection of any MSS. containing the work of either Liberale or Pietro da Perugia. It was Cardinal Francesco also, and not Pius II., who allotted to Michelangelo the fifteen marble statues to be placed in the chapel adjoining the library. They were to be of Carrara marble, two braccia high, except the two of Christ and the two angels placed at the extremities of the cornices. For their execution, to be completed within three years, the sculptor was to receive 500 golden ducats, to be paid from hand to hand as each statue was finished. The documents referring to this transaction were published by Milanesi in 1856.—*Vasari: Vite, &c.,* v. 265, 283; viii. 4; xii. 340 (Lemonnier).—*Milanesi: Documenti per la Storia dell' Arte Senese, raccolti e illustrati dal dottore G. M.,* iii. 19.

PICHORE, JEHAN. *Illuminator.*　　　**Saec. xv. et xvii.**

Worked for Cardinal Georges d'Amboise, as is proved by the following quittance: " Le vii^e de Janvier [1501] a Jehan Pichore de Paris, pour les histoires qu'il a faictes au liure de la Cité de Dieu, xii."—*Deville: Depenses du Château de Gaillon, &c.,* 437, 443. He is probably the same as Iehan Pinchon. *See* PLASTEL.

PIEDARGENT, DAN VIVIEN. *Copyist.*　　　**Saec. xv**

Wrote: " Le liure de l'information des princes." Paper. Sm. fol. 141 ff. In a small but heavy French secretary hand. No ornaments, but heading large, occasional rubrics. At end, in red: " Explicit de liure de linformation des princes Esc'pt par dan viuien piedargent ou chastel de pernes en la Conte de Set. pol. en lan mil iiij^e Soixante et cinq." Now in British Museum, Royal MSS., 19 B. 1.

Pierre, Guillaume de la. *Copyist.* Saec. xv.

Wrote, in 1480, for Louise de Savoie, Duchesse d'Angoulême, the mother of Francis I., a "Histoire du Saint Graal"; or, perhaps, for Giovanni Lodovico, Bishop of Geneva, uncle of Charlotte de Savoie, second wife of Louis XI., and mother of Charles VIII.; and afterwards given to Louise. It is now in the Royal Library at Brussels (No. 9,246).—*Marchal: Catal. des MSS. . . . des Ducs de Bourgogne,* i. 185.

Pierre, Jean. *Illuminator.* Saec. xv.

Illuminated : "L'Horloge de Sapience, trad. de frère Jehan de l'Ord. de S. François." The copyist and illuminator of this beautiful volume are made known in the *explicit* of the second treatise (as above), the first is the "Château périlleux par frère Robert," and the third the "Soliloques de St. Augustin." "Cy fini lorreloge de Sapience, escrit de la main de Thomas Valery (*see*) prestre a Bourges en Berry que fist escrire messire Estienne Chatart procureur de mesdames de Saint-Laurent Priez Dieu pour eulx." Then in beautiful ultramarine letters : "Anlumine de la main Jehan Pierre" (*see* also Jehan Pion, who placed an illumination of the "Three Dead and the Three Living" between the second and third treatises). Now in the National Library, Paris.—*Paris, les MSS. françois, &c.,* iv. 146, No. 7,034.

Pietkin. *Copyist.* Saec. xvii.

Otherwise, Father Placidus, Sub-prior of the monastery of St. Jaques at Liège.

Wrote, in 1663-4, "Missale Pontificium et Collectarium," in two vols. Vell. Fol. 149 ff. A beautiful example of calligraphy, richly decorated with ornamental titles and numerous initials in gold and colours. Belonged to Mr. Bragge, and sold in 1876 at Sotheby's.—*Sale Catal.,* 64, No. 361.

PIETRO D'ORLANDO, DON. *Miniaturist.* Saec. XVI.

Became a Benedictine monk at St. Martin's, of Palermo, in 1528, and worked on the Choir-books, completing the labours of Don Maurizio.—*Caravita: I Codici e le Arti a Monte Cassino;* i. 483.—*Blasii: Relazione della Nuova Libreria del Gregoriano Monastero di S. Martino delle scale. Opuscoli di autori Siciliani,* xii. 210. These Choir-books are quite as richly and finely executed as those at Monte Cassino.

PIETRO, MARIO. *See* RIMINI.

PIGNATELLI, FABRIZIO. *Patron.* Saec. XVI. et XVII.

Belonged to one of the most ancient and widespread families in Italy. The Pignatelli are said to owe their origin to the Lombard kings, the chief Neapolitan authorities tracing their ascent as far back as the year 390. Fabrizio is a name which frequently occurs in their pedigrees, but the one here referred to was the only son of Giulio Marchese di Cerchiara and Noia, colonel of infantry under Don Perafan di Ribera, Duke of Alcalà, and Viceroy of Naples (1559–1571). His mother was Donna Giovanna degli Spinelli, daughter of the Prince of Scalea. Fabrizio, Marquess of Cerchiara, was created Prince of Noia by Phil. II. of Naples and III. of Spain by a decree dated 1600. He enlarged his States by adding a district in Noia called San Giovanni, afterwards Terranova. He founded in Cerchiara a convent of Minor Friars, or " Frate dei Minori Osservanti di San Francesco." His wife's name was Violante de Sangro, daughter of the Prince of San Severo and of Donna Andriana Caraffa, by whom he had four children. He died in 1627.—*Lellis: Discorso delle Famiglie Nobile del Regno di Napoli,* ii. 153.—*Mugnos: Teatro delle Famiglie Siciliane —Tettoni e Saladini: Teatro Araldico,* viii. (not

paged). Milano, 1848, 4°. The arms of Pignatelli (*anc.*) are d'*or*, à
3 marmites (cooking-pots) de *sa.*, les deux du chef affrontées.
Those of Fabrizio, Marchese di Cerchiara and Principe di Terra-
nova, &c., were Qu. 1 as above ; 2 bendy (of 7 or 8) *or* and *az.* ; 3
arg. an eagle displayed *sa.*, bearing on its breast a shield of pretence
arg. a fesse checquy *arg.* and *gu.* ; 4 barry of eight *arg.* and *gu.* It
was at his expense that the handsome Choir-books formerly kept
in the Church of San Domenico Maggiore, at Naples, were written
and illuminated. *See* Rosa, G. B. de.

PILAVAINE, Jacques. *Illuminator, &c.* Saec. xv.

A calligrapher and illuminator of moderate abilities,
but exceedingly industrious.

We find him employed by Charles, Duke of Burgundy, and
also by Charles de Croy, Prince of Chimay. He was a native of
Peronne in Vermandois, but exercised his art at Mons in Hainaut.
Three MSS. from his hand are still preserved in the Royal
Library at Brussels. The finest of them is No. 9,069, a large
folio, on vellum of 52 c. high, containing the famous chronicle of
Martin Polonus, called "Les Histoires Martiniennes." It con-
sists of 274 ff. 2 cols. of 42 lines each, and is enriched with twelve
large miniatures, having floriated borders, full of sweet flowers and
lovely birds, animals, and other fanciful creations. These minia-
tures occupy half the page. *The whole* is the work of Pilavaine.
Besides the large miniatures are three smaller ones, one of which
is a portrait, supposed by Paulet to be that of Pilavaine himself,
and many illuminated initials. A rubric at the beginning indicates
its contents. At the bottom of the last folio is the note :
" Expliciunt les hystoires martiniennes escriptes par Jacquemart
Pilavaine *escripvan* et enlumineur demourant a Mons en Hayn-
naut natif de Peronne en Vermandois." And then, in the next
column, " Ce livre est appellé les Martiniennes traittant de la
creation du monde et des fais et rengne de plusieurs empereurs ou
il y a xv. histoires, lequel est a mons^r Charles de Croy, comte de
Chimay (signed) Charles (*see* Croy). This Charles became Prince

de Chimay in 1486, and his father died in 1483, so the book must have been executed between these two dates. Two other MSS. by Pilavaine are included in the same volume. They contain together 236 ff. The first is " L'arbre des batailles," composed by Honoré Bonnet (*cf.* British Museum MS. 20, C. viii.), the other " Les faits d'armes de chevalerie," composed by Christine de Pisan (a MS. of this is also in the British Museum MS. 19, B. xviii.). The " Arbre des batailles " has one large miniature of the presentation of the book to Charles VI. of France, and another representing a duel, on fol. 2. The subject ends on fol. 116. The " Faits d'armes " has two large miniatures on fols. 118 *v.* and 181 *v.*, each with a border of flowers and ornaments of the kind usual at the period, as in the " Valerius Maximus, Froissart," &c., of the British Museum,—a style which may be considered typical of this branch of Flemish illumination. Both the miniatures represent the authoress. In the first she is writing the book. The same attestation of origin and ownership occurs at the end of both the smaller treatises, and in addition is the motto of the Prince de Croy : " Moy seul," which is often repeated.—*Pinchart, A.*, in *Messager des Sciences historiques, &c.*, 1858, 352. About Honoré Bonnet and his book, see *P. Paris ; Les MSS. François de la Bibliothèque du Roi*, v. 101. M. Leon Paulet gives a description of each of the twelve miniatures of the " Histoires Martiniennes." In his miniatures and borders, Pilavaine constantly reproduces the motto or war-cry of Charles de Chimay and his branch of the House of Croy, " a moi seul." It will be remembered that the motto of another branch of the House, as seen in MS. No. 12, at Cambrai, written for Robert de Croy, Bishop and Duke of Cambrai, is " a jamais Croy." The sobriquet of " Cloche de Hainault " was specially applied to the renowned soldier, Philippe de Chimay (*see* CROY). The " Histoires Martiniennes," being very good average work, may be looked upon as a characteristic example of the art of the copyist and illuminator of the fifteenth century. The MS. was carried off by the Commissioners of the French Republic, and only restored to Belgium at the restoration of the Monarchy. As to Pilavaine, whose portrait M. Paulet thinks is given in the MS., but which the artist more probably intended for Charles de Croy, from the arms above it, there is little further known than that he was invited to Mons, doubtless by Charles de Chimay, to work for him on this very MS., and perhaps on others. When he was born or died is uncertain.—*Paulet : Jacmart Pilavaine, Miniaturiste du XVe Siècle*, 25–41.—Amiens, 1858. 8°.

PILIS, BETTINO DE. *Copyist.* Saec. XIV.

Wrote, in 1351 : 1. "The Inferno," &c., in Latin, translated by
Alberigo da Rosciate. Large fol. Beautifully written. Belonged
formerly to the Monastery of Stᵃ Justina of Padua. On fly-leaf :
"Questo codice fu scritto da Betino de Pilis come si vede a carte
7 tergo e a carta 104 tergo, dove si legge pure il tempo in cui
scriveva cioè il dì penultimo d'Agosto MCCCLI.," &c. (fol. 7) "a
quibus penis betinus de pilis qui hunc librum scripsit defendatū
deo auxilio" (fol. 107 v). A quorū 9versatiōe et *amicia* plene p
dei mis'icordia defendatur betinus de pilis qui hic spsit, die
penultimo Aujusti mill⁰ trecentesimo quinq3.esimo primo." Now
in the National Library, Paris, Fds. de Rés. 3. Also two other
codices in 1368. One in the library of Mr. Kirkup, the other in
the Biblioteca Classense at Ravenna. 2. "La Divina Commedia."
Vell. 290 ff. In a fine half-Gothic letter, titles and arguments in
red, and pretty little illuminated initials with arabesques. Fol. 80,
"quinto idus Octubris anno dñi. MCCCLXVIII⁰." fol. 180, "xviii.
kal. decembris MCCCLXVIII ." The iii. Cantica (Paradiso) ends on
fol. 201 : "Deo grās dantis libro toto finito, e scᵖto p betinum de
pilis xviiii kal' ianuarij Mccclxviij." 3. "La Divina Commedia."
Vell. 16⁰, 472 pp. The initials of each canto to end of xiv. cant.
of Purgat. illuminated. After that merely rubricated, except the
first in the Paradiso, which is illuminated. At end of Inferno :
"De suo betinus de pilis scripsit in *usu*, ix. kl. ianuarij anno dñi.
MCCCLXIX. — *Batines : Bibliogr. Dantesca*, ii. 101, 102 ; 218 ;
227, 228.

PINCHON, JEAN. *Illuminator.* Saec. XV.

Executed the colouring of the miniatures for the book pre-
sented by the corporation of Amiens to the Princess Louise of
Savoy, Duchess of Angoulême. — *See* PLASTEL.

PINE, SIMON. *Miniaturist.* Saec. XVIII.

Son of John Pine, the engraver of Horace, who kept a print-
shop in St. Martin's Lane, and was the convivial friend of

Hogarth. Simon was born in London, but resided at Bath and in Ireland. He exhibited miniatures at the Spring Gardens Exhibition from 1768 to 1771 ; and in 1772 at the Royal Academy. Died 1772.—*Redgrave : Dictionary of Artists of the English School.*

Pineau, Frère Charles. *Copyist.* Saec. XVI.

Wrote a beautiful copy of a Paraphrase of the Acts. Small fol. Vellum, 157 ff. In a fine, clear, upright, French engrossing or Chancery hand. Fol. 2 *v.* contains the first large illumination, representing the author offering his book, which in the text is thus dedicated :—"A tresillustre et puissant Seigneur Monseigneur Jehan de laual Sire de Chateaubrient son tres humble et tres oblige religieux, Fr. Charles pineau. Salut." The period and style of the painting is that of Francis I. Beautiful Renaissance furniture of a subdued purple and brown adorns the apartment, sometimes finely hatched with gold. The author wears a white tunic, and over it a black cloak and hood. The opposite page, containing the text, is surrounded by a border of the sort used in the Great Hours of Anne of Brittany, but in somewhat later handling. Initials and details as usual. At foot an armorial containing: 1. *gu.* powdered with *fleur de-lis, or.* 2. Parti per pale 1, ermine, 2 *gu.* powdered with *fleur-de-lis, or.* The border contains common field flowers on gold. Fol. 6 *v.* The second miniature. The Apostle Luke, in a well-furnished study, writing, the ox at his feet ; all within an architectural frame. This miniature forms an excellent illustration of the latest mode of representing this most familiar subject. The opposite page has a full border, except that at foot are two coats-of-arms on a blue ground, the first surrounded by a cordon of Minorite symbols, cords and scallop-shells ; the second by knotted cords only, the badge which obtained for the French Franciscans the name of Cordeliers, so well known to readers of the Heptameron. The MS. is now in the British Museum, Harl. MSS. 4,393.

PIOLA, GIOVANNI GREGORIO. *Miniaturist or Copyist.*
Saec. XVI. et XVII.

Famous at Genoa between 1583 and 1625.— *Zani: Encicl. Metod.*, xv. 163.

PION, JEHAN. *Miniaturist.* ## Saec. XV.

Executed a large miniature of the " Three Dead and the Three Living," which is placed between the second and third treatises in the MS. fr., 7,034. The treatises are : 1. Le château perilleux par frere Robert ; 2. L'Horloge de Sapience ; 3. Soliloques de St. Augustin. Vell. Sm. fol. 251 ff. 2 cols. With miniatures, borders, and initials. *See* PIERRE JEHAN.—*Paris : Les MSS. françois, &c.*, iv. 160.

PIPE, DU. *Miniaturist.* ## Saec. XVI.

Executed, in 1520, a miniature of the Visitation (3rd), with border, coats-of arms, &c., in the Missale Bavaricum, at Wolfen-büttel. *See* PRES.

PIQUEAU, GUILLAUME. *Illuminator.* ## Saec. XV.
Of Tours.

Illuminated, in 1482, for Charlotte de Savoie, second wife of Louis XI., a " Vita Christi," for which he was paid xii. livres. The account is still preserved in the National Library, Paris (Fds. fr., 407, 408) : " A Thibaut Bredinc, libraire, demourant a Tours, pour auoir fait escripre xxxv. cayers d'un liure de Vita Christi fleury et relye le dit liure pour ce, par marche L.l. A

Guillaume Piqueau enlumineur demourant a Tours pour auoir enlumine le dit liure et fait plusieurs lettres et paraffes, par marche fait, xii. l."—*Delisle : Cab. des MSS.*, iii. 342. The MS. contains two large miniatures by this artist.—*Grandmaison : Documents inédits, &c.*, 283.

PIRAMO, RINALDO. *Miniaturist.* Saec. xv.

Executed the miniatures of the " Ethics of Aristotle," now in the Imperial Library at Vienna. Thin folio, 90 ff. The MS., according to a note at the beginning, was presented by Johannes Sambucus to the Emperor Maximilian II. when he was only King of Bohemia. On fol. 1. A large broad painted border in compartments like Holbein's Tabula Cebetis ; and a figure under a rich architectural arch of a triumphal sort, which I suppose to be Philosophy. In the niches of the arch are other figures of warriors, virtues, &c. The title is on the floor : ΑΡΙΣΤΟΤΕΛΟΥΣ ΠΟΙΚΩΝ : .'. ΝΙΚΟΜΑΧΕΙΩΝ ΒΙΒΛΙΟΝ : Α : ." Then follows the text in the small, neat hand of the fifteenth century : " Πᾶσα τέχνη καὶ μέθοδος," &c. Another allegorical miniature below. The style is of the old Milanese, technically skilful, but not very attractive pictorially, but very interesting for its profusion of symbolism and fancy. Fol. 27. Another richly-designed border, showing a great advance in excellence of work, being for its time and locality really fine miniature painting. There is, indeed, a painted title-page to each of the ten books. Fol. 36. Another richly symbolical and architectural border beginning the text, Περὶ δὲ διακοσύνης καὶ ἀδικίας." A great central arch, separated from two smaller arches by heavy Byzantine pillars, on the capitals of which are richly-painted golden horses of Pegasi, forms a canopy for the figure of Justitia. Busy scenes of daily life occupy the side arches. In the lower part of the design or *dado* an oblong scene in the centre represents the three Judges of Hades. In the left arch a group of children, in the right a horribly realistic picture of the sufferings of Prometheus, which may be compared with a similarly dreadful Polyphemus on fol. 45 *v.* The ornamental details of this magnificent page are most rich and elaborate with

armorial bearings, gems, pilaster decorations, and figures. The Pegasi are most beautiful, while the general effect of colour and gold in the architecture is extremely rich and full. On the plinths of columns are respectively the letters A and M for Andreas Matheus (Dux Adriæ). Fols. 45 *v.* and 52 *v.* have rich compositions. Fol. 62 *v.* has another handsome full-page design with figures in arched compartments of arts, sciences, &c. Fol. 72. Another, bold and full of suggestive emblems. Fol. 80 *v.*, the last of these splendid pages, a very handsome and elaborate composition, with a view of Athens showing the statue of Athena Polias. At foot of the page, on a blue ground in golden letters, are the remains of an inscription . . . " naldus Piramus Napolitanus librum hunc picturis decoravit mirifice." The miniaturist is said to have been a native of the little town of Napoli, near Atri, on the Adriatic, and the MS. executed for Andrea Matteo Aquaviva, Duke of Atri.—*Bucher: Geschichte der Technischen Künste*, ii. 257.—*J. W. B.: MS. Notes of Visit to Vienna in* 1884.—*Waagen : Die Vornchmsten Kunstdenkmäler* in *Wien*, ii. 104. The patron for whom this MS. of Aristotle's " Ethics " was written was noted both for his love of learning and for his skill in arms. He was called, as shown in the MS., Andreas Matthæus (Andrea Matteo) Aquaviva, of the family of the Aquavivas of Naples and Aragon, Counts of Flaviano and Conversano, Dukes of Atri, Nardo, and Noci, and Princes of Caserta and Teramo. The arms borne anciently by the family were : *or*, a lion rampant *az.*, armed, &c., *gu.* Those granted by Ferdinand of Aragon and Naples to Giulio Antonio Aquaviva, seventh Duke of Atri, were : Quarterly 1 and 4, Sicily 2 and 3 *or* a lion rampant *az.* (Aquaviva). He married Catharina, daughter of Giov. Antonio Orsini in 1456, and was killed "in battle with the Turk," 1480. His son was the Andrea Matteo of this MS., eighth Duke of Atri, Prince of Terano, and Marchese di Bitonto. Born 1456, died 1528. He married—1. Isabella Piccolomini de Aragonia, daughter of Antonio, Duke of Amalfi. 2. Catharina della Ratta, heiress of the Counts of Caserta and St. Agatha, and widow of Cæsare d'Aragone. He lived in the stormy time when Charles VIII. of France invaded Naples, and remained firm in his loyalty to Ferdinand until after he was taken prisoner by the French. He was kept in captivity for two years, during which time he amused himself with books and literary composition, drawing up a sort of Commentary on the " Moralia " of Plutarch, of which the first book was published at Naples in 1526, and the

whole work at Helenopolis (Francfort-am-Main) in 1609, with the title : " Andr. Matthæi Aquavivæ Principis omnibus belli et pacis artibus excellentissimi Hadrianor. . . Ducis illustrium et exquisitissimarum disputationum lib. 4." Giovio gives a glowing summary of the qualities of the book and its author. About 1503, believing himself abandoned by the King of Naples, he joined the French army in Italy. When Gonsalvo de Cordova, having taken him prisoner again in a victory over the French, was about to send him with the other prisoners into Spain, Ferdinand interfered in his behalf, and restored him to freedom and favour. The Duke of Atri lived twenty-four years after this event, in the cultivation and encouragement of literature and the arts, and died in 1528, at Conversano, in the territory of Bari, when Lautrec was ravaging Apulia with his victorious armies. *Imhof: Corpus Historiæ Genealogicæ Italiæ, &c.,* 104.—*Giovio : Elogio,* 117.

Pisa, Enrico da. *Miniaturist.* Saec. (?)

Executed the illuminations, &c., of a volume of "Statuti Pisani," still kept in the Public Library of Pisa.—*Rosini : Storia de Pittura Italiana, &c.,* i. 187, &c. " This frate was a fine man courteous, liberal, and frank. He was a preacher most popular and acceptable both to clerks and laics. He knew how to write, to paint in miniature, or, as they say, ' illuminate ' (lumeggiare), to write music, to compose most beautiful and delicious songs," &c.—*Cronaca de Fra Salimbene Parmigiano,* i. 86. Parma, 1882.

Pisani, Francesco. *Copyist or Illuminator.* Saec. XVII.

Worked at Genoa about 1640.—*Zani : Enciclop. Metod.,* xv. 179,

PISTOIA. *See* TEANO.

PITTINGER. (?)

A Monk of St. Udalrick and Afra, at Augsburg. Died 1483.

"Scriptor erat celeberrimus et pingendi argentum et aurum pergameno imponendi arte eximia callebat. Plures libros pro bibliotheca, et ad chori usum scripsit." Among these was a Diurnale dated 1460.—*Braun : Notitia de Codd. MSStis. in Bibliotheca Monast. ad SS. Udalric et Afram*, iii. 25.

PITTONI, BATTISTA. *Painter and Engraver.*

Saec. XVI.
Of Vicenza.

Executed the designs for Cartels and Devices in "Imprese di diversi Principi, Dvchi, Signori, et d' altri personagi e hvomini illustri, &c., di M. Ludovico Dolce, M.D.LXVI." Also a set of plates of Frises and illustrations to later editions of Dolce's Book of Devices, by Ziletti, in 1583, and Bertoni in 1602.—*Guilmard : Maîtres Ornemanistes*, 291.—*L'Art pour Tous*, i. 164.

PITTONI, LELIO. *Miniaturist.* Saec. XVI.
Perhaps a son of the above.

Worked at Vicenza about 1580.—*Zani : Enciclop. Metod.*, xv. 191.

PLACE, GEORGE. *Miniaturist.* Saec. XVIII.

Son of a fashionable linendraper of Dublin.

Practised in London from 1791 to 1797, and exhibited at the Royal Academy. He afterwards retired to Yorkshire, where he died about the end of the century.—*Redgrave: Dictionary of Artists of the English School.*

PLACE, PIERRE DE LA. *Copyist.* Saec. XIV.

Given under 1388 in *Laborde: Ducs de Bourg.*, i. pt. II., 528.

PLACENTIA, JACOBUS DE. *Copyist.* Saec. XIV.

La Div. Commed. Vel. Fol. In characters called by Trombelli *tedeschi*, and adorned with beautiful figures ; at end, " Jacobus de Placentia scripto scripsit," with the date 1380. In the Bajno Library, Mantua.—*Batines*, ii. 129.

PLACIDUS. *Calligrapher.* Saec. IX.

Wrote in letters of gold a Book of the Gospels, long kept at the Abbey of Hautvilliers. Now in perfect preservation in the Public Library of Epernay.—*Cahier: Bibliothèques*, 130.

PLANETIER, CHRIST. *Copyist.* Saec. xv.

Wrote, at Quedlinb., 1. Johannis Indaginis Carthusiani Ordinis
Monachi Erfordiensis. Tractatus, &c., Varior. negotior. viz. 44.
2. Dated 1478. 8. 1479. 27. 1460. 32. Written at instance of
Marquess John of Brandenb. 40. " Scrip. a. Mcccclxx (1460)
per Christ. Planetier a. Mcccclxxii (1472) recollectus. Joh.
Indaginis v. ab Indagine was also called Joh. vom Hayn or
Hagen, and belonged to the Certosa of St. Salvator near Erfurd.—
T.Eckhard : Codices Msti. Quedl., pp. 25, 6, 7.

PLASTEL, JACQUES. *Miniaturist.* Saec. xvi.

Probably of Amiens.

Designed in black and white, about 1518, the copies of the
pictures belonging to the Confrérie du Puy-Nostre-Dame d'Amiens,
for transference into the book intended to be presented to Louise
de Savoie, Duchesse d'Angoulême, mother of Francis I.; and also
the scene-miniature of the presentation prefixed to the book. *See*
PINCHON. He was commissioned by Adrien de Moussures and
Pierre Louvel, " eschevins " of the city, who were deputed to pre-
sent the book to the said lady, then residing at Amboise (Comptes
de la Ville d'Amiens, xciie, 7, 3.) The MS., a large folio, contain-
ing 48 full-page miniatures, is now in the National Library, Paris,
MS. fr., 6,811. It is called " Chants Royaux en l'honneur de la
Sainte Vierge, prononcés au Puy d'Amiens." The first miniature
represents the Duchess seated on a richly-decorated throne in a
sumptuous apartment hung or panelled with blue or green. She
is costumed in a robe and hood of black. The figure is very care-
fully painted and is probably a good portrait. On either side stand
her attendants, perhaps also meant to be portraits. Kneeling in
front are the two deputies, one of whom presents the ponderous
volume bound in blue velvet. At the bottom of the page are the
arms of the City of Amiens ; *gu.* in chief, *az.* semé de fleurs-de-

lis, for France, supported by two white unicorns. The miniatures
in this volume are accompanied by the verses which give the name
to it, and are more or less skilful copies of the votive pictures
hung in the Mary Chapel of the Cathedral at Amiens by various
donors to the Puy. They are generally good in composition and
effect. At the foot of each is the figure of the alderman who
gave the original picture. Beside him usually kneels his wife, and
in the background the members of the Gild. It was about the
end of 1517 that the volume was presented. M. Gilbert, the
historian of the Cathedral of Amiens, described the MSS., and
cited an old document relating to its production. " This collection
of pieces owned by the Gild," he says, p. 118, " was painted in
grisaille,—he means really drawn in pencil,—by Jacques Plastel,
who received for the execution of the 48 drawings, 45 livres. For
writing the ' Balades,' Jean de Beguines received 12 livres. The
price of the vellum was 3 liv. 12 sols. Guy le Flameng for
illuminating the great initials, 13 liu. 12 sols. Nicolas de la Motte,
rhetoricien, for adding several ballads wanting to the pictures,
40 sols. Jean Pinchon, ' enlumeneur et historien ' (painter of
histories, or scene-miniatures, mostly in initial letters) at Paris for
applying the colours, 80 livres. For cleaning the vellum ' timpané
scelle d'or relié et couuert le volume,' 6 livres. The assistants of
Jean Pinchon received 50 sols. The large case of black leather
with strings, 38 livres (a rather costly case). The covering in
' velours pers ' 6 livres. The packing of the book 12 sols."
The next article brings the transaction home to modern ways.
For the " vin du marché avec l'enlumineur," or cost of the
wine consumed in negotiating the contract with the illuminator,
24 sols. Lastly, for the expense of the journey of the two alder-
men, Andrieu de Moussours and Pierre Louvel, deputed by the
city to carry the volume to Amboise, thirty-six days (imagine a
six and thirty days' journey from Amiens to Amboise,—they took
their time over it, did those leisurely aldermen) at the rate of
1 livre 16 sols per day ; 68 livres 8 sols, making a total, so says
the account, of 366 livres. How it does so is not very clear. I
fancy several items are wrong and several omitted altogether. The
presentation miniature of this notable volume has been several
times reproduced.—*Dusevel: Recherches Historiques sur les Ouvrages
exécutés dans la Ville d'Amiens, &c.,* 26, 27.—*Willemin : Monu-
ments français, &c.—Du Sommerard : Les Arts au Moyen Age ;
Album,* 9 sér. Pl. 29, 30, 32.—*Paris : Les MSS. français, &c.,*
i. 302.

PLATEA, JOH. DE. *Copyist.* Saec. xv.

Wrote, in 1463, " S. Aur. Augustini libri de Civitate Dei "—
" Scriptus per manus Johannis de Platea commorantis in Lyntris
superiori [Oplintere, near Tirlemont] A.D. 1463. Vell. 4to.
Formerly belonging to Parc Abbey, near Louvain. Now in British
Museum, Add. MS., 17,284.

PLATEAULX. *Copyist and Illuminator.* Saec. xv.

Wrote, about 1428, " Oraisons des Saints," for the Duke of
Burgundy, 1427-8. Rec. Génér. Nos. 43, 44. Pour cinq ymages
de sains et saintes et pour lescripture et enluminure de plusieurs
oroisons diceulx sains, pour mettre et asseoir es heures de MdS.
par marchie fait par MdS. de Bethleem. C. s. Pour la con-
sumaçon et escripture dun liure pieça commencie par lordonnance
de MdS. ensemble pour le parchemin, vii. lin.—*Laborde : Les Ducs
de Bourgoyne ; Etudes, &c., Pt. II. (Preuves)*, i. 249.

PLAYFORD. *Miniaturist.* Saec. XVIII.

Practised portraiture in London. Died in Lamb's Conduit
Street, Oct. 24, 1788.—*Redgrave: Dictionary of Artists of English
School.*

PLOT, JOHN. *Miniaturist.* Saec. XVIII.

Born at Winchester in 1732.

Began life as an attorney's clerk, but came to London and
became a pupil of R. Wilson, R.A., and of Hone, R.A. Practised
in London from 1777 to 1803, when he died at Winchester.—
Redgrave : Dictionary of Artists of English School.

PLUMETOT, J. DE. *Copyist.* Saec. xv. (?)

His name occurs at the end of MS. fr., 674, National Library, Paris. In the initial which commences this MS. are painted the arms of the family of Harcourt, *gules*, two fesses *or.—L. Delisle : Le Cabinet des MSS., &c.,* ii. 370.

POCIVIANI, FRANC. *Copyist.* Saec. xvi.

A Priest of Padua, called " Il Moro."

Worked about 1560.—*Zani : Enciclop. Metod.,* xv. 212.

POGGIO, GIOV. DI PAOLO DAL. *Miniaturist and Painter.*

Saec. xiv. (?)

Illuminated a Choir-book now in the Public Library at Siena, formerly belonging to the Convent of Augustinian Friars of Lecceto. His work, especially one initial " A," is " bellissima capricciosa e condotta con una mirabile diligenza." It has been doubted, how- ever, whether this work be not really the work of another artist, Antonio da Montecchio, also an Augustinian friar, as he is related to have illuminated the greater part of the books belonging to the church of this convent.—*Milanesi : Sulla Storia, &c.,* 74.

POISSON, JEAN. *Copyist.* Saec. xv.

Copied MS. lat., 16,437, in 1455, for " magister ursinus Tibout," who was elected prior of the Sorbonne in 1443.—*Delisle : Cab. des MSS.,* ii. 177.

POLA, DAMIANUS DE. *Copyist.* Saec. xv.

Wrote, in 1425, " Gasparini Peruzzii Bergomatis Opera." At end of 3rd tract, fol. 60 : " Has epistolas Gasparini Pergamensis viri eloquentissimi scripsit Padue Damianus de Pola eductas ex corruptissimo exemplari et complevit die decima mensis, Novembris Mccccxxv. Deo gracias. Amen." Now in the Library of Balliol College, Oxford.—*Coxe : Catal. MSS. Coll. Balliolensis.*

POLANI, NICHOLAUS. *Copyist.* Saec. xv.

Wrote, in 1459, a most beautiful copy of " Augustinus, de Civitate Dei." " Cité de Dieu, dite Petit Saint Augustin Italien." Now in the Library of Sainte Geneviève, Paris. Four borders from this manuscript were used by Curmer in " L'Imitation de Jésus Christ," 162, 3, 6, 7. At foot of two of these borders are the arms of Nicola Fortiguerri, Bishop of Teano, surmounted by an episcopal cross, and a cardinal's hat supported by two floating angels. The arms are chevrony of 7 *sable* and *or ;* in chief a label of 3 points *gu.* with 3 plates or *bezants d'argent*, on each point.—*Denis : Appendice à L'Imitation de Jésus Christ, Manuscrits*, 16, No. 93.

POLISMAGNA. *Copyist.* Saec. xv.

Wrote Savonarola Michele : Il Confessionale. Vell. 8°. Title in red : Il Confessionale de Michele Savonarola felicemente comenza a li monaci de la Certosa che habitano fuori apresso le mure di Ferrara scripto. At end also in red : " Polismagna scripsit illustrissimo principi et divo Borsio duci Mutinæ et Regii Marchioni Estensi, Comitiq. Rodigii, &c., anno nati^{tis} Dni nr̄i Jhesu Christi millesimo quadringentes. sexages. primo die xxvi martii hunc libellum." Cat. No. cxvii. Now in the Este Library.—*Modena : Cenni Storici, &c. Estense*, 53.

POLLINI, PADRE DOMENICO. *Calligrapher.* Saec. XIV.
A Sardinian Monk of St. Catherine's, at Pisa.

> Spoken of by Marchese as a calligrapher.—*Marchese: Memorie,*
> *&c.* i., 177 (Meehan's transl., i. 121).

POLLINI, PAOLO. *Calligrapher.* Saec. XIII.
A Monk of the Convent of St. Catharine's, at Pisa.

> "Pulcherrimus scriptor exstitit."—*Archiv der Gesellschaft für*
> *ältere deutsche Geschichtskunde,* iv. 350.

POLLINI, CESARE. *Miniaturist.* Saec. XVI.
POLLINO,

> Orlandi mentions him as an excellent miniaturist, designing
> boldly in the manner of Michelangelo ; that he was employed by
> several of the Popes, and that various works of his were still to be
> seen at Perugia, his native town. Pascoli says he was born about
> 1560, and that he certainly painted and illuminated "a maraviglia,"
> but that he could not speak of any of his work except those
> miniatures alluded to by Orlandi, which were then (1732) to be
> seen in the congregation of the Nobili at the Jesuits' College in
> Perugia. Nor had he seen even these. But it was said that others
> were to be seen in Rome. "1 know that he worked for many
> princes, cardinals, and several Popes, by whom he was treated
> with distinction, and that many of his rare and beautiful miniatures
> remained to his heirs after his death, which happened about 1630
> in Perugia. I may add that he was known to many by the name
> of Cesare dal Francia, more commonly than as Cesare Pollini."—
> *Pascoli: Pittori Perugini, &c.—Orlandi: Abecedario Pittorico,*
> 122 (1753).

POLONIA, JOHANNES DE. *Copyist.* Saec. xv.
Lived at Padua.

Wrote " Francisci Zabarellæ Lectura super Clementinas." Vell.
321 ff. At end : "Ad laudem Individue Trinitatis Amen. 1417.
Joannes de Polonia 27 Martii." And below: "Explicit lectura
eximii Doctoris Francisci, &c., scripta per me Johannem de
Polonia in civitate Padue."

POMPHILE, PIERRE. *Copyist.* Saec. xv.

Wrote at Paris in 1464 an Antiphonarium in six volumes and a
Graduale in four, for Bertrand de Beauvau, " chevalier, seigneur de
Precigny conseiller et chambellan du Roy." At the end of a copy
of " Les Ethiques d'Aristote translate de Nich. Oresme," now in
the National Library, Paris (No. 7059 MS. fr.), is this note : " Acheve
descrire le iiij jour de may MCCCCXLI. Cest liure de Ethiques est
de messire Bertrand de Beauuau chevalier seigneur de Precigny
conseiller et chambellan du roy notre sire ; et le acheta à Paris le
xxiii. jour de may lan MCCCCXLVII." In the initials of several
books are placed the arms of Bertrand de Precigny—" qui joignit
la brisure d'une étoile d'azur aux quatres lionceaux de *gu.* armés
lampassés et couronnés *d'or*, des Beauvau." This nobleman was
the son of Jean de Beauvau, and was premier president-laic of the
Chamber of accounts and counsellor and grand maitre d'hôtel of
King René. Afterwards seneschal of Angers and captain of the
Château. René gave him the Château of Precigny. He figures in
history in the treaties concluded with England in 1444 and 1449.
He built two châteaux, Pimpean and Tigny, in Anjou, and died
in 1474 at Angers. Before the Revolution his tomb was to be
seen in the Church of the Augustines of that city. He was a lover
of books. By his will he left to the Augustines of Angers the MSS.
written by " Pierre Pomphille, escrivain demourant a Paris sur le
pont Notre Dame." They are now in the National Library,
Paris.—*Paris: Les MSS. françois, &c.,* iv. 331–2.—*Kirchoff: Die
Handschriftenhändler des Mittelalters,* 104.

PONTE, JOH. DE. *Copyist.* Saec. xv.

Wrote, in 1462, Imola's (Benvenuto da) Commentary on Dante. Paper. Folio. 267 ff. Containing Inferno and Purgatorio at end of Purgatorio. "Explicit sup Purgatorium Comm⁸. Scriptus per me Johannem de Ponte Conventus Cherii et finitus in Conventu Pratensi anno 1462 quo quidem anno absolutus fuit. Magister Ordinis frater Magister Martialis de Avinione per tres cardinales." Now in University Library, Turin. Cod. lat., No. Dcxxi.— *Batines: Bibl. Dantesca,* ii. 311.—*Pasini: Catalog., &c.,* ii. 170.

PONTE, MANFREDUS DE. *Copyist.* Saec. xv.

Wrote " Lucij annei Senece epistolarum ad Lucullum." Vell. Folio. 108 ff. In small upright cursive with contractions, headings in red. At end : ' Explicit liber ep'larȝ Senece scriptus p me Manfredinuȝ de ponte cancellariuȝ in Euriponte in Euboica insula 9pletus in Milłeo quadringentesimonona mēse scđa die vij decembris *incoatus* xvi. septembris p̃� Deo grās. Amen." In red : " Finito libro referē grās x̄po." Now in British Museum, Add MSS., 1,1984.

PORRO, GIROLAMO. *Engraver and Draughtsman, &c.*

Saec. xvi.

Of Padua. Born 1520. Died 1604.

An engraver and designer of devices, cartouches, &c., for book illustration. He was a pupil of Enea Vico of Parma. In 1586 was published at Venice an 8° volume entitled "Imprese illustri di diversi coi discorsi di Camillo Camilli, et con le figure intagliate in Rome di Girolamo Porro Padovano, &c. In Venetia appresso Francesco Ziletti, MDLXXXVI." In 2 parts. Many of the cartouches are very beautiful in design, and excellently engraved. There are copies of several editions in the British Museum. Examples of the cartels and devices of Camilli's Book of Devices are given in *l'Art pour Tous,* i. 8, 64, &c.

PORSCH, JACOB. *Copyist.* Saec. XV.

A Dominican.

Wrote, under Prior Ulrich Messingschlag, in the monastery at Bamberg, an Antiphonary of whole year, eight pictures, 358 ff., 1 col. fol. max.—*Jæck Beschreibung, &c.*, 147, 1,175.

PORTA, BARTOLOMMEO DALLA. *Painter and Miniaturist.*
Saec. XVI.

Called also Fra B. di San Marco, and Baccio dalla Porta, and Dal Fattorino.

Was the son of a *fattore*, or general dealer and carrier, called Paolo, in rustic speech Pagolo, of a village Suffignano (not Savignano, as stated by Vasari) in the district of Prato, ten Italian miles from Florence, and was born in 1469. He gained the *soubriquet* of dalla Porta from living as a boy in a small house beside one of the city gates of Florence. When 31 years of age, having for many years practised painting in the workshop of Pier di Cosimo (Roselli), and in association with Mariotto Albertinelli, who afterwards became his partner, he was induced by the preaching of Savonarola to bring all his studies and drawings from the nude to be burned, with the vast pile of objects of art condemned by the uncompromising monk as soul-destroying and profane. Among other artists who yielded to the same persuasion were Sandro di Botticelli, Lorenzo di Credi, and the della Robbias, who all sacrificed valuable property for conscience-sake. Lorenzo became a monk at Sta. Maria Novello, and Bartolommeo at San Marco. For five years the latter entirely abandoned his art, but the visit to Florence of Raffaello, then in his 22nd year, once more awoke the frate's slumbering passion, and eventually Baccio dalla Porta became one of the most distinguished masters of the Florentine School. The proofs of his having worked in miniature, it must be admitted, are not very clear. The assertion that he did so rests primarily upon the following passage in Vasari's Life of Donatello: "una Nostra Donna col figliuolo in braccio, dentro nel marmo di

schiacciato rilievo, della quale non è possibile vedere cosa più
bella : e massimamente avendo un fornimento intorno di storie
fatte *di minio* da fra Bartolommeo, che sono mirabili, come si
dirà al suo luogo." In the edition of 1568 this Fra Bartolommeo
was written *fra Ber.*, of which Bottari makes a Fra Bernardo, who
never existed. This name, however, was adopted by later editors,
who regret that Vasari, contrary to his promise, never mentions
him again. As Vasari, however, under Fra Bartolommeo, does
refer to this very statuette of the Virgin and its miniatures, we
may safely conclude that *fra Ber.* was a misprint for *fra Bar.*, and
meant B. della Porta. The reference in the Life of Fra Barto-
lommeo is in these words : " Aveva Pier del Pugliese avuto una
Nostra Donna piccola di marmo, di bassissimo relievo, di mano di
Donatello cosa rarissima ; la quale per maggiormente onorarla gli
fece fare uno tabernacolo di legno per chiuderla con dua sportellini,
che datolo a Baccio dalla Porto, vi fece drento dua storiette, che
fu una la Natività di Cristo, l'altra la sua Circucisione, le quali
condusse Baccio di *figurine a guisa di miniatura,* che non è
possibile a olio poter far meglio ; e quando poi si chiude, di fuora in
su detti sportelli dipinse pure a olio di chiaro e scuro la Nostra
Donna annunziato dall' Angelo. Questa opera è oggi nello scrittoio
del duca Cosimo ; dove egli ha tutti le antichità di bronzo di figure
piccole, medaglie, ed ultre pitture rare di mini, tenuto da sua
Eccellenzia. Illustrissima per cosa rara, come è veramente." The
sportellini, or small shutters, here mentioned, are still kept in
excellent preservation in the room containing the smaller pictures
of the Tuscan School in the Uffizi Gallery. They are engraved in
vol. ii. ser. i. of the *Galleria di Firenze illustrata.* The miniature
of the Circumcision is also given by Rosini, vol. iv. 54.—*Vasari :
Le Vite, &c.*, iii. 261, and note vii. 151, and note.

PORTIER, PIERRE LE. *Copyist.* Saec. xiv. et xv.

Named as "escrivain de lettres de forme " in 1398 and 1401.—
Vallet de Viriville : La Bibliothèque d'Isabeau de Bavière (Paris,
1858, 8°), 21. 24-27.—Also in *Bulletin de Bibliophile,* 1858.

PORTIOLO, JACOBUS, JUL¹. DE. *Copyist.* **Saec. xiv.**

Wrote, in 1378, at Ferrara, "Lucani Pharsalia." Vell. Fol. 127 ff. In a firm Italian (Bolognese) Gothic, as in the Monte Cassino MSS., with figured and floriated initials and bracket ornaments. Arms at foot of folio 1, *az.* a chevron *arg.* Amid the foliages of the border a boy riding on a goose; another riding a dragon and peering down its throat. At top in the initial "C" (Corduba me genuit, &c.) is the figure of a judge in scarlet and ermine, seated at a desk. Just below an initial "B" (Bella per emathios plusquam civilia campos) containing the picture of a battle, in which are two golden banners each bearing a black eagle *displayed*. The ordinary line initials are simple capitals, placed out from the text by means of a second ruling of vertical lines. At end in red : "Explicit liber decimus et ultimus Lucani." Then "Hunc ego Lucani scripsi domnus Jacobus Juliani de Portiolo Ferarie MCCCLXXVIIJ. et de mense Martii : Iste Lucanus est iuuenis Mathei cum fratribus quondam egregie memorie dñi Feltrini de Boiardis. Cui egomet ut supra *scriptæ* fidel'r exemplaui." Formerly in the Library of Bishop Butler, now in the British Museum, Add MSS., 11,990.

POTERNE, PIERRE DE LA. *Copyist.* **Saec. xv. et xvi.**

Worked for Cardinal George d'Amboise. "Le XXIII^e de Mars (1501) à Messire Pierre Delapoterne, pour l'escriture de trois cayés du breviaire de Mondit Seign^r XLV^s.—*Deville : Dépenses du Château de Gaillon, &c.*, 437.

POUARD, PIERRE. *Copyist, &c.* **Saec. xvii.**

Executed, in 1646, the volume of "Messes des Grandes fêtes." Vellum. Large folio. With miniatures and ornaments for the Church of St. Sauveur de Paris. Now in the National Library, Paris. MS. lat. 8,891. *Delisle : Inventaire des MSS. Latins, &c.*, 12.

POULET, O. *Copyist.* Saec. xv.

Wrote, in 1496, at Shene (near Richmond), I.'Imaginacion de Vraye noblesse, with seven miniatures. Vellum. Small folio, 97 ff. Written in a large French bâtarde or rounded Gothic hand (the hand made famous by the copyists of the Duke of Burgundy, Philip the Good). On first fly-leaf in red is the title, Imaginacion de Vraye noblesse. This is rather unusual, and shows late work. Then, after a blank leaf, the book begins with a historiated initial, containing a small miniature of the presentation of the volume to Henry VII. of England, with a broken border of cut flowers on a buff-gold ground, and over which at foot is a bear. The writer (author) conceals his name in his dedication.

Fol. 3. The first large miniature painted in the French manner, the features being rendered in a very expressive and masterly style. The landscape is of the ordinary type. The page is surrounded by a full border of cut flowers on buff-gold, the conspicuous flower being the red rose and the violet. In the lower border are the royal arms.*

Fol. 4. The second miniature with initial " E " and full border, the principal flowers being the columbine and the red rose.

Fol. 19. Third miniature and full border. The border contains a magnificent iris, red rose, violet, &c., and a quail or lark.

Fol. 33. A fourth very beautiful miniature, with full border.

Fol. 41. Fifth miniature, a complicated scene, among other things showing gentlemen engaged in archery. Full border.

The sixth miniature has been taken out, together with the beginning of the chapter between fols. 81 and 82.

Fol. 90. The seventh and last miniature (now the sixth), full border, containing a large owl in lower border. At end, fol. 97 *v.*, this note : " Explicit limaginacion de vraye noblesse paracheve le derrenier Jour ne Juyn au manoir de Shene lan mil cccc. iiijxx. et xvi. O. POULET."

POURCHASSOT, MONGIN. *Copyist.* Saec. xv.

Given under 1453 in *Laborde : Ducs de Bourg.*, i. pt. ii. 528.

* Quarterly: 1 and 4 : *Az.* three fleurs-de-lis *or.* 2 and 3. *Gu.* three lionels passant *or.*

POYET, JEHAN. *Illuminator.* Saec. xv.

Of Tours.

Executed the beautiful floral and fruit borders of a small book of Hours for Anne of Brittany, thought by Laborde to be the celebrated " Hours " now kept in the National Library, Paris, and formerly in the Musée des Souverains. Suppl. Lat., No. 635. Laborde puts it among his most valuable discoveries that he found the passages quoted below in the first " compte de Jacques de Beaune le Jeune, trésorier général des finances de la royne, pour ung an entier, commençant le premier iour d'Octobre, 1495, et finissant le derrenier iour de Septembre, 1496." But it will be seen that the account refers to " unes petites Heures," which can scarcely be said to describe the magnificent folio MS. referred to. The " Great Hours " of Anne of Brittany certainly had the miniatures executed by Bourdichon, and as only the ornaments or borders and initials, &c., are claimed for Poyet, it is possible that the latter artist did paint the borders of the " Great Hours," and that Bourdichon painted the miniatures of the " Small Hours," though had he done so, it seems natural that his name should have appeared in the account, unless indeed both " Hours " are one and the same MS. Flowers and fruit, insects, &c., are said to have been Poyet's special forte, while Bourdichon's skill is displayed most in figures and portraiture. The paintings of the " Great Hours " are clearly the work of two French artists, one working in the manner of the Flemish school, the other in that of Tours. Both, however, are influenced more by the style of Fouquet than by that of Beauneveu or Marmion. This famous MS. contains 48 grand miniatures, 61 grand borders, 279 smaller borders, and 1,500 initials. The account of the " petites Heures " says they contained 23 rich histories, 271 borders, and 1,500 versets. It is not impossible that these summaries may both refer to the same book, and that the extra miniatures and borders now reckoned in the list were added afterwards. The copyist, Jean Riveron, and the two miniaturists, Poyet and Bourdichon, all lived at Tours, the native town of Jean Fouquet ; it is, therefore, more than probable that the words of the order for payment granted by Anne of Brittany to Bourdichon for having " richement et sumptueusement histoiré et enlumyné unes grans heures pour nostre usaige," &c., may refer to a work executed in conjunction

with Poyet, and paid for in two separate accounts, because given
to Bourdichon after Poyet had done his part. Poyet's account is
dated 1497 ; Bourdichon's 1508 ; Riveron's share of the money
was 14 livres ; Poyet's 153 livres 3 sols 4 deniers ; Bourdichon's
1,050 livres, tournois. The accounts discovered by Laborde are
as follows :—

" A Jehan Riveron escripvain demourant a Tours, pour avoir
escript à la main unes petites heures, que la dicte dame a faict
faire, à l'usaige de Romme, et pour auoir fourny de velin (3 Sept.,
1497), xiiii. liv. A Jehan Poyet enlumineur et historieur demour-
ant audict Tours la somme de sept vingt treize livres trois sols
tournoys, pour auoir faict ès dites heures, vingt trois histoires
riches deux cens soixante et onze vignetes (floriated borders) et
quinze cens verses, par marché faict auec lui, par la dicte dame
(Queen Anne) esquelle somme de viixx xiij l. iij s. iiij d. luy a esté
payée, baillée et deliurée comptant, par ce présent trésorier, par
vertu des-dits roole mandement dont est faict mention ainsi
qu'il appert par sa quitance cy rendue dattée le xxix. iour de aoust,
lan mil cccc. quatre vings et xvij. montant semblable somme de
viixx xiij l. iijs. iiij d. t. pour ce icy la dicte somme de
viixx xiij l. iii s. iii d. t." Now in the National Library, Paris,
Suppl. Cat., No. 635.—*Laborde : La Renaissance des Arts, &c.,*
i. 273, 4. Also ii. xxiv. 59. Under the impression that the
Grand Hours are really referred to in these notices, Laborde has
been followed in opinion by Renouvier and Leroux de Lincy.
Müntz, on the other hand, assigns the famous Hours to Bour-
dichon. If the " petites " and " grans" Heures are really distinct
books, Müntz is undoubtedly right as to the miniatures. But it is
quite possible that there is no case for denial, but that Poyet painted
the borders, initials, and smaller miniatures, while Bourdichon
painted the large figure subjects, which almost reach the indi-
viduality of the best Flemish miniaturists, combined with an
ideality peculiarly French. Poyet has been said even to have
excelled the Fouquets (presumably Louis and François, the sons
of Jean) as a miniaturist.—*Laborde : Les ducs de Bourgogne, &c.,*
i. 24.—*Id. : La Renaissance à la Cour de France,* i. 273, 274.—
Renouvier : Jehan Perréal, 4.—*Leroux de Lincy :* in *Gazette des
Beaux Arts,* May 1, 1850.—*Müntz : La Renaissance en Italie et
en France à l'époque de Charles VIII.,* 546.—*Mrs. Pattison :
The Renaissance in France,* i. *Appendix* ii.

POZAY, BERNARD AND JEAN. *Miniaturists.* Saec. XV.

Cited by Jean Breché, the Tourangeau jurist, as belonging to the end of the fifteenth century.—*Labarte: Les Arts Industriels, &c.*, ii. 298.

POZZUOLI, PIER ANTONIO DA. *Miniaturist.* Saec. XV.

One of those who worked on the Choir-books of the monastery of San Pietro and of Perugia. In 1471–2 Pier Antonio di Giacomo da Pozzuoli had illuminated two Antiphonaries, marked I L. I, p. 1, within the " A " : the Annunciation, with a St. Peter in the lower border. P. 119, in the " T " : the Apostles seated and Paul looking upward at a light coming from heaven. L. p. 1, within the A : (of Angelus) a half-length of Christ blessing with right hand ; a book in left. P. 8, with the " C " : (crucifixus) the Redeemer just rising from the tomb : three guards in consternation. —*Manari : Cenno Storico ed Artistico della Basilica di S. Pietro di Perugia.* (Perugia 1865–6.) In the initial " B " of the volume marked I, is a David praying, correct in drawing and rich in colour. He wears a tunic of crimson heightened with gold. The borders and foliage consist of good classical designs with medallions and cameos ; another, marked L, is also finely ornamented by this artist. These and two others marked K and M were adorned, in 1473, with miniatures by Giacomo Caporale. The Choir-books are now distinguished by Roman letters. They were written by various monks of the monastery of St. Peter, except the one marked T, which is due to Frate Ambrogio Agostiniano, whose name occurs on the first folio.— *Vasari : Le Vite, &c.*, vi. 319, 320. (*Nuove Indagini.*)

PRADO, GIRALDO FERN. DE. *Calligrapher.* Saec. XVI.

Executed, in 1560–1, at Lisbon, specimens of penmanship in various styles. Paper, 4° (7⅞ × 5¾ in.) 51 ff. Containing various pictorial alphabets, &c.— *Bragge : Sale Catalogue*, 1876, No. 122.

PRAGA, BATASAR DE. *Copyist.* Saec. XV.

Wrote "Terentii Comediæ," with interlineary gloss. Vellum.
Large 4º. 103 ff. Written in upright, large Bolognese Gothic.
Rough, illuminated inital at beginning; no borders; very wide
margins. At end: "Expliciunt Terentij Comedie, 1426, quarto
Mensis Maij p manus M. Baltasaris de praga Ip'e c̃ tenete (or
c̃ venete) euz. Formerly belonged to Dr. Butler, then to H. Drury,
afterwards to P. A. Hanrott. Now in British Museum, Add.
MSS., 11,904.

PRAGA, JOH. DE. *See* ALIAPS.

PRAGA, PETRUS, DE. *Copyist.* Saec. XV.

Wrote "Ordo Missalis sec. consuet. romane curie," for the use
of St. Mark's, Venice. Vell. Fol. 328 ff in 2 cols. with initials,
borders, and miniatures. On fol. 335 : "Explicit Missale scriptum
in Servallo per me fratrem Petrum de Praga, ord. scti. Benedicti,
de consensu et voluntate egregii militis et nobilis dom. dom.
Jacobi Delphini potestate dicti Servalli anno 1392."—*Valentinelli :
Biblioth. Mssta ad Marci Venetiar. Codd. Latt.*, i. 284.

PRATO, JOHANNES STEPHANUS DE. *Copyist.* Saec. XV.

Transcribed, in 1419, at Florence, "La Divina Commedia."
Now in the Laurentian Library, Florence (Pl. XXIV., XL.) At
end of the Paradiso: "Jouahn Stephanus de Prato *transchrisit*
hunc Dantem mea propria manu añj incarnat. milesº quatro cen-
tesimo decimonono doñj nostri ihū n̄tri die secūdo mēs maii
ciuitate liccij prouincia trāydronti."—*Batines : Biblioteca Dan-
tesca*, ii. 38.

P<small>RATO</small>, Q<small>UIRICUS</small> <small>DE</small>. *Copyist.* Saec. xv.

Wrote 1. "Eusebius de Præparatione Evangelica," &c. Vell. 4°, 180 ff. The first page of this MS. is splendidly illuminated—the head of Eusebius, or of Christ, in a nimbus, is painted in the first initial, and the arms and other insignia of the Medici placed in the ornamentation of the borders. At end : "Quiricus de Prato transcripsit anno M<small>CCCCLXII</small>."—*Bandini: Catalogus, &c.,* i. xvii. xxv. 2. "D. Hieron. Epistolæ." Vell. Fol. 377 ff. After the table of contents are two elegantly illuminated pages, the former containing the title of the work, the latter, St. Jerome before a crucifix kneeling in prayer. The scene is in the wilderness. In the lower border are the arms of Medici. There are finely ornamented initials to the books. At end : "Quiricus de Prato transcripsit anno M<small>CCCCLXII</small>."—*Bandini,* i. xix. 9. 3. "D. Hieron. Epistolæ," &c. Vell. Fol. 323 ff. This MS. is the finest of all those which bear the name of this copyist. On fol. 221 *v.,* and also at end, is the note : "Quiricus de Prato transcripsit, anno M<small>CCCCLXII</small>."— *Bandini,* i. xix. 10.

P<small>RÉCURSEUR</small>, J<small>EAN</small> <small>LE</small>. *Copyist, &c.* Saec. xiv.

Sacristan and "scriptor" of the abbey of Villers.

The chronicle of his monastery gives him great praise, and enumerates the works which he transcribed or composed. "Erat in monasterio Villariensi sacrista quidam nomine Johannes, dictus Præcursor, vir bonis moribus pollens . . . Fecit nobis librum qui intitulatur," "Agonia morientis," et "Psalterium beatæ Virginis . . . et alios plures in armario nostro positos."—*Martène et Durand: Thesaurus Anecdotorum,* iii. 1358.—*Messager, &c.,* 1855, iii.— *Pinchart: Archives des Sciences, &c.* Ser. i.

P<small>RES</small>, J<small>OSQUIN</small> <small>DES</small>. *Miniaturist.* Saec. xvi.

Executed the first miniature in the Missale Bavaricum of 1519–20. Vell. Fol. 186 ff. Now in the Public Library at Wolfenbüttel. The paintings of this Missal are chiefly in the style of Albert

Dürer. It contains 7 large miniatures with borders, initials and coats of arms. 1. By Josquin des Pres. 2. By Pierre de la Rue. 3. By Du Pipe (dated 1520). 4. By Constanz Festa. 5. By Noe Balbum. 6. Remarkable portraits of Maximilian I., Albert V., Charles. V. (when king of the Romans), and William Duke of Bavaria, which seem as if painted by Dürer himself. Perhaps they are the work of one of the Glockendons. 7. By P. de la Rue.—*Schönemann : Hundert Merkwürdigkeiten, &c., zu Wolfenbuttel,* No. 67.

PRESTINIEN, JEHAN LE. *Illuminator, &c.* Saec. xv.

"Varlet de Chambre, enlumineur, and relieur de livres" to the Duke (Philip) of Burgundy in 1441, for which offices he received a salary of 6 francs per month. Whilst in this service he illuminated a Prayer-book, a calendar in a small Psalter, and painted two miniatures in a large Book of Hours. Particulars are thus given : "Rec. Gén. No. 1349, 1440–1. A Jehan de Prestinien varlet de chambre et enlumineur de Mds. la somme de dixneuf liures quatre sols pour auoir fait plusieurs lettres dor et dazur que estoient fausses, et dauoir fait ung Kalendrier au petit Saultier de Mds . . . iiii. fr. xvi. sols. No. 1350. Item pour auoir fait deux ystoires aux grandes Heures de Mds. et y auoir aussi fait plusieurs lettres dor et dazur . . . vi. fr. No. 1351. Item pour auoir oste les armes du roy d'Angleterre (the common practice after the purchase or purloining of a MS.), qui estoient au liure de Mds. que lon appelle le liure du Tresor y auoir mis en ce lieu les armes de Mds. et de Mdme. la Duchesse, et y auoir figure les personnes de mesdits seigneur et dame, ou lieu des celles du roy et de madame de Hollande . . . lxxii. s. (It seems more likely to have been the portrait of Humphrey of Gloucester, than of either Henry V. or Henry VI., side by side with that of Madame de Hollande, if by the latter be meant the Countess Jacqueline. But it is easy to imagine, that after Philip's rupture with England through Gloucester's rash behaviour, he would not be anxious to retain any memorial of his former troublesome allies, or of his still more **troublesome niece ; and** Gloucester's portrait might

easily be mistaken for his brother Henry's. Assuming this, as
Philip's features are well known and Gloucester's not, the altera-
tion was a pity. In 1440 the Duke of Orleans was set at liberty
from his English prison, and Gloucester was in the height of his
unpopularity and quarrel with Burgundy and the Beauforts.)
" No 1352. Item, pour auoir enlumine dore et liure le parchemin
et relie ung liure de devotion four Mds. . . . xlviii. s. No. 1353.
Item, pour auoir relie dore et nectoie ung Saultier pour MS., le
conte de Charolois xlviii. s."—*Laborde : Hist. des Ducs de Bourg.*
ii. pt. i. 381–388.—*Kirchhoff : Die Handschriften-händler des Mittel-
alters,* 188.

PRESSE, ANGELOT DE LA. *Illuminator, &c.* Saec. xv.

Worked at Blois for Charles Duc d'Orleans. In 1464 he was
paid 11 livres for the ornaments and binding, which he had exe-
cuted, of a Missal of Notre Dame de Chambourdin, the particulars
of which are given in the following memorandum taken from the
Archives du baron Joursanvault in the National Library, Paris.
"No. 48, 25 Janvier 1463. Charles duc d'Orleans,. de Milan, et
de Valois, conte de Blois de Pavie et de Beaumont seigneur d'Ast
et de Coucy a nostre ame et feal conseiller et gouuerneur de toutes
nos finances Mr. Pierre de Refuge salut. Nous voulons et vous
mandons que par nostre ame et feal conseiller tresorier et receueur
general de nos dictes finances maistre Mace Guernadon, vous
faciez paier bailler et deliurer des deniers de icelles nos dites
finances a Angelot de la Presse peintre et enlumineur la somme
de onze liures tournois pour la parpaie de ce que luy puet estre
deu de auoir ·fait les lettres, enlumine et relie ung missel lequel
monseigneur le duc a donne a nostre dame de Chambourdin et
par rapportant ces presentes auec quictances sur le suffisant dudit
Angelot de la Presse nous voulons la dicte somme de onze liures
tournois estre allouee es comptes et rabatue de la recepte de nostre
dict tresorier par nos amez et feaulx gens de nos comptes ausquelz
nous mandons que ainsi le facent sans aucun contredit ou
difficulte car ainsi nous plaist il estre fait. Donne en nostre
chastel de Blois le xxve jour de janvier lan de grace mil cccc soix-
ante et trois. Par monseigneur le duc vus maistres Pierre de

Refuge Estienne le Fuzelier Guillaume le Bourrelier et autres presens. Villebresme."—*Le Roux de Lincy: La Bibliothèque de Charles d'Orleans, à son Château de Blois, en* 1427. *Appendix* 48. (Extr. from "Les Archives de Joursanvault," No. 852). We have also particulars of a Commission executed for the Duchess : "Pour auoir fait vint histoires aux heures en françois de madame la duchesse au prix de x s.t. pour chacune, pour deux lettres a vignettes x s.t. et iii^e. iiii^{xx}. (380) lettres a deux points et entrenelles (interlinear ornaments) au feur de viii. s. iiii. d. t. pour cent qui est en somme pour tout xii. li. s. viii. d."—*Delisle: Cabinet des MSS.*, i. 114.

PRETHAIMER, JOH. *Copyist.* Saec. XV.

Wrote a " Missale," now in Royal Library, Munich. Lat. MS., No. 7,550.—*Halm Catal., &c.*, iii. 170.

PREVOST, MORLET LE. *Copyist.* Saec. XV.

Given under 1439, and again under 1477, in *Laborde: Hist. des Ducs de Bourg.*, i., pt. ii. 528.

PREWITT. *Miniaturist.* Saec. XVIII.

A Pupil of Zincke.

Practised in London about the middle of the seventeenth century. Most of his works are executed in enamel, are brilliant in colour, and possess much merit.—*Redgrave: Dict of Artists of English School.*

PRICIUS ⎱ MICHAEL. *Copyist.* Saec. XII.
PRIKIOS ⎰

Wrote a collection of the Orations of Gregory Nazianzenus, in
Greek. Vell. Thick fol. 245 ff., 2 cols. On fol. 245 *v.*, 2 col.,
θκε̄, &c., much contracted, in full reads thus : " Θεότοκε βοήθει τῷ
σῷ δούλῳ Μιχαῆλ Πρικίῳ βασιλικῷ νοταρίῳ ἐπὶ τῶν οἰκειακῶν τῷ υἱῷ
ευλαμ π̄ (ευλάμπρου ?) πρικίου ἀνθυπάτου καὶ ἐπὶ τῶν οἰκειακῶν, τῷ
τήνδε τὴν βίβλιον γεγραφότι." The beginnings of the several
Orations have the usual Byzantine canopy borders of scroll-work in
colours and gold and ornate initials ; some really fine. Now in
British Museum. Arund. MSS., 549.

PRIMICERIS, JOANNES DE. *Copyist.* Saec. XIV.
Of Pistoia.

"Hunc librum sc'psit Joannes de primiceris."—*Zani : Encicloped.
Metod.*, xv. 295.

PRIORIBUS, LUDOVICUS DE. *Illuminator.* Saec. XV.
Of Nice in Provence. A Monk.

Completed, in 1437, a " Josephus," which had been begun by
Giov. Battista Pallavicini, for his uncle, the Marquess of Saluzzo.
At the end are these notes : " Per me Johannem Baptistam ex
marchionibus Palavicinis genere, patriaque Cremonensem, hec in
lucem carmina pro vita sunt ad laudem huius elegantissimi ac
prestantissimi ne dicam Judeorum sed Romanorum potius oratoris
. . . . memoriam, cui dum Farigliano moram traherem apud illus-
trem avunculum meum Johannem Galeazzum Marchionem Salu-
ciarum, &c., cui post Deum omnia debeo cum id sibi placere in-
telligerem presentem librum sicut apparet litteris exarare, cum
natiuitas Domini nostri Yhesu Christi quinque xxx[ta] quater centum
et mille, sub Aprelis mensis septima luce duceret annos." " Pre-
sens opus miniayit frater Ludovicus de Prioribus de Nicea pro-

vincie Provincie ordinis Sancti Benedicti M°cccc°xxxvii°, die xx. Novembris." Now in the National Library, Paris. MS. lat. 5,060. *See* also MS. 558 at Turin, described by Pasini. The latter, indeed, seems to be a copy from the one at Paris, and contains 193 ff. It is a very fine MS., illuminated ; and to each book is prefixed a series of portraits. At end : "Flavii Josephi Historiographi Antiquitatum xx., and ultimus explicit liber fauste, feliciterque Flavii Josephi Historiographi nempe clarissimi, laboriosum opus immensumque jam tandem satis egregie ut arbitror scripture mandatum est per me Johannem Baptista ex Marchionibus Palavicinis genere patriaque Cremonensem. sed tum agentibus fatis extorrem. et in Fariano moram trahentem. apud illustrem avunculum suum Dominum Johannem Galeazium Marchionem Salutiarum dignissimum. Non ex premio neve ullo optato commodo, sed sui sola grata contemplatione perscriptum anno a Nativitate Domini Nostri Jhesu Christi MCCCCXXXV. Februarii luce suprema." Under this : "Presens opus miniavit frater Ludovicus de Prioribus de Nicia Provincie Ordinis S. Benedicti MCCCCXXXVII die xv Novembris."—*Pasini: Catal.*, ii. 126 (Cod. DLVIII k. vi. 16). The discrepancies are not great, but sufficient to show that the copyist was not very careful of literal accuracy.

PROUSLIN. *Copyist.* Saec. XV. (?)

Wrote "De Casu Nobilium" of Boccaccio, with numerous poor miniatures.—*Lacroix et Fournier: Histoire de l'Imprimerie, &c.*, 55.

PROUVILLE, NIC. DE{ SIEUR DE. *Calligrapher.*
BRUNAULIEU, {

Saec. XVII.

Wrote, in 1609, a French translation, made by himself, from the Italian of "Méditations sur les Evangiles," &c., composed by

Aug. Vivaldi, to accompany the fine engravings made by Wierix for the " Evangelica Historiæ Imagines, auctore (Patre) Hier. Natalis, Antv. 1593." Folio. Paper. " Faict et Escrit de la Main du translateur, en l'an 1609." Beautifully written, the capital letters with elegant decorations in pen and ink.—*Catal. of the Library of Geo. Hibbert*, 94, No. 1646.

PRUSSIA, FRA GIOVANNI DA. *Copyist and Illuminator.*

Saec. xv.

Sometimes called Coppo, a Minor Observant.

Wrote and illuminated between 1456 and 1465, the eleven great Choir-books of the convent of S. Francesco della Mirandola at Bologna, belonging to his Order. Two bear the date 1464 ; three others 1465 ; and in one the artist has placed his signature: " Hoc volumen scripsit frater Johēs Coppo de Prussia, anno Dñi ꝉꝉo CCCCo L · Xo IIIIo." Other MSS. from his hand are kept in the convent of the Annunziata at Parma, and others in the convent of San Spirito at Reggio, with dates 1458, 1459. Lastly, the Choir-books still preserved at the church of San Nicolò di Carpi bearing his name. All have beautiful initials, but those of S. Francesco are perhaps the best. They do not contain miniatures, and later critics do not find in them the rich ornamentation discovered by Padre Flaminio, who first described them. The books of San Nicolò at Carpi had the initials at least executed by Don Sebastiano, a monk of San Benigno de *Capitefari* of Genoa. The Office or Diurnale, written by Sebastiano in 1477, has no notation, but the initials have flourished borders richly adorned with gold, after the fashion of the time—" messe ad oro stupendamente." The figures, frequently occurring at the beginnings of the verses, are executed in a simple style, but with little care, and with violent expression in the faces, and other faults. The figure which symbolises the Psalm beginning " Dixit Insipiens," deserves praise ; the rest are scarcely deserving of notice. It is probable that Fra Giov. da Prussia merely wrote and notated the books, and that the illuminations, especially of the books at Carpi, were added by another hand. In the San Francesco books, the first, marked A, bears the name of the writer, and probably also miniator, Fra Stefano de' Marciani da Cremona, with the date

1442, and the notice that it was done for the Church of S. Gabriele, near Cremona.—*Padre Flaminio da Parma : Memorie Storiche dell' Osservante della Provincia di Bologna*, ii. 31, 210, 407 (Parma, 1740).—*Campori : Gli Artisti Italiani e Stranieri negli Stati Estensi*, 165, 166.

PUCCINI, PAOLO. *Copyist and Notary.* Saec. xv.

Wrote, at Florence, in 1426, " Lat. Div. Commed. col Comento dell' Ottimo." Large fol. Vell., round, half-Gothic hand, 278 ff. Very fine and in good preservation. Came from Strozzi Library. Text stands in midst of page, and Commentary in smaller letters round it. A short argument in red in front of each Canto of Inferno, and of fifteen in Purgator., but left blank in Paradiso. Initials both of Canti and Commento are adorned with elegant miniatures in gold and colours. Those of Cantiche larger than the rest. 1st, represents Dante with his poem in his hand. Each cantica has, moreover, a rich border in gold and colours, in which are birds and flowers, at foot of each a shield of arms, erased. At end of Inferno : "Compiuto il primo libro della comedia didante Chiamato Inferno Colle sue chiose adi x del mese dottobre Mcccc°xxvj Ind. va scripto pme pagolo di Jacopo diguido puccinj notaio fiorentino." Now in the Ricardi Library, Florence, No. 1,004 (anc. n° 239).—*Batines*, ii. 81.

PUCELLE, JEHAN. *Illuminator.* (?)

See MACI and ANCIAU DE CENS.—*Delisle : Cabinet des MSS.*, i. 13.

PUCHARDI, FRANC. PAOLO DE'. *Copyist.* Saec. xv.
Of Florence.

Wrote : 1. Francisci Petrarche Vitæ Viror. Illustrium. P. I. Now in the Royal Library, Turin. 2. Boccaccio :—Il Ninfale. Written 23 Nov., 1454.—*Bibliotheca Capponiana*, 435.

PUGLIESE, PIETRO. *Copyist.* Saec. xv.

> Wrote, Virgilii Æneidos, lib. xii. Vell. 4°., 168 ff. At end :
> "Scripsit Petrus Pugliensis (of Apulia?) explevitque v. Nonas
> Januarii MCCCCLIII A. S. incarnatione Dñi nr̃i Jesu Christi
> Deo Gratias. Amen." With illuminated initials to each book.
> Now in the Laurentian Library, Florence. Pl. xxxix. xvii.—
> *Bandini : Catal.*, ii.—*Zani : Enciclop. Metod.*, xv. 317.

PULCETTA, FRA PIETRO. *Copyist.* Saec. xv.

A Minorite of Lucignano in Valdichiana, Siena, about
15 miles west of Cortona.

> Worked in 1470–1480.—*Zani : Enciclop. Metod.*, xv. 320.

PUYS, REMY DE. *Author and Copyist.* Saec. xvi.

> Author and scribe of a small folio now in the Imperial Library
> at Vienna (No. 2,591), containing an Account of the Entry
> of Charles V. into Bruges in 1515. Vell. 62 ff. "Redigee en
> escripte par Maistre Remy du puys son tres humble Judicaire et
> hystoriographe." On fol. 20 is a miniature of the Presentation of
> the Book to the Emperor, painted in *gouache.* The style is that of
> the Flemish Renaissance as to design and architecture, but German
> in the manner of painting. Fol. 3, "Epistre de lacteur a Mon-
> signeur tres hault, tres puissant," &c. The French way of labelling
> is used in the miniatures and Gantois initials composed of fine but
> heavy brown or blue foliages. The text is a small French Gothic
> interspersed with a good number of pictures with simple black line
> edges and wide margins. Many trophies and other ornaments.—
> *J. W. B.: MS. Notes of Visit to Vienna in* 1884.

PYERIUS, COLUCIUS. *Copyist.* Saec. xv.

Wrote "Annæi Senecæ Tragædiæ," &c. Vellum. 8°. 189 ff.
In upright half-Roman characters. On fol. 175 *v.* : " Lucii Annei
Senecæ Hercules Oetheus explicit feliciter, tragedia xᵃ. Colucius
pyerius manu propria scripsi " ; and at end, " Ulbertini Musati
patavini tragedia Eccrinus explicit feliciter Colucius pyerius
scripsi." Now in British Museum, Add. MSS., 6,8117.

PYROPULOS, ALEXIOS. (?)

Wrote "Hippocratis Vita et Opera." At beginning it has
" ὦ χριστὲ βοήθει μοι τῷ δούλῳ Αλεξίῳ τῷ Πυροπούλω."—*Montfaucon :
Palæogr. Græca,* 75.

QUEDLINBURG, AGNES OF. *See* AGNESE.

QUERCENTIUS, ROBERTUS. *Copyist.* Saec. xvi.
Of Cambrai.

Wrote, in 1557, at Liége, a " Diurnale." Vell. 71 ff. 2 cols.,
with illuminated Initials.— *Bibliotheca Meermanniana,* iii. 94,
No. 551.

QUESNE, JEAN DU. *See* DUQUESNE.

Quintano, Adrian de. *Copyist.* Saec. xv.

Wrote, in 1439, a Psalter with hymns, adorned with miniatures. In Library of S. Giov. e Paolo at Venice.—*Nuova Raccolta d'Opuscoli scientif.* Sér. xxxii. vi. 37.

Rabula. *Calligrapher and Illuminator.* Saec. vi.

A Monk of the Convent of St. John at Zagba, a town of Mesopotamia.

Wrote and decorated in a very graphic though rude and inartistic manner a copy of the four Gospels in Syriac. The MS., which, from its antiquity, is one of the most precious in existence, is now kept in the Laurentian Library at Florence. It is written on vellum 33 c. high by 26 c. wide, and was executed in the year 897 of the Era of the Seleucidæ, then in use in the old Greek empire of Syria, and corresponding to the year 586 of the Christian Era. It contains 26 miniatures. Of course the artist, shut up in a retired monastery situated in a remote corner of the empire, could not be expected to possess the talents of one employed in the capital, yet, though his smaller pictures are simply drawn with the pen and roughly tinted with colour, they are plainly not without a certain merit. The compositions, in which he has not been trammelled by a hard-and-fast rule,—and we must remember he would work chiefly on Byzantine traditions,—show that he possessed a considerable faculty of invention. Labarte gives a reproduction, in facsimile, of the Crucifixion, one of the most typical compositions in the book, and which shows the tendency of the teaching of the Church before the Council called *Quinisextum* authoritatively altered the current of artistic tradition. In that Council, held at Constantinople in 691, it was decided that it was better and more devout to represent Christ as suffering and dying for our salvation, and achieving thus the Redemption of the world, than to present the scene as hitherto, merely in the form of an allegorical lamb, or in some other similarly idealised and sentimental form. The lamb, indeed, was formally prohibited. In the first centuries it was repugnant to Christian ideas

to represent the sufferings inflicted by the Jews on Christ in a realistic manner; accordingly, the representation of the Crucifixion as a real scene was never attempted. Thus in the ivory diptych of the Duomo of Milan, which must have been executed during the reign of Justinian (527–565), though containing sixteen bas-reliefs of the Life of Christ from the Annunciation to the Resurrection, there is no picture of the Crucifixion. This Rabula miniature, therefore, is considered to be the most ancient known example of a realistic treatment of the subject. Notwithstanding the artist's poor skill in delineation, his imagination was extremely lively. The miniature referred to is in two compartments, the upper two-thirds being occupied by the Crucifixion, the lower third by the Entombment, or, rather, Scene at the Tomb. In the Crucifixion the sun and moon appear roughly, as in pagan art, while over the head of the soldier who pierces the Saviour's side is written the word ΛΟΓΙΝΟΣ, according to the tradition. Beneath the cross are soldiers disputing over the purple robe. Christ wears a plain purple tunic with golden *clavi*. The two thieves have simply a linen waist-cloth. Mary, on the extreme left, wears a purple gown with knotted fringes. Round her head is a large golden disk with a blue edge. She appears again in the scene below, in the same dress. The angel is draped in a white toga. The blue-edged gold nimbus surrounds his head, as it does that of Christ. Over the cross is an illegible inscription.—*Labarte: Les Arts Industriels au Moyen Age*, ii. 164. The lower part of the picture shows the open tomb in which the body has been laid, not as cut in the rock, but as the porch of an edifice, with pink pillars having brown gold capitals, and with a very fanciful gable. Rays of bright vermilion flash out from the interior and strike the soldiers who are guarding it. The curious part of this design archæologically is, that the general style of the work is Roman and somewhat in the manner of the paintings of the catacombs, but by no means good or exact. It is, however, really Byzantine, as shown by the ninth-century MS. of Gregory of Nazianzus (No. 510) in the Nat. Lib., Paris. The Rabula MS. has been frequently described, several times with the aid of engravings. Assemani, Biscioni especially, Montfaucon, and many later writers have busied themselves with it, and all have been impressed with its importance, both in point of theology and of Christian art. Biscioni, indeed, gives engravings of all the miniatures, and Westwood a good description of the MS.—*Labarte . Histoire des Arts Industriels au Moyen Age.* Album, Pl. LXXX. (1st edit.

Paris, 1864. 4°.).—*Gorius-Assemani : Mediceæ Laurentianæ et Palatinæ Bibliothecæ Codicum MSS. Catalogus.*—*Biscionius : Bibliothecæ Mediceo-Laurentianæ Catalogus.*—*Tyrwhitt : Greek and Gothic,* 107, 319, 341, 355.—*Westwood : Palæographia Sacra Pictoria ; Syriac MSS.*

RADAUSS, MATTHIAS. *Copyist and Miniaturist.*

Saec. XVII.

A distinguished Painter.

Wrote, between 1594 and 1604, at Königgrätz, a magnificent Hymnal in two volumes for the Stadtkirch, and adorned it with many pictures.—*Dlabacz : Künstlerlexicon für Böhmen,* ii. 527.—*Nagler : Künstlerlexicon,* xii. 185.

RADPECKH, WENCESLAS. *Copyist.* Saec. XV.

Wrote, in 1457, the Epistles and Gospels, on paper, 275 ff. In a good handwriting. At end : " Das puech Hat ausgeschriben Wennczlab Radpeckh, burger zu Klosternewnburg an Mittichen vor Sannd Dorothee tag. Anno domini, M° cccc. vnd im lvii^{ten}." Now in the Imperial Library at Vienna. Cod. DCCCXLVIII.—*Denis : Catal.*

RADULPHUS. *Copyist.* Saec. VIII.

A Monk of St. Vaast, of Arras.

Dehaisnes : L'Art Chrétien en Flandre, 29, 49.—*Cahier : Biblioth.,* 128.

RADULPHUS. *Copyist and Calligrapher.* Saec. IX.

A Monk of St. Vaast.

> Wrote " Augustini super Psalmos Commentarium." With minia-
> tures.—*Martène et Durand : Voy. de Deux Benedictins*, ii. 63.

RADULPHUS. *Copyist.* Saec. XVI.

> Wrote "Egloga de Victoria a Ludovico XII. Galliarum Rege
> contra Venetos. anno MDIX parta," &c. Vell., 34 ff. At end :
> " Libellus quem vides. Qui me tibi dedit. Radulphus artifex
> meus. Me scripsi exili stilo." Now in Royal Library, Turin.
> Cod. MXLI., l. i. 25.—*Pasini*, ii. 307.

RAES, MARGUERITE. *Copyist.* Saec. XV.

> Copied a MS. now in the Royal Library at Brussels.—*Cahier :
> Biblioth.*, 140.

RAET, ADRIAEN (DE). *Illuminator.* Saec. XV.

Pupil of Guillaume Vrelant.

> Joined the Gild of Illuminators at Bruges, in 1475. He had
> several pupils, among them Guill. Baselyn in 1487 ; Hans Moens
> and Hans Suwaert in 1502. In 1520 he was dean, and in 1523
> and 1530 was governor of the Gild. Died 1534. In 1489 he
> painted the Crucifixion before the Canon of the Mass, in a Missal
> belonging to the Church of St. Jacques, at Bruges, for which he
> received the sum of four escalins de gros.—*Beffroi*, ii. 301.

RAGENARD. *'Copyist.* Saec. IX.

A Monk of Deux Jumeaux, in the diocese of Bayeux.

Copied the "Breviarium Alarici," or abridgment of the Theo-
dosian Code. Now in the National Library, Paris (MS. lat.,
4,413). Delisle gives a facsimile from this important fragment,
which is a palimpsest; and belongs to the year 833. "Ego
Ragenardus clericus, Esau rogante, hunc librum scripsi sub
tempore chludouico Imperatore anno XVIIII. imperii sui, et sub
tempore Erimberto urbis Baiocas episcopo Duos Gemellis abbate,"
&c.—*Delisle : Cabinet des MSS.*, ii. 360 ; iii. 253 ; iv. pl. XXV. 3
(fol. 105).

RAGUSA, FELICE DA. *Miniaturist, &c.* Saec. XV.

Called also Felix Ragusinus.

Director of the staff of copyists and miniaturists employed by
Matthias Corvinus at Budapest. He was an accomplished scholar
and linguist, and an excellent miniaturist, "præterea in ipsa quoque
pictura exercitatus," accustomed both to correct the texts of the
authors submitted to his scrutiny, and to assist in their pictorial
and other ornamentation. *See* CLOVIO AND MATTHIAS CORVINUS.—
Olahus : Hungaria, i. 20.—*Kukuljevic Sakcinsky : Slovnik umjetni-
kah Jugoslavenskih (South Slavonic Biographical Lexicon of Artists.*
&c. Art. "*Felix Dubrovcanin.*")

RAHINGUS. *Copyist.* Saec. IX. et X.

A Monk and Prior of Flavigny, 872–5 and afterwards.

Wrote "Virgilis Æneis," &c., now in the Vatican Library.—
Seroux d'Agincourt : Hist. de l'Art, &c., iii. 105. It is now
MS. lat., 1570, and is a large volume containing 154 folios,
executed during the Carolingian time. Its contents are the Works
of Virgil with the Commentary of Servius. At the end is a notice

in prose and a prayer in verse to this effect: "I, Rahingus, monk of the Abbey of Flavigni and deacon, whilst in the interest of our brethren I was charged with the affairs of the Community, was desirous of occupying myself in collecting books, rather than to slumber in indolence and exhibit ignorance. The more I was harassed by the care of material and perishable interests, the more it was in my heart to increase the provision of intellectual and lasting benefits. Fearing that for want of good copyists we might be deprived of books which we wanted, I determined to consecrate my activity to a work so useful, in order that knowledge might not be trampled under the feet of ignorance. You will come to this conclusion when you look upon the characters of this book, which I devote to God and to St. Peter, so that during a long revolution of ages it may serve for the instruction of youth. I intend that the present collection of the Poems of Virgil may be preserved in this house, and that it may be studied here, and I forbid any fraudulent alienation of it. May he who shall infringe my purpose be condemned, in the great day of Judgment, to eternal pains. And thou, studious reader, who seest these lines, remember me, and say this prayer: 'A porta inferi erue, Domine, animam famuli tui Rahingi.'" In the elegiac distichs which follow this dedication, Rahingus beseeches the Almighty to accept the homage of his book, and again forbids the ignorant from carrying off, in the spirit of evil, the volume which he has dedicated to God. Delisle has discussed the date of Rahingus in an article in "Mélanges d'Archéologie et d'Histoire," published by the École Française de Rome, VI., and reprinted by Cuggiani, Rome, 1886. Rahingus also wrote a copy of the Epistles of St. Paul with glosses, in fol., 155 pp., now in Library at Orleans, No. 79. The two volumes form excellent models for the study of the handwritings adopted in Burgundy under the successors of Charles the Bald. A facsimile in photography, from the Vatican MS. of Rahingus, is given by Delisle. It reproduces the commencement of the Georgics, with the commentary on each side of the text.—*Delisle : Mélanges d'Archéologie, &c.* Rome, 1886.

RAIMBAUCOURT, PETRUS DE. *Illuminator and Miniaturist.* Saec. XIV.

Illuminated, in 1323, a Missal now in the Royal Library at the Hague. It is thus mentioned by Jubinal: "No. 48. It is a

Missale Romanum in folio, in modern binding of red morocco It contains some very beautiful initial letters and twenty-one magnificent miniatures. On the last folio, in large letters, as in the rest of the MS., Frater Joannes Marchello abbas ecclesiæ scti Joannis Ambioriensis ordinis præmonstratensis fecit scribere istum librum per manum Garneri de Morolio anno Domini millesimo trecentesimo vicesimo tercio." Then, in golden letters : " Et Petrus dictus de Raimbaucourt illuminavit istum librum, in anno prædicto." Underneath this inscription is the latter individual on his knees, presenting his book to the Abbot, who receives it seated, and holding the abbatial crosier. In the number of miniatures I have not counted the borders of the pages, yet these are no less remarkable for their spirit and grotesqueness. They consist of flowers and birds, and of comical monstrosities, engaged in hunting scenes and combats. The military costume is that of the thirteenth century, *i.e.*, the coat of mail with hood of mail and the buckler " en point." The horses are richly caparisoned. As we go on, we see monkeys spinning, shooting with the bow, threshing corn, rocking infants, engaged in cookery, bird-catching, &c. In other places are wolves and foxes disguised as monks, singing at the desk. In one spot is a lion wearing a crown (Messire Noble le Lion of the Roman de Renard) seated on a lofty tripod, holding in his hands a label, on which is inscribed : " Palardie, orgueul, envie." A Calmelite and a Dominican, in the shape of a wolf and a fox, prostrate themselves before him. It must be confessed that master Peter de Raimbaucourt here exhibits a considerable degree of independence and audacity in venturing to insert such illustrations in a Missal. These satires in painting are quite in the mediæval spirit, in which the belief in dogma did not exclude raillery towards the ministers of religion, even of the highest rank. Then painters, sculptors, trouvères, make fun to excess of the Court of Rome and of the religious orders, at the same time deeply respecting religion itself."—*Jubinal: Lettre à M. le C. de Salvandy, &c.*, 9, 10.

RAIMONDI, Donna Theresa de'. *Miniaturist.*

Saec. xvii.

Worked at Rome about 1695.—*Zani : Enciclop. Metod.*, xvi. 37.

RAIMONDI, LODOVICO. *Copyist.* Saec. xv.

Of Parma.

Wrote and notated, in 1472, a Psalter and part of a Hymnarium for the "Fabrica del Vescovato" of Ferrara. At end: "Ego Ludovicus de Raymundis de Parma hunc librum transcripsi et notavi anno domini 1472, die 10 Junii permanente venerabili viro D. Xpophoro de Rodulphis canonico et massario Fabricæ Episcopatus Ferrariæ." The account of payment of this work is still preserved in the archives of the Cathedral. "L.S. della Fabrica del Vescovato di Ferrara, fol. 44, 1471.—Mro Ludvigo da Parma Scriptore contrascrito debbe havè a die xxiii. Decemb., 1472. Lir. septanta tre sol. dni. de m(oneta) per sua mercegna et Scriptura de havere scripto uno psalmista et uno innario a la sagrestia del Vescoado de Ferr. et posto a debito a la fabrica in questo C. 64 Lir. lxxiii. s. ii. d., et a die xxx. decembr. Lir. vinticinq. sol. tredexe per lui se fano boni al dicto Nico. de Lardi per altretanti per lui pagati a Michelle di Arienti banchiere per altretanti chel dito Michielle havea fato pagare a Vinexia a Zulian de Paulucci per carte di vidello comprato in Vinecia e mandato per scrivere libri per la sagrestia del Vescoa de Ferr. et posto dicto Nico. creditore in questo C. 40, Lir. xxv s. xii d." Again, fol. 54, 1471, et a die xxviii. Marzo £. 2. s. cinq. m. pago et a Mo. Ludovigo da Parma scriptore per conto de sue scripture. Et a di iv Aprile L. quattro m. pago estado Jac. da Carlo per compto dela pixon de la caxa in la qual sta dito Mro Ludovigo da Parma scriptore la qual pixon se è obligato pagare il capitolo de Canonici de Ferr. per dito Mo. Lodovigo perchè el scriva alla Sagrestia ultra il suo pagamento."—*Gualandi: Memorie originali Italiane Risguardanti le belle Arti,* Sér. 6, 153, 172 (1845).—*Cittadella: Documenti, &c.,* 179. Also *Notizie relative a Ferrara,* 70.—*Manini Ferranti: compendio della Storia Sacra e Politica di Ferrara,* iii. 165.—*Zani: Enciclop. Metod.,* xvi. 17. *See* ARGENTA.

Another Choir-book, once belonging to the Monastery of San Martino de' Bozzi, contains the following note: "Iste liber est Monasterii Sanctæ Mariæ Palliserenæ alias Scti. Martini de Botiis Vulgariter nuncupati, cisterciensis ordinis Parmensis diœcesis scriptus et notatus per me Magrum Ludovicum de Raymundis de Parma, ad instantiam R. di Dni Sigismundi de Fulchinis suprascripti Monasterii Abbatis decimi, anno Dom. MccccLxxxxiii. die ultima mensis Julii."—*Antonelli: Estratti dalle Memorie*

Originali . . . di Belle Arti, Sér. vi., Pref. 7, 11.—*Pezzana :*
Continuazione degli Scrittori Parmegiani, in *Affò,* ii. 213.

RAIMONDO, VINCENZIO. *Miniaturist.* **Saec. XVI.**

A famous, but hitherto neglected, miniaturist of Rome,
a contemporary of Clovio.

He is mentioned by Francesco de Holanda as one of the best
known miniaturists of the time. Zani barely mentions him as
Vincenzo, with the year of his death, 1557. The documents
produced by Müntz have established his family name, Raimondo
or Raimondi. Possibly he was some relation to Antonio Raimondi
the engraver, who was living in Rome during the Pontificates of
Paul III. and Clement VII. Of his being the same person as
Vincenzo Miniatore there can be no doubt. The latter figures in
the list of Academicians of St. Luke at Rome, which was instituted
in 1535. He appears to have been a Frenchman by birth, and a
native of Lodève in Languedoc. He is not noticed by Monsigr.
Barbier de Montault in his notes on the Livres de Choir des
Eglises de Rome ; and, if any miniatures from his hand exist at
present, they pass unrecognised. The following memoranda are
taken from documents existing in Rome : [1542, Apr. 1] "A dì
1 Aprile, 1542. Scudi cento d'oro in oro pagati a M. Vincentio
miniatore a buon conto delle miniature che fa nelli libri della
capella di S. Sta=Sc. 105 " (T. S. 1542, fol. 50). Decr. Scudi
trecento pagati a Mro Vicenzo miniatore per sua mercede di
diverse . . . che ha fatte nelli libri della capella come appare
distintamente nel mandato (*Ibid.,* fol. 70). 1543. October. " Sc.
cento d'oro in oro pagati a M. Vincentio miniatore a buon conto
delle miniature delli libri di canto fermo, che hanno da servir per
la capella di S. Sta. (T. S. 1543, fol. 78 v.) 1546. 24 Jan. :
"Adi 24 di gennaro sc. ducento d'oro in oro a M. Vicenzo minia-
tore, a buon conto delle miniature de libri ch' ha fatto per la
capella di N. Sre." (T. S. 1546, fol. 78). 2 May. "A di 2 di
maggio sc. cento d'oro in oro a M. Vicenzo miniatore de libri
della capella e sacristia di N. Sre quali S. Sta gli da a buon conto
del credito che ha con S. Be. (*Ibid.,* fol. 87 v.). 1546. 22 June.

"A di 22 di giugno sc. cento et vintisette a M. Vicenzo Ray^do miniator della capella et sacristia di N. S^re, quali sono per resto della summa delli sc. 457. Quali se li pagha per conto saldo di tutti quelli libri miniati et stimati da fra Bastiano piombator et M. Perino del Vaga pittore, presente il R. M^r. de Ascisi M^r. di capella." (*Ibid.*, fol. 92 *v*.) 1547. 24 March: "A di 24 di Marzo sc. cento d'oro in oro a M^r. Vicenzo miniator della capella et sagristia di N. S. a buon conto per le miniature d'un messale del giovedi santo per uso privato di S. S^ta et altre opere che tutta via si fanno per detta sagrestia." (T. S. 1547, fol. 121 *v*.) 1548. 20 February: "Addi 20 di febr^o. Sc. cento di oro in oro a M. Vincenzo miniatore a bon conto per la miniatura di un libro quale restava a fare per la capella di N. S^re questo Ott^re pross. passato d. 110." ('T. S. 1545–1548, fol. 164). (1549. fol. 164), 1549. 10 Oct.: " Miniatori Vincentio Raymon . . . &c. (7 ducats, 82 baiocchi 1/2 for his salary for the month of September, 1549" (M. 1548–1552, fol. 91).—*Müntz : La Bibliothèque du Vatican au XVI^e Siècle*, 104–108. — *Raczynski : Les Arts en Portugal*, 55.—*Bertolotti : Artisti francesi in Roma nei secoli* XV., XVI., *e* XVII., 28, 29, *See* HOLANDA.

RAINALDI. *See* RINALDI, DON B.

RAINALDUTIIS, LUDOV. DE. *Copyist.* Saec. xv. (?)
Of Fano.

Wrote " Triumphos Petrarchæ."—*Mittarelli, præf.*, p. xviii.

RAINER, BONAVENTURA. *Miniaturist.* Saec. XVIII.
A Monk of the Order of Servites, of Innsbrück.

Famous for portraits and historical pieces in miniature. Born 1713. Died 1792.—*Nagler : Kunstlerlexicon*, xii. 272.

RAINERUS. *Copyist.* Saec. xv. (?)

Wrote a Pontifical, once belonging to the Chartreuse of Marseilles. At end: "Explicit liber quam scripsit Rainerus de Florentia, scriptor atque notarius." Now in the Cathedral Library, Lyons.—*Begull: Monographie de la Cathédr. de Lyon.* (Lyon. Fol. 1880.)

RAMBALDIS. *Copyist.* Saec. xv.

Wrote and illuminated (?) the MS. of Romuléon in Sebastian Mamerot's translation, now in the National Library, Paris (MS. fr. 6,984). It is a large folio. Vell., 379 ff. 2 cols. With very beautiful miniatures, initials, and borders. The MS. was executed for Louis Malet de Gravelle, admiral of France, under Charles VIII. (Died 1516.) The writing is manifestly by the able scribe of the Cité de Dieu (No. 6,712^2), whilst the miniatures were executed by the artist to whom we owe the copy of the Fleur des Histoires (No. 6,733). The frontispiece, representing the presentation of the MS., no doubt shows us L. de Gravelle in the midst of his household. The first initial contains his arms : "*gu.* à trois fermaux *d'or.*" The almost innumerable ornaments of this volume are often very curious, while the initials are in better taste than the miniatures. Yet the buildings evince an extensive knowledge of architecture, and a sentiment of true beauty, such as we understand it fifty years later, at the epoch of the Renaissance. Note especially fol. 27, the disappearance of Romulus during a tempest ; fol. 30 *v.*, the combat of the Horatii and Curiatii ; fol. 54, a view of Rome, and many others, very well worth study. The author of the book was an Italian of Bologna. The Abbé Lebœuf, who in vol. xx. of *Mém. de l'Acad. des Inscript.* has given a valuable paper on the works of Mamerot, observes that the Latin copy of the Romuléon preserved in the Library of Ste Geneviève calls its author Benvenuto d'Imola. The family name of the copyist was Rambaldis, and he lived about the end of the fifteenth century. If we may trust the MS. already cited, the Romuléon must be added to the list of MSS. already assigned to him by Fabricius. But if we refer to the lists of Casaubon.

Fabricius, and Montfauçon, we shall find that the name borne by
the MS. of the Romuléon in the Vatican is Roberto della Porta,
Casaubon, who accepts this as the truth, speaks of the obligations
of the writer to the authors of the Augustan Histories. In the
Paris National Library is a copy of the original text (MS. 5,823),
but the author is not named. Like the French version, it is
divided into ten books, and ends with the partition of the empire
between Galerius and Constans. In the preamble, the author
tells us that he is still young, and undertakes the work at the
instance " de très fort chevalier Gomorius de Albornouo."—*Paris:
Les MSS. fr., &c.*, iii. 65. The copy of the Romuléon in the British
Museum has this preamble. It is a magnificent folio, with broad,
white margins, miniatures, initials, and borders. On one of the
miniatures is the date 1480. It is written in two cols., 418 ff., and
was executed for "monseigneur *Gommets dalbornoce*, chevallier
espaignol, gouuerneur et capitaine de Bulloigne la Grasse."
Gometio Albernozzo was governor of Bologna in 1361. The
penmanship is exceedingly good. In the Paris copy the preamble
continues : " Cujus habenas regit prudens ac providus gubernator
et quam, sonantibus undique bellorum fragoribus guerrarum turbine
oppressam, revoca patria libertate jamdudum suis propulsa
doloribus, spectabile virtute sua potentes erexit." As for Mamerot,
it was at the request of the same patron who had already ordered
the Valerius Maximus that he undertook the translation of the
Romuléon, "monseign[r] Loys de Laval, Seign[r] de Chastillon,
&c. &c." He calls himself " Sebastian Mamerot de Soissons, son
chappellain et serviteur domestique," and says that he began it at
Troyes in 1466. He made the translation, " sans y adjouster ne
diminuer, si non en tant qu'il ma semble necessaire a la seule
decoration du langaige françois, et par especial du vray soissonnois."
The Soissonnois was the most polished French of the fifteenth
century, and a thousand times preferable to that of Christine de
Pisan, the Chatelains, the Molinets, and others. Of Louis de
Laval mention has been already made. He was the constant
patron of Mamerot. The following particulars may be added.
He was, as has been stated, Lord of Chastillon in the Vendelois,
and of Gael in Brittany, being the third son of Jean de Montfort,
Lord of Kergorlay, who, in right of his marriage with Anne Dame
de Laval, daughter of Jean VI. Duke of Brittany, took the title of
Guy XIII. Lord of Laval. Louis was made successively
Governor of Dauphiny, Genoa, Paris, and Champagne, and in
1466 Grand Master of Forests and Waters. He died childless in

1489. His sister Jeanne de Laval married Louis, Count of Vendôme, who was taken prisoner at Agincourt with the Duke of Orleans.—*De Limiers: Histoire Généalog. de France*, ii. 159. *See* LAVAL and MANSION. Mamerot was precentor and canon of the Collegiate Church of St. Etienne of Troyes.—*Paris: Ibid.*, iii. 65.—*Van Praet: Notice sur Colard Mansion*, 72.

RAMECOURT, JACOTIN DE. *Copyist.* Saec. xv.

Wrote, for Marie de Bourgogne, daughter of Charles le Téméraire, a "Vie de St. Bernard," in the translation made in 1396. Large 4°, 291 ff. With one miniature. In a good handwriting. After the final rubric is the motto: "Droyt et avant. Nans. ob." The copy is not dated.—*Paris: Les MSS. fr., &c.*, vii. 238.

RAMEDELLIS, RAMI DE. *Copyist and Illuminator.*
 Saec. xv.

Wrote and illuminated a copy of the Commentary of Benvenuto da Imola on the Inferno, Purgatorio, and Paradiso of Dante. In three large fol. vols. Paper. Vol. i., 126 ff., two cols., excellently written in a round letter, with many abbreviations, contains "Inferno." Titles and arguments in red. Initials illuminated. First fol. has a grand initial, with border to page. At foot a coat of arms, of which the interior has been erased. Begins thus: "Commentū siue Scriptuȝ super libruȝ primuȝ qui intitulātᵣ Infernus sacri poematis celeberimi Dantis Aldigherij ad clarissimum principū dmᵐ Nicholaum Illustrem Marchionē Estensē. p. dissertissimū et egregium gramatice professorē magistruȝ Beneventum de Imola sermone lucido compilatuȝ." At end: "Rami de Ramedellis q. Scriptuȝ hoc Cõrexit et miniauit anno dnj Milliõ quadringentesimo sextodecio apud aulā Magnifice Domine Mantuane in suo offitio Pincernatus." Vol. ii., 144 ff., two cols., contains commentary on the "Purgatorio." On first fol. a grand

initial containing miniature, and with a full border to the page. At end : " Benuenuto da Imola Scriptuȝ super purgatoriū Dantis feliciter explicit Rami Ramedellis." On the back of this volume is the date Mccccxvi. Vol. iii., 134 ff., two cols., contains Commentary on the " Paradiso." As before, there is a large initial and border at the beginning, including " stories " of the subjects of the poem. At foot an erased coat of arms. At end: " Explicit sc̄ptus Benuēute da Imola sup Paradisum Dantis, 1459." Now in the Laurentian Library, Florence (Cod. Strozziani, CLVII. CLIX). —*Bandini : Catal. Codd. MSS., Biblioth. Leopoldina Medicæa*, ii. 554-557.

RAMELLI, PADRE DON FELICE. *Miniaturist.*

Saec. XVII.

Canonico of San Giovanni Laterano. Born at Asti, in Piedmont, in 1666, of a noble family.

Became greatly celebrated as a miniaturist. His style of work is graceful, firm in drawing, and lively in colour. He was a pupil of the Padre Abate Rhò, and lived in Rome in the service of Pope Clement XI. He was also employed by the King of Sardinia to make miniature copies from the great masters in the Florentine galleries for the Royal collection at Turin, where there were formerly many examples which were carried off during the French War. He died in 1740.—*Orlandi : Abeced. Pittorico*, 404 (Ven. 1753. 4").—*Nagler : Künstlerlexicon*, xii. 280.

RAMELLO, FRANCESCO. *Copyist.* Saec. XVI.

Employed at the Papal Court under Leo X.—*Armellino : Un Clasimento della Città di Roma sotto il Pontificato di Leone X.* (Rome, 1882), 61.—*Müntz : La Biblioth. du Vatican au XVIᵉ Siècle*, 59.

Ramirez, Andres. *Miniaturist.* **Saec. XVI.**

A famous Miniaturist of Seville.

Worked in the year 1555 on the Book of the Festa de San Pedro, belonging to the Cathedral. For his work on the Choir-books he was paid, in 1555, 15,000 maravedis (this was for the above-named volume) ; in 1558, other 15,000 for the volume containing the service for the Holy Trinity ; and in 1559, 11,625 for twenty-seven letters, which he illuminated in the latter volumes (Archiv. de la Catedr. de Sevilla).—*Bermudez : Diccionario, &c.,* iv. 142.—*Nagler,* xii. 283.—*Riaño : Notes on Early Spanish Music,* 136. *See* Orta.

Ramirez, Cristobal. *Illuminator.* **Saec. XVI.**

An excellent illuminator of Valencia.

Employed by Philip II. on the magnificent Choir-books of the Monastery of S. Lorenzo of the Escorial. He was the first who fixed the size and order of the volumes, and of the writing in them. He presented Philip II. with several examples of his skill, and was appointed, in 1566, as writer of the Choir-book projected for the choir of the Chapel Royal of the monastery, with the annual salary of fifty ducats, and the obligation of residing in the Escorial. As the vellum which had been ordered for the work in Valencia was not as good in point of size or fineness as was expected, the king, in 1568, ordered the work to stop until vellum of a suitable quality had been obtained out of Germany. Meantime, Ramirez was permitted to retire to his native city, his salary being still continued, and further supplemented with a gift or honorarium of fifty ducats. He remained at Valencia four years, during which time he experimented on the skins obtained from Aragon and Catalonia, and wrote the *Intonario* in two volumes—the Office for the Dead in one, and a musical Breviary in the other, which he presented to the king in 1572. Bermudez gives considerable details concerning him and his work. His associates or successors were Fray Andrés le Leon, Fray Julian de Fuente de el Saz, Ambrosio Salazar, Fray Martin de Palencia,

Francisco Hernandez, Pedro Salavarte, and Pedro Gomez. The volumes have been already described. *See* LEON. *Bermudez: Diccionario, &c.,* iv. 142–5.—*Nagler,* xii. 283.—*Riaño : Notes on Early Spanish Music,* 137.

RANOLDO, FRANCESCO. *Miniaturist.*　　　Saec. xv.

Worked about 1444 in Sicily.—*Nagler : Künsterlexicon,* xii. 288.

RANOLDO, DI MESSER FRANCESCO.　　　Saec. XVI.

Son of the preceding.

Followed the same art about 1507.—*Nagler : Künsterlexicon,* xii, 288.

RAOUL. *Illuminator.*　　　Saec. XIII.

Lived in 1292, at Paris, in "la Rue de la Plastrière."—*Géraud : Paris sous Philippe le Bel., &c.,* 36.

RAOUL, JEHAN. *Copyist and Illuminator.*　　　Saec. xv.

A priest of Dijon.

Worked as copyist and illuminator for Louis XI. of France. He received, in 1477, 34 fr. 25 c. for two Genealogies of the Kings of France and Dukes of Burgundy, enriched with golden initials.—*Peignot : Catalogue d'une partie, &c.,* 37.—*Laborde : Les Ducs de Bourgogne, &c.,* i (Pt. ii.), 528, 572.—*Kirchhoff,* 189.

Rapaluto, Steph. de. *Copyist.* Saec. xv.

Wrote a "Vita Alexandri Magni," in verse, called "Alexandreidos," by a certain Julianus Pacer. 72 ff. At end : Deo gratias. Amen. Anno Domini 1475, die 25 Augusti finitum fuit hoc opus per me Sephanum de Rapaluto hora tertiarum." Now in the Royal Library, Turin (Cod. cdlxxxviii k. ii. 20).—*Pasini: Catalog. &c.,* ii. 111.

Rapicano,
Rabicano, } Nicola. *Illuminator.* Saec. xv.
Rubicano,

Put in the three illuminated pages of MS. Cat., 12,947, National Library, Paris, written by Palma (viz., ff. 3, 11, 127). They are mentioned in a schedule of 6th Nov., 1471 (Reccio : note 80) " per tres principes bells sturiats ab les testes del senyor rey don Alfonso, del senyor rey e de diversos emparadors e altres testes del natural fetes en lo libro intitulat Andreas Contrarius de Represencio et cet." Delisle also attributes to him the frontispiece MS. Cat., 3,063 : "Scotus super Sententiarum librum," the style of which, in many respects, resembles that of 12,947. This MS. of Johannes Scotus is part of a set. A further note of Riccio's (99) points out another MS. illuminated by Rabicano. "A Filippo Rabicano miniatore a xiii. de octubro de lo presente anno Mccccclxxxviii. xviii. ducati iiii. tar. e xiiii. grand, li quali li sonno comandati donare a complimento de xxviii. ducati iiii. tar. e xiiii. grand, quale erano dovuti a Cola Rabicano suo padre per lo miniare a facto de uno volume libro de forma reale de pergamino nominato "Scoto super le Sentencie," cioe iii. ducati iii. tar per lo preczo de una bella minia. A intro la quale sto la figura di Scotto che sta studiando, torniata tutta la carte de una vignetta anticha de fulgati fiori, animali, speritilli et divissi arme del S.R. che tene alo torno una laurea con duy speritelli tucto pieno de lictere mascule de oro, de lo titulo de lo detto libro tutto de oro et d'aczuro et altri colori fini. Et iv. ducati tari xvi. per lo preczo de trenta octo littere grande a l'antiche con codecto d'oro et d'aczuro et altro colori fini a xii. grani ciascuna. Et iv. ducati ii. tari et

xiii. grani, per lo preczo de cccii. lictere parossine de oro et aczuro et altri colri a grano i. et . . . l'una. Et xvi. ducati tari v. per lo preezo de octo milia cento vinticinque littere majuscule d'oro a rocio de i. tars lo centenaro ; loquale libro ha restituyto in la libreria del S.R. in potere de Baltesaro Suarillo; como li restanti ducati x. abia auto per mano de messer Michele da Flicto, olim thesoriero generale del S.R."— *Delisle : Cabinet des MSS.* iii. 360. Delisle also thinks that the illumination of the " Strabo " (MS. Cat., 4,798) is due to Nicola Rabicano, as it is to this volume, apparently, that the account mentioned under 22nd Jan., 1474, belongs, being a payment to him " per lo historiar e miniar de hun libro dit Strambone " (Riccio, n. 96). From the dialect of these memoranda it would seem that both the copyist and the illuminator were Sicilians.

RASO. *Copyist.* Saec. XV.

Wrote " Senecæ Epistolæ." Vell., thick 8°, 187 ff. In a small heavy French secretary hand. No ornaments. At end, in red, " Expliciunt epłe lucij Annei Senece ad luciliū." Those at foot in black : " Scriptus Anno M°cccc°li° p̣. Rasonē." Now in British Museum, Add MSS., 11,985.

RATBERTUS. *Copyist.* Saec. VIII.

A monk of Corbie.

Wrote " Expositum sc̣i ambrosii in Lucā Evangelistā. Formerly in the Library of Corbie (No. 122), now National Library, Paris. (Old style Germ. MS. Cat. 205). At foot of first page " Abba Jussit fieri RATBERTUS leutcharius jussit hunc sanctū scribere librū.—*Mabillon : De re diplomat.* 3602 (pl. ix. script. sæc. viii.)— *Delisle : Cabinet des MSS.* ii. 119.

RATH, HENRIETTA. *Miniaturist.* Saec. XVIII.

Born 1774.

Worked at Geneva in miniature and enamel.—*Nagler : Künstler-lexicon*, xii. 300.

RAUDENSIS, PAGANUS. *Copyist.* Saec. XV.

Wrote "Terentii Poetæ comici opera." Vell. 4°, 130 ff. The handwriting is a small half-Roman minuscule with contractions, and more rapid than the ordinary formal text. On folio 5 *v.* is a peculiar initial "V" in gold and colours, and an equally peculiar bracket flourish consisting of red and blue penstems terminating in foliages and of old Veronese type. There are several other similar initials and borders in the volume. On the last leaf, folio 131 *v.*, in pale red capitals : " Exscripsit Paganus Ravdensis qvarto kal. Septembres 1476." Now in the British Museum. Harl. MS., 2,526.

RAULET, BRETON (SON OF). *Copyist.* Saec. XVI.

Worked for Cardinal Georges D'Amboise. "Au Breton Raulet, pour v̄ cayers de la Mer des Histoires que son filz a escripte, au pris de ung escu d'or pour cayer, payé pour le reste le ix^e jour de Novembre v̄^{cc} ii. (1502), lxxv^s.—*Dépenses, &c., par M. Deville*, 440.

RAVANELLI. *Miniaturist.* Saec. (?)

Of Genoa.

Painted tapestries.—*Zani : Enciclop. Metod.*, xvi. 41.

RAVENGERUS. *Copyist.* Saec. XI.

A monk of Epternach under Abbot Regimbertus (1051–81).

In MS. lat., 9,668, National Library, Paris: " Regimberto abbati, Ravengero quoque, et Ereboni, scriptoribus requies eterna donetur, Amen."—*Delisle Cabinet de MSS.*, ii. 362.

RAVENNA, GIACOMO DA. *Copyist.* Saec. XVII.

Worked at Ravenna about 1644.—*Zani: Enciclop. Metod.*, xvi. 43.

RAVINE, PIERRE DE. *Copyist.* Saec. XIV. et XV.

One of the copyists employed by Etienne de Conty in Paris about the end of the fourteenth and the beginning of the fifteenth century. He was curé of the village of Villers-Bretonneux in 1411, and his signature appears in a Ceremonial now MS. lat., 12,892, Nat. Lib., Paris, formerly in the library of Corbie, for which monastery it was written.—*Cocheris: Notices et extraicts des docum. MSS. relatifs à l'hist. de la Picardie*, i. 656. The other copyists employed by Conty may be mentioned here: 1. Guillaume de Breuil, an ecclesiastic, successively Curé of St. Saturninus of Chartres, 1374; of Villers le Vicomte, 1375; Canon of St. Nogent le Rotron, 1375–6; Vicar of St. Opportune of Paris, 1377; and Chaplain of the same in 1381. His signature appears in MSS. of all these dates, in the library at Amiens (*Garnier: Catal. d'Amiens*, 278, &c.). 2. Jean du Vivier of Gand, "demourant à Paris rue des Poirées," in the house of Etienne de Conty, whose private chaplain and secretary he was in 1376. A MS. at Amiens (No. 383) is signed: "Per manum Johannis de Vivario de Gandavo." 3. Jean Galet of Amiens, a cleric in 1394 (MS. d'Amiens, 116). 4. Amiot Aubrey, of the diocese of Auxerre in 1405, whose signature occurs in MS. lat., 12,892, Nat. Lib., Paris, together with that of Ravine.--*Delisle: Cabinet des MSS.*, ii. 129.

RAY, FREDERICUS. *Copyist.* Saec. XV.

Wrote "Beati Johannis Crisostomi, &c., in Matheum Evange-
listam." Vell. Large folio, 272 ff., 2 cols. In small upright
secretary hand. A beautiful white stem bracket border and initial
on folio 1, and initials to each book. Altogether a very important
MS. At end, in red, Lib' scī Johis Crisostomi sc' Matheum a
Gregoīo trapezūtio 9versus explicit feliciter. Scriptus ꝑ me
fredericū Ray." Now in British Museum, Add. MSS., 14,795.

RAYNALDI,
RINALDI, } DON BENEDETTO DE. *Copyist and Illuminator.*

Saec. XV.
A Franciscan monk.

Copied and notated the Music of a Choir-book for the Propria
Sanctorum for the use of the Cathedral of Lecceto, in which there
is a miniature of St. Luke, the draperies of which are well executed,
and an Annunciation with architectural cornices and friezes in good
taste. At the end is the following note: "Hoc volumen fieri
fecit Rev[mus] in Christo Pater Sacræ theologiæ Eximius professor
Magister Anselmus de Monteflascone totius ordinis Heremitar.
Augustini Prior dignissimus. . . . conventui amore Dei donavit.
Scripsit vero ac notavit Ven. Relig[sus] frater Benedictus Pauli
Raynaldi Senensis, Ordinis fratrum minorum, nec non et ad finem
usq : perduxit hodie viii. idus Martii Mcccc. Lxxxx." He also
wrote and notated excellently a magnificent Choir-book for the
Hospital, at the end of which is written : " Hoc opus scripsit
Frater Benedictus Pauli de Senis Ordin. minorum tempore Dñe
Nicholai de Ricoveris Rectoris divi Ospitalis Sctæ Mariæ de
Scalis MccccLxxv." With miniatures executed in the mediocre
taste of the period.—*Della Valle Lettere Senese, s.v.* Also wrote
and illuminated a Service Book for the Cathedral of Siena in the
manner of Ansano di Pietro.—*Vasari : Vite, &c.*, vi. 224, 348.
That he had a hand in the Choir-book would appear from the
following memorandum : " Iste liber scripsit et notavit Venerabilis
Religiosus Dñs Benedictus Mag[i], Pauli de senis ord[is] S. Benedicti
Tempore Magnif[i] Dñi Alberti de Armigheriis digniss°. operario
ecclesiæ cathed[lis] Senensis, nec non, militi Hierosolimitano Subanno

Domini MCCCCLXXXI. die xx. Aug[i]." And in another dated 2nd
Aug., 1482, is added the name of " Mag[i] Pauli Raynaldi." We
may safely say that the grammatical blunders in this book do not
belong to Padre Benedetto ; for in the books of Lecceto, written
by him in 1490, and in those of the Ospedale notated by him in
1475, he declares himself, in good Latin, to be a Franciscan.—
Della Valle, l.c. A good example of his miniature work is given
in the letter " L " of the Alphabet published by the Arundel
Society, London, 1862. It is taken from the X gradual No. 6 D.
of the Choir-books of the Cathedral of Siena, now in the
Piccolomini Library. He certainly worked, in writing and musical
notation, on five of the Choir-books of the Duomo of Siena,
between 1480 and 1482, but it is an error to suppose that he
illuminated them. He has been confounded with an imaginary
Benedetto Matera. It was formerly confidently asserted that he
executed most of the illuminations of those famous Choir-books
of the highest class of work, but more accurate research has
determined that he was merely the writer and notator of them.
The illuminators are known.—*Milanesi Documenti, &c., dell' Arte
Senese,* ii. 381, 382. Also *Sulla Storia, &c.,* 74.

RECHENE, F. *Copyist.* Saec. XII.
 A monk of Engelberg.
 Serapeum (1849), 124.

REDINGER BENEDIKT. *Miniaturist.* Saec. XVIII.
 Worked about 1755 at Znaym in Moravia.—*Nagler: Künstler-
 lexicon,* xii. 358.

REDITA ANIELLO. *Miniaturist.* Saec. XVI.
 Studied under some Flemish Master at that time residing in
 Naples, very skilful in this kind of painting. Redita chiefly

excelled in portrait, though he also produced historical subjects for various persons of rank, as may be seen in the palace of the Marchese d' Avalos. The tragic story of this painter, the sorrowful end of his love affair and his death, are related by Dominici.—*Dominici: Vite dei Pittori, &c., Napolitani,* ii. 392.— *Nagler,* xii. 358.

REDMOND, THOS. *Miniaturist.* Saec. XVIII.

Son of a clergyman of Brecon.

Apprenticed to a house-painter at Bristol, afterwards came to London and studied at the St. Martin's Lane Academy. In 1763 became a Member of the Free Society of Artists, and exhibited at the Royal Academy from 1775 to 1779. Died at Bath 1785.— *Redgrave: Dictionary of Painters of English School.*

REES, ARNOLDUS. *Copyist.* Saec. XV.

A monk of St. Martin's at Cologne.

Wrote in 1485, "Legenda Sct\[i]. Severini, archiepiscopi Coloniensis." At end: "Finitus est liber iste ac *scriptitando* completus per fratrem Arnoldum Rees, cujus anima requiescat in pace." Now in the Royal Library Brussels, No. 442.—*Ziegelbauer: Hist. rei lit. S. O. Bened.,* i. 506. *Cahier: Bibliothèques,* 140.—*Marchal. Catal. des MSS. &c.,* i. 370.

REFLET, PAUL. *Miniaturist, &c.* Saec. XVI.

Miniaturist, "Brief-Maler" and wood-engraver.

Born, according to some, at Nuremberg, according to others at Prag. His work dates from 1560 to 1580.—*Nagler: Künstlerlexicon,* xii. 362.

REGELINDE. *See* IRMENGARD.

REGGIO, EVANGELISTA DA. *Miniaturist.* Saec. xv.

 Among the artists employed by Marquess Borso of Este at Ferrara. Many details of his work, including documentary evidence of payment to him and his colleagues, are given under ARGENTA. *See* ARGENTA *and* ESTE.— *Cittadella : Notizie relative a Ferrara,* 70, 641.—*Gualandi : Memorie Originali, &c.,* vi. 154, &c.

REGGIO, FRA FRANCESCO DA. *Miniaturist.* Saec. xvi.

A Minorite.

 Worked about 1508–1520.—*Nagler : Künstlerlexicon,* xii. 365. —*Zani : Enciclop. Metod.,* xvi. 57.

REGIMBERT. *Copyist, &c.* Saec. ix.

Librarian at Reichenau under Abbots Waldo, Heit, Erlbald, and Rudhelm.

 Gave a great impulse to his scriptorium by his example, and caused the execution of an incredible number of MSS.—*Cahier . Bibliothèques,* 129.

REGINPOLD. *Calligrapher.* Saec. xi.

 Wrote, in a sort of cypher, in which each vowel was replaced by the following consonant, at the end of a MS. which he had copied : " Quam dulcis est navigantibus portu ita scriptori novissimus

versus. Legentes in libro isto conscripto orate pro ipso ut veniam mereatur a Christo, qui prestat vobis ab ipso, pro indigno clerico Reginpoldo, quia ipse laboravit in ipso libro."—*Wattenbach*, 234, from *Cod. Bamb. A.*, ii. 53. In uncials. A facsimile is given in *Jaeck's Schriftmustern*, ii. 10.

REGNAUD, JEHAN. *Copyist.* Saec. xv.

Canon of the Cathedral of Cambrai.

> Wrote a Directorium, &c.—*Reiffenberg:* in *Bulletin du Bibliophile belge*, iii. 378.

REGNIER, D'ANJOU. *Miniaturist.* Saec. xv.

The celebrated René, Duke of Anjou, titular King of Sicily, &c. In the Tourney-book at Dresden he calls himself "Le Regnier d'Anjou."—*Götze: Merkwurdigkeiten, &c.*, i. 121. *See* ANJOU *and* RENÉ.

REICHENTHAL, ULRICH VON. *Copyist and Miniaturist.*

Saec. xv.

Wrote a History of the Council of Constance, which he enriched with miniatures. Now in the Public Library, Constance. The drawing and colour are both clever, and at times the compositions are of a satirical character. Of this Codex there is preserved in the Chancery of the city a printed copy, from the press of A. Sorg, of Augsburg, 1483, with woodcuts which are not, however, copies of the miniatures. The printed copy is one of the greatest rarity. —*Nagler: Künstlerlexicon*, xii. 383.

REIMS, ABP. AND DUKE OF. *Patron.* Saec. XVI.

Charles de Guise, Cardinal de Lorraine and Archbishop and Duke of Reims, was one of the most distinguished and magnificent patrons of his time. He was the son of Claude de Lorraine, first Duke of Guise, and born 1524. At an early age he became conversant with the busy political life of the reign of Francis I., crowned Henry II. and Charles IX., took a leading part in forming the Catholic League, and was bitterly opposed to any civil toleration towards the Protestants. He afterwards attended the Council of Trent in 1562, and died at Avignon, not without suspicion of poison, in 1574. Amidst his active interference in French and European politics, he found time for collecting pictures, sculpture, and books, and for conversation with the principal poets, scholars, and artists of the Renaissance. To him Pierre Ronsard dedicated his Book of Epitaphs, and several hymns and odes, always remembering the kindly way in which the Cardinal had noticed him when a youth at college. In one of the latest of his poems, which he calls an " Epistre a Charles Cardinal de Lorraine," Ronsard makes, perhaps, the most direct allusion to his character of patron and protector of letters. In the " Hymnes " he calls him, " Mon Charles, mon Prelat, mon Laurier de Lorraine," and celebrates his prudence and justice. In the " Epistre" he says : " Tel a Rome iadis s'apparut un Mecene Qui pere entretenoit les plus gentils esprits Pour enricher son nom de leurs nobles escrits et encore au iourd'huy Les Princes bienfacteurs se surnomment de luy. Or sus parlo de moy qui vous doy recognoistre Mon Mecene, mon tout, mon seigneur et mon maistre." Silvestre, in his examples of Greek palæography, reproduces the title of a MS. written for the Cardinal of Lorraine by Constantine Paleocappas. It is a splendid example of calligraphy, and contains a Treatise by Anastasius, Patriarch of Antioch (probably Anastasius IV., who lived in the eleventh century), on Providence. Its title, written in coloured capitals of a bold and striking character, is ΤΟΥ ΑΓΙΟΥ ΑΝΑΣΤΑΣΙΟΥ ΠΑΤΡΙΑΡΧΟΥ ΑΝΤΙΟΧΕΙΑΣ ΠΕΡΙ ΠΡΟΝΟΙΑΣ. The volume which contains it now belongs to the Communal Library of Reims. It is described by Harles as No. 517, written on cotton paper, and as comprising several other treatises. The ornaments of this title-page, which are very fine, are described under PALEOCAPPAS. Two miniatures, with the arms, emblem, and motto of the Cardinal, occurred among those collected by the late M. Didot, on a leaf of vellum, taken, doubtless, from a book of

Hours. M. Didot attributed them to Jean Cousin. On one side
are the arms of the Cardinal, with his devices, placed in an elegant
cartouche, over which are two stags, perhaps a gallant allusion to
Diane of Poitiers, of whom he was a warm admirer. One is white,
the other tawny. They are accompanied by two old men, wrapped
in large cloaks. At the sides are vases of flowers, masks, &c., with
butterflies, birds, and small animals. At the back of this, in an
oval frame, is a granite pyramid or obelisk, surrounded by a stem
of ivy and surmounted by a crescent, exactly as in the MS. of
Anastasius. In the background is a landscape, with ruins and
monuments. A cartouche in the lower portion of the frame con-
tains the motto-device of the Cardinal of Lorraine : "Te stante
virebo." The top of the frame is surmounted by an angel holding
two laurel crowns ; at the sides are couched two white *lévriers ;* at
the outer borders are two vases full of fruits, and underneath, on
the cartouche, the seated figures of Minerva and Diana. All this
painting is relieved upon a ground of tasteful ornament. A repro-
duction is given in the illustrated edition of the catalogue.—
Biographie Universelle, anc. et mod., xix. 198.—*Didot : Catal. des
Livres rares et precieux. Juin,* 1884, 63 (No. 89).—*Silvestre : Paléo-
graphie Universelle,* ii. Several dedications by Paleocappas are
given by *Omont : Catalogue de MS. grecs copiés à Paris au* XVIᵉ.
Siècle par Constantin Paléocappa (Le Puy,1886), *Extr. de l'Annuaire
de l'Association pour l'Encouragement des Etudes grecques en France,*
20ᵉ *année,* 1886, 241-279.

REIMUNDUS. *Copyist.* Saec. XII.
 Prior of St. Albans.

The Vitæ, xxiii., Abbatum Sⁱ. Albani, quoted by Matthew Paris,
says of him : " Ex eius industria et licita adquisitione libri nobiles
et perutiles scripti sunt, et hinc Ecclesiæ collati. præcipue Historia
Scholastica cum Allegoriis, liber elegantissimus."—*M. Parisiensis :
Hist. Major.*

REINERUS. *Illuminator.* Saec. XV.
 Probably of Pisa.

In a volume of "Statuti della Dispensatione della Helemosina,
ad uso della Compagnia di S. Giovanni Ev: quondam di S.

Jeronimo di Pisa," at the foot of fol. i., are the words, in red capitals, " Opus Reineri." The page has a roughly-painted border with initial " A," in which occurs St. John writing his Gospel. The outer marginal ornament is a branch of cherries with leaves, &c., tied to a ring. The others are rudely symmetrical, but by no means skilful in execution. The MS. is in the British Museum, Add. MSS., 22,828.

REINSPERGER, JOH. CHRISTOPH. *Miniaturist.*

Saec. XVIII.

He was a painter and engraver of Nuremberg, and was born 1711. He became a pupil of Leotard and went to Brussels. Afterwards he became Court painter to Charles of Lorraine. The latter years of his life were passed at Vienna in the employment of the Court. He died 1780. Nagler gives a list of his engravings. —*Nagler: Künstlerlexicon*, xii. 407.

REMI. *Copyist.* Saec. XV. (?)

Named in the chronicle of the Abbey of St. Hubert at Brussels. —*Pinchart : Archives des Sciences, &c. Documents inédits*, i. sér. i. The Chronicle is published in *Martène and Durand, Amplissima Collectio, &c.*, iv. 914.

REMONDINI. *Miniaturist.* Saec. XVIII.

Worked at Genoa about 1788.—*Zani : Enciclop. Metod.*, xvi. 68.

REMSHART-SEDELMAYE, ELEON. CATH. *Miniaturist.*

<div align="right">

Saec. XVIII

</div>

Worked chiefly on portrait. Born 1704 ; died 1767.—*Zani
Enciclop. Metod.*, xvi. 67.—*Nagler : Künstlerlexicon*, xii. 551.

REMSHART, SABINA. *Miniaturist.* Saec. XVIII.

Sister to the above. Died at Augsburg, 1775.

RENÉ. *Patron.* Saec. XV.

Duke of Anjou and Lorraine, &c.

To the particulars given under ANJOU may be added the
following :—

De Limiers gives his pretensions thus : " René, Roi de Naples,
de Sicile, de Jerusalem, d'Arragon, de Valence, et de Maiorque ;
Duc d'Anjou, de Lorraine, et de Bar ; Marquis de Pont ; Comte
de Barcelonne, de Province, de Forcalquier et de Piedmont, sur-
nommé *le Bon.*" He was born in the Château of Angers, 16th
Jan., 1408. Was a prisoner from 1431 to 1436. Succeeded to
the titles of his brother, King Louis III. of Naples and Sicily, who
had been adopted by Jeanne II., Queen of Naples and Sicily, and
who died at Cosenza in 1434. Was in turn adopted by the Queen
of Naples in 1435. He founded the Order of the Crescent in
1448, and died at Aix in Provence, 10th July, 1480. I have
appended these particulars as of interest, perhaps, towards
identifying any MS. formerly belonging to the " good King René."
Traditionally attributed to his hand as an illuminator is a MS.
called " Un court Roman de très doulce Mercy au cour d' Amour
espris sur les Tournois," now in the National Library, Paris.
Also, " Traitte d'entre lame devote et le cœur en mortifiement
de vaine plaisance," in the Imperial Library, Vienna. The
lists of *Hours* and similar books are uncertain and variable. René

had probably the artistic teaching of the brothers Van Eyck. His earliest work is found in the Schloss-Kirche, at Dijon, where he was imprisoned by Philip of Burgundy in the Tour de Bar. In his apartment he painted the arms of Bar. Indeed, his taste seems to have run mainly on arms and tourneys, and other matters in which heraldry played a chief part. On the window-shutter of the ducal chapel he painted, in 1431, his own portrait; and in 1433 the arms of the thirty-two knights of the Toison d'Or, whom he had encountered on the field of Bullegneville, on the fatal 2nd July, 1431. After the death of his first wife, Isabella of Lorraine, in 1454, he returned to Angers, and for a long time is said to have occupied himself exclusively with miniature painting, as a relief from the trouble of her loss. The Prayer-book of the deceased duchess was enriched with a variety of miniatures. There are two other MSS. that were adorned by him in a similar manner; one is the "Tresor des Martes," in the National Library, Paris, in which is a miniature representing how Johan de St. Maure did homage to him; the other is the "Liure de Moralites et Mysteries, *i.e.*, Moralite mortifiement ou mortification de vaine plaisance." In the "Roman en prose et en vers de tres doulce Mercy" are seventy excellent miniatures. In several places, curiously, Hope is represented wearing a sugar-loaf hat, and is mounted on a horse. Ardent Desire is dressed as a countryman in a red jacket. The heroes of Antiquity appear bearing their coats-of-arms, &c. René had a great Tourney Book written for him, which was published in a large folio volume in 1826–7 by Champollion-Figéac. Another MS. in the National Library, Paris, contains twenty-six miniatures said to be from his hand. Many of the works which, before the Revolution, existed in Angers, Lyons, Avignon, Marseilles, and Aix, have since disappeared, or have lost identification. The celebrated MS. of René, known as the "Psautier de Poitiers," has been photographed by M. Charles Barbier, Conservateur de la Bibliothèque de Poitiers. The reproductions of the miniatures of the Strabo of Guarino were procured for M. Heiss by Dr. Claudet, librarian of Albi; and the National Library, Paris, laid under contribution for other illustrations given by M. Heiss in "Les Médailleurs de la Renaissance." There is little, if any, direct evidence that René painted any of the miniatures so often attributed to him. It is only on the faith of tradition that the Prayer-book of the Duchess Isabella was illuminated by him. *It is said,*—this is the evidence,—that after the death of Isabella of Lorraine, in 1454, he returned to

Anjou, and occupied himself exclusively with miniature painting. It is on no better authority that in the "Trésor des Martes" at Paris he has painted the miniature of Jean de St. Maure, doing him homage. I do not remember any document that may be called original, making any express statement, or any signature in a MS. (signatures on panels and shutters are not quite the same thing) proving his actual work. It rests with those who pretend to know of such documents to produce them. Further notes may be found in *Lecoy de la Marche: Extraits des Comptes et Mémoriaux du Roi René.* Paris, 1873.—*Ib.: Le Roi René*, 2 vols. Paris, 1875. —*Hucer: Iconographie du Roi René et de sa Famille.* Le Mans, 1879.—*Mémoires de la Sociëtë d'Agricult., Science et Arts de la Sarthe.*—*Delisle: Cabinet des MSS.*, i. 55-6, 375, &c.; iii. 336.— *Nagler: Künstlerlexicon*, i. 130, 2.—*Falckenstein: Geschichte und Beschreib. der Königl. Biblioth. zu Dresden*, 427-9.—*De la Salle: Précis Hist. sur la Vie de René d'Anjou*, 39, 40, *n.* 1.—*Le Vicomte de Villeneuve-Bergement: Vie du Roi René, &c., passa Le Comte de Quatrebarbes: Œuvres complètes du Roi René, avec une Biographie et des Notices* (with many outline illustrations), cxliii., &c. &c.— *De Limiers: Annales de la Monarchie Françoise*, &c., ii., *partie* 115 (xix.).

RENIER, ADRIAEN. *Illuminator.* Saec. XVI.

Member of the Illuminators' Gild at Bruges in 1500-2. Died 1519.—*Le Beffroi*, ii. 229, 305 ; iv. 329.

RENOULT, JEAN. *Copyist.* Saec. XVI.

" Ecrivain et Secrétaire" to Henry III.

Executed certain "tablettes enrichies d'or et enluminées de plusieurs figures de batailles et rēcontres qu'il nous a naguères liurées, que nous luy auions cy deuant commandées pour nostre seruice (Bibl. Impériale, Lettres patentes de Henri III. à la date de 20 Août, 1581)."—*Delisle: Cabinet des MSS.*, i. 192.

RESTALLINO, CARLO. *Miniaturist.* Saec. XVIII.

Born in Italy in 1776, and came as a youth to Munich. Was famous as a portrait-miniaturist.—*Nagler: Künstlerlexicon*, xiii. 44.

RESTOLIO, NATALIS DE. *Copyist.* Saec. XIV. (?)

Copied for Gaufrid de Limoges a MS. now in the National Library, Paris (MS. lat., 15,796). "Natalis de Restolio clericus, scripsit librum istum pro magistro Gaufrido de Limogiis, LV. sol."— *Delisle: Cabinet des MSS.*, ii. 147.

REVELLE, FREMIN DE. *Copyist and Illum.* Saec. XIV.

Of Paris.

In 1372 he illuminated a copy of the "Liure des proprietes des choses, translate en françoys par Jehan Corbechon." Now in the University Library at Jena.—*Mylius Memorabilia Biblioth. Acad. Jenensis*, 349. The Inventory of the Library of Jean Duc de Berry, brother of Charles V. of France, which was made in 1416, seems to suggest that Revelle was also a dealer in MSS., Art. 575, "Un liure ouquel est contenu tout le Saultier couuert de cuir vermeil, a deux fermoirs d'argent dorez, emaillez aux armes de feu messire Jean de Montagu, lequel liure fu dudit defunct, et lenvoya querir mon dit seigneur apres sa mort, chez Fremin de Revelle escrivain demeurant à Paris, le 26 jour doctobre 1409. Prise xx liures parisis."—*Barrois: Bibliothèque Protypographique*, 98.

REVELLI, PIETRO. *Miniaturist.* Saec. XVIII.

Worked at Turin about 1747.—*Zani: Enciclop. Metod.*, xvi. 82.

REYNBOLDUS, JOHANNES. *Copyist.* Saec. xv.

A German.

Wrote a number of MSS. mostly containing the works of Duns
Scotus, now kept at Merton and Balliol Colleges, Oxford. In-
clusively they are Mert. lix. to lxv., and Ball. ccii. to ccvi., ccxvi.,
cclxi., and ccxci. For the signature and date, one example may
be given. It is written on vellum fol. 192 ff. "Johannis Duns
Scoti super Sententiar. . . . Opus Parisiense." At end : " Ex-
plicit lectura doctoris subtilis in universitate Parisiensi super
primum librum sentenciarum sc. Doctoris Johis Duns nati in
quodam villicula parochie de Emyldon, vocata Dunstan in
comitatu Northumbriæ pertinentes domui Scolarium de Merton
halle in Oxonia et quondam socii dicte domus, scriptum per me
Johannem Reynbold de Monte Ornato" (another MSS. adds,
"terre Hassie Theutonicum "), "anno Domini millesimo cccclv."
Another MS. has "per me Johannem Reynbold Almanicum de
monte Ornato." The MSS., fifteen in number, are almost all very
large folios, and are dated between 1451 and 1464 ; those from
1451 to 1456 being in Merton College Library, the rest, from 1460
to 1464, in that of Balliol College.—*Coxe : Catalogus Codd. MSS.
Collegii Mertoniensis*, 38, 39.—*Idem : Catal. Codd. MSS. Coll.
Balliolensis*, 65, 68, 87, 96.

REYNERUS. *Copyist.* Saec. xv.

Wrote, in 1432, "Summa de Casibus fratris Bartholomei de
Pisis Ord. Pred.," in 4°. With fine initials. On fol. 203 : "Ex-
plicit. Finitus est iste liber in terra noua comitatus Floriacensis
per manus Reyneri Arnoldi de *brande de duffle* cameracensis
dyocesis. Anno a natiuitate domini Mccccxxxii. die xviii.
mensis Martii. Deo Gratias."—*Caravita*, ii. 294.

REYNGOUT, JANNE. *Copyist.* Saec. xv.

Wrote a Martyrologium and other works for the Convent of
Notre Dame de Sion at Bruges.—*Beffroi*, iii. 325.

REYNHERUS, FRA. *Copyist.* Saec. XV. et XVI.

A monk of St. Michael's, Bamberg.

Wrote, in 1495, "Wymphelingi Jac. triplex candor B.V. Mariæ," a Poem, 14 ff. Formerly in the Library of St. Michael's, now in the Public Library, Bamberg.—*Jäck : Beschr., &c.,* 147, No. 1,170. Also, in 1503, an "Evangeliarium" for his monastery, sm. fol. 184 ff., and "Hämmerlein Epist.," 1495.—*Ibid.,* 39, 84.

REYNIERS, ADRIEN. *Illuminator.* Saec. XVI.

Designed four patterns for seals for Philip II., as Duke of Brabant, &c., after the abdication of his father, for which he received six livres Flemish, Oct., 1555.—*Pinchart : Archives des Arts, Sciences, et Lettres,* i. 253 (1 Sér.).

REZEL, RUDOLF N. D. *Miniaturist.* Saec. XVIII.

Born 1725, at Brunswick.

Worked at several Courts, and died 1795.—*Nagler : Künstler-lexicon,* xiii. 88.

RHO, DIONISIO (PADRE ABATE). *Miniaturist.*
 Saec. XVII.

"Canonico de San Giovanni Laterano."

Worked in copying the old masters and in painting portraits in miniature in Rome about 1680. He was the master of the more celebrated Don Felice Ramelli.—*Nagler : Künsterlexicon,* xiii. 19.

RHODIOS, PHILIPPOS. *Copyist.* Saec. XVI.

Wrote Aristotle περὶ ψυχῆς, &c. Paper, sm. 4°. 67 ff. Beautifully written. No ornaments, beyond one or two rough initials in red. At end, with contractions, in red, "φίλιππος ῥόδιως 'εξέγραψεν χάριν φιλίας τῷ συντελεστῇ τῶν καλῶν θέῷ χάρις." Now in British Museum, Royal MSS. 16, c. xxv.

RIARIO, FRANCESCO-PIETRO. *Patron.* Saec. XVI.

Priest-Cardinal of St. Sixtus.

Nephew of Sixtus IV. (Francesco d' Albescola della Rovere, 1471–1484). In the British Museum is a MS. containing portions of Livy, which was written and illuminated for him. (Burney MSS. 198.) Perhaps also the so-called Florentine Breviary, a Franciscan Service-book of most beautiful execution in the manner of Gherardo, which contains on fol. 127 *v.* the arms of a Cardinal Riario. (Add. MSS., 29,735.) He was born at Savona, in the Genoese territory, in 1446. His mother was sister to Sixtus IV., who, at the time of his birth, was a simple Franciscan friar. At twelve years of age Riario was sent to Siena to his uncle to be educated, and very soon assumed the habit, travelling from city to city in search of learning. Thus he visited Venice, Padua, Bologna, Perugia, and Ferrara. Eventually he became Theological Professor at Venice. At the time of his uncle's attaining the Papacy he was twenty-five years old. He was at once created provincial master of the Roman province, and Bishop of Treviso. In the first promotion of Cardinals held by Sixtus in 1471, Pietro Riario was the first appointed to the dignity, the only other at that time being Giuliano della Rovere, of Savona, another nephew of the Pope. This Giuliano, elected as Priest-Cardinal of San Pietro in Vinculo, afterwards attained the popedom as Julius II. No Pope ever laboured so openly as Sixtus for the aggrandisement of his family and the benefit of all his relations, and no Pope ever succeeded so perfectly. Cardinal Riario rapidly rose from his bishopric to the patriarchate of Constantinople, the Archbishopric of Seville, and that of Florence. Benefices were heaped upon him. In his court and retinue he

speedily showed himself equal to his circumstances. He rivalled
the magnificence of kings in his expenditure, and a few months
saw the Franciscan monk among the most voluptuous princes of
Italy. In 1473 he was legate of Umbria, soon afterwards of all
Italy. The Pope loved his brilliant nephew to excess, and hesi-
tated at nothing to add to his happiness and splendour. The
result was as might be expected. Within three years Pietro
Riario was worn out with his sudden change of life. The thin,
ascetic student had not the constitution to stand the wear and tear
of this life of ceaseless gaiety that was thrust upon him. He died
at Rome in Jan., 1474. It is seen that his opportunities for the
gratification of his literary tastes were unlimited, and, accordingly,
he got together a good number of precious things. For many
years the beautiful Missal preserved at Lyons, and now known to
be the identical Missal executed by Attavante for the Bishop of
Dol, was attributed to Riario's patronage. It is, however, by no
means impossible that the celebrated Astle-Esdaile Missal, so fully
described by Dibdin, and assigned by him to some Cardinal of
the Della Rovere family,—or perhaps a Pope, for it contained the
medallion-portrait of Sixtus IV.,—was in fact executed for Car-
dinal Pietro Riario as a present to Sixtus. The arms of Riario
are " coupé *d'azur* en chef, à la Rose *d'or* en point." Those of
Della Rovere : " *d'argent* au chêne ou *Rouvre* ayant les branches
passés en sautoir au bout de chacun d'un gland *d'or.*"—*Migne :
Dictionnaire des Cardinaux : Encyclop. Théolog.*, xxxi. 1,145.—
Dibdin : Bibliogr. Decameron, I. clxii.–clxiv. *See* LIBRI F. DAI.

RIBERO, DIEGO. *Cosmographer, &c.* Saec. XVI.

Drew, in 1494, a large " Mappa Mundi," now in the Vatican.
Along the upper margin is this inscription : " Carta Universal En
que se contiene todo lo que de mundo se ha descubierto fasta
agora, bizola Diego Ribero cosmographo de su Magestad Año de
1529 ā Sevjlla." It has the usual cartels, and wind lines in red ;
ships, flags, arms, and compass. The arms are those of the family
of Della Rovere; in this case, probably, belonging to Julius II.
This map has been published.

RIBLINGER, ANDREAS. *Copyist.* Saec. xv.
Of Weissemburg.

> Wrote, in 1447, "Ars bene moriendi."—*Braun: Notitia Msstor.*, vi. 104.

RICCIIS, NICOLAUS DE. *Copyist.* Saec. xv.

> Wrote, 1. "M. Tullii Ciceronis de officiis ad Marcum filium, Libr. iii." At end : "Nicolaus de Ricciis scripsit feliciter." Vell. 4º, 108 ff. With illuminated initials to the several books, and a miniature on the first page, with a full border and a figure of Cicero in the initial of the first book. Now in the Laurentian Library.—*Bandini: Catalog.*, &c., iii. (Pl. LXXVI. cod. xv.). 2. "C. Sallustius Crispus de conjuratione Catilinæ et de bello Jugurthino." Vell. 8º, 116 ff. A very fine MS. executed in Italy. With frontispiece and illuminated initials; the text in round or Roman letters. At end : "Nicolaus riccius Spinosus vocatus hunc librū diligentissime scripsit." Formerly in the Biblioth. La Vallière.—*De Bure: Catalogue des Livres de la Biblioth. de feu M. le Duc de la Vallière*, iii. 138, No. 4,885. 3. "Curtii Rufi Historiarum Alexandri Magni, Lib. viii." Now in the Laurentian Library.—*Bandini :* ii. Pl. LXIV. cod. 32. 4. "C. Plinii Veronensis Secundi Hist. Nat., Libri xxxvii." With illuminated initials, Now in Imperial Library, Vienna, No. CCXXXV. At end : "Explicit Plinius secundus, Nicholaus Ricius Spinosus vocatus diligentissime hunc librum scripsit."—*Endlicher : Catal. Codd. MSS. Bibliothecæ Palat. Vindobonensis*, i. 135, 136.

RICEMARCHUS. *Calligrapher.* Saec. xi.
Bishop of St. David's in 1088.

> Wrote a small Latin Psalter on vellum in Hiberno-Saxon minuscule characters with many contractions. The initials are of the pure Celtic kind of knotted-ribbon work, combined with

lacertine forms and terminals of the heads of birds, serpents, or dogs. Each psalm begins with a large ornamental letter two inches high, its outline entirely surrounded with red dots. Red, yellow, and green are the only colours employed. The titles are written on yellow bars or bands, and the interlinear spaces are coloured green. There are no miniatures. The text is not the usual Gallican version common in England during the sixteenth century. At end are some verses by the writer, stating that while he penned the text his brother John designed and executed the illuminations. Dr. Todd and Prof. Westwood both consider the MS. to be of Welsh origin, and to have belonged to the Cathedral of St. David's about the middle of the eleventh century. It is now in the Library of Trinity College, Dublin. — *Westwood : Palæographia Sacra Pictoria.—Idem : in Archæologia Cambrensis. —Idem : Anglo-Saxon and Irish MSS.*, 87.

RICHARD, BERTRAN. *Copyist.* Saec. xv.

The cash accounts of Charles, Duke of Orleans, for the year 1454–55, mention the parchment supplied to B. R. for a book on astronomy, and for a French translation of a book of Petrarch's. In 1457 the same copyist transcribed a number of ballads for the " Duchess." "A Bertran Richart, varlet de chambre de mon dit seigneur le xxiiiie jour du dit mois pour don à lui fait par le dit seigneur, pour sa peine et salaire d'auoir escript ou liure de ma- dame la duchesse aucunes des ballades du liure de mon dit seigneur, xiii s. ix d. t." A similar account exists for 1452.—*Cabinet des MSS.*, i. 113.

RICHARD, GILLES. *Copyist.* Saec. xv.

A native probably of Reims.

Wrote, for Louis the Outlaw, son of Charles I., Duc de Bourbon, in 1470, a " Liure de Vita Christi," by Ludolph of Saxony. Now in the National Library, Paris (MSS. fr., 6,841–3). Also a " Histoire de la Guerre des Juifs de Josephe," translaté par

Guill. Coquillart, in same Library (MSS. fr., 7,015-16). Both these MSS. have beautiful miniatures, borders, and initials, and are in the same style. At end of the former : " Explicit secundum volumen libri de Vita Xri scriptum et finitum per Egidium Richard scriptorem." Paris describes the Josephus as a fine example. Among the great number of miniatures are some really excellent and precious, especially in the first volume. In the first miniature is the translator and his secretary, the former dictating from a book which lies open before him. The composition is of a fine and delicate execution, and contains a portrait of Coquillart. The MS. was executed at Reims, and is exactly similar in style both of writing and miniatures to that of the "Vita Christi." The copyist was the same Gilles Richard, and, if he did not execute the minia- tures, it is most probable that they were executed at Reims. Among the great number of miniatures which crowd the volumes, several, chiefly in the first volume, are especially deserving of notice. They vividly recall the school of Jean Fouquet. Fol. 7, a battle. Fol. 17, Judas Maccabæus, prince of priests. Fol. 21, the Siege of Ptolemais. Fol. 24, erection of Temple of Ozias. Fol. 27, a city in flames. Fol. 53, chariot of the Queen Alexandra. Fol. 55, bed of Queen Alexandra with draperies. Fol. 99, portraits of Marianne and Aristobulus, presented to Antony. Fol. 184, decol- lation of John the Baptist. Fol. 197, coronation of Nero. In Vol. ii. fol. 1, Nero sends Vespasian into Judea (players on instruments). Fol. 136, execution of Matthias, and his three sons.—*Paris : Les MSS. franç., &c.,* ii. 75 ; iii. 381.—*Lacroix. et Fournier ; Hist. de l'Imprimerie,* 55. As to the "Ludolphus de Vita Christi," the MS. referred to is a French translation. The original author, a Carmelite of Strasburg, lived in the early part of the fifteenth century. Wishing to write a series of homilies on the Life of Christ, he took the ordinary Lectionary, and used from it the text of the Gospels as read in the lessons for each day of the Christian year. His work met with universal appro- bation, prevented much bad sermon writing, and formed the common resource of all ordinary preachers. It was twice trans- lated into French during the fifteenth century,—the first time, perhaps, by Jehan Mansel, the well-known author of the " Fleur des Histoires." See a reference to this by Van Praet in the Vallière catalogue. The next was by Guillaume de Menard. Neither of these, however, is the one in question here. Possibly Mansel's share in the work is to be traced to the extracts from it in his great work, which may have given the idea that he had translated the

whole. The remarkable thing about the present MS. is the astonishing brilliancy of the colours, and the careful attempts at perspective. The draperies, &c., are usually heightened with gold. The initials contain five half-lengths of Scripture personages, very well executed. The charm of the book greatly tempts us to dwell upon its miniatures ; we can only dismiss them with the remark that they are among the most beautiful of their kind. The historic interest of the MS. is also considerable. On the page preceding the thirty-second chapter in the third volume is a knight decorated with the cordon of St. Michael, kneeling before a table on which lies a book, and lifting his eyes devoutly towards a beautiful crucifixion painted on the opposite page. The coat of this knight is *armoriated* in the manner of the fourteenth century with azure, sprinkled with golden lilies, and crossed with the red bend or bâton denoting the House of Bourbon. At his feet are laid his gauntlets, and a casque bearing a crest of flames. It is impossible in this exquisitely-painted portrait not to recognise Louis, the famous bâtard de Bourbon, son of Charles I., Duke de Bourbon, afterwards legitimised in 1463. He was Knight of the new order of St. Michael instituted in 1469 by Louis XI., and admiral of France. In 1465 Louis XI. erected the barony of Roussillon into a county as a dowry for his natural daughter, Jeanne de France, the child of Marguerite de Sassenage, on her marriage with the bâtard de Bourbon. Originally the cordon or collar of St. Michael was made of double scallop-shells interwoven in the shape of love-knots of silk-laces with golden tags. Underneath was suspended a small figure of St. Michael on a rock, fighting the Dragon. Francis I. changed the shell love-knots into gold knotted laces called cordelières, in compliment to Anne of Brittany, and to his wife who was her daughter, but more especially to his mother Louise d'Angoulême, as these ladies were lay sisters of the third order of St. Francis, and himself a lay brother. Other alterations have been made from time to time. The MS. executed for Louis de Bourbon dates about 1470. He died in 1487, and was buried in the Church of St. Francis of Valognes, which he had founded. On the cover had been added an escutcheon, "*arg.* au trois fasces de gueule écartelé d'*az.*, à la fasce d'*or:* le tout chargé d'un écusson fascé d'*arg.* et d'*az.* à la bordure de *gu.*" It is supported by two ladies, each of whom carries a motto or device,—one, "La fin fera le compte"; the other, "Changer ne veulx." It is not known to whom these arms and mottoes belong.

RICHE, JACQUES. *Copyist.* **Saec. xv.**

Wrote " Le Mystère de la Passion, par Arnout Gresban." Now
in the National Library, Paris (MS. fr., 7,206). Fol. Vell. 277 ff.,
2 cols. With miniatures, initials, and borders. It was formerly
in the library of Gaston d'Orléans. The penmanship is beautiful.
The miniatures, two inches high, contain good ideas of costume,
At end : " Scriptū anno Dñe M° quinquagesimo septimo die sep-
timo Januarii "; and on last leaf, " Ce present liure appartient
à madame la princesse de Roche-sur-Yon." " Marie de Malingre
fame de noble Hector de . . . a fest feres sete passion."
This princess was Louise de Bourbon, daughter of Guilbert de B.,
Comte de Montpensier, who died 1496. She married first in 1492.
André de Chauvigny, seignr de Château Roux, and second, Louis
de Bourbon, son of Jean, Comte de Vendosme, Prince de la Roche-
sur-Yon, who died about 1520. She survived until 1561. A
second copy (MS. fr., 7,206²) is fol. paper, 236 ff. It contains
one miniature and two initials, fol. 1 and fol. 4. In these
initials are placed the arms of the persons for whom the MS. was
executed : " *d'argent*, au lion de *gu.*, accompagné d'un lambel
d'azur à trois pendants, parti de Savoie." That in the second
initial is supported by two bears, and recalls the name of Louis
de Luxembourg, Comte de St. Pol et de Ligny, who was beheaded
at Paris, in 1475. His second wife was Louise de Savoie, whom
he married in 1466, and who died also in 1475. She was
the fifth daughter of Louis, Duke of Savoy. One difficulty attends
this attribution. The branch of the Counts of St. Pol sprang
directly from those of Ligny, who bore the *lambel azur* over the
lion of Luxembourg, but in adopting these arms the Counts of
St. Pol had dropped the lambel, which is here resumed. The
signature of the second owner, " Philippe de Cleves," occurs at
the foot of the last folio but one. On the next the copyist has added
" Fait escript et accomply par moy Jacques Riche pbře indigne
le lundy xxii. jour de Fevrier lan mil quatre cent soixante et
douze." Paris has a long and interesting article on the literary
contents of the MS.—*Paris : Les MSS. fr., &c.,* vi., 281-311.

RICHENBERGH, JOHANN. *Copyist.* **Saec. XIII.**

Wrote a portion, at least, of a volume of short treatises. At
the end of No. 5 : " Expliciunt libri aphorismor. et prognosticor.

Ypo(cratis) cum commentarius Galeni. Scripti et completi per manus Johannis richenbergh apothecarii, sub annis dni M. cc. tricesimo nono In Vigilia viti martiris. Deo gracias. The MS. has rich golden initials.—*Murr: Memorabilia, &c.,* ii. 92, No. 129.

RICHTER, JOHANNA JULIANA F. *Miniat.* **Saec. XVIII.**
Born at Dresden.

Was employed in portraits at the Court of Poland. Died 1812.
—*Nagler; Künstlerlexicon,* xiii. 139.

RICHTER, SAMUEL CHRISTIAN H. *Miniaturist.*
Saec. XVIII.

Employed at the porcelain works at Meissen, where he died in 1776.—*Nagler: Künstlerlexicon,* xiii. 144.

RICKARDS, SAM. *Miniaturist.* **Saec. XVIII.**
Practised in London, exhibiting at the Royal Academy in 1776, 77.—*Redgrave: Dict., &c.*

RIDINGER, N. *Copyist.* **Saec. XVII.**
A German.
Worked about 1690.—*Zani: Enciclop. Metod.,* xvi. 115.

RIDOLFI, CARDINAL NICOLA. *Patron.* Saec. xv.

A Florentine, and nephew of Leo X.

Made a large collection of Greek MSS. especially, some by transcription, and others by purchase. Many also were given to him by Constantine and Giovanni Lascaris, who collected MSS. for Lorenzo de Medici. Constantine Lascaris, who was Librarian to Lorenzo about 1460, used the mark Λσ, which is found on many MSS. in the National Library, Paris. On the death of Cardinal Ridolfi, in 1550, Piero Strozzi, the French Marshal, who was a passionate lover of books, and who read Greek as well as any man of his time, bought his library, and had it transported into France, where it was most carefully kept until his death. He was killed at the siege of Thionville, and Queen Catherine de Medicis, his nearest relation, thought proper to possess herself of his books. They were said to be part of the spoils of the great Medici collection dispersed in 1494. Catherine's library, after some contention and delay, was acquired, by the exertions of the President De Thou, for the Royal Library, under Henry IV. It consisted of 800 MSS., mostly Greek, rare and ancient. But it was by no means the spoils of the Medici Library, and for the very simple reason that it never was spoiled, but when Piero de' Medici fled from Florence, and the palace was looted of other precious things, the library was put up to auction, and bought *en bloc* for three thousand florins* by the monks of San Marco. When Savonarola fell into disgrace, this library was turned out of its place in the monastery and kept elsewhere, not scattered, as it has been thought, until the return of the Medici, when it was repurchased for, or restored to, Giovanni and Giuliano. In order to provide against any future vicissitude of the family or of popular animosity, it was then permanently lodged with the canons of the Collegiate Church of San Lorenzo, where, after being put in order by Leonardo Bartolini, it still remains. Brantôme gives a lively picture of Strozzi's love of books, and tells us how he acquired his library: "elle estoit venue du cardinal Ridolphe et auprès sa mort acheptée, questoit au très sçavent prelat estimee plus de xv mille escues, pour la rareté des beaux et grands livres qui y estoient. Du despuis la mort du dict maréchal la reine mère la retira avecque promesse den recompenser son filz

* 2652 ducats.—*Müntz, from Piccolomini.*

et la luy payer un jour, mais jamais il nen a eu un seul sol. Je sçay bien ce qu'il m'en a dict d'autres fois en estant fort mal content." Four catalogues of the Ridolfi Library are still in existence all in the Paris Library.—*Delisle : Cabinet des MSS.,* i. 209–212 —*Brantôme : Œuvr.* (ed. Lalanne), ii. 242.—*Müntz : Les Précurseurs de la Renaissance,* 219. — *Piccolomini : Intorno alle condizioni ed alle vicende della Libreria Medicea privata.*

RIEGER, CLARA. *Miniaturist.* Saec. XVIII.

Probably a daughter of the following.

Worked, in 1748, for the Court of Bavaria, at Munich.—*Nagler : Künstlerlexicon,* xiii. 168.

RIEGER, MARIA. *Miniaturist.* Saec. XVII.

Worked, in 1698, at Munich for the Court, chiefly on portraits, Madonnas, and saints.—*Nagler : Künstlerlexicon,* xiii. 168.

RIEGER, THOMAS. *Copyist.* Saec. XV.

Sub-prior at Augsburg.

Wrote in 1495 " Stephani Parisiensis Commentar. Ampliss. in Regulam Scti. Benedicti." With miniatures.—*Braun : Notitia de Codicis Msstis. in Bibl. Monast. ad SS. Udalricum et Afram,* vi. 89.

RIES, JEHAN DU. *Copyist.* Saec. XV.

Of Bruges.

Wrote a number of large and beautiful MSS. for the Duke of Burgundy, Philippe of Cleves, and others. Among them are the following : 1. A " Histoire de la Toison d'Or—Deuxième partie— ou histoire de la Toison de Jason par Guill. fillastre." Vell. Large fol. 415 ff. 2 cols. of 41 lines each, on red lines. Summaries in red. Now in the Royal Library at Copenhagen. The first miniature corresponds exactly with those described by Paris. It represents Charles le Téméraire presiding at a Chapter of the Order. The miniature is surrounded by a rich border, in the midst of which are the arms of Cleves. The MS. bears the usual signature of Philippe of Cleves (*see* CHESNE, J. DU), and at foot of the last folio written in red are the words : "sc. J. Du Ries anno. (1476)" in old Gothic.—*Abrahams: Descriptions des MSS. franç. du Moy. Age de la Biblioth. roy. de Copenhague.* Respecting the author, &c., of this MS. see *Paris: Les MSS. françois de la Bibl. du Roy,* i. 273-6.—*Reiffenberg: Hist. de l'Ordre de la Toison d'Or,* 37, n. 3, and *Le Long: Biblioth. Histor. de la France,* iii. 705. The first two vols. of Guill. Fillastre's work were printed at Paris in 1517 and 1530, and at Troyes in 1530. Du Ries wrote also " Luire de prouffits champestres et ruraulx." Compiled by Pierre de Crescences. Fol. Vellum. Now in British Museum Royal MSS. 14, E. VI. With miniatures, borders, and initials. Written in a large, bold, bâtarde Gothic,—the usual Netherlandish and French hand for this class of work. At end is the signature in monogram : " J. du Ries manu propria." Other MSS. in the British Museum written by him, are: 1. " Histoire Scholastique [the 4th volume] contenant du liure de Thobie jusqua les Faiz des Apostres." Written for Edward IV. " Le quel Luire fut fait a Bruges par le commandement de Roy Edouard IV. lan 1470. Escript par J. du Ries. (Royal MSS. 15, D. 1.) 2. " Des proprietes des choses liures xix. translatez par Jo. Duries lan 1482." (Royal MSS. 15 E. ii., iii.)

RIFINE. *Calligrapher.* Saec. IX.

A Monk of St. Gallen.

Wrote "Sct¹. Athanasii altercatio contra Arium." Now in the Library of St. Gallen.—*Haenel: Catalogi,* 672.

RIGHETTI, DOMENICO. *Miniaturist.* **Saec. xv.**

Employed at Ferrara.—*Cittadella: Notizie relative a Ferrara,* 643.

RIGOT, FRÈRE JEHAN. *Copyist, &c.* **Saec. xv.**

In the National Library, Paris, MS. lat., No. 880, is a Missal in two volumes, formerly in the Colbert Library. It is in folio, written on vellum, and consists of 382 leaves, and, is decorated, not counting the "arabesques, fleurons, and lettrines," with a score or so of miniatures executed with remarkable elegance and delicacy. The charge for it was given in 1489 to a member of the Abbey of St. Peter of Melun, by a rich merchant of the city, to be presented to the Church of St. Aspasius. The MS. bears the date of its execution and the signature of the copyist, who seems also to have been the miniaturist. After a Calendar the Offices begin on fol. xxiii. with a large miniature, representing the glorification of the patron saint of Melun, St. Aspasius, with the Gospels in his hands. On the last page of the MS. is another large miniature containing the Virgin and St. John at the foot of the Cross on each side ; on their knees are the donor, Pierre Malhoste, and his wife and children, three sons and five daughters, whose figures possess the character of veritable portraits. Below are verses beginning :—

Lan quatre cens quatre vings neuf,
Mil deuant fut escript tout neuf.
Ce present messel mot a mot,
De la main frère Jehan Rigot.
Religieux du monastère, &c.

—*Grésy:* in *Archives de l'Art françois, &c.,* ix. 55.

RILINDIS.
REGILINDIS. } *Patroness and Copyist.* **Saec. XII.**

Abbess of St. Odiliens of Hohenburg. A relative of the Emperor, Frederic I., who gave her the title of Princess of the Holy Roman Empire,—a title borne ever afterwards by the Abbesses of Hohenburg. *See* HERRAD VON LANDSPERG.

Ziegelbauer : Hist. litter. Ard. S. Bened., iii. 508.

RINALDI. *See* RAYNALDI.

RINALDI, DON BENEDETTO. *Copyist.* Saec. XV.

Zani calls him Rainaldi, a Minorite, afterwards a Benedictine, and known as Don Benedetto di Matera, which latter statement Milanesi has shown to be an error. His name appears in the Graduals at Siena between 1480 and 1482 as Don Benedetto di Maestro Paolo Rinaldi da Siena, first a Franciscan, then a monk of Monte Cassino, but as Don Benedetto da Matera, and executing most of the miniatures of the Choir-books, he does not exist. The Rinaldi whose name appears in the Antiphonaries was simply a copyist, who worked also in the Choir-books of the Convent of Lecceto now in the public Library, and in those of the Church of Sta. Maria della Spedale, now kept in the Cathedral.—*Milanese : Documenti dell' Arte Senese,* ii. 381.—*Idem : in Vasari : Vite, &c.,* vi. 178 (Lemonnier).

RINALDI, MAESTRO PAOLO. *Copyist or Miniaturist.*

Saec. XV.

Of Siena.

Worked about 1440.—*Zani : Enciclop. Metod.,* xvi. 19.

RINGELSTORFFER, WOLFGANG. *Copyist.* Saec. XVI.

A Schoolmaster (of Munich ?).

Wrote a Prayer-book, in 1580, for Duke William V. of Bavaria. It is referred to in a chronological list of notes and extracts from MS. accounts respecting artists and literary men under Albert V William V., and Maximilian I. He is called " Wolfgang Ringelstorffer der Künstreich schuelmaister, hic für den Gnadigen Herrn Wilhalmben gebethbücher schrieb." From which it would seem that he wrote more than one.—*Westenrieder : Beiträge zur Vaterländische Historie,* iii. 87.

RINIERO, GIOV. DI. *Copyist.* Saec. XIV.

Worked at Rimini about 1350.—*Zani: Enciclop. Metod.*, xvi.
121.

RINIO (NOT RIVIO), BENEDETTO.

Son of Ludovico, Medico of Venice.

Composed a book, "Liber de Simplicibus Benedicti Rinij
medici et philosophi Veneti." This MS., in paper of fifteenth
century, was left by Alberto Rinio to the Library of SS. Giov. e
Paolo in our city. Now in the Library of St. Mark's, Venice.
Cl. xiii. No. X. (287 × 200 centim.). On it Valentinelli gives a
long article, at the end of which the writer speaks of Ruskin,
and his admiration of the work, from which he had several copies
made by Antonio Caldara, of Venice, for the Oxford Museum.—
See *Catalogue of Examples*, 56-58 (Oxford, 1870).—*Valentinelli:
Bibliotheca MSSta. ad S. Marci Venetiarum*, v. 61–67. One who
had seen it says, "in ea liber est herbarius tanta arte ac diligentia
pictas ut natas paginis illis suis herbas non effigiatas credas."
Jacopo Morelli has minutely described the volume, which remains
among the most precious works of its kind for its age, its repro-
ductions of plants, and the marvellous skill with which these herbs
are given in the miniatures. . . . Bened. was assisted by his father,
whom he calls "medico dottissimo," and by Nicolò Roccabonella,
also a physician of Conegliano, and also by Jacopo Rinio, his
eldest son. The excellent miniaturist who made the drawings
was Andrea Amadio, of Venice, as Benedetto affirms in his preface.
—*Cigogna: Inscrizione Veneziani*, ii. 152.—*Morelli: Notizia d'Opere
di Disegno*, 223.—*Morelli: Operette*, iii. 287 (Ven., 1820).

RINUCCINI, NERI (DI FILIPPO DI CINO). *Copyist.*
Saec. XV.

Wrote, in 1492, at Florence, "Josephus de Bello Judaico." Vell.
Fol. With admirable miniatures. It was written for Cardinal
Giovanni de' Medici, afterwards Leo X. On the first two pages
are the arms and devices of Lorenzo de' Medici, and also of Leo X.

Besides the ring with the three plumes, the yoke, and the word Semper, several times repeated, this MS. presents a French device which is less known, and which, like that adopted by Giuliano, the brother of Leo X, has reference to the misfortunes suffered by the family of the Medici and the well-founded hope of seeing them cease. This device consists of a crown formed by two branches of *laurel*, which have lost their leaves, and along which are written in Gothic letters, the words, " Le Temps revient par *le Fust reverdira.*" This sentence also occurs in the Plautus, printed on vellum at Florence in 1514, by the Giunti, being the dedication copy to Lorenzo II. de' Medici (Nephew of Leo X.) in show-case X. in the King's Library, British Museum. The ordinary device of Giuliano de' Medici, Duc de Nemours, is "Glovis," a word which greatly puzzled Bandini, who concluded it must be the name of the miniaturist, and was meant for Clovio! It occurs in its usual triangular shape in one of the cuttings in Add. MS. 21,412, British Museum, and is explained by Giovio to mean *si volg'* reversed, alluding to the happy fact that fortune had *turned herself* round, and better times had come. To describe the richness and beauty of the miniatures in this Josephus would be almost impossible. The numerous figures, the medallions in gold, the flowers, the precious stones scattered in profusion, exhibit a delicacy of design, a richness of colouring, and a preservation quite incomparable. The penmanship, also, is perfectly beautiful. The copying of the MS. was terminated on Saturday, 23rd March, 1492, at the fifteenth hour of the day, *i.e.*, a fortnight before the death of Lorenzo de' Medici, and whilst the illustrious patron of art was already sick unto death. This circumstance explains the device of the leafless laurel, which, in all probability, was added after the copyist had ceased his labours. The present MS. came from the Cibo Library, Rome, the sister of Leo X. having married Francesco Cibo, son or nephew of Pope Innocent VIII. Sold at the Libri Sale in 1862, to Pickering for £200. Libri Sale Catalogue, No. 303.— *Libri: Monuments Inédits, &c.* Pl. xiii., xiv.—*Giovio: Ragiona- mento dell' Imprese Venet.*, 1556, 33.—*Müntz: La Bibl. du Vatic. au XVI^e Siècle*, 54.

RIQUEL, Melchior. *Miniaturist.* Saec. XVII.

Worked about 1603 at Seville.—*Bermudez: Diccionario, &c.*, vi.

RISALITI, FRANCESCO. *Copyist.* Saec. XIV.

Worked at Florence (?) in 1349.—*Zani: Enciclop. Metod.*, xvi. 130.

RISSOLETIS, BAPTISTA DE. *Copyist.* Saec. XVI.

Named in the title page (fol. 2) of a Matricola de la scola del Smo corpo di Jesu Christo, 1582–1774, "scriba domino Marino de Acerbis." Fol. Vell. 37 ff. With ten vacant ff. at end. Fol. 1 *v.* has a picture of the kind usually found in Ducali, apparently of Venetian execution. The Doge and six other persons kneel round an altar on which stands a golden chalice, while above, in the clouds and radiance, is a figure of Christ ascending. Within a chiaroscuro gold frame shaded with brown rococo scroll moulding and rosettes. Now in British Museum, Add. MSS., 15,817.

RIVALLE,} MATTHIAS. *Copyist.* Saec. XVI.
RIVAU, }

A cleric of the diocese of Poitiers, but who resided in Rue Neuve de Notre Dame, Paris.

Wrote, in 1364, " Hist. Universelle en deux parties jusq'a la mort de Jules Cesar." Now in the National Library, Paris (MS. fr., 6,890). Fol. Vel., 2 cols. With miniatures, borders, and initials. From the Library of the earlier Dukes of Bourbon. On the first fly-leaf are arms of these princes surmounted with the ducal coronet, and beneath the " fair device," *Espérance Bourbon.* At end : " Ce livre de Genèse de Suetonne et de Josephe et autres histoires qui y sont contenues est a monseigneur le duc Pierre deuxièsme de ce nom, duc de Bourbonnois, et d'Auvergne, comte de Clermont en Beauvoisis, des Fourests, de la Marche et de Gien, vicomte de Carlat et de Murat, seigneur de Beaujeuloys de Bourbon Lanceys et de Nonnay, per et chamberier de France, lieutenant et gouver-

neur de Languedoc." Signé *Robertet.* Jean Robertet was private
secretary to the Duke de Bourbon and protégé of the celebrated
Anne de Beaujeu. It is a fine volume, but not so fine as No. 1,740
(*see* i., 76). The explicit gives the name of the copyist and the
date. "Hic liber fuit scriptus per Mathiam Rivalli clericum
pictavensis diocesis, a festo scti Remigii quod fuit anno dni
Mccclxiiii. usq. ad pascha inde sequens et infra. In civitate sub
vico novo beatæ Mariæ Parisiis." The Poitevin Mathias de Rivau
dwelling in the Rue Neuve de Notre Dame at Paris, was certainly
"one of the best scribes of the fourteenth century."—*Paris :
Les MSS. français, &c.,* ii. 259.

RIVER, PETRUS. *Copyist.*		Saec. xiv.
Of Munich, in Bavaria.

Vell. 308 ff. Epistolae Senecæ, &c. Expletum est opus in
civitate Januensi subanno Domi 1403 . . . per manus Petri River
de Bavaria civitatis Monacensis. (Turin, Cod., cmxvii., b. i. 5).—
Pasini, ii. 287.

RIVERON, JEHAN. *Copyist.*		Saec. xv.
Of Tours.

Wrote, in 1497, a Book of Hours for Queen Anne de Bretagne,
of which the miniatures were executed by Jehan Bourdichon, and
the borders of flowers, insects, &c., by Jehan Poyet, "enlumineur
et historieur." It is one of the fifteen volumes forming the private
collection of the Queen. M. de Laborde has cited a document
dated 3rd Sept., 1497, "xiv. liv. t. a Jehan Riveron escripvain
demourant a Tours pour avoir escript a la main unes petites heures
que la dicte dame a faict faire a lusaige de Romme et pour avoir
fourny le velin." This is followed by another payment of 153 liv.
3s. 4d. to Jehan Poyet. M. Delisle thinks De Laborde to be
mistaken in attributing this document to the famous MS. known
as the "Hours of Anne de Bretagne," as this MS. is not in any
sense "unes petites Heures."—*Delisle : Cabinet des MSS.,* iii. 347.
But see the question discussed under POYET.

RIVIERE, DIDIER DE LA. *Illuminator.*

Saec. xv. et xvi.

Born about 1460 at Langres, in Champagne. Went to Bruges in 1475, and joined the Gild of St. Luke and St. John in 1477. He died between 1509 and 1514 (Registre de la Chambre Echevinale, 1514–15, fol. 9 *v.*—Archives de la Ville de Bruges).—*Beffroi:* i. 281 ; ii. 301.

RIVO, ANTHON DE. *Copyist.* **Saec. xv.**

Wrote a French translation of the New Testament in eight books, viz., the four Gospels, the Epistles of St. Paul, the Acts, Canonical Epistles and Apocalypse. Each book is preceded by a miniature, surrounded by a full border. Three other pages have brackets. Initials in gold on coloured grounds. Transcribed for " Madalene, princesse de Vienne, fille et seur de roys de France " (f. 438). She was daughter of Charles VII. and sister of Louis XI., of France, In 1462* she married Gaston de Foix, Prince of Viane, who died in 1470. (*See* VIANA.) She survived until 1486. Her arms, which are repeated in the borders, are : Quarterly, 1, *gu.* a double orle, saltire, and cross, formed of a chain attached to an annulet in centre point *or*, for Navarre. 2. *Or*, 3 pallets *gu.* for Foix. 3. *Or*, two cows passant *gu.* for Bearn. 4. *Arg.* 3 fleurs-de-lis and a bend compony *arg.* and *gu.* for Evreux. On an inescutcheon *or*, 2 lions pass. *gu.* for Bigorre. The whole *parti* with arms of France. Now in Fitzwilliam Museum, Cambridge, 6 E. 2.—*Searle: Catalogue of Illuminated MSS. in Fitzwilliam Museum*, 73.

ROBBIA, PIETRO DELLA. *Miniaturist.* **Saec. xv.**

Worked at Milan about 1450.—*Zani: Enciclop. Metod.*, xvi. 142.

* 1461, " L'Art de Vérif. les Dates," xl. 450 (1818).

ROBERT. *Copyist.* **Saec. xiv.**

Of Dijon.

Wrote, in 1347, an Antiphonary, for which the following quittance
was given. "Maistre Robert scriptor divionensis, y demeurant
confesse que pour 6 liv. monnoye courant maintenant, desquels il
a *chu e recehu* de M. Briese 70s. et 50s. a la nativité St. J. B.
(Jean Baptiste), y cellui Robert doibt faire entierement *hun
antiffoney* auquel il faut environ dix quirs et plux, si plux il falloit
tant d'escripture et enluminure et *relorliure* comme de autres
chouses quelles quelles soient ; liquel doibt estre enlumine dazur
et de vermoillon, et les grosses lettres florelees, et lequel il doibt
rendre par fait deans la nativite St. J. B. prochain." Protocol de
Dominique curtiler sous le Duc Eudes iv. I cannot trace this in
Marchal.

ROBERT. *Copyist.* **Saec. xiv.**

Worked about 1374 for the Duke of Burgundy. Wrote an
Antiphonary now in the Royal Library at Brussels.—*Peignot :
Catal. d'une partie, &c.,* 23.

ROBERT, NICOLAS. *Illuminator.* **Saec. xv.**

A Frenchman.

Painter to the Duke of Savoy (Philibert I.), from 1473 to 1477.
"Probably he was [merely] a miniature painter or illuminator of
books."—*Lanzi : Storia Pittorica della Italia,* v. 299 (4th ed. 1882).
Bohn's English Translations, iii. 292.

ROBERT, NICOLAS. *Miniaturist.* **Saec. xvii.**

Born at Orleans, 1610.

Excelled in insects, animals, and flowers. He was employed
by Gaston, Duke of Orleans, to make a collection of drawings of
the most curious birds and plants in the Jardin des Plantes at

Paris ; and in other important commissions. But the most famous
of his undertakings was painting the flowers for the " Guirlande
de Julie," at the instance of M. Charles de Sainte Maure, Baron,
afterwards Marquis and Duc de Montausier. Sainte Maure had
been brought up as a soldier and had served with some dis-
tinction. For about ten years he had paid his addresses to the
beautiful and *spirituelle* Julie Lucine d'Angennes, daughter of the
Marquis de Rambouillet, when in 1640 it was suggested to him
to form the collection of poesies and flower-paintings, which has
since become historic. Some such idea had probably been floating
vaguely in his mind for some time, for the baron if not brilliant
was solid and sincere, and had urged his suit with persistent and
business-like patience, while on the other hand Mdlle. de Ram-
bouillet was highly-cultured and full of gaiety, and delighted to
meet his cumbrous and stately courtship with banter and procras-
tination. However, he held on until the suggestion of the happy
thought—not altogether original—of composing a set of madrigals,
each in praise of some flower, but all in some way conveying
delicate flattery of the lady in whose honour they were composed,
compelled her, if only out of politeness, to yield to his suit. As a
frontispiece to the volume, which was entrusted for transcription
to the celebrated Jarry, the flowers were wrought into a lovely
garland, in the painting of which Robert put forth all his powers.

The verses were written by various members of the best French
society of the time—all well-known frequenters of the Hôtel de
Rambouillet, and devoted admirers of the illustrious Marquise
and her accomplished daughter; and eventually the really charming
volume was presented to the cautious beauty in 1641 as a New
Year's gift. On this occasion she was thirty-three years old. She
was married in 1645—the dread of giving herself a master having
kept her lover at her feet for fourteen years. In 1664 Louis XIV.
made her husband a duke and a peer of France. About the
same time or a little earlier she herself was appointed first maid
of honour to the Queen in the place of the Duchesse de Noailles,
and governess to the Royal children. She lived to be sixty-four
years of age, and died at Paris in 1671. Jarry and another writer
made at least two other copies of the MS., but, except in one case,
without any miniatures. The copies still exist, and are now in the
National Library, Paris, Nos. 19,142 and 19,145. Within the
garland of the frontispiece of the present MS. are the words, in
fine capitals : " La . Guirlande . de . Julie .," and then on every
succeeding leaf to the number of twenty-nine, is painted a

flower. Next follow the madrigals, making in all ninety-five folios, besides fly-leaves. On the whole the number of madrigals is sixty-one. The best, perhaps, is that on the violet by Desmarets :—

> " Franche d'ambition, je me cache sous l'herbe :
> Modeste en ma couleur, modeste en ma séjour,
> Mais si sur vostre front je me puis voir un jour
> La plus humble des fleurs sera la plus superbe."

The volume ends with an alphabetical index to the poesies. From the hands of the Duchesse de Montausier the MS. at length found its way into the vast collection of the Duc de la Vallière. For a brief summary of its changes of ownership, see JARRY. It has several times been minutely described, and recent researches have added many particulars concerning the history of its composition and the authorship of the madrigals.—*Rive : Notices historiques et critiques de deux MSS., &c.,* 1–4 (and notes).— *Uzanne : La Guirlande de Julie.—D'Estrées : Nouvelles Recherches sur la Guirlande de Julie,* in *Le Livre,* 1884, No. 57.—*Nouvelle Biogr. Générale,* xxxvi. 126.

ROBERTUS. *Copyist.* Saec. XII.

Wrote "Petri Comestoris Hist. Scolastica." At end, "Hunc librum sc'psit Rob fili⁹ Rad descipťs, 7 (et) sc'ptor ultim⁹ Magr̃i Robti boñi de Bedeford' quoʒ anime 9socient, &c., &c., Amen." Then, over the leaf (fol. 196 *v.*), "Scriptus est liber ste anno tertio coronationis Regis Ricardi,* quem sc'bere fecit. C. de Chanuill. bonę. memorię abbissa beatę marię de Helenestow. in eruditionē 7 pfect'um 9uentus sue 7 cet'oʒ in spicientium, &c., Amen." Now in British Museum, Royal MSS. 7 F. iii.

ROBERTUS. *Copyist.* Saec. XV.
Fourth Prior of Bridlington.

Copied verses which occur in a collection of astrological treatises in the British Museum. An immensely thick fol. Vell. 291 ff.,

* *I.e.,* Richard I., therefore 1192.

2 cols. The volume is illuminated with initials and borders, and at the beginning has a number of extremely rude drawings of mythological and astrological figures. Many of the flourished initials are curious for the pen-drawn faces beside them. The gold, however, is very brilliant and skilful, and the initials often very peculiar in shape, *e.g.*, ff. 110, 111, 222 *v.*, &c. Arundel MSS., 66.

Roche, Laurent de la. *Copyist.* Saec. XIV.

Wrote "Exposition des Euangiles de toute lannee." Also "Lucidaire," " L'Evangile de Nicodeme," " La Vengeance de la M. de Jesu Christ," "Legende de Barlaam et de Josaphat." Contained in one volume. Large fol. Vell. 117 ff., 2 cols. With miniatures, borders, and initials. Now in the National Library, Paris (MS. fr., 6,847). It is a beautiful MS. obtained by Louis XII. in Italy, where it had formed part of the old library of the Visconti at Pavia. At end is the memorandum " de Pavye, au Roy Loys XII." The name of the original owner has been effaced. On the first fly-leaf are the words : "Iste liber est . . ." (rest erased), and on the last " Celui qui cest livre escrit. De la Roche Laurent. Benoit soit de par Jhû Christ. Prouoir estoit de Saint Jache. De son proprie nom Laurenz de la Roche Mesire " (erased). " Le fist seruir et compiler. Or prions donc Diu vrais que nostre terre tegne en pes." This Laurent was a good copyist, his writing the usual Italian Gothic of the period. The miniatures are numerous and deserving of particular attention. Their colouring is skilful, and the draperies preserve the striking tradition of the processes handed down from antique art. Fol. 160 is an especial example, showing the expression of sorrow of the Apostles on their separation from their Divine Master. The dialect of the rubrics is that of Sicily, a kind of Franco-Italian, but the text itself is in Parisian French. At the end of a long account of the MS. Paris adds the following interesting note : " I have vainly endeavoured to restore the effaced writings containing the indication of the original possessor of the MS. But later, in examining a note in front of another MS. (7,364), containing the words : 'Iste liber est illustris dñe Blanche de Sabaudia Donatus prefate dñe per d. comitem Virtutem,' it was easy for me

to recognise the great similarity of the writing in the two inscriptions. Here, then, are recovered the names erased from this MS. The first must have been Galeazzo Visconti of Milan, who, in 1350, married Blanche, daughter of Aimon, Count of Savoy, who died 1343. This illustrious founder of the ancient Library of the Visconti at Pavia died in 1378, and his son, Giovanni Galeazzo, Count of Vertus, succeeded him. It was he who presented to his mother, Blanche, many of the precious MSS. collected by his father. But as Blanche died at Pavia in 1386, her movables again become the property of the Duke of Milan, and here we see how Louis XII. was able to find again at Pavia the MS. now before us."—*Paris : Les MSS. françois, &c.,* ii. 97-109. These MSS. are not in the " Consignatio Librorum " printed by Count D'Adda.

RODRIGUEZ, JUSEPE. *Copyist and Illuminator.*

Saec. XVI.

A native of the town of Osma.

Employed by Philip II. on the Choir-books of San Lorenzo of the Escorial. He went to share in the writings more especially, but the king, having seen his work in illumination, added that also to the agreement with him. He was previously engaged in similar work on the Choir-books of the Cathedral of Burgos, but in Nov., 1577, the king wrote to Cardinal Pacheco, the Archbishop, to set him at liberty for the Royal Commission at the Escorial. He completed this work early in 1585 ; for an instrument dated 15 March of that year orders payment to be made to him of all that was owing to him. He received fifty ducats and returned home.—*Bermudez : Diccionario, &c.,* iv. 217.

ROEGNY, JACQUES DE. *Copyist and Miniaturist.*

Saec. XIV.

Wrote " La Cité de Dieu," in the translation of Raoul de Presles, and put in the miniatures. Now in the Public Library at Amiens.—*Garnier : Catalogue, &c.,* 171.

ROFFET, ESTIENNE. *Miniaturist.* **Saec. XVI.**

Entitled " Peintre-Enlumineur" to Francis I. in 1538.

He is also called Le Faulcheur, and bound and gilded several books for the Library at Fontainebleau. In 1540 a work was printed by Jean de Gagny, entitled "Briefve et Fructueux exposition sur les Epistres Saint Paul aux Romains et Hebreux, par Primasius, imprimé en 1540 à Paris pour Estienne Roffet dict le Faulcheur, libraire et relieur ordinaire du Roy demourant sus le pont sainct Michel à l'enseigne de la Rose." Roffet appears to have been the binder of the volumes for Francis I., with the crowned F cypher, the arms of France, and the special emblems of Francis I., such as the salamander and the motto "Nutrio et extinguo." If dolphins are added they denote the property of the dauphin. Roffet also bound the beautiful Decameron, translated in 1545 by Anthoine de Maçon, now in the National Library. He was not a printer.—*Delisle: Le Cabinet des MSS.*, i. 182.—*Fournier: l'Art de la Reliure en France aux derniers Siècles*, 68.

ROGERUS. *Calligrapher.* **Saec. XIII.**

Wrote "Missale beatorum apostolorum Jacobi Iohannis et Thomæ." Sm. fol. Vell. Signed with the writer's name in capitals of alternate red and black, "Rogerus me fecit." In two cols. Written in a large firm hand, with many splendid initials, enriched with graceful foliages and burnished gold. The MS. formerly belonged to the Abbey of Vauclerc, and is now in the Public Library of Laon, No. 228.—*Fleury: Les MSS. à Miniatures de la Bibl. de Laon, &c.*, ii. 17.

ROHAN, ANNE, DUCHESSE DE. *Patroness.* **Saec. XVII.**

Anne Chabot, second wife of François, Duc de Rohan, and Prince de Soubise, Governor of Champagne in 1691.

At the sale of the Dent Collection at Evans's in 1827, occurred a remarkably beautiful MS. called " Les Sept Pseaumes de la

Penitence : Fait à l'Hostel Royal des Invalides, 1691, par R.D.L.J.P." Vellum. With eight highly finished miniatures the size of the page, and each page of text ornamented with a rich border of gold. At the top of each page, where a Psalm commences, is a lovely miniature ; thus, besides the frontispiece, representing the Magdalene, there are (1) The Penitence of David, (2) St. John Baptist, (3) St. Peter, (4) St. Jerome, (5) St. James the Hermit, (6) St. Augustine, (7) St. Francis of Assisi. Also many splendidly illuminated initial letters. Bound in green velvet and in a green morocco case. Such is the description of the volume. It was bought by Payne and Foss from the Comte D'Antraigues, the unfortunate nobleman who was assassinated by his servant. The Count informed Mr. Payne that it was executed for the Duchesse de la Vallière, and that the character of the Magdalene—taken from the celebrated painting by Le Brun, which was formerly in the Palace of Versailles, but is now in the Louvre, was chosen to represent herself. The Duchesse was originally maid of honour to Henrietta, Duchess of Orleans, daughter of Charles I. of England, She afterwards became mistress of Louis XIV., and retained his affections for many years. When supplanted by Madame de Montespan she retired to the Convent of the Carmelites, assuming the religious habit and title of " La Sœur de la Miséricorde." She wrote a Treatise on the Mercy of God, and prays our Saviour to consider her as the Magdalene of the Gospel. The treatise was published in 1680, and may perhaps account for her being represented as in the MS. But it was undoubtedly executed for Anne Chabot, Princess of Soubise, whose arms are richly emblasoned at the commencement of the volume. She is there addressed by the writer as "Votre Altesse," a distinction to which she was entitled as " Princesse de Soubise," but which could not have been applied to the Duchesse de la Vallière. The Princess was " Dame du Palais" to the Queen until the death of the latter in 1683.—*Sale Catalogue of the Dent Library at Evans's*, 1827, 81, No. 1,317. Who was R.D.L.J.P.?

ROHAN, MARGUERITE DE. *Patroness.* Saec. XV.

In 1449 Marguerite, daughter of Alan, ninth Comte de Rohan, became the wife of Jean, Comte d'Angoulême, brother of Charles

d'Orléans, the poet, and son of Louis, Duc d'Orléans, and Valentina of Milan (*see* ORLEANS, TREVOUX, &c.). For her was executed " Le Miroir du Monde,"—a résumé of Ancient History to the Birth of Christ, being probably an abridgment of Mansel's " Fleur des Histoires " (MS. fr., No. 7,133, National Library, Paris). It is a very handsome MS. On the lower border of the frontispiece are the arms of Orleans, *parti* with Rohan, borne by her husband ; viz., *de France, au lambel d'argent, à trois pendants chargés d'un croissant de gueules,* for Orleans ; and *de gueules, à neuf mascles d'or,* for Rohan.

The mottoes of the Rohans were : 1. *A plus.* 2. *Roi ne puis, prince ne daigne, Rohan suis.*

This Miroir or summary of Ancient History is, in its way, a rather amusing book. On fol. 8 we are told how that dances were invented by the devil on the occasion of the honours rendered by Ninus to the memory of Belus. " Le deable (voulut) que hommes et femmes jeunes et jolis, princent l'ung lautre par les mains, et eussent jolis chapeaulx es testes, et entour lymage fessent une manière de sercle ronde en tournoiant a senestre, et en saillant et treppant (tripudiantes—tripping) et en regardant lun lautre chantassent et louassent lymage."—*Paris : Les MSS., &c.,* v. 316. (*See* ORLEANS.)

In a beautiful copy of " La Somme des Vices et des Vertus," also in the National Library (MS. fr., 7,292 $\frac{3.3}{4}$.), translated by frère Laurent, and transcribed in 1464 by Jean Hubert, contains a curious miniature, in which appears a lady of the Rohan family. Before a pietà are kneeling three ladies. The first is Isabella of Scotland, daughter of James I., and wife of Francis I., Duke of Brittany, for whom the MS. was written, wearing a robe *partie* Scotland and Brittany. On her left is St. Francis of Assisi. Then a young lady in a robe *partie* Brittany double. This is the eldest daughter of the dowager duchess of Brittany, married in 1455 to her cousin Francis II., Duke of Brittany. On her left is a sainted abbot, possibly St. Benedict. Then another young lady whose robe is *partie* Brittany and Rohan. This is Marie de Bretagne, second daughter of Countess Isabella, who in 1464 had become the wife of Jean II., Viscount de Rohan. On her left is the figure of Mary Magdalene.

Isabella died in 1494.—*Paris : Les MSS. &c.,* vii., 342,343.

The " Heures de Marguerite de Rohan " were exhibited by M. Didot in the Paris Exhibition of 1867. Her son Charles, also a patron of copyists and authors, became the husband of

Louise de Savoie, sister of the Filiberte de Savoie who was married to Giuliano de Medici. Francis, the son of Charles and Louise, obtained the French crown as Francis I.—*De Limiers: Hist. Généalogique de France*, ii. 106.—*Paris: Les MSS. françois, &c.*, iv. 101.—*Delisle: Cabinet des MSS.*, i. 150.

ROLAND. *Copyist.* Saec. XII.

A Monk of Moissac, a Cluniac abbey in Languedoc.

Wrote a copy of the Ecclesiastical History of Eusebius, now MSS. lat., 5,078, National Library, Paris. On fol. 157 are a number of verses, among which are found the following:—

" Preces ergo nunc rogito . Fundere stude Domino
 O bone lector premia . Suo ut donet famulo
 Rotlannus nempe nuncupator," &c.

The Abbey of Moissac is the subject of a learned study by Marion, in " Biblioth. de l'École des Chartes," 3 sér., i. 89.— *Delisle: Cabinet des MSS.*, i. 519.

ROLAND, JEAN. *Copyist.* Saec. XV.

Named in the Gild-rolls of Bruges.—*Weale's Beffroi*, iv. 117, 310, 320.

ROMA, GUGLIELMO DA. *Copyist.* Saec. XV.

Named among copyists employed at Ferrara.—*Cittadella: Notizie relative a Ferrara.*

ROMANO, GUGLIELMO. *Copyist.* Saec. xv.

Named under 1457 in a document citing "Scripture fatte per mano di Mr. Gujelmo romano."—*Cittadella: Notizie*, 10.

ROOST, M. *Copyist.* Saec. xv.

Named in the Gild-rolls of Bruges.—*Weale: Beffroi*, iv. 284, 333.

ROOVERE, JEAN DE. *Illuminator.* Saec. xvi.

" Enlumineur" of Brussels, and Clerk of the Oratory of Catherine of Austria, Queen of Portugal.

He painted for Marguerite of Austria, in 1526-7, three large miniatures, for which he was paid 9 livres of 40 gros each. (Registre, 1802, de la Chambre de Comptes aux Archives du Royaume.) The account seems to have been paid at Malines in 1527.—*Pinchart: Archives des Arts, Sciences, &c., Documents Inédits*, i., sér. i.

ROOVERE, JEROME DE. *Copyist.* Saec. xvi.

Perhaps a younger brother of Jean.

Qualified as clerk. In May, 1539, Philippe de Croy, Duc D'Arschot, paid him 11 livres 3 sous for the transcription of certain documents, and in 1541 he received 8 liv. for copying another concerning the territory of Lillers for the late Seigneur de Chimay. —*Pinchart: Archives des Arts, &c., Docum. Inédits*, ii. 26.

ROSA, GIOV. BATTISTA DE. *Miniaturist and Illuminator.*

Saec. XVI. et XVII.

Executed at Naples, between 1595 and 1606, various miniatures, borders and initials, in a series of enormous Choir-books. The miniatures on the whole are inferior to the ornaments, which show considerable power of design and ability in curve-drawing, added to artistic arrangements of colour. In one of the volumes, however, occurs a large initial " L " to the Service for the Feast of St. Laurentius, containing a figure of the saint, which is masterly in pose and expression, and skilful in manipulation. Though not a miniaturist of the highest class, Rosa claims a good place among those of his own time. A St. Mary Magdalene at the Sepulchre also shows considerable skill in figure drawing. Both these miniatures are signed, the former having along its left margin the inscription : " Miniato per Mano di Giov. Battista de Rosa Neapolitano nel anno 1606 "; and the latter having on the side of the tomb the words, " Rosa fecit." Originally, there were at least ten of these Choir-books, and some years ago they were kept in the Sacristy of San Domenico Maggiore in Naples. Two or three are now in possession of the Marquess of Lorne. The rest are in various hands. In one of them, which seems to be one of the latest, is this note : "Hunc libru3 una cu3 ceteris, Illm9 et Excelm9 D. Fabritius Pignatellus noťe Princeps grandi pecunia sed maiori pietate in Beata3 Virgine3 Sanitas cura et diligentia R. P. F. Dñici Guglielmini Neapolitani Opera vero ac labore Fris Joañis Bali Neapni. F. M. M. Dc. iiij." The title-page and other parts of the volume, are badly mutilated, but sufficient remains to attest the skill both of the penman and the artist. Another volume, beginning with Easter Day, contains at end the following : " Opus inceptum et absolutum auspiciis et liberalitate Illumi. Viri Fabritii Pignatelli Cerchiarij Domini ob Eximiam ejusdem in beatam Virginem e Sanitate Pietatem Gubernante locum R. P. F. Dnico Guglielmino Neapno. characteribus ornauit Fr. Joannes Ball9 Neap9, 1596." The names both of Ballus and Rosa are now, I believe, for the first time placed in the list of copyists and miniaturists, although a hearsay kind of reference seems to be made by De' Dominici to Rosa under the name of Rossi. But he had evidently never seen any of the MSS. painted by Rosa, though existing in Naples when he wrote his " Lives." Rossi is also referred to by Nagler, from Dominici.—*Nagler : Künstlerlexicon,* xiii. 433. *See* PIGNATELLI.

ROSASSETHO, MICH. DE.　*Copyist.*　　Saec. XV.

Wrote "Commentarius in Avicennam de Febribus." Paper, 88 ff. Now in the Imperial Library at Vienna. Cod. DXLV. R.V. 25. At end : "Ego Michael de Clara de Rosassetho hoc opus finivi die xiii. Julii hora xvii. cum dimidia currente anno MCCCCLXVII et tunc temporis illustrisimus princeps Dux Galeaz litem habebat cum Bartholomeo Caglione."—*Denis : Catal., &c.,* 123.

ROSE, JEHAN DE LA.　　*Copyist.*　　Saec. XIV.

Given under 1388 in *Laborde : Ducs de Bourg.,* i. Pt. ii. 528.

In 1398, "Gillet Daunai escripvain à Dijon est paye par le D. de escripture de xiij. quayers et demy du grand volume de la Bible que feu maistre Jehan de la Rose jadis escripvain avait commencié pour l'eglise des Chartreux, lesqueles quayers le prieur des chartreux a reçus. Scauoir iij. qu. et demi de l'accomplissement de Jérémie et tout ce liure de Jezrechiel qui contient ix. qu. et ung qu. du livre d'Ozée le prophète, au prix de 34s. 4d. (= 19fr· 8oc.) per quayer d'escripture."—*Peignot : Catal. d'une partie* . . . *&c.,* 26, 27.

ROSE, SUSAN PENELOPE.　*Miniaturist.*　　Saec. XVII.

A daughter of Richard Gibson, and wife of a jeweller.

She painted portraits in water-colours. In her husband's sale in 1723 was a half-length miniature of an ambassador from Morocco, 8 in. by 6 in., painted by her in 1682. Walpole possesses a portrait by her of Bishop Burnet in his robes as Chancellor of the Garter. She died in 1700, aged forty-eight, and was buried in St. Paul's, Covent Garden.—*Walpole : Anecdotes of Painting, &c.,* ii 238. (Wornum.)

ROSEGLI,⎱
ROSELLI,⎰ FRANCESCO. *Miniaturist.* Saec. XV.

Of Florence, son of Lorenzo Roselli, a master-mason,
and elder brother of the famous painter, Cosimo.

Was the pupil and companion of Liberale, of Verona, but
superior to his master in correctness of design, in expression, and
in the pose of his figures, though beneath him in vividness of
colouring, as he is also in decision of touch and rich play of fancy.
They worked together on the Choir-books of Siena, hence it is
easy to compare their work. In the Fourth Gradual (1 c.), from
Septuagesima Sunday to the third Quadragesima Sunday, are
seven miniatures, six said to be by Liberale, and one, the fourth, by
Roselli. It occurs in the "M" of *Misereri omnium Domine*
which begins the service for Ash Wednesday; and represents the
interior of a church—a priest standing on the step of the altar
places ashes on the head of a worshipper. Some idea of it may
be formed from a poor adaptation in Curmer's "Evangiles, &c.," 77.
The border, and perhaps the initial itself, is by Liberale. In the
Nineteenth Gradual (24 H.), from the seventeenth to the twenty-
third Sunday after Pentecost, are four miniatures by Roselli,
together with others by Pellegrino di Mariano and Liberale. We
learn from documents discovered by Milanesi, the payments for
these miniatures. In 1470, when that noted in Gradual IV. was
executed, he assisted in the production of others not specified.—
"1470. 22 marzo (n.s. 1471) Liberale da Verona—e die auere
adi 22 marzo lire centocinquanta, sol. 10 e' quali sonno pella sua
parte di lire 237 lire di 17 mini a facti in su uno volume delli
Antifonarj, insieme con Francesco di Lorenzo da Firenze; cioè
minii 1 grande per lire 31 minii sei mezzani, stimati lire 15 l' uno,
e minii 10 fioriti senza storie, per lire 10 l' uno, e lettere 26
picholine per sol. 10 l' una, e lire 85 sol. 10 sonno posti a Francesco
detto." Accordingly Francesco's account immediately follows,
same year and day:—"Le Antifanari—dieno dare adi 22 Marzo,
1470, lire ottantacinque sol. 10 sonno per la sua rata di minii 17;
cioè 7 colle storie, e 10 fioriti, e di lettere 26 piccholine."—*Archivio
dell' Opera del Duomo di Siena: Libro Nuovo Rosso*, 192. Milanesi
further finds that Francesco had previously received, in 1470, 38
lire, 15 soldi for his share of five large miniatures executed by
himself and Liberale, for which the latter received an equal sum.
Also 60 lire for three miniatures, one large and two small, in an

Antiphonary; and 62 lire for three others—one large at 31 l. and the others for 31 l. the two. It seems, from an examination of the miniatures thus charged, as if the initials themselves and the borders were mostly the work of Liberale, while the stories were put in by Roselli.—*Vasari: Vite, &c.,* v. 27-34, vi. (*Nuove Indagini*) 179, 180, 214, 221, 346.—*Milanesi: Documenti per la Storia dell' Arte Senese,* ii. 382, 384, 387. *See* LIBERALE.

ROSENBACH, JOANNES. *Copyist.* Saec. xv.

A Dominican Friar of Nuremberg.

Wrote, in 1441, "Liber de Gestis et Miraculis b¹ Henrici Imperatoris et confʳⁱˢ." Now in the Public Library at Nuremberg. At end: "Explicit hoc opus Frater Joannes Rosenbach, Ordinis Prædicator, conv., Norimb., ipsum ingrossando rubris signando, laboravit," with the date 1441.—*Breitkopf: über den Ursprung der Spielkarten, &c.,* ii. 31. *Jansen: Essai sur l'Origine de la Gravure,* ii. 26. *Cahier: Bibliothèques,* 140.

ROSENBEYN, LEONARDUS. *Copyist.* Saec. xiv. et xv.

Wrote, in 1399, "Sancti Augustini de libero arbitrio, libri iii.," &c. Vell. Fol. At end: "Explicit Liber Beati Augustini Episcopi di Doctrina Christiana. Scriptus per me Leonardum Rosenbeyn de Basilea de Allamania. Mccclxxxxviiij. die xviij. Decembris." —*Morelli: Bibliotheca Maphei Pinellii, Veneti, &c.,* iii. 349, No. 7,901.

ROSENDORN, ⎱ FRIEDRICH. *Copyist.* Saec. xvi.
RONDORN, ⎰

Wrote, in 1507, a Choir-book called "Das Gänsebuch." Signature, "iste liber . . . quem scripsit Fridericus." *See* also ELSSNER, JACOB, Illuminator. Now in the Public Library at Nuremberg. —*Rettberg: Nürnberge Briefe,* 178.

ROSENDORP, FRIDERIC. *Copyist.* **Saec. XVI.**

Vicar of St. Laurence, Nuremberg.

> Wrote, in 1507–10, a Choir-book in two volumes. Fol.—*Murr:*
> *Beschreibung von Nürnberg*, 132, 133.

ROSINI, PADRE ABBATE DON PIETRO. *Miniaturist.*

Saec. XVIII.

Born of noble parents at Lendinara, Rovigo, and an
Olivetan Monk.

> Worked about 1762.—*Zani: Enciclop. Metod.*, xvi. 203.

ROSSI, ANTONIO DE'. *Miniaturist.* **Saec. XV.**

Son or pupil of Giovanni de' Rossi, of Florence.
Died in 1495.

> *Marchese: Memorie, &c.*, i. 180.

ROSSI, FRANCO, }
RUSSI, FRANCHO, } DE'. *Miniaturist.* **Saec. XV.**

Son of Giovanni de' Russi, Mantua.

> Employed, in 1455, at Ferrara, together with Taddeo Crivelli
> in illuminating the famous Este Bible, in two volumes, which is
> still in the Estense Library. It is executed on vellum : "de' quali
> non va [vi ha] pagina alcuna che non sia messa a vaghissime
> miniature tutte l'una dall' altra diverse, e fregiate con gran copia
> d'oro, e con disegno più vago assai del comune a quei tempi."
> Written for Marquess (afterwards Duke) Borso d'Este, and cost
> a sum equivalent to 1,375 zecchini of modern money. The
> Bible was placed in the MS. room provided by the munifi-
> cence of Prince Francesco IV.—*Tiraboschi: Storia della Litter.*

Italiana, vi. 218.—*Campori : Cenni Storici Estensi*, viii.—*Citta-della : Notizie relative a Ferrara*, 641. *Idem : Documenti ed illus-trazioni, &c.*, 175.—*Marchesi : Memorie, &c.*, i. 174, n. 2.—*Codd. : Memorie Biografiche dei Pittori Mantovani*, 136. *See* CRIVELLI, ESTE, MARONI, &c.

ROSSIGNOL, L. *Miniaturist.* Saec. XVII. et XVIII.
A Frenchman. Born 1644, died 1739.
> *Zani : Enciclop. Metod.*, xvi. 221.

ROSSINI, PELLEGRINO DI MARIANO. *Painter and Illumi-nator.*

 Saec. XV.
Of Siena. Scholar of Ansano di Pietro.

Appears to have worked chiefly, though not entirely, on the ornaments and borders of several of the Cathedral and other Choir-books, from 1468 to 1492, when he died. He is mentioned by Della Valle when speaking of the expense of the Choir-books of the Spedale della Scala, which in 1820 were added to those in the Cathedral. Several miniatures appearing in the Lecceto Anti-fonaries are by his hand, and many others in the Choral-books of the Cathedral of Pienza. Milanesi describes his work in those of Siena : Graduale XXIV. (H.) From the seventeenth Sunday after Pentecost to the twenty-third contains twelve miniatures, of which four were executed by Pellegrino : 1. Third miniature, Christ on a journey met by a choir of angels with musical instruments, in initial " L " of *Lætatur cor querentium Dominum, &c.* The angel figures gracefully drawn and draperies good. Sixth miniature, Christ above, people kneeling below in "S" of *Salus populi ego sum, &c.* Seventh miniature, Christ in Capernaum—a king kneeling

before him, in the background with a bed on which lies a young man, in the "O" of *Omnia quæ fecisti nobis Domine*. Eighth miniature, a saint kneeling before the Almighty in the " I " of *In voluntate tua Domine*. 2. In the eleventh Antiphonary (25). From the Vigil of St. Andrew to the Feast of St. Luke, contains two miniatures, both by Pellegrino. First miniature, the calling of St. Andrew and Peter to the apostolate, in the "D" of *Dum perambularet Dominus*. This "D" is a very handsome letter, though the figures are badly proportioned. A border round the margin containing the arms of the Opera and of the Rector Aringhieri; in one circlet a couchant gazelle, in another an eagle pouncing on a gazelle. Second miniature, St. Ansano, a figure on foot with palm and standard within the " A " of *Ansanus Rome Tranquilini genitus*. In the sixteenth Antiphonary (7 B.). From the Vigil of the Nativity to the Octave of the same. With six miniatures, five of them by Pellegrino. Second, the adoration of the Shepherds, in the "T" of *Tecum principium in die virtutis tuo*. Third miniature, the martyrdom of St. Stephen, in the "S" of *Stephanus autem plenus gratia et fortitudine*. Fourth miniature, St. John seated in isle of Patmos, in " V " of *Valde honorandus est Beatus Johannes*. Fifth miniature, the Slaughter of the Innocents, in the " C " of *Centum quadraginta quatuor milia*, &c. Sixth miniature, St. John preaching, points to Christ, in the " E " of *Ecce Agnus Dei*. In the eighteenth Antiphonary (XXII.D). From the second Sunday after the Epiphany to the fifth, with two miniatures. First miniature, Christ seated as Judge with the Madonna on one hand and St. John on the other, kneeling. Beneath are hell and purgatory in the "D" of *Domine ne in furore tuo arguas me*. Second miniature, a Saint kneeling receives the heavenly benediction in "D" of *Deus in te speravi*. In the twenty-third Antiphonary (XI. I.). From Easter Sunday to the fifth Sunday after. With one miniature. The Maries at the Sepulchre whereon sits an Angel, in the "A" of *Angelus Domini descendit de cœlo*, &c. In the surrounding border are several circlets containing the arms of the Opera and of the Aringhieri. Among other examples of the work of this artist, kept in the same library, are those which are laid out on the desks, and which need not here be further specified than by mention of their locality. They occur in the Gradual (I.), fol. 103 ; in the Gradual (Y.), fol. 1, 8, 16, 25, 33, 47, and 54 ; and in Gradual (Z.), fol. 1, 13, 34, 41, 63, 72, 79, 86, and 94. On the latter page, in red capitals, " ISTE LIBER SCRIPSIT FRATER BENEDICTUS DE SENIS ORDINIS MINORUM,

TEMPORE DOMINI NICHOLAI DE RICOVERIS RECTORIS DIVI HOS-
PITALIS SENENSIS SANCTE MARIE DE SCALA SUB ANNO DOMINI.
MCCCC.LXXIIII." It may be added that Milanesi has explored the
archives for records of payments which confirm the above attri-
butions, and which with their respective dates may be found in his
" Nuove Indagini," &c., referred to below. The rate of payment
received by Pellegrino may be gathered from one of the accounts.
" 1471, 6, Maggio Maestro Pellegrino di Mariano dipintore die
avere adi vi. maggio lire trentaquattro, sol. dodici, sonno per
cinque minii a fatti in li Antifanari : cioè uno grande con fighure
ii. et iiii. mezzani fioriti per lire 5 l'uno, et per la dipintura d'una
tenda e armario per la sagrestia per detti Antifanari." Sept. 13,
1481, he received 20 sols for the miniatures of the Office of the
Virgin, viz., a St. Sebastian, St. Sigisimundo, and a Madonna. He
died in 1492, and left a son, Girolamo, who became a goldsmith,
and a pupil much inferior to himself, viz., the " rozzissimo "
Bernardo Cignoni.—*Della Valle : Lettere Sanesi*, ii. 248, &c.—
Milanesi, in *Vasari : Vite, &c.*, vi. 179, 184, 221, 237, 344, &c.
Also *Documenti per la Storia dell' arte Senese*, ii. 381, 387.

RÖSSLER. *Miniaturist.* Saec. XVIII.

Worked at Vienna about 1755.—*Nagler : Künstlerlexicon*, xiii
303.

ROSSO, DE PIEROZZO. *Copyist.* Saec. XV.

Wrote the "Monarchia" of Dante. At end : "Finita la
Monarchia di Dante Alighieri Poeta Fiorentino e scritta per me
Pierozzo di Domen⁰ di Jacopo de Rosso, e finita questo di xviii. di
Giugno. MCCCCLXI. Now in Riccardi Library, Florence. Pl. O.
II., 1.—*Lamius : Catal., &c.*, 21.

RöSZER, NICOLAUS. *Copyist.* Saec. xv.

Wrote Antonius de Butrio in Decretales libr. v. In two large folio vols. Paper, ff. 315, 356. Ordinary secretary hand. At end of vol. 1 : " Explicit lectura, &c. Nicolaus Röszer de Wormacia me scripsit deo concedente. mit willen." At end of second vol. : " Explicit lectura super quinto decretaliun ꝓ egregiū et excellentissi-muȝ utrusqȝ iuris doctorem virū venerabilem dmn. Anthoniū debutrio finita ꝓ nicolaum Röszer de Wormacia anno dñi 1423 xix. die mēsis Februarij." Now in British Museum.—Ar. 455, 456.

ROTH VON ROTHENFELS, JOH. GOTTFRIED. *Miniaturist.*
Of Cremnitz. Saec. XVII.

Worked at Vienna under Mytens, about 1730, and was very famous.—*Nagler : Künstlerlexicon*, xiii. 466.

ROUGEUL, PIERRE. *Copyist.* Saec. xv.
See LAVAL, JEANNE DE.

ROULIN, R. *Copyist.* Saec. xv.

Wrote " Boccace, Cas des nobles malheureux " for Jeanne de Bourbon, bâtarde de France, wife of Louis de Bourbon. *See* RICHARD, G.

2 A

Rous, John. *Miniaturist.* Saec. xv.

The Hermit of Guy's Cliff, near Warwick.

Among the Norfolk MSS. in the Heralds' College, is a long roll
about nine inches wide, in which are delineated the whole series
of the Earls of Warwick, with their arms emblazoned, down to
Richard Beauchamp. A similar roll was in the possession of the
late Earl of Sandwich. These and the drawings of a MS. in the
British Museum (Cotton, Jul. E. 4), a Life of Richard Beauchamp,
are attributed to him.—*Walpole: Anecdotes of Painting, &c.*, i. 56
(Wornum).

Roussée, Jacques. *Copyist.* Saec. xvi.

Employed, in 1525, on the MSS. of the Collegiate Church of
St. Pierre, at Lille.—*Bulletin du Bouquiniste* (Paris, April 15,
1858).

Rousselet, Jean Pierre. *Calligrapher and Miniaturist.*
Saec. xvii. et xviii.

A fine writer, whose penmanship is not inferior to that of Jarry.

In the Public Library at Dresden is a MS. entitled "Prières de
la Messe," written by Rousselet at Paris in the early part of the
eighteenth century. Every page is beautifully adorned with
borders in bright colours and gold, and with initials on handsome
gold panels. Besides the richly-decorated title-page is a full-page
miniature of Christ on the Mount of Olives, and three pretty
little vignette-miniatures of other scenes.—*Ebert: Geschichte und
Beschreibung der Königl. öffentl. Bibl. zu Dresden*, 310. Rousselet
executed also, perhaps somewhat earlier, another "Prières de la
Messe," in Roman letters, with beautiful miniatures, borders, and
tail-pieces. Sm. 4°. It was sold in the Gaignat sale for 75 liv. 1*s.*—
Catal. des Livres du Cabinet de feu M. Louis Jean Gaignat, i. 58,

No. 203. Of the same date, apparently, is another, described in Spanish as " Orasiones para la Missa, escritos por Rousselet, a Paris." Paper. 8°. Containing two large miniatures : Jesus Christ in the Garden of Gethsemane, and the Crucifixion, with golden initials. Sold in the collection of the Duc de St. Aignan in 1776. —*Dict. Bibliographique*, ii. 516. Also (if not the same as the preceding) " Prières de la Messe." Paper. 8°. A very handsome MS. with a remarkably finely-written text and richly-coloured miniatures. Not signed. It was exhibited in 1880 in the Exposition Nationale at Brussels, and was then the property of M. Ad. Rouvez, of Mons.—*Catal. de l'Exposition Nationale de Bruxelles,* 1880 ; *Manuscrits,* 25, No. 153. In the same Exhibition was also another of Rousselet's MSS. : " Preces Missæ." Vell. 4°. Written and painted by him in 1723. The penmanship is quite equal to that of Jarry. The binding has clasps of gold, encrusted with eighty-eight diamonds. Two years after its execution it belonged to Prince Windischgratz, and, it is said, was presented by him to pious Queen Marie Leczinska on her marriage to Louis XV. In 1880 it was the property of M. J. Gielen, of Maeseyck, Limburg. *Ibid.,* 25, No. 152.

ROUSSON. *Miniaturist and Cartographer.* **Saec.** XVII.

Executed three charts in a portolano, once in the Pinelli Library. On one : " Faict a Toullon par Rousson, 1645."— *Morelli : La Libreria. . . . Pinelli, &c.,* No. 3,908, v. 102.

ROUX, GUILL. LE. *Copyist.* **Saec.** XVI.

One of the able copyists employed in 1502–3 by Georges d'Amboise.

His principal work was a " Titus Livius richement enluminé et hystorié." His coadjutors were Pierre Boyvin and Michel le Roux. He copied also, in 1508, the " Mer des Histoires," assisted by the sons of Raoulet Breton and Michel le Roux.—*Deville : Comptes de la Construction du Château de Gaillon,* 437, 438, 440. *Delisle : Cabinet des MSS., &c.,* i. 249.

Roux, Jehan le. *Copyist.* Saec. xiv.
 Given under 1377 in *Laborde: Ducs de Bourgogne*, i., pt. ii. 528.

Roux, Michel le. *Copyist.*
 See Roux, Guill. le.

Rovere, Francesco della. *Patron.* Saec. xv.
 Cardinal of Teano, afterwards Sixtus IV. *See* Riario,
 and Teano.

Rovere, Francesco Maria I. della. *See* Urbino,
 Dukes of.

Rovere, Giuliano della. *Patron.* Saec. xv.
 Cardinal of Teano, afterwards Julius II. *See* Teano.
 About forty MSS. bearing the Della Rovere arms are in the
 Royal Library at Turin.—*Pasini*, ii. 24, &c. *See* Polani and
 Tianus.

Rovere, Guidobaldo I. della. }
Rovere, Guidobaldo II. della. } *See* Urbino, Dukes of.

RUANO, FERDINANDO. *Copyist and Calligrapher.*

Saec. XVI.

A professional calligrapher.

Employed in the Apostolic Chamber under Leo X. 1545, 24 January : " Ferdinando Ruano uni ex scriptoribus bibliothece apostolice, ducatos auri de Camera, quattuor, de paulis X. pro ducato, pro ejus presentis mensis ordinaria provisione (M. 1545–6 A. fol. 14 *v.*)." In the Vatican Library, MS. lat., No. 3,750, is a copy of Vegio on the Vatican Basilica, written by Ruano in 1543, with this note : " Ferdinandus Ruano C. Pacen. Bibliothecæ Apostolicæ scriptor, scribebat Romæ Anno dñi. MDXLIII."—*Forcella: Catalogo de' Manoscritti relativi alla Storia di Roma* (Roma, 1879), i. 30.— *Müntz : La Biblioth. du Vatican au xvi*e *Siècle,* 97. He also wrote "Sette alfabeti di varie lettere formate con ragion geo- metrica. In Roma per Valerio Dorico et Luigi fratelli Bresani nel MDLIIII. 4°.—*Bibliofilo,* 1884, 123.

RUARUS. *Miniaturist.* Saec. XVI. (?)

A famous miniaturist. Of uncertain date, probably the sixteenth century.

Nagler : Künstlerlexicon, xiii. 511. I think the name a mistake for RUANO.

RUATHELMUS. *Calligrapher.* Saec. IX.

Quoted for the peculiar term applied to the penwork :

" Scribam queris, qui me penna *coloraret,*
Ruathelmus devotus Otgarii fieri iussit."

Wattenbach: Das Schriftwesen des Mittelalters, 219. *Dummler: Forschungen,* vi. 119.

RUBCICII, ⎱
RUBEICH, ⎰ STANISLAUS. *Illuminator, &c.* Saec. XVI.

King-at-arms and herald-painter to Stephen Nemagnich, Emperor of Servia.

There is some little uncertainty whether this be intended for Stephen Dushan, the famous Tsar of the Serbs and Greeks, 1336–1356, but this seems most probable. Rubeich (or Rubcich as the MS. seems to prefer) executed a collection of insignia of the Emperor and the principal magnates of Servia in the fourteenth century, and the MS. was entrusted to the care of the "Igoumenos" or Prior of one of the Greek monasteries of Mount Athos, from which a copy was taken by some illiterate Dalmatian or Italian in the sixteenth century. The copy has the following title: "Libellus Sanctorum Patronorum et Publicorum Insigniorum Regnorum et Familiarum Illustrium Illyrici Imperij quæ Magna cura singularique Diligentia collegit atque depinxit Stanislaus Rubeich Rex Insigniorum Domini Imperatoris Stephani Stephanij Nemagnich. In Laudem Cæsariæ ac Regiæ Majestatis et Reliquorum Principum, Ducum, Marchionum, Comitum, Vice-comitum, Equitum et Nobilium, totius Illyriæ, sub quorum protectione, Fundamenta, munimentaque ejusdem Illyrici Imperij consistunt qui quidem. Translatus est ex antiquissimo Libro in charactere Illirico scripto, Reperto in Bibliothe*ta* Monasterij de monte Sancto ordinis Divi Basilij." The MS. is executed on paper. Fol. 164 ff., with 7 fly-leaves at end of beautiful thick white modern paper. After the title are 2 ff. of contents, in 2 cols. Then the index repeated in Serbian, but arranged alphabetically. Then a title and note in Illyrian, or a mixed Serbian dialect, with many misspellings and mistaken characters, to the same effect as the Latin one. Fol. 7. A gaudily-painted rococo cartouche frame, as if for another title, with a vacant space at top for insignia. It merely contains a note in old Serbian capitals by the Father Igoumenos, who has charge of the books presented to his monastery, probably intending to say who presented the MS. and when, but the latter part is omitted, and the space left. Fol. 8. A full-length portrait of a cardinal with patriarchal crosier and scarlet banner on which are emblazoned a crescent surmounted by a star in silver. Behind him crouches a lion, and beneath, the arms of a cardinal, *arg. :* a lion rampant *gu.* cr. *or*, and beneath, the words : "Patron*us* Speculum atque lux totius Illiriæ." It

looks as if intended for St. Jerome. Fol. 9. Another picture, very elaborately painted, of a deacon (St. Stephen?) presenting a standard or banner to the kneeling Emperor. Beneath: Patronus atque Duc Regni Illiriæ." Fol. 10. A complete emblazonment in metals and colours of the insignia,—arms, crests, and heraldic draperies, &c., of the Tsar of Servia, "Imperatoris Stephani Stephanij Nemagnich. Insignia." This forms a splendid page. The title is placed in a painted and gilt cartouche and the painting is neat and effective. Then follow the various "Regnorum et Familiarum insignia," referred to in the title-page. Inserted before the title is a page of the imperial insignia, apparently copied from the *present MS.* by another hand, and on the back of it a long Latin note mentioning how the MS. was shown to the writer by the "Most Noble Lord Frederic Henry Baron of Boit Selvar, Lord in Langevak and Schoot, enrolled in the Equestrian Order of Holland," to whom it belonged and who showed it to him. The writer then goes on to inquire who the Stephen Nemagnich was, but fails to make out. He rightly conjectures the collar of the order surrounding the imperial shield on fol. 10, to be that of St. Stephen, not, of course, the more recent order instituted by the first Grand Duke of Florence in 1561, but a more ancient order scarcely known in Western Europe. The MS. was in the Meermann Collection, whose catalogue speaks of it most inaccurately as written in Latin and Russian and having a title-page written in letters of gold. It is at present in possession of Mr. Quaritch, of Piccadilly. *Bibliotheca Meermanniana*, iv. 140, *No.* 812.—*Quaritch: General Catalogue*, 1534, *No.* 15,268. The Serbian portion explained in letter from *Mr. Morfill, Oxford.*

RUBEUS, BALDASALIS. *Copyist.* Saec. XV.
Of Genoa.

Wrote "Pomponius Mela de Cosmographia," &c. Vellum. 4°. 77 ff. In ordinary French secretary hand. A few rough initials in blue and red. On fol. 76 *v.*: "Julii Solini de situ orbis terrarum liber felicitẹ explicit manu mei Baldasalis Rubei ciuis Jañ(uensis) Dum sēm i rure castellito Ali monte sano dct̃o ppe Januã sub an ccccxvj° die penultia octobẹ hora vj noctẹ." Now in the British Museum, Add. MSS., 17,409.

RUDGER. *Copyist.* Saec. XIV.
Prior of Kaiserheim.

Under the year 1313, in an old book of historical extracts in
the Cistercian monastery of Kaiserheim, is this note: "Zu diser
zeit was prior zu Kais'heim bruder Rutger, und was ain guter
stulschreiber da. Rudolph Veirabend von Augsburg, der schrib
vil bücher. item in disem jar was ain guter stulschreiber zu
Kais'heim, Wernher von Eichstett, der schrieb auch vil bücher,
und Peter von Ulm der illuminierets, bruder Hainrich apotecker
band sy ain."—*Rockinger*, in *Quellen und Erörterungen zur Bayer-
ischen Geschichte*, ix. 841.—*Wattenbach: Das Schriftwesen im
Mittelalter*, 406.

RUE PIERRE DE LA. *Miniaturist.* Saec. XVI.

Executed, in 1519–20, two miniatures in the " Missale Bava-
ricum" at Wolfenbüttel, viz., the second, magnificently painted with
seventeen coats of arms in the borders on each side, and St.
George; the seventh, the Requiem with border containing a
" Todtentanz." *See* PRES.

RUINETTI, TOMMASO. *Calligrapher.* Saec. XVII.

Composed a series of inscriptions as examples of ornamental
penmanship, with borders and other embellishments. Published
at Rome in 1618, 4º, or rather oblong folio, consisting of plates
numbered 1–43. Plate 1 is the portrait of the calligrapher,
"Thomas Ruinettus Ravennas, MDCXVIII. ætatis suæ xxii."
Plate 2 is the long privilege granted by Paul V., with " Nicolaus
Borbonius sculpsit " in the corner. Plate 3 is the escutcheon and
hat of Cardinal Aldobrandini. Plate 4 is the Dedication to the
Cardinal by Ruinetti. Plate 5 is a Dedication to the Abbate
D Hippolito Aldobrandini. Plate 6 consists of four superscrip-
tions of letters addressed to various persons by way of supple
mentary dedication. Plate 7 is "ai Leggitori." Plate 8 begins
the alphabet. A copy of this work is at present in possession
of Mr. Quaritch.—*Quaritch : Rough List*, June, 1888, 67.

RUOTPERTUS. *Copyist.* Saec. XI.

A Monk of Epternach.

Wrote for Abbot Regimbert (1051–1081). MS. lat., 9,568, National Library, Paris.—*Delisle: Cabinet des MSS.*, ii. 362. Also a Bible, now in the Library at Gotha.—*Jacobs und Ukert: Beiträge zur ältester Litterat.*, ii. 12. *See* RAVENGERO.

RURAY, PETRUS. *Copyist.* Saec. xv.

Wrote "Lucani Pharsalia," lib. x. Large 4°. Paper. 102 ff. In thick half-Gothic, with contractions. Several very rough initials at beginning. No other ornaments. At end: "Explicit liber lucani Deo grās. Amen. Miłło quadrigētesimo quadragesimo sexto die decimo secūdo mensis settēbris In portimaonis. Ego petrus" (erased), "ruray nobilis civis studens in iur' ci'sub. famosissimo doctore dño Francisco de *capi listis*, (?) i. 1449." scripsit petr⁹ dictus cognomīe ruraŷ." Now in British Museum, Arundel MSS., 113.

RUREMOND, LEONARD DE'. *Copyist.* Saec. xv.

Monk of St. Martin's at Cologne.

Cahier: Bibliothèques, 140.—*Reiffenberg*, in *Biblioph. Belge*, vi. 332.

RUSSI, FRANCESCO DE'. *Miniaturist.* Saec. xv.

One of the artists of the Este Bible. *See* CRIVELLI, TADDEO.

Cittadella: Documenti, &c., 175.

RUSSI, GIOV. DA. *Miniaturist.* Saec. XV.

Employed at the Court of Ferrara from 1445 to 1455.—*Nagler :
Künstlerlexicon*, xiv. 82.—*Cittadella : Notizie, &c.*

RUSSO, GIACOMO. *Illuminator, &c.* Saec. XVI.
Of Messina.

Designed twelve maps and painted them elegantly. In the
fourth map is incribed : " Jacobus Russo me fecit in illa nobili
civitate Messana anno Dñi 1521 die primo aprilis," and in the
last, which contains the islands of the Indian Ocean, is the anno-
tation : " In questa ysola son quatro reg. quali sunno ydolatri
imacomentani e gentili, fasse de gran trafico de mercantia. dicta
ysola chamano Somatra e dicano che sia l'isola taprobana." Now
in the Este Library, at Modena. Cat. No. DL. (550).—*Cenni
Stor., &c., Estense*, 57. Also a Portolano of the Mediterranean,
with arms, figures of personages, banners, windlines, &c. At top :
" Jacobus Russo me fecit in nobili civitate messanæ anno dñi.
1528. Amē." Now exhibited in the Birmingham Museum of
Art. No. 36.

RÜTTELL, ANTHONIUS. *Copyist.* Saec. XV.

Wrote " Belial. Das Puch daz da betracht ob Ihs Marien sun
daz recht hab behabt da er die hell un die tiefel hat beraubt an
dem tag da er für alle menschen die mart'gelitte' hat." Sm. fol.
Paper. 70 ff. In neat old-German hand, with thirty-five large
and spirited drawings, coloured and illuminated. The copyist is
thus referred to : "Anthonius Rüttell de Pairmenchingn hoc
scripsit domino suo Gabriele Müller hoc tempore scriptor suus,
1450." The book is an extraordinary religious romance, com-
posed towards the end of the fourteenth century in Latin, and
translated afterwards into most of the European languages. In

design and execution the pictures recall some of the best produc-
tions of Wohlgemuth, who was, however, yet too young to have
executed them. Being signed and dated, they form a valuable
contribution to the art-history of the early Suabian School.—
Quaritch : Rough List, No. 88, 651.

RYE, MARGRIETE VAN. *Illuminator*. Saec. XVI.

Assisted her aunt, Marg. Bruunruwe (*see*), in the illumination
of certain Choir-books in 1512, and other works in conjunction
with Cornelie van Wulfskerke.—*Le Beffroi*, iii. 323.

SABULO, FLORENT DE. *Illuminator*. Saec. XIV.

Was a copyist and illuminator at Avignon in 1365.—*Archives de
l'Art français*, vii. 181.

SACCHA, GIOV. LODOV. DE. *Copyist*. Saec. XV.

Worked at Perugia about 1470.—*Zani : Enciclop. Metod.*, xvi.
308.

SAILLANT, PÈRE JEAN. *Copyist*. Saec. XVII.

An Augustinian monk.

Worked about 1620–35.—*Zani : Enciclop. Metod.*, xvi. 319.

Saint Cecilia, Johannes de. *Copyist.* Saec. (?)

A Monk of St. Catherine's of Pisa.

"Scribebat egregie."—*Archivio Storico Italiano, &c.*, vi. (II.), 535.

Saint Leger, Colart de. *Copyist and Illuminator.*

Saec. XVI.

Employed from 1512 to 1518 on the MSS. of the Collegiate Church of St. Pierre, at Lille.—*Bulletin du Bouquiniste* (Paris, April 15, 1858).

Saint Lo, Nicole de. *Copyist.* Saec. XVI.

One of the copyists of the Great Breviary, executed in 1501–3 for Cardinal Georges d'Amboise.

"Le ix^e de Juillet [1501] à Messire Nicolle de St. Lo, pour l'escripture de v cayers du bréviaire de mon dit seign^r iiii." The others were Pierre de la Poterne, Pierre le Boucher, and Pierre Pemetot.—*Deville : Comptes de la Construction du Château de Gaillon*, 437–442.—*Delisle : Cabinet des MSS.*, i. 248, 249. *See* Serpin.

Saint Omer, Henri de. *Copyist, &c.* Saec. XIV.

In conjunction with Guillaume de Saint-Quentin, executed, in 1322, the "Ceremoniale Blandiniense" now in the University Library at Ghent. Vell. 4°. With miniatures. Formerly belonged to the Abbey of St. Pierre at Ghent.—*Catal. de l'Exposition à Bruxelles*, 1880, *Manuscrits, No.* 41.

SALAVARTE, PEDRO. *Illuminator.* **Saec. XVI.**

Employed on the Escorial Choir-books.—*Riaño : Notes on Early Spanish Music,* 137. *See* PALENCIA.

SALAZAR, AMBROSIO DE. *Illuminator.* **Saec. XVI.**

Worked with Fray Andres de Leon, Fray Julian de la Fuente de el Saz, and others, on the Choir-books of San Lorenzo. *See* LEON, &c. Later he undertook important work at Toledo, the chapter of the cathedral charging him in 1590 with the decoration of a pair of Missals which had been commenced by Juan Martinez de los Corrales. Salazar worked on the remaining volumes until 1604, when he died. He is worthy of notice for the correctness of his drawing and the beauty and clearness of his colouring. Also for his excellent taste in ornament.—*Sigüenza : Descripcion del Monasterio di San Lorenzo (del Escorial).—Archivo de la Catedral de Toledo.—Bermudez : Diccionario, &c.,* iv. 303.— *Serapeum* (1850) 353.—*Riaño: Notes on Early Spanish Music,* 137. *See* SALAZAR, JUAN.

SALAZAR, ESTÉBAN DE. *Illuminator.* **Saec. XVI.**

Employed in 1585 on the Choir-books of San Lorenzo of the Escorial, under Philip II.—*Bermudez : Diccionario, &c.,* iv. 303.

SALAZAR, JUAN. *Illuminator.* **Saec. XVI.**

Employed on the Escorial Choir-books.—*Riaño : Notes on Early Spanish Music,* 137. *See* PALENCIA.—*Bermudez : Diccionario, &c.,* iv. 303.

SALAZAR, MANUEL. *Copyist.* Saec. XVIII.

A copyist of Choir-books, about 1775.

The scribe who wrote the Choir-books at the Cathedral of Toledo. He also indexed several ancient musical MSS. *Riaño : Notes on Early Spanish Music,* 24, 29.

SALLANDO, PIERANTONIO. *Copyist.* Saec. XV.

Of Reggio, near Modena.

Wrote and perhaps illuminated,—1. "Censorini Liber de die natali"; 2. "Apicii Cœlii Epimeles de re coquinaria, lib. x."— *Morellii : Bibliothecæ S. Marci, Gr. et Lat.* The first is very neatly written and has splendid initials. It is in the Library of St. Mark's at Venice. Of the second the first page is finely illuminated, and contains among the ornaments the arms of Mino Roscio of Bologna. At end : "Scriptum per me Petrum Antonium Salandum Regiensem die vigesimo septimo Maii, MCCCCLXXXX." Concerning Roscio, Barth. Blanchinius (Bianchini) in his "Vita Antonii Codri Urcei," says : "Minium Roscium celebratis monumentis a Beroaldo laudatum." Morelli (i. 325) says it is the MS. seen by Tiraboschi in possession of Bianchini at Bologna. There is no general title, but the work begins, as is often the case, with that of the first book : A. PICII CELII EPI MELES INCIPIT LIBER PRIMUS. Fol. 1 has a full border, the sides of which consist of columns supporting trophies of culinary utensils. Arms in the lower border. To each section is an illuminated initial, to which is attached a jewelled ornament in the margin with hatched shading in colour. The MS. is now in the Bodley Library, Oxford (*MS. Canon. Classic. Lat.,* 168). The style of ornament recalls that of the beautiful Josephus in the British Museum. (Harl. MS. 3,699).

SALOMO. *Calligrapher.* Saec. X.

A Monk of St. Gallen, afterwards Bishop of Constance.

"Erat scribendi lingua manuque artifex. Lineandi et capitulares literas rite creandi præ omnibus gnarus," &c.—*Eckart : De fatis S. Galli, apud Pertz, Monument. German.,* ii. 92.

SALOMON, BERNARD. *Book Illustrator.* Saec. XVI.

Born at Lyons about 1520, and died there about 1570.

He is called "Le Petit Bernard," and was one of the most skil-
ful of the numerous artists who adorned the many charming
volumes which issued from the Lyons, Paris, and Antwerp
presses during the latter part of the sixteenth century.
Among these he produced a "Bible Figurée," and a beautiful
little book in 18° of 100 ff., every page of which was
adorned with an elegant border and an exquisite little
woodcut. It was called the "Metamorphoses d'Ovide, figurées,"
published by J. de Tournes, the Lyons printer, in 1557,
1558. The borders of these pages are often strongly suggestive
of metal or niello work. Beneath each woodcut is an octave
of verses, in Dutch, descriptive of the scene. He also illustrated
"Le Livre des Hymnes du temps et de ses parties," printed at
Lyons about 1560. In this volume the subjects are contained in
ovals surrounded by square passe-partout frames, enriched with
ornament ; there is another edition of the work bearing date
1680. Also a set of nineteen plates, "Livre des termes," printed at
Lyons in 1572. A book containing many borders engraved on
wood is kept at the National Library, Paris (E.d. 7).—*Guilmard :
Les Maîtres Ornementistes, &c.* 20, pl. 7. The Lyons school, of
which Salomon is one of the ablest representatives, at this
time seems to have been quite independent, and not a
mere offshoot of that of Paris or Tours, much less of
Antwerp. Salomon's style is born of the French Renaissance,
and is almost entirely his own ; other draughtsmen not
quite falling into his vein, either in decoration or figures.
The illustrations to various editions of Sambucus, published
by Plantin at Antwerp, said to be in his manner, are not
by himself. But he and his imitators gave a great impulse to
the ornamentation of books. "We have him to thank," says
Butsch, "for the thousands of tasteful ornamental letters, breath-
ing high French elegance, the entourages, vignettes, and suchlike
ornaments:"—*Ruelins und Baeker : Annales Plantiniennes.* —
Butsch : Die Bücher-ornamentik der Renaissance, pt. ii. 14. Pl. 25,
26, 28, 31-33.—*L'Art pour Tous,* 4ᵉ-7ᵉ années, 115, 434, 518,
794.—*Zani : Encicloped. Metodica,* xvi. 337.

SALTO, FRA DIEGO DEL. *Illuminator.* Saec. XVI.

A Spanish Augustinian Monk.

Worked about 1575.—*Zani: Enciclop. Metod.*, xvi. 339.

SALVIATIS, CAMBIUS DE. *Copyist.* Saec. XV.

Wrote, in 1423, the Commentary on Dante by Benvenuto da Imola. On paper. 2 vols. sm. fol. 2 cols. Vol. i. 197 ff., contains cantiche 1 and 2. Vol. ii., 148 ff., the third. Illuminated initials to each cantica and canto. At end : "Explicit xxxiij. et ultim. caῆlus paradisi Scriptus et 9pilatus per me Cambium de Salviatis die xiiij mensis Ju. . . . Mccccxxiij laus Deo. Amen. Liber Cambii de Salviatis." Now in the Barberini Library, Rome, No. 2,193.—*Batines: Biblioth. Dantesca*, ii. 308.

SALVINO, SEBAST. *Copyist.* Saec. XV.

Wrote a collection of the "Opera Varia" of Marsilio Ficino, the Platonist. Fourteen treatises. Vell. 4°. 268 ff. The title-page is singularly splendid. It consists of ten golden circlets, enriched with foliages, forming an annular title disk, on which, in gold letters, the contents of the volume are inscribed. Each circlet contains a miniature of the emblems or arms of the Medici family. There is also a richly-ornamented initial to the text. At the end of the eighth tract, "Eiusdem liber de Voluptate, ad Antonium Canisianum," is this note : " Fighini, iv. kal. Januarius. M.ccc.Lvii." At the end of the twelfth : " Exscripsit clara hac opera Sebastianus Salvinus Marsilii Ficini *amitinus* (or, as Montfaucon reads, *amicissimus*) iii. Idus Februarii Mcccc.Lxxxx." Also "Marsilii Ficini Florentini et alior. ad eum Epistolæ cxxxiii." At end : "Transcripsit hunc librum Bastianus Salvinus presbyter, viii. kal. Mart. MccccLxxvi." In a letter of Ficinus to Martin Uranius, he cal.s Salvinus "amitinum suum." — *Bandini : Catal.*, i. xxi. 8 ; ii. li. 11.

SALVIONE, $\begin{cases} \text{ALESSIO.} \\ \text{OTTAVIO.} \end{cases}$ *Calligraphers.* Saec. XVII.

Ottavio wrote, about 1604, a collection of examples of penmanship, including " Gest. della Vita del B. Carlo Borrommeo, 1604." He calls himself "nepote et scuolare di Prete Alessio Salvione Milanese publico professore di scriuere cancellaresco, corsius, veloce, moderno, et altri," &c. Paper. Oblong folio, 196 ff. With rough drawings and some lines alternately black and gold. Now in the British Museum, Add. MSS., 24,899.

SAMBIN, HUGUES. *Architect and Book Draughtsman.*

Saec. XVI.

Of Dijon.

Published, in 1572, a collection of beautiful designs for statuaresque terminal figures, as pillars, with rich accessories. The work was dedicated to the famous Eléonor Chabot, Governor of Burgundy, who refused to massacre the Protestants in his province at the order of Charles IX. His arms occur on the magnificent frontispiece.—*L'Art pour Tous*, iii. 315 ; iv. 400.

SAMSON, A. *Copyist.* Saec. XVI.

Wrote, in 1553, a Ducale or "Commissio ad Francescum Foscarinum." Now in Bodley Library, Oxford, Laud. MSS., 533.

SAMUHEL. *Copyist.* Saec. X. (?)

A Priest.

Wrote a Latin Evangelium for the Abbess of Quedlinburg, in Jerome's translation. In folio, in golden capitals, very beautifully written. At end :—

" In nomine
Domini ego Samuhel indignus vocatus
Presbyter scripsi istum Evangelium."

Eckhardt thinks the MS. was given by Otho the Great to his daughter, Mechtilda, Abbess, on account of the number of gems with which it adorned. The celebrated historiographer Eccard

attributes it to the Carolingian epoch. See "Historia Genealogica Guelforum," &c., lib. ii. The Gospel-book was formerly in the Cathedral Library at Quedlinburg.—*Eckhardt: Codices Msti., Quedlinburgenses,* 4.

SANCHEZ, LUIS. *Illuminator.* Saec. XV.

One of the illuminators employed, in 1516, on the beautiful Choir-books of the Cathedral of Seville. These books contain the music for the Masses and Feasts of the year, and form a most interesting collection, owing to the artistic beauty of the miniatures, borders, and fine capital letters. They are even more varied and beautiful than the collection of books at the Escorial. Vellum. Large folio, varying in size from 97 × 66 c. to 63 × 44 c. There are upwards of 200 volumes, which may be divided into three groups : 1st. A collection of 107 volumes, which belong, by the character of their ornamentation, to the Gothic style used in Spain at the end of the fifteenth century ; to the Renaissance of the sixteenth century ; and to the decline of art in the seventeenth. Those that belong to the Gothic style are the finest ; they are 52 in number. 2nd. Another collection of 84 volumes, ornamented with fine Moorish designs combined with Gothic letters. These are 63 × 44 c., and belong to the fifteenth century. 3rd. Several volumes, which correspond to a later date, and are less important. All the music is written in black on pentagrams of red lines.— *Riaño : Notes on Early Spanish Music,* 136.—*Bermudez : Diccionario, &c.,* iv. 324.

SANCIUS, or }
SANCHEZ, } ANTONIUS. *Copyist.* Saec. XIV. et XV.

A Spaniard. Called Antonius Sancii de Balbuene, in a document in the National Library, Paris, where his name appears among those to be dismissed by the Pope from his mansion at Peniscola, Avignon (MS. lat., 1,479, fol. 187).

Wrote, in 1401, probably for Benedict XIII. at Avignon : I. A magnificent copy, bearing that Pope's armorials, of the Chronicle of Ptolemy of Lucca, which ends with these verses :—

" Benedicti tercii decimi septimo anno

* * * * * * *

Primoque Christi quadringentesimo nati
Dieque vere secunda vicesimo jani
Antonius dictus, Sancii cognomine fultus
Ispanus natu, Astigie fonte perunctus,
Hunc librum scripsit jussu sanctissimi patris," &c.

The volume is rather remarkable. At the end of each quire the illuminator has placed a summary of the miniatures, &c., in the quire. He distinguishes five species of ornaments : 1. *Littere auri magne, littere capitales, littere librorum.* Initials enclosing a miniature of mean dimensions, *i.e.*, square of about four centimètres high. These are placed at the commencements of the books, *e.g.*, fol. 10 *v.* col. 2. 2. *Littere auri parve, litt. parve stor*[iate]. Initials, about half the size of the preceding, within a gold edge, and containing a small " story." These letters commence the Life of each Pope, *e.g.*, fol. 16 *v.* col. 1. 3. *Littere flor*[ise]. Initials alternately red and blue, one on violet flourishes, the other on red ones, *e.g.*, fol. 9, cols. 1, 2. 4. *Versiculi.* Title of chapters in red. 5. *Par*[agraphi]. Little signs, ¶, alternately red and blue, marking the commencement of paragraphs in the body of a chapter. No note, however, seems to be given of the prices attached to the various kinds of ornaments. But information of this kind does occur in a Roman Pontifical which was probably executed for the chapel of this Pope (MS. lat., 968). In this MS. each quire ends with a list of the miniatures analogous to the one just mentioned. On the margins may still be read most of the notes made there to point out to the painter the subjects which he had to draw. Ex. :—

Papa sedens in sede (fol. 28).

Papa coram altare cum regno apertis manibus, et episcopi cum pluvialibus et mitris albis incumbentes super faldistoria (fol. 35).

Hic pingatur papa genuflexus (fol. 43 *v.*).

Episcopus mitratus extendens manum supra monialem genuflexam (fol. 62.)

Hic ponatur una mulier genuflexa in habitu viduali, tenens paternostres in manibus (fol. 70 *v.*).

Ad penellum pingatur stola (fol. 102 *v.*).

Ad penellum (fol. 115 *v.*).

Many of the marginal notes indicate the prices paid to the artist, and the names by which certain illuminations were known. Precium litterarum cum figuris : 1 grossus (fol. 4). Precium litt.

sine figuris xviii. denarii. Prec. litt. qui dicuntur "champide," viii.
den. pro pecia. Sunt litt. faciende in pontificale de novo clxi.
Item et alia parte sunt, "benedictiones" in fine brev'i xxiiii. Item
ex alia parte sunt, littere xlviii. et sunt de vermilione et non
florise (fol. 4 *v.*). The receipt at the end of the volume has
revealed to us the name of the illuminator: Ego frater Sancius
Gonterii habui pro illuminatura huius libri a Johanne Reginaldi xvii.
florinos vii. solidos. Now in National Library, Paris, MS. lat.,
5,126. II. A History of the Popes, and the "Chronique Marti-
nienne;" also having, fol. 232, the arms of Benedict XIII. On
fol. 212 *v.* is the signature: "Anthonius Ispanus vocatur, qui
scripsit." Now in National Library, Paris, MS. lat., 5,142.—
Delisle : Cabinet des MSS., i. 490–2.

SANCTI (*sic*) OLIM BLASII DE VALIANA. *Copyist.*

Saec. XIV.

La Div. C. Paper. Small folio, xiv., 217 ff. Every canto has
column initials, now red, now violet, and ends : "Anno Domini
McccLxxxvij. Die x martii expletus fuit iste liber per me Sancti
olim Blasii de Valiana in castro Puppi sub illustris et Magnif' viri
Dom' Com^tis Karoli de Battifolle bono et tranquillo dominio tem-
pore pontificatus Urbani VI." Once in the Libri Collection, Codic.
Pucciani, No. 10.—*Batines*, ii. 253.

SANDALENSIS, BARTHOL. FABIUS. } *Copyist and*
SANDALLO, BARTOLOMMEO FABIO DA. } *Illuminator.*

Saec. XV.

Wrote, in 1468 and 1470, "Livii Historiæ decas i." Now in
the Rhedig Library, at Breslau.—*Wachter : Thomas Rhedig und
Seine Sammlung,* 47, 48. Also illuminated, and, perhaps wrote,
in 1469, at Florence, an Office of the Virgin. This Office is a
copy of the translation into Italian terza rima by Filelfo. At end :
"Hoc opus fecit Bartholomæus Fabius de Sandallo MccccLxix.
It is a handsome volume in large 8º, and written in beautiful
Roman characters on the purest vellum.—*Caravita : I Codici
. . . a Monte Cassino,* i. 430.

SANDERS, CATHARINE. *Miniaturist.* Saec. XVI.
Daughter of Joh. Sanders de Hemessen or Hemsen.

> Went into Spain in the service of the Queen of Hungary, " Con buona provisione."—*Vasari* xiii. 154, n. 6 (Lemonnier).

SANDRETIS, STEPHANUS DE. *Copyist and Illuminator.*
Saec. XV.

> Wrote and illuminated, in 1447, " Bartholomæi de Glanville de Rerum proprietatibus." Now in the Library at Amiens.—*Garnier: Catalogue,* 316.

SAN GIOVANNI, FRA ANGELO DA. *Miniaturist.*
Saec. XVIII.
A Capucin of Bologna.

> Worked about 1780.—*Zani : Enciclop. Metod.,* xvii. 38.

SAN LORENZO, GIACOMO DA. *Copyist.* Saec. XV.

> Worked at Milan before 1437.—*Zani : Enciclop. Metod.,* xvii. 39.

SANTIAGO, SIMON DE. *Illuminator.* Saec. XVI.

> Was charged with the decoration of the Choir-books of the Monastery of San Lorenzo of the Escorial. In 1584–5 he obtained fifty ducats to enable him to return home and recruit his health. —*Bermudez : Diccionario, &c.,* iv. 345.—*Zani : Enciclop. Metod.* xvi. 350.

SANTORUS, RANUCCIUS. *Copyist.* Saec. XVI.

Employed, in 1549, in the Apostolic chambers as "scriptor librorum."—*Müntz : La Bibliothèque du Vatican du xvi. Siècle,* 101.

SANUTO, LEONARDO. *Copyist.* Saec. XV.

Wrote, in 1458, a beautiful MS. of the works of Virgil, called the Virgil of Petau. It is of a narrow 4o form, 228 ff. of the choicest white vellum, with very wide margins, and thirty-two lines to the page. The last book of the Æneid is followed by a poem called " The Edict of Augustus," and, after several other pieces, the MS. terminates with the "Culex." The " Edict " is written in letters of gold, and the whole volume is enriched with miniatures, initials, and borders. The miniatures are placed in the lower part of the page, beneath the text. One of them is reproduced by Silvestre (Pl. clix.). All the titles are written in golden letters, and consist of either Roman capitals or minuscules finely formed. The open spaces in the initials are occupied by miniatures. Beautiful arabesques of flowers, fruits, and animals, either surround the pages, or form brackets and terminals to the initials. The handwriting is slightly angular, as if under Gothic influence, but very distinct and legible. At the end is this note : " Publii Virgilii Maronis Eneidos xii[s] et ultimus explicit, manu Leonardi Sanuti, pro inclito Venetorum dominis tunc Ferrarie Vice domino MCCCCLVIII. die decimo Octobris." The arms of Sanuto occur among the ornaments of the borders. Now in the National Library, Paris (No. 7,939 A.).—*Silvestre,* ii. 435, 436 (English Text); iii. 101 (French).

SANZIO, RAFFAELLO. *Painter, &c.* Saec. XVI.

Many are the attributions to Raffaello of miniatures in various MSS. Those of the fine Missal of Cardinal Cornaro in the Sciarra Library at Rome, are claimed for him, as are the designs of the wretched German scenes painted at the foot of the pages in the Croy MS. of the British Museum, Add., 8,824. But the "Revue du Lyonnais" of May, 1855, contains an article by M. J. C. Hugon, pointing out the discovery of three miniatures : 1, St. Michael and the Dragon ; 2, The Annunciation ; 3, The Virgin Mary under a

canopy. On the collar of her mantle, in the latter miniature, M.
Hugon says he read the inscription: RAPH. P. V. ft. F., which he
interprets, "Raphael Pictor urbinensis fecit Florentiæ." The
paintings must have been executed, therefore, between 1503 and 1508.
As the "Revue du Lyonnais" is not a readily accessible book, I
translate a portion of the article referred to :—"There exist minia-
tures by Raphael Sanzio of Urbino. It may be objected that this is
impossible, otherwise his contemporaries would have known and
spoken of them. It is easy to reply that we have scarcely any
mention of Raphael as a youth, or of his two journeys to Florence
in 1503 and 1504, and that the important works which he executed
there, probably between 1506 and 1508, would not even be
suspected to-day if chance had not discovered them, nearly four
centuries afterwards, in the atelier of a carriage painter ; and, under
a coat of plaster, his great picture painted for the refectory of
Fuligno and St. Onofrio. If the memory of a grand work like this
had been allowed to slip away, how can it be affirmed that he did
not paint miniatures,—works intended to be shut up in books—
simply because no one remembers them? As one of these
miniatures is dated from Florence, can we not suppose, without
making too bold a guess, that they were destined for the Book of
Hours of the Countess Giovanna da Feltre della Rovere, his
protectress, as a mark of gratitude? As for the capability of
Raphael to execute such work, it is certain that he executed in
oil works quite as minute as miniatures, and Vasari cites, among
others, a picture painted for Guidobaldo, Duke of Urbino : ' Fece
un quadretto d 'un Cristo che ora nell' orto, e lontano alquanto i
tre apostoli che dormono, la qual pittura è tanto finita che un
minio non più essere, ne megliore nè altrimente.' Clearly, then,
Raphael could paint a miniature if he chose. Let us come to the
fact. A friend of mine made me a present some twenty years
ago of a Gothic Psalter, with a binding of the time of Henry III.
This MS., besides a number of Gothic miniatures, contained
three later ones, not having on their backs the characters of the
date of the rest, and without the usual initials and other orna-
ments. These three pieces seemed to me of great beauty, and,
wishing to have a reliable opinion upon them, I submitted them
to MM. Bonnefond and Vibert, professors in our School of the
Fine Arts, recently returned from Rome, and therefore fresh from
their lengthened studies in that city. These gentlemen replied
that it was impossible to say who was the painter of the miniatures,
but they would not be surprised to learn that they were by the

hand of Raphael. This caused me to reflect and search for some
sign which should put me in the way of finding out the truth. I
could, however, only find what appeared to be letters on the
collar of the Virgin's mantle. I persisted in reading them from
left to right, and could make nothing out of them, when one day,
reversing the book, I read distinctly, on the left shoulder,
' RAPH ;' then, by means of a magnifying glass, on the other
shoulder, ' P. V. Fᵗ F.'—Raphael Pictor Urbinensis fecit
Florentiæ. In the fresco of St. Onofrio (of 1505) a signature—a
very unlikely thing—is found placed on the shoulder of St.
Thomas. But during which of his journeys could he have
painted these miniatures? From all appearance the St. Michael
was painted in the first. The style is more youthful, less expe-
rienced. The Virgin under the canopy I attribute to a later
period, as it is riper in style and execution. The Annunciation
is difficult to class. The Virgin is in Gothic draperies, but the
figure, the hands, the pose, are not so ; they are more graceful and
supple, and then the angel is of the new school. The cause of
this difference I cannot explain. The three miniatures in the order
in which the binder has placed them are as stated above :—1. St.
Michael and the Devil. Height, 16 c., breadth 11½ c., including
the borders. All the miniatures are placed within borders com-
posed of ' rinceaux' of flowers, &c., on gold grounds. The
angel is armed almost *cap-à-pie*, even with gauntlets. The armour
golden, charged with ornaments in relief. A red buckler repre-
sents a radiant cross. He has wings, the wings of a swallow—
lilac with spots of gold. His head is bare, and his floating
tresses are bound by a circlet of gold surmounted by a small
cross. The Devil, lying on the ground, is as hideous as possible.
His beast-like arms are garnished with bat's wings, which are
attached to his waist, and his latter part represents the head of a
lion. The ground around him vomits flames, but the sky is per-
fectly serene. A grotesque figure, in the lower border of the page,
represents a monkey in a hood, playing a guitar. 2. The
Annunciation. Same size as 1. On the left is the Virgin,
kneeling on both knees, with eyes cast down, listening to the
words of the angel. Her tresses are blond and floating, her robe
dark violet, her mantle ultramarine blue. On her left, a prie-
dieu, covered with red damask and golden flowers, supports an
open book. The angel Gabriel, on her right, kneeling on one
knee, delivers his message. His robe is white, his wings green,
sprinkled, like Michael's, with drops of gold, and his right

hand bears a sceptre instead of the usual lily. The room is a rotunda with pilasters, of which the floor is covered with a pavement of rosy orange marble. The Holy Spirit, as a white dove, within a rainbow, descends from Heaven on a ray of gold. The grotesque in the border is a sort of orang-outang, mounted on an animal unknown, defending himself with a red shield, and carrying a lance in rest with a white pennon. Another figure occurs in the side of the border. 3. The Virgin of the canopy. Same size as the preceding. Four angels in white, and terminating at the knees in clouds of bluish hue, sustain above the Virgin a canopy of red damask with flowers of gold. Their wings are green, and behind them is a choir of angels, veiled in a blue vapour. The centre is occupied by the Virgin crowned, with floating hair, a robe of deep blue, a golden mantle faced with red, and holding in her right arm the infant Saviour, quite nude, on whom she gazes with a gentle glance. The principal figure, like the rest, terminates about the knees in a blue cloud, from which rays of golden light flash towards the earth. The Child is excellently drawn, not meagre ; the background of a blue colour sprinkled with golden stars. It is this figure of the Virgin which carries on the shoulder the inscription mentioned above. There is no grotesque in the border." Such is M. Hugon's account of these remarkable miniatures. The description, it is true, reads closely like that of the Netherlandish miniatures of the school of Gerard David or Hugo van der Goes. But, of course, the description, if genuine, should decide the question of the authorship of the work. It adds another proof to the series that the most distinguished painters of many schools—Raffaello, Perugino, Titian, Tintoretto, Paolo Veronese, Leonardo da Vinci, Mantegna, Rubens, and others, occasionally put their hand to the work of the miniaturist. The little tablets in our National Gallery by Raffaello and Correggio, not to mention others, are instances of what the great masters occasionally accomplished in oils.—*Revue du Lyonnais,* x. 503. Compare also the Stettin Album. *See* Stettin.

SARACINO. *Illuminator.* Saec. X.

Co-operated, in 976, with Vigila, of Castille, in ornamenting the MS. called the "Vigiliano." Now in the Royal Library, Madrid.—*Bermudez,* iv. 356.—*Nagler : Künstlerlexicon,* xv. 19.

SARDI, ALESSANDRO. *Copyist.* **Saec. XVI.**

Lived at Ferrara.

Wrote "M. Anton. Antimachi adnotatt in Nebulas et in Plutum
Aristophanis," &c., and other treatises in the same volume. At
end of book i. of Cicero's "Tusculanar. quæst." Finis : "18 Kal.
Jul. 1548," and at end of the fifth and last, "Finis. pridie non. Julii
MDXLIX." Altogether five works. All by the hand of Aless.
Sardi, a Ferrarese. Catal. No. C.—*Cenni Storici della R. Bibl.
Estense, &c.,* 30.

SARDIS, BERNARDINO. *Illuminator.* **Saec. XV.**

One of the number employed by Ferdinand I. of Naples. The
discovery of their names is due to Sig. Camillo Minieri Riccio
("Cenno Storico della Academia Alfonsina," Napoli, 1875), who
has examined the account-books of expenses.—*Delisle : Cabinet
des MSS.,* iii. 357, 358. *See* FERDINAND I. of Naples.

SARRATO, MOTTIA DA CONTANDOLO. *See* SERRATI.

SARTORI, FELICITA. *Miniaturist.* **Saec. XVII.**

Worked at Venice, and was an excellent paintress and minia-
trice. She studied under Rosalba Carriera, with whom she was
a great favourite. Having married a gentleman in the service of
the King of Poland and Elector of Saxony, named Hoffmann, she
retired with her husband to Dresden, where she continued to
exercise her skill to the gratification of the Court and its enlightened
sovereign. Her works, some of which are still in the Royal
Cabinet, were highly prized.—*Orlandi : Abeced. Pittorico,* 165.
(Venezia, 1753. 4°.)

SARTORIUS, FRA CHRIST. *Copyist.* Saec. XVII.

Monk of Langheim.

Wrote, in 1613: 1. Antiphonary de tempore, with twenty-eight miniatures by Oswald Schirmer (9 *v.*). Folio, max. 238 ff. 2. Ditto, 343 ff. in 1614, with fifty-nine miniatures. Folio max. 3. Gradualis (from Langheim). Written 1612. With fifty-seven miniatures in initial letters, by Oswald Schirmer, presbyter of Culmbach. Folio, max. 394 ff. 1 col.—*Halm.: Catalog.*, 148, No. 1,183.

SARTORIUS, CONRAD. *Miniaturist and Copyist.*

Saec. XVI.

Of Monheim. Monk of Tegernsee. Died 1531.

He copied a Psalter and painted borders to all the Psalms, on which animals and plants were delineated with wonderful fidelity to nature.—*Hefner*, in *Oberbaierisches Archiv, &c.*, ii. 27.

SASSENHEM, JACOBUS. *Copyist.* Saec. XV.

Wrote a beautiful copy of the works of Arrian : " Arrianus, De Gestis Alexandri Magni, Historia Indica," translated into Latin by P. P. Vergerio. Folio. Vell. 162 ff. With illuminated borders and initials. A superb MS. of the fifteenth century, still in its old Italian binding. It begins " Ad Sigismvndvm de Lvxenborch Romanvm . Imperatorem et Vngarie Bohemien : Regem . Petrus Pavlus Vergerivs Prohemium incipit, &c. In this dedicatory Epistle, Vergerio mentions that it is by the order and for the use of the Emperor Sigismund himself that he has undertaken this translation of the Expedition of Alexander the Great. Vergerio, called "the Elder," to distinguish him from a more celebrated man of the same name in the sixteenth century, was attached to

the service of Sigismund, and made this version, which is a sample of pure and elegant Latinity, between 1417 and 1419, when he was nearly eighty years of age. Until then, he says, the work of Arrian was still unknown in the West. This translation has never been printed, and MSS. of it are so rare that Hallam referring to it in his " Literature of Europe," says : "... is said to exist in the Vatican Library, but we know little of its merits." The first page is surrounded on three sides by a very simple yet graceful bracket in gold and colours. Above the upper border is written Jesu . Maria . Johannes. At foot, in the lower border, are the arms : Paly of six, *or* and *azure*, supported by two angels, each blowing a trumpet bearing a banneret. On one is the letter N, on the other the figure V., for Nicholas V., the illustrious founder of the Vatican Library and first librarian, for Cosimo de' Medici, of the Laurentian Library. A confirmation of this attribution is found on fol. 42 *v.*, where, in the outer border, is painted a shield, bearing, on a purple ground, the keys of St. Peter, white, *en sautoir*, surmounted by the tiara. In the lower border is a *golden owl*. The Expedition of Alexander begins on fol. 2, and ends on fol. 139, thus : " Finis Gestorvm Alexandri, Lavs Deo." It is immediately followed by : "Arriani de Rebus Indicis et navigacione classis Alexandri ex India in Persidem. Liber vii⁰. ; and ends : " Finis Rervm Indi carvm. Deo Gratias. Jacobus Çassenhem scripsit." Each book begins with a charming initial, and has marginal notes. Formerly in the Didot Collection.—*Catalogue des Livres Précieux, &c., de M. Ambr. Firmin-Didot*, 39, 40, No. 53 (Paris, 1878).

Savinus. *Calligrapher.* Saec. xi.
A Monk of Monte Cassino.

> Wrote a " Pontificale Romanorum Pontificum " in sm. 4⁰. Now at Monte Cassino, No. 451.—*Caravila*, ii. 71.

Savoie, Charlotte de. *Patroness.* Saec. xv.
Wife of Louis XI., and Aunt of Louise de Savoie.

> Collected a small library of MSS., which afterwards came into the Royal Collection, and are now in the National Library, Paris. —*Delisle : Cabinet des MSS., &c.,* i.—*Paris : Les MSS. fr., &c.*

SAVOIE, LOUISE DE. *Patroness.* Saec. XV.

The great and brilliant movement, known as the Renaissance of the Arts in France, is largely attributed to the favour and help of Francis I. It must, however, be remembered that he by no means originated the movement. We must go back to the reign of Louis XII., and even to that of his predecessor Charles VIII., if we would reach its true beginnings. And among the earliest promoters, such as the Cardinal Georges d'Amboise and Anne of Brittany, we must place Louise, daughter of Filippo II., and sister of Carlo III., Dukes of Savoy. Her brother was the first protector of Claude Seyssel. About 1487 she married Charles, Comte d'Angoulême (Engoulesme), Seigneur d'Epernay Romorantin, &c. In 1489 her husband, who was the son of Jean d'Angoulême, a younger brother of the poet Charles d'Orleans, was made Governor of Guienne. He died in 1495, leaving a son and a daughter,—Francis, afterwards King, and the celebrated Marguerite d'Alençon, afterwards Queen of Navarre, and authoress of the Heptameron. On her son's accession to the crown, Louise became Duchess of Angoulême, and in 1515 she was made Regent of France, resuming that office once again during the King's absence in 1524. Among the occupations of her busy widowhood not the least attractive to herself was the collection of books for the augmentation of her inherited library of Cognac. In 1497 she employed Jean Michel as copyist, and Robinet Testart as illuminator. Testart's name occurs on the list of varlets de chambre of Charles Comte d'Angoulême in 1484 and 1487, and in the latter year with the title of " enlumineur " (MS. fr., 7,856, 843). The annual wages paid by Louise to these men were respectively 24 and 35 livres per annum. A MS., called " Heures de Louise de Savoie," is now in the British Museum (Sloane MS., 2,710). The book of the " Triomphe de la Force de la Prudence," dedicated to her, passed from the Abbey of St. Germain to the Hermitage at St. Petersburg, where it still remains (Livret du Musée, 92). Another MS. executed probably under her supervision was a splendid one now in the Paris Collection,—" Commentaire sur le Livre des Echecs amoureux." Folio max. Vell. 2 cols., with superb miniatures—borders and initials (MS. fr., 6,808—Anc. No. 84). This beautiful book was intended for the use of her children, and really consists of a prose commentary on the poem.

In the first miniature are the arms of Orleans (France au

lambel d'*arg.*, each pendant charged with a crescent *gu.*—*parti* with Savoy—de *gu.* à la croix d'*arg.*) surmounted by a diadem.

1st miniature represents Francis, his sister Marguerite, and Artus de Gouffier, their tutor. 2nd contains a delicious figure of Fortune, holding in one hand (left) a sceptre, in the other a wheel (or rather la manivelle d'une roue). 3rd. La Nature appearing to the poet. 4th. Another figure of Nature. 5th. The three Fées or Fates. 6th. Another beautiful figure of Nature. 7th. The world. 8th. The world. 9th. How Nature induces the lover to flee Oysiveté. 10th. How Mercury leads to the author three goddesses. 11th. How *Jupin* chastises Saturn, and how the latter devours his children. 12th. How Jupin kills the giants. 13th. Mars in a chariot : a flail in his hand. 14th. The Three Graces and Apollo. 15th. Music : a curious figure. 16th. Venus, the Three Graces, Cupid, and Vulcan : a very lovely miniature. 17th. Mercury and Argus. 18th. Charming figure of Diana and her nymphs. 19th. Pallas. 20th. Juno. 21st. A beautiful figure of Neptune and his court. 22nd. Pluto and his court. 23rd. Cybele. 24th. Vulcan. 25th. Bacchus. 26th. Æsculapius. 27th. Pan. 28th. A delicious picture of the Judgment of Paris. 29th. How the author separates from Venus. 30th (last). The Palace of Nature—in which are seen Pallas Juno, and Venus.

No. 6,809. "Les triumphes des Vertus." Second part, i., 286–293. Vellum. Folio, max. Very beautiful miniatures—(Anc. No. 248). 169 ff. Remarkable for its cameo initials, on gold grounds, and cameo miniatures, enhanced with gold, having the effect of "tailles numismatiques." The drawing, notwithstanding the ill-effect of some of the heads, shows an admirable facility and well-directed study. Many groups, especially of naked figures, recall the disciple of Michelangelo or of Benvenuto Cellini (291, 292). The first of these grisailles (all allegorical) represents a grand and sumptuous fountain, with five basins. On each of the two lateral basins of the upper portions is *emblematised* an escutcheon : 1. France. 2. France *parti* with Dauphiné. On the right, two warriors represent Force ; on the left, a woman and the king, Francis I., represent Justice. The two lower lateral basins bear for escutcheons ; 1. On the right, France, quartered (à la quatrieme pièce) with Bretagne,—that is, Temperance represented by Queen Claude and a divinity. That on the left (*az.* au trois fleurs-de-lis engrélé de *gu.*, *parti* de France) is Prudence, represented by Marguerite, Duchesse de Alençon, and a warrior holding in his hand a horn.

Lastly, the grand basin in the centre, bearing at top the shield of France-Angoulême, quartered with Savoy, serves as seat for Louise de Savoie.

This is " La Fontaine de toutes Vertus." At foot of the monument a lapidary inscription bears the words, " DIVE . LATHONE . APOLLINIS . ET . DYANE . MATRI . VIRTVTV . FONTI . *Perhepui.*"

The author, kneeling before this stone, seems dedicating his book, bound in green velvet with golden clasps. But he wears a monastic habit, which does not agree with Jean Bouchet, who is supposed to be the author of the book. There are seventeen other miniatures.—*Paris*: *Les MSS. fr., &c.*, i. 279–282, 286–293.—*Ib.*, iv. 316, 317.

Delisle gives a list of about twenty of her books, most of which were executed expressly to her order. Many, however, contain the arms of Angoulême *parties* de Savoie. (Fds. fr., 144, 224, 875. 1,393, 1,959, 2,125). Others contain France and Savoy (Fds. fr. 145). In some are Orleans and Milan (Fds. fr., 252, 1,892). In others Angoulême and Savoy in a bordure *az.* and *or* (Fds. fr., 592, 1,817). The celebrated MS. of Chants Royaux of the Puy d'Amiens was executed for Louise. For particulars respecting it, *see* PLASTEL.—*Laborde : La Renaissance des Arts, &c. Peinture,* 170—*Delisle: Cabinet des MSS., &c.*, i. 80,183–7.

The MSS. executed for the Princess Marguerite comprised :

1. " Messe de Ste. Anne," dedicated to her as Duchesse d'Alençon. It contains arms : Parti : 1. d'Alençon (*i.e.* de France) à la bordure de *gu.* chargée de 8 becans d'*arg.* 2. de France. (Nat. Lib., Paris. Fds. fr. 1035).

2. " Le Miroir des Dames, translate par Maistre Ysamberd de Saint Leger, prestre," with miniatures (Fds. fr. 1,189).

In 1530 was executed the MS. alluded to above (Louise de S.) : " Cy est le liure nommé Fleur de Vertu, translate d'Italien en françoys par très reuerend pere en Dieu monseigneur Françoys de Rohan, archevesque de Sion, primat de France, et Evesque d'Angiers." It contains the arms : 1, of the Reverend trans- lator (fol. 1). 2, of France repeatedly. 3, Of France and Navarre (fol. 70 v.), and numerous miniatures. Possibly the miniaturist may be indicated by the monogram on ff. 26 and 75. On fol. 26, N. conjoined with L. and on fol. 75 two Ns. It is more probable, however, that they refer to the owner of the volume. It is dedicated "pour Madamoyselle d'Angolesme, Marguerite d'Orléans" (Fds. fr., 2,444). Among other MSS. are

the " Instruction en la religion chretienne pour les enffans," which afterwards belonged to Gaignières, and is now in the Arsénal Library, and a book of Hours, which since belonged to the Duchesse de Berry.—*Le Roux de Lincy : Heptameron*, i. ccliv.— *Meyer : Catal. des MSS. de la Duchesse de Berry, &c.*, 15, No. 2. —*Delisle : Cabinet des MSS.*, i. 183–7.

SAWALO. *Illuminator.* Saec. XII.

Monk of St. Amand, in Flanders.

Illuminated a Bible in five volumes, the first of 147 ff., the second 152, the third 153, the fourth 156, the fifth 178. Initials in colours to each chapter, and at the head of nearly every book a large historiated initial in gold and colours of great elegance and perfect execution. Prefixed to each volume is a large full-page miniature, surmounted by the words in red capitals : SAWALO MONACVS SCI AHMANDI ME FECIT. Perhaps this Sawalo was a canon and secretary to Robert, Bishop of Arras, who lived about 1128. —*Mangeart : Catalogue descriptif et raisonné des MSS. de la Biblioth. de Valenciennes*, i. (Paris, 1862, 8°).

SBIGNES, DE RATIBOR. *Pseudo-Copyist.*

Saec. XIII. or XIV.

Said to be the copyist of the so-called Jaromir'scher Bibel, described by Waagen in the *Deutsches Kunstblatt* (for 1850, 149) ; by Schnaase in his " History of Painting " ; and by Passavant in Otto and Quast's " Zeitschrift," under the name of the " Brzeznitzer Bibel." On the back of fol. 1 is a note, probably of the fourteenth century : " Iste liber est monasterii in Jeromir." Later the MS. was found in the castle of Brzeznitz, and formed part of the gift of 500 MSS. which Count Joseph Kolowrat presented to the National Museum at Prag in 1819. The writing is in a well-formed Gothic character, and the illuminations such as are usual in MSS. of the thirteenth century. They are confined to figure

representations at the beginnings of the different books. The large " I " at the beginning of Genesis extends the whole length of the page, and contains separate representations, according to custom, of the days of creation, the fall of man, &c. The remaining smaller initials present scenes or personages ; usually the author of the book which follows. But in the initial " E " of Baruch (fol. 278) is given the so-called portrait of the scribe, and in the " I," on fol. 340, that of the illuminator. In point of fact the one on fol. 278 is intended originally for the author of the book, who sits at his desk writing. On the blank leaf of the book lying before him is written, in very small letters, in black ink : " Sbignes de ratibor hoc scripsi." Woltmann concludes from this that the name is a forgery. This unusual mode of signature is so common in Bohemian MSS. as to suggest a possible custom, and no forgery at all ; but Woltman, who examined the MSS. at Prag most carefully, came to the conclusion that all the unusual signatures were forgeries.— *Woltmann,* in *Repertorium für Künst- wissenchaft* (ii. 1879).

SCALZINI, MARCELLO. *Copyist.* **Saec. XVI.**

 Called Il Camerino.

 Worked about 1599.—*Zani : Enciclop. Metod.,* xvii. 93.

SCARIGLIA, ANTONIO. *Illuminator.* **Saec. XV.**

 Employed by Alfonso I. and Ferdinand I., kings of Naples. *See* ALFONSO I. OF NAPLES. Baldassare Scariglia is named as a binder for the same princes.

SCARSELLI, ALESS°. *Copyist and Miniaturist.*

 Saec. XVII. et XVIII.

 Born 1684, died 1773.

 Worked at Bologna. He excelled also in music.—*Zani : En- ciclop. Metod.,* xvii. 99.

SCHACII, PETRUS. *Copyist.* Saec. XIV.

Wrote, at Verona, in 1323: "Dares Phrygius et Dictys Cretensis," in French. Vell. Fol. 159 ff. At end : " Ci finist le liure de lestoire de Troie qe nos raconte tout apertement ce qe Daire et Ditis nos en dit et raconte par ordre, deo grace Amen. Quant cist liures fu escrit il corroit lans de la natiuite dou nostre seignor Jesu Crist milloisme (?) trecentoisme et vinti trois endicions siste, et fu escrit en la cite de verone par la main de Piere Schach fils au meistre Bonaventure Schach de Verone ; liquel habite en la contree de notre dame de Sainte Marie Anne, et fu . . . par lui escrit en soisante et cinq iors seulement. Finito libro sit laus et gloria Christo. Qui scripsit scribat semper cum domino vivat Vivat in celis Petrus Scachus in nomine felix. Amen. amen. amen. Now in Bodley Library, Oxford.—Douce MSS. cxcvi.

SCHAFFLÜZEL, LUD. *Copyist.* Saec. XV.

Wrote, in 1469 : " Rabani Mauri lib. de cruce." With minia-tures. Once in the Monastic Library at Elchingen.—*Gerbert : Iter Alemannicum*, 185.

SCHALHAS, ULRICH. *Copyist.* Saec. XV.

Wrote, in 1462 : "Summa Vitiorum " Paper. 4⁰. 254 ff., and "Summa Virtutum." Paper. 4⁰. At end of the former : " Scripta per Udalricum Schalhas de Oberstorf fer 3. ante festum Simonis et Judæ, A.D. 1462," and of the latter : "Scripta per manus Udalrici Schalhas de Oberstorf, A.D. 1462." Now in the Royal Library, at Munich, Codd. lat., 3,789, 3,792.—*Steichele : Archiv für die Geschichte des Bist. Augsburg*, i. 122.

SCHÄTZLER, JOHANN. *Calligrapher.* Saec. XVI.
Of Salzfeld-am-Main.

> A skilful calligrapher and chancery secretary.—*Serapeum* (1855),
> 167.

SCHÄUFFELEIN, HANS L. *Miniaturist, &c.* Saec. XVI.

One of the most versatile and prolific artists that ever
lived, was born at Nüremberg about 1490.

> He became an indoor pupil with Albert Dürer. In design he
> approached the great master, but in no other quality. Most of his
> work consists of designs for wood engraving, and especially for
> contemporary books. He executed the drawings for many Augs-
> burg, Nüremberg, and Frankfort books. For some he also executed
> the engravings. Nagler gives a long list of his works, xv. 109–122.
> Among the more remarkable of the books he illustrated, is the famous
> "Tewrdannckhs," published by Hans Schönsperger, of Augsburg,
> in 1517, and again in 1519. The book was first printed at Nürem-
> berg, with the date 1517. It is a masterpiece both of printing
> and wood engraving, and contains 118 pictures. In the sale of
> Mr. Bragge's MSS., at Sotheby's, in 1876, was one (lot 418) of
> this remarkable poem, called "Tewrdannckh hochberümten helds
> und ritters Geschicht, von Melchior Pfintzing." It is thus de-
> scribed : " Beautiful MSS., written on 559 pages (13⅞ by 9¼ in.),
> in very singular characters, which seem to have been very closely
> imitated by Schönsperger for his printed editions of 1517 and 1519.
> This splendid volume contains 118 very artistic drawings in pen
> and ink, apparently the original designs from which the woodcuts
> were engraved by Jost von Negker and others for the 1517 impres-
> sion of this metrical romance, and if so they are in all probability
> the handiwork of the famous artist Hans Schäuffelein, whose
> monogram is to be found in several of the woodcuts, although not
> in the drawings. This MS. shows that the printed edition was
> intended to be as near as possible a facsimile. In the margins is
> a neat summary in French of the contents of each chapter—

which is omitted in the printed copies. It is only necessary to add that the MS. was not a facsimile of the printed book, many proofs of its priority being found both in its text and form."— *Bragge: Sale Catalogue,* 75. The metrical romance of the Knight Theuerdanck, a sort of allegorical life and adventures of the young Emperor Maximilian I., was written to amuse his bride, the Princess Mary of Burgundy. Melchior Pfintzing, the Emperor's Chaplain, is named as the author, but it is thought by some that Maximilian himself was the real author. The type used for the first edition was specially cut for it, and is very remarkable, being full of flourishes, knots, and interlacements. Schäuffelein left Nürembergin 1515, and went to Nördlingen, his father's native place. Here he developed that extraordinary fertility in drawing and engraving which is so marked a feature in his artistic powers. At length he returned to Nüremberg, perhaps with the intention of remaining. He was, however, by most tempting offers from the Nördlingen authorities, induced to go back once more, and for the rest of his life there he remained. He died most probably in 1539. His widow, in 1540, married Hans Schwarz, whose monogram appears with Schäuffelein's in various books, and has sometimes been mistaken for it. Dibdin (Bibliographical Decameron, i. 200), says that a Mr. Lang possessed a facsimile copy, done in Indian ink of the first edition of the " Tewrdannckh," a statement which throws some suspicion upon the genuineness of the " original " sold at Sotheby's in 1876. The original edition of the " Tewrdannckhs " was thought by some bibliophiles to be a block book, as, *e.g.,* M. de Laborde, in his *Débuts de l'Imprimerie à Mayence.*— *Quaritch: Monumenta Typographica,* Pt. I., No. 36,160.—*Jansen: Essai sur l'Origine de la Gravure,* ii. 128–140.

SCHEFFER, AMAND. *Copyist.* Saec. XV.
Monk of Salmansweiler.

Was, in consideration of his skill as a copyist, received into the monastery of Baumgarten, in Alsace, after the dispersion of his own community in 1494, and eventually became Abbot.—*Cahier: Bibliothèques,* 141.

SCHEIFFARTZ, MARGARET. *Illuminator, &c.* **Saec. xv.**

Executed the pictures and floritures of a large Missal, the modern backs of which are still adorned with the original bosses of bronze, and have in each corner a crowned eagle. It was bequeathed by the Count Karl von Wickenborg to the Pest National Museum. Many of the initials are richly illuminated, and borders containing strawberries, &c., on golden grounds, with the humorous figures common to the fifteenth century. On folio 84, for instance, some hares have captured a hunter and are roasting him on a revolving spit. This picture is noticeable as occurring more than once in contemporary MSS. Waagen saw it in two others. One of these is the beautiful Prayer-book illuminated by Alb. Glockenton, now in the Imperial Library at Vienna.— *Waagen: Kunstdenkmäler, in Wien,* ii. 22. In it also is the "Thierconcert," which occurs again in a MS. in the library at Heidelberg, described by Wattenbach (in Anz. d. Germ. Mus. xiv. 1867). The present Missal has on folio 33, with the miniature of the Assumption of the Virgin, also a portrait of the artist herself in a white dress. A label contains the inscription: "Omnis pictura ac floritura istius libri depicta ac florata est per Margaretam Scheiffartz de Meirroede quondam filia in Bornhem regularissa in Schillingscapellen. Orate pro ea." Schillingscapellen was a nunnery near Heimerzheim in the circle Rheinbach, in the diocess of Köln. It was founded in 1197, by Ritter Wilhelm Schilling (or Solidus), and the nun above named, who belonged to it, was a daughter of the Baron "Scheiffart vamme Roide herre zo Bornhem." The family is now called "von Merode."

SCHEMMEL, JEREMIAS. *Illuminator, &c.* **Saec. xvi.**

Worked at Augsburg. Some examples of his work said to be in the Wolfenbüttel Collection.— *Von Stettin: Kunst. Gewerb und Handwerks-Geschichte der Reichstadt Augsburg.* 8°. *Augsburg,* 1779. vol. ii, 258–9.

SCHEPPERS, MARGUERITE. *Illuminator.* **Saec. xvi.**

Illuminated a missal for the Convent of Sœurs de Notre Dame de Sion, at Bruges in 1503. She taught the art to Cornelie van Wulfskerke. — *Le Beffroi,* iii. 320.

SCHEYERN,
SCHEYREN, CONRAD VON. *Copyist and Illuminator.*

Saec. XIII.

Called "Conradus Philosophus." A Monk, and after-
wards Prior, of the Abbey of Scheyern in Bavaria,
under Abbots Conrad (1206–1216) and Heinrich
(1216–1259).

Was copyist, historiographer, calligrapher, and illuminator. He
devoted his whole life to the transcription and illuminating of a
great number of MSS., some of which are now in the Royal
Library at Munich. At least thirty such MSS. are named by various
writers. The five at Munich are, 1. Chronicon Schyrense;
2. Liber Matutinalis; 3. Mater Verborum; 4. Flav. Josephus
Historiographus; 5. Historia Scholastica Petri Comestoris. Some
confusion exists through the looseness of description; thus the
Missal with pictures cited by Wattenbach is probably identical
with the Evangeliarium et Lectionarium (No. 26) Cimelien-Saale,
described by Kugler. It bears at end this note: "Tu autem
domine Chuonradi scriptoris miserere. Amen. Hic labor hic
finit. Scriptoris et hic labor exit. Sis nostri memor hic. Melli-
flua qui legis istic." The illustrations are of the red and black
outline character usual at the time. Romanesque architecture in
the backgrounds, draperies well drawn in the folds, action and
attitudes lively, limbs and extremities rude and careless, features
very carefully drawn, but without much expression. In the His-
toria Scholastica, the artist, wishing to represent the various sciences
by allegorical figures, paints Astronomy accompanied by Ptolemy,
who examines the stars by means of a telescope with four slides.
Inscribed on the picture are these words: "Chonradus peccator
auctor et scriptor hujus operis." A very full account of Conrad
and his writings, with references to authorities, is given by Hefner.—
Hefner: Oberbairisches Archiv, für Vaterländische Geschichte,
ii. 157–159, 176–180.—*Aventin: Annales Scheyrenses,* 248
(Ingolstadt).—*Ziegelbauer: Hist. Rei Litter. Ord. S. Bened.,*
i. 550–553.—*Finauer: Versuch einer Baierische Gelehrten Geschichte,*
26, 27, n. 1.—*Mabillon: Iter Germanicum* (Ed. Fabricii), 54 (and
Frontispiece).—*Cahier: Bibliothèques,* 154, 197.—*Pertz: Monu-
menta Germanic. SS.* xvii. 614, Pl. 4 (vol. xix. of whole series).
—*Wattenbach: Das Schriftwesen, &c.,* 308.—*Kugler: Kleine
Schriften,* i. 84–87.

SCHMEEZER, MICH. *Copyist.* Saec. XVI.

A Monk of Alten-Zelle.

> Known, in 1516, as a copyist.—*Knauth: Altzellische Chron.*, ii. 260.

SCHMIDT, NICOLAUS. *Calligrapher.* Saec. XVII.

> Wrote, in 1645, the alphabet and Lord's Prayer in many languages. Large fol., 10 ff. In it is this note: "Geschehen im Yahr 1645. E. Churfl. Durchl. Unterthanigster Nicolaus Schmidt, sonst lüntzel zenandt, Bauersman aus dem Dorffe Rodenaeker Meine eigne Handt in allen Schrifften." It contains nearly 100 alphabets and about 50 Lord's Prayers, and in some languages also the Te Deum and Magnificat. Now in the Royal Library at Dresden.—*Goetze: Die Merckwürdigkeiten der Königl. Biblioth. zu Dresden*, i. 461.

SCHŒFFER, PETRUS. *Copyist and Printer.* Saec. XV.

Of Gernsheim.

> The associate of Fust as printer of the earliest printed Bible, &c. Previously occupied himself, among other things, with copying.— *Schœfflin: Vindiciæ Typogr.* One MS. which he wrote was in the Library of the University of Strasburg in 1808.—*Jansen: Essai sur l'Orig. de la Gravure*, ii. 27.

SCHURSTAB, CHRISTOPHER. *Calligrapher.* Saec. XVI.

> Wrote at Nuremberg between 1560 and 1562, under the teaching apparently, of the celebrated Johann Newdörffer, a book of fine specimens of calligraphy. Vell. Oblong 4° (small). 9 ff. Prefixed is a certificate by J. Newdörffer that the whole of the writing excepting the large initials is the work of Chr. Schurstab, of Tion (or Sion). On the first leather back is stamped in German text "Kunstbuch Gemacht durch Christo-phen Schurstab. Anno Salutis, 1562." Now in the British Museum, Add. MSS., 15,704.

SCHWANDTNERIUS, JOH. GEOR. *Calligrapher.*

Saec. XVIII.

Composed and published, in 1755, a folio treatise on Calligraphy: its "Nomenclatione, cultu, præsstantia et utilitate." Vienna, 1756. He gives an account of the antiquity of the arts, its professors, &c., and 172 plates of letters and flourishes of the pen; indeed, it may be said literally of this "writer," that he "flourished" in the year 1755. His enormous volume is in the British Museum.

SCHWARZ, HANS. *Illuminator, &c.* Saec. XVI.

An illuminist, wood engraver, and book illustrator, of Augsburg.

He succeeded to the business, and married the widow of Hans Schäuffelein, the illustrator of "Tewrdannckhs," and other works. His initials are often mistaken for those of Schäuffelein.

SCHWARZ, MATTHEW. *Miniaturist.* Saec. XVI.

Mentioned as a miniature painter and book illustrator, about 1538.—*Stettin: Kunstgewerb und Handwerks-Geschichte des Reichstadt Augsburg* (ii.), 258, 259 (1779, 8°).

SCHWARTZENBURG, MELCHIOR. *Book Illustrator.*

Saec. XVI.

Executed the illustrations for the 1532 and 1534 Bible, published by Hanns Lufft, of Wittemberg. His monogram M.S. has sometimes been mistaken to mean Martin Schœn.—*Nagler: Monogrammisten* (vi.), 686.—*Eitelberger: Quellenschriften, &c.* (xiii.), 48–51.

SCONZANI, LEONARDO. *Miniaturist.* Saec. XVIII.

Born at Bologna about 1695, died 1735.

Zani : Enciclop. Metod., xvii. 177.

SCOPULI, JACOBUS. *Copyist.* Saec. XVI.

Of Cyprus.

Employed, in 1550, in the Apostolic Chamber, as "Scriptor librorum."—*Müntz : La Bibliothèque du Vatican au XVI^e Siècle*, 101.

SCORIATIS, THADEO DE. *Miniaturist.* Saec. XVI.

Perhaps the same person as Thadeo Milanese. Employed at the Vatican, under Leo X.—*Müntz : La Bibliothèque du Vatican au XVI^e Siècle*, 59. *See* MEDICI, GIOVANNI DE'.

SCORZA, JUAN BAUTISTA. *Illuminator.* Saec. XVI.

A Genoese.

Studied under Luca Cambiaso. Philip II., in 1583, took him into his service to work on the Choir-books of the Escorial. Later he returned to Genoa, where he died, 1637, at the age of 90. He was especially skilful in painting animals and insects, and was much celebrated by the Cavaliero Marini, in his once widely-read poems.—*Bermudez : Diccionario* (iv.), 361.—*Nagler : Künstler-lexicon*, xvi. 175.

SCORZA, SINIBALDO. *Miniaturist.* **Saec. XVI.**

Of Voltaggio, in the Genoese territory.

Became a pupil of G. B. Corrosio and G. B. Paggi. At first
he occupied himself with great industry in drawing with the pen,
which he accomplished so well that engravings such as those of
Albert Dürer, which he copied, appeared exactly like originals.
In miniature he painted landscapes, animals, flowers, and scenes
from history. Cavaliero Marini celebrated him both in his letters
and in his Galleria, Scorza being a frequent contributor to the
cavalier's collection. Marini also assisted him to obtain a post at
the Court of Turin, where he painted many pictures in miniature,
among the rest six miniatures of the Creation of the World on as
many sheets of vellum, and with such skill that he was at once
compared with Julio Clovio. On the outbreak of the war between
France and Genoa he left Turin. He afterwards went to Rome
and painted a number of easel pictures in oil, by which he
obtained fresh celebrity and made a considerable fortune. He
now painted chiefly Biblical or historical scenes, introducing
animals in the manner of Berghem, and successfully combining
the Flemish and Italian styles, better, as Lanzi observes, than
any German master. Yet in these days his paintings are very
seldom seen in any gallery. They may be found in Genoa,
however, in the Palazzo Brignola. He died in 1631.—*Soprani:
Vite de' Pittori, &c.—Genovesi* (ed. Ratti, Gen., 1768, 4º), v.
277, 311.—*Nagler: Künstlerlexicon,* xvi. 175.

SCOULER, JAMES. *Miniaturist.* **Saec. XVIII.**

Obtained the Society of Arts premium at fourteen years of age
in 1755. Exhibited in 1761–62, was member of the Free Society of
Artists in 1763, and a constant exhibitor at the Royal Academy
from its foundation till 1787.—*Redgrave: Dictionary of Artists of
English School.*

SCUTIFIER, MARCUS. *Illuminator.* **Saec. XVI.**

Painted the initials, &c., of the magnificent Missal in the Library
at Cambrai, called Missa de tempore et sanctis per annum cum

notis. Vellum. Folio. Durieux calls it "Le plus beau de nos manuscrits de la Renaissance et parfaitement conservé." Occupying the whole of the back of the first folio are the arms of Robert de Croy, Duke and Bishop of Cambrai, supported by a unicorn. In the upper border is a ribbon with the motto "A jamais Croi." The volume contains nine large borders composed of fruits, flowers, and insects, and occasionally a beautiful child. The motto is repeated at the foot of the first border on fol. 2. On each of the pages with borders is a large and exquisitely-painted initial in brown-gold or a fine gold chiaroscuro, and each containing a scene of a Scriptural or devotional character, such as the Ascension, Circumcision, Pentecost, &c. Smaller letters, also richly painted in grisaille on coloured grounds, are much more numerous. The colours are extremely fresh and bright, and the work altogether of the kind seen in the large music-books executed for Philip the Good of Burgundy. On the last page is the date 1540 and this couplet :—

> "Marcus scutifer hec q̃ spectas gramata pixit,
> Odarumq̃ vias, sacre pia symbola muse."

In another hand, perhaps that of Robert de Croy :—"Sub Croy manes semper ditione Roberti!" Now in the Communal Library at Cambray, No. 12.—*Le Glay: Catal. descriptif et raisonné des MSS. de la Bibl. de Cambrai.*—2. *Durieux: Les Artistes Cambresiens, &c.*—*Durieux: Catal. des MSS. à Miniatures de la Bibl. de Cambrai,* 81, 82, and plate 16 of Atlas.

SCUTKEN, Jo. *Copyist.* Saec. xv.
Cleric of Windshem. Died 1423.

"Bonus scriptor artificialisq. notator." Wrote many Chantbooks, Antiphonaries, Lectionaries, Missals, &c.—*Buschii Chron. Winshemens,* 579.

SEAGER, Jane. *Calligrapher.* Saec. xvi.

Wrote a small square volume as a present to Queen Elizabeth, containing "The Divine Prophesies of the ten sibills, upon the birthe of our Saviour Christ," in English verse. Fol. 1. "To the Queen's most Excellent Ma^ty Sacred Ma^ty Maye y^t please those

most gracious eÿen (acquaynted with all perfections and above others most Excellent) to vouchsafe to make worthy of their princely view, the handy-worke of a (erased) Mayden yor Maties most faithful Subiect. It conteyneth (Renomed Soüfereigne) the divine prophesies of the ten Sibills (Virgyns) upon the birthe of our Saviour Christ, by a most blessed virgyn ; Of wh most holy faith your Maty being cheife Defendress, and a virgyn also, yt is a thinge (as yt weare) preordeyned of God, that this Treatis, wrytten by a Mayden yor Subiect should be only devoted vnto yor most sacred selfe. The which albeit J have graced both wth my pen and pencell, and late practize in that rare Arte of Charactery invented by D. Bright, yet accompting yt to lack all Grace withoute yor Maties most gracious acceptance J humbly presente the same, wth harty prayers for yor Maty.—JANE SEAGER. Fol. i. *v.* Agrippa. The "Charactery" referred to occurs on fol. 2, being, I suppose, the preceding verses in shorthand. Fol. 2 *v.* Samia, and the shorthand on fol. 3 opposite, and so on. Fol. 3 *v.* Libyca. Fol. 4 *v.* Cimmeria. Fol. 5 *v.* Europea. Fol. 6 *v.* Persica. Fol. 7 *v.* Erythræa. Fol. 8 *v.* Delphica. Fol. 9 *v.* Tyburtina. Fol. 10 *v.* Cumana. Fol. 11 *v.* Lines by J. S., addressed to the Queen, A.D. 1589. Opposite to it the charactery as before. This little volume is most beautifully written on thick vellum, and bound in a very peculiar way. A crimson velvet framework contains a decorative title consisting of a cartouche in the Antwerp, or so called Elizabethan style, with figures, wreaths, &c., painted on a black ground, on a plate of glass, with certain mystic "charactery" in the cartouche, and below it the date 1589. Now in the British Museum, Add. MSS., 10,037.

SEBÈCE, ALAIN. *Copyist.* Saec. XIV.

His name occurs among the copyists, &c., enumerated in an account of the Library of Isabella of Bavaria, wife of Charles VI. of France, in an account of the year 1398.

SEBENICO, GIORGIO DA. *Copyist.* Saec. XV.

Wrote, in 1464, the Third Decade of Livy. Large folio. Vellum, 216 ff. In a hasty Roman minuscule. The first 16 ff. are occupied by table of contents. Then come several pages of blank vellum. Fol. 21 begins the book with a large and handsome bracket

border and two illuminated initials. Throughout the work the remaining initials are merely penned in coloured ink. A medallion, surrounded by a green wreath, in centre of top border, contains a white swan on grass. In the lower border another wreath surrounding an armorial supported by two winged children, a third with wide outspread wings is seated on the top. The arms are : *azure*, a chevron *or*, between three swans *arg.* two and one. At end, in golden minuscules : " Ego Georgius de Sebenico filius et Mathei cōda3 Augustini de Violātis de Spaleto supraŝtum librum Titti Liuij manu mea scripsi et expleui Venetꝑ Cuṙentibus annis Año nⁱ̃i Jesu xp̃i M.cccclxiiii. Indictione tertia decima die quⁱtodecimo mēsis Martij felliciter. Cui sit Laus et gloria per infinita secula. Amen." Now in the British Museum, Add. MSS., 15,286.

Sedlčansky, Joh. Jak. *Copyist and Illuminator.*

Saec. XVII.

A citizen of Prag.

Wrote and illuminated on vellum, between 1620 and 1623, the Psalms of David, as he has handsomely recorded on the last page of the MS. Now in the Monastic Library of Strahov.—*Grueber : Die Kunst des Mittelalters in Böhmen.* Wien., 1871. 4°.

Seelken, Wilhelmus. *Copyist.* **Saec. XV.**

Wrote, in 1453, " Libri Moralium Beati Gregorii." At end : " Hic finiunt sedecim libri Moralium Gregorii papæ, quas scripsit magister Wilhelmus Seelken, &c., anno Mcccc.liii." Now in the Royal Library, Brussels, No. 3,264.—*Marchal : Catal. des MSS., &c.,* ii. 155.

Segaro, { Giambattista. } *Miniaturists.* **Saec. XVII.**
 { Giuseppe. }

Worked at Genoa about 1605–7.—*Zani : Enciclop. Metod.,* xvii. 198.

SEGER, } ANNA. *Miniaturist.* Saec. XVI.
SEGHERS, }

Probably a Daughter of Daniel Seghers.

Famous at Antwerp about 1550. In the Lichtenstein Gallery
are several pen-drawings with her signature.—*Guicciardini : Descrit-
tione di tutti i Paesi Bassi,* 144.—*Nagler : Künstlerlexicon* xvi.
212. *Orlandi : Abeced. Pittor.* (Ven. 1753), 62.

SEGO. *Copyist.* Saec. (?)

Monk of Anchin.

Wrote many MSS., some of which are in the Library at Douai.
No. 93 was written by him :—

"Scripsi solus ego, qui dicor nomine Sego.
Hunc librum totum—debetis [nunc ?] mihi potum."
See AGNESE.

SEGNITZ, JOHANNES. *Copyist.* Saec. XV.

Wrote in a heavy German secretary hand, with many contrac-
tions, "Reise Mandeville's." Paper. Sm. folio, 85 ff. No
ornaments except red initials. At end : "Explicit . . . ꝑ me
Johaēs Segnitz de Castel Moccccxlviiij in die palmarum." Now in
British Museum, Add. MSS., 18,026.

SENCA PAURA, HENRICUS AMSTERDAMMIS, AL. *Copyist.*
 Saec. XVI.

Wrote "Officium Beata Maria Virginis Secm Consuetm Romanæ
Curiæ." Vellum 8° (5½ × 4 in.) 217 pp. It is ornamented with
thirty initial letters, several borders, and miniatures ; and was
executed for Belondo di S. Bixio. On first leaf is the fol-
lowing inscription : "Belondo de Sc. Biaxio di focii pelacan
citadino da Bologna a fatto fare q'sto libro ꝑ sua consolatione e
dal anima e dal corpo. E cosi prega cada una persona a

ch'remagnara questo libro zoe o p heredita o in vendita o in dono ch'pregano dio per luy p amor de dio. Scriptum p h'ricum Amst'dammis al Senca paura Anno do. MCCCC.LXX. die v° xv. Marcii."—*Bragge : Sale Catalogue, No.* 360. *See* AMSTERDAM.

SENFF, FRIEDERICH T. *Painter and Miniaturist.*

Saec. XVII.

Born 1761 at Halle.

In his later years he devoted himself to miniature painting.— *Nagler: Künstlerlexicon,* xvi. 272.

SENGING, MARTIN DE. *Copyist.* Saec. XV.

A Monk of the Benedictine Abbey of Mölk in Lower Austria.

Cahier : Biblioth., 140.

SENIS, BENEDICTUS DE. *Copyist.* Saec. XV.

See SIENA, BENEDETTO DA.

SERBANDUS. *Copyist.* Saec. VI.

Deacon and afterwards Abbot of the Benedictine Monastery of S. Sebastian of Aletri, in Campania.

Wrote, in 541, a Latin Bible which afterwards came from the Monastic Library of Amiate, into the Laurentian Library at Florence.—*Bandini : Dissert. sull' antichiss. biblia creduta dei tempi di S. Gregorio, P.P.* (Ven. 1786, 4°, 18, &c.)

Serbopoulos, Joh. *Copyist.* **Saec. xv.**

A Greek of Constantinople, who worked, however, at Reading in England.

Wrote, in 1494, on paper, sm. 4°, 181 ff. "Θεοδώρου γραμματικῆς εἰσαγωγῆς τῶν εἰς τέσσαρα τὸ πρῶτον." At end, "ἐτελειώθη διὰ χειρὸς ἐμοῦ Ἰωάννου τοῦ Σερβοπούλου Κωνσταντινοπολιτάνου ἐν τῇ ἀββατίᾳ τοῦ Ῥαδίγκ μηνὶ Σεπτεβρίῳ πέμπτη ἐν χρόνῳ τοῦ Κυρίου ἡμῶν χιλιοστῷ τετρακοσιοστῷ ἐνενικοστῷ τετάρτῳ," and two orations of Isocrates. Now in the Library of New College, Oxford. No. ccliv.—*Coxe: Catal.*, &c., 91. Also, on vellum, l. 4°, 518 ff. in 1495, "Εὐστρατίου μητροπ. Νικαίας ἐξήγησις εἰς τὸ πρῶτον τῶν Ἀριστοτέλους ἠθικῶν νικομαχίων." At end: 'ἐτελειώθη ἡ παροῦσα βίβλος διὰ χειρὸς ἐμοῦ Ἰωάννου τοῦ Σερβοπούλου Κωνσταντινοπολίτου ἐν τῇ τῶν Βριτανικῶν νήσῳ Ἀγγλίᾳ ἔν τινι κώμῃ καλουμένῃ Ῥαδίνγ, μηνὶ μαίῳ τῇ τρίτῃ ἡμέρᾳ ἔτους ἀπὸ τῆς τοῦ Κυρίου ἡμῶν Ἰησοῦ Χριστοῦ σαρκώσεως χιλιοστῷ τετρακοσιοστῷ ἐνενηκοστῷ πέμπτῳ ἤτοι αυϟέ: δόξα τῇ ἀγίᾳ Τριάδι." (The numerals are peculiar, ἤτοι is for the customary *vero* of Latin MSS. αυϟέ is intended for 1495. Now in the Library of Corpus Christi College, Oxford. No. cvi.—*Coxe: Catal.*, &c., 37. Also, vellum folio, in two vols., 332 and 294 ff., in 1499 and 1500, neatly written and signed. Dated. Now in Library of Corpus Christi College, Oxford. Nos. 23 and 24.— *Coxe: Catal. Codd. MSS.*, &c., 5.

Serpin, Jean. *Miniaturist.* **Saec. XVI.**

Executed, in 1502–3, some of the miniatures of the magnificent Breviary of Cardinal Georges d'Amboise for the Library of Château Gaillon. Also the initials and other ornaments of "Valère le Grand" for the same patron. "Le xxiii° jour decembre MV° et ung, payé a Jehan Serpin enlumineur, pour vignetes et ung cent de lettres fleuryes faiete en troys cayés du breviaire de nostre dict seigneur Lˢ. Le vi jour de januier audit Cerpin pour avoir recouvert de lettres d'or lenvyronnement de huit histoires du grand livre de Vallère xxxˢ, &c." *Dépenses du Château de Gaillon. Mises pour livres*, &c., 437, 442, 443, *par A. Deville.— Collection de Documents inédits sur l'Hist. de France. Troisième*

série. (Paris, 1850, 4⁰.) Probably this is the copy now belonging to the Duc d'Aumale ; also " Les Epîtres de Sénèque," in which he was assisted by Robert Boyvin. Also " Les troys volumes de la Bible, escries par le soubz prieur des Augustins de Rouen " [Frère Jehan l'Anglois]. Also " Deux volumes des Oeuvres de Sénèque, contenant les Proverbes." Now, perhaps, MS. lat., 6,391, National Library, Paris. Also, in 1508, a " Cité de Dieu." Of this favourite book the Cardinal had two copies : 1.—Now in National Library, Paris, MS. lat., 2,070. 2.—In the Advocates' Library, Edinburgh (1.1.2). His colleagues were Nicolas Hiesse and Etienne du Moustier.—*Delisle : Cabinet des MSS.,* i. 249, 250.—*Deville : Comptes, &c.,* 437, 442.

SERRATI, MATTIA, FRA. *Miniaturist.* Saec. XVI.

A Cistercian Monk.

Highly praised by Libanori. He belonged to the Monastery of St. Bartolo, near Ferrara. He flourished about 1505, not, as Libanori, Zani, and Rio after them, erroneously say, in 1240.— *Cittadella : Documenti, &c.,* 179.—*Ricordi, &c., sul Cosimo Tura,* 21.—*Zani : Enciclop. Metod.,* xvii. 65.

SERTINI, MICHELE. *Miniaturist.* Saec. XV.

A Monk of Sta. Maria Novella, of Florence.

Painted two great Psalters for his Monastery. He died in 1416.—*Marchese : Memorie, &c.,* i. 1789.—*Bucher : Geschichte der Technischen Künste,* ii. 257.

SETA, JACOPO. *Miniaturist.* Saec. XIV.

Famous at Bologna, 1330–50.—*Zani : Enciclop. Metod.,* xvii. 229.

SEWER, PAUL. *Copyist.* **Saec. xv.**

A Monk and Choir-brother of Undersdorf.

Wrote " Io. Tucheri Iter in Palestinam," with many illustrations in 1489.—*Pez : Thesaurus, Anecdd.*, i.; *Diss. Isag*, xi.

SFEDERICUS. *Copyist and Miniaturist.* **Saec. xiv.**

In the Library at Cassel is a Bible written and illuminated by him, completed in 1385.—*Nagler : Künstlerlexicon*, xvi. 325.

SFORZA, FAMILY OF: *Patrons.* **Saec. xv.**

The House of Sforza-Visconti claims a special record as having once possessed the exceptionally notable library which for beauty and value ranked only second to that of Corvinus, and which afterwards became the chief glory of the Collection of Louis XII. The founder of the name of Sforza was the celebrated Condottiere Giovanni Attendolo of Cotignola, a village in the province of Romagna. Beginning as a mere soldier of fortune, he rose, by means of his various distinguished services, to rank and wealth. The name of Sforza was at first merely a by-name given to him in token of his great personal strength. It was accepted by his son, Francesco, who, though illegitimate, was the worthy inheritor of his wealth, his titles, and his abilities. In 1425, the year following his father's death, Francesco accepted service under Filippo Maria Visconti, Duke of Milan, and for fifteen years, during a great part of which his fortunes were mixed up with those of Alfonso V. of Aragon and Naples, and Louis and René of Anjou, continuously increased his reputation both as a soldier and a statesman. In 1441, being then just forty years of age, he had acquired a fair province in the centre of the peninsula, possessed several fiefs in Naples, was lord of one of the richest principalities in Lombardy, and husband of Bianca Maria, only daughter and heiress of the Duke of Milan himself, then the most powerful sovereign in Italy. In 1447, Visconti died, and

Milan was declared a Republic. The names of its last dukes and of Sforza were held in detestation. For three years the heir-presumptive to the dukedom had to maintain a ceaseless struggle against successive factions, which, however, he successively overcame. By dint of a skilful combination of dissimulation, intrigue, and force he induced the self-constituted Republican Government unanimously to resign the sovereignty which it could no longer maintain; and, in 1450, Francesco Sforza made his triumphal entry into Milan as its acknowledged master, and the successor of the ducal House of Visconti. Such was the origin of this distinguished family.

What concerns us immediately here is the encouragement afforded by Francesco and his successors (only three in number) to art and literature. The MSS. executed for him bear the same arms and devices as those of his predecessor, and he considerably augmented the collection. The arms are (*see* Visconti) Quarterly: 1 and 4, *or* an eagle displayed *sa*. 2 and 3 *arg*. the viper, *az*. They occur in many MSS. now in the National Library, Paris (*e.g.*, MSS. lat., 7,855, 8,126, 8,128, 8,381, &c.). The frontispieces of some are further ornamented with two other escutcheons: 1. Vairé, *arg*. and *az*. 2. *gu*., three annulets interlaced, *or*. The latter charge is similar to one of Cosimo de' Medici. (MSS. lat., 6,980, 8,126, 8,382, MS. Ital., 1,023 ("Philipus Henzola scripsit."). Also the arms of France accompanied by his cypher F.S.: Fr.: Fr. Sf.: *or* Fr. Sf., and sometimes the motto A bvn droit (8,128), and merito et tempore (8,126). The cypher of Blanca Maria Visconti, wife of Francesco; bl.m accompanies that of her husband in the frontispiece of 8,128. Some of the MSS. were presented by their authors, as 8,126-7, which bear the arms of Francesco Filelfo the humanist. In 1459 the Ducal camerario, Fabriano, drew up a catalogue of the library, of which perhaps the one kept at the Brera is a copy. It shows that the collection of Francesco Sforza was one of the finest in Italy. Under Galeazzo Maria, his son and successor (1466–76), it was still more increased, for Galeazzo was a lover of art, and a good scholar. He had several MSS. copied during the lifetime of his father, for in the National Library, Paris, we find in 1457, MS. lat., 8,523; in 1458, MSS. lat., 5,791, 6,361; in 1459, MSS. lat., 5,837, 7,779; in 1460, MS. lat., 7,910, 8,560; in 1461, MS. lat., 7,703; in 1462, MS. lat., 5,890; and in 1465, MS. lat., 4,586. Francesco died in 1466. In 1469 Gal. Maria added twenty-six fresh volumes. All his MSS. are ornamented in the same taste as

his father's, with mostly the same arms, and the cyphers G.M. or GZ-MA. The illuminators often put in the margins the doves and the greyhounds with mottoes : ICH VERGES NIT (ich vergess nicht) . MERITO ET TEMPORE . A BON DROIT . MITZAIT (the last may mean either *mit zeit* as a translation of the *tempore*, or possibly *mit rait* —i.e., *recht* for *a bon droit*—MSS. lat., 4,958, 5,889, 7,703, 7,779, 8,550). Another emblem found in the MSS. of Gal. Maria Sforza, and which, according to a contemporary fifteenth century author, recalls the exploits of Galeazzo Visconti, consists of a lion seated, and holding in his paws a knotted twig or stick, to which are suspended two buckets, accompanied with the legend ICH HOF repeated a certain number of times (MSS. lat., 4,586, 4,685, 8,131). Yet a lion crest was granted to Giov. Attendolo in 1401, the year of Francesco's birth. MS. lat., 5,811, has merely three knotted sticks with buckets (probably intended for the burning branch, with water-bouges of Galeazzo Visconti, whose motto used with it was the phrase from Ovid, *humentia siccis*), an emblem and motto which occur in the British Museum MS., 21,413. The knotted stick was an emblem also used by Louis of Orleans, husband of Valentina of Milan. In MS., fr. 343, are added the GZ-MA and the motto MODERATA DVRANT hastily written, possibly by the Duke's own hand. Guido Bonatti has put his signature in 5,811 ; possibly he was the copyist. In MS. lat., 4,586 is the signature of Jeronimus de Murigiis. Leodrisius Cribellus had his arms painted in the front of the "Vita Francisci Sfortiæ" (Johannis?) which he presented to Giov. Maria (MS. lat., 5,889). The Life of Giovanni Sforza, written by this Leodrisius Cribellus, is given in the nineteenth volume of the Rerum Italicarum Scriptores ed. by Muratori.

Giovanni Galeazzo Maria, who succeeded Giovanni Maria (1476 to 1494), added his signature to a volume that had been written for his father, and this seems to be nearly all his contribution to the Sforza Library (MS. lat., 6,355). No trace of any additions by him to the books appears in any MS. in the Paris Collection. Nor is this surprising. Connected, however, with his troubled and ineffectual sovereignty is the famous "Trivulzio Servius on Virgil," sold in New York in 1886. It was executed for the use of Giovanni Galeazzo, and has two full-page illuminations and borders in the contemporary style of Renaissance art of the highest class, executed, it is said, by Ambrosio Marliano. Both the pages have large initials. The border to the first page has at top a Ducal crown and below the Visconti arms, surmounted by two

Sforza crests, a demi-griffin devouring a child, and an aged triton or merman winged, and holding in his hand a golden ring. Among the other historic emblems on the first page is a white greyhound, with loosened red collar, and lodged beneath a tree, near which is a hand issuing from a golden glory. This was a device assumed by Lodovico il Moro. Another is three pomegranates (or quinces?—Ital. *cotogne*) on a red mound, and the motto "met zeit" below. The motto *Merito et tempore* occurs on a device on the left of the border, and above it the three golden rings, interlaced. On the second page, the illuminations are similar, but principally armorial. At foot is the Ducal crown and mantling, with the Dove (turtur) within a golden glory, and the motto A BON DROIT. Portraits of the youthful Duke appear on these pages. In both he is represented as a boy of about fifteen years of age, with golden hair and aquiline features. He holds a flower in his hand, and around one of the portraits is the legend "Sfortia Tertivs." "Il Gran Trivulzo" was one of the guardians of the prince, and the bitter, unrelenting enemy of his uncle, who after being supreme during his Regency, assumed the government on his death. Ludovico, like his brother Galeazzo, had been educated with the greatest care, and was a scholarly and accomplished prince. In consequence of assuming the *moro* or mulberry—emblem of prudence—as his device he was popularly termed the Moor, a conceit that he himself afterwards adopted by a play on the Italian word, which signifies Moor as well as mulberry. On Christmas Day, 1463, when he had attained his twelfth year, he addressed his parents in a discourse written with his own hand, " Ego Ludovicus Maria Sfortia Vicecomes pronunciaui hanc orationem ad illustrissimum principem Franciscum Sfortiam et illustrissimam Blancham Mariam Vicecomitem Mediolani duces parentesque meos anno nativitatis Domini Mcccclxiii. in die natali et manu propria scripsi anno ætatis mee undecimo et mensibus iiii. et diêbus xxii." This very interesting autograph is now in the Royal Library, Paris (MS. lat., 7,855). In the same library is also one MS., and only one—that once belonged to Ludovico,—a Sallust copied, perhaps, at Milan, in 1467 (Fds. La Vallière, 116). In the borders of the two principal folios are the arms as above, with the turtle-dove and greyhound, and the mottoes, A BON DROIT : MERITO ET TEMPORE : ICH VERGES NIT : MIT RAIT (not ZAIT, though probably intended for it). The cipher L.S. painted over the second border, Delisle rightly concludes is intended for Ludovico Sforza, though it is possible that the MS.

may originally have been executed for Lorenzo de' Medici, as suggested in the Catalogue de La Vallière, iii. 139, where this MS. stands as No. 4,886. The Lo. Ma which occurs in the Cicero, No. 2,271 of the same Catalogue with the same emblem of the interlaced rings—a Medicean emblem—may very well stand for Lorenzo Magnifico. It *may* also mean Lodovico Magno. In this MS. the interlaced rings with L.S. are less doubtful. As we have seen, Francesco Sforza the Condottiere, received grants and badges from almost every notable prince in or out of Italy, and the rings may very well have come from Florence, among the rest.

The British Museum possesses two or three MSS. executed for him, and a number of letters, grants, etc., by other members of his family. Thus Add. MS., 14,817, "La Felicità del Mondo," is addressed to Ludovico Maria Sforcia, etc. Burney MS. 175, is a copy of Aul. Gellius. Vell. Fol. 404 ff., written for him when Duke of Bari, and has his insignia on fol. 3, and some once finely coloured initials, now, however, faded and almost colourless. The handwriting is very good. Also Add. MSS., 21,413, a grant of lands in Novara, Pavia, and Milan, to his wife, Beatrice of Este, finely illuminated by Antonio da Monza. It is written on a sheet of vellum 2 ft. ¾ in. by 1 ft. 10¼ in. It is dated January 24th, 1494, the year of his accession to the Dukedom, and three years after his marriage. The name of the scribe was Stephanus Guspertus, of Cremona, the Ducal Chancellor. Altogether, the library formed by the last ten dukes or lords of Milan was one of the choicest ever got together, both for the beauty of the calligraphy and the exquisite perfection of the miniature work to be found within their pages.—*Delisle: Cabinet des MSS.*, i. 125-138.— *Urquhart: Life of Francesco Sforza*, i. 166, &c. ; ii. 188, &c.— *L'Art de Vérifier les Dates*, xvii. 243-274. Most of the devices, etc., are explained by Litta, in his great work, but these we must pass over. This record, imperfect as it is, must not, however, omit to notice those remarkable books, mostly printed volumes, called "Sforziadas," or Records of the Deeds of the Sforzas, more especially Francesco. The exquisitely beautiful volume, now in the Paris Library, No. 9,941 (MSS. Ital., 372) "De Gestis D. Sfortiæ," vellum, sm. fol., is the only MS. copy that I know of. The rest are all printed on vellum. Few MSS. in any library are more magnificently and elaborately painted than this Paris manuscript. The painting is as nearly the absolute perfection of miniature work as it is possible to imagine. Executed with all the

patience and minuteness of a Clovio, or a Hœfnagel, it possesses
the richest brilliancy of colouring added to the boundless inven-
tion of ornamental detail characteristic of the Milanese school of
decoration. Its perfection of finish clearly proves it to be the
work of a miniaturist of the highest rank, such as Girolamo dei
Libri or Antonio da Monza, but it contains no record of the
artist's name. An engraving of the title-page is given in *Müntz :
La Renaissance en Italie, &c.*, 228, and in Count Bastard's Abridg-
ment. The copyist of the text was Bartolommeo Gambagnola, of
Cremona (*see* GAMBAGNOLA). In the pilaster ornaments of a
succeeding page occurs a medallion portrait with the legend :
"LVDOVICVS MA. SF. VICO. DVX. BARI. DVC. GVBERNA," thus
showing it to have been executed during the minority of Gian
Galeazzo. The text is an ordinary Roman minuscule written
slightly above a set of ruled lines. Two initials adorn fol. 1. I
of "Initium et Origo generationis magnanimi et prestantissimi viri
domini Sfortie de Attendolis de cotognola repertum per sereniss.
principem dominum Robertum de baveria romanorum regem in
padua año domini MCCCLXXXXVII." Below this is most elaborate
H. A title in burnished gold capitals begins "Compendio de
Gesti del Magnanimo et Gloriosissimo signore Sforza," &c., &c.
(The word *del* is inserted above the line). The work was com-
posed by Antonia Placentino in the year 1458, in Milan, for
Francesco Sforza, the fourth Duke. An equestrian portrait, said
to be that of Attendolo, occurs under a grand architectural portico
on one of the splendid opening pages, and again in a frame in the
upper right corner of the beginning of, and next to, the text. Is
it possible that the equestrian portrait is a copy of the model
executed by Leonardo da Vinci of Francesco, which has so utterly
disappeared ? As this MS. was most probably executed for
Ludovico il Moro, Leonardo's great friend and patron, for whom he
was constantly busy, it is by no means unlikely that the miniaturist
would, in this very appropriate place, endeavour to commemorate
so important a work. In looking at the miniature we can scarcely
avoid connecting it, however actually unlike, with Da Vinci's
statue, and fancying we see in it the true finished representation
of the lost model, of which only a number of conjectural sketches
now remain. Two other illuminated Sforziadas are known to me
in England. Of course there must be other copies of the two
printed editions of Zarotto, but probably not on vellum, and
certainly not many so beautiful as these. One other is in the
National Library, Paris. This is the copy of the Latin original

that was in the MacCarthy collection. "Ioannis Simonetæ rerum gestarum Francisci Sphortiæ mediolanensium Ducis ab anno 1424 ad annum usque 1466, &c.," libri xxxi. Mediolani, Antonius Zarotus, 1479 (1480), folio. Printed on vellum, and considered to be unique. Petrus Galeratus, who intended this volume as a present to Louis XI. of France, had suppressed the first three folios containing the dedication of Simonetta to Ludovico Sforza, and had replaced them by three others, on the first of which is printed a letter to Louis; but he dying in the interval, Galeratus sent the book to Charles VIII. with a MS. letter, which he added in front. Of the subsequent history of the volume little is known. It emerged again into notice in the sale of the Prince de Soubise's library, when it was bought by Count MacCarthy Reagh, and at the MacCarthy sale for the King of France.

The second is the Italian translation: " La Sfortiada, overo, la Historia delle cose facte dallo invictissimo duca Francesco Sforza, scripta in latino da Giovanni Simoneta, et tradocta in lingua fiorentina, da Christophoro Landino, Fiorentino." In Milano. Ant°. Zarotto, 1490. Folio. 200 ff. At beginning are five separate leaves containing: 1. An Epistle of Fr. Filelfo, addressed to Simoneta, and dated Milano, 1479. 2. Introduction by the translator, addressed to Lodovico Sforza-Visconti. 3. An oration to Lodovico by Fr. Puteolanus, and 4. The preface of the author. At the end of the work: "Questa sfortiada traducta de ser. mone litterale in lingua . firentina, la impressa Antonio . Zarotto parmesano. In Mila.no, nelli anni del signori . M . cccc . Lxxxx . Finis." A book of the greatest beauty, and in the most perfect preservation, being, indeed, the presentation copy to Ludovico il Moro. It has thirty-four initials. The first page (fol. 6) of the Dedicatory Epistle is surrounded by a superbly-painted border, in which occur, in the initial, the portrait of Francesco Sforza and on the border those of Cardinal Sforza, and of Ludovico il Moro, exquisitely finished. The other ornaments and numerous large initials are in the finest taste and most beautiful colouring. Two of the portraits have been engraved: that of Francesco occurring in the frontispiece to the Hibbert Catalogue, and that of the Cardinal in the Bibliographical Decameron of Dibdin (iii. 177). The portrait of Ludovico il Moro is given also on the Vigevano Grant in the British Museum, together with that of his girl-wife, Beatrice of Este. From certain details in the ornament of this grant, and of the Paris MS. Sforziada, it is almost certain that both were painted by the same artist. The Paris MS., therefore, may

with some confidence be assigned to Fra Antonio da Monza, the one able miniaturist who was directly inspired by the instructions and superintendence of Leonardo da Vinci himself. The splendid Italian Sforziada which, as we have seen, was the companion of the Latin original in the Soubise Collection, passed thence into that of Count MacCarthy Reagh, and thence again into that of Mr. Hibbert. It is now one of the gems of the Grenville Library in the British Museum. For accounts of other Sfortiadas the reader may consult Dr. Waagen and Van Praet, as under. Among the MSS. which came into France from Milan, was a collection of about forty, called "La Galliacza," probably distinct from that of Pavia, and consisting mostly of law-books.— *Waagen : Art and Artists in England*, iii. 452—*Van Praet : Livres sur Velin dans la Bibliothèque du Roi*, v. 76.—*Archivio Storico Lombardo Anno primo*, 25 —*Delisle : Cabinet des MSS.*, i. 128, 231.—*Litta : Celebre Famiglie d'Italia, Visconti-Sforza.*—*Ruscelli : V. Impr se*, lib. iv. 32 (Ven. 1583).—*D'Adda : Indagini Stor. Artist. libr. Viscontea-Sforzesca*, pt. i., appendix.

SFORZA, FRANCESCO. *Patron.* Saec. xv.

Duke of Milan. Born 1401, died 1466.

Greatly increased and enriched the Library formed by his predecessors. The volumes copied or bought for Francesco bear generally the same arms as his uncle's, viz., Quarterly : 1 and 4 *or*, an eagle *sa.* 2 and 3 *arg.* la guivre *az.* The frontispieces, however, are often decorated with two other escutcheons : 1. vairy, *arg.* and *az.* 2. *gu.* three rings interlaced, *or.* His arms are often accompanied by his cypher. F.S., FR., F.Sf., or FR.SF., sometimes by A BVN DROIT (as in National Library, Paris, MS. lat., 8,128) or MERITO ET TEMPORE (as in 8,126). The cypher of his wife BL.M. Blanca Maria, accompanies that of Francesco in 8,128. For the books which contain the life and deeds of Sforza, *see* GAMBAGNOLA, and SFORZA, FAMILY OF.

SGUROPOLUS,
SGYROPOULO, } DEMETRIUS. *Copyist.* Saec. xv.

Wrote for the celebrated Francesco Filelfo, two books of the Morals of Aristotle, and the Elocution of Demetrius Phaleræus.

Vellum. 4°. 205 ff. On fol. 118, at the end of the Aristotle : "Magnis Aristotelis moralibus pulchrique bonique Huc usque finem imposuit Demetrius Sguropolus, qui hæc Francisco Scripsit Philepho."—*Bandini : Catal., &c.* iii. 227.—*Silvestre : Paléogr. Universelle,* ii. 56. The volume was completed at Milan, July, 1444, the year of the cruel victory by Amurath II. over the Christians. It has large illuminated initials of the Italian white stem pattern, on coloured grounds, in imitation of enamel. The arms of Filelfo occur on the title-page.—*Montfaucon : Palæogr. Gr.,* 79, 97. He wrote also the magnificent Geography of Ptolemy in 1445, at Florence, now in the Laurentian Library.—*Bandini :* iii. 227.—*Silvestre,* ii. (61).

SHELLEY, GEORGE. *Calligrapher.* Saec. XVII.

Writing Master of Christ's Hospital.

Mentioned as one of the most worthy ornaments of his profession in Tomkins's " Book of Examples of Handwriting."

SHELLEY, SAMUEL. *Miniaturist.* Saec. XVIII.

Born in London, 1750, died 1810.

Was famous for small subject-pictures, such as Abelard and Heloise, and for sentimental pictures and portraits.—*Nagler : Künstlerlexicon,* xvi. 334.

SHIRLEY, SIR JOHN. *Copyist.* Saec. XV.

Transcribed many of the poems of Chaucer, Lydgate, &c. Some are now in the British Museum (Add. MSS., 16,165. Paper. Fol. 258 ff.); Harley 2,251. (Paper. Fol. 293.) Others in the Ashmole Library at Oxford (59); and in the Library of Trinity College, Cambridge (R. 3. 20). The handwriting varies from a fairly regular Chancery hand to a tremulous cursive, as if in keeping with the advancing years of the enthusiastic copyist. The Harley Manuscript seems to have been the earlier copy. It has red and blue flourished initials.

Siegmund. *Copyist and Illuminator.* Saec. ix.

A Monk of Herschau.

> After 894, Bishop of Halberstadt, where he died, 924.—*Nagler :
> Künstlerlexicon*, xvi. 367.

Sieher, Fridolin. *Calligrapher and Miniaturist.*
 Saec. xvi.
A Monk of St. Gallen.

> The following MSS. are attributed to his hand both for writing
> and illumination : 1. "Missale Diethelmi Blarei ; Exposit.
> Cæremoniarum."—*Haenel : Catalogi*, 688, Nº. 351. Five others
> are given by Haenel, namely 696 (532), 696 (533–8), (539), (542).
> The last is an Antiphonale with Calendar, Part II. Easter to
> Advent, written 1544. Lastly, "Joachim Vadiani epitome trium
> part. terræ habitatæ."—*Weidmann : Geschichte, &c.*, 432.

Siena, Benedetto di Paolo da. *Copyist.* Saec. xv.

A Franciscan Monk of the Hospital of Sta. Maria
della Scala at Siena.

> Worked at Siena between 1475 and 1490. Wrote a Gradual
> now in the Piccolomini Library, at Siena. *See* Rossini.—
> *Milanesi : Nuove Indagini* in *Lemonnier's Vasari*, vi. 237.—*Zani :
> Enciclop. Metod.*, xvi. 19. *See* Rinaldo, Don B.

Siena, Bernardino da. *Miniaturist.* Saec. xv.

> Worked about 1474—*Zani : Enciclop. Metod.*, xvii. 259.

SIENA FRANCESCO DA. *Miniaturist.* Saec. xv.
Called F. di Stefano.

Worked about 1446–50.—*Zani: Enciclop. Metod.*, xvii. 258.

SIENA, MATTEO DA. *Miniaturist.* Saec. xv.

Is considered by Della Valle to be the painter of a Missal executed for Cardinal Enea Piccolomini, afterwards Pius II., in which, after the calendar, we read : " Istud missale fecit scribere R^{mus} in xp° pat. et dom. Dñs Eneas de Piccolominib. Cardinalis Senensis anno Dñi Mccccxlvi." Two angels, on the frontispiece, support the arms of the Cardinal within a green wreath and decorated with exquisite arabesques on an azure ground. The faces of the angels are like those painted on the altar of the Madonna della Neve by Matteo da Siena. The miniatures of the initials are by another hand, and are wretched.—*Della Valle : Lettere Senese*, ii. 245.

SIENA, MERLO DA. *Miniaturist.* Saec. xvi.

Worked about 1500.— *Zani : Enciclop. Metod.*, xvii. 260.

SIFREWAS, JOHANNES. *Illuminator.* Saec. xv.

Executed the illuminations, including beautifully-figured initials containing royal heads, of the Louterell Psalter in the British Museum. He is also said to be identical with the Johannes Was who illuminated the famous Sherborne Missal, now in the possession of the Duke of Northumberland. This MS. formerly belonged to the Abbé Rothelin, at whose sale it came into the hands of the President Foucault, who in a letter to M. de Gaignières describes

his purchase: "20 Mars, 1703. J'ay faict un voyage à Lisieux le plus heureux que je feray de ma vie. M. l'Evesque m'ayant donné un missel qui est la pièce la plus curieuse que vous ayés veue. Il a esté faict à l'abbaye de Schurborn en Angleterre, qui d'évesché quelle estoit est devenue abaye. Il est plus gros et plus grand que les livres de chant du plus grand volume qui soient dans les Eglises. Les armes et les portraits au natural des roys, fondateurs, évesques et abés, y sont peintes en belle mignature ; l'établissement des ordres et le temps de la naissance des anciennes hérésies en Angleterre y sont marqués et il y a une infinité de choses curieuses et de traits d'histoire que l'on trouve dans ce livre, qui d'ailleurs est enrichi de vignettes de testes naturels d'hommes, d'oiseaux, de bastimens, est de mile autres choses. Le nom du moine qui les a faict est escrit dans le livre, en plusieurs endroits mais la datte du temps au quel il a esté escrit n'y est point. On présume, cependant par beaucoup de circonstances, qu'il doit estre du mileu du quinzième siècle. J'espère vous le faire voir un jour ; mais comptés qu'il n'y a rien de plus beau dans le cabinet du roy."—*Delisle : Cabinet des MSS.*, i. 176. The Abbé Rothelin, at whose sale the Sherborne Missal was given away for 18 livres 10 sous, thought the MS. belonged to the time of Edward III., and probably between 1354 and 1369.—*Catalogue des Livres de l'Abbé de Rothelin*, x. xi. He was mistaken, and Foucault was right. The work is that of John Was or Sifrewas, and dates from the early years of the fifteenth century, *i.e.*, from the reign of Richard II. Since Foucault's time the MS. figured in the sale of M. de Selle, where De Bure says it did not find a buyer.—*Bibliographie Instructive Théol.*, 190. But if not, it was reserved at the price of 800 fr. (De Bure says "mille livres"). It is No. 81, entitled, "Missale ad Usum Monasterii Shisburn (Sherburn), in Anglia Ordinis S. Benedicti." MS. sur vélin du XIV. siècle très bien conservé, décoré de miniatures singulières qui regardent les églises, les monastères et les familles d'Angleterre. Très grand in fol. mar. r."—*Catalogue des Livres de la Bibliothèque de feu M. de Selle, Trésorier-Général de la Marine*, 9, *No.* 81 (Paris, 1761).

Sighicello Giov. di. *Miniaturist.* **Saec. xiv.**
Worked at Bologna in 1390.—*Zani : Enciclop. Metod.*, xvii. 269.

SIGISMUNDIS, SIGISMUNDUS DE. *Copyist.* Saec. xv.
A native of Ferrara.

One of the most distinguished copyists and calligraphers of his time. He calls himself "Comes Palatinus," which gives occasion to Zani to descant on the example of a nobleman—a count, whom he calls a native of Lucca—devoting himself to the labours of the scribe. The title, however, probably means no more than that he was employed in the palace. He seems to have worked chiefly in Florence, among the number of those employed by, or on behalf of, King Matthias Corvinus of Hungary. In 1488 he wrote for this patron :—

1. "Commentarii Hieronymi super Matthæum." Folio. Vellum, 238 ff.—*Denis : Catal., &c.*, i. 862. No. 247. In a most elegant handwriting, and illuminated with magnificent borders, initials, and miniatures. Fol. 1*v*. In a wreath or garland, rich with fruit and flowers, is the title, in golden capitals on blue circular disc : " In hoc volumine haec continentur, Divvs Hieronymus in Matheum, in Marcum, in Ecclesiasten, item quaedam al¹a opuscula." On fol. 2 opposite is a rich border, in the medallions of which are figures of Christ and the Evangelists ; also of Corvinus, Μουσαγέτου, with his arms and emblems. In the initial "P" is the figure of the learned commentator in the act of writing. Fol. 206 has a fine Medusa's head. Fol. 215: "Vita beate Marie, secundum Epiphanium," and "Vita beate Virginis Marie secundum Hieronymum." Fol. 222 begins another work, with a border of trophies and fine initial "E." And so on. At end : "Scriptum hoc opus per me Sigismundum de Sigismundis Comitem Palatinum Ferrariensem, anno domini MCCCCLXXXVIII., mensis Octobris die xviiii." Now in the Imperial Library, Vienna, Cod. CCXLVII. It has been thought by some that the blue ground of the title is a distinctive mark of the work of Attavante, as compared with the crimson grounds of Gherardo and others, but here the illumination is in quite a different style from any other work of Attavante. The wreath of chestnuts, oranges, apples, quinces, grapes, acorns, &c., shows Netherlandish influence, such as it is known was followed by Gherardo. There are four armillary spheres at the four corners of the page, and the wheat-ears are especially prominent, and a belt or band like the K.G. garter binds the wreath in the middle of each margin. The whole is surrounded by an abundance of fringed golden globules. Altogether the work looks more like that of the Neapolitan illuminators

than of the Florentine. The panel on fol. 2, beginning, "Incipit præfatio," is a rich blue violet with golden capital letters. The scene of Jerome in his study is most interesting in its details of ordinary life. The panel on each side is a deep rich sap green with golden letters : "Plures fuisse " . . . down to "serit." The arms of Corvinus at foot differ slightly from their usual form. The children are pinker than those of Attavante, which shows decisively that they are not Neapolitan ; but the foliage colours are much the same as his, quite following the Florentine manner. The portrait of Corvinus is very finely painted, and the Christ with the orb.

2. Another MS. written by Sigismundus was, "Ambrosii Epistolæ quædam." Vellum. Fol. 281 ff. Fol. 1. Finely illuminated, and bearing the arms of Leo X. as Giovanni de' Medici, and as Pope. In the initial letter is the figure of St. Ambrose in pontificals, with a book in his left hand. At the ends of chapters xiii. and xvi., and also at the end of the work (chap. xix.) is the signature of the copyist. At chap. xiii., in red: " Expliciunt quædam epistolæ Beati Ambrosii Episcopi Mediolanensis. Die 28 Junii Mcccccl.xxxix., per Sigismundum de Sigismundis. Carpen. in Florentia." After chap. xvi. occurs the date, 15th September, 1489, and at end: " Explicit hoc opus per me Sigismdum de Sigismdis Fer. anno Dominicæ Incarnationis Domini nr̄o Jesu Christi Mccccclxxx. die xiv. Octobris. Florentiæ." Now in the Laurentian Library.—*Bandini: Catal.,* i. xiv. 6.

3. "Gregorii Papæ Moralia super Job." Pts. I., II. Forming two volumes. Fol. Vell. In vol. i., fol. 8, the Prologue has a splendid title, surrounded by illuminations, among which are the Medici arms. Finished in 1492. Vol. ii., on fol. 6, contains the date, 1493. Fol. 7 begins lib. xix. with finely illuminated initial and title, the Medici arms as before. The title is in alternate gold and blue capitals. At end : "Expliciunt Moralia B. Gregorii Papæ Urbis Romæ in Libro Job manu Sigismdi de Sigismundis Ferrariensis anno dñi millesimo quadringentesimo nonagesimo tertio die prima Augusti in ciuitate Florentina per Magnif. Dom Petr. Medicem," &c. There is an illuminated initial at the beginning of every book. Now in the Laurentian Library.—*Bandini: Catal., &c.,* i. xviii. 1, 2, col. 457, &c.

4. "Symbolum D. Gregorii," &c. Written at Florence, March 18, 1499, " per me Sigismundum de Sigismdis Ferrariensen." Vell. Fol. 447 ff. With beautiful initials and other ornaments. Now in the Laurentian Library.—*Bandini: Catal., &c.,* i. xviii. 3.

5. "D. Hieronymi Expositio in Isaiam Prophetam." Vellum. Fol. 447 ff. Most splendidly illuminated, and with Medici arms and various emblems. At end: "Hoc opus scriptum fuit per Sigismundum de Sigism^dis vi₃ manu sua anno incarnatiõis Dominicæ MccccLxxxxi mensis Octobris xiv. in Florentia per Magnificum et Potentem Dom^m Laurentium Medicem patriæ suæ patrem *ac heredum suorum.* Sit laus semper Domino nřo Jesu Christo ac toto cœleste curiæ triumphanti. Explicit fœliciter. Amen. Deo Gratias." This MS. may compare for beauty with that executed for Corvinus. It is now in the Laurentian Library. —*Bandini: Catal., &c.,* i. xix. 2.

6. According to Raczynski he also wrote one of the Bibles of Belem, now kept in the Torre do Tombo, Lisbon. "Il a fait en 1495 l'une des riches bibles de Belem qui se trouve maintenant à la Torre do Tombo. Une autre porte la même date et la signature de Alexandre Verzanus ; la troisième est de l'année 1496, et ne porte pas de nom d'auteur ; le quatrième, cinquième et sixième ne presentent ni date ni nom ; la septième porte la date de 1497." —*Raczynski: Lettres,* 237. *Dictionnaire,* 273.

As to the second and remaining volumes of this collection, we learn from another source that they were actually the work of Attavante and the other miniaturists and calligraphers employed at Florence by Lorenzo de' Medici. It is said that they were given to the monastery of Belem by Julius II., or rather to King Manuel of Portugal in return for a nugget of pure Indian gold sent to the Pope as a present. During the Peninsular War the volumes were carried off, and much search was made for their recovery. Eventually, Louis XVIII. got possession of them, and sent them to John VI., who restored them to the Royal monastery. Count Raczynski, who examined them minutely, says that not only Father Sousa, but many other amateurs, consulted only the first volume, and gathered from it the conclusion that all the rest were written by the same scribe and finished in the same year. The first, no doubt, was finished in 1495 by Sigismundo de' Sigismundi of Ferrara, but the second, though finished the same year, was written by Verazzani ; the rest are unsigned, as stated above. Who was the Portuguese connoisseur who started the notion that the miniatures were done by Giulio Romano? It is astonishing that any one should be so ignorant, or could suppose his readers so credulous, as to believe such an anachronism, quite apart from the style of the work itself. "Questia Bibbia noi crediamo che sia quella medesima che Clemente Sernigi allogò

a miniare, insieme col libro del Maestro delle Sentenze, ad Attavante, con strumento del 23 d'aprile 1494, rogato da Ser Giovanni Carsedoni notajo fiorentino."—*Vasari: Le Vite, &c.* (edit. Milanesi, iii. 235). *See* FRANCISCO DE HOLANDA.

SILVESTER. *Copyist.* Saec. XV.

Wrote "Salustius in Catellinario et Jugurta, cum expositione." Paper. 8º. In a beautiful half-Gothic text, with initials. In the first initial is an arm carrying a sword. On the last page : ' Scriptum ponzani per me Silvestrum bartholomei de fabrica, 1464. Mense Januario die xv." Now at Monte Cassino, No. 393.— *Caravita : I Codici e le Arti a Monte Cassino,* ii. 317.

SILVESTRO. *Miniaturist.* Saec. XIV.

A Camaldolese Monk of the Convent of Sta. Maria degl' Angeli, at Florence (founded 1294), and a pupil of Taddeo Gaddi.

Together with a fellow monk, named Jacopo, worked on the Choir-books of the foundation, and executed such grand miniature initials, that the books became the admiration of all who saw them. They were especially praised by Lorenzo de' Medici, and Leo X. would gladly have transferred them to Rome had they been written conformably to the Roman usage. Vasari seems to confound his work with that of Don Lorenzo ; speaking of certain Choir-books, as illuminated by him, which were written by Don Jacopo Fiorentino, who was "il migliore Scrittore di Lettere grosse, che fosse prima e sia stato poi non solo in Toscana, ma in tutta Europa ; come chiaramente ne dimostrano non solo i venti pezzi grandissimi di Libri da Coro, ch' egli lasciò nel suo monasterio, che sono i più belli, inquanto allo scritto, e maggiori che siano forse in Italia, ma infiniti altri ancora, che in Roma, e in Venezia, e in molti altri luoghi si ritrovano, e massimamente in San Michele ed in San Mattia di Murano, monasterio della sua religione Camaldolense." Vasari then goes on to speak of his

right hand being religiously kept as a relic by the fraternity together with that of another monk, Don Silvestro. It is a fact that two hands are preserved, but it is not so certain to whom they belonged. In his first edition Vasari assigned both of them to Don Lorenzo. And they certainly appear to have been the hands of one person, not only from the fact of one being right, the other the left, but from their similarity in form and size. Don Silvestro, continues Vasari, " minio i detti libri che gli avesse scritti Don Jacopo." Now from this it would seem as if Don Jacopo were simply a copyist, and Don Silvestro a miniaturist. But Cicognara thinks otherwise (*see* LORENZO). At any rate, Vasari, who says he has seen these Choir-books often, does not appear to know the difference between the earlier work of Silvestro and Jacopo, and the later work of Lorenzo, for it is of the latter that he speaks when he mentions how the books were admired by Leo X. Unhappily it is no longer possible to compare notes. Of the twenty Choir books referred to which passed into the Laurentian Library, seventeen are without miniatures, two are mutilated, one only appears complete, and this bearing the date of 1410,—the year probably of its completion by the copyist,—cannot have been the work of Don Silvestro, as he died many years previously. The more complete are the Diurno Domenicale containing the Missæ from Easter to Trinity Sunday, and the one containing those from Trinity to Advent. On the third folio of the former, within the initial, is the date : " Anno Domini Mccccix. completum est hoc opus," and its miniatures correspond with this date. The other has a similar inscription with an initial O, but with the year Mccccx.; but here the miniatures do not correspond; they manifestly belong to a later period, so that the date must refer only to the completion of the writing. This opinion is shared by Cicognara in his letter to the Canonico Moreni. In 1350 Silvestro painted the Choir-book— afterwards badly mutilated—out of which Mr. Ottley had a series of large initials. One containing the Death of the Virgin was 14 inches high. In the National Library, Paris, is a Bible with miniatures attributed to Silvestro.—*MS. fr.*, 6,829. Waagen says it recalls in some respects the manner of Spinello Aretino, and some of the earlier works of Gentile da Fabriano. It is probably the work of several artists.— *Waagen : Künstwerke u. Künstler* in *Engl.*, i. 401.—*Ditto*, in *Paris*, iii. 343, 345.—*Nagler : Künstler-lexicon*, xvi. 415–416.—*Rosini : Storia della Pittura Italiana*, ii. 103 (Pisa, 1848).—*Vasari : Vite, &c.*, ii. 213, 214, note (*Lemon-nier*).— *Cicognara*, in *Antologia di Firenze*, xxii. (1826).

Silvestro, Giov. di Fra. *Miniaturist.* Saec. xv.

Of Bologna.

> But living at Siena, brought an action in 1429–30 against
> Giuliano de' Nelli, of Florence, to recover payment for illumination
> done by the artist in a certain "Lectura."—*Milanesi: Documenti
> dell' Arte Senese,* ii. 154.

Simon, Fabro del. *Copyist.* Saec. xv.

Perhaps the same person as Simone d'Alemagna.

> Given under 1458 in documents preserved at Ferrara.—*Citta-
> della: Notizie,* 639.

Singleton, Jos. *Miniaturist.* Saec. xviii.

> Exhibited at the Royal Academy from 1773 to 1784.—*Redgrave:
> Dict., &c.*

Singleton, Wm. *Miniaturist.* Saec. xviii.

> Exhibited at the Royal Academy from 1779 to 1791.—*Redgrave:
> Dict.*

SINIBALDI, ANTONIO. *Copyist.* Saec. XV.

One of the most justly-celebrated transcribers of MSS. coeval with the invention of printing.

It was from the handwriting of such copyists as Sinibaldi that Aldus and others formed their types; the beauty and regularity of the handwriting not only equalling, but sometimes surpassing, anything that could be produced by typography. The works of this skilful and industrious penman are well known, and copies of the magnificent MSS. executed by him are found in several of the great public libraries of Europe. Delisle counts half a score at Paris and elsewhere. Wherever found they are among the most perfect in existence. The following list embraces the majority of them. *See* MATTHIAS CORVINUS.

1. "Prudentius." Copied at Florence in 1481. Now in the Vatican Library (Cod. Urbin. 666).—*Dressel: Aurelii Prudentii Clementis quæ extant Opera,* lix.

2. "C. Suetonii Tranquilli de XII Cæsaribus liber et alia." At the end is this note: "Antonius Sinibaldus Florentinus illustrissimi Domini Dõ Joannis de Aragonia familiãis *exscripsit* Neapoli. MCCCCLXXVII. Jun. xxv. On fol. 1 are the arms of the original owner. The page is surrounded by a beautiful border, containing a medallion of Julius Cæsar. The headings of all the Lives have on the front of the leaf a border, in the lower part of which is a portrait of the Emperor. The initials are exquisitely painted, and the character of the handwriting is an especially beautiful minuscule. Every page except the first of each Life contains twenty-five lines. The MS. was at one time in the possession of the Duke of Altaemps. And also in that of the Chancellor of Cleves, Daniel Weinmann, and was presented by him to the Elector.—*Wilken: Geschichte der Königl. Bibliothek zu Berlin,* 225.—*Pertz: Die Königl. Bibl. zu Berlin in den Jahren* 1842 *bis* 1867, 33.

3. "Il Canzonieri ed i Trionfi di Francesco Petrarca." Dated Sept. 30, 1476. Now in the National Library, Paris.—*Marsand: I MSS. Italiani della Regia Bibl.,* i. 800.

4. "Divi Hieronimi Breviarium in Psalmos David." Vell. Fol. 370 ff. One of the most splendid MSS. in existence. Fol. 1 *v.* The title of this superb MS. is written in golden capitals on a blue disk in the midst of a finely-painted frame-border. DIVI HIERO . NIMI BREVIARI . VM IN PSALMOS . DAVID

FELICI . TER INCI . PIT . within a gold moulding surrounded in the usual Attavantesca manner with foliages, flowers, and globules of gold. In the four corners of this border, outside the disk, are placed four devices of Matthias Corvinus, thus showing at a glance for whom the MS. was executed,—viz., the dragon with tail twining around his neck, the flint and steel, the hour-glass, and the well, over which is hung a bucket attached to a pulley. On fol. 2 commences the text, surrounded by a rich border formed of arabesques or scrolls of fine acanthus foliages, among which are placed six portraits, the arms of Corvinus, four of his devices,—the hive, well, hour-glass, and barrel,—and again the royal arms supported by two draped angels. The arms are quarterly : 1. Barry of eight *arg.* and *gu.* (Hungary) ; 2. *gu.* a patriarchal cross *arg.*, *alésée and plantée* on a triple hill vert (Hungary) ; 3. *az.* three leopard heads crowned *or* (Dalmatia) ; 4. *gu.* a lion *arg.*, crowned *or*, his tail knotted, and then borne double and saltirewise (Bohemia), and over all a shield of pretence *arg.* bearing a crow *sa.* perched on a twig *vert*, and holding in his beak a ring *or* (Corvinus). The general appearance of this MS. is like that of the Martianus Capella at Venice ; both, undoubtedly, as to illumination, the work of Attavante. The initial " P " to the first page contains a portrait of St. Jerome in the loop, and a scroll of fine ivory foliage below on a gold ground. The book is beautifully written throughout in the small, round minuscules usual to Sinibaldi, Verazzi, and other copyists of the time. At end : " Explicit tractatus sancti hieronomi presbiteri in numerum cl. Psalmi. Antonius sinibaldus . florentinus quondam regis ferdinandi regis sicilie scriptor et librarius exscripsit florentie anno dñi MCCCCLXXXVIII. ultimo men. februarii pro serenissimo math. rege ungharie virtutum cultore ac alumno." In small letters on the first page are the words : " Attauantes pinsit." A number of reference figures of various dates are written on the fly-leaves, and lastly on a ticket pasted inside the first back. Latin, 16,839. Now in the National Library, Paris. It is described briefly in the La Vallière Catal., 1, 162 and Addit., 20. I carefully examined this MS. in 1878 in connexion with my studies of Attavante, whose work it certainly is.

5. A book of Hours, exhibited at the Paris Exhibition of 1878, which had belonged to Cardinal della Rovere, at end of which is the signature : " Antonius Sinibaldus scripsit pro dignissimo Donato Perut. Anno Domini MCCCCLXXXXI. Florentiæ."—*Delisle: Cabinet des MSS.*, iii. 359. Now in the Royal Library, Berlin.

6. A fine Service Book called the Prayer-book of Duke Albert IV. of Bavaria. Now at Munich (Cimelien S. V. a. 9, *Catal.* No. 42, marked zz 639.) (zz means author or artist unknown.) Small 8vo. Bound in marvellously rich covers of goldsmith's work, clasped *at back* with five clasps, of silver inlaid with enamel, under which is a binding of crimson velvet; one cover contains two flowers in ovals and a central lozenge enclosing the Angel of the Annunciation, the other cover contains the remainder of the subject. Two gold clasps out of three remain on the front of the book. The illumination of this precious MS. is in the style of the little Clementine (Medici) books in the British Museum, *i.e.* the "Boethius" (Lansd. 842) and the "Vita di Manetti" (Add. MS., 9,770). (*See* VERAZZO.) The initials are like those of the Paris "Hieronymus," and altogether the illumination suggests the hand of Attavante. But the miniatures do not support this attribution. Possibly more than one artist may have worked on the volume. As we examine the pages the ornament recalls the "Philostratus" of Vienna and the rich "Diurnale" of the Laurentian Library. On fols. 91 *v.* and 92 is a beautiful miniature of the Raising of Lazarus, and the initial "D" opposite contains the story of Adam and Eve. Below the latter are the arms of Bavaria. There are many small yellow fruits and wreaths of green, and an infinitude of small golden studs. The little central circlets at foot have rings of cherubs and jewels. Fols. 155 *v.* and 156 are the richest pages in the book. On the left is a fine miniature of David with harp, evidently executed by a painter accustomed to larger work. On a crimson ground are bunches of all manner of fruits, but mostly oranges (the apples of the Hesperides) with floating children. A gorgeous escutcheon at foot presents the arms of Bavaria. On a blue ground are rings of gold, separated by golden anthemions, and enveloped with a perpetual fluttering wreath of white ribbons all round the main ornaments, and a repetition of the word "semper." This would seem to indicate that the book originally belonged to one of the Medici, and was presented to the Duke of Bavaria. It appears distinctly to have been executed at Florence. In the "D" opposite to the miniature is a David with the head of Goliath. But it is impossible to give an adequate idea by mere description of the rich and fascinating beauty of the work. On fol. 156 is a miniature of the Crucifixion. In the opposite "D" a Christ before Pilate. On fol. 220 the Deposition from the Cross, and, in the opposite "P," Jesus praying on the Mount of Olives.

These are the last pictures. At end : "ANTONIUS . SINIBALD^S . SCRIPSIT . AN . D . MCCCCLXXXV." The only MS. that in my mind can be compared with this, is the marvellous little Prayer-book of the Duchess Leonora of Urbino, in the Douce Collection (No. 29) at Oxford.—*Serapeum :* 1844. 84.—*J. W. B.: MS. Notes, &c.*

7. Sinibaldi must have been busy in this year 1485, for, in the Laurentian Library is a "Lucani Poetæ Cordubensis Pharsalia." Libri X. Vellum. Small 4°, 115 ff. Adorned with most lovely illuminations, and containing the arms and devices of the Medici. In a golden circlet on a blue (?) ground and in golden capitals, is the title, and at beginning of text is an illuminated initial "Q" of "Quis furor, O cives," &c., while in a golden circlet at top of page are the letters, GLOVIS, about which Bandini blunders so amazingly ("nomen fortasse pictoris"). Except at the beginning, the spaces for the initials are left vacant. At end : "Antonius Sinibaldus scripsit. Anno Christi, MCCCCLXXXV."—*Bandini : Catal., &c.,* II., xxxv. 2.

8. In this same year, 1485, still another MS. claims to come from the same busy hand, which surely must have been as unresting as that of Sir Walter Scott, but with much greater need for delicacy of manipulation,—"Virgilius," also in the Royal Library at Munich.—*Duchesne : Voyage d'un Iconophile,* 19.

9. "Lotharius Lævita et Cardinalis de utilitate Condicionis humanæ." Written MCCCCLXXXVIIII.—*Bandini : Catal., &c.,* I. xxi. 17.

10. "Augustini Quæstiones." On fol. 1 of this noble MS. is a figure of St. Augustine in Pontifical vestments and the arms of Leo X. The MS., however, appears to have been originally executed for Matthias Corvinus, and to have been among the number purchased at his death by Lorenzo de' Medici. At end, on fol. 300 : "Antonius Sinibaldus Florentinus scripsit Florentie. Anno Dom. MCCCCLXXXVIIII: pro sereniss. Matt. R. C. Vngarie." *Bandini : Catal., &c.,* I. xii. x. Bandini adds that the MS. just preceding this (No. IX.) is probably by the hand of Sinibaldi though not signed, and also No. XIII. Both are beautifully written and illuminated.

11. "Ambrosii Varia." Vell. Fol. 267 ff. Forming a frontispiece to this volume are seven circular titles, presenting the works contained in it, while on the opposite page is a large illuminated initial with various emblems, and in the lower margin the arms of Lorenzo de' Medici, supported by two nude winged

children, as in the British Museum Boethius (Lansd., 842), *cf.* the Bodley "Propertius" (Can. lat., 31). The initials to the separate books are splendidly illuminated. At end in red : "Antonius Sinibaldus scripsit Florentie."—*Bandini : Catal.*, i. xiv. xxiii.

12. "Augustinus adversus Julianum" [hæreticum]. Vell. Fol. 255 ff. The first page on fol. 1 *v.* is most elaborately illuminated, and contains the Medici arms and emblems ; and opposite, as usual, a series of circlets containing the titles of the various contents of the volume. The remaining large initials to these sections are also illuminated. At end : "Antonius Sinibaldus scripsit A. D. MCCCCLXXXXI., xv. maij."— *Bandini : Catal.* i. xii. viii. (c. 13).

13. "Horatii Opera." Written for Cardinal John of Aragon. Now in the Escorial Library.—*Hænel : Catt.*, 948, ii. 5.

14. "Chrysostomi adversus Vituperatores Vitæ Monasticæ. Interpr. Ambros. Monacho Camaldulensi." Dated 1461. In the Library of the Canons Regular of Fiesoli.—*Montfaucon : Diarium Ital.*, cap. xxvi. 392. Signed, "Sinibaldus scripsit MCCCCLXI."—*Catal. de La Vallière, Additions,* 22.

15. Another MS., written by Sinibaldi, is cited in the same catalogue (Additions, 22), with the signature : "Antonius Sinibaldus veloci calamo exaravit Florentiæ, 20 Septemb., 1481," but no mention is made of its locality.

SINTRAMN. *Calligrapher.* Saec. IX.

Called "Sintramn of the wondrous hand." A Monk of St. Gallen, famous for his skill, above all others of his profession.

He copied the famous Gospels called the "Evangelium Longum," to which the diptychs of ivory used by Charlemagne, and which the monk Tuotilo had enriched with sculptures, served afterwards as covers.—*Cahier : Nouveaux Mélanges d'Archéologie, &c., Bibliothèques,* 131. This Gospel-book was Sintramn's masterpiece. Speaking of it, Ekkehard the younger says : "Hoc hodie est evangelium et scriptura, *cui nulla,* ut opinamur, *par erit ultra.*"—*Ekkehardus : De casibus Monasterii S. Gall.,* i. cap. xxii. The MS. is now at St. Gallen, No. 53.—*Rahn : Das Psalterium Aureum von Sanct Gallen,* 49.

Sivesta, Martino. *Miniaturist.*　　　Saec. xvi.
Lived 1500–40.
Worked in Spain.—*Zani: Enciclop. Metod.*, xvii. 300.

Skeysert, Clara. *Miniaturist.*　　　Saec. xvi.
A famous miniatrice of Ghent.
Vasari: Le Vite, &c.—Orlandi: Abeced. Pittorico, 124 (Venezia, 1753, 4°).

Skirving, Archibald. *Miniaturist.*　　　Saec. xviii.
Born in Haddingtonshire, 1749.
Studied at Rome about 1794. His miniatures are excellent in drawing, colour, and expression. Died 1819.—*Redgrave: Dict.*, &c.

Slater, J. W. *Miniaturist.*　　　Saec. xviii.
Practised in Dublin about 1770. Came to London and exhibited at the Royal Academy 1786–7. His miniatures are good.—*Redgrave: Dict.*, &c.

Smart, J. *Miniaturist.*　　　Saec. xviii.
Born 1740.
In 1755 he received the premium of the Society of Arts for a head in chalk. He was a pupil of Dodd, and fellow-student with

Cosway at the St. Martin's Lane Academy. Exhibited at Spring
Gardens in 1762-3-4, and occasionally till 1783, and became
Vice-President of the Society. In 1788 he went to India. Occa-
sionally exhibited on his return until 1811, when he died. His
miniatures are usually signed " J. S."—*Redgrave: Dict.*, &c.

SMART, SAM. P. *Miniaturist.* Saec. XVIII.

 Exhibited from 1769 to 1787 at Royal Academy.—*Redgrave:
Dict.*, &c.

SMITH, MARGARET. *Miniaturist.* Saec. XVIII.

Daughter of James Smith and wife of Sir Charles
Bingham, Baron Lucan, created Earl of Lucan in
1795.

 Her miniature work is first mentioned in Vertue's MSS. Wal-
pole says of her that she had "arrived at copying the most ex-
quisite works of Isaac and Peter Oliver, Hoskins, and Cooper, with
a genius that almost depreciates those masters, when we consider
that they spent their lives in attaining perfection, and who, soaring
above their modest timidity, has transferred the vigour of Raphael
to her copies in water colours."—*Walpole: Anecdotes of Painting
in England.* (Advertisement to vol. iv. of the original edition.
Also edit. 1798, ii. 425.*) The work by which she distinguished
herself most signally was the illustration, in five folio volumes, of
Shakespeare's Historical Plays, now kept in the Spencer Library at
Althorpe. " During sixteen years this accomplished lady pursued the
pleasurable toil of illustration, having commenced in her fiftieth,
and finished in her sixty-sixth year. Whatever of taste, beauty,
and judgment in decoration by means of portraits, landscapes,
houses and tombs, flowers, birds, insects, heraldic ornaments and
devices, could dress our immortal bard in a yet more fascinating
form has been accomplished by a noble hand, which undertook an

 * Wornum's Edit. I. xviii.

Herculean task ; and with a truth, delicacy, and finish of execu-
tion, which have been very rarely imitated."—*Dibdin : Ædes
Althorpianæ*, i. 200. It would be difficult to say which of these
two flattering accounts is the more extravagant. Walpole is
smartly rebuked by Walcot in the following verses :—

> " Do not to Lady Lucan pay such court,
> Her wisdom will not surely pay thee for 't ;
> Ah ! don't endeavour thus to dupe her,
> By swearing that she equals Cooper."—*Redgrave.*

And excessive raptures over illuminations is one of Dibdin's
prominent characteristics. His enthusiastic love of the subject
always outran his experience, while he lacked the knowledge of
technical qualities and processes necessary to give value to
his opinions on art. The idea of comparing the necessarily
slighter and less learned work of any ordinary amateur with the
masterly efficiency of ﹀a long-practised artist, like Oliver or
Cooper, is absurd. Nevertheless, this work of Lady Lucan's is
of the highest class of its kind, and shows not only great genius,
but great experience in manipulation. Sixteen years, besides the
previous qualification of practice and study of the best models,
afford a very fair approach to professional skill, so that the latter
portion at least, allowing for possible infirmities of age, ought to
offer some rivalry with the most thorough artistic work. At end
of the fifth volume is a note of the accomplishment of the task,
together with the portrait of the gifted lady who performed it
" MARGARET, COUNTESS OF LUCAN, ÆT. SUÆ LXVI. Genius,
Affection, and Perseverance record the Completion of this beau-
tiful work, happily conceived, cordially undertaken, and zealously
pursued. Begun in MDCCXC; Finished in MDCCCVI." A some-
what detailed description of each volume is given by Dibdin in
the work already cited.

SMYTERS, ANNA. *Miniaturist.* Saec. XVI.

Worked about 1560 at Ghent. She painted very small figures.
She was the mother of Lucas de Heere.—*Nagler : Künstlerlexicon,*
xvi. 536.

SNELLING, MATTHEW. *Miniaturist.* Saec. XVII.
"A gentleman who painted in miniature."
> *Walpole: Anecdotes of Painting in England*, iii. 121.

SOAVI, GIUSEPPE. *Miniaturist.* Saec. XVII.
> Worked in 1686 at Monte Cassino. In the library is a minia-
> ture painted by him bearing this date.—*Nagler: Künstlerlexicon*,
> xvi. 549.

SOBICA, JOHANN. *Miniaturist.* Saec. XV.
> In Dobner's *Collectio Monumentorum*, &c., iii. 454, he is called
> "Illuminator Domini Regis."—*Nagler: Künstlerlexicon*, xvi. 549.

SOLAROLO, JACOPO. *Miniaturist.* Saec. XV.
> Illuminated, in 1459, a Missal and Breviary for Duke Borso of
> Este. The Breviary was written by Fra Martino, a Servite, and
> finished in 1462. Also a treatise on birds, and other books in
> 1458; legends of the Fathers in 1462; another Breviary in
> 1469, and the Cento Novelle in 1467.—*Campori: I Miniatori degli
> Estensi*, in *Atti e Memorie*, &c., vi. 255.

SOLBRIG, JOHANN GOTTLIEB. *Miniaturist.*
Saec. XVIII.
Born 1765 at Marienthal-Zwickau.
> Excelled in portrait and in cutting silhouettes. Died 1815.
> —*Nagler: Künstlerlexicon*, xvi. 570.

SOLDATO, DI BONAFEDE GIOVANNI. *Copyist.* Saec. XIV.

Worked at Bologna in 1356.—*Zani : Enciclop. Metod.*, xvii. 322.

SOLIS, VIRGIL. *Illuminator, &c.* Saec. XVI.

Born at Nuremberg 1514. Died 1562.

Famous as a designer of book-illustrations, armorials, &c. ; and as a painter, "illuminist," and engraver. In each department, but especially in engraving, he has left a vast variety of works. —*Doppelmayr : Historische Nachricht von den Nürnbergischen Mathemat. u. Künstlern,* ii. 200. He is especially celebrated by Sandrart as an illuminator of engravings, in which he seems to have excelled all his contemporaries. Examples of his skill, however, are very rare. One of the most notable, perhaps, is the Frankfort Bible of 1561, mentioned by Nagler, of which the wood-cuts are brilliantly illuminated by Solis with gold, silver, and colours. There is an engraved portrait of him extant, accompanied by the following lines :—

" Mit Moln, Stechn, illuminiren
　　Mit Reissen Eczn und Viesiren
　　Es thets mirs Keiner gleich mit Arbeit vein
　　Drum bis ich billig Solis allein," &c.

The engraver of this portrait was Balthasar Jenichen. The mere list of his works, cited by Nagler, extends over thirty pages.— *Nagler : Künstlerlexicon,* xvii. 10–41.—*Sandrart : Teutsche Academie* vii. 224 (1774).

SOMENERZIO, PETR. MART. *Miniaturist.* (?)

Lived at Cremona.

Painted several books for the Congregation of that town.— *Nagler : Künstlerlexicon,* xvii. 50.

SORMANO, ANDREAS DE. *Copyist.*　　Saec. XV.

Wrote a copy of Virgil's Bucolics with a line-for-line commentary. Vell. Sm. 4º. 108 ff. On fol. 108 *v.* is this explicit : "Explicit liber, Bucolicoꝑ scriptus ꝑ Pꝑeru3 Andrea3 de Sormano die 5 mensis septembris uel nonis septembris 1.4.9.7 regnante Lodouico sfortia vicecomite duce.　Inclite ciuitatis Mediolani."　Then in red : " Ego pꝑr Andreas de Sor̃."　Below this, "τελως.　Deo Gratias. Amen.　Hoc opus expleui tempore credo brevi.　Opere finito reddantͬ grates aïco."　Now in the British Museum, Add. MSS., 15,341.

SOUBISE, CARDINAL DE. *Patron.*

Saec. XVII. et XVIII.

Armand-Gaston de Rohan-Soubise, Archbishop of Strasbourg (1674–1749), founded the great Soubise collection on a portion of the Library of the President De Thou and his successors, which was sold by auction in 1679 to Jean Jacques Charron de Menars, *Président à mortier* of the Parliament of Paris, and by Menars in 1706 to the Cardinal.　The latter placed it in the Hôtel Strasbourg, which he had just built on the site of the Hôtel de Guise. Here the Soubise collection remained until the Revolution. It was not, however, 15,000 volumes, but 8,000 which were bought by the Cardinal, and the Princes of Soubise during the eighteenth century raised the number to 15,000, valuable mainly for their sumptuous bindings.　The story of the Soubise collection and its origins would be indeed the story of a series of famous Libraries.—*Paris : Les MSS., &c.*, iv. 191.

SOZZINI, MARIANO. *Copyist.*　　Saec. XV.

Worked at Siena in 1490.—*Zani : Enciclop. Metod.*, xvii. 338.

SPADA, VALERIO. *Miniaturist.*　　Saec. XVII.

Born 1613 at Valdesa.

Worked at Florence, where he died, 1688.—*Zani : Enciclop. Metod.*, xvii. 346.

Spadari, Ottolini de'. *Miniaturist.* Saec. xv.

Worked at Ferrara in 1484.—*Zani: Enciclop. Metod.*, xvii. 347.

Spalato, Andreas de Andreis de. *Calligrapher.*

Saec. xvii.

A Minorite of Spalato and Prefect of Music in the cathedral.

Wrote, in 1675, "Missæ Pontificalis Præparatio," &c. Vell. Fol. 24 ff. Dedicated to Bonifacio Albani, Archbishop of Spalato, whose arms are emblazoned on the title-page. This beautiful MS. has a title-page written in letters of gold, surrounded by a very artistic border, finely painted with flowers and angels playing with birds. All the other pages have floriated or ruled borders, which, together with the initials, are executed in colours and gold. On page 30 is the painting of a rose and grasshopper. Belonged to Mr. Bragge, and sold in 1876.—*Sale Catalogue,* No. 297.

Spanocchi, Camillo. *Copyist.* Saec. xvi.

Wrote at Siena about 1554, an entire Virgil, on a single sheet of paper. Vincenzo Ruscelli says of him, " Ch' egli è di tanta eccellenza nell' arte dello scrivere, che fa lettera così picciola et minuta, che in un sol foglio di carta scrive tutte le opere di Virgilio," &c. Zani mistakenly calls him Girolamo, which was the name of his father.—*Zani: Enciclop. Metod.*, xvii. 353.—*Ruscelli : Il quarto libro della Imprise Illustri,* 60, Venice, 1583. 4º.

Spanzotto, Pier Antonio. *Miniaturist.* Saec. xvi.

Of Casale.

His name appears attached to the marriage settlement of his daughter, and also in an account of money paid to him, 26th April, 1548.—*Bertolotti : Artisti Subalpini a Roma,* 77-79.

SPENCER, GERVASE. *Miniaturist.* Saec XVIII.

Originally a gentleman's servant. Frequently amusing himself with copying, and having made a successful copy of a miniature of his master's family, he was encouraged to apply himself to study. After this he persevered until he became the fashionable painter of the day. He exhibited at the Society of Artists, 1762, both ordinary miniatures and enamels, usually signed "G. S." His portrait was painted by Reynolds. Died 1763.—*Redgrave: Dictionary of Painters of the English School.*

SPERA, BARTOLOM. *Copyist.* Saec. XV.

Worked at Treviso in 1430. "Ego Bartholomeus spera Tarvisinus."—*Zani: Enciclop. Metod.*, xvii. 359.

SPERLING-HECKEL, CATHARINE. *Miniaturist.*

Saec. XVIII.

Born in Germany, 1699. Died 1741.
Zani: Enciclop. Metod., xvii. 361.

SPEYER, FRA GERARDUS DE. *Copyist.* Saec. XV.

Wrote "Bertini (sancti) Chronica sive Historia." Paper. Fol. (11½ by 8 in.) 222 pp. With painted capitals, &c. On fol. 12 v. "Hunc librum scripsit frater gerardus de Spyere religiosus istius monasterii. In anno dni millesimo quadringentemo quinquagesimo sexto undecima die Augusti."—*Bragge: Sale Catalogue,* 1876, No. 36.

SPEYR, JOHANN VON. *Copyist.* **Saec. XV.**

Monk of the Benedictine Abbey of Mölk, in Lower Austria.

Cahier: Biblioth., 140.

SPIERINCK, $\left\{ \begin{array}{l} \text{Niklas.} \\ \text{Claes.} \end{array} \right\}$ *Copyist and Illuminator.*

Saec. XV.

Was both copyist and illuminator of several copies of the new ordinances which were entrusted to Jacques de Bregilles, jeweller to the Duke of Burgundy, to set in rich bindings for the Duke's personal use.—*Pinchart: Archives des Arts, Sciences, &c.,* 206-8. He also illuminated a Book of Hours, now in the British Museum (Harley MS., 2,943). It is written in Dutch in a fairly good hand, and very neatly ruled-in red double-lined margins to every page. The style of ornament in the borders is based on German foliages, but the design is heavier. The miniatures, which are mostly small and within the initials, show a good deal of black outline, especially in the hands and faces. Rubrics are placed before each heading. Large full-page miniatures occur in front of the several Offices or Hours. There are 12 ff. of Calendar. Then the Hours, with a bracket-border to three sides of page.

F. 17 *v.* A miniature of the Annunciation, within a full border, with the label phrases from the Gospel usual in old German and Flemish miniatures and paintings. In the borders are other labels amid the foliages and figures. On the page opposite fol. 18 begins the Office of the Virgin with an initial " H," containing a small miniature of the Madonna and child. The work is rather dull in colour and very mannered in execution, but with the skill of an artist long accustomed to work without much thought. Among the foliages at the foot of this page is the signature in very small Gothic letters Spierinck, 1486. The scene of the Tiburtine Sibyl pointing out the Madonna (in the initial) to the kneeling Emperor, whose crown is beside him on the grass, is depicted in the corner of the right border *en vignette.* An immense crow sits on the summit of a neighbouring tree. The label contains the explanation of this storiette. The penwork ornaments to the plainer pages are very skilful and elegant.

He seems also to have illuminated another Book of Hours, written in Dutch, and, judging from the saints mentioned in the Calendar, for some religious house in the neighbourhood of Maestricht. Vellum. Sm. 8°. 138 ff. Fol. 13 *v.* Miniature of Annunciation, Gabriel kneeling, with label and usual words, Ave Maria, &c. ; Mary also kneeling. The border consists of the usual style of foliages common to Hainault and the valley of the Meuse ; heavy but well-drawn soft acanthus in grey or brown, with the common flowers rose, violet, daisy, &c. Fol. 14. Initial and border, " Heer beghint die vrouwe ghetide." A Madonna and child in the initial, borders on a yellow ground (traces of gold). In the lower border of this page are the words or parts of words ʃpïc . . 7or,—*i.e.,* Sperinc. What the second word was I cannot determine. It may be a date, or . . *tor* or . . *ror.* A figure of a royal prophet in the cup of a flower occurs in the upper part of the border, and along the top is a ribbon containing the words : " Ecce Virgo concipiet." . . . Several indications are found of the book having originally belonged to a convent of nuns. At foot of fol. 38 is the common mediæval symbol of virginity,—the maiden and the unicorn. Fol. 57 *v.* The Tiburtine Sibyl and the Emperor Augustus, with borders of foliages, flowers, &c. In the lower border is the contracted word spïc, and another that looks like ʃr̄oȝ. Fol. 75. Initial and border, in the latter a halberdier holding a shield containing arms : *az.* a lamb *arg.* bearing a pennon *or,* perhaps the arms of the convent. At foot are the contracted words as before. Fol. 110. A bracket-border with arms at foot, a griffin supporting the shield *gu.,* three lilies *arg.* (the feigned heraldry of the Virgin Mary). With one of the signatures occurs the date 1498. The MS. is now in the Reference Library, Aston, near Birmingham. Another Book of Hours, executed for the same neighbourhood, very similar indeed to the above in style, but only containing one miniature, belongs to Mr. S. Jevons, and is now exhibited in the Birmingham Museum.

SPINALLO, JOANNES DE. *Copyist.* Saec. XV.

Wrote many books for the Malatestas of Rimini and Cæsena. In the library at Cæsena are numerous MSS. from his hand, referred to by Muccioli. Among them are : 1. " Tractatus Scti. Augustini Episcopi." 125 Discourses of St. Augustine. On fol. 1

several interesting features are observable, besides the elegance of the handwriting. The page is enriched with three oblong tablets, the first containing the initial " A," with various richly-painted floral ornaments; the second, various geometrical figures on a gold ground; the third, a portrait of the author, holding his book before him, and gazing upwards at a crucifix. The MS. contains many beautiful initials. At end : " Scriptor fuit Joannes Antonii de Spinallo anno Mcccclv." 2. Ten tracts of Augustine on the Epistle of St. John, &c. &c. Signed as above with date, " Mcccclv. mense nov." 3. " Scti. Hieron. Breviarium in cl. psalmos." At end : " Scriptus per me Joannem Antonii de Spinallo, pro magnifico Domino Domino Malatesta Novello de Malatestis Anno Dñi Mcccclv." The whole of the series is not of sufficient importance to transcribe ; I shall cite, therefore, only the more remarkable of those catalogued, as showing some peculiarity either of ornament or signature. 4. " Elhavii Opera " : lib. xii., and other portions. With large initial ; and at foot of first fol. the ancient arms of the family of Malatesta, with two letters, one on each side, " M " and " N " (Malatesta Novello). 5. The remaining lib. viii. of same author. At end : " Explicit Tractatus quem composuit Machumet filius Zacharia Elrazez in exponendis synonymis nec non ponderib⁹ et mensuris incognitis inventis in libris Medicinæ, et scriptus per me Joannem Antⁱ de Spinallo pro magnifico et potentissᵒ Domᵒ Dñᵒ Malatesta Novello de Malatestis." The first folio is most splendidly illuminated and brilliant with gold and colours, at the foot being the cyphers M.N.C. and the arms of Malatesta. Among these MSS. is a copy, in two parts, of the Commentary of St. Augustine on the Psalms, the second part of which is deserving of notice for the beauty of its illuminations. At the foot of the first page is a tablet on which are the words : MAL . NOV . PAN . FILIVS . HOC . DEDIT . OPVS, and in tablets at the side are the insignia of the family, on gold grounds, together with a splendid initial, the whole producing the most lovely effect. — *Muccioli : Catalogus Codd. MSS. Malatestianæ Cæsenatis Biblioth., &c.,* i. Pl. iii. *Codd.* 3, 4, 5 ; iv. 3 ; v. 3 ; ix. 2, 3, 4 ; x. 1, 2 ; xi. 2 ; xiii. 3, 4 ; xiv. 2 ; xv. 3, 4, 5 ; xvii. 1 ; xxi. 6, 7 ; xxiv. 3 ; xxv. 5. *See* Bononia, Alex. de.

SPOLETO, NICOLAUS DE. *Copyist.* Saec. XIV.

Wrote " Valerius Maximus." Vell. Sm. fol., 54 ff. Two volumes closely-written in a small Italian Gothic, with red and

blue flourished initials. On front fly-leaf is a ticket : " Ex libris auditoris Josephi M. Silvestrini Anconitani." At the foot of the first fol. is an erased signature, which is made out as " Josephus Caietanus Rubeus Romanus." On fol. 54 *v.* the following explicits, &c.,—the second black, the other two red, following the table of contents : " Explicit liber Maximi Valerij et ipsius capitu-laque sunt ī nūo lxxxi. Explicit iste liƀr scriptor sit a crimine liber. Nicolaus de Spoleto q non sit crimine leso. Deo gratias. Amen." Formerly in the library of Bishop Butler. Now in the British Museum, Add. MSS., 11,977.

SPRINGINKLEE, HANS. *Illuminator.* Saec. XVI.

House-pupil of Albr. Dürer, at Nuremberg, where he learned his art so well that he was famed for his drawing and painting. He designed the figures and borders in the " Hortulus anime " (printed in 1516 by Anton Koberger); and illuminated many designs made by Georg Dummen in a small Prayer-book, written by Alexius Birnbaum. Thausing recognises his hand in such of the marginal illustrations of the Maximilian Prayer-book in the Munich Library as were not the work of Dürer.— *Woltmann und Woermann : Geschichte der Malerei,* ii. 401.—*R. v. Rettberg. Neudörfer., &c.* In 1524, he completed a Missal for the Abp. of Mainz. Now in the Library at Aschaffenburg. *Rettberg : Nurnberg'sche Briefe,* 179.

SQUARCIONE, FRANCESCO. *Painter and Miniaturist.*
Saec. XV.
Born about 1394. Died 1474.

Was the son of a notary, studied art from a boy, and travelled in Greece, making sketches and collecting remains. On his return he became a famous teacher of young painters.—*Zani : Enciclop. Metod.,* xviii. 5.—*Rosini : Storia, &c.,* iii. 45.

Squille, Jacopo. *Miniaturist.* Saec. XVI.

Among the signatories with Castello to the petition for the pardon of a fellow-painter.—*Bertolotti : Il Bibliofilo,* iii. 68.

S. José,
St. Joseph, } Simon de *Copyist and Illuminator.*

Saec. XVI.

A Portuguese to whom D. Luis de Souza, Archbishop of Lisbon, assigned a share in the illuminations of the Register of Arms in the Royal Archives of La Torre do Tombo (*Taborda* 52). But Cyrillo attributes to him the execution of the collection of armorials themselves which is at Torre do Tombo. He also adds (174) that of the volume made in the time of John III. The prologue is surrounded by a fanciful architectural border.—*Raczynski : Dictionnaire,* 168.—*Lettres,* 435. *See* Contreiros.

St. Maur, Lambert de. *Copyist.* Saec. XI.

A Monk of St. Maur-des-Fossés.

Wrote a treatise of St. Augustine, "Adversus quinque Hæreses," in a legible Roman minuscule with many contractions, under Abbot Oddo, or Eudes (1029–1030).—*MS. lat.,* 12,219 (copied in three months).—*Delisle,* ii. 74 ; iii. 276.

Staciola, Michilinus de. *Copyist.* Saec. XIV.

Wrote "Guido de Columna de Casu Trojæ liber." On vellum, in folio. Initials beautifully painted in gold and colours. At end : " Liber iste est Michilini de Staciola scriptus in M.ccclxxx de mense *agusti* indictione tercia tempore sāctissi in xto. patris et Dñi Urbani divina providentia papæ vi. quo tempore dictus Michilinus extitit *potestas* in dicta civitate Euggubbii provincie ducatus Spoletini." Now in Este Library, Modena.—Cat. No. ccclxxii.— *Campori : Cenni Storici, &c., Estense,* 38.

STAFFORD, MORYS. *Illuminator.* Saec. XIV.

Painted the initial and bracket ornament, in the St. Albans or Sarum style of English illumination, to " Registrum Brevium de Canc. Ric. II." Vell. Sm. thick fol. 217 ff. At foot of bracket is a crossed label bearing the words in gold Gothic letters : " Morys Stafford me fecit." Now in British Museum, Harl. MSS., 1859.

STAGNENSIS, JOH. *Copyist.* Saec. XV.

Wrote, in 1458, "Frontinus de Re Militari." Paper. Small 4⁰. 62 ff. Initials and ornament containing arms on fol. 1, *az.* a stag salient *pr.* on 3 hills *vert* in a green wreath on a burnished gold ground ; ornaments roughly executed in manner of Girolamo da Cremona. At end, in faded red: "Explicit liber frñ̃e de Re Militari Foeliciter Scriptus p Joħem Stagnēsē de florētia sħ anno Mcccclviij Die ꝑma julij Bononiœ. Laus deo omĩpotēt." Now in British Museum, Royal MSS., 12, c. xxi.

STAMMLER, MATHYAS. *Illuminator.* Saec. XIV.

A Franciscan.

Wrote and painted a beautiful Missal, in the first initial of which he put his own portrait.— *Wattenbach : Das Schriftwesen, &c.,* 288. A copy from this MS. is given in *Anzeiger des Germanisches Museums,* xiii. 132 (1866).

STÄPFEN. *Calligrapher.* Saec. XVIII.

Wrote and published in 1749 at Leipzig, " Getreuer Schreibmeister," containing various handwritings.

STAVELOT, JEHAN DE. *Copyist.* Saec. XV.

Given under 1438 in *Laborde : Ducs de Bourg.,* 1. pt. ii. 528.

STEFANO DEI MARCIANI, FRA. *Copyist, &c.* Saec. XV.
See PRUSSIA, FRA GIOV. DA.

STEPHAN. *Copyist.* Saec. XV.

Made a "Musterbuch" or collection of examples for initials, handwritings, and borders, almost without any explanatory text, and not specially fine. Later is written in it the address of the Count of Würtemberg, who, in 1495, became Duke; and on fol. 4*v*. "unsern lieben getriwen Stephan Schriber, in unser Stadt Urach," where probably the MS. was executed. Now No. 420 in the Royal Library, Munich.— *Wattenbach : Schriftwesen,* 308.

STEFANESCHI (P. F.), GIO. BATTISTA. *Miniaturist.*
Saec. XVII.

Was the son of a builder, of Ronta, a small "castaletto" of Mugello, about twenty Italian miles from Florence. His secular name was Marchionne or Melchiorre Stefaneschi, and he was born in 1582. He became a monk of the Servite Monastery of Monte Senario, at Mugello, in 1604. It was after his admission to the cloister that he became a painter, and, in accordance with his taste and religious inclinations, devoted himself to miniature, making acquaintance with an excellent painter, Andrea Comodi, of Florence, and obtaining instruction from him. He also obtained assistance from Ligozzi, and from the celebrated Pietro da Cortona, during the time the latter was in the employment of the Grand Duke at Florence. By his zeal and application he speedily gained extraordinary skill in the art, and arrived at such a degree of excellence that the Grand Duke sought for examples of his work to place in the Ducal gallery, where they still remain. He copied in miniature several of the famous pictures of Andrea del Sarto, Raffaello, Correggio, and Tiziano. Whilst working on these miniatures he constantly conferred with Comodi, who founded his taste in colour on Correggio. Stefaneschi attained to an astonishing brilliancy of colouring by means of almost imperceptible dots or points, in the manner of Clovio and Bodoni. Besides these

more important works, he executed a vast number of single figures of saints, &c. Baldinucci relates a story of a miniature which contained several months of labour being ruined by mice (iv. 470), who had gnawed it to pieces for the sake of the vellum (or carta-pecora). The Frati of the SS. Annunziata at Florence, preserve in their sacristy a frontispiece of a volume entitled Acta B. Philippi Benitii Ord. Serv., and a head of Christ, encased in a reliquary of wood gilt, from the hand of Stefaneschi. Like Clovio, he also painted many portraits. He lived to be seventy-seven years of age, and died in 1659, and was buried in the Convent of the Servites at Venice.—*Baldinucci : Notizie dei Professori del disegno, &c.,* iv. 467-472.—*Fir.,* 1772, xv. 3-10. This notice is also given with his portrait in the *Museum Florentinum : Pictores,* ii. 107.

STEIER, WOLFGANG VON. *Copyist.* Saec. xv.
Prior of St. Peter's in Salzburg.

Wrote, in 1436, a Missal in six months.—*Wattenbach : Das Schriftwesen, &c.,* 241, note.

STELLA, GIULIO. *Miniaturist.* Saec. xvi.
See CASTELLO, PAGLIARA, &c.
Bertolotti : in Il Bibliofilo, iii. 68. 1882.

STEPHANOS. *Copyist.* Saec. xv.
Wrote, in 1417, a copy of Polybius in Greek. Paper. Folio. 160 ff. Formerly in the Library of the Benedictines of St. Mary, of Florence.—*Montfaucon : Palæograph. Gr.,* 76, 107. This copy, it appears from Montfaucon, was received in exchange for another made from it by Antonios, of Athens, called Logothétes.

At end it has this note in red ink and contracted characters :
'πολύβίον ίστοριῶν έ :—ἐτελειώθη τὸ πεμπτὸν βιβλίον χειρὶ στεφάνου
ἱερομονάχου καὶ σκευοφύλακος τοῦ τιμίου προδρόμου τῆς εὐλογημένης
Πέτρας, μηνὶ ὀκτοβρίῳ ϛ' ἰνδ. ι. τοῦ στ'.π'.κέ ἔτους. "The five
books of the Histories of Polybius. The fifth book completed
by the hand of Stephanos Hieromonachos and Treasurer of the
venerable Prodromus of the famous Petra, (?) on the 2nd of the
month of October. Indict[n] 10 of the year 6925 " (*i.e.* A.D. 1417).
Now in the British Museum, Add. MS., 11,728.

STEPHANOS. *Calligrapher.* Saec. XI.

Wrote " Gregorii Moralia," books 22 to 35. Now at Monte
Cassino, No. 80, in large Lombard characters. A line at end
says : " Hunc Stephanus scribere decrevit, atque complevit."—
Caravita, ii. 66.

STEPHANUS. *Copyist.* Saec. XIV.

Wrote " Liber Carminium Flacci Oratij," &c. Vellum. Folio.
184 ff. Large illuminated initials, with sweeps of foliage some-
what roughly executed in the old Tuscan manner. Written in
large handsome Bolognese or Cassinese Gothic, with wide mar-
gins. On fol. 56 *v.* : " Stephanus scripsit." Again on fol. 128 *v.*:
" Explicit Liber Persij Deo Grās. Amen. Stephanus scripsit."
On fol. 184 : " Explicit Liber Juvenalis Facto fine pia laudetur
virgo Maria Stephanus scripsit." Then in red : " Istud volumen
Satirorum scilicet oratij persij et iuuenalis est magistri iohannis de
trauesis de Cremona ti . . . philosophie doctoris." Now in British
Museum, Butler (Add.) MSS., 11,964.

STEPHANUS. *Copyist.* Saec. XV.

Wrote at Rome, in 1462, and in thirty-eight days, " Julii Cæsaris
Commentarii." Vellum. Large 8°. 206 ff. Begins : " C. JULII

CÆSARIS COMMENTARIORUM DE BELLO GALLICO LIBER PRIMIS,
INCIPIT," all in capitals with a side bracket border of white stem
pattern and initial G(allia), in bright gold on coloured panel. The
writing is an ordinary upright Italian hand. On fol. 205 *v.* : " C.
JULII . CÆSARIS . COMENTARI. ORIORUM . LIBER . XIII ET ULTI .
MUS . DE . BELLO CIVILI HISPANO . EXPLICIT . DEO . GRATIAS .
AMEN . SCRIPTUS ROMAE PER ME STEPHANUM DIEBUS XXXVIII.
MCCCCLXII., all in faded crimson capitals. Now in the British
Museum, Add. MSS., 16,982.

STEPHANUS. *Copyist.* Saec. XV.

Wrote " La Div. Commedia con chiosi di Fr. Stephano."
Paper. Folio. 210 ff. Well written. "Codⁱ Trivulziani,
N° VII. At end in red : "Ego fr. Stephanus S. Francisci de
florentia ordinis fratrum predicat. sacre theologie humilis pfessor
scripsi hunc librum et glosavi año dñi Mccccviij in castro ciuitatis
bononiensis.—*Batines*, ii. 140.

STETTIN, PHILIPPE II., DUC DE. *Patron.*

Saec. XVI. et XVII.

Philippe II., Duke of Stettin and Pomerania, succeeded Bogislas
the Good, his father, in 1606. He was born in 1573, and died
1619. Literature and the fine arts were among the chief pleasures
of his life. He laid the first stone of the Ducal Palace at Stet-
tin, and during his reign several of the beautiful churches of the
city were restored and beautified. Proposing to decorate his
palace with portraits of contemporary princes and others, he
addressed the so-called Archdukes Albert and Isabella in 1617,
and in a letter which he wrote afterwards, thanked them separately
for the magnificent reply they gave to his request in the shape of
a collection of drawings for his album. This Album was very
remarkable. It was a precious collection, composed chiefly of

miniatures and pen-drawings. Every piece was the work of one of the most renowned artists of the time. Pinchart had the good fortune to find among the Royal Archives of Belgium a list of the thirty-eight drawings which composed the Album in 1612. The inventory contains the indication of the subjects, which are all taken from the History of the New Testament. Most of the donors' names are mentioned, as are those of the artists, which include Tobias Bernhart, Paul Bril, Johann Bullen, Iohann Fischer, Jeremias Gunter, Marc Kager, Lucas Kilian, Johann König, Johann Rotenhamer, and Anton Mozart. In 1607 Philippe had married Sophia, daughter of John the Young, Duke of Holstein-Sonderburg, who died in 1618. The inventory, of which the following is a condensed translation, is in provincial German. It is interesting as showing how frequently ordinary painters occupied themselves with miniature.

1. Miniature given by his Imperial and Royal Majesty the Emperor Matthias, King of Hungary and Bohemia, and Archduke of Austria, painted by Jeremias Gunter, his Majesty's Court painter.

2. From William II., Duke of Bavaria—The Annunciation, painted by Thobiass Bernhart, from a design by Hanss Rottenhamer.

3. The Visitation. Painted by Paul Bril at Rome.

4. From Ferdinand of Bavaria, Elector and Archbishop of Cöln—the Nativity, painted at Rome by Hanss König.

5. From Christian, Margraf of Brandenburg—the Adoration of the Magi. Painted by Antonie Motzart.

6. From Ferdinand, Archduke of Austria—the Flight into Egypt. Painted by Paul Bril.

7. From Johann Conrad (of Gemmingen), Bishop of Eystätt (Eichstädt)—Jesus in the midst of the Doctors. Painted by Tobia Bernhardt.

8. From Maximilian, Duke of Bavaria—Christ's Baptism. Painted by Martz Kager.

9. Donor not named.—The Temptation of Christ in the Wilderness. Painted by Paul Bril.

10. From Lady Sophia of Holstein, Duchess of Stettin-Pommern (Pomerania) (daughter of John the Young, Duke of Holstein-Sonderburg. She married Philippe II., Duke of Pomerania and Stettin)—the Marriage at Cana. Painter not named.

11. From Augustus the Younger, Duke of Brunswick and Lunenburg (son of William and brother of Christian, to whom he

succeeded in 1633)—Christ and the Woman of Samaria. Painter not named.

12. From Lady Clara Maria of Stettin-Pommern, Duchess of Brunswick-Lunenburg (daughter of Bogislas the Good, Duke of Stettin. She married—1, Sigismund Augustus, Duke of Mecklenburg ; 2, in 1607, Augustus, Duke of Brunswick-Lunenburg, and died 1623), Jesus with Mary and Martha. Painter not named.

13. From the Archduke Leopold of Austria, Bishop of Strasburg and Passau (in 1607). Died 1625.—Christ blessing little children. Painted by Hanss König.

14. From George, Duke of Stettin-Pommern (brother of Philippe II., Duke of Stettin and Pomerania)—Jesus Calming the Tempest.

15. From Joachim-Ernest Margraf of Brandenburg, Margrave of Anspach, son of John George Margraf, of Brandenburg—the Miracle of the Loaves and Fishes. Painted by Antonie Motzart.

16. From Johann Adolph, Duke of Schleswick Holstein (Duke of Holstein-Gottorp. Died 1616)—the miraculous Draught of Fishes.

17. From Philippe, Duke of Holstein (Holstein-Glücksburg. Born 1584, died 1663)—Christ healing the Man sick of the Palsy.

18. From Lady Elizabeth, Duchess of Brunswick-Lunenburg (daughter of Frederic II., King of Denmark. She married in 1590 Henry Julius, Duke of Brunswick, Wolfenbüttel, who died 1613. She died 1626)—the Raising to Life of the Widow's Son.

19. From Lady Anne of Schleswick-Holstein, Duchess of Stettin-Pommern (daughter of John the Young, Duke of Schleswick-Sonderburg, and second wife of Bogeslas the Good. She died 1616)—Christ healing the Woman with issue of blood.

20. From Moritz Landgraf, of Hesse (died 1632)—the Transfiguration.

21. From Ulrich, Duke of Stettin-Pommern (brother of Phil. II., named Bishop of Camin in 1618)—the Resurrection of Lazarus.

22. From Phil. Julius, Duke of Stettin-Pommern (son of Ernest Louis, Duke of Wolgast and Grandson of Phil. I., Duke of Pomerania and Stettin. Born 1584, died 1625. In 1600 he inherited the Duchy of Stettin by the death of his uncle John-Frederic)—the Story of the rich Man and Lazarus.

23. From Lady Agnes, Margravine of Brandenburg, Duchess of St. Pomm., &c. (daughter of John George, Elector of Brandenburg. She married in 1604 Phil. Julius, above, Duke of Stettin) —Jesus on the Mount of Olives.

24. From Archduke Maximilian Ernest of Austria (Grand Master of the Teutonic Order, son of Charles, Archduke of Gratz, died 1616). The Crowning of Christ with thorns, painted by Lucas Kilian from a pen-drawn design by *Rottenhaimtes* (Rotenhamer).

25. From Archduke Maximn of Austria, Grand Master of the Teutonic Order (son of the Emperor Maximilian II., died 1618)— the Resurrection of Christ.

26. From Albert, Duke of Bavaria (Landgraf of Leuchtenberg and Count of Halle. He married, 1612, Matilda of Leuchtenberg)—the Crucifixion, painted by *Hanss* Fischen.

27. From *Bogisslas*, Duke of Stettin-Pommern (Bogislas, Duke of Stettin-Pommern, brother of Phil. II., Duke of Stettin-Pommern, died 1637)—the Parable of the Ten Virgins.

28. From Lady Maria von Holstein, Abbess of *Itzehow* (Itzehoe in Holstein)—the Deluge, painted by *Hanss* Bullen.

Perhaps the rest are portraits, as they have no subject-title.

29. From Johann Frederic, Duke of Würtemberg. Died 1628. Succeeded his father Frederic in 1608.

30. From Julius Frederic, Duke of Würtemberg (brother of the preceding). Founded the branch of Weitlingen.

31. From Georg Frederic, Margraf of Baden (Baden-Durlach). Born 1573, died 1638.

32. From Phil. Ludwig, Pfalzgraf of the Rhine (Duke of Neuburg). Died 1614.

33. From Wolfgang Wilhelm, Pfalzgraf of the Rhine (son of the preceding). Succeeded his father and died 1635.

34. From Augustus, Pfalzgraf of the Rhine (brother of the preceding). Died 1631. Founded branch of Dukes of Sulzbach.

35. From Johann Frederic, Pfalzgraf of the Rhine (brother of the preceding). Count of Hippolstein.

36. From Ernest Ludwig, Duke of Saxony (son of Francis II., Duke of Saxe-Lauenburg). Born 1587, died 1620.

37. From Franz, Duke of Stettin-Pommern, &c., Bishop of Caminn. (At first Bishop of Camin, succeeded his brother Phil. II., Duke of Pomerania, and Stettin 1619, and died 1620.)

38. From Lady Sophia of the Electoral House of Saxony, Duchess of Stettin-Pommern (daughter of Christian I., Elector of

Saxony. She married, 1610, the preceding Franz, Duke of Pomerania and Stettin, and died in 1635).—*Pinchart: Archives des Arts, Sciences, et Lettres*, sér. i., tom. ii., 12–18.

STILLYNGFLETE. *Copyist.* Saec. XV.

An Englishman.

Wrote a large folio containing an "Expositio verborum difficiliorum in Officiis Ecclesiasticis." Vellum. 169 ff. 2 cols. Closely ruled in black lines, and written partly in Gothic text and partly in small secretary. Handsomely illuminated with initials and other ornaments in English work. Arms on fol. 1, at top, *gu.* a St. George's Cross (perhaps arg., now blackened). At foot, 1. *az.* a chevron *gu.* (?), accompanied by 3 fleurs de lis *or* 2 & 1. 2. *gu.* engrailed *az.* a chevron *arg.* (?) Along the upper margin of each page are pen-flourishes curiously embellished with faces, fishes, &c. Headings in red. On fol. 154 in red : " Explicit exposiciō v̄boꝛ difficiliū tocius missalis temporalis et scōꝛ p. totum annū ac correpcio et pductiō eoꝛdem sᵖᵐ vsum Saꝛ ad utilitatem et comodū omē addisteᵉ volencium. Stillingflete." The signature qᵈ. Stillyngflete occurs also on fol. 128 *v.* Now in British Museum, Add. MSS., 14,023.

STIPHEL, GUILLAUME DU. *Copyist.* Saec. XIV.

Wrote at Finchale, in 1381, for Uctred, a monk and doctor in theology of Durham : 1. "Eusebii Pamphili, Episcopi Cæsavansis. Historiæ Ecclesiasticæ," &c. 2. "Rufini Aquiliensis Hist. Eccles." 3. "Bedæ Venerabis Hist. Eccles. gentis Anglorum," &c. Vellum. Folio. 176 ff. 2 cols. No. 3 is apparently a transcript of the Durham MS. B. ii. 35, which was written about 1166.—*Stephenson: Preface to Beda*, xxxiii., *Church Historians of England* (1853). The volume has been a very handsome one, being beautifully written in a firm and regular Gothic text, with flourished initials in red and blue, both large and small. It is now in bad condition, as if it had suffered much from damp. On fol. 89 *v.* is

this note : " Explicit liber historie eccliastice scdm̄ eusebiū script⁹ per manū guill'mi dr̄i du stiphel de britania. pro uen'abili et religioso m'ro. dño vtredo dunel'm monacho . ac scē sacre pagine doctore. Anno dñi mill'o ccc° octuagesimo p'mo . uicesimo sexto die mẽsis augusti. In fincal." Again, on fol. 158 : " Explicit liber eccl'iastice hystorie gentis anglor' venerabilis Bede pbr̄i et doctoris ! G. du stiphel." Now in the British Museum, Burney MS., 310. Also : Wrote and illuminated in the same year, Nicolaus de Lyra, Commentar. in Pentateuchum, &c. Now in the Cathedral Library, Durham. — *Botfield: Notes on Cathedral Libraries,* 119.

STIRLEYN, GEORGE. *Miniaturist.* Saec. XVI.

One of the illuminators of the Missal executed for the Elector Albert of Brandenburg in 1533, now in the Church of St. Peter and St. Alexand. at Aschaffenburg. Inscribed on a ribbon-label "Georg. Stirleyn—faciebat."—*Becker und Hefner-Alteneck : Kunstwerke und Geräthschaften des Mittelalters, &c.,* Pl. 26.

STITNIJ, THOMAS. *Illuminator.* Saec. XVI.

Executed, in 1373, the drawings, &c., of a MS. "Essay on the Doctrines of the Christian Religion." Now in the University Library at Prague, No. xvii.ᵃ 6. They show with what taste, sentiment, and vivacity the Bohemian artists of this early time rendered the ordinary events of daily life. The best of these miniatures are a young man and a young girl on fol. 37 *v.,* several girls consecrating themselves to religion on fol. 44 *b.* a woman praying on fol. 47 *v.,* and a nuptial benediction on fol. 124. The MS. is described in Kunstblatt, No. 37, 1850.—*Waagen: Manuel de l'Hist. de la Peinture, &c.,* i. 66.

STOCK, MART. *Miniaturist.* Saec. XVI.

A Monk of St. Martin's of Köln.

"Arte pictoria clarissimus anno 1555."—*Ziegelbauer: Hist. Rei Litter., Ord. S. Bened.,* i. 520.

STOK, RADULPHUS DE. *Copyist.*

Saec. late XII. or early XIII.

Wrote "Petri Comestoris Historia Scolastica." Vellum. Sm. fol. 162 ff. In small half-Gothic. Initials and bracket ornaments in usual style of period. On fol. 1 : " Per Raduphū de Stok Mo^ni Liber Histoȝ Scolasticaȝ de claustro Roffenš. q̃u q^e inde alienaūit alienatū celaūit ul' hūc titulū in fraudē delaūit Anathema sit Amen." Now in British Museum, Royal MSS., 2, C. i.

STORK, CONRAD. *Copyist.* Saec. XV.

Transcribed, in 1462, "S. Gregorii M. liber regulæ pastoralis." At end : " Finitus et scriptus est liber iste per me Conradum Stork Canonicum Collegii B.V.M. in Eychstetten novem die S. Dorotheæ V. & M. a. 1462. Orate," &c. Now in Royal Library, Munich, Cod. lat., 3,785.—*Steichele: Archiv, &c.,* i. 112.

STOS, VEIT. *Calligrapher.* Saec. XVI.

Called here " Scriba Cæsareæ Majestatis."

Wrote a book of specimens of calligraphy in German and Roman texts with ornamental initials, very finely and skilfully executed. Vell. Obl. 4°. 15 ff. Both writing and initials are most masterly. The latter in black ink with gold outline are exceedingly beautiful. Notice especially folios 4, 5, and 14. Now in British Museum, Add. MSS., 15,703.

STRADA, OCTAVIUS. *Miniaturist.* Saec. XV.

Of Rossberg.

Son of Jacopo Strada of Mantua. Executed the portraits and armorials of a "Genealogia Domus Habsburgiensis," &c., and also wrote the descriptions. Vellum. Folio. It contains portraits of 171 personages, their coats of arms, emblems, devices, &c., and the genealogies of the various families. Now in the Royal Library, Dresden.—*Goetze: Merkwürdigk.*, &c., iii. 81. Also two beautiful volumes containing Lives of the Roman Emperors, with their portraits, and "Symbola Divina et Humana," &c. The latter was published with an Introduction by Jac. Typotius, and engravings by Egid. Sadeler, 1601. Now in the British Museum, Lansd. MSS., 1212, 1213.

STRATTER, ERASMUS. *Copyist.* Saec. XV.

Wrote, in 1469, a German Bible, on vellum. Folio. 656 ff. With numerous figure initials. At end: "Also hat die Bibel ain enndt. Vnd hat geschriebñ Erasm. stratter zu Saltzpurg, MCCCCLXIX." Exhibited in the Church Furniture Exhibition at Vienna in 1887. *Illustrirter Katalog der Austellung, &c.*, x. No. 50.

STRAUCH, GEORGE. *Miniaturist.* Saec. XVII.

Born Dec. 17, 1613. Died 13 July, 1675.

"Is very good in little things in miniature and gum colours," &c. At ten years of age he is said to have illuminated in the finest manner, and in 1626 went as a pupil to Johann Hauer. In 1635 he painted his diploma picture—a Saint Sebastian. He also designed the illustrations to Johann Michael Dillheim's various works. There is also an allegorical picture by him, engraved on copper, in the Belvedere at Vienna.—*Neudörffer: Nachrichten von Künstlern und Werkleuten aus dem Jahre*, 1547, 203. In *Eitelberger: Quellenschriften*, x.

STRAYLER, ALAN. *Illuminator.* Saec. XIII.

Worked at St. Albans in the time of Matthew Paris. In 1259 he painted a portrait of the famous historian and illuminator as he lay on his bed after death. The portrait is still extant in one of the Cotton MSS. (Nero, D. 7) in the British Museum.—*See* PARIS, M.

STRETTON, or ⎫ RICARDUS DE. *Illuminator.*
STYRTON, ⎭
 Saec. XIV. et XV.

Illuminated some of the Choir-books of York Minster. *See* ELLERKER. Besides the accounts of payment already mentioned there is one under 1399 : " Domino Ricardo de Styrton pro alumpnacione unius magni gradalis novi, in choro 20s." And 1402 : " In expensis in alumpniacione magni gradalis in choro per dominum Ricardum de Stretton, 20s.—*Raine : The Fabric Rolls of York Minster*, 132.

STRIGL, SIMON. *Copyist.* Saec. XV.
Vicar of the Choir of St. Moritz.

Wrote, in 1430, a Collectarium super libros Psalmorum. Collectus per Petrum de Heienthcls. Now in the Imperial Library, Vienna.—*Denis :* ii. pt. i., 212, No. 138.

STROZZA, ⎫ FAMILY OF *Patrons.* Saec. XV. et XVI.
STROZZI, ⎭

The first of this honoured name who comes within our special notice was Palla Strozzi or Strozza, di Noferi (1372–1462), the contemporary and rival of Cosimo de' Medici, the elder. He was

born in Florence, and from an early age devoted his immense
fortune to the cultivation of letters and the encouragement of
learned men. He was one of the first to invite Greek exiles
to Florence, and chief among his own guests was Emanuel
Chrysoloras, who, at his request, undertook the Professorship of
Greek. At Constantinople, also, he caused to be collected many
valuable MSS., including such works as Plutarch's " Lives and
Morals," the Dialogues of Plato, the Politics of Aristotle, and the
Cosmography of Ptolemy. In his own house he kept employed a
great number of copyists charged with reproducing the master-
pieces of ancient authors. "To him," says Symonds, " belongs the
glory of having first collected books for the express purpose of
founding a public library," but he was prevented from carrying out
his plan by the course of events. " Being passionately fond of
literature, Messer Palla always kept copyists, in his own house and
outside it, of the best who were in Florence, both for Greek and
Latin books ; and all the books he could find he purchased, on
all subjects, being minded to found a most noble library in Santa
Trinità, and to erect there a most beautiful building for the
purpose. He wished that it should be open to the public, and he
chose Santa Trinità because it was in the centre of Florence, a
site of great convenience to everybody. His disasters supervened,
and what he had designed he could not execute." The Latin and
Greek languages were among his own accomplishments, and he
passed the greater part of his time in study. And yet he devoted
much of his life to public affairs, and was several times appointed
ambassador to foreign courts. In 1428, as President, he reformed
the University of Florence and created several new Professorships,
attracting to them the most distinguished scholars of Italy. In
1434, after holding the balance evenly between the Albizzi and the
Medici, he shared the defeat of the former although he had been
among their adversaries, and went into exile mainly because his
zeal for the protection of literature gave umbrage to Cosimo de'
Medici, who aspired to be without rival as the Mæcenas of his
age. Palla Strozzi,—a true philosopher and a truly ripe scholar—
retired to Padua, where he resumed his studies and drew to his
side many of his former friends, among whom was Argyropulos,
and, with the assistance of the learned Hellenist, translated into
Latin various Greek authors. He left several sons, whose education
he confided to Tommaso Parentucelli, afterwards selected by
Cosimo to be the Prefect of the Library of San Marco. (*See*
Medici.) One of Palla's sons became the founder of the Ferrarese

branch of the family,—famous in arts, in arms, and in commerce, —indeed, wherever its various members were scattered they became distinguished and wealthy. The next who appears before us in connection with MS. production is Filippo, called the Elder, the son of Matteo Strozzi, of Florence, who, after acquiring a considerable fortune as a banker, was deprived of it in 1434 by a decree of the rival House of Medici, then supreme in Florence. Filippo was born in 1426, and began life as a merchant and banker in Naples, where he was instrumental in doing the King several excellent services. In return for the valuable aid thus afforded, Ferdinand, using his good offices and usual courtly suavity with the Florentines, obtained for Filippo the joyful permission to re-enter his native city. It seems to me not improbable that, considering also the tastes of the King himself, in gratitude for this fulfilment of the dearest wish of his heart, and in accordance with the custom of the time, Strozzi would present Ferdinand with some costly and beautiful book ; and I cannot but think that in the exquisitely beautiful Pliny of the Bodley Library we possess the identical volume. On examining that most splendid example of typography and illumination for possible discoveries relating to miniature art, I found that many of the arms had been repainted. There was, of course, nothing unusual in this, but as I found the volume described as having been executed for Strozzi, this peculiarity became curious. Very little investigation showed that the arms so covered with those of Ferdinand, King of Naples and Sicily, were in fact the well-known three crescents of the Strozzi. These crescents have frequently been converted into "palle," a circumstance which, to an active imagination, might suggest that the volume had been part of the property seized by the Medici on the banishment of the elder Strozzi, the arms altered, and afterwards, on the presentation of the book to Ferdinand, again altered in some cases in compliment to the King. But, on the whole, the date and other circumstances throw the event later than the time of the Strozzi banishment. This truly splendid and noble folio contains the Natural History of Pliny in Landino's version, "Historia Naturale di Caio Plinio Secundo tradocta di lingua latina in fiorentina, per Christophoro Landino. Venetiis per Nic. Jenson. 1476." Fol. Vellum. Fol. 1 has a three-side bracket-border, in which the arms are erased, containing beautifully-painted children in the manner of Antonio da Monza. A portrait in a large medallion at foot in which the face is as perfect as possible,—

suggesting, indeed, the finest miniatures of Petitot,—and as full
of individual character as a Samuel Cooper. The background is
most sweetly painted with tender green foliages and a sunny sky.
A view of the Baptistery and Campanile of Florence, in which the
latter has a tiled-peaked roof. A cameo of Apollo and Marsyas
in chiaroscuro grey, heightened with gold, stands on the side
border. Two smaller cameos in an open landscape of two lovely
lambs, with motto, " Mitis esto." The initial " D " (i nessuna
cosa) is gold in a richly-coloured panel. The various ornaments,
&c., very much in the style of those in the British Museum Riario
Service Book (Add. 29,735). Fol. 5. Another Title with full
border, extremely rich in ornaments. A lioness reposing among
grassy slopes and fine leafy trees, is painted in the upper right
corner. Beautiful children are placed here and there among the
ornaments, while gems and flowers, vases and fine golden tracery
complete the marvellous enrichments of the border. In the
initial is the portrait of a philosopher, holding in his hand an
armillary sphere whilst he reads from a paper. There is the view
of a city seen through the open window, and in the apartment a
great variety of interesting detail of contemporary furnishings. He
wears a scarlet cap and gown, and a gold-gleaming robe. In left
upright border is a naked figure of Apollo the Healer with
caduceus in right hand. A cameo in violet heightened with gold,
of another mythological scene adorns another portion, while at
foot are the Strozzi arms,—viz., *or*, a fess *gules*, charged with three
crescents *argent ;* surmounted by an eagle with outstretched wings.
Several children stand on either side, and a hedge of roses passes
behind. In the left lower corner is a portrait of Ferdinand. In
the right that of the orginal owner of the volume. A similar
adornment commences every book, some of which are remarkable
for fidelity to the objects delineated, such, for example, the
elephant at Book viii. The portraits throughout are finished
with the most scrupulous exactitude, force, and delicacy. Not
many illuminated books can be found to surpass this printed one
in the endless variety, yet unfailing richness and beauty of its
ornaments. It is a volume deserving a much more careful
description, and one of which the curators may well be proud.
It goes far to support the opinion that among the most superb
of illuminated gift-books, those executed after the invention of
printing are among the richest and most perfect in the paintings
which they contain, and in the splendour of decoration with which
the miniatures are surrounded. The high excellence to which

painting had attained is reflected in these exquisite miniatures, as it is in those of Attavante, Clovio, Hoefnagel, Holanda, and other miniaturists whose work was executed since the last years of the fifteenth century. To return to Strozzi. Filippo the elder, whose life extended from 1422 to 1497, and who, as I think, had the Pliny illuminated for his own library, was the constant friend and patron of Benedetto da Maiano. The Maiani were a dynasty of artists as the Strozzi were of patrons. They were architects, sculptors, painters, and stone-cutters. Giuliano and Benedetto attained to the front rank of art. Giovanni had less talent, and was content with the humbler calling of an ordinary trade. Benedetto began his career at the court of Matthias of Hungary, at first with *intarsiatura*, or wood-inlaying, but afterwards, as his powers developed, he rose to the loftier demands of architecture and sculpture. His greatest work was the Strozzi Palace at Florence. Filippo Strozzi, or, as he wrote it himself, Strozza, the younger (1488–1538), whose noble bust by Maiano is now in the Louvre, was the husband of Clarice, daughter of Piero de' Medici. This Filippo was the famous Strozzi, whose tragic suicide and strangely pathetic last words have placed his name beside those of Hannibal and Cato. It is a curious fact that, on being taken prisoner in the battle of Montemurlo,—fought to break, if possible, the tyranny of the Medici, but which failed disastrously,— Filippo was immured in the fortress called the Fortezza da Basso, the very place which Clement VII. had hesitated to build, and only reluctantly consented when urged by Strozzi himself, and against the advice of his friend Salviati, who remarked to Strozzi that he might perhaps "be digging his own grave." His gaoler was the Marchese del Vasto. His son Piero (1500–1558) was, like his grandfather, a great lover of books. He is, perhaps, better known as a soldier and as the great French marshal, yet he was bred to the Church, and only abandoned it on being refused the Cardinalate by his relative Clement VII. Amid his military duties he found time to translate the "Commentaries of Cæsar" into Greek and to compose poetry. His works were published at Bassano, 1806, and have been several times reprinted. For an account of the seizure of his library at his death by Catherine de' Medici, *see* RIDOLFI, CARD. N. Several members of the Strozzi family have since become famous in eloquence or poetry. Of the branch that settled at Ferrara, Lucia became the mother of Matteo Boiardo, author of the "Orlando Innamorato."—*Tiraboschi : Della littera-*

tura Ital., &c, vi. pt. ii. 231.—*Muratori: Scriptores Rer. Italicar.,* xxiv. 401.—*Ginguené: Hist. Littér. d'Italie,* iii. 448.—*Nouvelle Biogr. Générale.—Symonds: Hist. of the Renaissance in Italy.---Revival of Learning,* 166, 167.

SUBLEYRAS-TIBALDI, MARIA. *Miniaturist.*

Saec. XVIII.

Sister or Daughter of Pierre Subleyras, a Frenchman, living in Rome.

SUBLEYRAS-TIBALDI, FELICITÀ. *Miniaturist.*

Saec. XVIII.

Wife of Pierre Subleyras.

Worked in Rome. Born 1707 ; died 1770.

SUBLEYRAS-TIBALDI, CLEMENTINA. *Miniaturist.*

Saec. XVIII.

Daughter of above.

Worked in Rome about 1784.—*Zani: Enciclop. Metod.,* xviii. 71, 72.

SUEVUS, CONRADUS. *Copyist.* Saec. XIV.

Wrote, in 1333-4, a copy of the New Testament. Folio. Vellum. 278 ff. At end : "Anno incarnacionis dom¹ nostri Jhesu Christi M°ccc°xxxiii. Sequenti die processi et Martiniani, Ego Chunradus Sueuus scriptor incep. hoc opus a deo dante perfeci. Prisce v. M°ccc°xxxiiii°. Deo Gracias." Now in the Laurentian Library, Florence. Cod. x.—*Bandini: Catal., &c.*

SUPERCHI. *Miniaturist.* Sec. XVIII.

Worked at Parma (1785–1807).—*Zani: Enciclop. Metod.*,
xviii. 78.

SUSA, FRANCISCUS DE. *Copyist.* Saec. XV.

Wrote a Summula or Concordance to the Scriptures. Vellum.
84 ff. At end: " Frater Franciscus de Susa hunc veloci calamo
scripsit Librum ad laudem Dei et ad legentium consolationem
anno Domini MCCCCLIX. de mense Junii. Veneciis. Turin Cod.
DCLIX., d. i. 17.—*Pasini*, ii. 207.

SYACO, ⎫
SYNACO, ⎬ JOHANNES DE. *Copyist.* Saec. XIV. (?)

Wrote " Magistri Thomæ de Ybernia quond. socio de Sorbona.
Manipulus florum," &c. Vellum. Thick 4°, 241 ff., 2 cols. In
small Gothic text, illuminated initials, and a few bracket ornaments
with ivy leaf. Fol. 1 : In initial "A" the author presenting his book
to the Madonna and Child. Fol. 241, in larger text : " Explicit deo
grãs Filia pro pena scriptori detur amena. amē. Explicit este
lib⁾ scriptor sit crimine liber. Amen. Explicit manipulus florum
sine extractões originalium compilate a magistro thoma de ȳbernia
quondam socio de S'bona, deo grãs. Scriptor qui scripsit cum
xpo vivere possit. Johannes de Sȳaco." Now in the British
Museum, Add. MSS , 17,809.

SYMEON. *Calligrapher.* Saec. XII.

Wrote " Regestum S. Angeli ad Formas," in large 8°. The MS.,
which is in small Lombard characters, was written after 1149, and
adorned with figures. Signed : " Ego Frater Symeon diaconus et
monachus scriptorque."—*Caravita*, ii. 179.

SYNESIUS. *Copyist.* Saec. XI.

Wrote, about 1034, a MS. of the four Gospels in Greek. On fol.
285 is a prolix setting forth of the date in minuscule letters,
occupying, together with the writer's usual petition, about fourteen
lines, to the effect that the MS. was completed in December of the
year 6542, or A.D. 1033–4 ; and :

 Χειρὶ γραφείσα εὐτελοῦ πρεσβυτέρου
 Συνεσίου τοὔνομα πάντων ἐσχάτου, &c.
 ῎ΕΤΟΥΣ ͵ϛφμβ'.

Now in the British Museum, Add. MSS. 17,470.

TABORSKY, JAN. Saec. XVI.
 Of Klokolska (now Pimpernusberg).

A famous mechanician, horologist, painter, and art writer.
He was a pupil of Paul Przibram in 1519, and executed the
astronomical clock which is in the tower of the Council Chamber
in the old town of Prag, where he was living in 1552. In 1563 he
wrote a great Hymnal or Choir-book in Bohemian, with musical
notation and adorned with several miniatures, for the town church of
Laun, and instead of a preface he gave a Sapphic ode in Bohemian
verse, the initials of which form his name thus : " Jan Taborsky z
Klokolské, Hory 1563." In 1800 this MS. was in possession of
Herr Frantz Ortina, a townsman of Laun, who also had others,
e.g., the beautiful choir-book of Teplitz and that of the church of
the Moravian Brothers, both executed by Taborsky. He appears
to have been an editor of such works, and to have employed
scribes to write them under his direction.—*Dlabacz :* ii. 249.

An account of the Cesky Kancional (Bohemian Choir-book) at
Klatovech, containing miniatures and other ornaments, and signed
in acrostic form with the name of Jan Taborsky z Klokolské, is
given in the *Památky Archaeologické a Mistopisné*, i. 188.

TADEO. *Miniaturist.* Saec. XVI.

In the sale of Sir W. Tite's library, at Sotheran's in 1874, was a
MS. " Lectionarium et Sequentiæ cum antiphonario et orationibus

pro festis ecclesiæ Romanæ." Very pure vellum, titles in gold. The initials illuminated in glowing colours heightened with gold, and eight excellent paintings with superb borders, executed in the highest style of the finest period of Italian art, and attributed to "Tadeo, miniatore," Pope Leo X.'s famous illuminator. In oak boards, covered with crimson velvet, gilt corners, and clasps. Niello portraits, Leo X., Cardinal Bembo on obverse, and their arms on the reverse of covers. Given by Leo X. to Cardinal Bembo, his amanuensis. The eight miniatures represent : 1, The Nativity ; 2, The Resurrection ; 3, Birth of St. John, Baptist ; 4, St. Augustine expounding the Scriptures to four kneeling monks ; 5, St. John, Evangelist, writing his Gospel ; 6, the three Maries at the Sepulchre ; 7, High priests and scribes ; 8, Four monks praying beside corpse of a bishop. To each of these miniatures is a magnificent border. Formerly in the possession of Count Cicognara.—*Sale Catalogue*, May 18 to June 6, 1874. *See* MEDICI, GIOV. DE'.

TAGLIENTE, GIOV. ANTONIO. *Calligrapher.* Saec. XVI.

In 1545 published a Method of Writing entitled, " Lo presente libro insegna la vera arte de lo excellente scrivere de diverse varie sorte de lettere le quale se fanno per geometrica ragione ; et con la presente opera ognuno le potra imparare in pochi giorni per lo amaistramento, ragione ed essempi qui seguente vederai : Opera del Tagliente nuovamente composta con gratia vel anno di nostra salute MDXXXXV." 4°, 28 ff., twenty-two of which are entirely engraved on wood. He has borrowed largely from Palatino, but is inferior to him. His best letters are five sorts of "lettere can-cellaresche," two kinds of "lettere fiorentine," and several ancient alphabets, but especially an alphabet called "fractur," or in Italy "francese," formed on a plan probably borrowed from Dürer.— *Jansen : Essai sur l'Orig. de la Gravure*, ii. 51. A copy of the edition of 1546 is in the British Museum.

TAINGUI. *Copyist.* Saec. XV.

Wrote the magnificent copy of " Les Decades de Tite Live, traduction de Pierre Berceure," 3 vols. folio. Vellum. With minia-

tures, initials, and borders. Now in the National Library, Paris, MS. fr., 6,901, 3.3, 4.4, 5.5. Only the miniatures of the first volume have been completed. The handwriting is very fine, and by the same hand as the "Valere Maxime," MS. fr., 6,726, $^{3.3}$. On the fly-leaf at beginning, "C'est Titus-Livius lequel est à Jehan, fils de Roy de France duc de Berry et d'Auvergne conte de Poitou d'Estampes et Bouloingne et d'Auvergne. J. Flamel." (Should it not be N. Flamel?) Fine miniatures, vignettes, initials, beginning of fifteenth century (Fonds Colbert, 253). At end of the first volume we see that Simon de Hesdin finished it in 1375. After the table which begins the first volume, we find in the same hand as the body of the work the signature P. Taingui, M. It is one of the most beautiful hands possible to see. At end : "Cy fine les trois decades de Titus qui sont moult sades. Escriptes par Raoul Taingui." Pierre Bercheure (Berseure, Berceure, or Bertheure) was a Dominican monk of St. Eloi, at Paris.—*Paris: Les MSS. fr., &c.,* iv. 41. Also, 2. Valère Maxime, trad. par Simon Hesdin, et Nic. de Gonesse. Now in National Library, Paris.— *P. Paris,* ii. 287, 6,901 ; i. 48, 6,726$^{3.\ 3}$, 6,726^4, 6,901, as above. Folio, maximum. Vellum. 2 cols. Vignettes and initiales, XIVe. A superb MS. Executed for Jean Duc de Berry, who has placed his signature at the end. He was probably also the copyist of the Miroir Historial in Jean de Vignay's translation (MSS. fr., 6,930, 6,931, 6,392, and 6,933). Large folio. With very numerous miniatures, vignettes, and initials, the sole complete copy of this immense work in the National Library. Paris thinks the frontispiece of the first volume comparable with the work of Perugino or Fouquet. It represents the Triumph of the Almighty over the rebel angels. At end of fourth volume : "Cy fine le Mireoir hystorial et fu accompli lan Mcccclv. le vi. jour de Septembre.—*Paris: Les MSS. fr. &c.,* ii. 324. The work came from the Library of Louis de Bruges, as proved by the devices and cyphers. "Magnifique manuscrit," says Van Praet, "sur velin, du quinzième siècle, écrit en ancienne bâtarde, sur 2 colonnes, de 44 lignes chacune, et enrichi d'un grand nombre de très jolies miniatures en camaïeu gris, rehaussé d'or, avec des bordures et autres ornamens d'une délicatesse extrème." The contents table is thus inscbried : "Cy commence le premier volume du mireoir hystorial translate de latin en francois par la main de jehan du Vignay selon loppinion frere Vincent qui en latin la compila a la requeste de monseigneur Saint Loys, Roy de france." Three times in the second volume occur the L. M. initials of Louis and

his wife, Marguerite de Borssele, whom he married the same year in which this MS. was executed. The M, as usual, has been converted into an A, for Anne of Brittany. Similar cyphers occur in the fourth volume. This French translation was printed by Antoine Verard, in five volumes folio. (Paris : 1495–1496).— *Van Praet : Recherches sur Louis de Bruges,* 205, 206.

TANUCCIO, CRISTOFANO DI. *Copyist.* Saec. xv.

Called Fiorentino.

Wrote La Div. Commed. Paper. Folio. At end of last cantica : "Compiuto e ellibro di dante allaghieri da firenze scripto per Cristofano ditto fiorentino di tanuccio del monte Sct° Sauino die xx. di magio, 1466, nella piubicha deo gratias. Amen."—*Batines,* ii. 142.

TAPPARELI, DERSANUS. *Copyist.* Saec. xv.

Wrote "Amedei VIII. sabaudiæ Ducis decreta," &c. Cod. cccxciii. h. vi. 25. Paper. 2 col. ff. 66, xv. "Expleta sunt . . . per me *Dersanum Tappareli de Savilliano* ad opus magnifici et potentis Dom[i] Gottofredi ex Dominis Strambini et ex comitibus Sct[i] Martini, &c., de anno Dom[i] 1466, de mense Madii.—*Pasini,* ii. 95.

TARAVICENSIS, JOHANNES ANTON[s]. *Copyist.* Saec. xv.

La Div. Commed. Paper. Folio. 205 ff. Good letter round hand, title and latin arguments, red initial in col. to each canto. Frontispiece to each cantica and a grand initial in gold and colours. At end fol. 201 : "Explicit liber Illustriss[i] poete Dantes aligerij Florentini." "Scriptus per me Johānem antonium tarauicensem in Castro Stronconi Anno dñi Millo cccclxv. Now in the Albani Library, Rome.—*Batines,* ii. 192.

Tarroni. *Miniaturist.* Saec. xv.

Worked at Parma in 1478.—*Zani*, xviii. 126.

Taschetti, Camillo. *Miniaturist.* Saec. xviii.

Padre Abate Rocchetino di Laterano. Born at Verona, 1703. Died, 1772.

Zani: Enciclop. Metod., xviii. 104.

Tassi, Vincenzo. *Miniaturist.* Saec. xvii.

A Priest of Terra del Sole, Tuscany. Born, 1631. Died, 1698.

Zani, xviii. 131.

Taurus, Franciscus. *Copyist.* Saec. xv.

Wrote, in 1470, "Aristotelis Metaphysicor.," lib. xii. Now in Bodley Library, Oxford (Canon. lat., 190).

Tavernier, Jehan le. *Miniaturist.* Saec. xv.

Of Audenarde.

Executed, about 1458, the beautiful "grisailles" of a "Histoire et Conquestes de Charlemagne," in three enormous volumes, folio, written by David Aubert. They are the same size as the "Roman de Charles Martel," written by Aubert, in the

same library. Now in the Royal Library, Brussels. Vol. i. begins in red : "Cy commence la table du premier volume des anciennes croniques et conquestes du très-excellent empereur Charlemaine, le conquerant, qui sont dignes de haulte louenge et recommandation." A compilation of the best historians then known on the reign of Charlemagne. It was translated and put together under the direction of David Aubert during or immediately after the completion of the "Charles Martel." It seems as if the magnificent patron of these works, Philippe le Bon, had ordered it to be executed on a scale more magnificent than its predecessor in order to mark the superiority of Charlemagne over Charles Martel, and as placing the realities of history above the imaginations of fiction. As to the material execution of the manuscript the miniatures are not in various colours like those of the "Charles Martel," but in the black and white and gold, with touches of fine blue called "grisaille." They are superbly executed, and among the finest of their kind in existence. In the Life of Antonio de Holanda by his son, it is related that Antonio was the first who introduced that style of painting into Portugal, and one of the first who adopted it in miniature. Be this as it may, it is certain that Netherlandish miniaturists carried it to the utmost perfection, so that nothing can be imagined more exquisite in finish and delicacy than these grisailles of Jehan Tavernier. It is said that when the Commissioners for the recovery of MSS. belonging to the Bibliothèque de Bourgogne, brought them back from Paris in 1815, the keepers of the MSS. made special arrangements for the protection of this work. In the Barrois Inventory it numbers 733 ; in that of Gérard, 800. It is now 9,066–68 of the Royal Library. On the first folio is the signature of the Archduke Philippe the Fair, afterwards King of Castile, with his autograph "devise" *Qui Vouldra.* Also the signature of "Juana de Castilla" (Jeanne la Folle), wife of Philippe, and mother of Charles V. The last volume at end has this rubric : "Cy fine le second volume [it is in two parts] des conquestes du noble empereur Charlemagne, lequel par le commandement et ordonnance de tres-hault, tres excellent et tres puissant prince Phelippe, par la grace de Dieu Duc de Bourgoingne, &c., a este extrait et couchie en cler françois, par David Aubert, lan de grace mil quatre cens cinquante huit." The second volume was exhibited at the National Exhibition in Brussels in 1880.—*Marchal : Catalogue des MSS., &c.,* ii. 290, 291, Nos. 9,066–68.—*Catalogue de l'Exposit. de Bruxelles,* 1880, No. 74.

TAYLOR, ALEX^{R.} *Miniaturist.* **Saec. XVIII.**

Exhibited at the Royal Academy from 1776 to 1796.—*Redgrave: Dictionary of Artists of the English School.*

TEANO, NICOLA FORTIGUERRI DA. *Patron.* **Saec. XV.**

Bishop of Pistoia.

A number of finely-illuminated MSS., including several copies of the " De Civitate Dei " of St. Augustine now in the library of St. Geneviève, Paris, attest the princely tastes of this prelate. From the one on paper, dated 1459 (No. 674), it appears that he kept a professional copyist at his palace in Mantua, named Johann Gobelin of Lintz, clerk of the diocese of Trèves. He also employed Nicola Polani, in the same year, to write another copy now in the same library. It would appear that some relative of the bishop also busied himself with transcribing MSS.; as in the National Library, Paris, are three MSS. written by Franciscus Tianus Pistoriensis, in 1469 and 1474. These MSS., however, were written for Francesco della Rovere, Cardinal of Teano, afterwards Sixtus IV. (Hieronymi Epistolæ, MSS. lat., 8,910, 8,911), and Giuliano della Rovere, Cardinal of Teano, afterwards Julius II. But Tiano of Pistoia may be no more than a coincidence with Fortiguerri of Pistoia, Bishop of Teano. Still, the similarity of names in connexion with Pistoia is curious.—*Denis: Appendice à l'Imitation de J. C., Manuscrits,* 18, Nos. 92, 93. *See* TIANUS.

TEDALDI, GEMINIANO. *Copyist.* **Saec. XIV.**

Wrote part of " Io. de Lignano in quarto et quinto libris decretalium comment. Io. Calderini," &c. At end of Book V.: " Explicit Liber Reportatorium Domini Ioannis de Lignano super Decret. utriusque juris eximiæ Professoris. Geminianus ser Nicolai Domini Tedaldi de Prato propria manu scripsit. Qui scripsit hunc Librum locum habeat in Paradisum."—*Bandini : Catal. Biblioth. Aedis. Florent. Eccles.,* 78 *Cod.* liv. Also " Io. de

Lignano Comment. in Libro II° Decretalium." At end: "Expliciunt reportationes super sec° libro Decretalium. Scriptæ per me Geminianum Ser Nicolai Domini Tedaldi de Prato in Mccclxxxx die xii. mensis septembris. Amen. Qui scripsit hunc librum," &c. On paper, 288 ff.—*Bandini: Ibid. Cod.* liii. Also "Casparis Calderini Recollectæ super lib. i° Decretalium." At end: "Recollectae super primo libro Decret. sub Domino Guasparo de Calderinis (the famous Jurisconsult) Decretorum Doctore in orbe famosissimo. Scriptæ per me Geminianum Ser Nicolai de Prato tunc actu audientem et scribentem sub ipso, in ciuitate Bononiæ, inceptæ anno Domini Mccclxxxxiii.—*Bandini: Ibid.* 82, *Cod.* lvii. Also *Codd.* lviii. and lix. in same Collection.

TEDESCO, GIORGIO. *Miniaturist.* Saec. xv.

Executed a "Missale Secund. Consuetud. Romanæ Curiæ." Vellum. Folio. In beautiful preservation. "Oltre i fregi molto variati e vaghi vi sono tre quadri assai bene conservati con casamenti e figure di pregio e di maniera tedesca. Il miniatore fu Giorg. Tedesco il quale impregò otto anni in tale lavoro cioè dal 1449 al 16 Maggio 1457.—*Campori, G.: Notizie dei Miniatori dei principi Estensi,* 9. "Questo codice conserva tuttora un' antica coperta di velluto con due contorni e uno scudetto dargento dorato che mostra l' arma estense." Now in the Este Library, Modena.— *Cat.* No. ccxxxix.—*Cenni Storici, &c., Estense,* 35.

TEERLINC,
TEERLINCX, } LIEVINE. *Miniaturist.* Saec. xvi.

Eldest daughter of Simon Bennynck or Bynninck of Bruges.

She was a pupil of her father, and married a townsman of Blankenburgh named Joris, or George, Teerlinc. Before 1547 she came over to England, where, possibly, as a widow, she married a second time. Guicciardini says of her, "Nel miniare come il padre

è tanto felice et excellente, che il prefato Henrico Re d' Inghilterra
la volle con ogni premio haver a ogni modo alla sua Corte, ove fu
poi maritata nobilmente, fu molto amata dalla Regina Maria et
hora è amatissima dalla Regina Elisabetta." In 1547 Maistris
Levyn Terlinq, paintrix, received a quarterly salary of ten pounds
(not xli., as given in some accounts, the x li. meaning simply *decem
libræ*, ten pounds). In 1556 she gave Queen Mary, as a New
Year's offering, a small picture of the Trynitie. In 1558 she
presented Queen Elizabeth with her portrait painted on a card, in
return for which the Queen gave her a silver-gilt smelling-bottle,
weighing 2½ oz. In 1561 she again gave the Queen a portrait of
the Queen's person and others on a box, and received in return a
gilt salt-seller, with cover, weighing 5½ oz. This seems to have
been the usual mode of remuneration for these portraits, as
Petruccio Ubaldini received similar bounties —*Guicciardini: De-
scrittione di tutti i Paesi Bassi,* 145.—*Clayton : English Female
Artists,* i. 9.

TEERPENNINC, GERARDUS. *Copyist.* Saec. xv.

Wrote, in 1414, on paper, folio, 278 ff., " Petre Herentalii,
Psalmor. expositis." At end : " Gerardus Teerpenninc curatus in
Lexmeude hunc scripsit et finivit anno Domini M.ccccxiiij. in festo
Dyonisii et Socior. eius martirum sctor." Now in Library of St.
John's College, Oxford.—*Coxe: Catalogus, Codd. MSS. Coll. S.
Johannis Baptistæ,* 18.

TEGLIACCI, NICCOLÒ. *Miniaturist.* Saec. XIV.
Son of Ser Sozzo de' Tegliacci of Siena.

Executed about 1336 several miniatures in the Cartulary of the
Republic and other MSS. at Siena. Ser Sozzo di Francesco, the
father, was the first citizen who was made Capitano del Popolo, and
was elected 1355. Niccolò was a syndic in the same year, and
held other offices in the Republic, until finally, in 1357, 1359,

and 1362 he became supreme magistrate. In the Roll attached
to the Statutes of the Guild of Painters drawn up in 1355, his
name does not appear; but it is inserted in the book of the arts
made in 1363 in his capacity as master of the timber-merchants.
He died in the same year, and was buried in San Domenico.
" 1363, Nicolaus ser Sozzi, pictor, sepultus est die xv mensis
Junii." From his hand we only know of the beautiful miniature
which adorns the first leaf of the so-called Caleffo, of the Assump-
tion, in the Archivio delle Riformagioni di Siena. We cannot say
precisely in what year it was painted, but as the copy of that
instrument was commenced in Sept. 1334, and finished in May,
1336, it is reasonable to suppose that Tegliacci painted it within
that period. Few miniaturists of that time were able to surpass
him, or indeed to reach the level of his skill. He is a miniaturist
who has all the qualities of a painter, and knew how to apply
them to his art. The Caleffo, above mentioned, is a manuscript
on vellum, in small folio, written in a beautiful running hand,
and containing 891 ff. It contains the copies of the deeds con-
nected with the conveyance of lands and fortresses belonging to
the Republic of Siena, from 1137 to 1332. It is called the
Caleffo from an Arabic word which answers to the Low Latin—
Cartularium, and is particularised *dell' Assunta*, from the accounts
and a gift of a wax candle being rendered on that festival of St.
Mary. On the first page is a very graceful miniature on a gold
ground representing the Assumption of the Virgin, who is seated
with her hands joined as in prayer, within an azure *mandorla*,
rayed and starred. Overhead are several cherubim, and sur-
rounding her several ranks of angels engaged in choral music,
some with instruments of various kinds, others singing; while
others support the mandorla within which the Virgin is enthroned;
beneath is St. Thomas on his knees receiving the sacred cincture,
and near him is written, in minute Gothic characters, " Nicholaus
ser Sozzi de Senis pinxit." In three of the four corners of the
surrounding border are the busts of the patron saints of the city,
viz. : San Vittore, San Crescenzo, and San Savino. The fourth,
Sant' Ansano, is a figure within the initial " I " of the words " In
nomine Sancte et individue Trinitatis." Under the curvature is
a blue and red band with golden capital letters, "Salva Virgo
Senem Veterem quam noscis amenam." Surrounding it a
border of foliages in gold and colours, among which are small
figures of children, birds, &c. At foot are the arms of the Com-
mune, together with those of the People. In the upper border is

the figure of Christ in the attitude of benediction.— *Vasari: Le Vite, &c.*, vi. 185, 308. Nuove Indagini.

Since the above was written by Milanesi, it would appear that other miniatures by Tegliacci had been discovered, as Lombardi of Siena has photographed a number of the grand initials of the choir and other books, among which he gives a Resurrection, No. 57, and a "Missa Pauperum," No. 58, from the Cathedral Library. Others ascribed to him are manifestly by a much inferior hand.—*J. W. B.: Notes of Visits to Italian Libraries.*

TELLI, GIUSEPPE. *Miniaturist.* Saec. XVIII.

Worked at Venice in 1736.—*Zani:* xviii. 145.

TENEYKEN, JAC. *Copyist.* Saec. XV.

Wrote, in 1465, for Jacques, duc de Nemours, "Le Déchet des nobles hommes"; translated from Boccaccio by Laurent de Premierfait.—*Delisle: Cabinet des MSS.*, i. 87.—*Van Praet: Recherches sur Louis de Bruges*, 263.

TERRANOVA, JOHANNES DE. *Copyist.* Saec. XV.

Prior of the Monastery of St. George of Terranova.

Wrote part of a " Lectionarium ad usum Ecclesiæ Florentinæ," in four volumes. Vellum. Small fol., 2 cols. This is the Lectionary illuminated by Bartolommeo d' Antonio, described in the "Nuove Indagini." In vol. i., fol. 229, is this rubric : " Ego Johannes Francisci, monachus ordinis Vallis Umbrosæ scripsi hunc librum sub anno Domini M.CCCC.XL.VI." Vol. ii., at end : "Frater Peregrinus Cruceius a Mediolano ordinis minorum observantie in conventu sancti jacobi secus Arnum scripsit anno domini millesimo quingentesimo sexagesimo sexto, nonis Januarii." This refers to the additions merely, from fol. 218 to the end. In vol. iv. fol. 322 *v.* : " Facto fine pia laudetur Virgo Maria qui scripsit scribat semper cum domino vivat. Johannes adhuc Prior Sancti Georgi

Terre Nove ordìnis Vallis Ambrose scripsit sub anno domini, M.CCCC.XL.VIII die iiii. mensis februarii expletum fuit. Orate Deum pro me." *See* BARTOLOMMEO and GIOVANNI D' ANTONIO.— *Vasari: Le Vite, &c.,* vi. 245, 246.

TERRANOVA, MATTEO DA. *Miniaturist.* Saec. XVI.

One of the distinguished artists who worked on the Choir-books at Monte Cassino from 1519 to 1524. Concerning the payments for his work and materials, &c., copious extracts are given by Caravita from the account-books of the monastery, of which the following may serve as specimens :—" M° Matteo miniatore lo quale servi al Monasterio ad miniar libri deve dar per tanti mandato a lui in Roma d. 5 de carlini romaneschi fanno d. 4 gr. 12 mezzo." —Libro de' Salariati, A. 1505–21, p. 112. " 1520. M° Mattheo miniatore de dar per tanti contati allui per lo uenir suo da Roma d. 5 romaneschi valeno generaliter d. 4 gr. 12."—*Libro de' Conti,* 1516–20, 192. " 25 Luglio. Per M° Matteo miniatore a capsa d. 1 . 2 . 10. Contati ad zuccha per suo ordine per comprare oro."—*Libro de' Conti,* &c., 145. " 1521. Gennaro. Per M° Matteo miniatore a capsa duc. 1 gr. 14 contati a Loisi suo discepolo per finale pagamento de mesi 2 et giorni 22 compiuti carlini 22 li contò M° Matteo a lo decto Loisi per avante come appare per la sua polise."—*Libro de' Conti,* &c., 169. " 21 Giugno. Per M° Matteo miniatore duc. 3 li contò lo per p. d. Ignatio in Monte cassino."—*Ib.,* 180–84. " Agosto. Per M° Matteo miniatore a capsa duc. 2 . 1 . 10 spese per lui il p. procuratore nostro in Napoli in comprar certo oro et colori."—*Ib.,* 187. " Et a dì 27 Octobre conti ad M° Cima ad suo nome per comprare colori in fiorenza. Et a dì primo febraro conti allui per mano del p. d. Ignatio ducati sette quando andò ad gaietta. Et per tanti contò lo p. d. Ignatio Celleraro ad napoli alli parenti de Aluisio suo lavoratore de Commissione de decto M° Mattheo duc. 2." This assistant of Matteo's seems to have been a rather unsteady character, drawing his money in advance and making excuses for holidays to get away and spend it. He died in extreme poverty whilst still quite young ; and so miserably destitute were his relations, that when the messenger of the monastery was sent to reclaim the money that had been advanced, he could

find no one able to pay it. The final entries about Matteo are these :—" 20 giugno. Per Sacristia : a lo reverendo p. d. Justino duc. 22 . 2 . 14 contati ad M° Mattheo miniatore de suo ordine per finale pagamento di tutte le opere due facte fino a dì xxi di Jugno, 1523, 60." "Nota. Et de hauere M° Matteo per ultimo et finale pagamento de tutto la opera facta in Monte Cassino fine al presente giorno xxi di Jugno 1523, daccordio col p. d. Bene-detto et d. Giordano come appare in scripto pósto in filza, duc. 135 . 2 . 10. 69."—*Caravita : I Codici e le Arti a Monte Cassino,* i. 448, &c. Of Matteo and his assistant Loise the family names remain quite unknown. From Monte Cassino they went to Perugia, where they are found at work on the Choir-books in 1526, 1527. The final payment is recorded with considerable formality on June 21, 1523.—*Caravita,* i. 448, 461, &c. Matteo is said repeatedly to come from Terranova, but there are several Terranovas up and down Italy. Caravita thinks him a Neapolitan. Manari calls him a Tuscan. The Perugino Graduals, which are his work, are executed in the richest and most beautiful manner. In 1525 Matteo was working at Florence, and went from Florence to Perugia, where he also worked in 1527-8.—*Manari (Luigi, Cassinese di Perugia) : Cenno Storico ed Artistico della Basilica di S. Pietro di Perugia,* i. 461.—*Caravita : I Manoscr. e le Arti. &c.,* ut sup.

TERSTELT, HENRY. *Copyist.* Saec. xv.

Wrote, in 1467, the "Hexameron" of St. Ambrose. At end : "Explicit liber sextus Beati Ambrosii episcopi in Exameron. Scriptus ac finitus per manus fratris Henrici Terstelt, anno Domini M.CCCC.LXVII.," &c. Now in Royal Library, Brussels, No. 1,834. —*Marchal : Catalogue des MSS., &c.,* ii. 148.

TESTART, ROBINET. *Illuminator.* Saec. xv.

Employed by Louise de Savoie Duchesse d'Angoulême, at a salary of 35 livres a year. His name occurs in the account-book of "L'etat des officiers domestiques de lostel de Charles

d'Orléans, Comte d'Angoulesme" in 1473–87. "Varlets de
Chambre—Robinet Testart en 1484, enlumineur en 1487." And
in similar volume for 1522–23: "Robinet Testart enlumyneur
. . . . 100 livres," and lower down: "A maistre Robinet
Testart enlumineur et varlet de chambre ordinaire du Roy, la
somme cent livres pour sa pension durante ceste presente année
commencé le prem^r jour de Janvier, 1522, and finie le dern^r
jour de decembre," 1523.—*Delisle: Cabinet des MSS.*, i. 184.
The Hours of Louise de Savoie are now in the British Museum,
Sloane MSS., No. 2,710. *See* MICHEL, JEAN.

TEUER, JACOBUS.　*Copyist.*　　　Saec. XV.

Wrote, in 1443, "Biblia Latina, cum prologis B. Iheronimi."
In two vols. Vell. Fol. (11¾ × 8¼ in.) 848 ff. Contains floriated
borders, initials, and miniatures. At end of vol. i. is this note:
"Anno Domini MCCCCXLIII., in Vigilia Beati Thomæ Apostoli
Completus fuit iste liber per manus Jacobi Teuer, sumptibus et
expensis venerabilis viri Magistri Wolteri Grawert Ecclesiæ Sẽti
Salvatoris [Ultrajecti] decani." Belonged to Mr. Bragge, of
Sheffield. Sold, in 1876, at Sotheby's.—*Bragge: Sale Catalogue*,
No. 217.

TEUTSCHOLD.　*Illuminator, &c.*　　　Saec. XVI.

A herald-painter and miniaturist under Charles V. of Germany.
He left behind him a MS. "Ueber die Vornehmsten Reichstände,"
with richly-painted coats of arms. Now in the Ducal Library at
Gotha.—*Nagler: Künstlerlexicon*, xviii. 285.

THEOBALDUS.　*Copyist.*　　　Saec. XIII.

Of Aspromonte.

Wrote an abridgment of the "Speculum Historiale," made by
Adam, Bishop of Clermont. Now in the National Library, Paris
(MS. lat., 17,551). On folio 298 *v.* is an interesting passage given

in facsimile by Delisle, relative to the treaty concluded between John, "Sans Terre," King of England, and Innocent III. On folio 314 *v.* is this note :—"Expliciunt flores hystoriarum ex Hystoriali speculo fratris Vincentij de ordine fratrum Predicatorum, Parisiensium. Excerpti a magistro Adam clerico, episcopo claromontensi, scriptus fuit iste liber anno Domini millesimo ducentesimo octogesimo tercio circa nativitatem Domini, a Theobaldo de Aspero Monte. Dextram Scriptoris servet genetrix genitoris— Amen."—*Delisle : Cabinet des MSS.*, iii. 301, iv. pl.

THEODERICUS. *Copyist.* Saec. XI.

A Monk of Epternach.

Wrote for Abbot Regimbert (1051–1081) part of MS., lat., 8,912, National Library, Paris.—*Delisle : Cabinet des MSS.*, ii. 362. Also 9,528, in same library, for Abbot Ravengerus (971–1007).—*Ib.*

THEODERICUS, ALBERTUS. *Copyist.* Saec. XII.

Abbot of SS. Mary and Nicholas in Arenstein.

Wrote "Augustini Confessiones." Vellum, thick 8⁰. 165 ff. In small, firm, and upright half Roman. A few large initials roughly illuminated. In later hand at beginning : "Hic liber ut in calce videtur a Ven. dño Theoderico abbate huius Monasterij Arensteyn, conscriptus, a me Henrico Schupio eiusdem non lic^t Abbati indigno suis titulis capitib' atȝ annotationib^e Sacre scripture respondẽtib^e iuxta æditionẽ Erasmi Roterodami est elucidat^e Anno dñj Saluatori nrj Ihesu Chrj Millessimo Quingentesimo Septuagesimo Benedictus Deus." At end, in red : "Explicit liber 9fessionũ saNctj Augustini feliciter in xp̃e. A M E N. Then in small black letters : "Quẽ scripsit aḃḃs theodericus." Now in British Museum, Harl. MSS., 5,004.

THEODORIC. *Copyist.* Saec. xv.

Wrote, in 1468, " Augustinus di Civitate Dei." Vellum. Folio. 264 ff. Ornamented with numerous painted initials and three miniatures and floriated borders. Formerly belonged to Mr. Bragge, and sold in 1876.—*Catalogue of Sale,* No. 21.

THEODORICUS. *Copyist.* Saec. xi.

Abbot of St. Evroul about 1050.

Ordericus Vitalis says of him : " Ipse scriptor erat egregius et inclytæ insitæ sibi arti monumenta reliquit." Collectaneum enim et Graduale ac Antiphonarium propria manu in ipso cænobio conscripsit. He also taught a number of monks the art of calligraphy.—*Duchesne: Histor. Normannor. Scriptor.* 470.

THEODORICUS DE ANDREA, TEUTONICUS. *Copyist.*
 Saec. xv.

Wrote a Commentary on Dante (by Fr. da Buti). Bibl. Riccardiana Flor., 1006, 7, 8 (O. I. IX.). Vellum. 3 vols. Grand folio. Part fourteenth and part fifteenth century. Tom. i. 224 ff. 2 cols. Good letter. " Inferno," most beautifully preserved. Titles red. To each canto two graceful initials in gold and colours, with arabesques. The first folio has a rich border in gold and colours, and at foot a shield. In front, " Incipit scriptum sup. comedias Dantis aligerii de florentia editū a magr̃o francisco de Butrio de ciuitate pisarū." At end : " Et qui finisci lo xxxiij canto et la prima cantica Deo grās. Amen. Compiuto nelli ani del nostro signori ihū xp̃o M.ccccxij nel xix. di daprili." Tom. 2. Purgatory. 208 ff. 2 cols. in another hand. First fol., adorned with a rich border in gold and colours, with same shield at foot, but much rubbed. This commentary on the Purgatory ends on fol. 184. " Deo grās Finito libro sit laus et glia xpo Theodoricus de Andrea teutonic⁹ sc'psit 1413 cōpiuto d di xxix. di genaio." Vol. iii. was written about the end of the fourteenth century.

223 ff. in 2 cols. Similar hand to second volume. Back of first folio has a magnificent miniature, full size of page, representing Dante, Virgil, and Beatrice on the circular mountain of Purgatory, and over them the celestial court. One of the two initials at beginning of this part is very large, and in the interior has a beautiful figure of Christ at foot, and a shield like that of the second volume. This volume wants title. At end: " Qui finisce locāto 33° dela terza cantica dela Comedia di dante alighieri et la sua lectura facta p. mō francescho di Bartholo dabuti. Et cōpiuta lo di della festa discō Bernardo adi 11 di guigno nel 1394." In the inventory of the Riccardi Library it is attributed by mistake to the fifteenth century.—*Batines*, ii. 318–19. It is, however, curious that the two former volumes should have been written in 1412 and 1413, and the third in 1394.—*Lami: Cat.*, 20.—*Novelle Lettere di Firenze*, 1746, col. 803.—*Lezioni di Antichità toscane*, i. 279.—*Mehus : Vita di Traversari*, 182.—*Estratti MSti.* XI., 203–5.—*Invent. della Riccardiana*, 24.

THEODOROS. *Copyist and Calligrapher.* Saec. XI.
A Monk of Cæsarea.

Wrote and illuminated a " Psalterium " containing an additional psalm (CLI.), with canticles and hymns at end. Vell. Fol. 208 ff. The first two psalms are written in golden letters, and the whole is profusely illuminated. On fol. 208 is a colophon in golden and red minuscules. First in gold : Ἔσχεν οὖν τέλος ἡ τοιάδε τῶν θείων ψαλμῶν δέλτος κατὰ τὸν φεβρυάριον μῆνα τῆς δ' ἰνδικτ . τοῦ ¸ζφοδ' ἔτους, &c. Then in red : Χειρὶ δὲ γραφὲν καὶ χρυσογραφηθὲν Θεοδώρου μοναχοῦ πρεσβυτέρου τῆς αὐτῆς μονῆς καὶ βιβλιογράφου τοῦ ἐκ Καισαρείας, ἧς ποιμὴν καὶ φωστὴρ ὁ κλειν . . ., &c. And again in gold : Χριστῷ ἄνακτι δόξα καὶ κράτος πρέπει. Now in the British Museum, Add. MS., 19,352.

THEODORUS, FLAVIUS. *Copyist.* Saec. XIII.

Wrote " Prisciani Cæsariensis de Arte Grammatica, libri xvi. priores." Vellum. Small folio. 94 ff. Blue and red initials.

No other ornaments. At end of book viii.: "Flavius theodor⁹ Dionisij vi(viri) D'(Disertissimi) memorial' sac' scrinij epl'arū et adiutor. Q. M. questoris sacri palacij sc'psi artem Prisciani, eloqūtissimi Graͫatici doctoris mei manu mea in urbe roma 9stantinopoli die t'cio Jd⁹ Jañ. Mavortio q'nto. 9sulᴇ." Now in British Museum, Add. MSS., 17,394.

THEODOSIOS. *Copyist.* **Saec. XIV.**

Wrote, probably, the Gospel of St. John, in a MS. of the Gospels, part of which was written in the twelfth century. By the second hand, in a red minuscule, is this note of the year 1380 :— "Τὸ παρὸν ἐγράφη διὰ χειρὸς ἐμος Θεοδωσίου τοῦ μεγάλου Βασιλέως ἐν ἔτει ϛτπ' χριστοῦ." Now in the British Museum, Harl. MSS., 5,567.—M. Omont has printed a list of the Greek MSS. and some of their copyists in the British Museum, in *Bibliothèque de l'École des Chartes*, xlv. 314–350. Reprinted, Paris, 1884, 8°, 22–40.

THEODOSIUS II. *Calligrapher.* **Saec. V.**
Greek Emperor, 408–450.

Called καλλιγράφος because of his fondness for the art of book illumination.—*Séroux d'Agincourt*, ii. 49, and Pl. 19, 20.

THEODOSIUS III. *Calligrapher.* **Saec. VIII.**
Emperor of the East, 716–717.

Is called both calligrapher and chrysographer, and is said to have practised the art during his stay at Ephesus. Οὗτος ἦν καὶ χρυσογράφος.—*Cedrenus*, 449.—*Wattenbach : Das Schriftwesen des Mittelalters*, 210 (2ᵗᵉ *Aufl.*).

THEOFRID. *Copyist.* Saec. (?)

Monk and Abbot of Epternach.

> Wrote " Vita Williborde." Now in the Ducal Library at Gotha.—
> *Jacobs und Uckert, Beiträge,* ii. 345, f.

THEOPHANIA, ⎫
THEOPHANO, ⎬ *Patroness.* Saec. x.
 ⎭

Daughter of Nicephorus, Emperor of the East, and wife, in 972, of Otho II., Emperor of Germany.

> She introduced Byzantine artists to her husband's court, and
> brought about a great revival of art in the West. Among the
> MSS. produced under her auspices is the famous Codex Aureus
> Epternacensis, or Golden Gospels of Echternach, now at Gotha,
> presented to that Luxemburg monastery about the year 990. The
> Byzantine method of working in ivory and laying on gold in MSS.
> was again revived, after the somewhat faded practice of the Caro-
> lingian epoch. As this MS. is one of typical character and
> striking splendour, it has been frequently described or referred to.
> The beautiful twining stem-work of the initials is similar to that
> of the Trèves Gospels and the St. Gallen Golden Psalter ; and the
> Coronation Book of King Edgar in the British Museum has an
> initial " L " similar to that of the Echternach Gospels.—*Rathgeber :
> Beschreibung des herzogl. Musœums zu Gotha,* 6–20. Miniatures
> of the Gotha MS. are represented in *Hefner-Alteneck, Trachten,*
> &c., i. pl. 57. The cover is reproduced by Quast and Otte,
> *Zeitschrift für Christliche Archæologie und Kunst, II.* It is said
> that the original contract of marriage between Otho and Theo-
> phania, written in golden letters on purple vellum, is still pre-
> served. It was once kept in the Library of the Monastery of
> Gandersheim.—*Abrégé Chronol. de l'Histoire et du Droit publ.
> d'Allemagne,* 91.

THEOTONICUS, PETRUS. *Copyist.* Saec. XIV.

Son of Conrad of Nuremberg.

> Wrote, in 1373, " Senecæ tragædiæ," in ten books, with minia-
> tures, initials, and borders. Vellum. Folio. The books are—1,

Hercules furens; 2, Thyestes; 3, Thebais; 4, Hippolytus; 5, Œdipus; 6, Hecuba; 7, Medea; 8, Agamemnon; 9, Octavia; 10, Hercules Œteus. The first tragedy begins with an enormous initial " S," with flourished, wing-like foliages, common in Italian illumination of this century. A kingly figure sits across the middle of the letter. The text is a large Italian-Gothic. At end : " Explicit liber tragediaru; Marci anei senece Scriptus p manus Petri Theotunici De Nurnberga Cunrate. Anno Dñi M°ccc°lxxiij°. In vigilia Sc̄e Katherine." Now in the Vatican Library, No. 1,585.—*D'Agincourt : Painting*, Pl. lxxiv.

THEUTATUS. *Copyist.* Saec. IX.

Wrote a MS. of the Book of Job. Now in the Vatican Library. —*Séroux d'Agincourt : Hist. de l'Art, &c.*, iii. 105.

THEVENIN. *Copyist Agent.* Saec. XIV.

A native of Anjou, employed by Louis Duc d'Orleans.

There is a receipt in his handwriting, quoted by Laborde, to the following effect : " Je, Thevenin Angevin, confesse avoir receu à plusieurs fois de MS. le Duc d'Orléans, par les mains de Gode-froy le Fevre—la somme de trois cens frans, c'est assavoir le xiij^e jour de feurier, lan iiij^xx et xiiij. dix frans ; le xxvj^eme dudit mois cinquante ; le xix^e jour d'auril l'an iiij^xx et xv cent ; le xxviii. jour d'aoust ensuivant, cent, et le iiij^e jour de decembre ensui-uant, quarante, pour acheter parchemin à escrire le livre nommé *le Mirouer hystorial*, contenant quatre volumes et autres livres et pour paier les escripvains et enlumineurs qui escripsent et enluminent lesdiz liures pour ledit seigneur. En tesmoing de ce j'ay escript ceste cedule, de ma propre main, le xij^e jour de fevrier, l'an mil trois cens iiij^xx et quinze.—*Laborde : Les Ducs de Bour-gogne, &c., Second*, iii. 110, Art. 56–78.—*Le Roux de Lincy : Biblioth. de Charles d'Orléans*, 9, 19, 35, &c.

THIEBAULT. *Illuminator.*

Entered the Gild at Bruges in 1470.—*Laborde*, 77.—*Kirchhoff*, 188.

THILMANNUS, "DE ARE." *Illuminator.* Saec. XIV.

Wrote "Jacobi Januensis Præd. ord. Legenda Sanctorum, quæ communiter historia lombardica appellatur." 4º. "Insignis cod. qui multo auro multisq. picturis elegantibus atq., ridiculis sæpe excellit." At end : "Explicit legenda sanctorum. Siue Summa lombardica. Scripta per Thilmannum de are. Anno domini Millesimo, trecentesimo, vicesimo quarto," &c.—Cod. CXV. In St. Bartholomew's Stift's Bibliothek at Frankfort-am-Main.— *Archiv der Gesellschaft für ältere Deutsche Geschichtskunde, &c.*, Bd. ii. 209.

THOLA, BENEDIKT. *Miniaturist, &c.* Saec. XVI.

Of Brixen.

Painter, musician, &c. (1550–60), in the service of the Electors, John Frederic, &c., of Saxony. In the Royal Library at Dresden is a Psalter containing portraits of the Electors painted by him, and in the Frauenkirche a painting of the Raising of Lazarus.— *Nagler : Künstlerlexicon*, xviii. 356.

THOLA, GABRIEL. *Miniaturist, &c.* Saec. XVI.

Brother of the above.

Also in the service of the Electors of Saxony. In the Frauenkirche at Dresden were tablets with paintings by both brothers.— *Nagler : Künstlerlexicon*, xviii. 356.

THOLICA, JOHANNES. *Copyist.* Saec. X.

Wrote "Libro de Maravelles, in the Catalan dialect, in ten books. Paper. Large 4º. 187 ff. Very much stained. Rough initial in red and blue. No other ornaments. At end, almost illegible : "Die Veneris vij Julij anni octuagesimi quinti incepit scribere Johannes Tholica presentem librum et patravit die Veneris duodecimo Januarij anno a natiuitate domini millesimo trecentesimo octuagesimo sexto." Now in British Museum, Add. MSS., 16,428.

Thomas. *Calligrapher.* Saec. VIII.

Wrote and ornamented the Gospels preserved in the Cathedral of Trèves.—*Westwood: Anglo-Saxon Miniatures, &c.,* Pl. xix. xx. 72–77. Reproductions in outline of the two miniatures of St. Luke, &c., with the words "Thomas scribsit" at foot, are given by *Dr. Lamprecht : Initial-Ornamentik,* des viii. bis xiii. *Jahrhunderts,* 44. Pl. Fol. (Leipzig, 1882), Pl. 4, 5.

Thomas. *Illuminator.* Saec. XIII.

Lived at Paris in 1292.

Géraud: Paris sous Philippe le Bel, 128.

Thomas. *Copyist.* Saec. XV.

Wrote "La Legende Dorée trad. de Jeh. de Vignay." Folio. Vellum. 2 cols. Two miniatures, vignettes, and initials. The two miniatures are pretty. The copyist has signed his name, "Thomas." Now in the National Library, Paris.—*Paris : Les MSS. fr., &c.,* t. ii. 256, 6,889.

Thomasse. *Illuminatrix.* Saec. XIII.

Lived at Paris in " la rue au Foin."

In 1292 this "enlumineresse et tavernière" earned nine sous. —*Géraud: Paris sous Philippe le Bel, &c.,* 173.—*Kirchhoff: Die Handschr.-händler des Mittelalters,* 183.

Thorem, Ludovicus. *Copyist.* Saec. XV.

A Priest.

Wrote, in 1457, "Summa Casuum Conscientie fratris Bartholomei de Sancto Concordio de Pisis Ordinis Predicatorum." Paper.

461 ff. 2 cols. At end : " Consummatum fuit hoc opus in civi-
tate Pisana, anno Domini 1338, in mense Septembris tempore
Sanctissⁱ Patris Domⁱ Benedicti Pape XII. Explicit iste liber
per manum Ludovici Thorem de Nouschia presbyteri quem
scripsit in dicto loco, anno Dñi 1457, et finivit in mense
Decembris die xx." Now in the Royal Library, Turin.—
(Cod. CXLIII. e. iv. 5).—*Pasini : Catalog.*, ii. 42.

TIANUS, FRANCIS. *Copyist.* Saec. XV.

A Priest of Pistoia.

Wrote, in 1474, MS. lat., 4,192, National Library, Paris, " Pro
reverendissimo domino cardinali Sancti Petri ad Vincula,
Franciscus Tianus Pistoriensis scripsit anno Domini 1474, Rome."
The Cardinal here named was Juliano della Rovere, afterwards
Julius II. In 1478, " Herodoti Halicarn. Historiar. libr. ix. ex
Laurent. Vallæ interpret."—*Biblioth. Ehrenkroniana*, 493, No. 9.
Also two MSS. Nos. 8,910 and 8,911, Fds. lat., same library,
for Francesco della Rovere, Cardinal of Teano, afterwards
Sixtus IV. " Scti. Hieronymi Epistolæ." At the end of the
second volume is this note : " Anno Christi 1469, die vero
18 mensis maii Rome, in domo reuerendissimi domini Cardinalis
Theanensis et pro eodem. Franciscus de Tianis Pistoriensis
scripsit."—*Delisle : Cabinet des MSS.*, ii. 400.—*See* POLANI and
ROVERE.

TIERGEVIELLE, PET. DE. *Copyist.* Saec. XIII.

Wrote, 1278, " Le Roman de Tristan " (incomplete), National
Library, Paris. A volume in an excellent handwriting, small
folio. 2 cols. 317 ff. Miniatures in the initials, of a peculiar
style, are nearly all spoilt. At the end, " Anno Dñi MCC.
septuagesimo octavo scripsit petrus de Tiergevilla istud
Romanum. Benedictum sit nomen Dñi." Tiergeville is in
Normandy, in the sub-prefecture of, and five leagues from,

Ivetot. The miniatures are so arranged as to present two or three subjects one over another. The horses are *bien élancés,* the tone of the figures crude and gaudy. Colours badly applied, hence they have scaled off.—*P. Paris,* t. vi. 4, 7,172.

TIMO. *Copyist.* Saec. XII.

Canon of SS. Mary and Nicolas, in Arenstein.

Wrote "Excerpta de diuersis opusculis diui Augustini." Vellum. Large folio. 82 ff. 2 cols. Red flourished initials in firm German half-Gothic of the twelfth century. On fol. 1, in large letters: "Liber sc'e Marie Scĩq̃ Nicolaj in ᴀʀenꜱtein. Quē scripsit Timo canonicus ibidem." Now in British Museum, Harl. MSS., 3,050.

TIPTOFT, JOHN. *Patron.* Saec. XV.

Or Tibetot, son and heir of John de Tibetot, who died 1443. He was created Earl of Worcester in 1449, and was the friend of Caxton, and of Anthony Wydville, Lord Scales. He studied at Balliol College, Oxford, and acquired a brilliant reputation as a scholar. He travelled in the East, and when he arrived in Italy succeeded so well in an oration before Pope Pius II. (Æneas Silvius Piccolomini), as to obtain the warmest friendship of the learned Pontiff. He expended large sums in collecting books, and on his return to England presented as many as had cost him a hundred marks to the University of Oxford. He is known as a translator of classical taste and good learning, and had an exact knowledge of matters connected with the ordering of tournaments and pageants. His literary tastes brought him into association with Caxton, for whom he prepared several texts. His political bias, as a favourer of Edward IV., was the cause of his ruin. On the flight of Edward, in 1470, Tiptoft was taken, and beheaded on Tower Hill within a month of the

king's departure. Caxton says of him : " In his time he flowered in vertue and cunning, and to whom I know none like among the lords of the temporality in science and moral vertue."—*Timperley :* *A Dictionary of Printers and Printing,* &c., 136. The arms of Tiptoft were, *arg.* a saltier engr. *gu.*—*Notitia Anglicana,* i. 21, 110, &c.

TODESCHINO, JOAN. *Miniaturist.* Saec. xv.

" In arte di illuminare sive (ut frequenter dicunt) miniare libri havemo havuto qua un singolare artifice a tempi nostri Joan Todeschino homo oltri ea excellentia di questa arte di vita ancora santissima." Quoted from Pietro Summamonte by Müntz in *L'Art,* 1885, ii. 159.—*Giornale di Erudizione Artistica,* ii. 315–325.

TODI, STEPHANO DA. *Miniaturist.* Saec. xv.

Given in list of artists employed at Ferrara,—*Cittadella : Notizie relative a Ferrara.*

TOLENBEKE, DE. *Copyist.* Saec. xv.

Wrote a large folio, containing " opuscula varia Ecclesiastica," Vellum. 200 ff., 2 cols. Written in small thick secretary hand, with rubrics, but no ornaments. On fol. 52, in red : " Expliciunt liber duodecim Cassiani p̄s̄bite'i," &c. " Translata s̄t iȝ (sunt ista) a dc̄o (dicto) dyō (dyonisio) anno dōⁿº (1453). Iñsc̄pta est at (autem) a fr̃e ardᵒ tolenᵏᵉ mōcho (fratre arnoldo Tolenbeke monacho) doꝑ capˡₑ (domus capellæ) eiusdē ordīs. Anno dōⁱ ᵐ (1478) die vᵗⁱ Sixti ppē̃." And at end, in same hand as rest of work, but now nearly erased by damp : " Scriptū est hoc opꝑ in domo capelle ord. carthus. Cameracens' dyocesis ac, finitum p manꝑ fratȝˢ Arnoldi beelt'isen (?) de Tolenbeke monachi pfessi ibidē Anno dñi Mºccccºlxxixº in crastino beate M'ᵉ Magdalene. Sub p̄'oratu domini Arnoldi Hodeman (?) anno xxii. regim'is eȝ (eusdem). Orate p̄ sc'pto'c." Now in British Museum, Arundel MSS., 355.

TOLLENARE, GHEERAERT. *Illuminator.* Saec. xv.

Illuminated two choir-books, written and annotated by Lievine Moreel and Cornelie Van Wulfskerke for the Convent of Notre Dame de Sion, at Bruges, in 1495.

TOMKINS, THOMAS. *Calligrapher.* Saec. XVIII.

A famous teacher of writing in London in the latter part of the eighteenth century.

In 1777 he published a work called " The Beauties of Writing," republished by T. Varty, Strand, London, in 1844. Among the number of his predecessors in the art, whom he calls "admired penmen," he names Snell, Ollyffe, Velde, Chambers, Champion, Bland, Shelly, and Clark (fol. 35). On fol. 36 is a tribute to the merit and genius of Shakespeare dedicated to D. Garrick, Esq., 1776. A copy of the work is in the British Museum.

TOMMASINI, GIOVANNA. *Miniaturist.* Saec. XVIII.

Daughter of Antonio da Porto Ferrajo.

Worked at Rome in 1736.—*Zani :* xviii. 225.

TOMMASO. *Copyist.* Saec. XIV.

Of Lucca.

" Iste liber scripsit tomazus olim fil Petri benecti civis et mercatorij Lucæ, anno nativitatis dñi mcccxlvij. in prim. sex mensib9 de dicto anno in ciuitate pisana."—*Zani :* xviii. 226.

Tommaso. *Copyist and Illuminator.* Saec. xiv.

A Monk of Sta Maria Novella, Florence. Died 1336.

Marchese: Memorie, &c., i. 176.

Tommaso, di Mascio. *Miniaturist.* Saec. xv.

Called Carafone or Scarafone.

One of the illuminators or "miniatori" of the Choir-books at Perugia.—*Manari: Cenno Storico, &c., di Perugia, fasc.* 21, 249, vol. iv. n. 7.

Tommaso di Ramina. *Copyist and Illuminator.*

Saec. xiv.

Another Monk of the same monastery. Died 1358.

Marchese: Memorie, &c., i. 176.

Toni, Michele Angelo. *Miniaturist.* Saec. xvii.

Born at Bologna in 1640.

Was, first, a writing-master, afterwards applied himself to oil-painting and miniature, and copying the works of the old Masters, so excellently as to cause his works to be mistaken for the originals. He died in 1708.—*Nagler: Künstlerlexicon,* xviii. 558.

TONIS, ANTOINE. *Copyist.* Saec. xv.

Wrote part of the Bible named under OTHO.—*Pinchart : Archives des Arts, &c.,* ii. 192.

TONIS, GUILLAUME. *Copyist.* Saec. xv.

Wrote, in 1465, a Gradual, and a small Book of Hours for the Chartreuse of N.D. de Sheut lez Bruxelles.—*Pinchart : Archives des Arts, &c.,* ii. 192.

TONNELIER, JEAN LE. *Copyist.* Saec. xv.

Wrote, in 1464, for Charles d'Orléans, three books on parchment, for which he was paid 13 golden crowns—*Delisle : Cabinet des MSS.,* iii. 344.

TOPHIUM, A. *Copyist.* Saec. xv.

Wrote a beautiful copy of "Macrobii Theodosii . . . Saturnalium, primi diei (et sex aliorum) liber incipit feliciter." At end : "Completus Roma die v Aprilis, 1466, per A Tophium." Folio, violet morocco, &c. (Italian and fifteenth-century binding). 180 ff. The seven books of Macrobius complete, with the passages in Greek. The calligraphy is very careful. The text of the first page executed, as frequently in books of this period and locality in capitals of various colours (gold, violet, green, and rose), and a grand illuminated initial and a most beautiful border painted in *camaïeu* on grounds of violet, blue, and red, in graduated tints. Among the ornaments of the borders are various medallions containing tiny miniatures painted with great delicacy. Armorials occupy places at the top and bottom. There are also splendid initials to each book. That to Book IV. contains two small miniatures, &c. (*Ref. mislaid.*)

TORELLI, FILIPPO (DI MATTEO). *Miniaturist.* Saec. xv.

Worked at Florence, in 1440, on two large Psalters written by Don Giovanni di Michele. In the Archivio dell' Opera del Duomo di Firenze, stanziamenti E. 149, is entry of payment : " Filippo

Mattei miniatori lib. quatraginta que sibi dantur pro parte magisterii pro miniando duos Salterios magnos de choro pro ecclesia Sancte Marie del Fiore." In 1450 is another entry of work and payment. Giornale H. 54. In 1467, "die xxx iunii. Filippo Mattei de Torellis miniatori lib. ottuaginta, sol xiii. sunt pro miniatura unius Vangelistarii pro ecclesia." In 1468 is the last entry, "die xxx iunii. F. M. Torelli, miniatori, lib. sesaginta otto, sol decem novem, sunt pro parte miniature Vangelistarj lib. 68, 19. Deliberazioni e stanziamenti 54, 72 *v.*" *Milanesi: Notes to Lemonnier's Vasari*, vi. 164, 325. The Evangelistarium is described in detail in vi. 246–8. There are also miniatures attributed to him in MSS. in the Church of the Hospital of Stᵃ Maria Nuova and in the Riccardi Library at Florence.

TORELLI, GIACOMO, or
IL FRATE DELL' OSSERVANZA. } *Miniaturist.* Saec. xv.

A Monk of Florence.

Worked on the Choir-books of Siena. He was son of that Filippo di Matteo, who, from 1440 to 1468, illuminated several Choir and other books for Stᵃ Maria del Fiore. Several MSS. in the manner of Filippo Torelli, but not by him, now in the Riccardi Library at Florence, were, perhaps, by his son.—*Vasari: Le Vite, &c.*, vi. 179 (*Nuove Indagini*). A memorandum of 1466 in the Archives of Siena, records : " Iachomo di Filippo da Firenze, die avere a di 14 d'Aprile per minii 49 grande à fatti in quattro quaderni delli Antifanari grandi scrive dono Andrea monacho a sol di 9 l' uno : monta d' achordo lui con missere cipriano operaio lire 20.2.8."—*Milanesi: Documenti dell' Arte, Senese*, ii. 383.

TORNIELLO, FRANCESCO. *Calligrapher.* Saec. XVI.

A Milanese.

Executed a book of Examples, entitled : "Opera del Modo di fare de lettere majuscole antique con mexura di circino et resone de penna. . . ." Milano, Gerardo da Ponte, 1517, 4⁰.—*Riccardi, in Il Bibliofilo*, 1884, 122.

TORRE, BARTHOL. *Miniaturist.* Saec. XVI.

Of Arezzo. Born 1529. Died 1554.
Zani, xviii. 240.

TORRE, NICOLA DELLA. *Copyist.* Saec. XVI. et XVII.

A Spaniard residing in Candia.

Worked from 1572 to 1612.—*Zani,* xviii. 239. Bermudez calls him a Dalmatian, but a native of Candia. Invited to the Escorial, and received, in 1572, a commission from Philip II. to transcribe Greek MSS. for that library. Was still living in 1612. *Bermudez: Diccionario,* v. 57.

TORRES, DON GABRIEL DE. *Miniaturist.* Saec. XVII.

Of Madrid. Born 1660. Died 1685.

Was the son and pupil of Matias de Torres, and worked on the Choir-books. His colouring was fresh and clear. *Bermudez: Diccionario,* v. 60.

TORY, GEOFROY. *Miniaturist, Copyist, and Designer for Books, &c.* Saec. XVI.

This great artist, who, says Didot, appears to have been, like the other great men of his epoch, a man of universal genius, was versed in Greek, Latin, and even Hebrew literature. He was one of the most zealous reformers of French orthography. He abandoned his professorship in order to learn the art of printing, and published at Paris, through the eldest of the Estiennes, in 1512, the first edition of the "Itinerarium Antonini." Born at Bourges in 1485,

he began, whilst still a youth, to labour in that city for the spread of the great school of French art, of which for two centuries his native province had been the nursery, and which has bequeathed so many masterpieces of architecture, sculpture, painting, glass-work, and miniature. In 1503 he went to prosecute his classical studies in Rome, and to listen to the lectures of Filippo Beroaldo in Bologna. The former was the great literary and artistic centre of Italy; the latter famed from the earliest times as the great school of calligraphy and miniature art. On his return to Paris, about 1505, he was named professor in the college of Plessis, then in those of Coqueret and Burgundy, and published several learned works, first with Henri Estienne, then at Lyons and Paris with Gilles de Gourmont, the publisher eventually of his famous "Champfleury." Again travelling in Italy, and drawn more and more to the study and practice of art, he brought back the materials for his great work, and sought the advice and assistance of Jean Perréal, the miniaturist to whom he refers in the work. Didot and Bernard state that he was admitted a printer in 1529, and exercised this profession until 1538. Lacroix and Fournier deny that he ever was a printer. And in the sense of his carrying on printing as a business, possibly they may be right, for at the very time when he is styled "typographus regius," his books are published with the imprints of other printers. It was natural that the King, seeing the skill and knowledge of typography displayed in "Champfleury" should bestow the title of "imprimeur du roy" on its author, and it probably did convey the oversight of such works as were issued by royal authority or at the King's expense, without necessarily implying the setting up of a printing establishment in the ordinary sense. He may, however, have set up a press which was strictly confined to works edited by himself or published under the immediate patronage of the King. Lacroix's words are: "Tory n'était pas imprimeur, mais simplement libraire." Delisle accepts Bernard's opinion, and calls him "imprimeur et graveur." But whether Tory were an actual practical printer or not, it is clear he was more than simply a bookseller. Bernard has given lists of books, including the Books of Hours, edited and published by or for Tory, and as he has thoroughly examined the whole question he is certainly entitled to be considered the best authority upon it. On this authority Tory must be styled printer, engraver, designer, and painter. It appears certain that he was also an able miniaturist. Didot the Elder once possessed a MS. of Diodorus Siculus, which had been presented to the King by Tory, and is

justly considered to have been transcribed and ornamented by his own hand. If the admirable painting which serves as a frontispiece, representing Francis I. in the midst of his courtiers was by him, then Geofrey Tory deserves to rank as a miniaturist with Perréal and Jean Fouquet. In 1810 the MS. passed from Didot's library to that of Brunet the bibliographer, for 1,300 francs. In 1863 it belonged to the Hamilton Collection, and is now probably at Berlin. It is a small folio, and was, as said above, the presentation copy to Francis I. Bernard suggests that the Godefroy, who painted the Commentaries of Cæsar and the Triumphs of Petrarch (*see* GODEFROI), was Geofrey Tory, but the birthplace of that artist appears to have been Besançon, not Bourges. I say appears, from the more than ordinary care bestowed on the drawing of that city in the Cæsar, with the date 1519. If Tory, who was then living in Paris and busy with all manner of classical and artistic studies, really added this elaborate performance to the rest, it is difficult to see how he could find time for sleep or repose of any kind. Yet it is not impossible. In 1516 Tory had made his second journey to Italy, and had just returned full of projects and enthusiasm. The masterly skill and experienced touch shown in the Cæsar drawings appear, it is true, too far advanced for such a beginner as Tory is supposed to have been at this time. On the other hand, the varied archæological knowledge and scholarly accuracy shown in the details and inscriptions are such as no mere miniaturist would be likely to possess, and in 1519 Tory was 34 years of age. His first Italian journey took place in 1503, so that he might have been engaged in the study of art for at least sixteen years. The Cæsar miniatures show great rapidity of execution, and a strong north Italian influence, such as might be the production of one of the many clever assistants employed at Fontainebleau. There is nothing to show that Tory himself was not frequently among the artists, both there and in Paris, nor that in 1519 and 1520 he was not practising miniature ; but that the artist who in several known inscriptions is called Godefridus Torinus was the Godefroy of the Cæsar's Commentaries requires more positive proof than is afforded either by the date or the style. Allowing that Tory actually printed, as well as painted and engraved, he must have combined a remarkably varied list of accomplishments in the production of the Diodorus of 1535, for the same picture which appears in the Hamilton MS. reappears in the printed volume as a woodcut. Didot was willing to believe that this woodcut was Tory's own work. But it is his Books of Hours

for which he is chiefly celebrated. In his hands the ornaments
of these favourite illustrated volumes, pass from the well-known
type of Pigouchet and Vostre, which are mainly reproduced from
Flemish illuminated borders, to the most beautiful type of the pure
French Renaissance. His first edition appeared in 1523, printed
by Simon de Colines. A number of the copies at least bear the
name of this printer, the rest that of Tory. In the proprietorship
of these works he is protected from time to time by privileges.
In 1529 his "Champfleury" receives the Privilege du Roy, which is
also by the same instrument extended to certain other works of
his, named therein, " luy donner et ottroyer Privilege, permission
et licence d'icelluy livre imprimer ou faire imprimer ; ensemble
certaines Vignettes a Lantique et a la Moderne. Pareillement,
Frises, Bordures, Coronemens, et Entrelas, pour faire imprimer
Heures in telz usages et grandeurs que bon sembleras, durant le
temps et terme de Dix ans," &c. In 1531 this protection was also
accorded by the Pope, Clement VII., assuring to Tory the
monopoly of the beautiful borders and other ornaments of his
famous Books of Hours, and other books which he should print here-
after for ten years, under pain of excommunication against offenders.
The King's edict inflicted a penalty of 25 marks of silver, and
the entire confiscation of every copy printed contrary to this
prohibition. A further period of six years was added to this patent,
and eventually another four, making altogether a twenty years'
monopoly of his copyright. Among others of his patrons we find
the name of Jean Grolier, the Minister of the War in the Milanese,
Tory designing for him many of those remarkable bindings which
have made the minister's name well-known to our own time.
Thus he says in his " Champfleury : " " Le matin du jour de la
Feste aux Rois, apres avoir prins mon sommeil et repos et que mon
estomac de sa legiere et joyeuse viande avoit faict sa facile con-
coction, que l'on comploit M.D.XXIII., me prins a fantasier en mon
lict, et mouvoir la roue de ma memoire pensant a mille petites
fantaisies, tant serieuses que joyeuses, entre lesquelles me souvins
de quelque Lettre antique que javois nagueres faicte pour la
maison de monseigneur le Tresorier des guerres maistre Jehan
Groslier, conseiller et secretaire du Roy nostre sire, amateur de
bonnes lettres et de tous personnages savans," &c. Delisle
speaks of Tory as painter, engraver, and the first royal printer. He
was also a copyist, for it was he who transcribed at Paris, in 1511,
for Philibert Babou, the copy of the Itinerary of Antonine, his
printed edition of which is referred to above. The MS. is now

No. 265 in the Public Library at Orleans. His "Champfleury," to which reference has been made so often, has the following title : "Champfleury auquel est contenu l'Art et Science de la deue et vraye proportiō des lettres attiques quō dit autremēt lettres antiques, et vulgairement lettres romaines proportionnées selon le corps et visage humain, &c., par maistre Geofroy Tori de Bourges, libraire et autheur du dit livre, &c., 1526." It is ornamented with vignette borders, initials, &c., besides the plates of letters. Several editions of it may be seen in the British Museum, for it was several times reprinted, *e.g.*, Paris, 1529, folio, and again including "instructions et maniere de faire chiffres et lettres pour bagues d'or, pour tapisserie, vitres et peintures, etc." Paris : Vivaut Gaultherot, 1549. The year 1540, in which Jean Cousin first comes into notice as a designer, is the last which gives us any dated work of Tory. Didot explains this by saying that in 1549, when he devoted himself to the art of the potter, he had given up painting for eleven years, and for the rest of his life merely busied himself with the designing and engraving of the "poteries" of Diana of Poitiers. Then, says Didot, he died about 1554. But Bernard completely overturns this theory by the statement that Tory died in 1533. It may be mentioned that the double or Lorraine cross, supposed to be a test-mark of Tory's work, was in use both before and after his time.—*Didot : Essai . . . sur l'Histoire de la Gravure sur Bois,* 134-150, 156, *&c.*— *Lacroix and Fournier : Hist. de l'Imprimerie, &c.,* 103.—*Catalogue de la Biblioth de . . . Vallière,* i. 539.—*Breitkopf : Ueber den Uspr. der Spielkarten,* ii. 40.—*Delisle : Cabinet des MSS., &c.,* II., 418, *n.* —*Guilmard : Les Maîtres Ornemenistes,* 9.—*Bernard : Geofrey Tory, Peintre et Graveur, Premier Imprimeur Royal, &c.* Paris, 1857. 8⁰.

TOSI, ANGELO MARIA. *Miniaturist.* Saec. XVIII.
Of Bologna.

Worked about 1731.—*Zani,* xviii. 253.

Tosi, Giacomo Maria. *Miniaturist.* Saec. xviii.

Of Bologna. Son of Pier Francesco.

Worked from 1670. Died 1690.—*Zani*, xviii. 253.

Tosi, Paolo di Duccio di Pisa. *Copyist.* Saec. xv.

Wrote "La Divina Commedia." Vellum. Large fol. Beginning of fifteenth century. Written with much diligence, and well preserved. Adorned at every canto with beautiful and large painted initials, and the first to every cantica has the portrait of Dante, holding the poem in his hand. The text is surrounded by a commentary. At end : " Explicit tertia et ultima cantica comedie Danti Alligerii de Florētia Dō. grās. Finito isto libro referamus gratias Xpo. Am̄. Scripto per mano di me Paolo di Duccio Tosi di Pisa, negli anni Domini, Mcccciii. a di xxx. Ottobre. Et e il detto libro del Nobile huomo Francesco di Bartolomeo de Petruccio da Siena. Nel tempo che gli era honorevole executore della città di Pisa lo fece scrivere."—National Library, Paris, 7,255.—*Batines*, ii. 243.

2. "La Divina Commedia." Vellum. Folio. Fifteenth century, beauty and elegance of letters. At end : "Scripto per mano di me Paolo de Duccio Tosi da Pisa negli anni dñi Mcccxxviiii. a di viij di Septembre. Deo grat. Amen." Batines says the date 1329 is indubitably wrong, and should perhaps be read 1429, as another Codex, copied by the same copyist, dates 1457. This MS. is described by *Mehus* Estratti, MSS., xi. 173, 174, and Lami, "Novelle Lettere di Firenze," 1756, col. 613, 614. Now in Riccardi Library, Florence, No. 1,046 (O. I. xxv.).—*Batines*, ii. 81.

3. "La Divina Commedia." Cols. Coment. di Jac. di Luna. Vellum. Large folio. Fifteenth century, with miniatures and borders in gold and colours : " Explicit Liber Dantis Allegerij. Scripto per mano di me Paolo di Duccio tosi da Pisa negli anni dñi Mccccv. ad xxv. d' Aprile. Deo grās." and No. IV. Codic. Trivulzianii Milano.—*Batines*, ii. 140.

4. "Alighieri Commedia, con un breve raccoglimento in terza rima," &c. In the Riccardi Library at Florence.—*Joh. Lamius : Catalogus Codic. MSStor. Quini Bibl. Riccardiana Florentiæ asservantur, &c. Liburni,* 1756 fol. 20, 21. Pl. O. II.

xvii. Quoted thus : "Cod. membr. nitid. et eleganter script." On
p. 1, in a different hand : "Est Io. Baptistæ Guidi Catil. di
Castilione et amicor. ejus," and " E græco in Latinum Carmen Io.
Baptistæ Catil. di Castilione.

Dum fueram iuvenis, nocuit mihi tristis egestus :
Nunc subito dives, sum miser ipse senex.
Infelix nimium, nimium cui fata negarunt
Divitias poterant quando iuvare. . . .
Infelix iterum nimium cui fata dederunt
Divitias possunt quando iuvare nihil."

Then, in another hand : "Antoninus Catelinus e Castelione."
At end : " Scripta per mano di me Paolo di Duccio Tosi di Pisa,
negli anni Dñi 1419 (Mcccxviiii.) a di viii. di Septembre."

Tosi, Pier Francesco. *Miniaturist.* Saec. XVIII.
Of Bologna. Son of Angelo Maria Tosi.
Worked from 1680. Died 1702.—*Zani*, xviii. 253.

Tosini, Fra Benedetto. *Copyist and Miniaturist.*
Of Florence. Saec. XV.
Worked in 1445. *Zani*, xviii. 254. Called by other authors
Benedetto da Magello. (*See* Magello).

Tosini, Fra Guido. *Copyist and Miniaturist.* Saec. XV.
See Angelico.

Toulouse, Bernarde de. *Illuminator.* Saec. XIV.
Named as "enlumineur de manuscripts," et Marie "enlumineuse"
in 1367. The following are the documents referring to this fact :

" Magister Bernardus de Tholosa, illuminator librorum et proba mulier Maria illuminatrix similiter libror. qui illuminaverunt et miniauerunt dictum librum (Terrarium Episcopi) inclusis ymagine Beate Marie Virginis et alio opere." Now in the Archives departementales of Vaucluse. " Solvi in diversis vicibus et multis diebus cuidam mulieri vocate Marie et Magistro Bernardo de Tholosa illuminatoribus librorum qui illuminaverunt dictum librum ' Directorium Clavarii ' appellatam, et fecerunt quasdam litteras et ymagines ac signa domini nostri Pape ac prelibati domini mei cardinalis in principiis dictorum librorum ad decorandum et intitulandum ipsos libros obreverentiam et honorem dominorum predictorum et ad eternam memoriam eorundem. Viz. dicte mulieri xxix. solidos et residuum alteri, qui similiter illuminavit ' Inventarium et Repertorium,' factum noviter de omnibus instrumentis, vii. libr. viii. solid. vi. den."—*Archard : Archives de l'Art francais*, vii. 181.

TOURNAY, JAN DE. *Copyist.* **Saec. XV.**

A Monk of Notre Dame de Malines.

Copyist and binder.—*Pinchart: Archives des Arts, &c.,* ii. 26, *&c.*

TOURS, GERHARD OF. *Illuminator.* **Saec. X.**

Executed for Baudri, Abbot of Bourgueil, a copy of the abbot's poems, written by Hugo.— *Wattenbach : Das Schriftwesen im Mittelalter,* 301.—*Delisle : Note in* " *Romania* " (Paris, 1872), 27, 35.

TOUSSAINT, AUGUSTUS. *Miniaturist.* **Saec. XVIII.**

Son of an eminent London jeweller.

Gained a premium in 1766 at the Society of Arts. Exhibited at the Royal Academy from 1775 to 1788. Painted both on ivory and in enamel. Died at Lymington between 1790 and 1800.-- *Redgrave : Dict. of Artists of the English School.*

TRACHET, JEAN. *Copyist and Illuminator.* Saec. XV.

Wrote, in 1434, for the Duke of Burgundy, a Breviary with miniatures. " A Messire Jehan Trachet pour lescripture de grosses lettres de forme noter enluminer liurer estoffer et rendre tout prest ung demi Breviaire commencant le dimanche d'apres les octaves de Panthecoste et finissant le samedi de l'Advent, en grant volume et pareil a ung autre demi temps de Breviaire tout neuf estant en la chappelle de MS. pour marchie fait au dit messire Jehan en lx. couronnes dor lxxv. francs."—*Laborde :* *Hist.*, *&c.*, t. ii., pt. i., 343, 1160, R. g., 1434, 5.—*Ibid.*, i., pt. ii., 528.

TRAJECTO, ARNOLDUS DE. *Copyist.* Saec. XV.

Wrote " Petri de Ancharano, Lectura super texto Decretalium." Paper. Folio. 722 pp. Contains 76 painted initials, and on fol. 1 a large illumination of the adoration of the Magi, and, underneath the arms, " Dñi Henrici de Piro licentiati in Decretis, civis Coloniensis." Belonged to Mr. Bragge, and sold in 1876 at Sotheby's. –*Catal.*, 68.

TRAJECTO, PAULUS DE. *Copyist.* Saec. XV.

A Monk of the Convent of St. Margaret's of Utrecht.

Wrote "Compend^m Theologicæ Veritatis in vi. libros divisum," &c. Vellum. 4°. 170 ff. Now in St. Mark's Library, Venice. At end : " Explicit Compend^m . . . scriptum per me Paulum de Scta. Margarita de Trajecto superiori, die ultim. Aug^i Mccccxxx. —*Zanetti : Catal. Latin et Italian Codd.*, *&c.* 66.

TRAMOGGIANO, EUSTACHIO DA. *See* EUSTACHIO, FRATE.

TRAMOGGIANO, PIETRO DA. *Miniaturist.* Saec. XV.

Prior of the Dominican Monastery of S. Maria del Sasso, near Bibbiena. Died 1596.

Worked on the Choir-books of his convent. In 1577 he was invited to restore and complete the Choir-books of San Marco at Florence, left unfinished by Benedetto da Muzello ; but owing to a dispute with the Prior he speedily left. He, however, returned later and completed the work. The convent of Sta. Maria del Sasso once possessed 14 large Choir-books containing beautiful miniatures by him. Not one of them is now to be seen, nor any except a volume without miniatures.—*Marchese : Memorie dei più insigni pittori, &c., Dominicani* i. 207–210. Firenze, 1845.— *Bucher: Geschichte der Technischen Künste*, i. 260.—*Nagler : Kunstl.-Lex.* xix. 46.

TRAPPIS, MAGISTER DE. Saec. XIV.

Notary.

" La Div. Commed." Bibl. Albani Bergamo. Paper. Folio. Fourteenth century. At end : " Explicit liber Dantis Alaghieri per eum editus sub anno Dñicæ Incarnis milesimo trecenteso de mense martii Sole existente in Ariete et Luna nona in Libra laborante. Scripsi et complevi ego Magister de Trappis notarius McccLxxxx. xxv Aprilis." And also other notes among which " Iste Dantus est mei petri quondam magistri amboxj de balbis quondam pergami grammaticæ professoris."—*Batines*, ii. 126, 127.

TRAVERSAGNIS, JACOBUS DE. *Copyist.* Saec. XV.

Wrote " Septimini de Bello Troiano." Paper. Sm. 4°. 72 ff. In ordinary upright half-Roman. No ornaments. At end : Septimini de bello Troiano sextus et ultimus liber feliciter explicit. Per me iacobum de Trauersagnis die decima mensis Marcij ad honorē dei genit'icisq matris . . us . . tr'q triūphantis curie celestis. AMEN." Now in British Museum, Add. MSS., 15,429.

TRAVERSARI, FRA GIROLAMO.　*Copyist and Miniaturist.*
Saec. xv.
Of Florence.　Born 1397.　Died 1483.

Zani, xviii. 267.

TREVERIS, MICHAEL.　*Copyist.*　　　Saec. XVI.

Wrote " Cassiodorus Landalphus."　Paper.　Sm. folio.　247 ff.
2 cols.　In half-Gothic minuscules, with contractions.　At end,
in red : " Explicit hic presēs historia romanorū per me fratrē
michaelem treueris Anno dñi *milessimo* quīgentesīo ipsa die
cōuersionis pauli apostoli."　Now in British Museum, Harl. MSS.,
3,242.

TREVOU,　}
TREVOUX,　}　HENRI DU.　*Copyist.*　　　Saec. XIV.

One of the copyists employed by Charles V. of
France.

Wrote " Boece de la Consolation philosophique."　Now MS. fr.,
1728, National Library, Paris.—*Delisle,* in *La Bibliothèque de
l'École des Chartes,* 1873.

Also in 1374, " le Rational des divins Offices de Guil. Durant
Ev. de Mendo.* Traduit par Jehan Golein.　Now in National
Library at Paris.—*Paris, les MSS. fr.,* t. iv. 100, &c. (7,031).　A
very long notice.　Large 4°.　398 ff.　Vellum.　In two columns.
One miniature, vignettes, and initials.　Red morocco ; arms of
France.　Originally in the Library of Charles V. in the Tour du
Louvre.　The signature of Charles V. occurs on the last folio,
together with this note : " Cest liure nome Rasional des diuins
ofises est a nous Charles le Vᵉ de nostre nom, et le fismes tran-
later escrire et tout parfere . Lan M.ccc.lxxiiii."　This MS. was
among the number of those which the Duke of Bedford
carried away to England about the beginning of the fifteenth
century.　But it did not stay here long.　A note in it (in the in-
side of one of the backs), says : " cest livre est a Jehan Comte

* Mende in 1286.　Died at Rome in 1294.

d'Engolesme lequel l'acheta a Londres en Engleterre lan de grace 1441." This Jehan was the third son of Louis, Duke of Orleans, and of Valentina of Milan. Hence it is probable that the books bought by the Duke of Bedford of the keeper of the Louvre Library were soon dispersed and sold piecemeal. Some of them were again picked up from London dealers by the French Princes, then prisoners in London. Jean, Comte d'Angoulême, born in 1404, had been sent as hostage into England in 1412, and was still there in 1444. Five years later he married Marguerite de Rohan, who was still living in 1496, whilst he died at Cognac in the Angoumois, April 30, 1467. (*See* ROHAN, SAVOIE, &c.) Trevoux was calligrapher also to the Chancellor, Pierre d'Orgemont ; his arms,—*d'azur* a trois épis *d'or*,—appear in this and other volumes written by Henri du Trevoux. The grand miniature which surmounts the prologue, represents J. Golein, the translator, seated on a low seat between the king, the queen, their two sons and their two daughters. Their dresses are heraldic. Montfaucon has given an engraving of this miniature, but incorrect as to the dress of the young Duke of Orleans. It should be France charged with *two dolphins d'az.*, but Montfaucon has represented it as France charged with a *chevron à trois branches*. This chevron does not exist in the original. Montfaucon gives two other miniatures of the coronation of the king and of the queen, again incorrectly ; and he completely misleads his readers by saying that he gets the miniature from a MS. in the Library of the Celestins. It is certain that this MS. has never been out of the possession of the Royal Library since the end of the fifteenth century.— *Montfaucon : Monum. de la Monarchie française,* tome iii. 35, 45, 50, 51. Trevou is mentioned by Leroux de Lincy under the name of *Trenon.—La Biblioth. de Charles d'Orléans,* 33.

TRITHEMIUS (TRITHEIM), J. *Copyist and Patron.*

Saec. xv.

Abbot of Spanheim, near Trèves ; afterwards of St. James of Wurzburg.

Contemporary of Guillebert de Metz, and of Thomas à Kempis. He says, in speaking of work in the Scriptorium : " Let

one correct the text which another has written, then a third put in the ornaments in red ink ; let this one charge himself with the punctuation, another with the miniatures, another glue the folios together, and bind them with tablets (backs) of wood. *You* prepare these tablets, you obtain, &c., the leathers ; you, the plates of metal which are used to ornament the bindings. Let one of you cut the leaves of parchment, another smooth them, a third trace with a pencil the lines which are used to guide the writer. Let another prepare the ink and another the pens."— *Lacroix et Fournier : Hist. de l'Imprimerie et des Arts que s'y rattachent,* 18. Thus the monastic workshop embraced the whole manufacture of the book.

TROCHERAU PÈRE, ANTOINE. *Copyist, &c.* Saec. XVII.
A Frenchman. Born 1602. Died 1675.
Zani, xviii. 283.

TROMBETTA, GIAMBATTISTA. *Miniaturist.* Saec. XVI.
Of Bologna.
Worked about 1520.—*Zani,* xviii. 286.

TROMPES, ANTONIO DES. *Copyist and Illuminator.*
Saec. XV. et XVI.
Appears on the accounts of the Gild at Bruges, 1496. He was then a master, and had an apprentice. He seems to have been a man in good circumstances from the gifts which, from time to time, he bestowed on the Gild. In 1524 he wrote the " Canon of the Mass," in a Missal belonging to the clerks of the tribunal of Bruges, and painted a Crucifixion to go in front of it, for which he received four shillings Flemish. He died in 1539.—*Le Beffroi,* ii. 305.

TROSTER, JOH. *Copyist.* Saec. XV.

Canonicus of Ratisbon.

Wrote "Opuscula varia Onosandri," &c. Paper. Sm. 4°. 105 ff. On fly-leaf in a later handwriting: "Hūc libellū dono dedit clar^mo utriusq, jur℘ doctore Johanni perckheymer Consillaïo ducali Johs Troster Canōicus Ratispan a sua māuppia." No ornaments, but written in a neat upright hand. On last fly-leaf (fol. 105 *v.*): "Libellus iste, mei Johīs Troster ppti Matra℘ Canoïci Rat℘ sc'ptus Padue, 1468." Now in British Museum, Arund. MSS., 223.

TROTINO, ZBISCO (ZBYSÈEN) VON. *Illuminator.*

Saec. XIV.

Supposed to have executed the miniatures of the "Libri Viaticus" of Dom. Joannis Lutomyslensis episcopi, in 1360. Now in National Library Museum, Prag. Also he decorated a Prayer-book of Bishop Ernest von Pardubitz, with miniatures, also in same Collection. — *Wocel: Grundzüge der bömischen Alterthumsk. S.* 132, 152, *f.* These and other MSS. at Prag are suspected of being falsified, and the signatures of the alleged illuminator to be forgeries.—See *Woltmann in Repertorium für Kunstwissenschaft*, II. (1879).

This name occurs in a Bohemian MS. belonging to the Prag National Museum, called the "Mariale Arnesti." Vell. 4°. (295 by 210 mm.). Its proper title is "Psalterium de Laudibus Beatissima Virginis, sive expositio nominum ejus"; and its authorship is attributed to Ernest von Pardubitz, first Archbishop of Prag. With the question of authorship, however, we are not here concerned. The reader may see it discussed on the one side in *Balbini: Vita Arnesti*, 401–12 ; on the other in *Friedjung: Kaiser Karl IV. und sein Antheil am geistigen Leben seiner Zeit.* 99 *folg.* (Wien, 1876). The MS. contains elegant initials, with foliage scrolls in good taste, and two large miniatures, the Return from Egypt, and the Annunciation. On the latter in the label held by the Archangel Gabriel, which usually and naturally holds the "Ave Maria gratia plena," &c., are the words, in small Gothic letters, ḥoc . Ꞩbisco . ꝺe. trotina . p. This alleged painter's name occurs

here in a most unusual position. The original artists of these books never used these labels for any such purpose as putting in their names. They were solely employed for texts of Scripture or brief prayers, or in some way relating to the subject of the book. Just in the same way the Prophet Haggai, of the Jaromir Bible, is made to carry the statement that he is not Haggai, but the painter Bohusse, of Leitmeritz. (*See* Bohusse.) As examples of unusual placing may be mentioned the Bechinia Gradual, now at Vienna, i., fol. 23 (*see* Olmucz, Jacob von), and the famous Bible written by Robertus de Bylling, in the National Library, Paris (Fds. lat., 11,935). (*See* Anciau de Cens.) Another MS. in which Woltmann affirms forgery to have been practised is the "Liber Viaticus" of the Bishop of Leitomischl or Leitmeritz. This is a MS. of extreme beauty, in an old binding of red silk with metal clasps. On the first two pages, facing each other, is the title, in a contemporary hand: "Liber Viaticus Domini Johannis Luthomuslensis Episcopi Imperialis Cancellarii." Johann von Neumarkt, the Chancellor, was Bishop of Leitomischl from 1353 to 1364, so that the book must have been finished within those years. In 1364 he became Bishop of Olmücz. The rich ornaments are not numerous, but they are extremely fine and of the highest finish. Stories are enclosed in the large initials relating to subjects in the text. Floral arabesques surround both columns of the writing and small scenes again at foot. The latter are sometimes monsters and drolleries, sometimes scenes from the services of the Church. Medallions in the borders often contain figures, as the bishop kneeling, also his episcopal arms. In the flowers of the scrolls are half-figures, sometimes with labels, carrying their names, being prophets, kings, patriarchs, &c. In the large initials, containing New Testament scenes, the labels are generally empty, or have been filled up by a falsifier; the writing, being white paint on the white vellum, is only visible when held up to the light. These inscriptions then show names of a Slavonic character, for the most part no longer quite legible. Fol. 254 *v.* has the figure of a prophet with a label bearing the name Sbisco de Trot. . . (Sbisco is not given by Dlabacz.) Another illuminator, of the time of Charles IV., appears as Petrus Brzuchaty (*see* Brzuchaty), whose work is said to exist in the Missal of Johann Otzko von Wlasheim, Archbishop of Prag (1364–80). In the initial "P" is the Nativity, and among the foliages is the signature Petr Brzuchaty (Brzuchaty is not in Dlabacz). Woltmann supposes this name also to be a forgery made by some one who had

seen its Latin form of Petrus Ventosus in the Gild-book of the Painters' Union of Prag, in order to give importance to the volume, or to the painter, by claiming it as an example of native art. " But though," he continues, " we must consign the names of these two imaginary artists without mercy to perdition, still the worth of the work itself to which their names have been falsely attached, is not in the smallest degree rendered less precious or beautiful. They stand in the highest rank of the art which stood so deservedly high in the fifteenth century, and they are certainly products of the school of Prag." There can be no doubt of the great influence of Italian artists in this school, as shown by this MS. " Viaticus." Yet the best miniatures prove that the artists of this and the " Mariale" had reached the highest position in the school of Paris. As I have said elsewhere, this naturally arose from the circumstances of Charles the Fourth's education and relationship. John, Duke of Berry, the famous collector, was the son of King John of France and of Bonne or Guta of Luxembourg, and she was Charles the Fourth's sister. Hence it is that the Berry Psalter (Paris, MS. fr., 13,091), the Hours of Louis of Anjou (MS. lat., 18,014), and even the later Hours of John of Berry (MS., lat., 919) are decidedly of the same art-lineage as the " Liber Viaticus." For a more complete account of Bohemian miniature art the reader may refer to *Woltmann* in *Repertorium für Kunstwissenschaft*, ii. (Stuttgart, 1879).— *Waagen : Kunstwerke und Künstler* in *Paris* III., 337.—*Passavant :* in *Otto und Quast,* 197, &c.—*Grüber : Kunst des Mittelalters* in *Böhmen.* (Wien, 1871-9. 4°.)

TROTTIS, JOHANNES DE. *Copyist.* Saec. XV.

Wrote a small treatise, " De immortalitate animæ : in modum dialogi." Dedicated to Ercole I., Duke of Ferrara, the patron of Boiardo. In front is a miniature of Hercules slaying the Hydra, in brown gold under a crimson canopy, formed of a kind of monumental sculptural design, on the upper cornice of which is inscribed in golden capitals " ADEO FORTITVDO MEA," and in the plinth below these elegiac couplets :—

" Candida cum tociens referat victoria palmas
 In tua damna tibi quid uiuat esse feram
 Ille deus sum̃um petet insuperatus olympū
 Torrida lerneis flebis echidna uadis."

The arms of the Duke are given (a) on the left, as Gonfalonier of the Church, quarterly, separated by a pale *gules* bearing the arms of Ferrara, and the papal keys ; (b), quarterly 1 and 4 on a field parti *or* and *sable,* a two-headed eagle countercharged of the field; 2 and 3 paly of 6 *argent* and *gules.* At top in the tympanum of the arch is a diamond ring encircling a daisy. Four once beautiful children, now much faded, stand or kneel in the cornices of the monument, holding the strings by which the ring and shields are supported. The dedicatory title is written in coloured inks, blue, crimson, and yellowish-green. An initial " D " in gold, on a crimson panel on which is painted in thin wash-gold another figure of Hercules and a scroll of bay-leaves. Then follows the dedication in ordinary small Roman. The ordinary initals are simple coloured capitals. At end, on fol. 62, in red minuscules : " De immortalitate anime opusculam i modum dialogi. Explicit feliciter per me Johannem de trottis, die 4 Aprilis, 1472, Scriptum." Vellum. 8⁰. 62 ff. Now in British Museum, Add. MSS., 22,325. A note on one of the fly-leaves tells us that the book was printed at Milano by Ulderico (Uldenio) Scinzenzeler in 1487. Mentioned by Antonio Marsand, *MSS. Italiani nella Regia Biblioteca di Parigi,* i. 222, No. 8,286. The Trotti of Lombardy were a noble family, originally from Saxony.—*Tettoni e Saladini : Teatro Araldico,* i.

TRUTENHAUSEN, NICOLAS DE. *Copyist.* Saec. xv.

Canon Regular of Odilienberg.

Copied, in 1467, a Strasburg Missal for Bishop Rupert, of Bavaria.—*Cahier : Bibliothèques,* 141.—*Yemeniz Catalogue,* 1867, 37.

TULA. *Copyist.* Saec. XIII.

A widow.

Styled in the Cöln " Schreinbuchern " *rubeatrix* or *rodere.* In the fourteenth century German copyists are often called " rodere," from their use of minium or red ink, which was usually made of cinnabar, or vermilion and water, mixed with a little white and yolk of egg.—*Wattenbach : Das Schriftwesen, &c.* 290.

Tumulo, Silvestro de. *Copyist.* Saec. xv.

One of those employed in 1492 by Ferdinand King of Naples.—
Delisle : Cab. des MSS., iii. 357.

Tura, Cosimo. *Miniaturist.* (?) Saec. xv.
Called Cosmè da Ferrara.

Vasari and others made this artist a disciple of Galasso of
Ferrara, who flourished about 1400, and Court painter to Borso of
Este. "Il suo stile e secco ed umile, com' era il costume di
quella età ancor lontan dal vero pastoso e dal vero grande. Le
figure sono fasciate sul far Mantegnesca, i muscoli molto espressi,
le architetture tirate con diligenza ; i bassi rilievi con tutto ciò
che fa ornato, lavorato d'un gusto il più minuto, e il più esatto
che possa dirsi. Ciò notasi nelle sue miniature che come cose
rarissime si monstrano a forestieri ne' libri corali del Duomo e della
Certosa." See, however, remark under Cuca. There seems no
authority, according to Gualandi, for attributing the Choir-books
to Cosimo Tura, notwithstanding the long-existing tradition,
perpetuated by Zaccaria. Tura died 1469, aged sixty-three.—
Lanzi : History of Painting in Italy. (Bohn's Translation, iii.
189.) It has been the custom from the time of Padre Zaccaria, at
least, to assert that many of the miniatures of the Choir-books of
the Cathedral of Ferrara were executed by Tura, "who," says
Della Valle, "excelled in such works, as one may see by these
magnificent examples, which he executed for the Duomo of the
said city, about 1468."—*Lettere Sanese.* Indeed, the whole
story seems to have gone in a faulty circle. First, the miniatures
are assigned to Tura, and then his style of painting is ascertained
by reference to them. Gualandi shows how the story may have
arisen.—*Gualandi : Memorie Originali Italiane risguardanti le
Belle Arti.—Documenti risguard. i Libri Corali del Duomo
di Ferrara.* Serie vi. 153. (Bologna, 1845.) *See* Argenta,
Magro, &c.

Tura, Gerardino del. *Miniaturist.* Saec. xv.

Among artists employed at Ferrara.—*Cittadella : Notizie, &c.*

TURBO. *Copyist.* Saec. x. et xi.

Wrote " Augustinus in Epistolam Johannis." Sm. fol. In Lombard characters, with large initial. The writer is named on fol. 21.—*Caravita : I Codici e le Arti a Monte Cassino,* ii. 52.

TURNOW, WILH. VON. *Copyist.* Saec. XIV.

At the end of the fourteenth century lived at Mechlenburg. Wrote the poems of Hugo v. Trimberg. Now in the University Library, at Leipzig.—*Gottsched di rariorib. nonnullis Bibliothecæ Paul Codicib.*

TURPIN, JOS. *Copyist.* Saec. XVII.

Wrote, in 1688, at Paris, " Sacer Evangeliarum Textus pro præcipuis festivitatibus anni ad usum ecclesiæ regalis et paro-chialis S. Mariæ et S. Ludovici in Insula (*i.e.*, the Sainte Chapelle at Paris). " Scribebat Parisiis Josephus Turpin cura et studio magistri Bernardi Cros, Doctoris in utroque Jure . . . et eius-dem Ecclesiæ Pastoris vigilantissimus anno MDCLXXXVIII." Vellum. 4°. Folio. Now in British Museum, Add MSS., 17,435. This handsome MS. is written in a bold print hand, with golden and coloured initials and other ornaments.

TURRE, CHRISTOFORUS DE LA. *Copyist.* Saec. XV.

Wrote, in 12mo on vellum, " Officium Beate Marie Virginis Romane Curie," containing " Missa B. Marie V. Offic. Mortuor. Septem Psalmi penitent. et Letanie. Offic. Scti Spiritus et Offic. Scte Crucis." With six miniatures and numerous richly decorated initials in gold and colours. At end of Offic. Mortuor. : " Et scriptum manu M. Christofori de la Turre." Prefixed is a calendar, in front of which is the miniature of the Annunciation.

A miniature is prefixed also to each of other Offices, in the style of Maitre Simon, called the " Master of the Distances." Sold at the Libri sale in March, 1859. At Sir W. Tite's, in 1874. —*Tite: Sale Catal., No.* 732.—*Libri : Sale Catalogue,* 161.

TURRIANUS, CONRADUS. *Copyist.* Saec. xv.

Wrote " Ovidij Metamorphoses." Paper. Folio. Upright half-Roman, with contractions. No ornaments. At end : " Bissex millenos usus in iudice septos s3t quiq3 miñ 9ciniet ouidius. Iste ouidius est mei cōradi turrīā ꝑpia manu." Now in British Museum, Add. MSS., 11,968.

TURRINUS, JOSEPH ANTONIUS. *Calligrapher.*

Saec. XVII.

Wrote with rich ornamentations and initial letters in gold, silver, and colours : " B. Martigiani Divozione alla Santissima Vergine Maria, con Orazioni." Signed, " Josephus Antonius Turrinus scripsit, 1692."—*Ridler : Sale Catalogue,* pt. 175, ii. No. 255, (Sept. 1888).

TURRIS, PETER. *Copyist.* Saec. xv.

Of Brandenburg.

The private secretary of Cardinal Bessarion. Wrote : " S. Basilii Magn[i] ad Amphilocum adv. apologiam impii Eunomi," &c. Translated into Latin by Georg Trapezuntius. With prefatory epistle, written by Bessarion, who presented this version to Pope Eugenius IV. Cod. xlv. (Bess.), 4°. Paper. 245 ff. Now in Library of St. Mark, Venice.—*Zanetti : Latin and Italian, &c.,* 23. At end : " Ad amphilochiam de Spiritu Scto adv[s] Euno-mium Capitula xxx. exemplata per Petrum Turris clericum Brande-burgensem familiarem revers[si] in xti patris Dñi Dñi Bessarionis Basilicæ XII. Apostolor. Cardinal digniss[i] Nicæni vulgariter nomi-nato, 1442, ultima die mensis Febr[i]. completa." Laus deo. Amen.

Tutinger, Petrus. *Copyist and Miniaturist.*

Saec. xv.

Prior of the Monastery of Ober Altaich.

Wrote in 1477, a large Antiphonary, which a painter, Rupert von Passau, adorned with pictures. He also wrote a large Gradual and enriched it with many historical scenes.—*Nagler : Künstlerlexicon,* xix. 76.

Ubach, Gerardus. *Copyist.* **Saec. xv.**

Wrote, in 1462, "Ordinarium Divini Officii," for the Monastery of St. John Baptist, Aquisgrani. Vellum. Sm. 4°. 93 ff. Mostly in thick German Gothic, with bright vermilion rubrics. Preceded by a calendar. Now in British Museum, Add. MSS., 17.401.

Ubaldini, Petruccio. *Calligrapher, Illuminator, &c.*

Saec. xvi.

A Florentine, who resided in England during the reigns of Queen Elizabeth and James I.

He executed many works, both on vellum and paper ; among them the Psalms of David, in folio, with miniature of David praying, and the arms of the Earl of Arundel, on fol. 2 and fol. 1 *v.* At end : " Petruccius Ubaldinus Florentinus Henrico comiti Arundellio Mæcenati suo, scribebat Londini M.D.LXV." Now in the British Mus., Roy. MSS., 2 B. ix. Another vellum book, written and illuminated by him, was made by order of Sir Nicholas Bacon, and by him presented to the Lady Lumley. It contained the sentences of Scripture (and passages and mottoes from classic authors) painted in the Lord Keeper's gallery at Gorhambury. This MS. is also in the British Museum, Royal MSS., 17 A. xxiv. Another containing various kinds of writing is in the Cotton Collection in the same Library. In the King's

Library also is " Scotiæ descriptio a Deidonensi quodam facto, A.D.
1550, et per Petruccium Ubaldinum transcripta, A.D. 1576." On
Paper. No. 13 A. viii. In Corpus Christi College, Oxford, is a
MS. on paper, folio, 40 ff., entitled : " Descrittione del Regno de
Scotia et delle cose piu degne di memoria che quivi se trovano
conosciuta nuovamente per opera et diligenza di Petruccio
Ubaldini Fiorentino, 1576." It was printed at " Anversa, 1580."
—*Coxe : Catalog. Codicum MSS., Collegii Corporis Christi,* 102.
No. ccxlvi. Other examples in the British Museum are :—
" Petruccio Ubaldino un libro d' essemplari." On paper.
No. 14 A. i. " Un libro della forma et regola dell' eleggere e
coronare gli imperadori." On paper, 14 A. viii. " Commentario
del successo dell' armata Spagnuola,"&c. 14 A. x. "Relazione dell'
impresa fatta contro il regno d' Inghilterra dal re Cattolico, &c.,
scritta da Petruccio Ubaldino cittadino Florentino, in Londra il di
15 d' Aprile, 1589." 14 A. xi. " Le vite et i fatti di sei donne
illustre." 14 A. xix. He seems to have published a work of this
kind, entitled " Le Vite delle Donne illustre del regno d' Inghil-
terra e del regno di Scotia e di quelli che d' altri paese nei due
detti regni sono state maritate." Thin 4°. London, printed by
John Wolf, 1591. His merits as an author are very moderate ·
but he was a skilful calligrapher, and illuminated in a neat and
rather peculiar style. The Lumley Book, as the collection of
mottoes, &c., at Gorhambury, is called, gives them painted in
gold or silver on coloured panels, or written in the usual hands of
the time, within frames richly decorated with gold and silver,
pencilled ornaments on coloured grounds. Some of these
panels are very delicately painted with a kind of Oriental style of
ornament. The colours are buff, violet, blue, crimson, and green,
usually in pairs. 14 A i. also contains some fine penmanship and
initials ; 14 A 6 has good penmanship about the middle. 14 A. x.
and xi. are roughly written, but 14 A. xix. is good toward the end.
14 A. xvi. is very finely written, texts and passages of Scripture, &c.
Texts all black. A good set on p. 41. On p. 42 is the in-
scription : " Petruccius Ubaldinus Florentinus Scribebat Londini,
Anno Dñi. 1550. Edwardi vero regis Regni quarto." The gallery
and inscriptions at Gorhambury, near St. Albans, are still extant.
This mansion was built by the Lord Keeper, and much improved
by Sir Francis Bacon, who added Italian porticoes and loggias in
a tasteful manner. " It is," says Walpole, " a sweet retirement
without ostentation, and adapted to Bacon's motto : " Mediocria
firma." It was purchased by Sir Harbottle Grimston, and much

of the old furniture the purchasers and present possessors have had
the good taste to preserve. Ubaldini was in great favour at Court,
and is frequently mentioned in the rolls of New Year's gifts, which
used to be kept in the jewel office, and in which even the names of
Hilliard, Oliver, and Garrard do not appear. Thus, in 21st Eliz. :
" To Petruccio v. l." He returns a book of Italian with pictures
" ad vivum," and the " Metamorphoses of Ovid." In 1585 he
executes a pedigree, and receives gilt plate, 5 oz. In 1588, " to
Petruccio, gilt plate, 5 oz.," he returns a book covered with vellum,
in Italian.— *Walpole : Anecdotes of Painting in England.*

UBERTUS. *Miniaturist.* Saec. XII. (?)
 Of Lucca.

Said to have illustrated the famous MS. of Donizzone's poem on
the Countess Matilda, written in 1115. Written by Zanelinus.
Now in the Vatican Library.—*Séroux d'Agincourt : Hist. de l'Art,
&c.*, iii. 72-75. At end : " Hæc pinxit certus lucensis Pictor
Ubertus. Ecce Dei magnos qui protegit agnos. Sacra Dei
dextera benedic nos intus et extera. Pando petrus portas, &c. . . .
Scriptori libri tribuatur gratia Christi."—*Trenta :* in *Memorie e
Documenti per servire all' Istoria del Ducato di' Lucca,* vii. 23.

This is wrong. D'Agincourt says, at the end of *another poem
on Genesis* by the same authority, Donizon, we read the name
of a Lucchese painter, &c., quoting the line given more fully by
Trenta from Muratori : " Rer. Italicar. Scriptores," v. 337. But
Muratori does not say which he painted, as the poem of Matilda is
appended to the Genesis, and the verses follow the latter.—
Seroux d'Agincourt, iii. 73, 74.

UDALRICUS. *Calligrapher and Copyist.* Saec. X.
 Bishop of Augsburg (923-973).

Wrote an Evangeliarum with splendid large initials, now in the
Royal Library, at Munich. Concil. vi. 2 a. At foot of fol. 2 of
the MS. is written, in golden rustic capitals (Caroline), " Dš
propitius esto Udalrico peccatori."—*Silvestre* P. U., iv. 47.

UDALRICUS. *Copyist.* Saec. XI.

A Monk of Benedictbeuren, and pupil of Gotthelm.

Wrote with extraordinary ability a Liturgy, for which in 1074 a vineyard was given as an equivalent.—*Meichelbeck : Chronicon Benedictoburanense, &c.,* in *Monumenta Boica,* vii. 92.

UDINE, GIOVANNI DA. *Copyist.* Saec. XIV.

A Minorite.

Wrote "Compilatio Librorum historialium totius Bibliæ." Dedicated to the Patriarch of Aquileia. At end : "dicit se hanc chartam manu propria in civitati Utini Aquiliensis Diocesis, anno dñi 1344 de mense ·Januarij cum eis figuris conscripsisse." Fol. Fairly good work.—*Zani : Enciclop. Metod.,* xviii. 333.

UDINE, GIOVANNI DI PANTALEONE DA. *Miniaturist.*

Saec. XV.

Employed in 1468 by the Opera of Siena.—*Milanesi : Documenti per la Storia dell' Arte Senese,* ii. 382, 387. Also in *Vasari : Vite, &c.,* vi. 179.

UGOLINO. *Miniaturist.* Saec. XIV.

Or Ghino de Guglielmo, da Bologna. Born 1313. Died 1350.

Zani, xviii. 337.

ULBALDUS. *Copyist.* Saec. XIII.

A Priest.

Wrote a collection of various Biographical and Theological Tracts.
Vellum. 4°. 150 ff., partly 2 cols. With red and blue initials,
some large and finely drawn in the usual style of the twelfth and
early thirteenth century. Headings, &c., in red. The text is a
good upright half-Roman. A list of the contents of the volume
is given on fol. 1. " Incipit pfatio s̄cī iheronimi pbrī in libro de
uiris illustribus," &c. At end in red : " Liber eccliæ beatæ
Marie de Camberone, scriptus ab Vlbaldo peccatore sacerdote."
Now in the British Museum, Add. MSS., 15,218.

ULRICUS. *Copyist.* Saec. XIV.

Abbot of Lilienfeld (1345–1351).

Wrote " Concordantia caritatis." Vellum. Folio. 263 ff. With
ornaments and miniatures in outline with tinted colours.
Exhibited in Church Furniture Exhibition, Vienna, 1887.—
Jahrbuch der k. k. Central-comm., v. 27.—*Neuwirth :* in *Denkschrift
der k. Acad. der Wissensch.*, cix.—*Illustrirter Katalog der
Ausstellung, &c.*, 5, No. 25.

ULTAN. *Calligrapher.* Saec. XIV.

An Irish Monk, called by Leland " Scriptor et pictor
librorum optimus."

" First, however, and far more ancient than Cybo, appear the
venerable forms of Dagæus and Ultan."—*Dibdin : Bibliogr.
Decam.* I. cxxi., cxxii.—*Leland : Collectanea*, ii. 364. Ethelwulf, in
a metrical epistle to Egbert, at that time resident in Ireland with
a view of collecting MSS. there, extols Ultan, an Irish Monk, for
his talents in adorning books. " Ex quibus est Ultan præclaro
nomine dictus comptis qui potuit notis ornare libellos."—*O'Conor :
Rerum Hibernicarum Scriptores Veteres*, clxxvii. (1814, 4°).

UNDELOT. *Pseudo-Miniaturist.* Saec. XV.

It was stated by Labarte, after Laborde, that an artist of that name was known as a miniaturist of the first rank through his painting in the Hours of Charles le Téméraire, Comte de Charolois, belonging to the Royal Library at Copenhagen. This miniature signed by its author, and dated 1465, represents the young prince and his wife kneeling under the sudarium. The portraits are at once microscopic and grand, and are placed in front of a landscape worthy of the great masters of the period. Laborde detected in the painter Undelot a pupil of Roger of Bruges. His name is not found on any other work.—*Labarte: Les Arts Industr.*, ii. 242.— *Laborde : Les Ducs de Bourg.*, i., lxxxvi. n. 3. Writing on the MS. of "Les Miracles de Nostre Dame," now in the Bodley Library, Oxford, M. Delisle says "Charles le Téméraire is an utter stranger to the book which bears his name in the Royal Library at Copenhagen, ar.d which comes from the collection of the Count de Béthune. To prove this I shall produce some notes taken in 1880 on the MS. itself:—The volume, in 4⁰, which bears the No. 1612 in the old Royal Collection of Copenhagen, and which came from an acquisition made at Paris in 1743 by Kleve, is a collection of prayers in French and Latin. It consists of 44 folios of vellum 22 c. high by 16 broad. Each page is surrounded by a border of flowers and "vinceaux" on coloured or gold grounds. An image of the Trinity which covers the rest of fol. 2 serves as frontispiece. Besides this are 39 small miniatures representing saints of both sexes at foot of the pages. The first folio contains a miniature *inserted* and applied more or less neatly within a border of flowers and scrolls in a style altogether different from the other borders of the volume. In this miniature the painter has figured a lord and lady on their knees before a sacred visage. At foot on a plot of grass is written in golden capitals the inscription : "FAIT PAR JACQVES UNDELOT, 1465." Underneath, in the border, are painted the arms of Charles le Téméraire, and those of the Princesse de Bourbon, his first wife. A strip of parchment has been glued to the bottom of the page, and on it the hand which traced the date 1465 above has added in capitals: "Heures de Charles de la Maison de France. Dernier Duc de Bourgoyne, qui fut tue au Siege de Nancy. Lequel est icy represente a genoux devant la face de nostre Seigneur. Avec Marie de Bourbon. Sa seconde femme. Mere de Marie. Unique heritiere de Charles. Mariee a l'Empereur Maximilian D'Autriche. Ce Duc Charles avoit pour

corps de sa devise un lion rugissant, ou estoit escrit a l'entour *a qui voudra* pour monstrer qu'il ne craignoit rien et deffioit qui que ce fust." The very terms of this inscription and the blunders with which it abounds, amply prove that it is one of those fraudulent interpolations, examples of which are by no means rare among the Béthune MSS. The learned director of the library, M. Ch. Bruun, has no kind of doubt of the falsity of this attribution. The compiler of this Dictionary has also to thank Dr. Brunn for a note of warning with respect to Undelot, showing the error in Laborde's statement describing the MS., and referring to other forgeries in the Béthune collection. The portraits in the miniature referred to were engraved for Montfaucon's "Monuments de la Monarchie française," iii. (Paris, 1731), pl. lxiv.; but, as M. Delisle and Dr. Brunn say, they do not represent the Count de Charolois and his wife. The MS. is only the third part of a larger work, a Prayer-book, of which another part is also in the same library. Where the third part is Dr. Brunn does not know. On the sides are stamped the arms of Count Philippe de Béthune (xvii[th] century). The larger Prayer-book was in his library, and it was his librarian who cut the volume in pieces, and who committed the forgery, creating the pseudonym of Jaques Undelot.—*Delisle : Cabinet des MSS., &c.,* i. 163, 256, 268; iii. 392.—*Brunn : De illuminerede Haandskrifter i det Store Kongelige Bibliothek,* 157–161 ; *Brunn : Aarsberetninger og Meddelebrer fra det store Kongelige Bibliothek Kjobenhavn,* iii. 155–161.

UOTA. *Patroness.* Saec. XI.

Sixth Abbess of Niedermünster, near Ratisbon, Bavaria.

Perhaps was the calligrapher of the beautiful MS. now in the Royal Library at Munich.—*Cahier : Biblioth.,* 118, 134, &c. Cahier gives many illustrations from this precious MS.

URBANI, FRA. *Miniaturist.* Saec. XVII.

A Dominican of Porto Bufole, Venice. Born 1631. Died 1704.

Zani, xviii. 349.

Urbino, Dukes of. *Patrons.* Saec. xv. et xvi.

Among the lesser sovereigns of Europe who, with restricted
territories and by no means unlimited revenues, rivalled the
magnificence of kings, few have gained a greater renown than the
Montefeltri and Della Rovere of Urbino. The House of Monte-
feretro, or, as it is usually called, Montefeltro, dated its origin as far
back as the twelfth century, but the first prince of the name who
demands distinction in respect of art or literature is the celebrated
condottiere Federigo, first count, afterwards duke, of the moun-
tainous but compact and well-peopled little district lying east of
Tuscany, beyond the Apennines, and between Romagna and the
March of Ancona. With his long and busy reign as a statesman,
politician, and warrior, strongly recalling that of his master, Francesco
Sforza, we have nothing to do. We can merely give the briefest
possible sketch of his share in the forward intellectual movement
of his age. When the dukedom was conferred upon him in 1474,
the House of Della Rovere, whose representative married his
daughter, was established at the little town of Sinigaglia, on the
coast. In the fifteenth century almost the whole of Italy was
broken up into a number of petty despotisms or of tiny republics,
whose power naturally fluctuated with the perpetual rectifications
of their narrow frontiers. Some, it is true, are tolerably constant,
such as the Medici in Florence, the Estensi in Ferrara, the Mala-
testa in Rimini and Cesena, and in a lesser way the Bentivogli in
Bologna, the Baglioni in Perugia, and the Manfredi in Faenza.
But in turn all are disturbed or extinguished. We find the
Estensi shaken out of Ferrara, the Bentivogli out of Bologna, and
even the Medici out of Florence, and the Montefeltri out of
Urbino. It was a strangely restless time, full of volcanic heat and
ferment. Ceaseless contentions, seizures, and reprisals kept every
town and community on the alert. Yet the total effect of all the
jealousies, rivalries, and survivals was elevation and progress ; for
the wealth and culture of capital cities were frequent, because of
the number of seignorial courts and centres of government. It
developed a continuous aristocracy of intellect and talents, if not
genius, and fostered a succession of schools of art. Instead of
the ordinary rusticity of a host of provincial towns, counterbalanced
only by the refinement of a single capital, there was a general
diffusion of metropolitan polish throughout almost the whole
peninsula. These circumstances largely account for the rapid
growth of Italy in the arts, and her universal pre-eminence at the
commencement of the sixteenth century.

Federigo, the second Duke of Urbino, was born about 1422, and was the natural son of Count Guidantonio, but formally legitimated in 1424. Forty years afterwards, and whilst in the zenith of his reputation, he began that magnificent palace on which were employed the best architectural and artistic skill of the age. At the time when it was begun, the city of Urbino happened to possess at least two of the greatest luminaries of Italian art. It was the birthplace of one of her greatest architects, and of her greatest painter. The palace, built at a stupendous cost, and minutely described by one of Federigo's biographers, can only be mentioned here as having afforded a home for the superb library collected by successive dukes. As regards Federigo, we are fortunate in possessing the account of an eye-witness who was most deeply interested in the production of books, namely, Vespasiano de' Bisticci, of Florence. It was Vespasiano who transacted the library business of the Medici, the Pope, the kings of Naples and Hungary, and the dukes of Milan. He was personally acquainted with the most famous copyists and miniaturists of his time, and was the friend and adviser of its wealthiest patrons. "Grande transporto," says Ugolini, "aveva Federigo pei libri e pei codici . . . Egli non guardò a spesa, e dove sapeva che erano buoni codici, la mandava per farne acquisto." From thirty to forty copyists were maintained in Urbino itself, four of whom permanently resided in the palace. In Florence and other cities, a still greater number of professional pens were employed in transcribing the Latin poets, orators, and historians. Nor were their labours confined to Latin authors. What was done for Latin was done, says the record, for Greek, for modern authors as well as for ancient, and for ecclesiastical writers equally with those on civil or scientific subjects. The labour was enough to appal the most courageous, the expense was enormous. The library was formed at the same time as that of Sixtus IV. of the House of Della Rovere, in Rome, when Matthias Corvinus was all but monopolising the whole copyist skill of Italy in forming his vast collection at Buda, and when Lorenzo de' Medici was collecting the treasures of his Museum in Florence,—"talchè questa impresa del duca Federico, di trovare e far scrivere libri di tanto numero fu più difficile e di maggiore spesa, perche li scrittori di libri grechi e latini e di altre lingue, li miniatori ed altri artefici che servirono per le librerie di quei tempi, erano ricercati e condotti da lontano con maggior pregio che prima non facevano." From comparing various accounts it would appear that not fewer than four thousand

manuscripts were thus gathered together. And it was the agent's
boast, that whatever might be the state of other libraries, this, at
least, possessed no copy that was either defective in condition or
incomplete in text. If space permitted we might go on to
describe the numerous volumes more particularly. One or two,
however, must serve as specimens, and we shall select the most
famous. First is the richly-illuminated Bible in two volumes, once
covered with gold brocade, and encrusted with silver ornaments,
but now wearing a more economical dress of crimson morocco.
Its pages are profusely adorned with borders, initials, and minia-
tures. Ugolini speaks of it as being the one captured at Volterra,
and accepted by Federigo as his sole but sufficient share of the
spoil. Dennistoun describes briefly these wonderful volumes, but
suggests that it was rather the enormous Hebrew Bible which was
thus somewhat mythically obtained, or more probably by a subse-
quent exchange. He calls it the most ponderous volume he ever
met with, being nearly a foot in thickness, and containing 979
leaves of stout vellum placed within substantial *boards*, measuring
23 in. by 16 in. Two men are required to carry it. As a testimony
of its value, it is related that some Jews once offered to buy it for
its weight in gold, equivalent to about 30,000 crowns, and Philip II.
of Spain offered 20,000. It dates from the fourteenth century.
The Latin Bible first mentioned, in two volumes, measures 22 in.
by 18 in. Each separate book, as Genesis, is preceded by a
large miniature of some notable scene, and the rest of the text is
enriched with most perfect arabesque ornaments, rendering it " one
of the most important works of the golden days of manuscript
illumination." Considering that its date is within twenty-five years
of the sixteenth century, we see that the golden days of illumination
in Italy fall rather late. Much discussion has taken place as to
its authorship, but after various conjectures we are still uncertain
to whose skilful hand the miniatures are due. It was executed at
Florence, so that the authorship should not be far to seek. In my
brief visit to Rome, in 1874, I had barely time for a momentary
glance at its pages,—my impression is, that the borders, at least,
were the work of Francesco d' Antonio, called del Cherico, of
Florence, whose work for Piero de' Medici still exists in the
Laurentiana. Its colophon may be compared with the inscriptions
on the cornices at Urbino ; "Finit prima pars Bibliæ a divo
Hieronimo translata, quam illustrissimus princeps Federicus, Urbini
dux et Montisferetri comes Generalisque Capitaneus, et Ferdinandi
Regis et Sanctæ Romanæ Ecclesiæ vexillifer, atque omnium suæ

ætatis præstantissimus imperator faciendum curavit non minus Christianæ religioni tuendæ atque exornandæ intentus quam disciplinæ militari amplificandæ. Absolutum autem Florentiæ opus est, anno ab humanatione Christi Millesimo quadringentesimo septuagesimo sexto, Februarij mensis die quinto et vigesimo." The two volumes contain 550 ff. The miniatures are of very unequal merit, those of the first volume being the best. Probably they are the work of different hands. Another of the marvels of the library is the folio Dante (Nat. MSS. No. 365), quite one of the richest examples of Renaissance illumination extant. On the frontispiece are the arms of Montefeltro, with the insignia of the Order of the Garter bestowed on Federigo by Edward the Fourth. It is embellished throughout with the devices and initials of the Dukes, but the latter part is clearly the addition of a later period, and has been attributed, on its intrinsic merits, to Clovio. The seventy-three miniatures are said to be "characterised by a more accurate perspective than Florence could then boast." Correct foreshortening, elaborate action, and varied movement in advance of the age, are nevertheless combined with short figures, mean faces, and want of ideality. The Inferno is treated with severity in colouring and accessories befitting a grand mysterious theme : the Purgatorio, though less startling, is still supernatural. Towards the close commence the more modern paintings, forty-one in number, and now a " sudden transition of feeling and execution occurs exactly in harmony with the subject. All becomes at once bright and beautiful, sunny and smiling ; flowery meadows are peopled by fair damsels." Exactly what one would expect from a transition from the dry, matter-of-fact manner of the fifteenth century to the more highly accomplished execution and perfect idealism of the sixteenth. Séroux d'Agincourt ascribes the older work to Perugino, in which, no doubt, he was wrong. Other ascriptions to Piero della Francesco, then blind, and to other artists who happened to be living, including even Fra Carnevale, who was a resident miniaturist at Urbino, are not a scrap better. Nor are the critics happier with the rest of their guess-work, which rests merely on haphazard comparisons of style, or on fanciful combinations of probabilities. The last manuscripts to be noticed are the two exquisite volumes containing the " Lives of the Dukes of Urbino," composed by Muzio and Leoni. They were finely written by Monterchi, one of the famous copyists of the sixteenth century. On more than one occasion his penmanship is accompanied by the miniature work of Giulio

Clovio, a fact which renders more probable the suggestion that the
illuminations of these volumes were executed by that celebrated
miniaturist. They consist of finely-designed and richly-coloured
borders and highly-wrought historical pictures. Besides the
portrait and ornamental title-page, each volume contains three
such scenes, those of the first volume relating to the life of
Federigo, those of the second to that of his grandson, Francesco
Maria I. della Rovere. The incidents represented are, in vol. i.—
1. The Reception of Count Federigo in 1443. 2. The Battle, by
moonlight, of San Fabbiano. 3. The Siege of Volterra. In vol. ii.—
1. The Investiture of Francesco Maria by his uncle, Pope Julius II.,
as Captain-General of the Papal army. 2. An incident in the cam-
paign of 1517. 3. The Duke's reception in Venice by the Doge
Antonio Grimani. Although Plattner's suggestion of the name
of Baroccio is not to be lightly set aside, yet it is now generally
conceded that these miniatures are the work of Clovio, "and
afford a favourable example of his exquisite though somewhat
meretricious style." It has been mentioned that Federigo received
from the English king admission into the noblest of English orders
of knighthood. It is interesting to know not only that the honour
was most highly appreciated by the Italians, but that the chronicler
who celebrates the event was no other than Giovanni Sanzio, the
father of the divine Raffaelle. His metrical recital, however, is
insufferably tedious, nor is it much improved in the version given
by Dennistoun. A MS. in the British Museum (Add. MSS. 6,298)
gives a summary of the merits which obtained for Federigo the
high distinction. From this we make one extract: "The arming
sworde which hee wore had this inscription: 'Son quella che
difende la ragione, non ti fidar di me s'il cor ti manca.' "—"I am
she who defends the right, rely not on me if thy heart fail thee."
Among books dedicated to him, as a well-known patron of litera-
ture, was a wearisome translation of Ptolemy's Geography into
Latin verse, the work of Berlinghieri, which must have severely
tried the Duke's most courteous patience to read. Perhaps he
only looked at it, for it is a splendid MS., richly illuminated, and
now reposes in the Brera Library at Milan. Many other works
both in manuscript and printing were thus dedicated to Federigo,
or were published under his liberal patronage. Like Corvinus, he
was himself an excellent classical scholar, and extremely fond of
ancient history. For the further list of his accomplishments, which
were extraordinary considering his active military life, we must
refer to Vespasiano, whose glowing account is supported by all

contemporary authorities. Marsilio Ficino, the Platonist, cited
him as the ideal of a perfect man and wise prince. We have
already exceeded the space allotted to our notice, so that we can
only make the most rapid allusion to the handsome, highly-gifted,
but sorely tried Guidobaldo I., son of Federigo, and to his brilliant
court as it existed under the charming sway of the lovely and cul-
tured Duchess Isabella. The story is told in the classic pages of
Castiglione. Nor can we do more than barely refer to Francesco
Maria I., and the Duchess Leonora, whose peerless Book of Hours
is treasured in the Bodley Library (Douce MSS., No. 29). Of
Guidobaldo II., son of Francesco Maria, we have a memorial in
the British Museum. It is a small folio on vellum, containing acts
of Investiture of the territories of Orciano and Torre to Pietro
Bonarelli and his wife, Hippolita: (1559–1568), in Latin, with
signatures of the Duke. It is a charming example of the style of the
later Renaissance, and although somewhat frivolous in its idea of
ornament, in one of the titles is exceedingly skilful in manipulation.
The other is much inferior. The borders contain various devices,
arms, and monograms relating to the duchy. A further curiosity
of the volume is its rich Oriental binding (Add. MSS., No.
22,660).

The devices, badges, cyphers, &c., of the dukes of Urbino are
collected by Dennistoun (i., append. v.). The principal are:—
1. The *ventosa*, or cupping-glass, which looks like an exploding
bomb, and has sometimes been described as such. 2. A unicorn.
3. A white ostrich, with a horseshoe in his beak, or sometimes an
arrow-head, with the motto "Ich an vordait ein grosseres"—"I
would prefer a bigger one." Varied as a stork on one leg holding
a stone in his raised claw, to be dropped as a signal of alarm to
his companions. 4. A lion. 5. A bear. 6. A panther. 7. A
muzzled dog. 8. The black eagle of Montefeltro; sometimes
standing on a tortoise. 9. The garter of England, with its well-
known motto. 10. The ermine of Naples (the order instituted by
King Ferdinand I.), with motto "Non mai" or "Nunquam."
11. St. George and the dragon. 12. An Italian brush or whisk.
13. An olive-tree. 14. The cypher FE DX with a small v in the
D. 15. A shield quartered: 1 and 4 *vert* charged with flames;
2 and 3 *azure*, the small Gothic letters ꜰꜱꝟ. 16. In circlets or
medallions (a) *az.*; three suns *or*; (b) a rainbow between four stars;
(c) three winged thunderbolts. 17. Two palm-branches passed
through a golden finger-ring. 18. A lighted lantern. 19. Arms
gu. a lion rampant proper, holding a rapier. Motto: "Non deest

in generoso pectore virtus." This was an invention of Bernardo Castiglione, and refers to the affair of the Cardinal of Pavia. 20. The palm-tree with bent branch on one side and the motto : " Inclinata resurgit." Adopted by Francesco Maria I. 21. Three *metæ*, or goals, as supposed to be used in ancient racecourses, with motto : " Φιλαρετοτάτῳ." (Guidobaldo II.) 22. Two circular temples united by a balustrade. Motto : " Hic terminus hæret." 23. Head blowing to represent the wind. Motto : "Ὄλβιος, πανόλβιος." 24. The oak-tree with branches crossed saltire-wise, the emblem of the Della Rovere family. Sometimes with name or monogram of Feretria. 25. An oak-tree, with shield suspended bearing the arms of Montefeltro. Motto : " Tuta tueor." 25. An altar bearing the Sibylline leaves. 26. Monograms variously composed, such as GG : V.V : &c.

Several in the list given by Dennistoun are incorrect ; both the Greek mottoes being misspelt, and the latter one misunderstood. The so-called cupping-glass invariably gives the idea of an inverted brasier, and this seems to accord more with the flames in Federigo's shield. But it is a case in which history alone can decide. Francesco Maria I. assumed the device of a flame with motto : " Quiescat in sublime." Also the lighted lantern or candle, with " Non degener addam." The *chantepleure* of Valentina Visconti has a very similar appearance to this *ventosa*.

The arms of Montefeltro are combined with those of Della Rovere as usually given in the MSS., and consist of a tripartite shield. 1. Coupé, *or* and *az.*, the upper part bearing an eagle displayed *sa.*, the lower three bends *or.* 2. *Gu.*, the *gonfanon* of the Papal army *or*, with the keys of St. Peter *arg.* 3. Coupé, above *az.*, the oak of Della Rovere *or* ; below, the arms of Naples. The other shields are : (a) Parti, 1, *az.*, the Della R. oak *or* ; 2, quarterly : 1 and 4, *or*, a castle, surmounted by an eagle displayed, *sa.* ; 2 and 3, coupé in chief *az.*, three fleurs-de-lis *or*, *gu.* a bend *arg.* (b) Coupé in chief *az.*, three fleurs-de-lis *or*, below quarterly 1 *arg.* six mounds (1, 2, 3) *gu.*, 2, *gu.*, six mounds *arg.* ; 3, *gu.* ; 4, *arg.* (c) The shields (b) and (c) borne together parti. All these occur in Add. MSS. 22,660, British Museum. This combined shield would be that of Francesco Maria's father and mother, and therefore borne by right by Guidobaldo II. As for Francesco Maria II. and his dissipated son, whose sudden and premature death put an end to the duchy, their lives are outside our inquiry, except for the single fact that in 1657 Pope Alexander VII. caused the remains of the libraries belonging to the Court of Urbino, which had been

plundered by Cæsar Borgia in the time of Guidobaldo I., to be collected and conveyed to Rome, " for the increase of its splendour and the benefit of Christendom," stipulating, of course, certain favours and immunities in return. One of the conditions was that the librarian should always be a native of Urbino. The removal was unquestionably a benefit to the library itself. An inscription over the entrance of the apartment in which the collection is deposited records the transaction thus : " Alexander VII. Pont. Max. | Antiqua omnis generis omniumque linguarum | Urbinatis bibliothecæ manuscripta volumina | Repenso cedentibus beneficio | D. tutiorem custodiam atque proprietatem | Vaticanæ adjunxit an. sal. MDCLVIII." All about the celebrated faïence, or majolica, of Faenza, Pesaro, Gubbio, Castel Durante, and Urbino, which nevertheless often bears the badges, devices, or arms of the Della Rovere, must reluctantly be omitted, as it cannot on any pretence be considered as belonging to our subject.— *Ugolini : Storia dei Conti e Duchi d' Urbino*, i. 294, 447, 456–7, &c. (Firenze, 1859).—*Dennistoun : Memoirs of the Dukes of Urbino*, i. 57, 142, 155–160, 212, 258, 420–2 ; ii. 39, 272, 449 ; iii. 82, 154, &c.—*Giovio : Dialogo dell' Imprese, &c.*, 72 (Lione, 1559).—*Ruscelli : Le Imprese Illustri*, i. 209, 239.—*Ritratti et Elogi di Capitani Illustri*, 154, 276 (Roma, 1647, 4°.).—*Castiglione : Il Cortegiano*, i. 4, &c.

URFÉ, MATT. *Miniaturist.* Saec. XIV.

Painted natural history subjects. In the Library at Modena is a MS. entitled " Herbier," containing pictures of plants, and bearing his name.—*Nagler : Künstlerlexicon*, xix. 261.

URSULEUS. *Copyist.* Saec. XV.

One of the copyists employed by the Aragonese Kings of Naples.

He transcribed the "Orationes Quintiliani" (MS. lat., 7,804) now in the National Library, Paris. At end he notes the deficiency of his model : " Duorum exemplarium quæ habui, rex Sapentiss[e] in altero, nona et decima declamatio imperfecta videtur. Et ne

tale opus maiestati tuæ incompletum visum sit, ideo illam non transcripsisse mihi honestius arbitratus sum. Bene et æternum vivat tua maiestas. Petrus Vrsuleus scripsit." Also : " Diogenes Laertius," dated November, 1448. Now in the Royal Library, Stockholm.—*Delisle : Cabinet des MSS., &c.*, i. 221 ; iii. 392.

VACEREDO. *Copyist.* Saec. XIII.

Wrote, according to the inscription in it, the " Mater Verborum " of the Bohemian National Museum at Prag. It was formerly in the Brzeznitz Library, and was executed in some monastery where German art and Czeck speech were contemporaneous. The character of the writing and the style of the illumination point to the early part of the thirteenth century as the time of its production. Being a word-book it naturally possessed an alphabet of initial letters. It has in fact two alphabets of highly ornate letters, sometimes containing Biblical subjects, sometimes fanciful scenes of everyday life. Among other illustrations, on f. 456, occurs the picture of a Madonna and Child, with two kneeling monks in Byzantine manner. But curiously, on one of the labels, instead of the usual Scriptural quotation, are the words ORA P SCRE (scriptore) VAC'EDO. On another ORA P ILLRE (illuminatore) MIROZLAO . A . MCII . (*see* MIROSLAV). This date is intended to be read 1102, but it is clearly a forgery, as in the beginning of the twelfth century the MS. was not in existence. Besides the style of art proves its impossibility. In 1840 Schafarzik and Palacky examined the MS., and concluded it to be at least an error. They, however, thought that the line over the C was meant to double it, and this conjecture was generally received as correct. But Wattenbach dissented from it as against ordinary usage. Hannsch says the date is neither 1102 nor 1202, but 1302. It is, however, not proved that A means anno. Woltmann seems to have hit upon the true solution. " After repeated examination," he says, " I have come to the conclusion that the whole of the inscription is not falsified, but merely the date, and that formerly after the word Mirozlao stood the word AMEN.—*Wocel :* in *Mittheilungen der K. K. Central-commission* 33 (1860).—*Schnaase : Geschichte der Bildenden Kunst,* v. 491 (2ᵗᵉ Aufl.).—*Schafarzik & Palacky :*

Die Aeltesten Denkmale der Böhm. Sprache. (Prag, 1840).—
Wattenbach: Schriftwesen, 310 (2^te Aufl.).—*Hannsch: Sitzungs-
berichten der Kgl. böhm. Gesellschaft der Wissenschaften* 1865, i. 48.
—*Woltmann: Gesch. der Böhm. Miniatur Malerei,* in *Repertorium
für Kunstwissenschaft,* ii. (Stuttgart, 1879).

VAL, NICOLAS DU. *Calligrapher.* **Saec. XVII.**

Secretary in Ordinary to the King (Louis XIV.).

Sworn master scrivener and expert for the verification of hand-
writings at Paris. Published, in 1670, the "Livre d'Ecriture et
d'Ortographie à present en usage," which he had engraved on
copper on twelve leaves. 4°. Well executed. He invented new
proportions to the two hands called bâtarde. Also "Nouvelles
Heures gravées au burin, dédiées au Roi." 12°.—*Jansen:
Essai sur l'Origine de la Gravure, &c.,* ii. 67, 179.

VAL, ROBERT DU. *Copyist.* **Saec. XIV.**

"Bachelier en Théologie de Paris."

Wrote copies of Livy and Appian. The Livy is now in the
Public Library, Tours (No. 984), and the Appian in the National
Library, Paris (Fds. lat., 5,785). Delisle quotes the accounts for
their transcription and illumination.—*Dorange: Cat. des MSS.
de Tours,* 431. — *Delisle: Cabinet des MSS. &c.,* i. 82, 83,
iii. 341.

VALAPERTI, IGNAZIO. *Miniaturist.* **Saec. XVIII.**

Of Como.

Worked about 1680.—*Zani,* xix. 14.

VALDES, DOÑA MARIA. *Miniaturist.* Saec. XVIII.

A Nun in the Cistercian convent of San Clemente at Seville.

> Daughter and pupil of Don Juan de Valdes Leal, and painted both in oil and miniature. Died 1730.—*Bermudez : Diccionario*, v. 107.

VALENS. *Copyist.* Saec. XV.

Of Nuremberg.

> Wrote in 1425, "Quintus Curtius Rufus, de rebus gestis Alexandri," lib. x. Now in Bodley Library, Oxford (Canon. lat., 306).

VALENCIENNES, ROB^T· DE. *Illuminator.* Saec. XIV.

> Worked on Antiphonaries, written for the Chapter of St. Wandru at Mons. "A maistre Robert de Valenchiennes pour Jehan de Hautrage, le lundi apres le St. Mahin pour partie de l'enluminure des anthiffoniers xxviij liu. iij s." (Arch. de l'Etât à Mons).—*Pinchart : Archives des Arts, &c.*, 242.

VALENTIN. *Copyist.* Saec. XV.

> Was "Stadtschreiber" at Augsburg in 1475. "Geschenkt Meister Valentin (Stadtschreibern in Augsburg) um deswillen dasz er einem Rath ein Buch geliehen hat iv. Gulden vnd seinem schreiber 1 Ort." "Balthasar Brigels von von dem Buch abzuschreiben das Meister Valentin von Augsburg einem Rath geliehen ii. gulden."—*Beyschlag : Beytrage, &c.*, ii. 48.

VALERIANUS. *Copyist.* Saec. VII.

Wrote a Latin Evangeliarium. In describing this MS. Champollion, or whoever wrote the text for Silvestre's Paléographie, falls into the curious error,—and he had a large capacity for blundering,—of supposing that the scribe had only three fingers, being led into it through not understanding what was really meant by the common inscription : " Memento mei peccatoris quia tribus digitis scribitur. Et *totus membrus* laborat." At end a rude cross with inscription on either side : " Finit liber scī Evangelii," &c. On the middle of the cross, in small capitals, are the words : " Ego va le ri a nus scr ip si."—*Silvestre : Paléogr. Univ.*, iv. 158.

VALERIANUS. *Copyist.* Saec. XVI.

Wrote " Βίβλος Φιλοσοφική : Ὀλύμπιο δώρου φιλοσόφου, σχόλια εἰς τὸν τοῦ πλάτωνος φαίδωνα," &c. Paper, finely polished. Folio. 141 ff. Very wide margins. Written in a handsome Greek text. At end, in red : " Ὁ οὐαλεριᾶνος φορολίβιος ὁ ἀλβίνου κανονικ. ἔγραψε ἐν τῷ τοῦ ἁγίου ἀντονίου μοναστερίῳ ἐνετῆς ? ἔτει τῷ ἀπὸ τῆς ιϋ χῦ κῦ ἡμῶν ᾳϕμα ἐσχάτῃ Δεκεμβρίου." " Valerianus Forolivensis, son of Albinus, canonicus, wrote (this) in the monastery of St. Antonio. In the year of our Lord Jesus Christ, 1541 on the last (day) of December." Once belonged to Richard Heber. Now in the British Museum, Add. MSS., 10,063.

VALERY, THOMAS. *Copyist.* Saec. XV.

A Priest of Bourges.

Wrote the copy of " L'Horloge de Sapience," which was illuminated by Jean Pierre (*see*). At end : " Cy fine lorreloge de Sapience escrite de la main de Thomas Valery prestre a Bourges en Berry, que fist escrire messire Estienne Chotart procureur de Mesdames de Saint-Laurent. Priez Dieu pour eulx." In National Library, Paris.—*Paris : Les MSS. fr., &c.*, iv. 146. The translator of this work into French, which was written in Latin by

Henri de Sews, appears to be unknown. In the copy transcribed by Jean Dardenay (*see*) he is called simply a Franciscan, of 1398. In this he is called Frère Jehan de l'Ordre de St. François. In that belonging to the Feuillans of Paris he is called Père Jean de l'Ordre des Mineurs du Couvent de Neufchâteau en Lorraine. It was printed by Vérard in 1493. The original Latin, at Venice, by Jean de Guarengis, in 1492. A German version, at Augsburg, by Anton Sorg, in 1482 ; lastly, an English one without date, by Caxton.—*Van Praet: Recherches sur Louis de Bruges,* 105, n. vii. It has been thought that the German version is, in fact, the original work by Heinrich von Seuss, which he himself translated into Latin. Mortara seems to confound the French translator with the original author.—*Mortara : Catalogo dei MSS. Italiani, &c., nella Bibliot. Bodleiana. MSS. Canonici,* 108, *No.* 93.

VALESIO, FERNANDO. *Copyist.* Saec. XVII.
Of Bologna.

Worked from 1611 to 1628.—*Zani,* xix. 28.

VALESIO, GIOVANLUIGI. *Miniaturist, &c.* Saec. XVI.
Of Bologna.

Belonged to the school of the Caracci. He was better, perhaps, in miniatures than in larger works, though possessed of great versatility, being good at designing for tapestry, and a very fair poet.—*Malvasia : Felsina pittrice,* ii. 95. Passing to Rome, he worked for the Lodovisi in the pontificate of Gregory XVI., and obtained great wealth.—*Lange : Storia Pittorica,* v. 80 (Firenze, 1822).

VALGAERDE, VAN DEN SIMON. *Illuminator.* Saec. XV.
Of Malines.

"Enlumineur de Livres." In 1476 received 10 liv. 8 sous, "monnaie de flandre," for having "escript ung calendrier, comme

pour auoir enluminé et historié les sains et sainctes des festes gardies par la court " (*i.e.* the Parliament of Malines) "y comprins le parchemin et l'aisselle sur lequelle le dit calendrier est atachie (Registre 21,437, Chambre des Comptes du Royaume)."—*Pinchart: Archives des Arts, Sciences, et Lettres. Documents inédits, s. v. Messager des Sciences Historiques, &c.*, 1855, 119.

VALLERS, NICOLAS. *Miniaturist.* Saec. XV.

Employed by Ferdinand I., of Naples.—*Delisle : Cabinet des MSS.*, iii. 357.

VALOIS, PHILIPPE DE. *Patron.* Saec. XIV.

Son of Charles of Valois, and nephew of Charles IV. Became king as Philippe IV. (1328–1350).

If not as active as some of the kings of France as a patron of authors and copyists, yet he is not deserving of the reproaches cast on him by Petrarch, as is shown by the author of the " Discours sur l'état des lettres au XIVme siècle," in the " Hist. Littéraire de France," xxiv. 163. He bought some of the books of Clementia of Hungary, including two breviaries and other religious books, and a " Metamorphoses d'Ovide moralisées." (Mélanges de Clairambault, xi. 29). His father had received the dedication of the " Travels of Marco Polo." He ordered a volume of medical recipes (now 12,323, Fds. fr.), and the " Hist. de Charlemagne " (No. 7,188), and of Girard d'Amiens.* His mother had had written a " Life of St. Geneviève." His sister, Jeanne de Valois, possessed one of the earliest copies of those great historical Mirrors (16,918 ² ²). One volume folio. Vellum. 2 cols., miniatures, &c. On the first folio, in the border, are the arms of France *bordé de gueule au lambel*

* Et je Girars d'Amiens qui tout sui desirans
 De fere son plesir de cuer liés et joians
 Ai fit ce liure ci dont fet me fut comans.
Fol. 143, also on 169, for Rob. de Valois, Comte de Valois, 1270-1325.

de quatre pendans (Artois) parti de France à la bordure de gu. (*Valois*), which is the shield of Jeanne de Valois, son of Charles de France. In 1318 she married Robert, Count of Artois (the third; died 1343). His first wife, Jeanne de Bourgoyne, commanded Jean du Vignay to translate the "Miroir Historial" of Vincent de Beauvais. This is proved by a passage in the preamble of his translation of "La Legende Dorée": "Monseigneur Saint Jerosme, dit ceste autorité, 'fay tousiours aucune chose, que le deable ne te treuve oyseux.' Et Mons^r Saint Augustine dit ou liure de l'œuvre des moines, que nul homme puissant de labourer ne doit estre oyseux. Pour laquelle chose, quand jay parfait et accompli le mirouer des histoires du monde, et translate de latin en francois, a la requeste de tres puissant et noble dame Madame Jehanne de Bourgoigne, par la grace de Dieu royne de France, je fus tout esbahu a quelle euure faire je me mettroye apres si tres haille et longue euvre."—*Paris,* ii. 89. (*See* MS. fr., also 6,938; *Paris,* ii. 328.) This volume (folio, vellum, 2 vols., miniatures, &c.), has a curious frontispiece, containing Vincent of Beauvais, St. Louis and Jeanne de B., with J. de Vignay, below the shield of ancient Burgundy: bandé *d'az.,* et *d'or* a la bordure de *gueules.* Contains the first eight books of Vincent, compiled in Latin, "a la requeste de monseignor Saint Loys." At end: "Ce finist le premier volume du Mireoir hystorial translate par la main Jehan de Vingnay. Cest volume fu acheve lan de grace mil ccc. et xxxiii. la veille Sainte Katerine." Delisle thinks the date should be read mil ccclxxxiii., and, therefore, not the original, but a copy. If so, it is not so important critically, as M. Paris thought.—*Paris: Les MSS., &c.,* vi. 149; ii. 330.—*Delisle: Cab. des MSS.* i. 14.

VALOIS, RENÉE DE. *Patroness.* Saec. XVI.

Daughter of Louis XII., King of France, and Anne de Bretagne; and wife of Ercole II. d'Este, Duke of Ferrara, Modena, and Reggio.

After the death of her husband, Renée returned to France. She died at the age of sixty-five, in the Château of Montargis, 1575. The palace of this princess, whilst she lived in Italy, was the asylum of all the French refugees whose religious opinions

made it dangerous for them to remain at home. Renée was not only a protectress of scholars, but was herself learned and pious, adopting the Calvinistic form of the reformed religion. This tendency caused some anxiety to her husband, but he never very actively interfered with her ways. In the Este Library is a beautiful little volume of prayers executed for her use in France about two years before her marriage. She entered Ferrara in November, 1528. The MS. consists of two quaderni of ten sheets each, of fine and smooth parchment, 8°, accompanied by two other quaderni, smaller and almost unwritten on. The miniatures are richly coloured and profusely heightened with gold, the margins of the pages adorned with foliages, flowers, fruits, and insects, but not by a first-class artist. The titles are in gold. On the first folio is this note, in a later hand :—" Renea de Valois, moglie di Ercole II. quarto duca di Ferrara, figlia di Luigi XII. Re di Francia, detto il Giusto e di Anna di Brettagna, e sorella della moglie di Francesco primo, re di Francia." The 1st miniature represents the Almighty with long white beard, in Papal vestments, and wearing the tiara. He is seated on a rainbow, painted on a gold ground, with the terrestrial globe beneath his feet. His right hand is raised in benediction, the left resting on the Book of the Gospels, which lies on his knees. Title, " Cy comance l'oraison dominicale. Pater noster," &c. 2nd miniature : The Virgin Mary in white, with aureola on her head. She kneels at a *prie-dieu* in prayer, with clasped hands. Opposite stands the Archangel Gabriel, pointing to the dove, from which streams down upon her a golden ray of light. Behind is a golden baldacchino, near the top of which is inscribed a series of letters, as if merely for ornament. They are : OMTEARTAS NOIVECHBAS . . . These letters are more or less illegible, and perhaps may be not quite correct. Title, " Le Salutation de l'Ange a M. V. Marie, *Ave Maria*," &c. 3rd miniature is a half-length of the Princess Renée as a girl, praying with an open book before her. Her dress is rich cloth of gold. 4th miniature : The Apostles at supper. 5th miniature : Christ at Emmaus. 6th miniature : Renée as a girl, in a white dress. 7th miniature : A youthful bishop in pontificals and mitre, in act of pronouncing the benediction on Renée, who kneels before him. 8th miniature : Christ, with left hand extended towards Renée, who kneels at a *prie-dieu*. 9th miniature : Mary Magdalene at the foot of the Cross. 10th miniature : A guardian Angel standing with raised wings, holding a lantern and a lily. 11th miniature : Salvator Mundi ; his right hand raised to bless

the princess, who kneels at a *prie-dieu* beneath a baldacchino. 12th miniature : St. John writing his gospel.—*Cavedoni :* in *Atti e Memorie, del' Accad. di Modena,* serie ii. 313.

VALTELLINA, LORENZA DA. *Miniaturist.* Saec. XV.

Worked at Valtellina about 1410.—*Zani,* xix. 37.

VAN BLARENBERGHE, H. D. *Miniaturist.* Saec. XVIII.

Painted portraits and battle-pieces.—*L'Art,* iii. 339.

VANDALGARIUS. *Copyist.* Saec. XI. (?)

Wrote several parts of the Theodos. Codex, with miniatures. Now in the Library of St. Gallen.—*Waagen : Kunstblatt,* 1850, 12, 91.—*Mone : Anzeiger Jahrg.* i. s. 491-3.

VANDAMME, ANTONIS. *Copyist and Calligrapher.*

Saec. XV.

A skilful copyist of Bruges.

Member of the Gild of St. Luke and St. John. His name occurs in the Register of the Gild for 1495.—*Weale.*—*Beffroi : les Enlumineurs de Bruges,* iv. 329.

VAN DEN BERGE, THIERI. *Copyist.* Saec. XV.

A native of Lombeck St. Catherine in Groenendael.

Copied several Missals and Psalters and other works for the church. He was also a clever mechanician, and constructed two

clocks. Died 20 May, 1420.—*Reiffenberg:* in *Monuments pour servir à l'Histoire des Provinces de Hainaut, Namur, et Luxembourg.*

VANDERBORCH, MICHAEL. *Illuminator.* Saec. XIV.

Put in the miniatures of the " Vlamische Reimbible des Jakob Van Maerland," a translation made about 1270 of the " Historia Scholastica" of Peter Comestor. Vellum. Folio. In 2 cols. Written in a small minuscule character, and enriched with seventy-two miniatures and many initials. At the end is the note : " Doe men scref int jaer ons heren Mcccxxxii., verlichte mi Michiel van der Borch." The miniatures are in the form generally of those of the first half of the fourteenth century. The heads of one type, with sharp noses, pen-drawn and slightly tinted with red on the cheeks, hair slightly indicated. Colours more broken than in the thirteenth century, and a minium and deep rich blue introduced. Drapery folds, of course, in Gothic taste, but here modelled with unusual care. Trees still in the conventional toy-box style of the Byzantine School. The MS. formed part of the Meerman Collection incorporated with the Westreenen Museum at the Hague. —*Waagen: Kunstblatt,* iii. 239, 1852.

VANDETAR, } *Copyist or Miniaturist.* (?) Saec. XIV.
VAUDETAR, }

It is uncertain whether this Vandetar was actually the copyist of the beautiful MSS. of the Bible with which his name is associated, but as it was the usual practice of the copyists to present their books to their patron, we may almost presume that he was. At any rate, his name affords an opportunity for speaking, not only of a remarkable MS., but of one or two artists who have often been confounded together, and about whom there is still very considerable uncertainty. The province of Limburg, in the Burgundian Netherlands, which lay along the right bank of the Maes from

Liége to Maestricht, seems to have been, if not the cradle of Netherlandish art, at least the district in which miniature painting rose to very high perfection in the fourteenth century. The miniaturists of the Maes valley rivalled the distant illuminators of Paris, and even competed with them in the book-marts of that busy city. Illuminating had long left the cloister, and was practised as a handicraft by laymen, who had their schools in Maestricht and Liége. Their art contrasted strongly in its perfection and skill with the mediocrity of monumental tempera. A Missal, now in the Bodley Library at Oxford, dating about 1320, compared with the contemporary wall paintings discovered in various Flemish cities, affords convincing proof of the superiority of miniature. In this MS. (No. 313, Douce) the pictures are enclosed in small square panels. But small as are the compositions, the artist has succeeded in conveying the impression of dignity in the mien of the figures, of kindly expression in the features, and has shown a remarkable power of composition and drawing, in the arrangement of the drapery, the symmetry of the general subject, and the accuracy of his outline. The heads are broad and heavily bearded, the eyes clear, the fingers long and slender. As usual in Netherlandish and French work, as contrasted with Italian, the bare parchment is left for the lights, while the shadow is lightly but effectively thrown without painful elaboration, showing a skilled hand. The Flagellation and the Crucifixion may be mentioned as specially worthy of examination. As an early example of the school which during the next fifty years was to form the leading style of Northern Europe, it is of great interest. It was from Bruges, Liége, and Valenciennes, that Paris derived its finest artistic inspirations; and after 1400 it was still from various Burgundian centres that Paris kept up her supply of artists. One striking feature of this Netherlandish mastery, is the great use made of architecture and sculpture in miniature work. Indeed, the draperies of all MS. pictures executed under Gothic influence point to the same studied reference to sculpture. Stonework is the mother-art of the illuminator, notwithstanding the brilliant gold and sparkling colour. "Peintre-imagier" was the craft linked with that of the "enlumineur," and whether in stone or wood, sculpture and carving preceded the work of the pencil, and we see the influence of this connexion in the development of the Netherlandish schools of Ghent and Bruges; in the foliages of the border ornaments, both in form and tone, the sculpturesque leafage, and the prevailing grey, and, eventually, in the fondness for

grisailles, such as the marvellous miniatures of Tavernier in the "Histoire de Charlemagne" of the Royal Library at Brussels. Returning to the valley of the Maes, and passing still down the stream from Maestricht, we come to Maes Eyck, where one of the earliest monuments of Netherlandish miniature art was produced, and where, after ten centuries, it is still preserved—the Gospel-book of Herlinde and Renilde. But still more famous is the little village of the oak-tree by the Maes, as the birth-place of the great painters and miniaturists, Hubert and Jan Van Eyck. From some neighbouring spot in this picturesque district eastward of the river, we find also comes another family of master illuminators—Pol van Limburg and his brothers. It is known that Pol was in the service of Jean, Duc de Berry, from 1400 to 1416. In 1410 he and his brothers are recorded as illuminating a rich Book of Hours (*See* Limbourc), and in the same year as giving the Duke a rather curious Christmas-box. "Item un livre contrefait d'une piece de bois paint en semblance d'un livre, ou il ny a nulz feuillez, ne rien escript, couverts de veluzan et blanc a deux fermoers d'argent esmaille aux armes de Monseigneur, lequel *liure* Pol de Limbourc et ses deux freres donnerent a mondit seigneur aux estraines mil cccc et dix. Pris. xl. l. parisis." Possibly Pol, and not Beauneueu, was the painter of the three miniatures "de l'enlumineur du Duc Jehan de Berry" in the Josephus at Paris (MS. fr., 6,891). (*See* Foucquet.) It has sometimes been imagined that the Jehan de Bruges, mentioned as the miniaturist of the Vandetar Bible, was Jan Van Eyck. But when the Bible was presented to Charles V. of France, in 1372, Van Eyck was not born. Nor was he the father of the Van Eycks, for they belonged not to Bruges but to Maes Eyck. Jehan de Bruges was simply an illuminator, and is otherwise unknown. The MS. was probably written, or rather translated, by Raoul d'Orléans, and the first of the three minia-tures represents the presentation of the book to the king. A copy of the miniatures was made for the Gaignières Collection, which is now in the Print Room of the National Library at Paris (Pl. iv.). An engraving also exists in Montfaucon's "Monumens de la Monarchie Française," iii. Pl. xii. At the end of the volume are some verses referring to the presentation :—

> " A vous Charles roy plain donneur
> Qui de sapience la flour
> Estes sur tous les roys du monde
> Pour le grant bien quen vo^9 habonde
> Presente et donne cestui liure

Jehan Va*n*detar uotre seruant
Qui est cy figure deuant
Onques je ne vi en ma uie
Bible dhystoires si garnie

 * * * *

Si fu au prince susnome
Ce luire baille et donne
Par le dit Ieh. que je ne mente
Lan milcccxij. et soixante
De bon cuer et . . .
xxviij. jours du mois de mars."

Besides these indications of the giver of the volume, is an inscription in a later hand conveying what must be called the traditional history of its execution : " ANNO DOMINI MILLESIMO TRECENTESIMO SEPTUAGESIMO . PRIMO ISTUD OPUS FACTU FUIT . AD PRECEPTŪ AC HONORE ILLUSTRIS . PRINCIPIS KAROLI REGIS FRANCIE . ETATIS SUE tricesimo quinto et . regni sui octavo et Johānes de brugis pictor regis predicti . fecit hanc picturā propria sua manu." This Bible does not occur in the inventory of Charles the Fifth's library drawn up in 1373, but it is described as follows in that of 1423, after the death of Charles VI. : " Item. Une tres belle Bible en françois que Jehan de Vandetar donna au Roy tres parfaitement bien escript et historiee a ij col. couuert de soye azuree a fleurs de lis dor de bordure garnie dune grande chemise azuree et de iiij ferm. et une pipe dor (estimee xv liures parisis"). Since this time it has belonged to an advocate of Paris named Bluet, then to the Jesuits of La Flèche, who presented it to Nicholas Joseph Foucault. After the death of the latter in 1721, it is not known what became of it, until 1764, when it fell into the hands of the Receiver-General, Gaignat. It appears in the catalogue of the Gaignat Collection of 1769 (No. 58), and was sold for 399*l*. 19*s*. At the Gaignat sale it was bought by the elder Meerman, and was in the possession of the younger Meerman in 1814, but does not appear in the catalogue of 1824. " Now," says Van Praet in 1831, " on ignore à present ce qu'elle est devenue." The frequency of the name Jehan in the fourteenth and fifteenth centuries leads to much confusion in dealing with the painters and copyists of the time. It might, on a hasty glance at the dedication, be inferred that Jehan Vandetar was himself Jehan de Bruges. It is not impossible, but the custom of the inscriptions would have most likely stated their identity had it been so. Besides, Jehan de Bruges is called the King's painter, while Vandetar is not charac-

terised by any such notice. It has been conjectured that his son
was the Guillaume Vandetar who was "varlet de chambre" to
Jean II., and who was charged with forming the inventory of the
unfortunate king's property, on his being carried prisoner to
England. Jehan de Bruges must, therefore, be left at present
without identification.—*Van Praet: Recherches sur Louis de
Bruges*, 84.—*De Bure: Catalogue des Livres, &c., de feu M. L.
Gaignat*, 18.—*Delisle: Cabinet des MSS.*, i. 375.

VAN EYCK, JAN. *Miniaturist and Painter.* Saec. XV.

Among the number of attributions to this artist is a Livy now
in the Arsénal Library, Paris, B.L. lat., 102. The borders of this
MS. are certainly very fine, and precisely in the style assigned to
Van Eyck, as in the Bedford Breviary and Missal. Whilst Jehan
de Bruges (whoever he was), the great Flemish artist, was being
admired at the Court of France, the Prince-bishop of Liége, John
of Bavaria, called from his grossly unfeeling behaviour to his niece
Jacqueline, and for other reasons, Jean sans Pitié, had the glory
of bringing into notice the then unknown Jan or Jean Van Eyck,
afterwards the greatest artist of his time. In the lists of officers,
pages and other servants attached to the Court of the Hague, he
is called " Johannes mijns genadichs heeren scilder." But this
was not, as Denis supposes, about 1418 : it was between 1422 and
1424. It was in 1418 that the Bishop, laying aside his ecclesi-
astical dignity, married Elizabeth of Gorlitz, widow of Anthoine,
Duke of Brabant and Limburg, and retired to the palace of the
Hague, where he died in 1425. Van Eyck left his patron's
service about three months before his death, and, after residing a
short time at Lille, passed into that of the Duke of Burgundy.
Philippe not only extended his protection to Van Eyck, but
assigned him considerable emoluments, and attached him to his
person by employing him in commissions of a private and politi-
cally confidential nature. This, indeed, as we see in the cases of
Creton, Bourdichon, Guéty, and others, was not unusual at the
time, but it speaks highly in favour of Van Eyck's abilities. He
was something more than the ordinary " peintre-imagier " of the
Court. In 1428 he accompanied the embassy from his master to
the Court of Portugal, in order to execute a portrait of the Infanta
Isabella. He seems to have eclipsed in both landscape and
portraiture all his contemporaries, even his brother Hubert, who

died in 1426. Jean lived probably until 1440, and the father of Raffaelle, Giovanni Santi, with some confusion of identity, called him " il gran Joannes." The Livy, once belonging to the Library of Philippe le Bon and now in the Arsénal, represents the Netherlandish art of this epoch, and shows the graceful use made of field flowers in the ornamentation of books. This, indeed, inspired by Waagen, is all that Denis can affirm as to the authenticity of Van Eyck's share in its execution, and, like all the rest, it depends on no firmer foundation than the opinion of a very hasty and often mistaken observer. This Livy was executed in 1454.—*Curmer : L'Imitation de Jésus Christ*, 40, 41, 48, 49.—*Denis : Appendice à l'Imitation*, 87, 88. (*See* EYCK.) To attempt here any reference to Van Eyck as a panel or oil painter would be impossible, but though no direct proof has hitherto been offered, strong traditional opinion seems to permit the connexion of his name with the famous Missal and Breviary already alluded to. Of these two precious MS. the former is in the British Museum, Add. MSS., 18,850 ; the latter is in the National Library, Paris, MS. lat., 17,294. Description of these MSS. may be found, one in a thin 4° published by Nichols in 1794, the other in Crowe and Cavalcaselle's " Early Flemish Painters," and in Waagen's " Kunstwerke und Künstler, in Paris." Waagen's fanciful assignment of certain portions of the work to Jean, others to Margaret, and even Lambert, may be taken for what it is worth. As to Lambert, the very supposition of his being a painter at all rests upon a misreading of these words from an account of some business done for the Duke of Burgundy : " 1431, A Lambert de Hech frere de Johannes de Hech paintre de MdS., pour auoir este a plusieurs foiz devers MS. pour aucunes besongnes que MS. vouloit faire, vii. l. ix. sols."—*Laborde : Hist. des Ducs de Bourgogne, &c.*, i. 257. The words " paintre de MdS." clearly refer to Johannes, not to Lambert, as any one accustomed to these documents would see at once. Margaret, to whom Waagen assigns part of the Paris Missal, died soon after Hubert. A daughter, Lievine Van Eyck, is mentioned as having retired, on the death of her mother, into the Convent of Maes-Eyck. —*Crowe and Cavalcaselle: Early Flemish Painters*, 30, 79, 129–134 (2nd ed., 1872).—*Gough : An account of a rich Illuminated Missal executed for John, Duke of Bedford.—Waagen : Kunstwerke und Künstler* (in Paris), 351–357.—*Vasari: Vite, &c.*, iv. 75.—*Laborde : Hist. des Ducs de Bourgogne*, i. 395.—*Woermann: History of Painting*, ii. 45. Other authorities in Crowe and Cavalcaselle, and Woltmann and Woermann, ii. (Appendix I.).

Van Middelere, Gérard. *Copyist.* Saec. xiv.

Employed by the Duke of Gueldres on yearly wages in 1342.
—*Pinchart : Archives des Arts, &c.,* ii. 189.

Van Os. *Copyist.* Saec. xv.

Wrote, in 1432, at Delft, in Holland, a Book of Hours in Dutch. Sm. 12º (4½ × 3 in.). 157 ff. Now the property of the Liverpool Free Library.

Van del Valgaerde, Simon. *Illuminator.* Saec. xv.

" Enlumineur de liures a Malines." *See* Valgaerde.

Van der Wyckt, or } Jean. *Painter and Illuminator.*
Van Battel,

Of Malines. Saec. xvi.

A decorator, whose specialty lay in painting shields of all dimensions. He also illuminated MSS. Early in the sixteenth century he shared with another artist of the name of Jean van Lathem the monopoly of all works of decoration ordered by the Parliament. He finally attained the title of Painter to Charles V. in 1549 or 1550. He is first mentioned in 1504 in connexion with the decoration of the church of St. Gudule at Brussels for the service celebrated in memory of Isabella, Queen of Castile, mother of the Archduke Philip the Fair. He did similar work in 1509 at the Church of St. Jacques sur Coudenberg on occasion of the service celebrated for Henry VII. of England. Also at the Church of St. Peter of Malines in 1520 for the obsequies of the Emperor Maximilian, and again in 1527 for those of the Duke of Bourbon, killed in the siege of Rome. He received, in 1509,

various sums for having " accoustré et painct les armes de Ms[r]. (l'Archiduc Charles) et d'autres plaisantes paintures ung chariot pour mesdames ses seurs pour aller jouer dessus à leur plaisir et passetemps." He designed the patterns for the seal and counter-seal engraved in 1516 by Jean van der Perre, goldsmith, of Brussels, for King Charles, receiving for the work 6 livres. The most important works of Van der Wyckt as an illuminator are the two great volumes on parchment of the Order of the Toison d'Or, which he ornamented with escutcheons and figures. The first was ordered in 1535, the second in 1549. He worked several years on the latter, which much excels the former in richness of execution. For his work of 1535 he received a sum of 85 liv. 16s., Flemish. For the volume begun in 1549 a much larger sum was paid. It cost more than 1,000 livres. Another painter of Valenciennes did the portraits, including five from life, of Philippe le Bon, Charles le Téméraire, Maximilian, Philippe le Beau, and Charles Quint. Van der Wyckt put in the shields and other ornaments (Arch. at Lille). Since writing the above, Pinchart discovered another document giving a detailed description of the magnificent volume of 1549, which has disappeared. The book was finished in 1552, and delivered by the artist. The Chamber thought his price too high, hence three master-painters were called in to value it. The three were Jan Rombaults, Henri van der Brugghe, and a glass-painter, Adrien van Diependale. The report of these artists is the document in question. They accepted, with very little abatement, Van der Wyckt's prices for the execution of the numerous armorials and other rich ornaments on each of the 120 folios of the MS. The experts, moreover, declared that no artist in Louvain would have dared to undertake the work. Jan Van der Wyckt or Van Battele (his own signature) therefore received for his salary and expenses 1,024 livres 16 sous, instead of 1,092 livres 6 sous, his own demand.

—*Pinchart: Archives des Arts, &c.,* i. 243–245 ; ii. 213.

Vanni, Lippo di. *Miniaturist, &c.* Saec. xiv.

Illuminated, in 1344, a Lectionary for the Hospital " della Scala," and, in 1352, a Coronation of Our Lady in an Office " della Biccherna," as is attested by the inscription : " Lippvs . vannis . de . senis . fecit . hoc . opvs . anno . domini . millesimo . trecentesimo . lii." In a document still kept in the Archives of the Hospital of Santa Maria della Scala at Siena, 1317 to 1416,

fol. 101, is this entry : " 1344 . 14 Agosto. Lippo di Vanni miniatore ebbe ij fiorini vij soldj, le quagli sette libre li demo in sua mano contanti per compiemento della miniatura che fecie del nostro lezionario el quale avia cominciato Simone di Gheri (Bulgarini)." Again, on 31 September, is another entry (fol. 176 *v.*) and others showing that he also painted in large.—*Milanesi : Documenti per la Storia dell' Arte Senese,* i. 27.—*Ib. : Sulla Storia dell' Arte Toscana,* 73.

VANNUCORRI, LODOVICO. *Copyist and Miniaturist.*

Saec. XV.

A native of Lucca, spoken of as a copyist and miniaturist in that city.

Trenta : Memorie e Documenti per servire all' Istoria del Ducato di Lucca, viii. 36.

VANTINI, DOMENICO. *Miniaturist.* Saec. XVI.
Of Brescia.
Worked from 1675 to 1708.—*Zani,* xix. 58.

VANYE, PETER. *Illuminator.* Saec. XVI.
Of Leyden.

Illuminated a great Bible, or, at least, the Psalter, in five volumes, now in the Bodley Library, Oxford. *See* BEAUJARDIN, H.

VARSIO, BAPTISTA DE. *Copyist.* Saec. XV.

Wrote " Il Canzoniere edi trionfi di Fran. Petrarca." Paper. 4°. 177 ff. On fol. 141, " Finis per me bptam de Varsio Januēsem in castro saxoli ad laudē dei glorioseq3 Virginis, 1478, die 22 Augusti." Now in Bodley Libr., Oxford, MSS. Canonici, 71.—*Mortara : Catalogo, &c.,* 90.

VASCO. *Illuminator.* Saec. xv.

Lived in the times of Alfonso V. of Portugal.

He succeeded Gonzalo Eannes, in 1455, as illuminator to
Alfonso. Taborda thinks he was the same person as El gran
Vasco, the celebrated painter, but Raczynski says this is an error.
—*Raczynski : Lettres, &c.,* 160–1.

VASLET, LEWIS. *Miniaturist.* Saec. xviii.

Practised at York from 1770 to 1775.

In 1782 he worked at Bath, and occasionally exhibited at the
Royal Academy until 1782.—*Redgrave : Dict. of Artists of the
English School.*

VASQUEZ, ALONZO. *Miniaturist.* Saec. xvi.

Illuminated (1514–18) a portion of the great Missal of Cardinal
Cisnéros, now at Toledo. "Contienen differentes historias figuras
y adornos, segun el gusto di aquel tiempo, y conservan frescura
y brilliantez en el color." (Arch. de la Catedr. de Toledo.)—
Bermudez, v. 143.

VAUCELLIS, ALBERICUS DE. *Copyist.* Saec. xiv.

Wrote, in 1332, a magnificent copy of the Decretals of
Gregory IX., with the gloss of Bernard of Parma. On vellum,
very large folio. Although the copyist of this splendid MS. is
probably not in the least responsible for its miniatures ; still, as he
was certainly a contemporary, and the miniaturist is unnamed,
remarks on the art of these precious pictures, called for by their
special importance, must fall under his name. Had we been able
to place them under the name of Cimabue, the MS. would, of
course, be considered still more precious. And it seems only to
want this name, or that of Giotto, to complete the story of its
excellence. A similar defect attaches to the Fitzwilliam MS. at

Cambridge, and one or two others, as the only defect, indeed, but a fatal one, which prevents their estimation from rising to a fabulous height.

It has usually been asserted and believed that Italian art, though revived in the early years of the fourteenth century by the fresh study of Nature, both in landscape and figures, only reached France and the north, as a practical influence, in the days of the Van Eycks and Fouquet, and that the school of Tours was the earliest product of this Renaissance of painting. The author of the very interesting "History of Christian Art in Flanders," the Abbé Dehaines, even goes so far as to say that it was Flemish art which, penetrating southward, modified that of Italy. In later times, and to some extent, this is true, especially in Venice. But, in the fourteenth century, it remains to be proved that either Flemish or any other, except, perhaps, ancient Greek, had any share in the immense improvement which took place in the art of Italy. In the tenth century art was French, in the eleventh German, in the fourteenth Italian. In the fifteenth century Flanders certainly took a front rank, while France and Italy fell somewhat behind. But the comparative rank is even then by no means very decided, and only when we reach the sixteenth can we say with absolute certainty that, in painting, Italy is mistress of the world.

This copy of the Decretals of Gregory, together with two others, now in the Public Library of Laon, contains miniatures that are important in the history of Art. They are numbered respectively 357, 378, 382. The Decretals written by Albericus are 357. Nos. 378 and 382 are commentaries of Johannes Andreas on the sixth book of the Decretals, and the Glossary of the same commentator on the Clementines. All three are in precisely the same style, and may have been executed by the same hands. They may, therefore, be grouped together for our purpose as one work. On fol. 1 of the last is an oblong miniature representing the presentation of the book to the Pope. I have said that the three MSS. are all precisely similar in style. The first is dated. On the back of its first folio is the note : "In nomine Domini, amen. Incipiunt Rubrice super Decretales scripte per magistrum dominum Albericum de Vaucellis, anno domini M.ccc.xxxii. in die beati Cosme." Now, unless this means that the Rubrics were composed by Albericus, as a jurist, and finished in 1332, since which this copy was made by an unnamed copyist, we have here a standpoint for the history of miniature-painting in Italy, which is of some importance. It is well known that by far the greater quantity

of early fourteenth-century work, though painted in gouache or firm rich body-colour, is of the kind so highly praised by Ruskin in " Modern Painters," as the perfection of illumination,—a kind of painting, that is, without light and shade, and without perspective. The idea that this is the perfection of the art arose probably from some fanciful notion of the appropriateness of such a style for work to be shut up between the leaves of a book. But that is surely a false idea of the purpose of the miniature-painting itself. The flat mode of treatment was simply a docile following of the method employed by necessity in glass-staining for use in windows. It need not here be argued that this was only one point in which illumination was the humble handmaid of architecture. (*See* VANDETAR.) And, while it lasted, it was right in itself,—but by no means to be set up as the acme of all perfection. As a departure, then, from this usual flat painting of fourteenth-century miniature art this picture, this presentation scene in 382, is a true painting in the modern sense.

It is no longer even the conventional two or three personages of the ordinary French or Flemish dedicatory miniature, but a scene containing twelve or fifteen figures. At the end of a grand apartment covered with hangings of Cordovan or Hungarian leather, and glittering with golden arabesques, the Pontiff is seated on a couch of equally splendid tapestry. Behind him stand his bodyguard. Cardinals and other dignitaries attend on either side, amidst doctors of the law, and members of various religious orders. In front kneels an author (the writer probably of these glosses on the Clementines) presenting his book. Such is a general idea of the richly-finished picture. Over it is the curious figure of an angel with outstretched wings, looking down upon the scene, and wearing the very unusual angelic appendage of a *beard*. The grandeur and dignity of the surroundings in these dedicatory miniatures give us a true idea of the great importance attached both by author and patron to the occasion, and of the lofty place taken by creative thought and intellectual capacity in mediæval times ; and not less, of the honour accorded to the labour of the pen and pencil in clothing and completing the thoughts of the author in so beautiful a guise. In this miniature the mediæval method is discarded,—it is to all intents and purposes a modern picture. It has no Byzantine hard and dry adhesion to dusky models. It is true to costume, expression, attitude. In French miniature of the period the figures are scattered, meagre, without movement, and without expression. The draperies are careful, but

angular and often meaningless. Here they are natural, soft, and suitable. The grouping is skilful, the perspective possible. In short the picture is an epoch in miniature art. These MSS. deserve special study in the point of view of historical development, for they advance, by the space of a century almost, the date of the introduction of Italian Renascence into the art-history of France. They formerly belonged to the Cathedral of Notre Dame of Laon, being given to it by Michael Casse about 1346, and are now, as aforesaid, in the Public Library of that city.—*Fleury : Les MSS. à Miniatures de la Bibl. de Laon, &c.*, ii. 82–91, Pl. 40–42.

VAULX, ESTIENNE DE. *Copyist.* Saec. XVI.

Transcribed, in 1502, the "Canon en parchemin" for the library of Château de Gaillon.—*Deville : Comptes de la Construct.*, &c., 443.—*Delisle : Cabinet des MSS.*, i. 249. Also, "Les troys volumes du grand decret" (Gratian).—"A Estienne de Vaulx pour ce quil a escript au decret de monss' le v^e de novembre mil v^{cc} et ii. (1502) xxv^s.," &c. &c. (other entries).— *Deville : Dépenses, &c.*, 440, 441, 443.

VAVYSUR, WILL. *Copyist.* Saec. XV.

Wrote in part, on paper, sm. 4°, **212** ff. "Duns Scoti Erigenæ in secund. et tert. libros de anima commentarius." In one place has "Nomen scriptoris si tu cognoscere velis Wyl tibi sit primum medium hel. musque sit hymum. Hoc opus exegi sit celi gratia regi." And, at end, "Expliciunt quæstiones tertii libri metheorum secundum doctorem subtilem ordin. minor. ac scripte per manum fratris Wyllelmi Vavysur, eiusd ordinis Anno Dominice incarnationis, 1491, Amen." Now in Library of Corpus Christi College, Oxford, No. ccxxvij.—*Coxe : Catal., &c.*, 92. Also, on paper, sm. 4°, 61 ff., "Tractatus variæ," signed in two places. At end : "Amen quod frater Wyllelmus Vavysur Expliciunt questiones de anima valde perutiles, anno Domini, 1490."—No. ccxxviii. In same library.—*Coxe : Catal.*, 92.

Velasco. *Copyist.*　　　　　　　Saec. x.

Transcribed the collection of Canons, preserved in the monastery of S. Millan de la Cogolla, about 992. — *Cahier : Bibliothèques*, 131.—*Laserna* and *Luis Blanco : Noticia de las Antiguas Colecciones, Canónicas*, 41, &c.

Veli, André de. *Copyist.*　　　　Saec. xvi.

Canon of St. Victor at Paris.

Delisle : Cab. des MSS., ii. 211.

Vellizlaus. *Copyist or Miniaturist (?).*　　　Saec. xiii.

Said to have executed, with richly-ornamented text, the famous illuminated Bible called "Wellislaw's Bilderbibel." In the Library of Prince Lobkowitz at Prag. Vellum. Fol. 188 ff. Each page contains two miniatures, one from the Old Testament, the other from the New, with explanatory text. From fol. 180 to 188 are illustrations of the life of St. Wenceslas. In a label on this last picture is the inscription : "Sta Katerina exaudi famulum tuum Vellizlaū." He appears as a beardless young man.—*Wocel : Wellislaw's Bilderbibel* (1871).—*Grüber : Kunst des Mittelalters*, iii. 27.—*Bucher : Geschichte der technischen Künste*, i. 320. Woltmann, however, thinks the young man, Vellizlaus, is evidently the donor, not, as formerly assumed, the artist.—*Woltmann : History of Painting*, i. 373.—*Waagen : Deutsches Kunstblatt*, 1850, 148.

Velox, Johannes Marcus. *Copyist.*　　　Saec. xv.

Wrote, 1. in 1469, "Narcissi de Verduno Oratio ad Ant. Petrucianum." Vellum, thin 8°, 77 ff. Beautifully written in half-Roman, like the handwriting of Verazanus, or of the copyists employed by the Arragonian kings of Naples. Fol. i. Border and initial by a good Italian miniaturist, half-white stem border, half landscape ; initial (L) contains the Nativity. The dedication is in gold letters : "Clarissimo nře ętatis uiro Antonio Petruciano equiti felicissimi Regis Ferdinandi de Aragonia secretario unico atque dignissimi. Narcissus de Verduno Licentiatus Aeternam

Beatudin. E. M." At foot of page is the Baptism of Christ, over which in label the words: "HIC . EST . FILIVS . MEVS . DILECTVS." On fol. 77 *v.* in red : " Joannes M. Velox MCCCCLXIX. tranquille transcripsit." Now in British Museum, Add. MSS. 24,895. 2. A Treatise on " Hawks," in 106 chapters. Vellum, 95 ff. Beautifully written. At end : "Joannes Marcus Velox, Chrysopolitanus Neapoli, 1463, xxiii. Septembris. Illustri Domino Pyrrho Duci Venusino tranquille transcripsit." In the Royal Library, Turin.—*Cod.* cxix., i. iii. 46.—*Pasini,* ii. 445. 3. For the Duke of Amalfi Ant. Piccolo, Minister of Aragon at Naples, 1470,—" Virgilii Maronis Bucolica." Once in library of Jos. Valetta.—*Neuer öffneter Büchersâl,* 58te. *Eröffnung,* 761. 4. Soviani Pontani, de obedientia libros V. ad Robertum Sanse-verinum Principem Salernitatem. Dated 3 Jun. 1470. Naples. Vell. 109 ff. Written in a most beautiful hand, and adorned with illuminated initials. At end, in capitals : Joannes . Marcus . Velox . Petri . Strozae . Florentini . Discipulus . Parma . Oriundus . Insigni . Litteris . et . Marte . Roberto . Sanseverino . Principi - Salernitano . Christi . Anno . MCCCCLXX . Neapoli . III . Idus Iunias . Sub . Alphonsiade . Ferdinando . Obedienter . Tran-quilleque . Transcripsit. Now in the Royal Library, Turin (cod. ccxxvii. f. iii. 3).—*Pasini,* ii. 68.

VENDRAMINO, FRANCESCO. *Miniaturist.* Saec. xv. Of Padua. Worked about 1480.

One of the artists appointed to assist Cosimo Tura in illu-minating the Choir-books at Ferrara.—*Zani,* xix. 98. Gualandi's citations refer to Zuane or Giovanni Vendramino, not Francesco, as doing the work, but not as assisting Cosimo Tura.—*Gualandi : Memorie Originali, &c.,* vi. 157.

VENDRAMINO, ZUANE (GIOVANNI). *Miniaturist.* Saec. xvi. Of Padua.

Worked on the Choir-books at Ferrara. In the Antiphonary containing the music from the Nativity to the Epiphany, he placed the frontispiece ; all the initials and other ornaments having been done by Fra Vangelista and Jac° Filipo Dargenta (*see* ARGENTA).— *Gualandi : Memorie, &c.* sér. vi. 157.—*Cittadella : Notizie,* 171.

VENEXIA, DOMENEGO DA. *Copyist.* Saec. xv.

Wrote "La Vita di Maria Virgine" in the Venetian dialect. On paper. Fol. 103 ff. In two cols., with coloured initials. Fol. 101. . . . "chella schrito zoe domenego da veniexia in lano del 1472 adi primo feurer." Now in Bodl. Libr., Oxf., MSS. Canonici, 262.—*Mortara : Catalogo, &c.*, 237.

VENEZIA, CARLO DA. *Miniaturist.* Saec. xv.
A Priest.

Assisted Girolamo da Cremona in illuminating the Choir-books of the Cathedral at Siena.—*Vasari : Vite, &c. (Nuove Indagini),* vi. 179.

VENTURE, NICOLÒ DE'. *Miniaturist.* Saec. xv.
Of Siena. Worked about 1443.

Appears to have executed the miniatures, &c., of a History of the famous battle of Montaperto, written in 1443. It begins thus : "In nomine Dñi anno MCCLX. comincia la Storia per ordine chome i Sanesi isconfissono i Fiorentini a Monte Aperto con tutt le circonstantie appartenenti," &c. The MS. contains 29 ff., and at foot of every page is a miniature representing the principal fact mentioned in the text, and under the figures the names of the warriors engaged. Described in detail by Della Valle. At end : "1443 . . . di Luglio fu finito tutto questo libro di dipingere, le quale dipinture fece, e vi pose e cholori Nicolò di Francesco di Giov. Venture da Siena detto ; e in quel tempo Eugenio Papa IV. abitò in Siena *cho* suoi Cardinali il quale venne assiena a dì 14 di Settembre, 1442, e andonne a Roma con tutti i Suoi Cardinali laudando e magnificando il nostro Signore Dio Gesù Xpto in sempiterna secula seculor. Deo gratias." This curious MS. is now among the precious MSS. of the University Library of Siena, No. 12, xxvi. E. 12.—*Della Valle : Lettere Senese,* ii. 244.—*Zani,* xix. 113.

VENTURINO, DE' MERCATI. *Miniaturist.* Saec. xv.

Called Venturino da Milano.

Employed on the Choir-books at Siena as assistant to Girolamo
da Cremona in 1473 and 1475. He appears, from the docu-
ments, to have executed the initial letters and ornaments into
which Girolamo put the miniatures.—*Vasari : Le Vite, &c.,* vi.
179, 348. (*Nuove Indagini.*) *See* MERCATI.

VÉRARD, ANTHOINE. *Illuminator, Painter, &c.*

Saec. xv.

This most illustrious of the old French booksellers was a writer,
illuminator, and dealer. Born in the second half of the fifteenth
century, he established himself in Paris on the Pont Notre Dame,
both sides of which were then covered with shops, and about
1485 commenced his fine editions with a "Decameron" in French,
by Laurent de Premierfait. He was accustomed to take a
certain number of fine copies on vellum or paper of each book
published by him, in which authorised painters added miniatures
and ornaments. The cost of one of these copies has been pub-
lished by M. Senemaud in "Bulletin de la Société Archéologique
de la Charente, 1859," ii. 91, which enables us to penetrate into a
printing-office of a great French printer of the fifteenth century.
According to this document, Vérard did not disdain to put his
own hand to the work, even to carrying the book to the house of
his patron if he were a man of consequence. The books were
special impressions on vellum of the "Romance of Tristan," the
" Book of Consolation" of Boetius, the "Ordinaire du Chrétien,"
and "Heures en François," each with illuminations and binding
in dark-coloured velvet, the whole costing 207 liv. 10 sous = from
200*l.* to 240*l.* of present money.—*Bouchet and Bigmore : The
Printed Book,* 76-78. Laborde gives a long and minute account
of expenses due to him for vellum, &c., for a "Livre de
Tristan," in two volumes, including " 7 grans histoires à plaine page
audit pris de 35 sols piece," and 85 and 90 small ditto at 5 sols
piece, 28 verses in "ormoulu," &c.—*La Renaissance, &c.,* i. tom. i.
275-77. Lacaille says he was one of those who gave to the public

the greatest number of works, especially romances, of which there exist more than a hundred volumes printed upon vellum, ornamented with beautiful miniatures, and exhibiting the most studied and exact imitations of the MSS. from which they were copied. —*La Caille: Hist. de l'Imprimerie.* The impressions of Antoine Verard and of several of his contemporaries, having been taken off on the finest vellum, for the gratification of the rich, and at their liberal expense thus superbly ornamented, exhibit a most agreeable union between the labours of the printer and of the scribe and illuminator.—*Greswell: Annals of Parisian Typography,* 41, 42.

VERARDO. *Miniaturist.*

Called Il Chierico or the Cleric. Saec. XVI.

Employed at Ferrara.—*Cittadella: Notizie, &c.*

VERAZANUS,
VERAZUS, } ALEXANDER. *Copyist.* Saec. XV.
VERRAZANUS,

Called by Montfaucon Verrakanus. One of the copyists employed by Corvinus and Lorenzo de Medici.

Wrote, at Florence, 1. D. Augustini Varia. Vellum, folio, 303 ff. An illuminated MS., "mira pulchritudinis." The text is preceded by a most ornate list of contents. Initials in gold and blue. Others with miniatures or rich ornaments. The first page contains the arms and symbols of the Medici. At end: "Alexander Verazanus exscripsit Mccccxci."—*Bandini: Catal. Codd. MSStr. Latinor., &c.,* i. (Plut. XII., cod. ii.), cols. 6, 7. 2. D. Augustini Opera Varia. Vellum, folio, 210 ff. Illuminated with most lovely miniatures and initial letters. On first page are the Medici arms and insignia, in gold and colours. The title is placed in a circlet, as in many works by Attavanti. (Not signed, but attributed by Bandini, who was, no doubt, right in this opinion, to Verazanus.)—*Ibid.,* cod. iii. col. 7.

3. Divi Augustini Varia. Vellum, folio, 282 ff. Illuminated. The titles of the various works contained in this "ornatissimo codice" are placed in eight circlets. Medici arms, &c., splendidly painted. At end, in red capitals : "Alexander Verrazanus exscripsit MCCCCLXXXX.—*Ibid.*, cod. iv. col. 8.

4. D. Augustini Varia. Vellum, folio, 304 ff. Illuminated. Bandini seems to think Verazanus was also a miniaturist,—"Idem Alexander Verrazzanus exscripsit et egregiis ex ornavit picturis." But it is more probable that Verazanus was the copyist only, and an artist of the Gherardesca school was the miniaturist, perhaps Attavante. Medici insignia, &c., as before.—*Ibid.*, cod. v. col. 8.

5. Minei Marciani Felicis Capella Afri Carthaginiensis Satyricon, libri ix. constans. Item, Chirii Consulti Fortunatiani de Arte Rhetorica, libri iii. And several other works, the titles of which are given under ATTAVANTE. This is the celebrated MS. of the Martianus Capella, illuminated by Attavante, now in the library of St. Mark's at Venice, one of the most beautiful in existence. It is described by Morelli. Verazanus was one of the ablest of copyists, and his productions are usually accompanied by the miniature work of the ablest miniaturists of his time.

6. "Vita di M. Giannozo Manetti, cavaliere strenuo et clariss. citadino fiorentino," &c. A superb MS. on vellum, executed at Florence. Vellum. 8°, 149 ff. Written in a Roman hand. The title is in golden capitals on a blue ground surrounded by a handsome border. On the second leaf is another border containing five small medallion portraits, among which is that of Manetti, with his arms, device, &c., executed with great delicacy. The volume is dedicated by the copyist or author, Alexander Verazzus, or Verazanus, to Janoctius, grandson of the one whose life it contains. At the end are the words :. "Idem Alexander V'az⁹ escripsit MDVI."—*Catalogue des Livres de la Bibliothèque de MacCarthy Reagh*, ii. 237, No. 5,402. Now in the British Museum, Add. MSS., 9,770.

7. One of the famous MSS. at Belem also bears his name, a further confirmation of the fact that Attavante or Gherardo was the illuminator of it.—*Raczynski : Lettres, &c.* (*See* SIGISMUNDIS.)

VERGARA, LUCAS DE. *Copyist.* Saec. XVI.

Wrote, at Brussels, in 1597, an "Exercitia Diurna" for Alexander Farnese, Duke of Parma, containing pen-drawings by Wicrix. 12mᵒ. 44 ff. (*See* WIERIX.)

VERGECIUS, ANGELUS. *Copyist.* Saec. XVI.

Called in French Ange Vergèce. A Cretan Greek, and the most celebrated of Greek copyists.

Employed some time as a copyist at Venice, and invited by the French ambassador to Paris, where he was employed by Francis I. in forming, classifying, and cataloguing the Greek MSS. in the King's Library. Among many beautiful MSS. from the hand of this supremely accomplished scribe, whose unrivalled skill gave rise to the expression, "écrire comme un ange," is a volume of the Cynegetics of Oppian. The work is a poetical treatise on the chase, composed in the third century, in four books, and was transcribed by Vergecius in 1554. Oppian is followed by the similar treatise in prose of Xenophon, and another by Manuel Philes dedicated to the Emperor Michael Palæologus. With small oblong miniatures, in the ordinary Byzantine manner ; lavishly enriched with gold. On fine paper. Small folio. 104 ff. At foot of fol. 104 is this note : "Εγεγράφει τὸ παρόν βιβλίον ἐν λευκητία [sic] τῶν παρησίων ἐπί βασιλεῖ ἐρρίκου βᾱ χειρὶ αγγέλου βεργικίου τοῦ κρητός." Then follow the contractions for the year 1554. "The present little book was written at Paris in the reign of Henry II. by the hand of Angelus Vergecius (BERGEKIOS) of Crete, in the year 1544." Between 1535 and 1566 Vergecius copied many Greek MSS., some in Italy, others in France, of which the National Library, Paris, possesses more than twenty.

He was fortunate in obtaining the protection of four kings in succession, dying in the reign of Charles IX. His penmanship obtained quite a European reputation, and, besides giving rise to the proverb already quoted, is said to have become the model for the type of the first Parisian Greek press. The miniature reproduced by Silvestre (ii. 59) represents Oppian presenting his Treatise to the Emperor Caracalla, and asking, as his only reward, the freedom of his aged father, a senator exiled for his opposition to Septimius Severus. The Emperor, usually considered as without ordinary humanity, honoured the filial piety of Oppian, by granting his request and accepting his book. The miniatures, it is said, were the work of the daughter of Vergecius. Now in the National Library, Paris, No. 2,737.—*Silvestre : Paléogr. Univ.*, i. 241. (English text by Madden.) Among many other works he wrote "Carmina Novem Poetriarum Græce." Paper. 12⁰. According to a printed note prefixed to this MS., which contains the poems of the most celebrated women of Greece, it was written

by Vergecius (not Vergerius, as in the Libri Catal.). This example belonged to Horace Walpole. At page 5 are two pretty medallions. In the Libri Collection, and sold 1862.—*Sale Catalogue,* No. 115. He also wrote, and his daughter is said to have illuminated, a Greek MS. on paper, now in British Museum, Burney MSS., 97. (*See* VERGECIUS, daughter of ANGELUS, MINIATURIST.) Besides this the British Museum possesses six other MSS., attributed to Vergecius, viz., Add. MSS. 11,356, "Phocylides Pythagoræ, &c. Carmina." On last fol. (38 *v.*) in red minuscules:—Τουτὶ τὸ βίβλιον γέγραπται ἐν Λουτηκίᾳ τῶν παρησίων· τῇ χειρὶ Ἀγγέλου βεργικίου τοῦ Κρητός· δεδώρηται· δὲ δῶρον παρ᾽ αὐτοῦ τῷ ἐπιφανεστάτῳ ἀνδρὶ Μιχαήλῳ τῷ Κληνίῳ βουλευτῇ ἐν τῇ αὐλῇ τοῦ παλατίου ἀγαθῇ τύχῃ, ἔτει ἀπὸ τῆς θεογονίας αφξς', ἐν μηνὶ ἀνθεστηριῶνι." See also *Omont: MSS. Grecs. du British Museum,* 24. Burney, 104 (above) is not signed, but is dated αφμγ'. The five others are Roy. 16, c. xii. Harl. 5,536 and 5,671. Burney, 97. Add. 10,971. None of these are signed, but affirmed by Omont to be authentic. In the National Library, Paris, are five MSS. written by him from 1535 to 1537, at Venice. Distinguished for the beauty of his (Greek) handwriting. He established himself as copyist and agent at Paris in 1540. Composed the Catal. of Greek MSS. at Fontainebleau for Francis I., and was employed in a similar capacity by Henry II.—*Delisle: Cabinet des MSS.,* i. 153–183, &c.

VERGECIUS (Βεργίκιος), PETR. *Copyist.* Saec. XVI.

A Cretan. Probably a relative of the celebrated Angelus Vergecius.

Wrote, in an elegant character, two treatises: 1. "Ἐξήγησις εἰς τὴν τετράβιβλον τοῦ πτολεμαίου." 2. Πορφυρίου φιλοσόφου εἰσαγωγὴ εἰς ἀποτελεσματίκην πτολεμαίου." Paper. Folio. 128 ff. On folio 120 is the note, with contractions, in red: "τελὸς τῆς Ἐξήγησις εἰς τὸν πτολεμαίου κλαυδίου μαθηματικου τετραβίβλον .. πετρὺς ὁ βεργίκϊος ὁ κρής." Now in the British Museum, Burney MSS., 104.

VERGECIUS, Daughter of ANGELUS. *Miniaturist.*

Saec. XVI.

It is said on all hands that she constantly assisted her father in

his work, especially in adding pictorial embellishments to the MSS. which he wrote. The " Oppian " has been already mentioned in the account of her father. Another copy, however, of the " Manuel Philes de Animalibus," in Greek iambic verse, exists in the British Museum, with miniatures of animals of all kinds, attributed to this lady artist. Paper. Sm. 4°, 45 ff. (Burney MSS. 97). It is a very curious book. Folio 1. In red : "Sapientissimi Doctissimique Manuelis Philis versus Iambici ad Imperatorem Michaelem Paleologum Juniorem. De animalibus proprietate." Then in small black italics : " Philes hic temporibus Imperatoris Michaelis Palæolog. Junioris floruit," &c. Fol. 2 begins the verses. Fol. 20, an aquarelle, in the modern manner, of an eagle, beside which is written in red : ἀετός. Then below περὶ ἀετῶν. The verses begin with a small ornamental initial "T" in gold. Fol. 3, περὶ γυπός and a picture of a vulture. 3 *v.*, another picture ; and so on throughout the volume. The κόραξ on fol. 4 *v.* is very good. The remaining initials, except one, are merely rubricated. The following are among the best drawings :—The nightingale (ἀηδών). The swallow (χηλιδών). The owl, and three houseflies on fol. 15 *v.* Fol. 16 begins a new chapter with beautiful plain capitals ΠΕΡΙ ΖΩΩΝ ΤΩΝ ΧΕΡΣΑΙΩΝ. Begins περὶ λέοντος. There is a curious animal on fol. 19 *v.* called the ἀνθρωπώμορφος or ὀνοκένταυρος. The bear on fol. 20 *v.* is good. And some of the fishes are very good, as fol. 32, ἡ δελφίς. The folios are numbered in centre of top. Notwithstanding the great reputation of Angelus Vergecius as a Greek calligrapher, I do not think his penmanship equal to that of Dr. Parr, the English Greek scholar. Perhaps the examples in the Paris Library are finer than the present MSS.

VERONA, JACOPO DE. *Miniaturist.* Saec. XV.

Is said to have executed or completed the " Petrarca " now in the Imperial Library at Vienna. At end it bears the signature and date, " Jacobus Veronensis, 1459."—*Frimmel (Dr. Th.) Die Ikonographie des Todes*, 49. Wien, 1887. — *Waagen : Die vornehmsten Kunstdenkmäler*, in *Wien*, ii. 102.

VERONA, LUDOV. DE. *Copyist.* Saec. XV.

Wrote : " Nic. de Ausmo supplementum in summam pisanel-

lam." Thick 4°. Vellum. 2 cols. 416 ff. On fol. 395, col. 2, at foot : " Ego Frater ·Ludouicus de Verona Ordinis minorum Indignus scripsi " 4°. in capitals, black in initial crossed with red, Mᵒccccᵒlvjᵒ Dɪᴇ viijᵒ Marcij. In loco scti petri ī vimenario in noře Dñi, Amē." And in a paler contemporary script, " Et ego fř Rogerius Veronensis oř minoř3 Sacĕdos cũ licentia p̄bitor3 meor3 Emī ab ipõ frē Ludovico di3 (dictum) supplemtu3 ano χρī 1466 p̄cio ducℓ (ducatos) 18. Et post mõte3 (mortem) mea3 ptinet ad locū Sancti Bernardini Veronæ ut ad locum arcħ ruptiᵍ prope Veronam." Written in small, good, upright engrossing. Many red and blue initials, with pen-flourish ornaments ; lines close as here. 2 cols. Now in British Museum, Add. MSS. 14,070.

VERONESE, FRANCESCO (VECCHIO). *See* LIBRI, DAI.

VERONICA. *Copyist.* **Saec. xv.**

A Nun.

Wrote at Verona, " Augustini, de Civitate Dei." Dated 28th August, 1472. With miniatures. Andres saw it in possession of Abbate Berio of Genoa.—*Andres: Cartas familiares*, v. 206.

VESE,
VEZE, } ANDREA DALLE. *Miniaturist and Copyist.*

Saec. xv.

Cittadella: Notizie, &c.—Gualandi: Memorie Originali, &c., vi. 156.

VESPASIANO, AMFIAREO. *Calligrapher.* Saec. XVI.

A Franciscan.

Examples of his work, dated 1554, are given by *Merius: Escuela, &c.,* pl. 55, 56, 58, 410, 415, 422. His formal Gothic letter is that of the missal "lettre de forme," but with the addition of much pen-flourishing between the lines, especially in the smaller hands.—*See* MERINO.

VESPASIANO, DE' BISTICCI. *Copyist and Agent.*

Saec. XV.

The celebrated book-dealer of Florence. He was the chief agent for all the great collectors of his time,—the Medici and other nobles of Italy and other countries. In the British Museum are several volumes that most probably were executed through his agency. Among them, "C. Julii Cesaris Commentariorum," &c., has this note in the copyist's handwriting opposite the title: "Vespasianus Librarius florentinus hoc opus florentie transcribēduʒ curauit." The MS. is adorned with a bracket border to the title and initials to the books in the white stem style, and is written in a hand like that of Mennius or Verazanus. Vellum, folio, 195 ff., wide margins. Now Royal MSS., 15 C. XV.

VESPASIANO, DE FILLIPPO. *Copyist and Agent.*

Saec. XV.

"Librarius Florentinus," &c. *See above.*

VESPASIANO, PADRE FRANCESCO. *Miniaturist.*

Saec. XVI.

Of Florence. Celebrated about 1530.

Zani, xix. 152. Probably means Vespasiano Amfiarco *Francescano, above.*

VESPRÉ, VICTOR. *Miniaturist.* Saec. XVIII.

A Frenchman.

Worked at Dublin, but sent works to the Spring Gardens
Exhibition from 1770 to 1778.—*Redgrave : Dict. of Artists of the
English School.*

VESPUCIIS, A. DE. *Copyist.* Saec. XV.

"Titi Livii Patavini de secundo Bello Punico," libri x. a xxi.
usq. ad xxx. inclusive, "seu Decas tertia." Contains the notes :
" Georgii Antonii Vespucii liber " ; and " Anastasius Ser Amerigi
de Vespuciis * scripsit MCCCCLXIII." At beginning are verses
written by Georgio Vespucci. At end : —

"Surge viator abi : revocat Deus unde fuisti
 In cruce quære Deum crede, precare cole,
Lux huic, vita, salus, requies et gloria nostra est
 Tolle hanc teque negans me coli Christus ait."
Vellum, fol. xv., in a handwriting most elegant beyond description,
and with the initials of the several books in gold and colours.
197 ff.—*Bandini, op. cit.,* c. 492.

VETERANO. *Copyist.* Saec. XVI.

Librarian to Federigo, Duke of Urbino, and his two successors
in the celebrated palace of Urbino. Among the examples of his
transcription is a " Commentary on the Triumphs of Petrarch,"
now in the Vatican, a note in which tells us that it was one of
some sixty volumes copied by him for the Urbino Collection.—
Dennistoun : Memoirs of the Dukes of Urbino, i. 429.

VIANA, PRINCE OF. *Patron.* Saec. XV.

The title of the eldest son of the King of Aragon, transferred
by John II., of Aragon and Navarre, from his eldest son, the un-

* This was the father of the discoverer of America.

fortunate Don Carlos, called " El Noble," who died in 1461, to
his grandson, Gaston Phœbus, Count of Foix, son of his second
daughter, Leonora, wife of Gaston, Count of Foix. Viana is a
small town in Navarre, forty-five miles south-west of Pamplona.
The story of the life and death of Carlos, Prince of Viana, the
imprisonment and murder of his sister, Blanca, the heiress to the
kingdom of Navarre, and the persistent struggle of the Countess
of Foix to obtain the crown, is one of the darkest in history. It
was the prospect of this kingdom, which led to the magnificent
espousals of the youthful heir of Foix to Madeleine of France.
The ambassadors of Ladislaus, King of Hungary and Bohemia,
the predecessor of Mathias Corvinus, had come in December,
1457, to ask for the hand of the princess for their master, and
the king, in company with the Count of Foix, gave them audience
at Tours ; splendid fêtes were given, Gaston, specially charged by
the king to entertain his guests, besides executing his charge in
the king's name, gave among the rest a magnificent banquet at
his own expense, in which, says Jean Chartier, there was an
immense superfluity of the most delicate viands, and the most
exquisite wines. Morris-dances and mystery-plays were added to
the festivities, and it is said that the repast cost the Count of Foix
eighteen hundred livres. Just, however, as the princess was
about to be handed over to the ambassadors, news came that
Ladislaus was dead. In fact, after his treacherous and cruel
treatment of the two sons of John Corvinus, he became very
unpopular, and was obliged to retire to Prag, where he died
suddenly, in all probability by poison, at the age of eighteen.
His death occurred on the 23rd November. The news reached
Tours on the 26th December. The festivities were at once con-
verted into funeral ceremonies, and any idea of sending the young
princess abroad now seems to have been relinquished. Possibly
the event of the festivities had introduced to her the handsome
young prince whom she chose for her husband, or the turn of
events in Navarre may have decided the event. At any rate, we find
that during 1458 the Count of Foix was created a peer of France,
and on the 7th March, 1461, the Princess Madeleine was married
to Gaston de Foix, second Prince of Viana. The prince, who,
like his father, as the chroniclers tell us, was immoderately fond of
jousts and tournaments, was killed in a tourney at Libourne, in
the Gironde, about nine years after his marriage (November, 1470).
The princess lived until 1486. Of their numerous children,
Marguerite, the third daughter, married, in 1471, François II.,

Duc de Bretagne, and became the mother of Anne, afterwards
Duchesse de Bretagne and twice Queen of France. It is interesting
to find that the Fitzwilliam Museum at Cambridge possesses a
relic of the Princess Madeleine. (*See* Rivo.) It is a French
translation of the New Testament with eight miniatures and many
borders and initials. On folio 438 is a note that it was transcribed
for " Madalene, princesse de Vienne (Viana), fille et seur de roys de
France." True, for she was daughter of Charles VII., and sister
of Louis XI. Her arms, as shown by this MS., were,—*Quarterly*,
1. *Gu.*, a double orle, saltire and cross formed of a chain attached
to an annulet in centrepoint, *or*, for Navarre. 2. Three pallets
gu., for Foix. 3. *Or*, two cows passant *gu.*, for Béarn. 4. *Arg.*,
three fleurs-de-lis and a bend compony *arg.* and *gu.* for Evreux.
Lastly, on an inescutcheon, *or*, two lions passant *gu.* for Bigorre.
The whole *parti* with the arms of France.—*L'Art de vérifier les
Dates*, vii. 436. ; ix. 439 (1818).—*Searle : Catal. of Illuminated
MSS.* in Fitzwilliam Museum, 73. A still more interesting,
because more personal, work, however, is the MS. of the "Ethics of
Aristotle," translated by Carlos, first Prince of Viana. It is now
in the British Museum, Add. MSS., 21,120. Vellum. Folio. 238 ff.

This MS. is one of the finest ever executed in any country. It
begins with the prologue :—" Prologo del muy illustre dō
Karlos principe de Viana primogenito de Navarra, Duque
de Nemose, de Gandia, drecado al muy alto e eccellēte
principe e muy poderoso rey e sennor don Alfonso tercio
rey de Aragon e de las dos secilias etc su muy redaptable
sennor et hio de la translacion de las ethicas de Aris-
totéles de Latin en Romance fecha." This heads the said
prologue in small Gothic capitals written closely together without
spaces between the words. The letters are alternately blue and
gold. Then comes initial P, very beautifully executed on a gold
Gothic panel, the interior filled with finely-painted foliage, in the
midst of which are the triple loop in gold with the motto " bonne
foy " in golden Gothic minuscule. The page is surrounded by a
border formed of thick branches of vine twisted into a continuous
serpentine ornament, with flowers in each curl, and here and there
a figure. In centre of top the triple loop in gold with the motto
" bonne foy " below it, and at each side near the top a magnificent
peacock, then a richly-dressed gentleman on the left, and a lady
on the right. *Amoretti*, with musical instruments, birds, and
rabbits, are other embellishments. At foot are three coats of
arms :—1. Quarterly 1 and 4, Navarre ; 2 and 3, Bourbon. 2. Aragon.

3. Sicily. Supporting the central coat of Aragon are two white
greyhounds with golden collars seated on mounds, on which can
be read two letters or monograms 𝔘𝔖 : 𝔣𝔢 : which are given again
below larger, apparently in (now blackened) silver.

The text is a small but clear and beautiful upright Gothic minus-
cule. Folio 4 begins the letter of Leonardo to Pope Martin V.,
upon which he undertook the present translation, with a beautiful
initial N. Folio 5, " La permission de Leonardo de Aretço a su
nueua traduccion en los libros de la ethica en laqual declara
porque razones se movio a la fazer," with beautiful initial L of a
type originally invented by Netherlandish illuminators, in imitation
apparently of carved wood-work with perforations, on a panel of
burnished gold. Seated on the lesser limb is a white dove. Fol.
11, Ch. i. with a heading in pale lakey red, an initial E in blue
with red pen-flourishes. Then below a grand initial T in colours
and gold with white stem ornament on coloured ground, in the
usual Neapolitan style. Seated on the top of the bracket orna-
ment is a figure of St. George slaying the Dragon. And at foot
the arms of Sicily *parti* with Nemours-Navarre, being the personal
arms of Alfonso (Add. MSS., 18,610, f. 80).

The MS. then continues with a fine initial to every chapter, very
wide margins containing notes and elucidations. But at the
beginning of each book is an initial to which the epithet of
magnificent is not inappropriate. Exquisitely drawn, finely
coloured, and blazing with burnished gold, sometimes overwrought
with a fine filigree of indented points, few examples of calligraphic
skill can possibly surpass them. They occur on fols. 1, 5, 35, 50,
75, 98, 121, 139, 164, 189, and 210, and the volume ends with a
lament for the death of Alfonso, for whom this lovely MS. had
been executed. On fol. 238 is the conclusion in red : " Finis
Ethicorum cum miseranda lamentatione libri, ab. G. altadello
Summi Aragonum et Navarre principis librario." So it seems to
have been penned by the purveyor or keeper of the books of
Alfonso himself, and illuminated by the VG. or VS. indicated
by the monogram on the first folio. The margins of the
leaves are not less than $2\frac{1}{2}$ inches wide at the sides and
4 inches at the bottom, with proportionate widths at top and
inside, and are faintly ruled to the fixed dimensions with very fine
pale lines. The total height is $12\frac{1}{2}$ inches, of which 7 inches only
is reserved for the text. As a contemporary work executed by
artists of the highest class, for presentation to the most learned
and accomplished king in Europe, this translation by the Prince

of Viana from Leonard Aretin's Latin version of the Ethics possesses unusual interest, and deserves to rank with the specially select MSS. of European reputation.

VICENTINUS, MARCUS. *Copyist.* Saec. xv.

Wrote "Petri Marcelli, pro illo P. Andrea Vendramino Funebris Oratio." Vellum, small 12°. 20 ff. Bound with other tracts. Beautifully written in upright half-Roman. Initial M in brown-gold on coloured panel. At foot of 1st folio are the arms of Vendramini supported by two kneeling Cupids, and surmounted by the ducal cap of Venice. Very finely painted. The arms are : Parti per fess *az.* and *gules*, a fesse *or.* The pages are closely ruled in red. On fol. 20, at foot, in Roman capitals, "MARCVS VICENTINUS, *scripsit, calamo volante.*" Now in British Museum, Add. MSS., 19,061.

VICINO, { BONELLO. MARANINO. } *Miniaturist.* Saec. xiv.

And others of the family. Celebrated about 1350 at Bologna.

Zani, xix. 166.

VICO, ENEA. *Engraver and Designer.* Saec. xvi.

Born at Parma about 1520. Died 1563.

A most industrious author, draughtsman, and engraver, particularly of coins, medals, cartels, vases, and frontispieces. Some are of remarkable delicacy and beauty. His principal work, "Le Imagini delle Donne Auguste," or in Latin "Augustarum imagines, aereis formis expressæ," passed through many editions, and was repeated, with fresh designs, in Paris. The best edition,

containing the highest examples of Vico's own handwork, is that
of Venice, 1557. It contains sixty-three plates, most of them con-
taining medallion portraits enclosed in richly-designed cartels,
usually ornamented with graceful figures, masks, foliages, &c. ;
others contain coins. Besides these are numerous woodcut
initials. The National Library at Paris possesses a good collection
of his miscellaneous designs and engravings (Enée Vico. E. b. 11).
The Royal Library at Brussels has also many examples of vases,
trophies, &c. Of his books, I have copies of the following five
or six : " Le Imagini delle Donne Auguste, intagliate in istampa
di rame : con le vite et ispositioni di Enea Vico sopra i riversi
delle loro medaglie antiche : In Vinegia appresso Enea Vico
Parmigiano et Vincenzo Valgrisio all' insegna d' Erasmo M.D.LVII."
Small 4°. An extraordinarily fine copy, formerly in a private
library in Milan. It has the beautiful frontispiece of the altar,
with festoons of fruits on the two centaurs, male and female ; the
former with a trumpet, the latter with a lyre ; both mounted by
lovely naked children. Standing on the wreath, a Roman eagle
with wings outspread supports the panel containing the title, and
a finely-drawn mask forms the centre of the ornamental wreaths
above. This frontispiece is a refined reproduction of an actual
Roman altar existing in a museum in Rome, a fine engraving of
which, by Theodore de Bry, is given in *Boissard: Antiqq. Roma,*
i. pt. iii., Pl. 144. The date of De Bry's engraving is just forty
years later than that of Vico, and the plate is reversed. Vico's
drawing was probably made from the altar itself, as were his
drawings of medals, &c., from the actual examples. This frontis-
piece is repeated in succeeding editions, and in other of Vico's
works. Thus it occurs, engraved by a later and inferior hand—
Giacomo Franco of Venice—in the " Reliqua Librorum Æneæ
Vici Parmentis ad Imperatorum Historiam ex antiquis numis
pertinentium, Olim Jacobo Franco Veneto edita. Nunc a Joanne
Baptista du Vallio restituta." 4°. Venice, 1612. And, again,
in " Augustarum Imagines aereis formis expressæ, &c. Nunc
a Joanne Baptista Du Vallio restitutæ." 4°. Paris, 1619. The
latter is an inferior reproduction altogether of the Italian edition
of 1557. The frontispiece to the edition of 1558 is a remarkable
one. On the frieze of a Corinthian doorway is placed an elegant
cartel containing the title of the work, over which is a medallion
of the head of Janus supported by two children, and below it an
oval shield containing the dedication. At either side are statuesque
figures of Minerva and Saturn, the latter devouring a child,—of

course, symbolical respectively of Wisdom and Time, "edax omnium rerum." Another cartel contains the date. Beneath Minerva is the inscription : " Deo homines proximos facit "; beneath Saturn, " Profert in apricu et destruit omnia." Two sphinxes sit beside the pedestals which support the figures. This frontispiece is repeated in the Paris edition by Du Val of another work of Vico's, " Ex libris xxiii. Commentariorum in vetera Imperatorum Romanorum Numismata," &c., the original portions of which were published in Venice from 1548 to 1557. Besides this work on the Roman Empresses, Vico composed and illustrated several works on numismatics : " Discorsi di Enea Vico Parmigiano, sopra le medaglie degli Antichi," &c. " Opera restituta da Gi. Battista du Vallio." Paris, 1619. In two books. Without illustrations. " Augustarum Series altera ab antiquis historicis deprompta." Paris, 4°, 1619. From Plotina to Cornelia Salonina. Fifty-two plates. Plate 3, of Sabina Augusta, very far superior to the rest, and a very poor frontispiece, added, according to the date upon it, in 1630. " Omnium Cæsarum verissimæ imagines ex antiquis numismatis desumptæ," &c. Editio altera. Æneas Vicus Parm. F. anno M.D.LIII. With a beautiful architectural and sculpturesque frontispiece, enriched with figures and bunches of fruit. Contains eighty-two plates. The title-page to each set of coins consists of an ornamental panel containing a brief character of the Emperor, surrounded by figures of children, termini, &c., and surmounted by a medallion portrait, most beautifully finished and accurate. Of these portraits there are, of course, twelve, from Julius to Domitian. The volume of Vico's original pen-drawings for this work is now in the British Museum, Harley MSS., 5,381. Lastly, a later edition of this work, with the altered title, " Primor҃ XII. Caesarum verissimae imagines et antiquis numismatib⁹ desumptae, &c., Editio tertia. Romæ apud Jacobum Mascardum, &c., MDCXIIII." 4°. Impressions of the plates used in the preceding editions. Full indexes, as in the second edition. But beautiful as are the engravings in these books, they are inferior in magnitude and richness to the plates of vases, &c., published separately.— *L'Art pour Tous*, i. 6, 11, 76; ii. 140, &c.—*Guilmard : Les Maîtres Ornemanistes*, 289, &c.

VICOMERCATO, } BATTISTA. *Miniaturist.* Saec. xv.
VIMMERCATA, }
 Cittadella : Notizie, &c.

VIDRUG. *Calligrapher.* Saec. VIII. (?)

Wrote a small 8° volume in Irish, like that of St. Mulling's Gospels, on coarse vellum. Each gospel preceded by a figure of the Evangelist, as in the gospels of MacRegol. At end in golden letters : " Hoc Evangelium Sc̃tus Bonifacius martyr Domino gloriosus ut uobis seniorum relatione compertum est proprius conscripsit manibus, quod etiam Ven'abilis abba Huoggi obnixis precibus a rege piissimo Arnulfo impetravit et Sanctæ Fuldensi ecclesiæ honorabiliter restituit cui Salvator Jesu Christe præmia sempiterna pro devotione sua en cælestibus clementes redde eumque uobis feliciter dominari tempora longa concede." It happens, however, that the real scribe of the volume, Vidrug, has inscribed his name in the ordinary Irish fashion at the end of St. John's Gospel : " Finit. Amen—Deo Gratias ago. Vidrug scribsit." The MS. is now in the Abbey at Fulda.—*Westwood : Anglo-Saxon and Irish MSS.*, 92, pl. LI.

VIELLART, GERMAIN. *Illuminator.* Saec. XV.

Became a member of the Gild at Bruges in 1470.—*Laborde*, 79.—*Kirchhoff*, 188.

VIERWIC. *Copyist.* Saec. XII.

Together with others named in the explicit, wrote a large and important folio volume in good clear handwriting, with rough-coloured initials, containing " Sc̃i Isidori de Etymologia, de Mundo," &c. Vellum. Folio, 167 ff. 2 cols. On fol. 166 is this note : " Hec sunt nomina illarum q̃ scripserͭ librū istū. Gerdrut, Sibilia Vierwic, Walderat, Hadewic, Lugart, Uota, Cunigunt. Ipsūq̃ scripserͭ monasteriensib⁹ dñis qtin⁹ đm ꝑ eis rogent. ut a peniis eas liberet et in paradyso collocet. Qsq̃s eis abstulerit anatematizat⁹ sit. 1134." Now in British Museum, Harl. MSS., 3,099.

VIGILA. *Copyist and Illuminator.* **Saec. x.**

A Priest of S. Martino da Albelda.

Wrote and illuminated, with the help of Sarracino and Garcia, the well-known MS. called the Vigilano. " Un codice que . . . concluyo el dia 25 de mayo del año de 976. Contiene varios concilios generales, algunos toledanos, e fueron juzgos y otros opusculos; varias pinturas que son retratos del rey D. Sancho el Craso, de D. Ramiro de Navarra, de la reyna Dona Urraca y del mismo Vigila e erosticos iluminados y algunos odornos. Le ayudáron en esta obra otros dos artistas llamado el uno Sarracino y el otro Garcia." The paintings of this venerable codex are, as Bermudez says, appreciable for their antiquity and brightness. Of course allowance has to be made for the ignorance of art-rules in the time and locality in which it was produced.—*Bermudez:* v. 232.—*Merlino: Escuela,* 101–5 (gives a fac-simile).

VIGOROSO. *Illuminator.* **Saec. XIII.**

Illuminated the account books of the Camerlengo of Siena.— *Rumohr: Italienische Forschungen,* ii. 24.

VIGRI, CATTERINA. *Miniaturist.* **Saec. xv.**

Born in Bologna in 1413. A Nun of the Order of St. Clara in the Convent of Corpus Domini.

She was a most diligent miniaturist and paintress, and also used to make tiny "bambini" to carry to the sick, "upon kissing which many recovered their health." Hence she was styled Saint. She died in 1463, and was canonised by Clement XI. in 1712.—*Orlandi: Abecedario Pittorico,* 120. (Venice, 1753. 4°.)

VIGRI, SISTER CATERINA. *Miniaturist.* **Saec. xv.**

A Nun of Bologna. Died 1463.

Distinguished as a miniaturist of service-books.—*Pautassi: I Codici Miniati, &c.,* 63. Di cui restano miniature.—*Lanzi: Storio Pittor.,* v. 15. Firenze (1822).

VIHBERG. *Copyist.* Saec. xv.

Wrote "Symonis de Erfordia Summa Curiæ." Vellum, 4°. 178 ff. 2 cols. Initial O and rubrics. No other ornaments. Written in a small Chancery hand, with contractions. Fol. 166 in red : " Der mich geschriben hat. Der musze leben an schande not Des bitte ich Got durch sinen tot Albert Vihberg de Nurenbg." Now in British Museum, *Arundel MSS.*, 240.

VILLA DIEGO, FRANCISCO DE. *Illuminator.* Saec. XVI.

Worked with Diego de Arroyo, in 1520, on the miniatures and ornaments of the Choir-books of the Cathedral of Toledo. Famed for the "exactitude of his drawing and the brilliancy of his colouring."—*Bermudez : Diccion.*, v. 245.

VILLAFANE, PABLO DE. *Miniaturist.* Saec. XVII.

Distinguished about 1635 at Madrid as an illuminator and miniaturist, and for his pen-drawings, which were executed with great fineness and delicacy. He died young, and was celebrated for his ability, in the verses of D. Francisco de Quevedo y Villegas.—*Bermudez : Diccion.*, v. 246.

VILLANELLI, GIOVANNI. *Copyist.* Saec. XV.

Mentioned in a document of 1458 as having a law-suit with Girolamo Todeschi about the writing of a breviary.—*Cittadella : Documenti, &c.*, 179.

VILLANI, PH. *Copyist.* Saec. XIV.

Wrote " La Divina Commedia." Paper. Folio, 212 ff. A fine MS. with wide margins, of most beautiful handwriting, with notes, comments, and various readings. Known as the Codex

Villani, or as the Cod. di Frate Tedaldo. After the Paradiso is this note : "Complet⁹ in feste seč anni in quo dux Athenarū gualterius tyrañ ciuitatis florentie pulsus" (1343). The date in the handwriting of Sebast. de Bucellis, Librarian of the Laurentian Library in the middle of the fifteenth century. On the recto of fol. 199 is (with other notes) : "Questo libro fu sc'pto p' mano di Mess. Phylippo villani il quale ī firenze in pubbliche scuole molti anni gloriosamente con expositioni lrāle allegorice anāgice et morali lesse il predetto et sue expositionj a molti sono 9icate." In a later hand, which Mehus thinks to be that of Seb. de Bucellis : " Fu eldetto mess philippo villanj cancelliere del comūe di perugia piu et piu añj. Sicome appare in molte sue epistole scritte a diue'se p'sone." Now in the Laurentian Library, Florence, Codici di S. Croce. Pl. xxvi.—*Batines*, ii.

VILLEGAS, JOH. DE. *Copyist.* Saec. xv.

Wrote, in 1472, "Thomæ Aquinatis in P. Lombardi Sententias." 4⁰. Now in Bodley Library, Oxford (Canon. Misc., 514).

VILLET, JEAN. *Copyist and Illuminator.* Saec. xv.

Employed by Charlotte de Savoie. In a document of her expenses, dated 28 April, 1482 (now in National Library, Paris), is mention of Guillaume Piqueau, illuminator, demeurant a Tours pour avoir enl. &c., xii. *l.*," and " A Jean Villet pour auoir escript et enlumine certaines oroisons en deux cayers mys et reliez es heures de la dite dame pour ce xv. *l.*"—*Delisle : Cabinet des MSS.*, iii. 343. (*See* SAVOIE.)

VILLHELMUS, }
WILHELMUS, } DE ALAMANIA. *Copyist.* Saec. xv.

Wrote, as under, on paper, 240 ff., with arms of Cardinal della Rovere on title. At end : " Expliciunt Recollecte composite per famosissimum Decretorum Doctorem Dominum Domitianum de S. Geminiano, quas legit in studio Bononiensi, que scripte fuerunt anno Domini, 1423, die 2 mensis Decembris. Scripsit Villhelmus de Alamania. Now in Royal Library, Turin, Cod. cclxxiv. f. vi. 3.—*Pasini*, ii. 79.

Villot, Frederic. *Miniaturist.* Saec. xviii.
Of Halle.

> Celebrated in the latter half of the eighteenth century. Born 1739. Died 1793.—*L'Art*, i. 313 (1875).

Vincent (St.), Contyn de. *Copyist.* Saec. xiv.

> Paper, 130 ff. Moral tracts in French. "Cy finist le livre que le Chevailler a fait pour l'ensegnement de ses fillies, escript a troys doys de la main du petit Contyn de Saint Vincent en la Valdouste. L'an mil. iiiᶜ lxxii., et commence du moys de Janyer," &c.—*Cod.* I., e. iii. 40.—*Pasini*, ii. 459.

Vincentia, Cambius de. *Copyist.* Saec. xiii.

> Wrote a Bible. Vellum, 4°. 490 ff. Now No. 177 (L. 8) at Donaueschingen. On fol. 217 *v.*, at end of Psalter : "Laus tibi christe quum liber explicit iste. Qui scripsit scribat semper cum domino uiuat. Vivat in celis. Cambius scriptor de Vicentia. In nomine felix. Amen."—*Barack : Die Handschr. der Fürstl.— Fürstenbergischen Hofbibl. zu Donaueschingen, &c.*, 169.

Vincentia, Marcus de. *Copyist.* Saec. xvi.

> Wrote "Officium Beatæ Mariæ Virginis, secundum Consuetudinem Romanæ Curiæ, cum Calendario." Vellum. Sm. 80. 105 ff. This MS. was executed for a member of the Medici family. It contains eight exquisite miniatures, sixteen splendid borders, in which are placed portraits of saints and eminent persons, Cupids, flowers, &c. Formerly in possession of Mr. Bragge, of Sheffield, Sold at Sotheby's in 1876.—*Catalogue*, 62.

Vincentius. *Copyist.* Saec. xvi.
Monk at the Abbey of S. Maximin at Trèves.

> Wrote, in 1510, the beginning of a handsome Bible, which was completed by Jacobus Gladbach in 1530.—*Archiv des Gesellschaft für ältere Deutsche Geschichtskunde*, ii. 332.

VINCENTIUS, LUDOVICUS. *Copyist.* Saec. XVI.

Wrote at Rome, in 1517, "Aristotelis Ethicha" in Latin, with miniatures.—*Uffenbach: Reisen*, iii. 571-2.

VINCENZO. (Miniatore.) *Miniaturist.* Saec. XVI.

A celebrated contemporary of Clovio. *See* RAIMONDI.

VINCHINT, ⎫
VINCENT, ⎬ JOHANNES. *Copyist.* Saec. XV.

Wrote, in 1453, "Speculum Historiale fratris Vincentii." At end: "Explicit liber octavus Speculi hystorialis et finitur primum volumen eiusdem Ego Johannes Vinchint presbiter scripsi et complevi hoc presens volumen anno Domini millesimo CCCCLIII." Now in the Royal Library, Brussels.—*Marchal: Catalogue des MSS., &c.*, ii. 257, No. 9,330.

VINCI, LEONARDO DA. *Painter, &c.* Saec. XVI.

Besides the pen-drawings executed by this celebrated artist to accompany his own works, and the instruction and assistance afforded to Antonio da Monza and other miniaturists, he executed with his own hand the miniatures of an Introduction to the Study of Grammar, composed for the use of Maximilian Sforza, son of Ludovico il Moro, Duke of Milan. The MS. was seen by Andres. —*Andres: Cartas familiares*, iv. 148. Many MSS. in our great libraries claim either the actual work or the immediate influence of Da Vinci. It is, however, impossible to speak confidently, owing to the want of documentary evidence.

Vinck, Michael. *Copyist.* Saec. xv.
Of Bayreuth.

Wrote, in 1436, an immensely thick German Bible, with rough ornamental flourishes, &c. Vellum and paper. Fol., 483 ff. 2 cols. Small German lettre de somme, neat and clear. On fol. 455, in red: "Deo Gracias; dein wille geschei. Michael Vinck von Beyereut, 1436 (*see* Cockran's Catal. for 1837, No. 21). Now in the British Museum, Egerton MSS., 855.

Vindelot, Windelot, } Jacques Vindelot.

Erroneously supposed to have executed, in 1465, one miniature inserted in the Hours of Charles the Bold. Now in the library at Copenhagen.—Almost equal to Roger Van der Weyden. "Ce nom n'est pas trouvé à ma connaissance sur d'autres productions des arts."—*Laborde*, t. i., pt. ii. ; pt. i., t. ii.; pt. i. lxxxvi.–vii. n. 3. (*See* Undelot.)

Vingles, { Peter de. Jean de. } *Designer.* Saec. xvi.

Printers, designers, and engravers of Neuchatel and Lyons. They had been printing at Lyons from 1495. Jean de Vingles cut the blocks for the writing book of J. de Yciar, printed at Saragosa, in 1550 (*see* Yciar). Examples of Vingles' borders occur with the initials P. V. in Alciati's Emblems, published at Lyons, by Mat. Bonhomme, 1551.—*Douce: MS. Notes to Bonhomme's Emblèmes.* D'Alciat, Lyons, 1549.—*Brunet: Manuel du Libraire*, v. 1506 (1864).

Viridario, Guillelmus de. *Copyist.* Saec. xv.
Or Dujardin.

Wrote, in 1455, "Cato glossatus, seu speculum regiminis." Vell Fol., with miniatures. At end: "Hunc librum scripsit Dns. Guill. de Viridario, Presbiter Bituricensis Diocesis; notarius

Lugdunensis, et Forensis, pro nobili et potentissimo Viro Dno. Ludovico de la Vernade, Milite, Consiliario Excellent. Principis Ducis Borbonii et Alverniæ, Milite Presid. Comitatus Forensis, et fuit finitus die Veneris post Quasimodo xviii. Aprilis, Anno 1455." In the Hohendorf Collection.—*Bibliotheca Hohendorfiana, &c.,* MSS. 236, No. 29.

Visconti, Family of. *Patrons.*　　Saec. xv. et xvi.

The earliest known piece of literary work for this family, bearing name and date, is the Pantheon of Geoffrey of Viterbo. written by Joh. de Nuxigia, in 1339, for Azzo, Lord of Milan, Azzo was succeeded by his uncle, Lucchino, and the latter by his brother, a Cardinal and Bishop of Novara, a most masterful prince, who at his death left the Lordship to his three nephews, Matteo, Bernabo, and Galeazzo Visconti. Many of the books carried off to France by Louis XII. bear the signature "Johannis Vicecomitis Dei gratia episcopi Novarensis et comitis," and his taste for learning seems to have been inherited by Bernabo, but the latter was too avaricious to be entitled to great praise on this account. Galeazzo, who survived his two brothers, was succeeded in 1395 by his son, the more famous Gian Galeazzo, who had been created Count de Vertus, in 1360. To him or his father are due most of the Visconti Milanese MSS., which bear the arms *arg.* a "guivre" *az.* crowned, &c., *or* issant *gu.*, such, *e.g.*, as Nos. 1,615, 5,784, 5,798, &c. This shield is sometimes accompanied by the cypher G Z (MSS. lat., 6,069, 7,242), or, as in 364, written for Gian Galeazzo on his marriage with Isabella or Elisabeth, daughter of King John, of France. The arms on the frontispiece are quarterly, 1 and 4 for France, and 2 and 3 Milan. On the same frontispiece, is another shield *or,* an eagle *sable,* which is often seen figured on the books of the Lords of Milan. MS. lat., 11,727, contains a work which Baldus de Perusia dedicated to Gian Galeazzo, Count de Vertus, in 1393. Possibly it was the presentation copy. At foot of the frontispiece is a shield, *or* two fesses *sa.* The four corners of the border have each a golden sun. Two copyists who worked for Gian Galeazzo or his father are known by name. Armannus, in MS. lat. 5,067, and in MS. lat., 6,417, Armannus de Almania ; and again in 6,541 and

7,258. To Gian Galeazzo Visconti, who is called the first Duke
of Milan, are due the foundation of the Cathedral of Milan, the
Citadel of Pavia, and the remarkable monument of mingled
Renaissance and Gothic architecture called the Certosa of Pavia,
in which he lies buried. He protected arts and letters, and
established in the University of Pavia the most celebrated scholars
of the time, the two Raffaelli, Fulgoso, Il Comasco, Emanuel
Chrysoloras, and others. He established order in the administra-
tion of his dominions, and was the first to collect and place in the
public archives the documents and acts of his government. If not
a perfectly just or gentle ruler, he at least made a peaceable life
possible beneath his sway, enriching his country by the encourage-
ment of agriculture and the industrial arts. His conquests led
him to the point of aspiring to the Kingdom of Italy, and had he
lived he might even have realised his aspiration. He was strict in
compelling the observance of justice among his subjects ; although
he frequently violated it himself. " I am determined," he used to
say, "that there shall be no other thief in my dominions besides
myself." With him departed the glory of the Visconti. His two
successors, Gian Maria and Filippo Maria, were, the one, a fero-
cious tyrant of the worst type, and the other a wily and treacher-
ous politician ; but neither capable of reaching the character of
a great, enlightened, or liberal prince. Gian Galeazzo held the
Duchy from 1402 to 1412. A MS. in the Paris Library (lat. 5,888)
contains a genealogy of the Visconti from Venus and Anchises.
On the frontispiece of this volume is a device which adorns many
of the MSS. of the ducal library—viz., a turtle-dove amid the sun's
rays with various mottoes,—"Tronus ejus sicut sol " : " Gene tue
sicut turturis " ; " Sub ipso erunt radii solis" ; " Dedit illi virtutem
continendi" ; " Mortuus est occidente sole." From the end of
the fourteenth century the Visconti had adopted the emblem of
the dove. Another emblem like a kind of compass often figures
beside that of the dove. According to a quittance of Nov. 17,
1394, the compass and turtle with the motto, "A BON DROIT," formed
the principal ornaments of a litter and carriage which Louis, Duke
of Orleans, had decorated by Colart de Laon for his wife, Valen-
tina, daughter of Gian Galeazzo.

The last Visconti was Filippo Maria, a catalogue of whose library
was prepared in Jan. 142⅞, and was found among the books of the
Count of Firmiani, Governor-General of Lombardy, who died in
1782. On the MSS. executed for Filippo Maria is the quarterly
shield, 1 and 4 *or*, an eagle *sa.* 2 and 3 *arg.* a viper *az.* It occurs

e.g. in MSS. lat., 4,772, 7,023, and MSS. ital., 118, 119, 131. The frontispiece of 119 has the dove and the motto "A BON DROIT," which would seem to indicate rather the Orleans claim than the original hereditary holding. In 4,772 the arms are accompanied by the cypher FI–MA. (*See* SFORZA.)—*Delisle : Cabinet des MSS.*, i. 131, 132.—*L'Art de vérifier les Dates*, xvii. 264, &c. (Paris, 1819).

In the British Museum are numerous documents relating to this family, but few MSS. executed for their use. Burney MSS., 132. " Caii Julii Cæsaris de Bello Gall. Commentarior. lib. vii.," and other works of Cæsar and Hirtius, contain the arms of Visconti. Add. MSS. 22,817 : " Plutarchi *chiromonensis* Apophthegma," &c., in Latin, is dedicated "Ad Magnanimum et Illustrissimum Principem Philippum Mariam Anglum inclitum Mediolanensium ducem." It was written "sub auspiciis D. Antonii Peraugustini J.C. Com. anno Dñi Mº ccccº LVIº die sexta Januarii. Vellum. 8º. With an illuminated border and initial on fol. 1.

VITO, ANDREA DI. *Miniaturist.* Saec. XVI. et XVII.

Was considered to be an excellent miniaturist, all his works being completed with the highest degree of finish. He was of a very independent character, and would only work for those who would come to his house to give their orders. Some of his best miniatures were executed for the Prince of Avellino, his chief patron. He was fond of retouching and going over his work again and again, and thus often rendered his work dry and wanting in harmony. Yet he was in great repute, and his works obtained high prices. Died 1610. — *De Dominicis : Vite dei Pittori, &c. Napoletani*, ii. 2,394.—*Zani : Enciclop. Metod.*, xix. 210.

VITO, ANTONIO DE ST. *Copyist.* (?)

Wrote three Missals, one of which belonged to the Church " Rupis Claræ, diœcesis Veronensis." Once in the Library of St. Michael's, of Murano, near Venice.—*Mittarelli : Præf.*, xix.

VIVARIO, JOH. DE. ⎱ *Copyist.* Saec. XIV.
VIVIER, JEAN DU. ⎰

Clerc to Etienne de Conty, Benefactor of the Abbey of Corbie. Died 1413.

> MS. 383, in the Library of Amiens, has this note : " Per manum Johannis de Vivario de Gandavo.—*Delisle*, ii. 129. He lived with Etienne de Conty at Paris, Rue des Poirées, in 1376.—*Garnier : Catal.*

VLIEGE, ELIZ. *Copyist.* Saec. XV.

A Nun.

> Wrote a MS., now in the Royal Library at Brussels.—*Cahier : Bibliothèques,* 140.

VOGT, ANTON. *Copyist.* Saec. XVI.

A Monk of St. Gallen.

> Wrote, in 1507, " Lectionarium in matutinis : Pars estivalis " (or festivalis), and, in 1522 " Benedectionale solemne." Both are adorned with miniatures. The MSS. are well written, and the ornaments, consisting of figures, fruits, flowers, and insects, and illuminated initials, show Vogt to have been a consummate artist. Now in the Library of St. Gallen.—*Hænel. : Catall.,* 692, 696. Nos. 421, 540.

VOGTHERR, HEINR., SEN. *Illuminist, and Designer for Books.* Saec. XVI.

Lived at Strasburg.

> Published two small and large alphabets. Strasburg, 1534, and numerous designs for heraldic shields and other ornaments.—*Guilmard : Les Maîtres Ornemanistes,* 364.

Voisin, Thomas. *Copyist.* **Saec. xv.**

Given under 1430 in *Laborde : Ducs de Bourg.*, i. pt. ii. 528.

Volkerus. *Copyist.* **Saec. xi.**

In MS. lat., 8,912, formerly belonging to the Abbey of Epternach, " Dominis abbas Regimbertus, auctor hujus libri, et Volkerus et Theodericus, scriptores, in memoria eterna habeantur. Amen." Regimbert was abbot from 1051 to 1081.—*Delisle : Cabinet des MSS.*, ii. 362.

Volterra, Alberto da. *Calligrapher, &c.* **Saec. xii.**

Worked at Bologna, or perhaps Ferrara in 1169, and was called " Scriptor de licteris maioribus de auro et de colore." He drew and illuminated the grand initials of a Bible in four large folio volumes, formerly belonging to the Monastery of San Vito, now kept in the Certosa of Pisa. Possibly, also, he painted the initials of a copy in two volumes of the " Moralia " of St. Gregory, now in the public library of Volterra.—*Bonaini : Memorie inedite intorno alla Vita e ai Dipinti di Fr. Traini*, 87 (Pisa, 1846).— *Cittadella Notizie, &c.*, 640.

Voocht, Nicolaus. *Copyist.* **Saec. xiv.**

Wrote, on vellum, folio, 219 ff., neatly, " Thomæ Gualensis et Nicol. Triveti in S. Augustini de Civ. Dei libros xxii. Comm.," &c. On fol. 183 : " Firmiani Lactancii de opificio Dei . . . liber explicit Deo gratias : Nicholaus Voocht." " Scriptor qui scripsit bene melius si potuisset. Sed quia non potuit indeclinabile mansit." Now in the Library of Merton College, Oxford.—*Coxe: Catal. Codd. MSS., Colleg. Mertonensis*, 22.

VORNIKER, WILH. *Illuminator.* Saec. xv.
Prior of Windsheim. Died 1455.

"Variis picturis altaria decoravit et libros pro libraria et pro choro in bona copia per fratres fecit conscribi, quos ipse quamplur. illuminavit."—*Buschii : Chron. Wendeshem.*, 481.

VRANCKENZONE, WAUTIER. *Copyist.* Saec. xv.
Precentor of the Court Chapel of Philippe le Bon at La Haye.

In 1465 or 1466 he received 15 florins (du Rhin) on account of salary for having written, notated, and bound a certain Choir-book for the chapel.—*Pinchart : Archives des Arts, &c.*, i. 245.

VRELANT, GUILLAUME. *Miniaturist.* Saec. xv.
It is under this form that the name of this artist occurs most frequently in the registers of the Confrérie of Bruges. He is named together with Yvonnet le Jeune, Pol Fruit, and Loyset Liédet. In the Registre (June, 1469): "A Guillaume du Vrelant, enlumineur, pour auoir fait les histoires de plusieurs couleurs en ung liure, nomme Vita Christi, au pris de xij solz piece, font xxxij liures." Vrelant's name first appears, however, in 1454, 1455, as Vredelant, and he paid his annual subscription down to 1481. In 1478, when the Confrérie of St. John ordered of Master *Hans*, who is generally acknowledged to be Jean Memlinc or Van Memmelinghe, the two wings of the picture for the altar of the Corporation, Guillaume Vrelant received a sum of 12 gros for his services as commissioner for the same. Later two other wings were added to this picture at Vrelant's expense, in which he is represented together with his wife. The picture, I believe, is now at Munich.—*Pinchart : Miniaturists, Enlumineurs et Calligraphes employés par Philippe le Bon et Charles le Témé-raire, et leurs Œuvres*, 11, 15 (Bruxelles, 1865).—*Weale : in Journ. des Beaux Arts*, 1861, 54.—*Weale : Beffroi*, iv.—*Delepierre : Précis analytique des Documents des Archives de la Flandre occidentale*, i. 155 (1840).

VRIDRIC, GUERARD. *Illuminator.* Saec. xv.

Of Louvain.

Was engaged for six days at 7 sols per day on the occasion of
the marriage of Charles le Téméraire to Marguerite of York in
1468. "A Guérard Vridric Verlichter, paie pour vi. jours quil a
ouvre a vii. s. (sous) pour jour, xlii. s."—*Reiffenberg: Comptes* in
his edit. of *Barante, Hist. des Ducs de Bourgogne*, x. 239.—
Michiels: Hist. de la Peinture Flamande, ii. 419.—*Messager des
Sciences, Hist. de la Belg.,* 1855, 118. "Un centaine de peintres
furent employés par Charles le Téméraire en 1468 pour les
décorations de ses noces faites à Bruges. On les appela de
Tournay, de Bruxelles, d'Anvers, du Hainaut, de Cambray,
d'Arras, de Valenciennes, de Douay, de Louvain, et d'Ypres.
Comme Hugo Van der Goes se trouva dans le nombre, mêlé,
confondu avec les autres on doit croire que ce n'était
pas de simple barbouilleurs. On possède maintenant leurs noms
(*see* notes to vol. ii. of Michiels), mais qui sait s'il existe encore
de leurs ouvrages ?"—*Michiels: Histoire de la Peinture Flamande
et Hollandaise,* ii. 260, 419.—*Laborde: Les Ducs de Bourgogne,
Preuves,* ii.

VUAREMBERTUS. *See* GAREMBERT.

VUC, JOORQUIN DE. *Copyist.* Saec. xv.

Given under 1419 in *Laborde: Ducs de Bourg.,* i. Pt. ii. 528.

VÜCHTER, ELIPHIUS. *Copyist.* Saec. XVI.

A Monk of St. Martin's of Köln.

Wrote "Libellus, continens varias litterarum formulas et artis
pictoriæ specimina."—*Ziegelbauer: Hist. Rei Litter., Ord. S. B.,*
i. 520.

VULPIUS, NICOL. VICENTINUS. *Copyist.* (?)

Wrote part of "Justini Duplicem Historiar. Epitomen," in
Library of S. Mich., prope Murano.—*Mittarelli: Præf.,* xviii.

Vulteris, Andreas Justi de. *Copyist.* Saec. xiv.

Wrote, in 1370, at Città di Castello, " La Divina Commedia,"
with Latin notes and commentary. Vellum. Folio. Each Canto
has a grand illuminated initial. In the first of the " Inferno " is a
figure of Dante holding a book. The first folio has also an
illuminated border, and several other pages have pictures. At end :
" Andrei Justi de Vulteris quẽ scripsi et compleui ĩ ciuitate castelli
año dñi M°ccc°lxx° Inde viii. die vj. nouembr." Now in the
Laurentian Library, Florence, Pl. xl.—*Bandini: Catalog., &c.*

Vulterris, Mattheus, de. *Copyist.* Saec. xv.
" Domini Herculani."

Wrote, and probably illuminated, a Breviary (or rather a Book of
Offices), in crimson velvet, with Russia leather case. This ex-
quisitely neat, perfect, and beautiful MS. is written on the finest
vellum, in an elegant Roman hand. The Kalendar is written in
gold, red, and blue letters. On the first most beautifully illumi-
nated leaf is written in gold letters on a crimson ground, " Incipit
Officium Bea . te Virginis Marie s̄m . Consuetudinem . Ro . mane
Curie ad . Matutinum." The border round this leaf consists of
small pictures in rounds and ovals. Birds, flowers, gems, pearls,
and the arms of the Duchess of Urbino with supporters, the whole
most exquisitely drawn and painted. The initial " D " contains the
Annunciation, most admirably executed. All the five illuminations
in this MS. are in the initials of the several parts of the Offices of
Our Lady, &c., and consist of holy men (some of which seem
intended for particular portraits) ; saints, hermits, holy women,
St. Agnes, David ; arms of Urbino ; Holy Ghost, the Virgin, the
Cross ; instruments of crucifixion, flowers, death, &c. The
borders down the sides of the leaves where the illuminated
initials are, consist of small oval or round pictures (in some of
which are represented the Crucifixion, Circumcision, Saints, &c.,
most exceedingly small, but most neatly executed) ; birds, arms,
flowers, fruits, books, sentences, lamps, &c. ; there are likewise
neat and varied borders down many other of the leaves of this book.
In one of the initial " D's " is written, in golden letters, " Dionora

Gonzaga, Duc . Urbini et C." She is likewise mentioned in others, but not so fully. At the end of this valuable book, after " finis," is written in the same hand as the MS. itself, " MANU . MATTHEI DOMINI HER . CHULANI . DE . VULTERRIS." Leonora, Duchess of Urbino, was the daughter of Francesco III., di Gonzaga, last Marquess of Mantua, and of Isabella, daughter of Ercole I., Duke of Ferrara. She married, first, Antonio, Duca di Montalto, and second, Francesco Maria, Duca d'Urbino, to whom she was united in 1509, and perished, it is said, by poison, in 1538. The exquisite Prayer-book, now in the Bodley Library, Oxford (Douce MSS., 29), was also executed for the same lady. The Offices written by Matteo da Volterra belonged in 1824 to Andrew Fountaine, who added a memorandum that the MS. was illuminated by Julio Clovio. As Clovio most probably illuminated the Oxford MS. this is possible (*see* CLOVIO). Dr. Waagen refers to it as follows : "It is a Prayer-book with pictures by Don Giulio Clovio, 8°, one col., written on fine parchment in an almost Roman text. No connoisseur of the miniatures of this master can doubt that the figures and most of the initials and border decorations are by his hand. Moreover, the purer taste observable in the figures, indicative of the school of Raphael, proves that they belong to his earlier and better time, not long after he had quitted the school of Giulio Romano at Mantua, and before he had fallen into the exaggerated imitation of Michel Angelo. My opinion is also confirmed by the circumstance that this Prayer-book was executed for Eleanora, or, as she was also called, Dionora Ippolita Gonzaga, daughter of the Marquis Francis III. of Mantua, and Isabella of Este, daughter of Ercole, Duke of Ferrara ; and wife of Francesco della Rovere, Duke of Urbino. In the Kalendar only the letters K L at the beginning of each month are elegantly decorated. The frontispiece is very rich. In an initial D the Annunciation is executed with great delicacy. On the border is the Almighty in the act of blessing. Above and below, in a circle fantastically formed of tritons, are the arms of the Dukes of Urbino, with the motto around alluding to Eleanora ' Diva Dio Duci : Ur.' The very beautiful and rich decorations, executed on a dead-gold ground, display a peculiar mixture of Italian and Netherlandish taste. To the first belong the symmetrically-arranged cameos and pearls ; to the latter the single flowers, strawberries, and birds distributed around them. As the heading of the next page is John the Baptist, a very delicate little figure. Many other initials and border decorations further on are by

another and less refined hand. Among the miniatures by Giulio
Clovio, the following are especially worthy of note. St. Jerome
with a crucifix in his hand, in a " D." The Crucifixion, with the
Virgin and St. John at the sides. St. Augustine, St. Ambrose,
St. Sebastian (of particular delicacy), a Saint with a crutch, and
King David. There is also a picture of the Duchess, with a
death's head, looking at herself in a mirror. The decorations
accompanying these pictures are tasteful in design, and of the
utmost beauty and elegance of execution. An inscription at the
end enlightens us also as to the writer of the book : " Manu
Mathei Domini Herculani de Vulterris."—*Waagen : Treasures of
Art in Great Britain,* iii. 431.—*Fenn : a Descriptive Catal. of the
. . . MSS. of B. P. Fountaine, Esq.,* Add. MS. 22,931, British
Museum.

WAGNER, CONRAD. *Illuminator.* Saec. XV.

A native of Ellingen.

Was sub-prior of SS. Udalrich and Afra, at Augsburg. Illu-
minated the MSS. written by Leonard Wagner, viz., a Missal,
1479.—*Braun : Notitia de Codd. MSStis., &c.,* iii. 23 ; also a
Gradual, 1490.—*Braun : Ibid.,* iii. 28.—*Veith : Biblioth. Augustana
Alphabet.,* iii. 128.

WAGNER, LEONHARDUS. *Copyist.* Saec. XV. et XVI.

Of Schwabmenchingen. A Monk of SS. Ulrich and
Afra in Augsburg, under Abbot Henr. Fryess.

Called also Wirstlin, and Hamaturgos (= Chartier, or Carter, *i.e.,*
Wagoner). Born at Schwabmenchingen in 1454. Died 1523. Priest
in the Monastery of SS. Udalrich and Afra, at Augsburg, and one of
the most skilful calligraphers produced in that famous scriptorium.
He travelled about to various monasteries in order to learn his
art, as to Zunefalten, Marienberg, and Salem. The number of
MSS. from his hand is considerable. A list of them is given in

Klamm: Hierarchia Augustana, iii. 116. Others are noticed by *Braun : Notitia,* &c., iii. 27 ; vi. 41, 45, 47. One of his MS., executed for the Emperor Maximilian I., is now at Munich. Another, a Hymnale Notkeri Balbuli, written and illuminated for the monastery of St. Gallen, but now in the Public Library at Zurich.— *Weidmann : Geschichte,* 429.

In 1479 " Scripsit librum Missale pro communi seu officio publico ad summum altare S. Narcissi et finiuit eundem librum proxima die ante festum S. Kunegundis virg. et regine anno gracie 1480. Laus Deo et retribuetur sibi merces in futura vita, Amen. Et illud Missale illuminavit et corporavit preciose fr. Conradus Wagner professus, hujus loci, nacione de Ellingen prope Weyssenpurg versus Neurenberga. Similiter alios libros plures, scil., Breviaria, Diurnalia ac Missale domini Johannis de Giltlingen abbatis nostri illuminavit et corporavit. Fuit enim in illa arte preciosus ac peritus." Under the same abbot, John of Giltlingen, he is named again, in 1490, " sponte et gaudenter se obtulit ad scribendum et notandum illum librum [scil. a gradual for the choir]. Deinde incepit scripsit ac notavit illud gradale omni diligencia qua potuit in preciosa litera et nota ; quod et inchoavit 1489 et finivit illud 1490 feria tercia post dominicam Palmarum illius anni id est octavo idus Aprilis. Illud autem gradale similiter et obediencia et bona voluntate fr. Cunradus Wagner de Ellingen conventualis et presbiter huius loci pulchre ac preciose illuminavit diversis picturis et ymaginibus in locis eiusd. libri convenientibus et figuris aptis ad festa Christi b. Virginis et alior. sanctorum per circulum anni. Illuminavit eciam in eodem libro vnam literam tantum fr. Stephanus Degen eciam conventualis." In 1491 Leon. Wagner again : " voluntarie scripsit pro choro et communi utilitate, &c. Leccionarium hyemale de tempore et sanctis juxta consuetudinem nostram—continens lecciones ab Adventu Dñi usque in Pasca tam de tempore quam de sanctis quem finivit feria sexta post festum Penthecostem, *i.e.* sexto kal. Junij de mane hora octaua, etatis sue anno tricesimo septimo, presidente dno. abbate anno ut supra." In 1492 he wrote another Lectionarium, " a Pasca usque ad adventum Domini quem finivit feria quinta post Pasca, *i.e.* sexto kal. Maij hora nona ante meridiem, presid. huic loco dño. Johanne de Giltlingen, etatis sue anno trices. octavo." Leonard Wagner is mentioned again in 1493, and there called " optimum scriptorem diversarum scripturarum." In 1494 he is by a special grace of the Abbot exempted from the choral and other labours, in order that he

may write a Psalter " quod voluntarie et obedienter onus acce-
pit." In this he is assisted by Balthasar Kramer. And when this
was finished they did another. Concerning the former, a note on
fol. 394 of Steichele's "Archiv" tells us that "infra spacium septem
hebdomadarum scripsit et notavit pro choro hujus loci preciosum
' Commune Sanctorum.' " And Balthasar is called ' substitutem et
scolarum prefati irĩs Leonardi Wagner." After the mention of his
Psalter, the historian writes : " Et predicta duo psaltaria corporavit
fr. Conradus Wagner de Ellingen conventualis et bonus illuminista.
Et idem fr. Conradus decoravit el illuminavit ac corporavit multos
libros, sc., missalia, breviaria, diurnalia devocionalia, fratribus hujus
loci eciam gradale vnum pro choro sua arte illuminavit. Et idem
frater diversis artibus fuit instructus ; cuius anima requiescat in
pace ! Sed illuminatura psalteriorum facta est in ciuitate per
quendam laycum sc. Jeorium Beck, et filium ejus ambo illuministe."
These notices of the Wagners, &c., are taken from Fr. Wiltwer's
"Catalogus Abbatum monasterii SS. Udalrici et Afræ Augustensis,"
in *Steichele : Archiv für die Geschichte des Bisthums, Augsburg*, iii.
302, &c.

WALTÈRE, PÈRE. *Copyist.* Saec. XV.

 Wrote, in 1466, "B. Hieronymi Epistolæ." Vellum and paper.
Folio, 2 vols. Now in the Library of the University of Liége.—
Catal. of Exposition Nationale, Bruxelles, 1880. MSS., No. 77.

WALTERUS. *Copyist.* Saec. XII.

 Wrote " Petri, Cantoris Verbum Abbreviatum." Vellum. Thin
folio, 57 ff. In small upright Gothic text, 2 cols. At end, in capi-
tals : " WALTERUS." Now in the British Museum, Add. MSS.,
30,056. Also, if not the same work, " Petri, Cantoris Parisiensis,
Summa de Pugillatione Vitiorum," &c. Vellum. Folio, 56 ff.
Formerly belonged to Cardinal Richelieu, and afterwards to Mr.
Bragge. Sold at Sotheby's in 1876.—*Catal.*, 67.

WARD, NICHOLAUS. *Copyist.* Saec. XV.

Wrote, in 1440, on vellum, 4°. 50 ff. various tracts : 1. "Vita prothoplasti Adæ." 2. " De Signo di Crucis." At end of which : " An. do. milleno. c. quater ter duodeno Bis seno primo fuit hoc scriptum memorando. Nomen scriptoris factoris qui fertur Warde Nicholaus. Pro quo letetur et semper glorificetur." Now in Library of Queen's College, Oxford, No. ccxiii.—*Coxe : Catal., &c.,* 47.

WAREMBERT. *Copyist.* Saec. XVII.

A Monk of Corbie.

Who, at the end of his MS., gives the usual verses about his trouble, and advises his reader to keep his finger off the writing, lest he should smear it. At end : " Ego in dei nomine Vuarembertus scripsi." — *Wattenbach,* 235. — *Delisle : Recherches sur l'ancienne Bibl. de Corbie,* in *Mémoires de l'Institut,* xxiv. 292.— *Serapeum* xxiii. 215.

WAREUX, PETER DE. *Copyist.* Saec. XV.

Wrote " De penitentia Ade ex libro colorum vel mythologiac mulierculum Biblia." At end : "Finitus fuit liber iste per manus dompni Petri de Wareux religiosi monasterii S. Petri Gemblacencis anno Domine M.CCCC.LVII.," &c. Now in the Royal Library, Brussels, No. 5,629.—*Marchal : Catalogue des MSS., &c.,* ii. 10.

WAS, JOHANNES. *See* SIFREWAS.

WEERT, FRANCISCUS. *Copyist.* Saec. XVI.

Of Louvain.

Wrote, about 1522, two enormous folio volumes—a Latin Psalter and an Antiphonary for the use of the Præmonstratensian

Abbey of Tongerloo, in Brabant. These books are enormously heavy, with wooden covers studded with brazen bosses, and thick leathern thong-clasps, capped with brass plates. Corners also tipped with brass. The text is a large and bold Gothic character half an inch high, with borders, initials, and miniatures, on vellum. Vol. i. has 222 ff. 2 cols. Fols. 1–7 *v.* are occupied by the Calendar, containing numerous Netherlandish saints. On the back of the second fly-leaf is the following inscription : " Ad laudem omnipotentis dei patris et filii et spūs sancti deipare Virginis Marie totiusq. celestis curie, istud Psalterium scribi fecit Reverendus Pater dñs Anthonius tsgrooten, de Oester- wyck Abbas modernus hujus monasterii Tongerlensis ordinis pre- monstratensis. Per franciscum weert scriptorem lovanii residentem. Anno verbi incarnati Mᵒccccc xxij. mensis martii die xxij finit feliciter. Deo gratias." And lower down, in the same large, bold, handsome hand :

" Si cupis eximias christo depromere laudes
Que cecinit psalter cantica sacra cane.
Ducit ad ethereos mentem psalmodia tractus
Et vehit ad superas pectora nr̃a domos."

Fol. 8. " Venite exultemus," &c. Fols. 8 *v.* and 9, have two large and beautiful borders of late Netherlandish style, consisting of jewelled candelabrum, flowers, birds, wreaths, &c., finely painted on scarlet, emerald, and golden grounds, in the manner of the large music books executed for Philippe le Bon, Duke of Bur- gundy, and now in the Royal Library at Brussels. The initials are large (two inches high), and executed with the pen, or rather painted, in red or blue, with the brush, and decorated afterwards with the pen and thin washes of colour. Folio 8 *v.* At foot of second col., a miniature of the Anointing of David, fairly executed. On fol. 9, at top, in a grand initial " B " of " Beatus Vir," is David at a desk composing his Psalms. The whole border round this page consists of detached flowers, birds, &c., on a wash gold ground. In the lowest right-hand corner a fine miniature of a bishop kneeling, and behind him his patron saint in black cloak. At foot, of fol. 8 *v.* also, are the episcopal arms : *or*, three chevronels *gu.*, on a blue ground within a green wreath, behind which is the golden episcopal crook. At foot of fol. 9 another coat; having, *or*, a tree proper on a small mound *vert*, accompanied by the letters A T, probably for Abbatiæ Tongerlensis. Behind is a large ribbon- label, bearing the motto : " Veritas vincit." This motto also

appears on a Flemish Renaissance arch over the bishop in the lower corner, together with the episcopal arms as on fol. 8 *v.* From fols. 9 *v.* to 40 are many initials, some painted in gold and colours, with jewels or flowers on coloured grounds. The letters themselves are usually painted in brown gold or in chiaroscuro, heightened with fine gold brushwork. Fol. 40 *v.* Miniature, David slaying Goliath, "Dominus illuminatio mea." Fol. 53. David praying; behind, an open landscape with architecture, "Dixi custodiam vias," &c. Fol. 63. Large initial "D," with David enthroned, and before him a clown with horned cap and fool's-staff, "Dixit insipiens in corde," &c. Fol. 73. David naked in a river, appealing to the Almighty, who is seated with the Virgin, St. John, and an angelic host in the clouds. In a grand initial "S" (Ps. lxviij.), "Saluum me fac deus : quoniam," &c. Folio 86. Initial "E" a party of monks, in white tunics and black cloaks, playing on musical instruments within an open court, a landscape beyond, and a figure of the Almighty in the sky. "Exultate Deo adiutore nostro" (Ps. lxxx.). Fol. 96 *v.* Initial "C," monks chanting "Cantate Domino" (Ps. xcvij.). Fol. 111. A full border, containing figures of angels with various musical instruments against a sky ground with blue clouds; at foot the abbatial arms as on fol. 9, and the motto as before. Also at top a grand initial "D," containing the Trinity, in the Netherlandish manner, *i.e.*, two figures seated, or enthroned, with dove floating between. Here they have golden robes; in many German and other MSS. the robes are scarlet. "Dixit Dominus domino meo" (Ps. cix.). Fol. 151 *v.* A bracket and initial "E," "Ecce ego mitto vos." Flowers, &c., and the motto, "Virtus vincit." Fol. 168. Large initial "A," holding the abbatial monogram and tree. Fol. 176 *v.* Initial "A," in which are jewelled flowers. The letter is silver-grey, on a pale crimson ground, with gold traceries; the large flower is a yellow pansy. Fol. 186. Initial "E," in brown, heightened with gold, on a rich ultramarine ground in panel with brown gold frame. On the lower limb of the letter a beautiful yellow and green bird is attacking an enormous yellowish-green caterpillar. Above, are a snail, and a violet with red and yellow petals. Fol. 197 *v.* Initial "D," "Diffusa est gracia." Gold brown letter on fine emerald panel-frame in brown gold, festoon of scarlet beads, and below a brown gold *tau,* enriched with pearls. Vol. 207 *v.* Initial "F," "Feliciter Virgines." Brown gold letter on ultramarine panel in brown gold frame. The letter, which is formed of foliage and stems, is decorated with a festoon of scarlet beads.

Vol. ii. contains 317 ff. Fol. 1. Initial "E" and border. "Ecce dies veniunt dicit dominus," &c. With musical notation on four red-lined stave. Subject of miniature in initial, the Last Judgment. Letter spoilt by rubbing. Border of golden ecclesiastical ornaments (*i.e.*, brown heightened and finished with fine gold hatchings), blue ribbon label, with motto, "Veritas vincit," vases of apples, and wreaths on a rich crimson ground. Here and there other initials, and many blue, red, and black capitals throughout. Fol. 46. A rich border, the upper part containing flowers on a gold ground; the lower, a number of peasants dancing. In the background, an angel appearing to a shepherd and unfolding a large label containing the words, "Gloria in excelsis." Large initial "S," with the Virgin Mary and angels adoring the Babe in the stable. St. Joseph stands in the doorway. "Scitote quia prope est regnum." Fol. 58. The Martyrdom of St. Stephen in initial "H." "Hesterna die dominus natus est," &c. Fol. 66. Initial "V." "Valde honorandus." St. John in Patmos. Fol. 74 *v.* Initial "S." "Sub altare dei." Murder of Innocents. Fol. 81. Initial "B." "Benedictus qui venit," a curiously-twisted letter with figure of a man and a dove. Fol. 91. Initial "M." "Magi videntes stellam." The Adoration of the Magi. Fol. 147 *v.* Initial "E." "Educ de carcere animam meam." A most curious subject of three devils of frightful aspect, and a woman, naked, floating in the air above them. Fol. 158 *v.* Initial "T." "Tolle armatum a pharetram." A nobleman seated at a table, and served by an attendant; through window a landscape with man shooting. Fol. 166. Initial "P." "Pater, peccavi in celum." The Return of the Prodigal Son. Fol. 176 *v.* Initial "N." "Nemo te condempnauit." The woman taken in adultery. Fol. 193 *v.* Initial "C." "Circum dederunt me." Christ's entry into Jerusalem. Fol. 218. Initial "O." "Omnes amici." The Crucifixion. Fol. 224 *v.* Initial "S." "Sepulto domino." The Entombment. Fol. 231. Full border and initial "C." "Conditor alme syderum." Figure of Christ walking—the attitude one of dignity and grace. The border is divided into compartments, with alternate crimson and gold grounds, except in centre of lower border, where the artist has placed a quaint representation in a landscape of the Martyrdom of St. Andrew. On the gold grounds are flowers and insects, on the crimson brown gold foliages, richly painted and blue flowers. Fol. 239. Initial "U." "Uidit dominus petrum et andream." Christ by the seaside, and Peter and Andrew in a boat drawing a net. Fol. 248. Initial "A." "Amauit eum domi-

nus." St. Nicholas and the three children. Fol. 257 *v.* Initial "G" and full border. "Gaude mater ecclesia." The Visitation. Border in compartments; gold and slate grounds, containing flowers, &c. At foot, miniature of the birth of the Virgin. On the backs of the chairs are the letters, in a circlet, I. O. V. Fol. 277. Initial "I." "In tua paciencia." St. Lucia in a landscape scene, a sword pointed at her throat, a book in her right hand, and a palm in her left. Fol 270. Initial "B." "Beata Agnes in medio flamarum." Figure of St. Agnes, with sword and lamb. Fol. 267. Initial "O." "O lumen omnium ecclesiarum." The Conversion of St. Paul. Fol. 285 *v.* Initial "H" and border. "Homo erat in iherusalē." The Presentation in the Temple. The upper part of border, candelabra, beads, wreaths, &c., on a crimson ground. Lower corner, priest receiving gifts from devotees before the high altar of a cathedral. At side of this, in lower border, the abbatial arms. Fol. 293 *v.* Initial "S." "Stans beata Agatha in medio carceris." The Martyrdom of St. Agatha. Fol. 30 *v.* Initial "S." "Simon bariona tu vocaberis cephas." Coronation of a Pope (St. Peter). Fol. 310. Initial "M" and border. "Missus est Gabriel." The Annunciation. Border consists of beautiful flowers and insects on gold ground. Episcopal arms at side. This is the last ornament in the volume, which ends on fol. 317. Formerly in the Library of the Duke of Sussex (lot 380 in the sale catalogue). Now in British Museum, Add. MSS., 15,426, 15,427.

Anthony Tsgrooten was the thirty-second abbot, and succeeded in 1504. He died 1530.—*Sanderus : Chorographia Sacra Brabantiæ,* i. 329 (fol. Hag. Com. 1726).

WEGELHEIM, JOHANN V. *Copyist.* Saec. XV.

Monk of Abbey of Mölk in Lower Austria.

Cahier : Bibliothèques, 140.

WEICKMANN, GEOR. *Illuminator.* Saec. XVI.

Illuminator at Court of Bavaria in time of Duke Wilh. V.

Often mentioned in the accounts. Under date 1571 of extracts from registers, among other interesting particulars, it is just

mentioned that "Georg Weickmann der Maler um 2 baier. *Mappas* zu illuminiren 20 fl." Fol. 88, under 1580, Item "Georg Weickmann der illuminist die baier. Wappen für die Kunstcamer, unndt Gorg Neidhart der Rottschmied Rechenpfenninge gemacht hat," and immediately follows "Dernach Georg Hufnagl unndt Christian Tegler allbaid Maler." Fol. 92, under 1584, Item, "Georg hufnagel nederländischen Mallern pr. Arbeit 575 fl. ihm auf seine hochzeit ain becher verehrt." Fol. 24, fl. 56 : and "Georg Weichmann der Illuminist, Görg hebenstreitt der glasmaller von wegen seines Meisterstuckhs, so es seiner fürstl. gnadten abergeben 40 fl."—*Westenrieder: Beyträge z. Vaterländ. Historie*, B. 3, S. 82, 88. (*See* HOEFNOGEL.)

WEISSENBURG, OTFRID VON. Saec. IX.

Monk and Abbot of Weissenburg, in Alsace.

Wrote "Die Evangelienharmonie," now in the University Library of Heidelberg (Pal. lat. 52x).—*Bartsch : Catal.*, 1.—*Oechelhauser : Die Miniaturen der Universitäts-Bibliothek zu Heidelberg*, 5. The ornament inclines rather to Anglo-Saxon than Carolingian, though it is often spoken of as being of the latter kind, as some of the ornaments are similar.—*Lamprecht: Die Initial-Ornamente, &c.*, 6.

WENCESLAS, or ⎱ *Patron.* Saec. XIV. et XV.
WENZEL. ⎰

Emperor of Germany.

An eccentric art-loving prince. For him was executed the German Bible in six volumes, now in the Imperial Library at Vienna (No. 2,759), the beautiful foliages of which may compare very favourably in elegance of design and pleasant colouring with the finer but more formal illuminations of France and Flanders. Its figure-drawing is out of proportion and clumsy, and certainly not better than the Italian figure-painting of the same period, both inferior to the French ; although the study of the nude is wretchedly backward even in the last.—*J. W. B. : MS. Notes at Vienna.*

WENCESLAUS,
WENZEL, } ST. *Patron.* Saec. X.

Wenceslaus I., Duke of Bohemia, was educated by St. Ludomilla, his grandmother, and succeeded his father, after whose death the country became embroiled through his ambitious mother, Drahomire, who ruled during the minority of her two sons. She persecuted the Christians, shut up their churches, and at length murdered Ludomilla in 922. But Wenceslaus, on his accession, compelled her to obedience and quiet. In 930 he was besieged in Prag by the German Emperor, Henry the Fowler, and submitted, but was soon in friendly relation with the conqueror. During his reign, Bohemia suffered greatly from the incursions of the Huns, and his zeal for religion and the reform of abuses made him many enemies; and, among others, his own brother, Boleslaus, it was said privately instigated by their mother. He was invited to Boleslaus' capital, Buntzlau, to a festival, and assassinated in the church in September, 936, at the age of thirty. He was afterwards canonised. In the University Library at Prag is a MS. of the Gospels, called Vysrader or Wysschrader Codex, because it formerly belonged to the Collegiate Church of Wyschshrad, on vellum. Large 4°, 108 ff., written in capitals, which appears to be contemporary, or nearly so, and of northern influence. The pictures are chiefly from the New Testament, and such as are usually found in work of the eleventh century, and closely resembles the Passionale in the Library at Stuttgard, which belongs to the early part of the twelfth. The gold is raised and burnished, and silver and bronze also used, which, especially the silver, have become quite black. The ornaments of the borders, specimens of which are given by Grüber, are quite similar to the glass-paintings of the twelfth century. Fol. 1 *v.* begins a series of seven full-page miniatures,—the four Evangelists, Patriarchs, and Fathers, and the Jesse tree of Christ. The figure of Christ is in the costume of the Karolingian kings; the cross-sceptre in his left hand, the lily-sceptre in the right, enthroned in a Romanesque building. At the side of the Baptist is the Jordan, symbolised as a naked youth. In addition to these are eighteen other figures in the text, also the size of the page. There are also many large initials on bright gold grounds. In the initial D on fol. 28 is the figure of Saint Wenceslaus enthroned and surrounded by the inscription: "S. VEN . ZEZLA . VVS . DUX." The MS. is 415 by 335 s.—*Grüber : Die Kunst des Mittelalters* in *Böhmen,* i. 93. (*See* SBISCO.)

WEND, BERNHARD. *Copyist.* Saec. XVI.

Wrote, in 1509, a Prayer-book, richly adorned with miniatures, now in the National Museum at Budapest.—*Jahn: Jahrbücher der Philologie und Pädagogik. Suppl.*, v. 618.

WERKEN, THEODORICUS. *Copyist.* Saec. XV.

Apparently a native of Abbenbroeck, but working in London, and on the Continent. Wrote a number of MSS. now kept at Balliol College, Oxford. They are Nos. xxxiv., lxvi., lxvii. A, cxxvii., ccxxxviii., cclxxxvii°, ccxcv.

1. Vellum, large folio, 253 ff. "Thome Ringstede Dominicani, expositio super Parobolas Salomonis," &c. At end: "Postilla Thome Ringestede, Anglicis super proverbia Salomonis ordinis Prædicator. sacre pagine professoris, scripta London. 1461, 28 Febr. T. Werken." No. xxiv. (cat. 10).

2. Vellum, large folio, 252 ff. "Francisci de Maironis sive de Mayronibus, sermones," &c. At end: "Theodericus Nicolai Werken de Abbenbroith scripsit hunc librum." lxvi. 18.

3. Vellum, large folio, 257 ff. "Francisci de Mayronibus, sermones, æstivales." At end: "Per manus Theoderici Nycolay Werken de Abbenbroeck liber explicit Deo gratias. Anno Domini, 1444." lxvii. A, 18.

4. Vellum, small folio, 161 ff. "Francisci Petrarchæ poetæ Laureatæ de secreto conflictu querimoniarum suarum libri tres, cum promio, M. Tullii Ciceronis liber de Senectute, Eiusdem l. de Amicitia, Eiusd. l. de Paradoxis." At end of this: "Anno domini nostri Jhesu Christi, 1450. T. W. T. Werken." Followed by two tracts of Poggio Bracciolini, "De vera nobilitate liber. Eiusd. in Avaritiam." No. cxxvii. 36.

5. Vellum, folio, 135 ff. Vellum, folio, 242 ff. "Dominici Bandini de Arecio Fontes memorabiles," &c. At end of vol. ii., "Iste liber inceptus est Colonie anno domini, 1447, 20 die mensis Decembris et finitus est Rome anno domini, 1448 et 10 die mensis Februarii, T. Werken." ccxxxviii. 80.

6. Vellum, folio, 106 ff. In part. Signed, "T. Werken, 1450." cclxxxvii. 95.

7. Paper, folio, 148 ff. "Xichonis sive Siconis Polentani in Ciceronis opera Expositiones," &c. Signed after the first on

fol. 122, "Iste liber scriptus et completus est per me Theodoricum Nicolai Werken de Abbenbroec, anno domini, 1445." ccxcv. 97.

8. "Leonardi Bruni aretini Epistolarum ad Familiares." At end : "T. Werken, 1449."—*Coxe : Catologus Codd. MS. Collegii Balliolensis*, 10, 18, 36, 95, 97.

WERNHEM, WERNER VON. *Illuminator.* Saec. XII.

Monk of Tegernsee, famous as an artist.

Among other works, decorated the Life of the Virgin Mary with miniatures. Now in Royal Library at Berlin.—*Kugler F. (Kl. Schriften) de Wernhero, Sæc. XII. monacho, &c., &c.— Berolini*, 1831, 8°.—*Ziegelbauer : de Rei Litterar. Bened.*, t. i., pt. i. 540.

WERNHER. *Copyist.* Saec. XV.

A Monk.

Transcribed a number of tracts by St. Cyril, Albertus Magnus, John Gerson, &c. Vellum. Paper. Large 4°, 208 ff. Formerly in the Cathedral Library at Augsburg. Now in the Royal Library at Munich (Cod. lat., 3,801). Before tract 13 stands this note : "Sunt decem tractatus scripti per manus fratris Wernheri."— *Steichele : Archiv, &c.*, i. 124.

WERONAR, JODOCUS DE. *Copyist.* Saec. XIV.

Wrote, in 1380, "Gebete des Heiligen Bernard u. Anselm," or, as in the MS., "Hie hebet sich an des hei ligen herren Sand Bernharts gebette das er gemachet hat von unsers herren marter," &c. Vellum, 4°, 71 ff. This would have been a choice and

beautiful book if the illuminator had taken more pains, as the writing is fairly good German text. But with good arrangement of colours, in themselves of better quality than usual, he has been a heavy-handed sort of wall-painter, with no sense of delicacy. Large hands and feet, coarsely-marked features, and rough handling, with an attempt at expression showing some artistic qualities, are the characteristics of this miniaturist. The ornaments are precisely in the style of the Wenzel Bible at Vienna, but far from being so graceful or finished in execution. On fol. 60 *v.* is this note in blue : " Hie hat daz buch ein end hilf uns her nach diesem ellend." Then in black : "Completus hic liber sub anno domī Mccc octuagesimo vicesima secunda die mens⁹ septembr⁹ fm̄ (feriam) ii. proxᵐ. pˢᵗ Bartholomei. In Nurebg p̄ Iodocum de Weronar." Of this MS. the catalogue says, it is "a German translation of the ' Meditatio de humanitate Christi ' of S. Anselm, erroneously ascribed to St. Bernard," and other devotional writings. Now in the British Museum, Add. MSS., 15,690.

WESEMAEL, J. DE. *Copyist.* Saec. XIV.

Calls himself " scriptor librorum missalium " in a document dated 4 Dec., 1346. He then resided at Louvain.—*Messager des Sciences historiques de la Belgique,* 1855, 110. Original notice in Archives of Abbey of St. Gertrude at Louvain. —*Pinchart : Archives des Sciences, &c.,* i. Sér. i. 94.

WESTPHALIA, MATTHIAS DE. *Copyist.* Saec. XIV.

Wrote " Bartole de Saxoferrato in secundum librum Infortiati lectura." Paper. Folio. 305 ff. Partly illuminated. On fol. 300 : "Scriptum per me Mathiam de Westfalia." And the following note as to cost :—"Ser. Bar. super ii. Infortiati, ducata 44 vᵃ. Item pro pictura armorum cum pilleo holl. 3. Ista non fuit empta ad petias, sed in summa cum prima parte, est autem ista petiarum 70. Costant miniatura et ligatura ducata 3, et sic remanet petia pro s. 8." Now in St. Mark's Library, Venice.—*Valentinelli : Bibliotheca MSSta. ad S. Marci Venetiarum,* iii. 7.

WHETHAM, JOHN. *Copyist.* Saec. XV.

A Carthusian Monk of the Convent of Bethlehem at Sheen.

Wrote "Sancti Chrysostomi Homeliæ super Evang. S. Joannis." Vellum, 4° (11 × 8½ in.). 230 ff. The MS. agrees in every respect with the first edition printed in the Monastery of St. Eusebius, at Rome, in 1470. At the beginning is this inscription : "Liber domus Ihū de Bethleem de Scheene ordinis Carthusienš quē scripsit domͧus Ioh Whetham monachus professus domus londoñ. eiusdem ordͧis p ven'abili patre d. Radulph Tracy tūc pore dc̄e domus de Stheene ad instancias Rev'endi pris et dni J. Yngylby tūc ēpi Landavensis q̃ etiā quõdā fuit prior de Stheene et pdecessor imͧediatus pdicti patris Radulphi Tracy A° dõ, 1496. Ad laudem dei. Amen." At the end : "Orate specialiͬ p aia d. j. Whetham qui hūc librū scripsit anno dni m̄° cccclxxxxvii ipm̄ inchoans in medio q̃dragesime cui⁹ finē fecit circa ftm̄ St. Mathei apťi eodē anno pro cui⁹ labore premiū sit ipē largitor bonoᴣ oim̄ Ihūs xp̄us in Bethleem ex Virgine natus. Amen." Formerly in the Library of the Duke of Sussex.—*Pettigrew : Bibliotheca Sussexiana*, i. cxxii.

WICK, PAULUS. *Copyist.* Saec. (?)

Of Deckingen.

A monk and copyist of Tegernsee.—*Jos. v. Hefner : Oberl. Archiv, &c.*, ii. 27.

WIDRUG, ⎱ *Copyist.* Saec. VIII.
WINTRUG. ⎰

Probably a companion of St. Boniface.—*Cahier : Bibliothèques*, 128. (*See* VIDRUG.)

WIERIX, { JAN, } *Draughtsmen and Engravers.*
WIERX, { JEROME. }

Saec. XVI.

Executed two or three pen-drawings for a MS. called " Exercitia Diurna," written for Alexander Farnese, Duke of Parma, Commander of the Spanish army in the Netherlands. Vellum. 12°. (4¾ × 4 in.) 44 ff. The miniatures are, 1. Charles V. praying; 2. Crucifixion, with distant view of Jerusalem; 3. Sacrament of the Mass. Besides these are two very rare portraits of the Duke of Parma, by Jerome Wierix, to whom also the third drawing is attributed. On the last leaf is a prayer added by the copyist, " Lucas de Vergara en Brusselas. Ano 1597." Formerly in possession of Mr. Bragge. Sold in 1876 at Sotheby's.—*Catalogue*, 30, No. 161. The brothers Jan, Jerome, and Anthoine Wierx were all skilful engravers, and excellent draughtsmen. Jan, the eldest, was born at Bréda, in 1550; the other two at Amsterdam, in 1551 and 1553. When twelve years of age, Jan executed a copy of the " Man of Sorrows," by the Master of Nuremberg, and Jerome at about the same age produced " St. George on Horseback." Anthoine was not long behind with good work, and the three speedily became famous. The mass of work they produced is immense. In the Print Room of the National Library in Paris the pieces number eleven hundred. Those of the cabinet de Maroles reached a hundred more.

The name of Wierx closes the period begun by Lucas van Leyden.—*Joubert: Manuel de l'Amateur d'Estampes*, iii. 214.— *Curmer: Evangiles, &c., Appendice, &c.—Guilmard: Les Maîtres Ornemanistes*, 488.—*Nagler: Künstler-lexicon*, xxi. 396–490.

WIKING. *Copyist.* Saec. XI.

Monk of Prüm, under Abbots Hilderich and Stephanus.

Perhaps wrote MS. No. 641, Suppl. lat., National Library, Paris.—*Cahier: Bibliothèques*, 134.—*Waagen: Kunst und Künstler in England und Paris*, iii. 276.

WILD, CONRAD. *Copyist.* Saec. XIV. et XV.

Wrote "Plauti Comœdiæ." Vellum, small 12°, 110 ff. In a close upright text of Gothic type. Red capitals and headings. No other ornaments. At end in red: "Explicit amphitrion ꝑme Mgrm. Conradum wild de alamaniā oriūdū Anno do Mcccc., 31 die 19 mēsis Septembris." Now in British Museum, Add. MSS., 11,900.

WILFRID. *Patron.* Saec. VII. et VIII.

Archbishop of York (664–709).

Was a great lover of books, and made frequent journeys to the Continent in order to obtain them. For example, he brought from Italy a Gospel-book, "de auro purissimo in membranis de purpura coloratis," and founded a library of books, of which many were bound in covers of gold set with precious stones, which the biographer calls "inauditum ante sæculis nostris quoddam miraculum."—*Wattenbach: Das Schriftwesen des Mittelalters,* iii. 210. He introduced Byzantine and Italian art among his fellow-countrymen, by which the Anglo-Saxon calligraphers learned the application of gold, an art unknown to their Celtic predecessors of Iona, Armagh, Durrow, and Kells. It is used sparingly in the Lindisfarne Gospels or Durham Book, which is one of the earliest instances known in Saxon art.

WILHELM. *Copyist.* Saec. XIV.

A Cistercian Monk of Heilbronn.

Mem. de l'Acad. de Turin : Littérat. et Beaux Arts, 1809, 10-(11), 594.—*Bulletin du Bibliophile Belge,* ii. 5.—*Le Glay : Catal. des MSS. de la Biblioth. de Lille.*

WILLELMUS. *Copyist.* Saec. XII.

Called "Anglicus."

Wrote, in a clear Roman hand, for Henry, Count of Champagne

a "Valerius Maximus," now in the National Library, Paris (MS. lat., 9,688). At end : "Feliciter emendavi. Descriptū Pruuini jussu illustris comitis Henrici Willelmus Anglicus. Anno incarnati Verbi M⁰c⁰L⁰xvii^{mo}. ind. x v."—*Delisle : Cabinet des MSS.*, ii. 352, and iv.: xxxvii. 5, 6.

WILLELMUS. *Copyist.* Saec. XIV.

Wrote and notated a fine Antiphonary in folio, vellum, 291 ff. With eleven sets of bars of music on each page, between which is written the text. It is entitled " Antiphonarium secundum usum Sarum." Begins with rubric of office for Feb. 14, St. Felix, and is otherwise imperfect. On folio 49 : "Si queratur nomen scriptoris Willelmus ei detur." On fol. 155 *v.* : "Amen quod Ludlou Scholasticus Cantabrigie." The writer's name, perhaps, was William Ludlow.—*Catal. of MSS.* in the Library of University of Cambridge, iv. 130.

WILLELMUS. *Copyist.* Saec. XV.

Wrote, about 1401, "Speculum Devotorum." Paper, 4°, 146 ff. It is called in English, "A Myrowr to Deuot Peple," being meditations on the life of our Lord, but not the work of Bonaventura. Addressed to a lady, probably the Abbess of Bethleem, at Shene. On fly-leaf, at beginning : "Speculum Deuotorum et est liber domus Ihū de Bethleem ordinis Cartusiensis de Shene, et nomen scriptoris Willelmus plenus amoris."—*Catal. MSS.* in the Library of University of Cambridge (Gg. i. 6), iii. 18.

WILLIELMUS. *Illuminator.* Saec. XIII.

Called in the Close Rolls of 36 Henry III., "pictor Regis." "Mandatum est Radulpho de Dungun custodi librorum regis, quod magistro Willielmo pictori regis habere faciat colores ad depingend*um* parvam garderobam reginæ et emendend*um* picturam magnæ cameræ regis et cameræ reginæ."—*Westwood : Palæogr. Sacra Pictoria*, xiv.

3 H

WILMART, GEO. HERMAN. *Copyist.* Saec. XVII.

Wrote, in 1658, at Brussels, a Book of Hours. Vellum, with miniatures. Now in the National Library, Paris, MS. lat., 10,569.—*Delisle : Inventaire des MSS. latins, conservés à la Bibl. Nationale,* 81 (Paris, 1863, 8°).

WIMERCATO, GUINIFORTE. *Miniaturist.* Saec. XV.

Cittadella : Notizie, &c., 179.

WINPIA, JOANNES DE. *Copyist.* Saec. XV.

A Monk.

Transcribed, in 1449, "Discipuli Sermones—pars æstivalis." Paper. Folio. 325 ff. At end : "Explicit liber iste per me fr. Joannem de Winpia. Ord. Præd. sub A.D. 1449. Now in the Royal Library at Munich, cod. lat., 3,753—*Steichele : Archiv, &c.,* i. 116.

WIRSTLIN, LEONARD. *Calligrapher.* Saec. XVI.

An "Antiquarius" of St. Ulrich, of Augsburg.

Compiled a treatise on Calligraphy, with models and details of one hundred different Latin texts. This collection was presented to and accepted by the Emperor Maximilian. It includes, it is said, models of writing from the eleventh century of the most curious character, imitated with an admirable elegance and fidelity. But the authors of the "Nouveau Traité de Diplomatique" make very light of this remarkable book (though they are not always quite happy in their so-called facsimiles), and suspect with apparently little reason the busy palæographer of the sixteenth century of having invented some of his texts as well as their names. It should be said, by the way, for the sake of the honour of the poor German Benedictine, that his *confrères* from Paris never saw his work.—*Cahier : Bibliothèques,* 142.—*N. Traité de Dipl.,* ii.

Wislabertus. *Copyist.* Saec. ix.

Wrote at Uzès, in 842, the religious compendium called the "Manual of Dhuoda, or Duodana, wife of Bernard, Duke of Septimania," now in the Public Library at Nîmes. The princess for whom the Manual was written, married in 824, Bernard, son of the famous William of Gellone, for whom the celebrated Sacramentary of Gellone was executed. The Manual was composed for the instruction of her son William. Its sixty-three chapters contain much curious information respecting the history of the ninth century. The Acta Sanctorum (Sæc. iv., p. 1, pp. 750–757), in 1677, gave its table of contents and thirteen of its chapters, and Migne has reproduced them in his "Patrologia." Baluze, in 1688, published the preface and conclusion. Both or all these are not only too brief, but are, moreover, very incorrect, the idea given in them that Dhuoda was a daughter of Charlemagne, being quite without foundation. There have been several transcripts of the Manual, one of which is now in the National Library, Paris (MS. lat., 12,293). In another, made by Pierre de Marca, was the inscription :—" Qui legis, ora pro prescripta Duodana, et pro scriptore Wislaberto, qui magno labore hunc codicem, scripsit manualem." The Paris copy contains some Latin verses, the initials of which give the acrostic: "DHVODA DILECTO FILIO VVILHELMO SALVTEM LEGE,"—a motherly prayer for her boy, then fifteen years of age. The verses themselves allude to the troubles which followed the death of the Emperor Louis le Debonnaire.—*Delisle :* in *Comptes Rendus de l'Acad. des Inscript.* Reprinted Jan., 1886, and sent to me by the author.

Wissbach, Johannes de. *Copyist.* Saec. xiv.
Monk and Abbot of St. Ulrich, at Augsburg.

Is recorded as constantly engaged in copying MSS., even after becoming Abbot. — *Ziegelbauer,* ii. 516 ; quoted by *Cahier : Bibliothèques,* 139.

Withoos, Jan. *Miniaturist.* Saec. xvii.
Born at Amersfoort, 1648.

Was the eldest son and scholar of his father, Matthew Withoos. Afterwards went to Italy, and made drawings of places near Rome.

He worked in a neat and finished style, his usual subjects being flowers, plants, insects, &c., painted on vellum.—*Hobbes: Picture Collector's Manual*, ii. 529.

WITHOOS, FRANZ. *Miniaturist.* Saec. XVII.

Born at Amersfoort, in Holland.

Was the youngest son of Matthew Withoos, and practised the same kind of work as his father and brothers, but was greatly inferior to them. He died in 1705.—*Hobbes: Picture Collector's Manual*, ii. 529.

WITHOOS, MATTHEW. *Miniaturist.* Saec. XVII.

Born at Amersfoort, in Holland, 1627.

Was a scholar of Jacob van Kampen, and afterwards travelled in Italy with Otho Marcellus, and distinguished himself as a painter of plants, fruits, flowers, reptiles, and insects, which he represented with surprising fidelity. In execution his work is neat and highly finished, and his miniatures are greatly admired and obtain high prices. He died in 1703.—*Hobbes: Picture Collector's Manual*, ii. 466.

WITHOOS, PIETER. *Miniaturist.* Saec. XVII.

Born at Amersfoort.

Studied under his father, Matthew Withoos. He excelled in painting flowers, insects, &c., on vellum, accurately designed, coloured from nature, and finished in a delicate style. His works are highly esteemed. Died 1693.—*Hobbes: Picture Collector's Manual*, ii. 529.

WITSGOIOUS. *Copyist.* Saec. XV.

Wrote Ovid's Metamorphoses. In 8ᵛᵒ. Vell. " Sum Scriptor
talis demonstrat littera qualis Ille qui scripsit vocatur WITS-
GOIOUS."—*Senebier : Catalogue Raisonné des MSS. . . . de
Genève,* 229.

WOGAN, THOMAS. *Miniaturist.* Saec. XVIII.

Practised at Dublin and in London.

Exhibited at the Royal Academy from 1776 to 1778. Died in
Dublin 1780.—*Redgrave : Dict. of Artists of the English School.*

WOHLGEMUTH, MICHAEL. *Designer and Painter.*

 Saec. XV.

Designed the woodcut illustrations for a work entitled the
" Schatz Behalter," a sort of ascetic compilation without interest,
and without arrangement. It was undertaken for Antony Koburger,
the first Nuremberg printer, called by Badius the " prince of book-
sellers," since he directed an immense establishment employing
more than a hundred workmen, without counting smaller houses
at Basel and Lyons. Wohlgemuth, born at Nuremberg, in 1434,
was then in the full vigour of his talents. He set to work, and,
thanks to the ability of his engravers, of whom William Pleyden-
wurff was probably one, Koburger was able to put the book on sale
in the course of 1491, in 352 folios of two columns. Without
reaching perfection, the designs of Wohlgemuth, very German, very
striking, present the vigour and merit of the future school of
Nuremberg. The figure is no longer a simple line, as in the block-
books, but a combination of interlaced cuttings, intended to imitate
colour. If there is less grace there is more individuality than in
the Italian book-illustrators of the time. Wohlgemuth also com-
posed the designs for the Nuremberg Chronicle of Dr. Hartmann
Schedel, printed by Koburger, 1493.—*Bouchot and Bigmore : The
Printed Book, its History, Illustration, and Adornment,* 60–62.

WOOD, WILLIAM. *Miniaturist.* Saec. XVIII.

Born, 1768, in London.

Exhibited at the Royal Academy from 1791 to 1807. He improved the stability of colours on ivory. Died 1809.—*Redgrave : Dict. of Artists of the English School.*

WORLIDGE, THOMAS. *Miniaturist.* Saec. XVIII.

Born 1700. Died 1766.

For the greater part of his life painted portraits in miniature, afterwards, with worse success, in oil ; but at last acquired reputation and money by etchings in the manner of Rembrandt, which became a fashionable craze of the time. His last work was a book of gems from the antique. His wife used to copy paintings in needlework.—*Walpole : Anecdotes of Painting, &c.,* ii. 334-5 (Wornum).

WOUTER, BRO. HUGH. *Copyist.* Saec. XIII. et XIV.

Wrote, in 1401, " Horæ Beatæ Mariæ Virginis c. Calendario." A Dutch MS. with the copyist's name, " Broeder Hugo Wouter, die bruyn loue." With fifty-eight borders and eleven initials.— *Sale Catal.,* Feb. 7, 1870, 29, No. 254.

WULF, PIETER DE. *Copyist and Illuminator.* Saec. XV.

Is named first in the accounts of the Illuminators' Gild (of St. John and St. Luke) at Bruges, in 1489. One of his pupils was Jan Moes, of the Convent of Carmelites at Bruges, who became a member of the Gild in 1509.—*Beffroi,* ii. 300.

WULFRINUS. *Calligrapher.* Saec. XI.

Wrote a Latin and Saxon Psalter, now at Paris (MS. lat., 8,846).—*Delisle : Cabinet des MSS.,* i. 65. Facsimiles from this

precious MS. are given by Silvestre, pl. ccxxxi., and in Cooper's
Report on the Fœdera, App. B. The text was published by
Thorpe. Oxf^d. 1835, 8°.—*Delisle : Ib.*, iii. 339.

WULFSKERKE, CORNÉLIE VAN. *Illuminator.*

Saec. xv. et xvi.

A Nun of the Sœurs de Notre Dame de Sion, at
Bruges.

Illuminated, in 1503, certain Missals, Antiphonaries, &c., for her
convent.—*Le Beffroi*, iii. 320-322.

WULSTAN. *Calligrapher, &c.* Saec. xi.

A native of Warwickshire.

His parents sent him to school at Evesham, and afterwards to
Peterborough. There he had a master called Eruentus (Ervenius),
who could write admirably, and draw anything in colours. He made
Wulstan, when but a boy, write two books: a "Sacramentarium" and
a "Psalterium," and flourish the principal letters in pictures with
gold. The former of these his master presented to King Cnut,
the latter to Queen Emma. Wulstan afterwards became a monk,
and was made Master of the Boys, then Chanter, then Sacrist ;
afterwards Præpositus, or Prior, and at last Bishop of Worcester
After a long and troubled life, he died in 1095.—*Gunton : History
of the Church of Peterburgh*, 259. 1686. Folio. "Habebat tunc
magistrum Ervenium nomine, in scribendo et quidlibet coloribus
effingendo peritum. Is libros scriptos, sacramentarium et psal-
terium quorum principales litteras auro effigiaverit, puero Wolstano
delega curavit. Verum doctor ad sæculi spectans commodum spe
majoris pretii sacramentari regi, tunc temporis Cnutoni, psalterium
Emmæ reginæ, contribuit."— *Will. Malmesburiensis : Scti. Wolstani
Vita.* (See ERVENIUS.)

Wurmprecht. *Copyist.* Saec. xiv.

Lived at Vienna.

Wrote a Calendar in 1373; now in University Library at Grätz.
— *Kohl: Hundert Tage in den Oestr. Staaten,* B. 5, s. 39, &c.

Würzburg, Brun von. *Illuminator.* Saec. xv.

A writing-master of Erfurt, taught "floritura et illuminatura."
—*Wattenbach: Schriftwesen,* 307.

Wyeland, Guill. *Illuminator.* Saec. xv.

Worked for Philip, Duke of Burgundy, from 1467 to 1471, when
he entered the Gild at Bruges.—*Kirchhoff,* 188. "Item à Guillaume
Wyelant, aussi enlumr. pour lx. ystories et de plusieurs couleurs
quil à faités ou second vol. des ystories des nobles privees de
Haynnau, au pris de xxiiij. sols chacune ystorie l'une xiiij. l'autre
font," Lxxij. *l.—Laborde: Les Ducs de Bourgogne, 2nde partie,
Tome* i., 503. This illuminator possessed the usual qualities and
defects of his profession. Facility of hand comprises all his
qualities. His defects are of all sorts,—abuse of brilliant colours,
loud tones, predilection for blue in the draperies and the
roofs of houses—a vivid blue which renders badly the slate;
monotony in the expression of the figures, and uniformity of
type; eyes astonished, head often in the air, feet badly posed
on the ground; figures designed as if seen from above, and in a
bird's-eye view; background minutely detailed, but cold in effect,
insipid, and unnatural. Yet most MSS. which I find so much
praised in other libraries are not a bit better in character than
this. Wyeland was assisted by a *confrère,* who gave a quieter
look to his figures, but had not his ability. Wyeland is not to
be confounded with Vrelant, who is a different person.—*Laborde,*
503, 581.

Wyke. *Copyist.* Saec. xv.

Wrote, 1. "Johannis Scharpe vel Scharpæi Quæstiones de
Anima, &c." At end : "Ecce finis titulacionis istarum quæstionum
super totam metaphisicam. Quod Wyke."—*Coxe : Catal. Codicum
Collegii Mertonensis*, 99, No. ccli.

Wylde, Johannes. *Copyist.* Saec. xv.
Precentor of Waltham Abbey.

Wrote a collection of musical treatises, among which are
"Musica Guidonis Monachi," "Metrologus Liber," "Regulæ
Magistri Johan Torksey," and "Magistri Thomæ Wal-
singham," and "Tractatus Magistri Johannes de Muris, de
distantia et mensura vocum," and others. In red, on first fol. :
"Hunc Librum vocitatum Musicam Guidonis, scripsit Dominus
Johannes Wylde quondam exempti Monasterii Sanctæ Crucis
de Waltham, præcentor." "This MS. belonged before the
Reformation to the Monastery of the Holy Cross at Waltham, in
Essex, afterwards to T. Tallys, and others ; lastly, to the Earl of
Shelburne, who lent it to Dr. Burney, when compiling his 'History
of Music.' "—*Burney : A General History of Music* (1782, 4°),
ii. 412.

Wyss, Urban. *Calligrapher.* Saec. xvi.
Schoolmaster at Bischoffszell Switzerland.

Published : 1. "Mancherley Geschrifften ein zierlich neu
Fundament Buchlin, &c., durch Urban Wysz, diser zyt Schul-
meister zu Bischofszel, geordnet (ū) uszgangen in 4 ohne Yahrzahl,
in 12 Vorschriften v. deutchen sehr Klemen Current un Canzley-
schriften die Meisterlich in Holz geschnitten sind."

2. Also an important work in 1549 at Zurich, "Libellus valde doctus elegans et utilis multa et varia scribendar. literar. genera complectens," on 56 leaves in square 4°, together with many woodcuts. The whole "conscripta sculpta et impressa per Urbanum Wyss. Tiguri Anno Dn., 1549." The last leaf contains his signature with the well-known initials, J. A. of Jost Ammon and the monogram of Tobias Stimmer—these two famous artists probably taking part in the work. The whole work is a copy of the one written in Italy by Palatino, but much enlarged, and with the German hands added.

Another work of his was published at Basel in 1606 : "Fundamentalbuch von Mancherley Schriften," in folio.—*Breitkopf,* ii. 57.—*Jansen: Essai sur l'Origine de la Gravure,* ii. 115.

WYTENS, ELIZ. *Copyist.* Saec. XV.

A Nun.

Copied a Flemish MS. now in the Royal Library at Brussels.— *Cahier : Biblioth.,* 140.—*Marchal: Catalogue des MSS. de la Bibl. Royale,* ii. 103, No. 15,069.

XIMENEZ DE CISNEROS, CARDINAL FRANCISCO. *Patron.*
 Saec. XVI.

Archbishop of Toledo, and Regent of Spain.

Best known as having suggested, and aided the production of, the famous Polyglot Bible, called the "Complutensian Polyglot," because it was printed at Complutum or Alcalà in Spain. He was born in 1436, and died in 1517. He did not enter a religious order until forty-eight years of age, when he became a Franciscan monk. Eight years afterwards, in 1492, he was made confessor and counsellor to Queen Isabella, and, in 1495, Archbishop of Toledo. In 1500 he founded the University of Alcalà, and, in 1507, was made a Cardinal. On the death of Ferdinand he was appointed Regent. In 1514, two years before this event, he began the

publication of the Polyglot Bible, the plan of which had been ripening in his mind for many years, and continued it until his death. So vast and difficult a design required a man not only of wealth and position, but of considerable learning, unbounded energy, and unwearied patience. He had already undertaken the smaller, yet still laborious and magnanimous, task of providing magnificent Choir-books and the voluminous Missal for the use of his cathedral, which still remain. The famous Missal consists of seven folio volumes, containing a total of 1,543 folios, measuring about 46 by 33 c. ; vols. vi. and vii. are a little smaller. They are splendidly illuminated with very fine miniatures, initials, borders, and other ornaments. The music is written on red-line pentagrams. This Missal formerly belonged to the Cathedral of Toledo, but is now kept in the National Library at Madrid, No. 52 (16-22).— *Riaño : Notes on Early Spanish Music,* 69. .

YCIAR, JUAN DE. *Calligrapher.* Saec. XVI.

A Biscayan.

An able "escriptor de libros" of Saragossa. Published in 1529, "L'Arte sutilissima por la qual se enseña a escrivir perfectamente." 4°. The plates of this work were engraved by Juan de Vingles. A second and enlarged edition appeared in 1537, and a third in 1550. The writing surpasses in beauty that of the Italians of the same period, and the author gives examples of a great variety of characters and texts; including the "letra gotica," after the geometrical proportions of Albert Dürer.—*Jansen : Essai sur l'Origine de la Gravure, &c.,* ii. 55.

YSINNA, MATTII. DE. *Copyist.* Saec. XV.

Monk of Weiblingen.

Wrote, in 1465, "Ambrosii Exameron, seu de sex dierum operatione," together with several other tracts of the same author.— *Biblioth. Anonymiana (Hag. Comit.* 1728), 42, No. 521.

Dictionary of Miniaturists. [Yvo

YVONNET, LE JEUNE. *Copyist.* Saec. xv.

> Given under 1467 in *Laborde: Ducs de Bourg.*, i. pt. ii., 528.
> In the employ of the Duke of Burgundy, about 1467.—*Laborde*,
> 502, 3.—*Kirchhoff: Die Hdschr.-händler des Mittelalters*, 183.

YWEINS, BERLINETTE. *Illuminatrix.* Saec. xv.

> Became a member of the Gild at Bruges in 1470.—*Laborde*,
> 82.—*Kirchhoff*, 189.

ZABARELLIS, FRANCISCUS DE. *Copyist.* Saec. xiv.

> Wrote, apparently from the Lecturer's dictation or notes:
> "Recollectæ sub Domino Joanne de Lignano iuris utriusque
> Doctore famosissimo Scriptæ per me Franciscum de Zabarellis
> de Padua tunc actu audientem et scribentem sub eo Anno
> MCCCLXXX in ciuitate Bononiæ." Johannes de Lignano died in
> 1383 at Bologna. This note is prefixed to the title of the
> volume which contains the commentaries of Johannes de Lignano
> on the second book of the Decretals. A portion of the book was
> copied by Tedaldi (*see* TEDALDI).—*Bandini: Catal. Biblioth.*,
> *Leopoldina-Laurentianæ* (Cod. liii.).

ZACCARIA, NICOLO. *Copyist.* Saec. xv.

> *Cittadella: Notizie, &c.,* 179.

ZANCHANI, ZORZI. *Copyist.* Saec. xv.

> Wrote " La Divina Commedia de Dante Alighieri con commento
> di Benvenuto d' Imola." Large folio, vellum, 433 ff., 2 and 3 cols.

With miniatures, borders, and initials; splendidly executed, and in perfect preservation. On one cover is the name Claudius Monanni, in gold letters. On fol. 1 : "Qui inchomincia la vitta chostumi de lo excellente poeta vulghari Dante Aleghieri di Firenze honore et gloria de lidioma Fiorentino scripto e chomposto per lo famosissimo huomo messer Giovanni Bochaccio di Ciertaldo poeta Fiorentino," &c. On fol. 10 *v.* : "Zorzi Zanchani lo scripto per amore. Per quel da Certaldo e Dante al suo honore." Then begins the text of the commentary with the rubric : "Commendatio in honorem et laudem magnifici et potentis domini dñi Nicolai illustris Marchionis Estensis Ferrare," &c. At the beginning of the eight cantos of the "Inferno" are as many charming little miniatures within the initials. From the ninth to the eighteenth only the sketch has been put in, with one exception. The rest are blank. The lines concerning illumination run thus : Canto xi., fol. 216 *v.* :—

> "O dissio lui non setu Hodorissi
> Lonor di Gubbio lonor di quellarte
> Che luminar chiamata e in Parissi
> Frate dissegli piu ridon le charte
> Che pennelegia Francho Bolognese
> Lonor et tutto or suo e mio imparte."

The last line makes quite a different sense from the ordinary reading. The MS. is now in the National Library, Paris, No. 70,022 (Italian MSS., 9).—*Paris: Les MSS. françois de la Bibl. du Roi*, i. 266. Marsand attributes the MS. to the end of the fourteenth century ; Paris to the beginning of the fifteenth. Batines says : " Apostolo Zeno, who speaks at considerable length on this MS. (bought in 1699 from a Florentine), in a letter to Fontanini (Lettere, 331–3, ed. 1785), says it is of the end of the fourteenth, and that the writer was Giorgio Zanchani, a noble Venetian."—*Batines Biblioteca Dantesca*, ii. 240.

ZBYSČK (ZBINKO) VON TROTTINA. *See Trotino.*

ZINCKE, CHRIST^N. FRED. *Miniaturist.*

Saec. XVII. et XVIII.

Born at Dresden about 1684, and came to England in 1706.

He studied enamel-painting under Boit, and soon surpassed his master, rivalling even Petitot. For many years he had as much business as he could execute, and at length was compelled to raise his prices from twenty to thirty guineas, in order to lessen the amount of his labours. He was particularly patronised by the late king and queen, and was appointed cabinet painter to the late Prince of Wales. The Duke of Cumberland bought several of his best works, including the beautiful copy of Mary, Queen of Scots, by Isaac Oliver. He died 1767.—*Walpole : Anecdotes of Painting in England,* iii. 29 (Wornum).

ZINTICKY, NIKLAS. *Illuminator.* Saec. XV.

Mentioned as member of the Painters' Gild in Prag about 1440.—*Grüber : Die Kunst des Mittelalters* in *Böhmen.* Wien, 1871. 4°.

ZIRALDI, or GIRALDI, } GULIELMO. *Miniaturist.* Saec. XV.

One of the illuminators of the Choir-books of the Cathedral of Ferrara, and referred to in the Expense-books of the Dukes of Ferrara, now in the Palatine Archives at Modena. In 1456 he received " per sua merzegna de aminiare quinterni cinque (5 quires) de el breviario de lo Ill^{mo}. S.N. in ragione (at the rate) de soldi sedese el quinterno ;" and in 1465 is called " Magister Gulielmus de Ziraldis, aminiator, filius quondam Magistri Joanis de Ziraldis dicti Magro," and elsewhere (*see* ANTONIO DA MILANO).—*Cittadella : Documenti, &c.,* 179-181. Painted a Breviary for a Duke of

Modena. Petr. Adolf Winkopp mentions in his "Bibliothek für Denken und Männer v. Geschemack," vol. i. pt. 4, in the "Nachricht von Italienischen Städten," s. 353 ff., an Expenses Register in the ducal counting-house in Modena, in which the expenses of the Dukes Leonello Borso and Hercules I. are entered, in the fifteenth century, for manuscript work, is mentioned, among whom the only one named for miniature-painting is Francesco di Rossi, of Mantua, and Taddeo Crivelli, for the copying and illumination of the two large folios in the library, received 1,375 ducats, and the painters, Wilh. di Magri and Wilh. Ziraldi, for a Breviary, 190 ducats.—*Winkopp*, in *Breitkopf*, ii. 150, 1. Note.

ZMOLKA, JOHANNES. *Illuminator.* Saec. XVI.

A Monk and Preacher.

"Pingebat et libros illuminabat."—*Archiv für Oestersreichen Geschicht Quellen, der Wiener Akademie*, xlix. 367.—*Wattenbach: Das Schriftwesen, &c.*, 305.

ZÖLLNER, MART. *Copyist.* Saec. XVI.

A Monk of St. Martin's at Köln.

Named among copyists at that monastery.—*Ziegelbauer: Hist. Rei Litter. O. S. Bened.*, i. 520.

ZONEBECK, HEINRICH. *Copyist.* Saec. XV.

Monk of St. Martin of Cologne, under Abbot Adam (Villicus).

Cahier : Biblioth., 140.—*Ziegelbauer : Historia Rei Litterar. Ord. S. Bened.*, ii.

Zoppo, Paolo. *Miniaturist.* Saec. xvi.

A skilful Miniaturist of Brescia.

Ridolfi relates that he died at Desenzano, on his way to Venice, of grief, caused by the breaking of a beautiful crystal basin which he was carrying as a present to the Doge Gritti (1538–1545), and on which, after long and patient labour, he had depicted the sack of Brescia, giving the portraits of Gaston de Foix, and other leaders engaged in that enterprise.—*Ridolfi: Vite de' Pittori Veneti, &c.,* i. 246. (Venice, 1648. 4°.)

Zuccaro, }
Zucchero, } Federigo. *Miniaturist, &c.* Saec. xvi.

The younger brother of Taddeo Zuccaro of St. Angelo in Vado, in the Duchy of Urbino. Born 1543.

In 1550 he was taken, with his brother, to Rome, and placed under him for study, making in six years such rapid progress that he was entrusted with important work, and afterwards assisted in the decoration of the Palazzo Belvidere for Pius IV. Besides this, he painted several large easel pictures and frescoes. In 1574 he came to England, and painted the portraits of Queen Elizabeth and many other distinguished personages. He is chiefly known for his easel pictures, but miniatures by his hand are still preserved, as the beautifully-executed one of J. Duckett. Zuccaro was a man of great energy and originality, but possessing more force than depth or substance. Hence the general emptiness of his works. He was, perhaps, most serviceable in his power of stimulating others. On his return to Rome he founded, about 1595, the Academy of St. Luke, of which he was the first President.

This, however, proved a very expensive undertaking, and he travelled to Venice to paint for the Patriarch Grimani and to print certain books which he had composed. From Venice he went to Turin, where he printed his " Idea de' Pittori Scultori ed Architetti " in 1607, and began the decoration of the Ducal Gallery. The book is too metaphysical to be of much practical use to a

painter, too full of learned phraseology to be ordinarily intelligible. Lanzi, somewhat unfairly, and on the strength of the decorations of Zuccaro's own house on the Monte Pincio, which were executed chiefly by his scholars, calls him the champion of mediocrity. However this may be, it is certain that he was one of the most popular painters of his time, and employed on some of the most important works. The colossal figures of the vault of Sta. Maria del Fiore at Florence were among the commissions executed by him. Baglione admired his versatility, for he was philosopher, poet, sculptor, and architect, as well as painter, but more admired his good fortune, in which he surpassed all his contemporaries. This distinction he owed mainly to his personal qualities, his noble bearing, his encouragement of letters, his faculty of attaching others to himself, and to his liberality, which led him to spend generously the large sums he obtained for his works.

But, notwithstanding the portraits and miniatures which he painted in England, his chief recommendation in this country is that he was really the influential master of Isaac Oliver, and effected the change from the ancient manner of Hilliard which Oliver had hitherto followed to the more rounded and vigorous style of modern painting. Zuccaro died on his way from Parma and Loretto to his native place at Ancona in 1609, aged sixty-six. —*Lanzi: Storia Pittoria, &c.,* ii. 93 ; iii. 153 (Firenze, 1822, 8°). —*Walpole: Anecdotes of Painting, &c.,* i. 161 (Wornum).— *Félibien : Entretiens sur les Vies, &c.,* iii. 300-304 (Trevoux, 1725).

ZUCHENRAUNFT. *Copyist.* **Saec. xv.**

Copied "Evangelia IV. cum prologo Scti. Hieronymi." Vellum. 8°, 142 ff. At end: "Expliciunt evang. iv. evangelistarum per me Johannem Zückenräunft fer. 4 post diem S. Nicholai a. 1432." Now in the Royal Library at Munich, Cod. lat., 3,723.—*Steichele: Archiv für die Geschichte des Bist. Augsburg,* i. 111.

ZURKE, HERMANNUS. *Copyist.* **Saec. xv.**

Wrote "Isagoge in Johannetium," &c. At end : "Expliciunt Ysagoge in Johannecium una cum questionibus huic operi valde

necessariis Anno Dñi millesimo cccc° quinquagesimo viij° vicesimo tercio die mensis Decembris in vico Draconum, Sarum. Hermannus Zurke, alias de Grypess-valdis scripsit." Also, in same volume, "Questiones in Galeni Zegni siue artem parvum." At end : "Expliciunt, &c. Anno domini M.cccc.lix. tercio decimo die mensis Marcii per Hermannum Zurke, alias de Grypess-Waldis." Now in Merton College, Oxford.—*Coxe : Catalog. Codicum MSS. Collegii Mert.*, 106, No. cclxviii.

ZUTPHANIA, ARNOLDUS DE. *Copyist.* Saec. XV.

Wrote "Johannis Paschal Homeliæ de Sanctis. Scriptæ per manus Arnolde (Alemanni) de Zultphania." Paper. Now 7 B. 1, Royal Library, British Museum.—*Casley*, 121.

ZWICKE. *Miniaturist.* Saec. XVII. et XVIII.

Born 1684. Son of a goldsmith of Dresden.

Came to England in 1706, and studied for a short time under Boit. Died, 1767.—*Redgrave: Dict. of Artists of the English School.*

APPENDIX.

As some indication of the mass of materials which have come to hand during the publication of the Dictionary, I append the following list of names, each of which implies some important addition or correction. Considering the bulk of the volume just completed, and that my publisher has pledged himself to three volumes, I regret that I cannot do more than give the list as it stands. It is not likely that very many names of the highest rank are overlooked, though many, no doubt, both of professional copyists and amateurs, may still be found. Librarians and those who have access to Collections of MSS. will be able to continue the tabulation.

Abraham, Pierre, cop., s. xv.
Adalbaldus, cop., s. ix.
Adam, calligr., s. viii.
Adelheid, calligr., s. xi.
Agiped, calligr., s. x.
Agustin, calligr. and cop., s. xvi.
Alamania, Andreas de, cop., s. xv.
Albertus (1), cop., s. xiv.
Albertus (2), cop., s. xiv.
Alençon, Marguerite d', patron, *see* SAVOIE.
Alexandria, Matt. de, cop., *see* MATTEO.
Alouisius, min., s. xvi.
Aloysio, min., *see* TERRANOVA, MATT. DI.
Alphonso III., K. of Portugal, patron, s. xiii.
Alphonso V., K. of Aragon, *see* ARAGON.
Amadio, Ambrogio, min., s. xvi.
Ambrosius, cop., s. xv.
Amsterdam, Enrico di, min., *see* SENCA PAURA and CORVINUS.
Andreas, Minimus, cop., s. xv.

Andreis, Fra Andreas de, cop., s. xvii.
Anjou, Louis I. of, K. of Sicily, patron, s. xiv.
Anna, calligr., s. xvi.
Ansano di Pietro, min., s. xv.
Anseher, cop., etc. (?).
Anthonius, *see* ANTONIUS and MARIUS.
Antonio di Girolamo, min., s. xvi.
Antonio di Mario, cop., s. xv.
Antonius, cop., s. xv.
Antonozzi, A. Maria, min., s. xvii.
Antonozzi, Leopardo, calligr., s. xvii.
Appiano, Don, min., s. xvi.
Aquila, Antonio de, cop., s. xv.
Arbalestre, Guill., cop., s. xv.
Armannus, cop., s. xv.
Arnoldus, cop., s. xiv.
Arretinus, Joannes, cop., s. xv.
Arroya, Diego de, illum., s. xvi.
Astezan, *see* NICOLAS ASTESANUS.
Assicus, calligr. (?).
Atenoff, calligr., s. xi.
Attavante, degli Attavanti, min., s. xv. and xvi.

Aubert, David, cop., s. xiv.
Aubriet, Claude, min., s. xvii.
Aubriet, L. F., min., s. xviii.
Augustin, Johann, min., s. xvii.
Augustinus, cop., s. xv. (1.)
Augustinus, cop., s. xv. (2.)
Aunoi, G. d', *see* ROSE.
Avila, Rodericus de, cop. xvi.
Aylward, cop., s. xv.

Baerts, Jo., cop., s. xv.
Baeurenfeind, Michel, calligr., s. xviii.
Bagnel, Jehan, cop., s. xv.
Balbus, N., min., s. xvi.
Balus, Frater Joh., cop., s. xvi.
Barbor, min., s. xviii.
Baretta, min., s. xvi. ⎫
Berretta. ⎭
Baring, Hen., cop., s. xv.
Bartolis, Bart. de, cop., s. xiv.
Bartolommeo, min., s. xv.
Bastiano, painter, etc., s. xvi.
Beale, Mary, min., s. xvii.
Beaugrand, B. de, calligr., s. xvi.
Becaro, Franc, cartogr., s. xvi.
Bedford, John, Duke of, patron, s. xv.
Beindt, Abbess of, *see* VERENA.
Belin, *see* HUGUENIN.
Bellefosse, Raoulet, cop., s. xv.
Belvis, Alphonso de, calligr., s. xvii.
Benedetto, Ser, min., s. xvi.
Benes, illum., s. xiv.
Benincasa, Gratioso, illum. and cartogr., s. xvi.
Benvenuti, Giamb., min., s. xvi.
Bergis, Antonius de, cop., s. xv.
Bernard, calligr., s. xviii., xix.
Bernardus, Januensis, cop., s. xv.
Bernyer, Ivo, illum., s. xv.
Beretta, *see* BARETTA.
Berry, Jean de, patron, s. xiv.
Berthold, Abbot of Weingarten, patron, s. xiii.
Bertram, Antonio, calligr., s. xvii.
Bessarion, *see* TURRIS, P.
Biagio, *see* BLAZIO.
Bicene, Gilles de, min., s. xvi.
Billing, Robert, cop., *see* ANCIAU DE CENS.

Bingham, *see* SMITH.
Birago, Pietro.
Biragus, Joh. Petrus, min., s. xv.
Bissutio, Leonardo di, min., s. xv.
Bisucci, min., s. xv.
Black, Solomon, min., s. xviii.
Blasio. ⎫
Blasius, min., s. xvi. ⎭
Blasius, Ragusensis, cop., s. xv.
Blazio di Napoli.
Bochout, Leonard von, cop., s. xvii.
Boit, Chas., min., s. xviii.
Bologna, Nicolo da, min., s. xiv.
Bolognese, Marsilio, min., s. xv.
Bolswaert, Nicolas di, *see* FRISIA.
Bonattus, cop., s. xv.
Borch, Vander, *see* VANDER BORCH.
Botoniates Nicephorus, calligr., s. xi.
Botticelli, Sandro, painter, etc., s. xv.
Boucher, F., painter, etc., s. xvi.
Bourbon, Chas. Duc de, patron, s. xvi.
Bourbon, Louis Duc de, patron, s. xv.
Boystelen, Cornelius, calligr., s. xvii.
Brame, Paulo, min., s. xv.
Brancalupus, Rodolphus, cop., s. xv.
Brechtel, Stephan, calligr., s. xvi.
Bregentz, *see* BRIGANTIA.
Breda, Nicolaus de, cop., s. xv.
Bretagne, Anne de, patron, s. xv.
Brigantia, Dionysius de, illum., s. xv.
Broquet, Jean, cop., s. xvii., *see* BEAU-JARDIN.
Bruges, Jean de, min., s. xiv.
Brugeois, Martin le, illum., s. xv.
Bry, Theodore de, calligr. and eng., s. xvi.
Buchinger, M., calligr., s. xvii.
Burgkmair, H., min., etc., s. xv. and xvi.
Bursa, Seb., cop., s. xv.
Bynnynch, Simon, min., s. xv. and xvi.

Calvaionis, Philippus, cop., s. xv.
Camançarinis, Jacobus de, cop., s. xv.
Camphaing, Arnulphus, cop., s. xiii.
Canes, P. de, *see* ARBALESTRE.
Canetti, Domenico, min., s. xv.
Canini, Henri, calligr., s. xvii.
Caporale, Giacomo, min., s. xv.

Capua, Jacobello da, cop., s. xv.

Carminatis Vivianus de, *see* VIVIANUS.

Carnesecchi, patron, s. xiv.

Carolo, Johann, calligr., s. xvii.

Carpi, Ugo da, *see* FANTI.

Castelli, Bernardino, min., s. xvi.

Castello, Francesco, min., s. xv.

Castello, Michele da, min., s. xvi.

Castro, Fra Lorenzo de, min., s. x.

Cavallini, Pietro, cartogr., s. xvii.

Cerasius, Gherardus, cop., s. xv.

Cexano, Franc., and Alvixe, cartogrs., s. xvi.

Chabot, Anne, Duchesse de Rohan, *see* ROHAN.

Champdivers, *see* HUGUELIN.

Charlemagne, patron, s. viii. and ix.

Chas. IV., Empr. of Germany, patron, s. xiv.

Cherico, Francesco d'Antonio del, min., s. xv.

Chicot, J. D., calligr., s. xviii.

Chose, Geoffroi, cop. and illum., s. xiv.

Christoforus, cop., s. xi.

Ciagnoni, Bernardino Michelangelo, min., s. xv.

Cignoni, Bernardino, min., s. xv.

Cisneros, *see* XIMENEZ.

Clouet, Franç., min., s. xvi.

Clouet, Jehan, min., s. xvi.

Cocker, Edward, calligr., s. xvii.

Cola di Giovanni, *see* NICOLA.

Colin, Jehan, cop., s. xv.

Colonna, Giov., cop., s. xv.

Como Alessandro di, min., s. xvi., *see* MASSARELLI.

Conchello, Don Paolo, min., s. xv.

Constancio Fray, *see* OLIVAS, FRA CONST. DE MONTE.

Constantius ?

Conty, Estienne de, patron, s. xiv. and xv.

Corbizzi, Littifredi de, min., s. xvi.

Cornaro, Federigo, patron, s. xvii.

Corsinus, B. D., cop., s. xv.

Corvina, Dama Maddalena, min., s. xvii.

Corvinus, *see* MATTHIAS CORVINUS.

Cosway, Richd., min., s. xviii.

Court, Jehan le, cop., s. xv.

Cousin, Jean, min., etc., s. xvi.

Coutere, Nicolaus de, cop. or min., s. xv.

Cozzarelli, Guidoccio, min., s. xv.

Cresci, Giov. Francesco., calligr., etc., s. xvi.

Crespano, *see* HIERONYMUS.

Crivelli, Taddeo, min., s. xv.

Crovato, Jeronimo, cop., s. xv.

Cruceius, Frater Peregrinus, cop., s. xvi.

Curione, Ludov, cop., s. xvii.

Curolo, Johann, calligr., s. xviii., *see* CAROLO.

Cynicu, cop., s. xv.

Cyrri, Gaspar, co., s. x.

Damiano, Fra, *see* GENOA.

Damoiselet, Etienne, calligr., s. xvii.

David, Geeraert, min., etc., s. xv.

Delarue, P., *see* RUE, P. DE LA

Despres, J., *see* PRES, JOSQUIN DES.

Dijon, Perreis de, min., s. xv.

Dinteville, François de, patron, s. xvi.

Du Chesne, J., *see* CHESNE, JEAN DU.

Du Jardin, Guillaume, *see* VIRIDARIO.

Dupipe, *see* PIPE DU.

Durand, Abraham, cop., s. xv.

Duval, *see* VAL DU.

Eaubonne, D. Dom., ill., s. xvii.

Ebesham, Wm., cop., s. xv.

Egbert, Abp., patron, s. x.

Enguerrand, *see* INGELRANNUS.

Erbach, Nycolaus de, cop., s. xv.

Erebonus, cop., s. xi.

Ernaldus, cop., n. d.

Este, Family of, patrons, s. xv., xvi.

Etienne, Angevin, MS. agent, s. xv.

Euthionius, cop., s. xv. (?)

Faenza, Marco da, min., s. xvi.

Fanti, Sigismundo, calligr., s. xvi. } Fanto.

Ferdinand, Duke of Calabria, patron, s. xv.

Festa, Constanz, min., s. xvi.

Ficino, Girolamo, min., s. xvi.

Fiorin, Nicolo, cartogr., s. xvi.

Florens, T., cop., s. xv.

Florentia, Jacobus de, *see* CAMAN-CARINIS.

Florentia, Rainerus de, *see* RAINERUS.

Florio, Fr., cop., s. xv.

Fortunato, cop., s. xv.

Fossa, Petr. (Camœracensis), cop., s. xv.

Foulques, cop. and illum., s. xi.

Francesco, *see* ROSELLI.

Francesco, *see* LIBRI DAI.

Francesco, d'Antonio, min., s. xv.

Franchi, Cesare, min., s. xv.

Francken, Paul, calligr., s. xvii.

Francon, cop., s. x.

Frisia, Nicolaus de, cop., s. xv.

Fuente del Saz, Fray Julian de la, illum., s. xvi., *see* LEON, FRAY ANDRES DE.

Fugger, Wolfgang, calligr., s. xvi.

Fullole Regnault, cop., s. xv.

Gaignières, Roger de, patron, s. xvii.

Gallonde, calligr., s. xviii.

Gangneur, Guill^me le, cop., etc., s. xvi.

Gangneur, Guill^me le, min., s. xvii.

Gaspar, cop., s. xv.

Gatari, Andrea di, cop., s. xv.

Gello, cop., s. xv.

Genoa, Damiano da, min., s. xv.

Gerbier, B., min., s. xvi. and xvii.

Gerardus, Abbot of Noyon, cop., s. xiii.

Gerardus, Abbot of Luxueil, calligr., s. viii.

Ghisleriis, *see* GUISLERIIS and QUISLERIIS.

Gibson, Willm., min., s. xvii.

Gilbert, L., calligr., s. xviii.

Giovanni, Francesco di Mariotto, min., s. xvi.

Giovanni, di Bartholomeo Nicholi, cop., s. xiv.

Giovanni, di Taldo, min., s. xv.

Girard, cop., s. xiv.

Giuliano, *see* JULIANUS.

Giunta, cop., s. xv.

Girolamo, di Giovanni, min., s. xv.

Gobelin, Io. de Lintz, cop., s. xv.

Gratus, cop., s. xv.

Guisleriis, Barthol., cop., s. x.

Gulielmus, cop., s. xiv.

Guspertus, Steph., cop., s. xv.

Gyghelin, Gerardus de, cop., s. xv.

Hall, Pierre Adolphe, min., s. xviii.

Hasselt, J., cop., s. xv.

Hayman, book-illustrator, s. xviii.

Heins, John, min., s. xviii.

Henris, illum., s. xiii.

Henzola, Philip, cop., s. xv.

Herrad von Landsperg, cop. and illum., s. xii.

Heyder, Bartholdus, cop., s. xv.

Hildebrant, Jean, illum., s. xvi.

Hilliard, Nicholas, min., s. xvi.

Hoefnagel, George, min., s. xvi.

Holt, John, cop., s. xv.

Holtmann, Joh., calligr., s. xvi.

Horn, H., cop., s. xv.

Hugh, illum., s. xii. (?)

Ingelrannus, cop., n. d.

Inglis, Esther, calligr., s. xvi.

Jacobus, cop., s. xv.

James, Thomas, patron, s. xv.

Jaquotin, cop., s. xv.

Jardin du, *see* VIRIDARIO.

Jeronimo, cop., s. xv.

Job, Leonardus, cop., s. xv.

Johannes, cop., s. xv.

Judenburga, cop., s. xiv.

Julianus, cop., s. xv.

Julius II., patron, s. xvi.

Koorten, Joanna, min., s. xvii.

La Fosse, min., s. xvii.

Lamesa, Lazarus de, cop., s. xv.

Langlois, Jehan, cop., s. xiv.

Langres, Jehan, cop., s. xv.

Lens, Bernard, min., s. xviii.

Ligozzi, min., s. xvi.

Leonardus, *see* BOCHOUT.

Leotard, *see* LIOTARD.
Limburc, Paul de, illum., s. xv.
Liotard, Jo. Stephan, min., s. xviii.
Lippo di Vanni, *see* VANNI.
Liresani, Nicolo, min., s. x. (?).
Lives, Bartolomeo, cartogr., s. xvi.
Loffelholcz, Joh., cop., s. xv.
Loggan, min., s. xvii.
Lorenzo, Spirito, *see* SPIRITO.
Luca, Phil. de, cop., s. xiii.
Lucarelli, Fr., cop., s. xiv.
Lucino, Paulo di, cop., s. xv.
Ludovicus, Vicentinus, cop., s. xvi.
Lupo, Thomas, cartogr., s. xvii.

Mados, Jeh., calligr., s. xiii.
Maisereulles, Philip, illum. and cop., s. xv.
Manby, cop., s. xv.
Manetti, Gian., patron, s. xv.
Mannellis, Jacobus M. de, cop., s. xv.
Marchio, cop., s. xv.
Mariani, Valeriano, min., s. xvii.
Marinis, Christoforus de, cop., s. xv.
Marius, Antonius, cop. and illum., s. xv.
Marmion, Simon, illum., etc., s. xv.
Marolles, Philip, illum., s. xv.
Martinez, Joan, cartogr., s. xvi.
Martius, Jo. Franc., cop., s. xv.
Mauro, Fra, cartogr., s. xv.
Mayer, F., calligr., xviii.
Mazzolino, L., *see* ORTOLANO.
Medici, Lor., patron, s. xv.
Meghen, Petrus, illum. and cop., s. xvi.
Melgar, N., cop., s. xvii.
Melisa, Joh., cartogr., s. xvi.
Melzo, Francesco, min., s. xvi.
Mielich, } Hans, min., s. xvi.
Mülich, }
Mielot, Jean, cop., s. xv.
Mocenigo, patron, s. xv.
Moeller, Arnold, calligr., s. xvii.
Montausier, patron, s. xvii.
Montgomery, Duc de, patron, s. xvi.

Napoli, Zuan de, cartogr., s. xvi.
Naso, Ludovico, cop., s. xvi.

Nesscher, Hermann, cop., etc., s. xvii.
Netcher, *see* NESSCHER.
Nicolai, Nicolas de, calligr., s. xvii.
Nicephorus, *see* BOTONIATES.
Nicholas, Prior de Muriano, calligr., s. xv.
Nicholas, illum., s. xvi.
Nogari, Paris, min., s. xvi.
Norgate, E., illum., s. xvii.
Nydero, Joh., cop. and illum., s. xv.

Pacy, G. de, cop., s. xv.
Parmensis, Cassius, *see* CASSIUS.
Pasqualin, Nicolo de, cartogr., s. xvi.
Paul, Jehan, cop., s. xvi.
Periccioli, Franc., cop., s. xvii.
Piero, cop., s. xiv.
Portogalexe, Gineo, cartogr., s. xvi.
Prag, Theodoric de, calligr., s. xiii.
Prevost, calligr., s. xviii.
Pugliesi, Gherardo, cop., s. xiv.

Quedlinburg, Johannes de, calligr., s. xi.
Quisleriis, *see* GUISLERIIS.

Remiet, illum., s. xiv. (?)
Rico, Andreas, cop., s. xii.
Rigot, Jehan, illum., s.xv.
Rodulfus, cop , s. xi.
Rolandus, cop., s. xii.
Roseli, P., cartogr , s. xvi.
Rosenbach, Jo., cop., s. xv.
Rossi, Francesco, called Salviati, min., s. xvi.
Rothelin, l'Abbe de, patron, s. xviii.
Rovere, della, Family, patrons, s. xv.
Roydault, Theod. du, calligr., s. xvii.
Ruffinus, Henrictus, cop., s. xv.

Salahardus, cop., s. ix.
Salviati, Card., patron, s. xvi.
Sandro, cop., s. xv.
Scarperia, Luca dalla, cop., s. xv.
Schenk, Sixtus, cop., s. xvi.
Senault, L., calligr., s. xvii.
Serantonj, Pietro, cop., s. xv.
Sigon, Abbot of St. Florent, illum., s. xi.

Soligo, Christofano & Zuan, cartogrs., s. xvi.

Spirito, Lorenzo, cop., s. xv.

Stavelot, Jeh. de, cop., s. xv.

St. Cesari, Hugues de, illum., s. xv.

Theodore, Abp. of Canterb., patron, s. xi.

Ursins, Joh. Juvenal des, patron, s. xv.

Vannuccori, Lod., cop. and illum., s. xv.

Vendôme, *see* BOURBON.

Walack, Gotfrid, cop., s. xv.

Waldiadus, cop., n. d.

Wilfrid, Abp. of York, patron, s. ix.

Willelanus, Anglicus, cop., s. xii.

Wittelo, cop., s. xii.

Yvo, Homo, cop., s. xiv.

My acknowledgments are again due to the gentlemen, many of whom are personally unknown to me, who have kindly assisted me with information, or have responded to my inquiries. Among them, I have especially to thank Professor Westwood and J. R. Morfill, Esq., of Oxford; M. R. James, Esq., Fitzwilliam Museum, Cambridge; Admiral Greville; and all the gentlemen at the British Museum, who always and unweariedly have helped me to the utmost of their power. To E. B. Nicholson, Esq., of the Bodley Library, Oxford, I am greatly indebted for the most courteous and patient attention and help. Also to J. E. Tinkler, Esq., of Chetham's Library, Manchester. And not least, to several American gentlemen, who possess valuable MSS., which they have described for me. Lastly, to my reviewers, from all of whom I have received valuable suggestions and advice.

J. W. B.